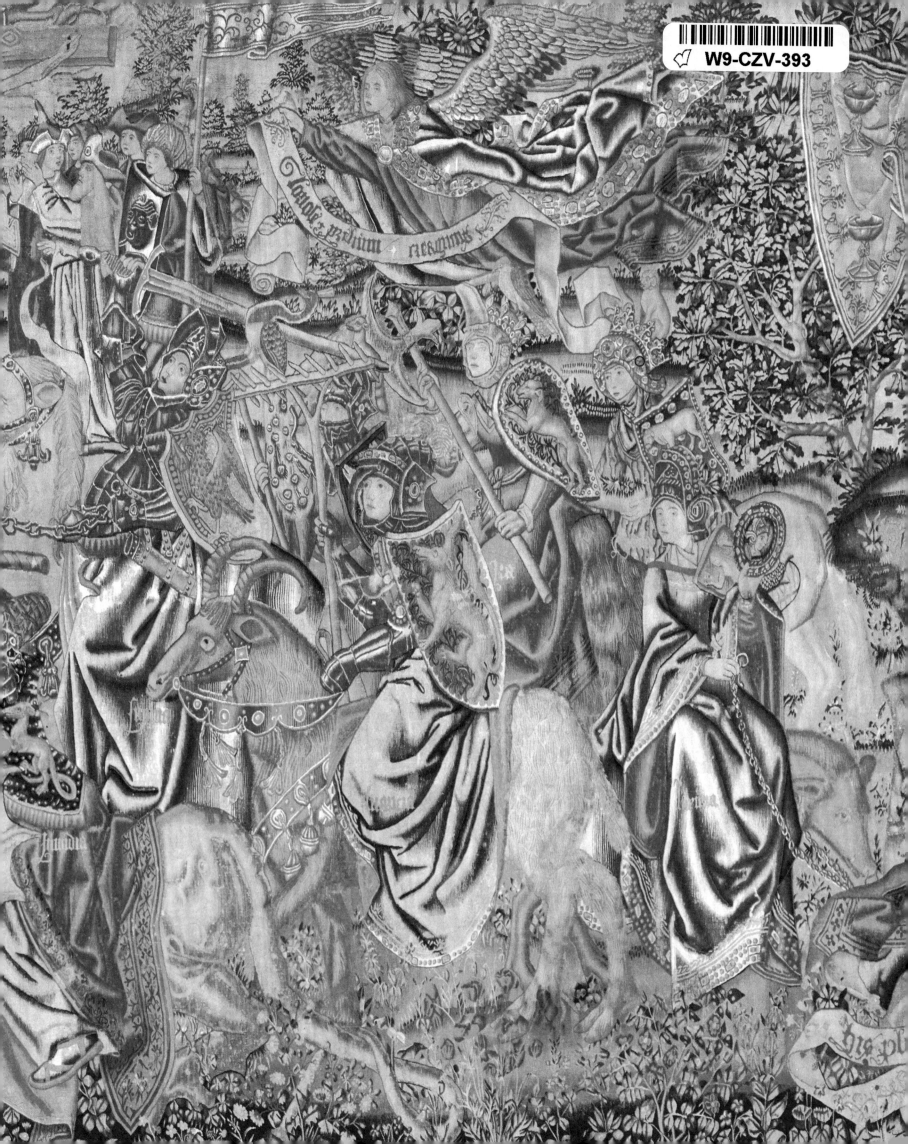

Hearst

the Collector

Hearst

the Collector

MARY L. LEVKOFF

✣

Abrams, New York

Los Angeles County Museum of Art

This catalogue was published in conjunction with the exhibition *Hearst the Collector*, organized by the Los Angeles County Museum of Art and made possible in part by the William Randolph Hearst Foundation. The exhibition was held at LACMA from November 9, 2008, to February 1, 2009.

This catalogue was made possible in part by the Andrew W. Mellon Foundation.

For the Los Angeles County Museum of Art
Directors of Publications: Nola Butler and Thomas Frick
Editor: Karen Jacobson
Designer: Katherine Go
Photography: Steve Oliver
Rights and Reproductions: Cheryle T. Robertson with Devin Flanigan
Proofreader: Dianne Woo
Indexer: Kathleen Preciado

For Harry N. Abrams, Inc.
Production Manager: Jules Thomson

Library of Congress Cataloging-in-Publication Data

Levkoff, Mary L., 1953-
 Hearst, the collector / by Mary L. Levkoff in association with the
Los Angeles County Museum of Art.
 p. cm.

 Includes bibliographical references.
 ISBN 978-0-8109-7283-4 (Abrams edition)
 ISBN 978-0-8109-8243-7 (LACMA edition)
 1. Hearst, William Randolph, 1863–1951—Art collections. 2. Art—Private collections—United States. I. Los Angeles County Museum of Art. II. Title.

 N5220.H47L48 2008
 709.2—dc22
 2008018763

Printed and bound in China
10 9 8 7 6 5 4 3 2 1

Abrams books are available at special discounts when purchased in quantity for premiums and promotions as well as fundraising or educational use. Special editions can also be created to specification. For details, contact specialmarkets@hnabooks.com or the address below.

HNA ■■■■
harry n. abrams, inc.
a subsidiary of La Martinière Groupe
115 West 18th Street
New York, NY 10011
www.hnabooks.com

Jacket front: View of the armory in Hearst's apartment at the Clarendon, New York, c. 1929. Reproduced from the Collections of the Library of Congress. Jacket back: Sitting room of the Doge's Suite, Hearst Castle. Photograph by Victoria Garagliano/© Hearst Castle/CA State Parks. Endsheets: *Combat of the Virtues and Vices* (detail), from the Redemption of Man series, Southern Netherlands (Brussels), 1500–1515 (cat. no. 33); *The Apostles' Creed* (detail), Europe, c. 1550–1600 (cat. no. 35). Pages 2–3: Paul Vredeman de Vries, *Interior of a Gothic Church*, 1612 (cat. no. 131). Photo © 2008 Museum Associates/LACMA.

❧ CONTENTS ❧

FOREWORD

In the past twenty years the history of collecting has become an established discipline within the history of art. It began earlier, primarily as the territory of archivists who brought centuries-old documents to light. More recently, collectors as diverse as the financier Sébastien Zamet (c. 1552–1614), Cardinal Pietro Ottoboni (1667–1740), and abbé Joseph-Marie Terray (1715–1778) have been studied. Modern collectors like the Havemeyers and Rothschilds were obvious and popular subjects, and within a few short years the history of collecting moved to the forefront of museum efforts. Exhibitions devoted to Ferdinando de' Medici at the French Academy in Rome and to William Beckford and Thomas Hope at the Dulwich Picture Gallery and the Bard Graduate Center for Studies in the Decorative Arts, Design, and Culture are prime examples. The establishment of the Provenance Index at the Getty Research Institute; the *Journal of the History of Collections*, founded at Oxford University; and the Center for the History of Collecting in America, just inaugurated at the Frick Collection, all attest to the growing interest in this field.

The Los Angeles County Museum of Art now takes its place in advancing this discipline through *Hearst the Collector*. Unprecedented in its scope of objects as well as the depth of fresh new scholarship, this groundbreaking exhibition addresses many distorted preconceptions about the man who was the most fascinating collector in American history. The subject of intense speculation and international notoriety throughout his life, he was a celebrity of his own making in the vanguard of modern mass media. Yet for all the assumptions about William Randolph Hearst's "omnivorous" appetite for art, he cannot accurately be cast as an indiscriminate consumer of material culture or as a manipulator of the art market as we know it in today's hot climate of celebrity artists and status acquisitions. Hearst collected simply because he wanted to be surrounded by art in magical contexts of his own devising.

Less well known was Hearst's philanthropy. As recounted in this book, Hearst's additional role in nourishing the Los Angeles County Museum in the 1940s and until his death in 1951 stands as an exemplar for all subsequent benefactors. He and his foundations gave wholeheartedly without asking for anything in return. It was truly in the spirit of the Greek *philadora*, the love of giving. On behalf of LACMA and our visitors, I would like to express our gratitude to the Hearst Foundations, the Hearst Corporation, and the Hearst family for continuing this remarkable legacy.

Studying a man who lived and collected on a superhuman scale required a superhuman effort on the part of a single scholar. Not only embracing the totality of Hearst's efforts in collecting but presenting it within an organizational principle that restored its rational coherence as well is a remarkable achievement. The story is brilliantly interwoven with a narrative that encompasses the political, historical, and economic spheres in which Hearst moved. Mary Levkoff has brought to life the singular phenomenon that was Hearst the collector.

MICHAEL GOVAN
CEO and Wallis Annenberg Director
Los Angeles County Museum of Art

The Hope Hygieia, Roman, mid-2nd century AD (cat. no. 110).

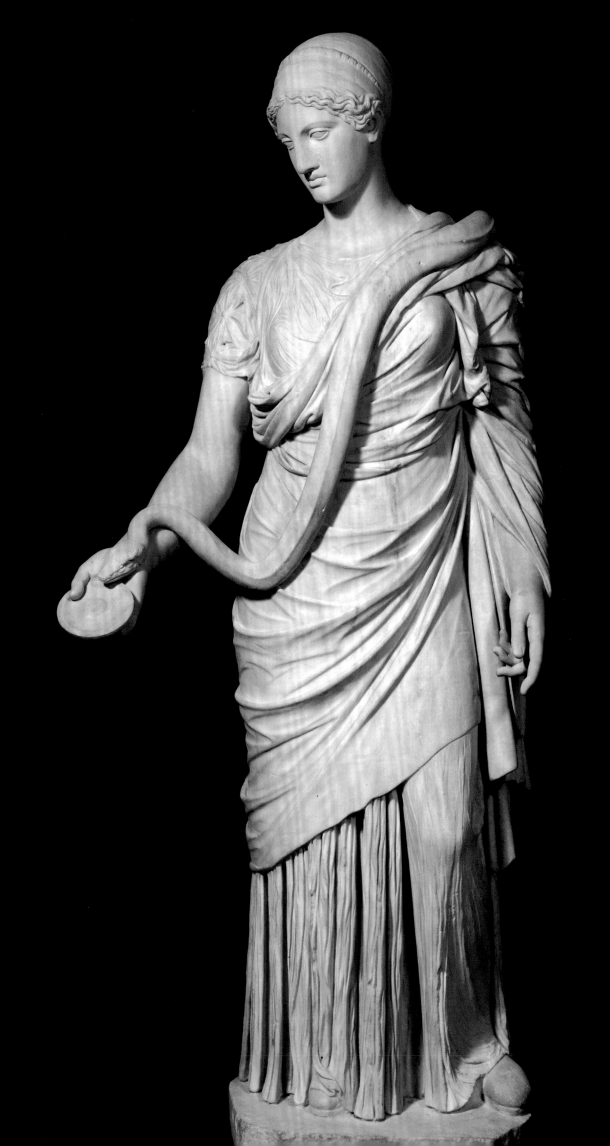

PREFACE

When William Randolph Hearst's former home was donated to the State of California by the Hearst Corporation at year's end in 1957, it was impossible to predict the ramifications of the gift. One concern was the relationship of the new public site to the sixty thousand surrounding acres that remained the property of the Hearst Corporation, for in 1958, when the castle opened to the public, the road to it twisted through a working cattle ranch, just as it does now. In Hearst Monument's formative years a larger sampling of William Randolph Hearst's exotic zoo herds populated the Hearst Ranch: zebra, tahr goat, gnu, aoudad or Barbary sheep, white fallow deer, axis deer, sambar deer, Rocky Mountain elk. Fifty years later, thanks to the stewardship of the Hearst Corporation and its concern for the environment, the fortunate visitor might still glimpse wild-roaming species that linger on the hills. Today, as in William Randolph Hearst's era, and as in the early days of Hearst Monument, cattle still abound.

In 1958 two critical questions emerged. Would enough visitors want to tour the estate to make Hearst Castle a viable operation? Could the Division of Beaches and Parks (now California State Parks) successfully manage and preserve such a complex property comprising historic architecture, art, and extensive gardens?

Both questions were answered in the affirmative quickly and decisively. Tours were sold out from the day Hearst San Simeon State Historical Monument opened to the public, on June 2, 1958. Women wearing gloves and hats and men in suits and ties acquired their tickets on a first-come, first-served basis on that June morning and throughout the early days of the castle's operation. Daily tours accommodated six hundred people; sometimes more than that number had to be turned away. (As a point of reference, today it is possible for fifty-four hundred people to experience a Hearst Castle tour in a single day.) The twin challenges of transportation and accommodation prohibited year-round operation and resulted in a five-month season for monument tours, from June through October, while the roads were passable.

To enhance the environment for visitors required ongoing organizational improvements. The first trial tour was two and a half hours long, which left participants dazed and exhausted. One hour and fifteen minutes—the current tour length—proved more manageable. Initially the large downstairs public rooms were the primary focus of tours; in subsequent years the route expanded to include the upstairs rooms and all three guesthouses in a variety of tours.

Then, as now, it was imperative to establish and maintain a balance between public access and site security. Visitors were bused to the hilltop location from the beginning, avoiding the need for individuals to drive the demanding road, which ended in an area with inadequate parking space. This also enabled management to regulate the number of people visiting the isolated hilltop site at any given time.

Guided tours—each one distinct—promoted the dissemination of information tailored to individualized interests, and also allowed the art-laden grounds and structures to remain much as they had been during William Randolph Hearst's lifetime. Operation of Hearst Castle as a historic house museum has greatly benefited from the absence of the intrusive gates, stanchions, and showcases that would have been required to protect the collection had self-guided tours been adopted.

Another constant in the castle's history is the perpetual zeal for improvement. Although construction and art-collection activities have ceased, organizational and operational changes continue. Accessibly designed tours have been developed, and special transportation has been provided. A living-history

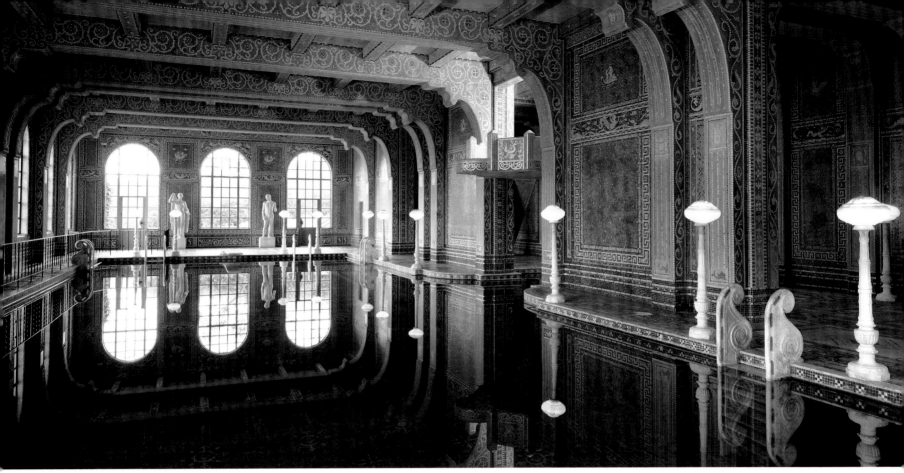

Roman Pool, Hearst Castle, San Simeon.

program features volunteers in period clothing who enliven seasonal evening tours that offer a glimpse into castle life during Hearst's era. Where originally a small trailer served to accommodate the sale of tickets, postcards, and simple snacks, a forty-six-thousand-square-foot Visitor Center now stands. It houses a sophisticated ticket office, offers opportunities for dining and shopping, features focused exhibits, and includes a large-format National Geographic Theater with daily screenings of a film that tells the castle story. Continuing innovations in collections care and art conservation culminated in Hearst Castle's accreditation in 2001 by the American Association of Museums, an achievement based on more than forty years of careful oversight.

When William Randolph Hearst left San Simeon for the last time, in 1947, construction on the hilltop estate remained unfinished. For Hearst and his tireless collaborator, the architect Julia Morgan, the estate was for nearly thirty years a work in progress, with the exhilaration of change and improvement ever on the horizon. Now, under the stewardship of California State Parks, it will always remain a work in progress, a place preserved but vital, alive with visitors eager to experience the architecture, the art, and the gardens of Hearst Castle.

This exhibition, which includes a significant selection of the art from San Simeon, provides additional opportunity to investigate, within a larger context, the unique perspective of William Randolph Hearst the collector.

HOYT FIELDS
Museum Director
Hearst Castle

ACKNOWLEDGMENTS

Many people participated in the realization of this book and the exhibition that it accompanies. Acknowledging their contributions is a great pleasure.

Frank A. Bennack Jr., CEO of Hearst Corporation and director of the William Randolph Hearst Foundation; William R. Hearst III, president of the William Randolph Hearst Foundation; Gilbert Maurer, director of the William Randolph Hearst Foundation; and Paul "Dino" Dinovitz, executive director of the Hearst Foundations, provided essential support to realize the exhibition, and Hearst Corporation director Stephen Hearst graciously allowed me to consult several corporation documents that pertain to Hearst's collections. Brennan Zerbe facilitated the loans of Hearst Corporation objects in the exhibition. Brian Schwagerl, vice president, real estate and facilities planning, Hearst Corporation, offered his encouragement. The goodwill and advice of Mitchell W. Barrett, Hearst Corporation special projects manager, were of inestimable value. Thomas Eastham, former vice president and western director of the William Randolph Hearst Foundation, long advocated an exhibition of this type. Special acknowledgment of the friendship and support of Anissa B. Balson, director of the William Randolph Hearst Foundation, must be made. She inspired me with a paradigm of excellence, encouragement, and commitment fully in keeping with William Randolph Hearst's unique legacy.

Hoyt Fields, museum director, Hearst Castle, championed this exhibition. Without him, the project could never have approached the level of completeness that it attained. Also at Hearst Castle, Jana Seely, Jeff Payne, Vickie Garagliano, Victoria Kastner, and Beverly Steventon facilitated my work. Their solidarity was extraordinary. At the Julia Morgan archive (Special Collections of the Robert E. Kennedy Library of California Polytechnic State University, San Luis Obispo), Nancy Loe, Catherine Trujillo, and Ken Kenyon assisted my research with grace and generosity. At the World College of the Atlantic, housed in Saint Donat's Castle, Malcolm McKenzie, Eira Purves, and Alan Hall made my visit as fruitful as possible. David Nasaw offered encouragement and advice, as well as his exemplary scholarship published in *The Chief*. Profound gratitude is owed to Carolyn H. Miner, now at Sotheby's, from whose assistance, tenacity, forbearance,

and experience I benefited for almost a year. Her insights and loyalty sustained my efforts.

At the Los Angeles County Museum of Art, particular thanks are due to Howard Fox, without whose friendship this book could not have been realized. Anne Smith, now retired from her duties as a registrar, corrected the faulty, generalized credit line of "William Randolph Hearst Collection" that was randomly assigned to about nine hundred Hearst gifts (whether they had belonged to Hearst, were purchased by him expressly for the museum, or were purchased by the museum with funds provided by his foundation) in 1965, when the art section separated from the old Los Angeles County Museum of History, Science, and Art. Much of my interest in Hearst's contribution to LACMA was encouraged in 1995, when Jane Burrell, then head of education, asked me to deliver a lecture on Hearst to commemorate the thirtieth anniversary of LACMA's inauguration as a separate institution. Steve Oliver, Tim Deegan, Ian Birnie, Janice Schopfer, Catherine MacLean, Nancy Sutherland, Chail Norton, J.-Patrice Marandel, Melissa Pope, Allison Agsten, Thomas Michie, Shannon Haskett, and Fionn Lemon lent their support. Nola Butler and Thomas Frick saw to publishing this book, while Katherine Go, as designer, took my concerns to heart. Karen Jacobson, enlisted as editor, performed her duties with compassion and intelligence.

At the Metropolitan Museum of Art, the encouragement of Olga Raggio, Stuart Pyhrr, Donald La Rocca, Jack Soultanian, Ian Wardropper, James Draper, Wolfram Koeppe, Tom Campbell, Peter Barnet, Denny Stone, Christine Brennan, Stefano Carboni, Carlos Picón, Joan Mertens, and Robyn Fleming benefited my work. Dietrich von Bothmer vividly recounted his early experiences with the Hearst collections. Colleagues at other institutions provided valuable information and assistance: Charissa Bremer-David, Mitchell Bishop, Jerry Podany, Karol Wight, Erik Risser, Jens Daehner, Claire Lyons, and Jay Gam (all J. Paul Getty Museum or Getty Research Institute); Sandra Barghini (American Museum in Britain); Alan Darr (Detroit Institute of Arts); the late Tracey Albainy (Boston Museum of Fine Arts); Brian D. Gallagher (Mint Museum of Art); Robert Wenley (Burrell Collection, Glasgow Museums); Toby Capwell (Wallace Collection); Thom Richardson (Royal Armouries);

Martin Chapman (Fine Arts Museums of San Francisco); Timothy Rub (Cleveland Museum of Art); Cassandra Albinson (Yale University Art Gallery); Joaneath Spicer and William Noel (Walters Art Museum), Shelley Bennett (Huntington Library and Art Collections); Kevin Stayton (Brooklyn Museum); Jutta Page and Andrea Mall (Toledo Museum of Art); Denise Allen (Frick Collection); Jack Hinton (Philadelphia Museum of Art); Ho Nguyen (Santa Monica Historical Society); David Kessler (Special Collections, Bancroft Library, University of California, Berkeley); Susan Oshima (Natural History Museum of Los Angeles County); and Maureen Russell (State Museums of New Mexico). I am of course especially grateful to all the contributors to the catalogue; their names appear on page 146.

Blaine Bartell (UCLA Film and Television Archive) and Cari Beauchamp contributed essential insights into Hearst's achievements in the history of moving pictures, as did Enfys McMurry for the story of Saint Donat's. Further support was offered by A. A. Donohue, Douglas Messerli, Alexis Kugel, Annemarie Jordan Gschwend, Joseph Baillio, Taylor Coffman, Russell Thomas, the late Robert Blunk, David Jaffé, Rosamond Westmoreland, Charles Janoray, Carlotta Pignatelli Monroe Chapman, Judith Sobol, Jennifer Montagu, Elisabeth Easton, Emma Hurme, Andrew J. Clark, John Stainton, Allison Whiting, Margaret Schwartz, Peter Fairbanks, John Willenbecher, Elfriede Langeloh, Gerald Stiebel, Myron Laskin, Jennifer Boynton, David Saunders, and Leonard and Nataalia Ross. My gratitude also goes to the lenders, listed at right, who made the exhibition possible.

MARY L. LEVKOFF
Curator of European Painting and Sculpture

LENDERS TO THE EXHIBITION

Dr. Dimitri and Mrs. Leah Bizoumis
Mr. and Mrs. Anthony Blumka
Brooklyn Museum
The Detroit Institute of Arts
Fine Arts Museums of San Francisco
The J. Paul Getty Museum, Los Angeles
Hearst Castle, San Simeon
Hearst Corporation, San Francisco
Huntington Library, Art Collections, and Botanical Gardens, San Marino, California
Robert E. Kennedy Library, California Polytechnic State University, San Luis Obispo
Kimbell Art Museum, Fort Worth
The Metropolitan Museum of Art, New York
Musée du Louvre, Paris
Museum of Fine Arts, Boston
National Gallery of Art, Washington, D.C.
Natural History Museum of Los Angeles County
Lynda and Stewart Resnick
Royal Armouries, Leeds
The Speed Art Museum, Louisville
Thorvaldsens Museum, Copenhagen
Toledo Museum of Art
The Walters Art Museum, Baltimore
Malcolm Wiener
Yale Center for British Art, New Haven
Anonymous lenders

Soon after I was hired by the Los Angeles County Museum of Art, in August 1989, I was told: "Half of what we received from Hearst was fake, and as for the other half, you will never find out anything else about it." This statement echoed earlier prevailing opinions. During Hearst's lifetime the eccentric tycoon around whom Aldous Huxley composed his novel *After Many a Summer Dies the Swan* was superseded by Orson Welles's indelible image of a tragic figure who amassed "the loot of the world" in the film *Citizen Kane*.[1] Observers as disparate as Umberto Eco and Madeline Caviness added more cynical remarks.[2]

For a few years I routinely challenged the authenticity of everything that had come to the museum from Hearst, until one day in Paris when I visited my friend Alexis Kugel, a brilliant young dealer whose passion for treasury objects I shared. At that time most of my colleagues associated me with my primary field of interest, French Renaissance art. Alexis said, "I have something to show you that you in particular will appreciate, but you must promise me that you will not mention it to anyone until the negotiations are concluded." Then he revealed a jewel-studded casket, clad with mother-of-pearl lozenges and framed in vermeil (cat. no. 45). I knew of this sublime masterpiece from photographs, and from a small variant preserved in the Museo Diocesano, Mantua, because I had studied the miniature box a decade earlier while researching Henri III's Order of the Holy Spirit.[3] Alexis was handling the negotiations for acquisition of the large casket on behalf of the Louvre. He called me

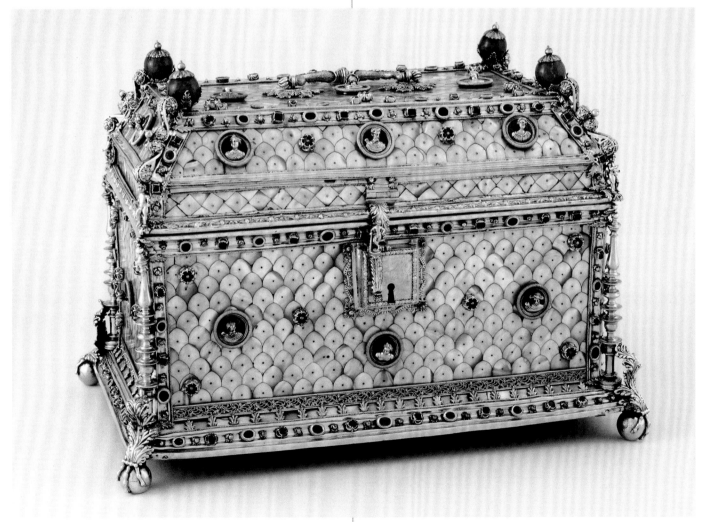

Pierre Mangot,
Casket, 1532–33
(cat. no. 45).

several months later when he was trying to secure an export license from England. The license might be obtained if he could prove that the casket had once been in an American collection, and the dealer Bernard Black told him that Black's father had bought the casket from Hearst.

Alexis's inquiry to the Hearst Corporation's office in New York was greeted with helpful cooperation, but no trace of the casket was found in their papers. Alexis now asked if I could put him in touch with Hearst Castle, where there was another inventory.[4]

Sandra Barghini, the castle's former chief curator, had extended a welcome to me in 1991, when Sylvie Béguin, the emeritus curator of Renaissance painting at the Louvre, asked me to take her there. Since then the castle's staff had continued their cordial responsiveness. I suggested to Alexis that if he still trusted me not to mention the casket, we might go to San Simeon to review the inventory together. It would be faster if two pairs of eyes searched the archive. Our request was quickly approved, and we made the 250-mile drive north from Los Angeles.

Before we began in earnest in the study room, a small bound volume labeled "Sculptures" caught my attention. Its ledgerlike pages were filled with delicately hand-ruled notations. Each listed item was illustrated by a thumbnail photograph. A dozen sculptures in LACMA's collection appeared there. They had all been in the castle. The date, price paid, and source of each object were meticulously recorded. Although the casket was not in the inventory, England granted an export license anyway, and the Louvre bought its masterpiece. With my awareness of this documentation, an unclouded view into the history of the Hearst gifts to Los Angeles opened. That is how this book began.

Next I established and clarified the provenance of myriad Hearst gifts at LACMA. Letters in the registrar's files recounted the remarkable process by which these objects had come to the old Los Angeles County Museum of History, Science, and Art. The information encouraged a random search of a copy of the somewhat daunting inventory of Hearst's warehouse in the Bronx, which had been published in about six hundred cards of microfiche in 1987.[5] On the first day, it immediately disclosed some delightful surprises: the alabaster statue of Saint Barbara in the National Gallery of Art (cat. no. 125), which had belonged to Samuel H. Kress; the terra-cotta relief of dancing maenads (cat. no. 119) that Clodion executed in 1765 in Rome;[6] and a painting of the Virgin and Child with donors by Lorenzo Lotto in the

J. Paul Getty Museum (cat. no. 129). The provenance of the statue published in the catalogue of the Kress Collection did not mention Hearst's name, nor did the catalogue of the exhibition *Art in Rome in the Eighteenth Century*, in which the relief was illustrated.[7] These lacunae suggested that further research would be fruitful. Selecting several works of art of obvious importance, I methodically located them. Then I examined photographs of the interiors of Hearst's residences. A few works of art that were known to me were easy to recognize in them. I decided to identify others.

Once a more well-defined image of what Hearst collected was established, it was necessary to explain how he accomplished what he did, and why. No respectable historian studies works of art as specimens isolated from the context in which they were created, or from the history of collecting, especially when the protagonist who acquired them had played such a flamboyant role in the popular imagination. Hearst's political activities weighed heavily on

Saint Barbara, France or Belgium(?), c. 1860–1910 (cat. no. 125).

Claude Michel, called Clodion, *Relief with Dancing Maenads*, 1765 (cat. no. 119).

his reputation, and negative opinions of what he published probably spilled over onto what he collected. Consequently, two distinct but complementary narrative axes can be discerned in this book and the exhibition that it accompanies. Furthermore, the graphic design of Hearst's publications, the art direction of his films, and the style of the buildings he commissioned had to be taken into account too. They testified to his extraordinary visual acuity and perceptiveness. As products of his patronage, they were extensions of his activities as a collector.

It was to be expected that the prejudices of others against Hearst's reputation would have to be overcome, just as mine were.[8] In this I was aided by the support of an anonymous philanthropist, allowing, among other things, the hiring of an experienced assistant for almost a year.

Time constraints are always imposed on exhibitions in a museum's busy calendar. Another full year would have been necessary to bring my research to a level I preferred. The oversize material from the Hearst papers at Bancroft Library was inaccessible during retrofitting of the building

against earthquakes, and there was no time to consult the Byne archive (Hispanic Society), Wiegand papers (Stanford University), or Brummer archive (Metropolitan Museum of Art). Therefore this book is little more than an introduction to the subject. It focuses on the interest that individual works of art have in their own right within the contexts that Hearst provided for them. Consequently the premise for the exhibition might seem to contradict what we know about Hearst in terms of the multitude of things that he bought, but the number of objects in the exhibition was limited first by the museum's budget. It also had to be limited to an amount that could be reasonably digested by a curious visitor.

There is no use in larding any exhibition with passepartout objects. Hearst had hundreds of these.[9] He loved to collect, and he was furnishing six huge, functioning primary residences and a few subsidiary ones. Conceiving these environments—and filling them with art—was his joy.[10] The exhilaration in his letters is palpable. He orchestrated the creation of five of these residences simultaneously. Their chronologies overlap, but for the sake of clarity, they have been treated here as discrete entities. The attentive reader will find some carefully selected vignettes that offer insights into Hearst's methods, his attitudes about how much he was willing to pay, how his dealers treated him, and what he wanted and why.[11] Throughout, there is a tension between Hearst's need for quantity and the desire for quality. He once declared to a cautious manager, "My particular mania is for over-expansion if anything."[12] This was expressed with regard to newspapers, but it applies to his jovial nature as a collector too. He frequently said that he wanted only the best, but he was not always willing or ready to pay for it.[13] Contradictions are numerous in a life that spanned almost ninety years. One of his mottoes was: "It is not as important to be consistent as to be correct."[14]

While the importance of individual objects validates Hearst's appreciation for quality and prestige, a selection cannot present an overall picture that is entirely accurate. Only a limited allusion could be made to forgeries. What might have been considered contemporary art in Hearst's day—such as the marble statuary by Charles Cassou, Leopoldo Ansiglioni, and other sculptors on the grounds of Hearst Castle—was more than the exhibition and the affordable but strict page limit allowed by the publisher of this book could contain. A significant amount of fascinating archival information had to be omitted, but I shall publish it eventually. Out of respect for the privacy of

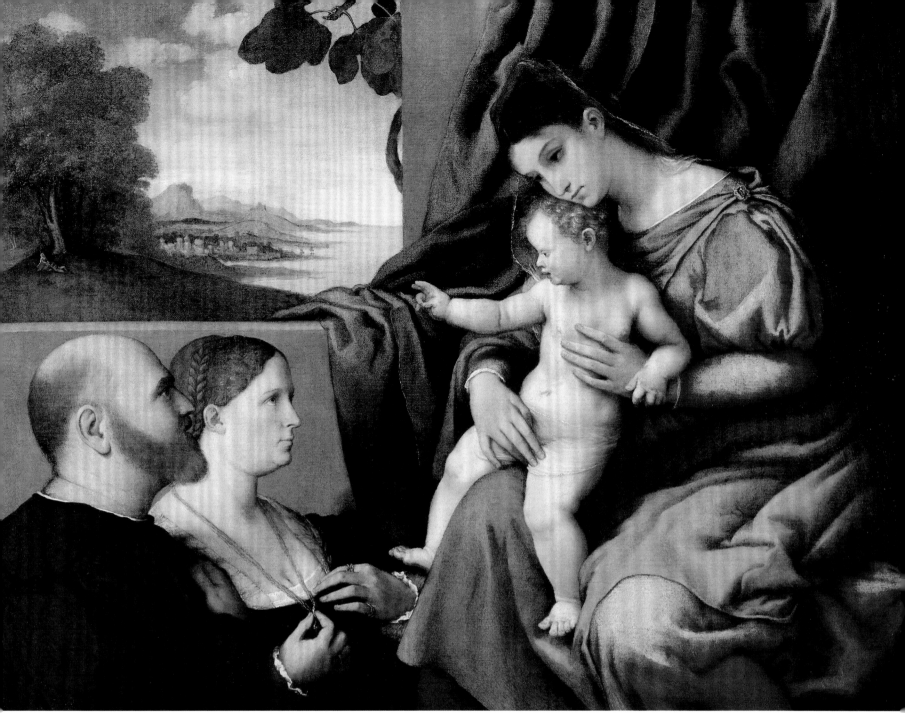

Lorenzo Lotto, *Madonna and Child with Two Donors*, c. 1530–35 (cat. no. 129).

Hearst's descendants and the discretion of the Hearst Corporation, I did not actively pursue any inquiry into their personal property.

Several areas of Hearst's collecting fell outside not only the time allotted for preparation but also my expertise. His Continental and American furniture, his stained glass, and his pre-Columbian art warrant examination. His collections of silver and goldsmiths' work defied the bounds of the exhibition. Comprehensive studies of Hearst's Greek and south Italian vases, and his arms and armor, will one day be books

in themselves. I hope that other Hearst objects (and additional documentation) will be identified as a result of this exercise, and that it brings about a better understanding of Hearst's activities as a builder, collector, and philanthropist.

Notes
1. Orson Welles's movie (1941) is the subject of innumerable studies; Huxley's novel (1939) fell into obscurity. The Hearst Corporation's own Avon Books printed a paperback edition in 1952. Hearst put Huxley on the payroll in 1931. See David Nasaw, *The Chief: The Life of William Randolph Hearst* (New York: Houghton Mifflin, 2000), 428. In the novel a British historian hired at a "princely" sum, just as Huxley had been, works for a philanthropic oil tycoon who lives in a neo-Gothic fortress near Los Angeles.

Huxley's droll narrative mocks equally the castle and the fastidious purists who derided it: see Aldous Huxley, *After Many a Summer Dies the Swan* (New York: Avon Books, 1952), 17–18, where indirect reference is made to Julia Morgan's expertise as an engineer and Marion Davies's pediatric clinic, as well as Hearst's bronze after Giambologna (23), Winterhalter (28), indoor swimming pool (29), Roman sarcophagus (34), great hall hung with tapestries (35), and sculpture by Thorvaldsen (50).

2. Umberto Eco, *Travels in Unreality* (New York: Harcourt Brace Jovanovich, 1986), 22–24, 62; Madeline Caviness, "Learning from Forest Lawn," *Speculum* 69 (October 1994): 972, 983.

3. Ilaria Toesca identified the miniature version: "Un coffret parisien du XVIe siècle," *Gazette des beaux-arts* 66 (November 1965): 309–12, which was consulted for my article "Henri III et l'art cérémonial de l'Ordre du Saint-Esprit," *Bulletin de la Société de l'histoire de l'art français*, 1987, 7–23.

4. A synoptic inventory at Hearst Castle (sometimes known as the Pacific Coast inventory but hereafter referred to as Hearst Castle inventory) lists what was in the castle and in the San Simeon warehouses during Hearst's lifetime and at the time of his death. An incomplete inventory of these West Coast possessions, but with more details about individual objects, belongs to the Hearst Corporation (called Hearst Corporation papers in this book). The inventory of Hearst's Bronx warehouse (see note 5) lists what passed through that warehouse on the way to other destinations or what stayed in that warehouse. The contents of Saint Donat's castle in Wales are not included in the Bronx inventory unless an object was stored first in New York, but some of the material from Wales is recorded in Hearst Corporation papers. Many personal possessions were not included in these inventories.

5. *The William Randolph Hearst Collection: Photographs and Acquisition Records* (New York: Clearwater Publications, [1987?]). The title has led some to believe that it records all the Hearst collection, but that is incorrect. See note 4 above.

6. The relief is mentioned in the Seligmann-Rey file, William Randolph Hearst Papers, Special Collections, Bancroft Library, University of California, Berkeley, 40:20, January 4, 1927: a Clodion relief "very fine," ex coll. Raoul Cabany, Paris, $4,000. See Mary Levkoff, "The Little-Known American Provenance of Some Well-Known European Sculptures," in *La sculpture en occident: Études offertes a Jean-René Gaborit*, ed. G. Bresc-Bautier (Dijon: Éditions Faton, 2007), 301–2.

7. Edgar Peters Bowron and Joseph J. Rishel, *Art in Rome in the Eighteenth Century*, exh. cat. (London: Merrell; Philadelphia: Philadelphia Museum of Art, 2000), no. 125.

8. Indeed, in the 1980s the western director of the Hearst Foundation was told that most of Hearst's gifts to LACMA were in storage. Thomas Eastham (former western director, William Randolph Hearst Foundation), personal communication to author, c. 1999–2002. Inventory numbers suggest that Hearst donated almost nine hundred items to the museum. About half were sold over the years. There are also Hearst objects at the Natural History Museum of Los Angeles County, including notable Navajo blankets (see chapter 9).

9. Hearst to his registrar Chris MacGregor in March 1929 (Hearst Papers, 39:9): "In the Ruiz sale…there is the usual collection of junk, some of which, however, may be useful."

10. Burton Fredericksen, *Handbook of the Paintings in the Hearst San Simeon State Historical Monument* (n.p.: Delphinian Publications in cooperation with the California Department of Parks and Recreation, 1977), unpaged, points out: "One can assume that he also intended to live with most of what he purchased." Michael Conforti also mentioned the importance of the decorative purpose of many acquisitions (lecture for the Hearst Monument Foundation, San Francisco, October 27, 1994).

11. For example, correspondence between the Duveen galleries in New York and Paris, November 19–23, 1929, regarding a tapestry: "a very fine purchase, or shall we let Hearst have it?" Paris replied, "Beautiful but not pretty…sell it to him while he is hot" (Duveen Archive, Getty Research Institute).

12. Hearst to one of his managers, March 29, 1929 (Hearst Papers, 36:7).

13. For example, an instruction to J. Y. McPeake Jr.: "Please never buy anything that is not good" (March 21, 1933, Hearst Papers, 37:38). Despite explicit orders to his proxies (for example, his registrar in New York, his curator of armor, various dealers, or a staffer in London), the proxy's intuition about how much to spend came into play. The proxies hesitated going beyond a maximum. Hearst avoided bidding wars, in particular against Clarence Mackay for armor. He tried to work out a compromise through Duveen, who also supplied Mackay.

14. On the back of a letter from McPeake Jr. to Hearst, Richard Berlin scrawled, "I sent him your quotation: 'I always feel it is not as important to be consistent as to be correct'" (February 29, 1940, Hearst Papers, carton 36).

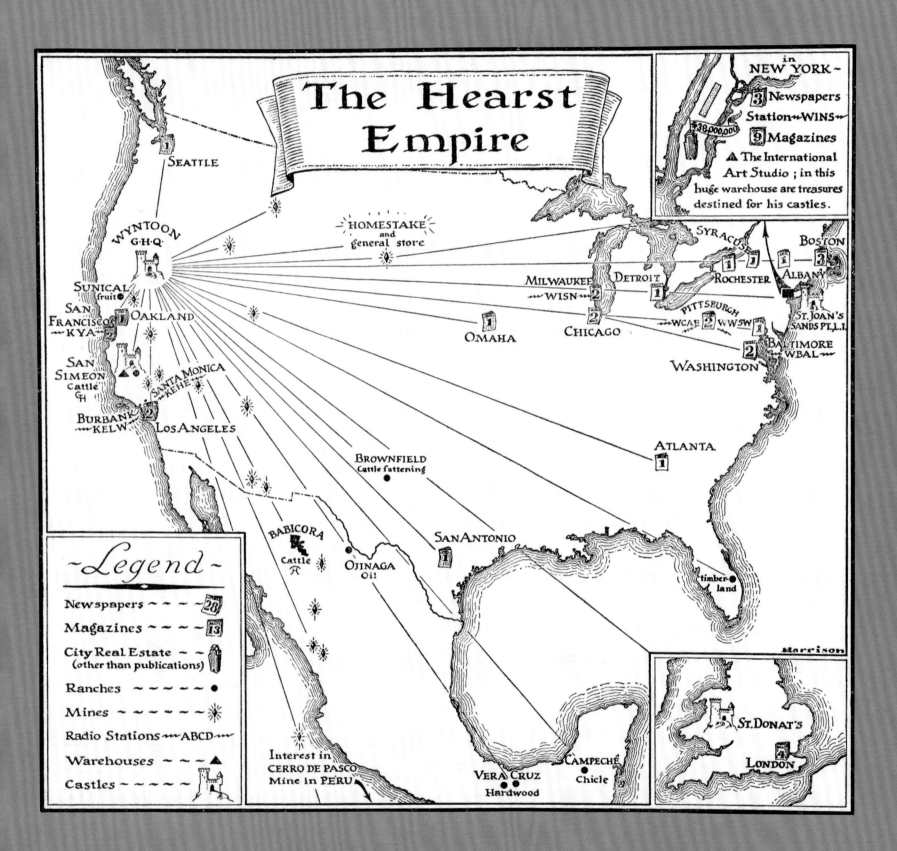

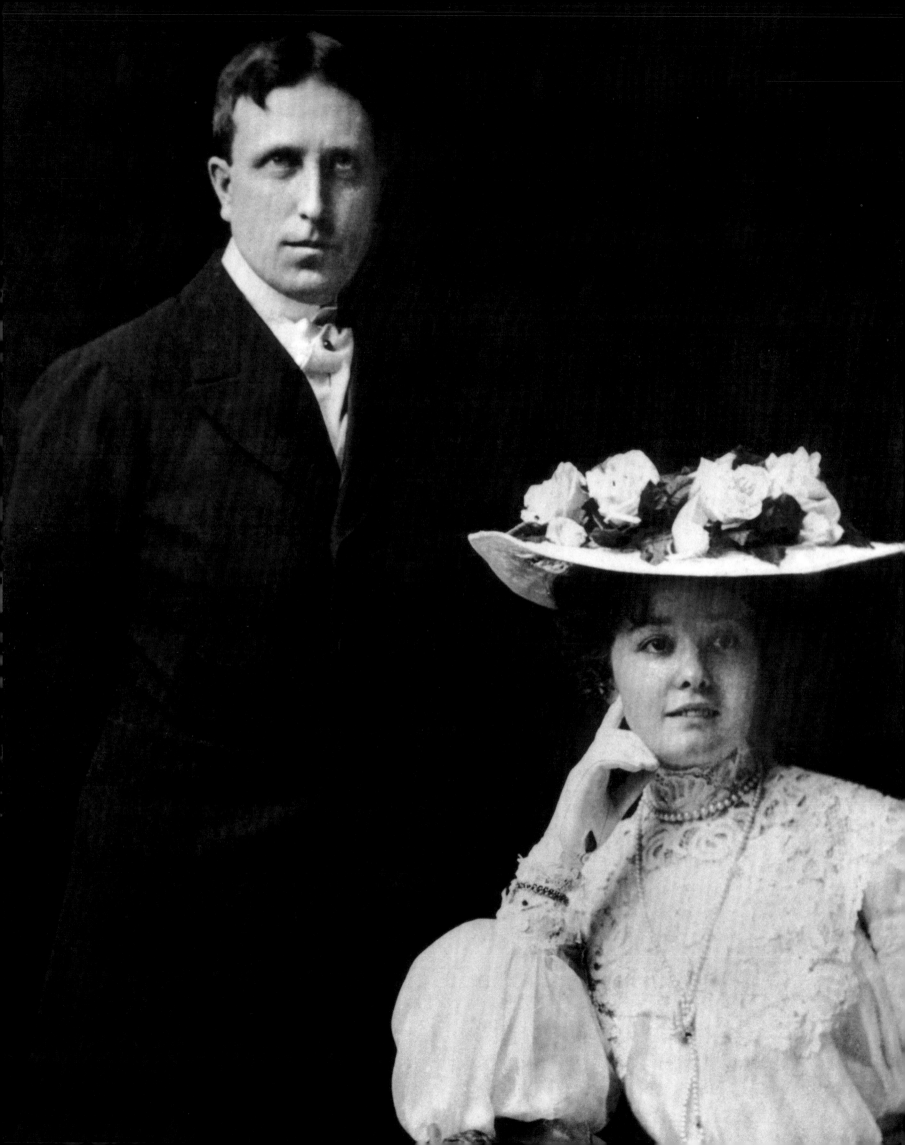

Willliam Randolph Hearst was born in 1863 in San Francisco and died in 1951 in Beverly Hills (fig. 1.2). He was the most flamboyant and controversial American art collector of all time. Notorious in his own day as much for his exploits as the world's foremost publisher of newspapers and magazines as for his flair for the improbable in architecture, he was irredeemably parodied by Orson Welles in the film *Citizen Kane* (1941), a pathetic caricature of the populist multimillionaire who, in reality, revolutionized the technology of news media, crusaded against political corruption, had a sentimental love for animals, and simultaneously encouraged excellence and wildly irresponsible sensationalism in reporting.[1]

Hearst's name has typically lent itself to descriptions defined by quantity as opposed to quality, and while we might think of the Frick and Mellon collections, the Morgan and Huntington libraries, or the Gardner and Walters museums, for Hearst's legacy, only one word, redolent with fantasy, comes to mind: *castle*. This refers, of course, to the estate he called the Enchanted Hill. It overlooks the Pacific Coast village of San Simeon, midway between Los Angeles and San Francisco, about 250 miles in either direction (fig. 1.3).

Hearst bought so much to furnish it and five other palatial residences that he is said to have overwhelmed the U.S. Customs Service, which appraised his imports by the pound as items for domestic use.[2] The liquidation of much of his treasure during the financial crisis that brought his corporation to the brink of bankruptcy from 1937 through 1942, followed by the further dispersal after his death ten years later, hindered an accurate assessment of what Hearst's collections comprised and prevented the identification of many works of art of outstanding quality, now in other collections, as his. The real treasure of "Citizen Kane" is scattered today among museums as far flung as New Zealand, Mexico, and Israel.[3]

Welles's hyperbolic characterization of Hearst reinforced the idea that his warehouses were crammed with junk and that the owner was hardly aware of what they contained.[4] An article in *Fortune* magazine in 1935 called Hearst "quantitatively the world's Number One collector of *objets d'art*," and an obituary in the *New York Times* estimated that on his own he accounted for 25 percent of the

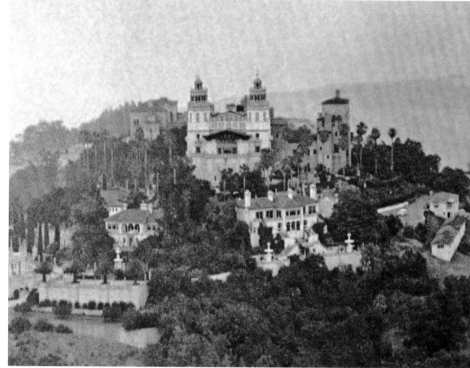

Overleaf: FIGURE 1.1. Map of Hearst Corporation assets as of October 1935 (from *Fortune* magazine).
FIGURE 1.2. William Randolph Hearst and his new bride, Millicent Willson Hearst, April 1903.
FIGURE 1.3. The Enchanted Hill, known as Hearst Castle, San Simeon, California.

world's art market. Although this must have been an exaggeration, the astounding number of things that he acquired naturally prevailed over the identities of the individual works of art themselves. A French observer, René Brimo, commented that if all Hearst's collections were ever gathered under one roof, they would rival those of the Victoria and Albert Museum. "No one really knows the extent [of the collection] in its totality," he remarked, "except Hearst himself, endowed with an astonishing memory."[5]

As a consequence, few experts today would readily attach Hearst's name to Anthony van Dyck's luminous full-length portrait of Queen Henrietta Maria (fig. 1.5) or to a monumental polychromed papier-mâché example of Jacopo Sansovino's relief *Madonna and Child* (fig. 1.4),[6] both of which are better known as Samuel H. Kress's gifts to the National Gallery of Art. The silver furniture by Johannes Bartermann (c. 1715) and Hans Philipp Stenglin (c. 1710) in the Maximiliansmuseum in Augsburg;

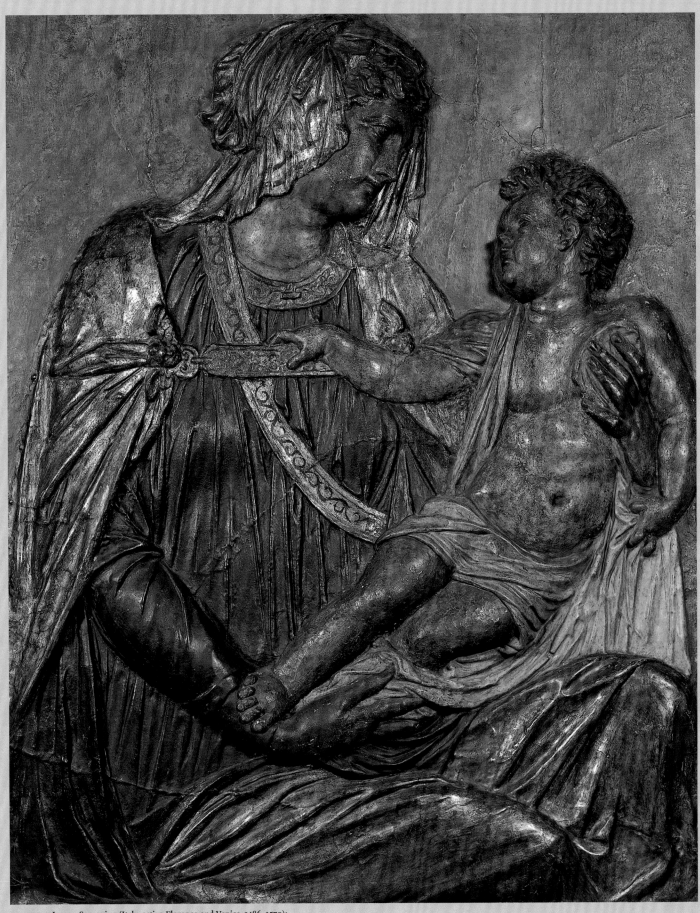

FIGURE 1.4. Jacopo Sansovino (Italy, active Florence and Venice, 1486–1570);
Madonna and Child, c. 1550; painted and gilded papier-mâché and stucco; 47 x 37⅝ in.
(119.4 x 95.6 cm); National Gallery of Art, Samuel H. Kress Collection, 1961.1.6.
FIGURE 1.5. Anthony van Dyck, *Portrait of Queen Henrietta Maria*, 1633 (cat. no. 132).

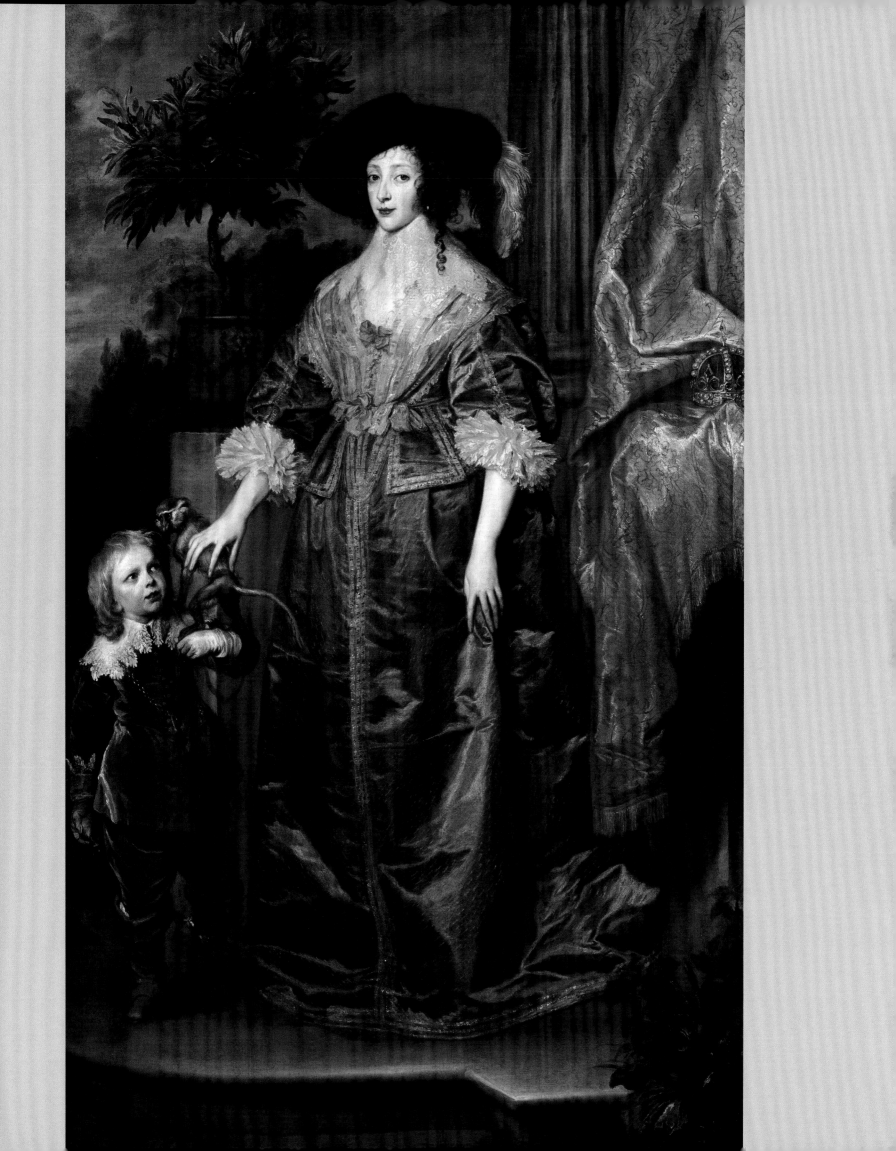

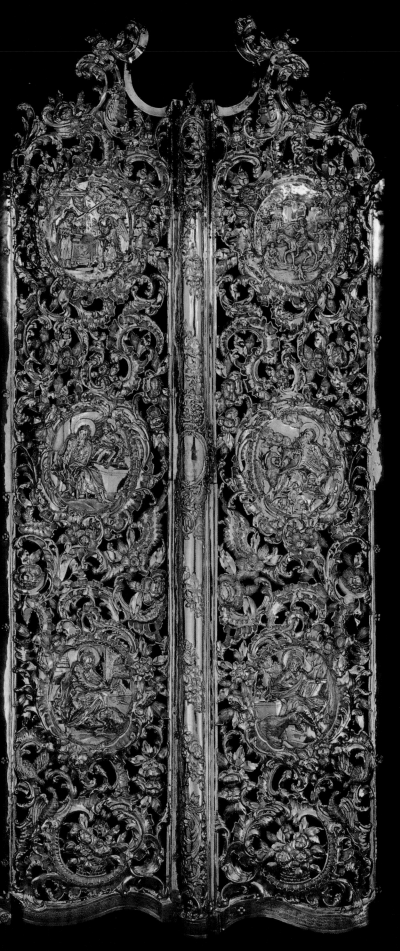

John Singleton Copley's tremendous portrait of the Pepperell family, now in the North Carolina Museum of Art (fig. 5.4);[7] and two splendid pairs of late eighteenth-century silver gilt gates from the monastery of the Pechersk Lavra, outside Kiev, now in Somerset House in London, also once belonged to Hearst (fig. 1.6).[8] His name is easily overlooked on the small label at the base of the gigantic gilded-iron choir screen, originally made for the Cathedral of Valladolid, that now dominates the Medieval Hall of the Metropolitan Museum of Art (fig. 1.7).

Hearst did buy an extraordinary number of works of art. There were innumerable prints, dozens of weepy Victorian portraits, insipid landscapes, and the woebegone shepherdesses of the Barbizon School, none of which he was really constrained to weed out until he was almost eighty years old. There were also 450 Greek and south Italian vases, which constituted what Dietrich von Bothmer described as the "biggest private collection of ancient pottery" formed in the twentieth century. He emphasized, however: "For its peers in scope and quality one has to go back to the nineteenth century.... The achievements of Hearst as a collector are the more remarkable as one recalls [that] his vases were acquired [when] the two factors that had given earlier collectors their critical edge, namely low prices and free export from Greece and Italy, no longer existed."[9] Among his vases were a renowned amphora attributed to the Berlin Painter (fig. 1.8) and a spectacular volute-krater that is the name vase of the Capodimonte Painter, two of sixty-five vases purchased by the Metropolitan Museum of Art from Hearst's collection in 1956.[10]

The greatest number of great tapestries in private hands during Hearst's lifetime belonged to him. To cite some from the early Renaissance alone, the renowned Virtues and Vices series from the Cathedral of Palencia (Musées Royaux d'Art et d'Histoire, Brussels),[11] the Virtues series (fig. 1.10), the Redemption series (now dispersed among several museums; see cat. no. 33), and the Twelve Ages of Man series (fig. 1.11) were owned by him. His collection of arms and armor was possibly surpassed only by Clarence Mackay's, and part of it now forms 25 percent of the Kienbusch Collection in the Philadelphia Museum of Art.[12] Hearst's silver, described in 2001 as "staggeringly important," was amassed in "an effort that could not be duplicated today."[13]

The fact that these four significant collections belonged to a single individual did not keep art historians from adopting a dismissive attitude toward Hearst, perhaps because

FIGURE 1.6. Attributed to Gregory Chizhevski (Ukraine, Kiev?); *Gates from the Monastery of the Pechersk Lavra*, c. 1784; silver, parcel-gilt, and iron; 91½ x 40⁹⁄₁₆ in. (232.4 x 103 cm); The Rosalinde and Arthur Gilbert Collection on loan to the Victoria and Albert Museum, London (inv. no. Loan:Gilbert.97:1&2-2008).
FIGURE 1.7. Attributed to the Amezúa family of Elorrio; *Choir Screen from the Cathedral of Valladolid*, completed 1763-64; iron with gilding; 52 x 42 ft. (15.8 x 12.8 m); Metropolitan Museum of Art (inv. no. 56.234.1).

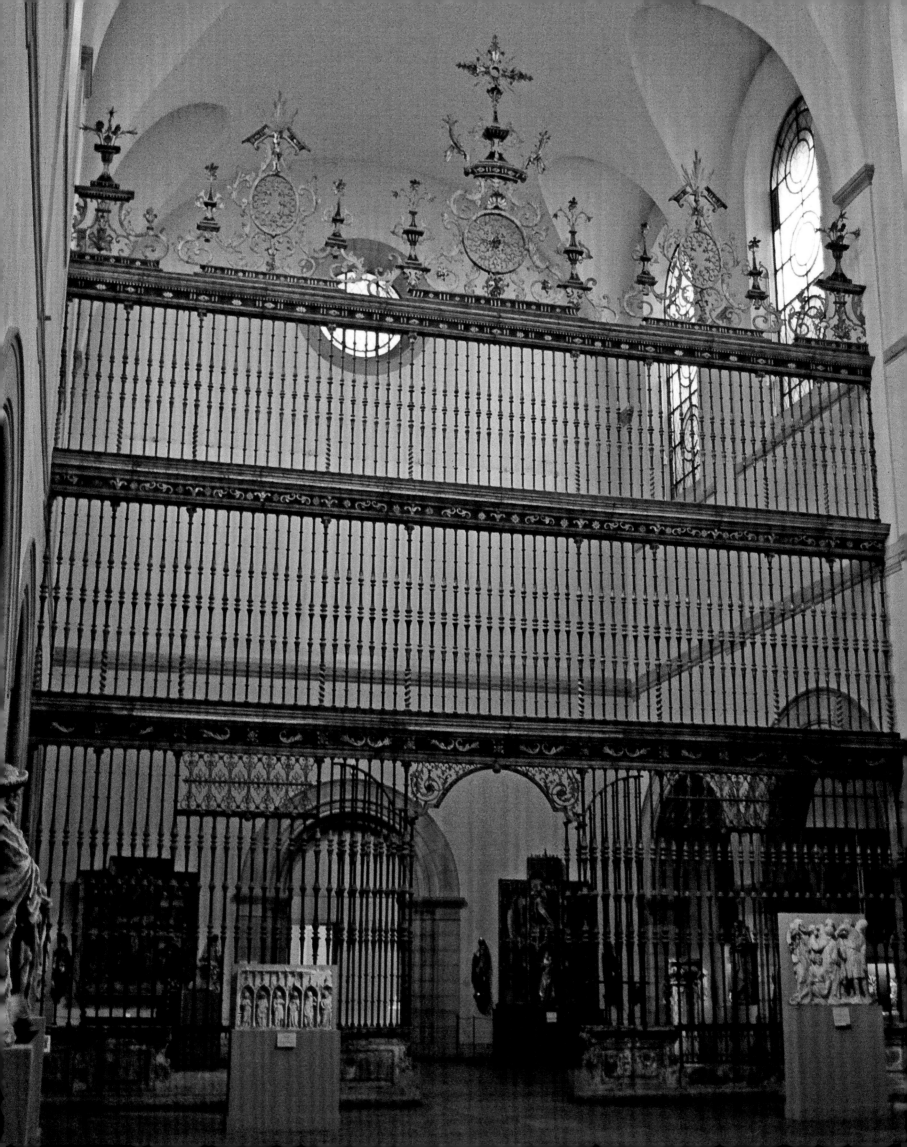

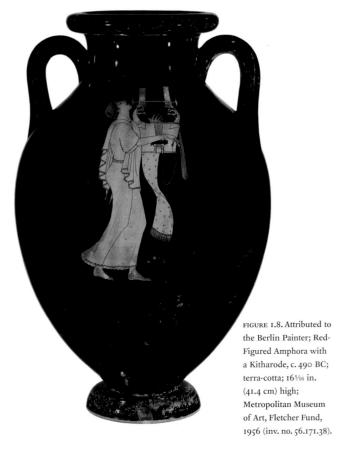

FIGURE I.8. Attributed to the Berlin Painter; Red-Figured Amphora with a Kitharode, c. 490 BC; terra-cotta; 16⅝ in. (41.4 cm) high; Metropolitan Museum of Art, Fletcher Fund, 1956 (inv. no. 56.171.38).

several radio stations, his own movie production studio, a quarter of a million acres at San Simeon, a castle in Wales, twenty-seven acres of Manhattan,[16] a forest retreat in Northern California, an estate on Long Island, and warehouses filled with carefully inventoried works of art.

‡ ‡ ‡

FIGURE I.9. George Hearst, c. 1880(?).

Hearst's life had epic proportions. He was born during the Civil War, before the Transcontinental Railroad was laid, and lived past the end of World War II. He was the only child of George Hearst (1820–1891), a self-taught, industrious, and fairly prosperous Missouri farmer who left the arduous life of the prairie for California in the wake of the gold rush of 1849. George Hearst (fig. 1.9) was driven both by a sense of responsibility toward his siblings and by his own ambition.[17] For almost a decade, with unshakable tenacity, he withstood cholera, penury, bouts of crushing loneliness, and reversals of fortune worthy of a picaresque novel. He was already familiar with mining—his father had owned a small copper mine, and smelters operated about fifteen miles from their farm—but his innate ability to interpret the morphology of the earth was remarkable by all accounts.[18] He astutely pursued reports of other strikes, and he was paid handsomely for his advice. "There was just this hole about six feet long," he recalled of his experience in Utah. "The boys were going to Pioche [in Nevada]…but I said, 'I am going to stay here and watch this little mine.'… I then took some [of the rock] and had it sampled." He paid $30,000 for the mine "and $3,000 to another fellow to get him out of the way. This was the 'Ontario' mine.… [It] yielded us net about $14,000,000.… From the $30,000 everything else came."[19]

With a few loyal partners, George Hearst adroitly negotiated trades of shares in productive mines and smelters. He and his partners bought springs and the water rights associated with the land where the mines were dug, and they built railroads to transport their products.[20] He amassed

the assessment was made by specialists in paintings, which, for better or worse, have always enjoyed top billing in the hierarchy of the arts. Marion Davies, the actress who shared Hearst's life for thirty years, explained: "He didn't like paintings so much. It was antique furniture, then armor, then tapestries, and then paintings last."[14] This is borne out by the underappreciated magnificence of the castle at San Simeon (fig. 1.12), where the stupendous ceiling from the Palazzo Martinengo presides over five sculptures by Thorvaldsen, including the marble roundels, each five feet in diameter, that were commissioned by Eugène de Beauharnais, Napoleon's stepson and viceroy of Italy; the *Venus Italica* commissioned by Lucien Bonaparte from Antonio Canova (fig. 1.13); and tapestries woven after the designs of Giulio Romano and Jacob Jordaens.[15] Not one of these is a painting.

Hearst did not collect with the intense forethought of J. P. Morgan, Isabella Gardner, or Henry Clay Frick. He was not focused, analytical, introspective, or cerebral. He was extravagant, amusing, intuitive, and voracious.

When Hearst's empire was at its peak, in the mid-1930s, he controlled twenty-eight newspapers, thirteen magazines, a chain of mines, a smattering of logging interests and ranches (one of them one thousand square miles in size),

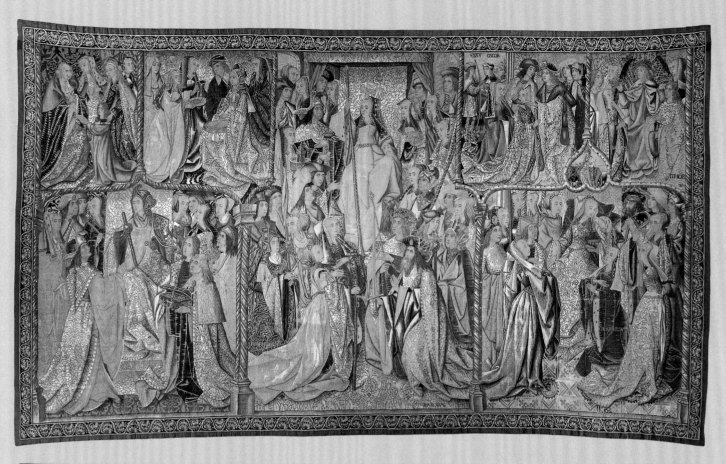

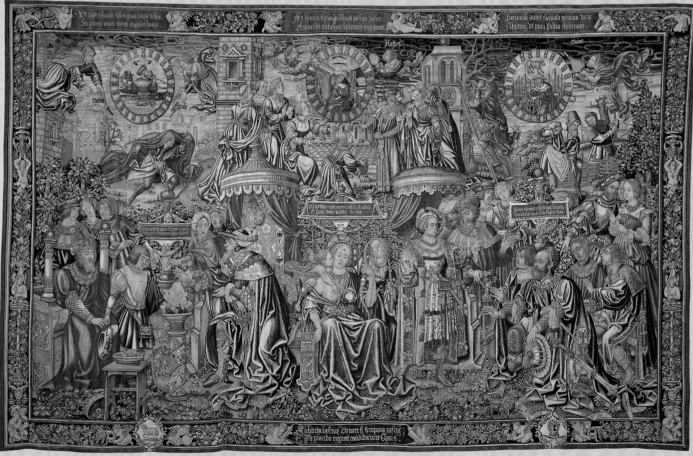

FIGURE 1.10. *Fortitude*, from the Virtues series; Flanders, c. 1500–1510 (cat. no. 32).

FIGURE 1.11. *Spring*, from the Twelve Ages of Man series; Southern Netherlands (Brussels), designed c. 1520–23, woven c. 1525–28 (cat. no. 34).

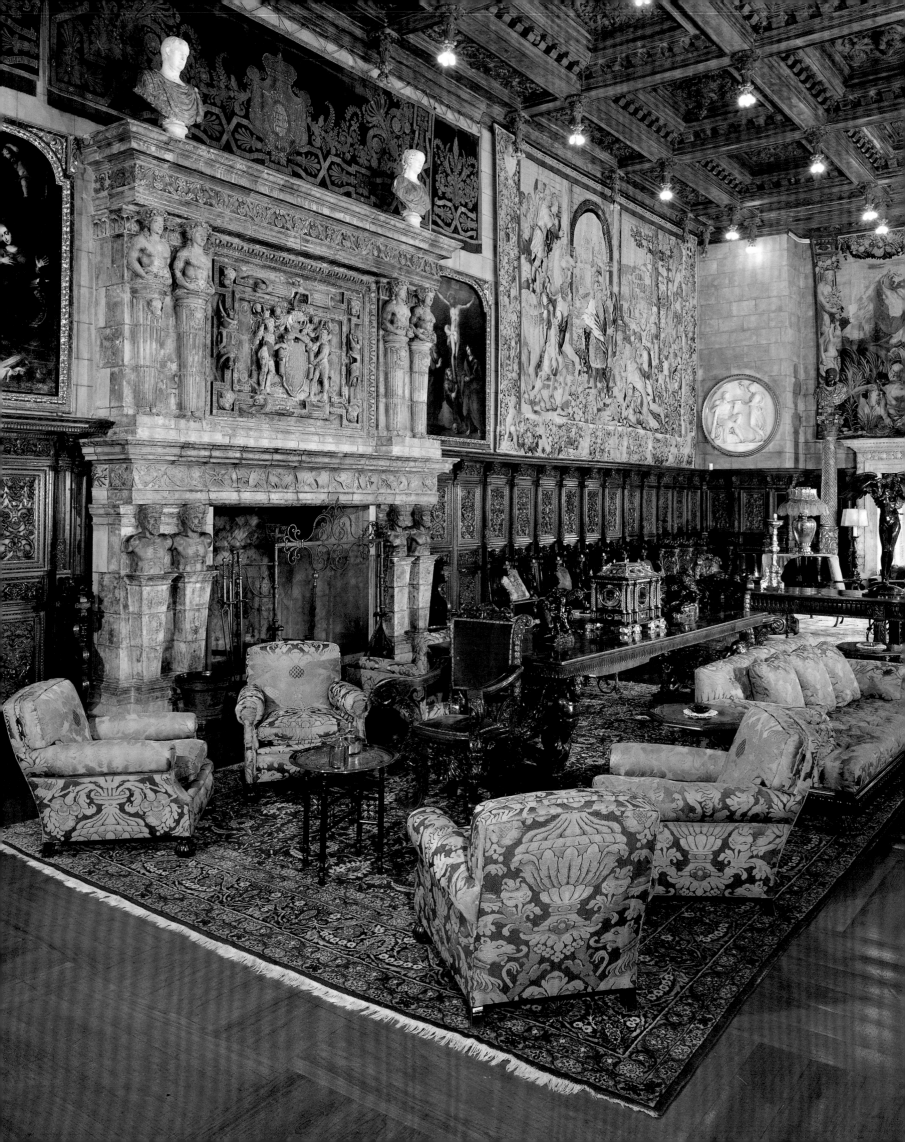

gigantic holdings of land across the western United States and Mexico, where his ranch at Babicora, near Chihuahua, spread over nine hundred thousand acres.

George Hearst's name was attached to four legendary American lodes: the Comstock (Nevada), with its vein of silver two miles long; the Ontario (more silver); and the Anaconda (near Butte, Montana), where he initially went for silver and made a collateral strike in what was then the world's biggest source of copper.[21] The most spectacular holding arose from the 250 claims in the Black Hills of South Dakota that his syndicate aggressively consolidated. These became the Homestake, the greatest gold mine in the Americas.[22] His wealth and pragmatism brought him into politics. He was elected to the California State Assembly in 1865 and was appointed to the United States Senate in 1886 to fill the term of a member who had died in office. He was elected to the Senate the following year.[23]

In 1860 George Hearst had returned to Missouri to look after his dying mother and to reestablish legitimate ownership of his farmstead, which was jeopardized by erroneous reports of his death in 1853, and by friends who cheated him of it in 1858. His attempts were futile.[24] After settling his mother's estate in 1862, he married Phoebe Apperson (1842–1919), a diminutive schoolteacher who, though less than half his age (she was not yet twenty; he was over forty), matched him in ambition. She was distantly related to him through marriage. They moved to San Francisco.

Phoebe Apperson Hearst (fig. 1.14) became one of the most illustrious and sophisticated philanthropists in California's history. With George Hearst's fortune supporting her, she went on to become the greatest early individual benefactor (and the first female regent) of the University of California, which then consisted only of the campus at Berkeley. She sponsored the architectural competition that defined its physical layout.[25] The scholarships that she provided and the practical school for young women that she established were unprecedented there. She underwrote significant anthropological and archaeological expeditions, including those that benefited the University of Pennsylvania, where one of her doctors was based.[26] Her philanthropy supported the preservation of Mount Vernon. She helped to establish vocational schools and founded the National Congress of Mothers, the forerunner of the Parent-Teacher Association (PTA). She paid for the land on which the National Cathedral was erected in Washington, D.C. It was thanks to Phoebe Hearst that her husband's company towns of Lead,

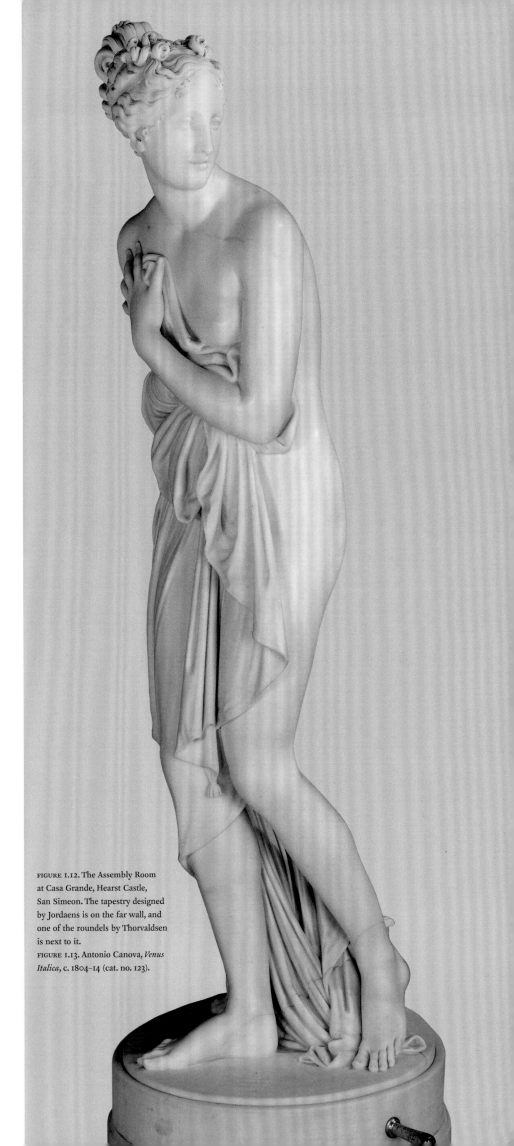

FIGURE 1.12. The Assembly Room at Casa Grande, Hearst Castle, San Simeon. The tapestry designed by Jordaens is on the far wall, and one of the roundels by Thorvaldsen is next to it.

FIGURE 1.13. Antonio Canova, *Venus Italica*, c. 1804–14 (cat. no. 123).

South Dakota, and Anaconda, Montana, had free public libraries.[27] She was also an avid collector. In addition to paintings, sculptures, prints, decorative objects, and Greek vases, she accumulated a remarkable array of Asian, European, and Native American textiles, as well as a significant group of illuminated manuscripts.[28] The Artemisia tapestries, now in the Minneapolis Institute of Arts, once belonged to her, as did the Coriolanus tapestries in the Brooklyn Museum.[29]

Phoebe Hearst furnished her residences with uninhibited eclecticism. The enormous mansion that she set up in Washington, D.C., during her husband's term in the Senate had paintings that were typical of the era, including Barbizon landscapes and a portrait then attributed to Joshua Reynolds.[30] Beamed ceilings, draped carpets, and intricate woodwork imparted an exotic flavor to some of the rooms, but others were decorated in a more subdued Louis XVI style. Her husband was said to have cared little about any of this extravagance because he disliked pretension in general, but his eyes were open to the attractions of modest refinement. Recalling the French settlers in Missouri, he said: "There were big merchants...that had every sort of nice French things. My people lived in log houses, and these French things were very extraordinary to us. We had tables and beds and chairs and that was about all, but these people had things which they brought from France which were very beautiful I thought."[31]

Phoebe elaborated the interiors over time. The sense of clutter began to grow with skied paintings. In the foreground of one view (fig. 1.16), the enameled silver "Orchid Vase" (fig. 1.15) appears as a lamp, refitted for her two years after it had been featured as the most splendid example of the work of Tiffany Studios in the 1889 Exposition Universelle

FIGURE 1.14. Phoebe Apperson Hearst, c. 1885(?).

in Paris.[32] The portrait of William Randolph Hearst painted by her protégé (and her son's friend) Orrin Peck in 1894 is in the background behind it, alongside Peck's tiny double portrait of Phoebe's parents.[33] A reproduction of Raphael's popular *Sistine Madonna* (original in Dresden, Gemäldegalerie) was turned into an incongruous fire screen.

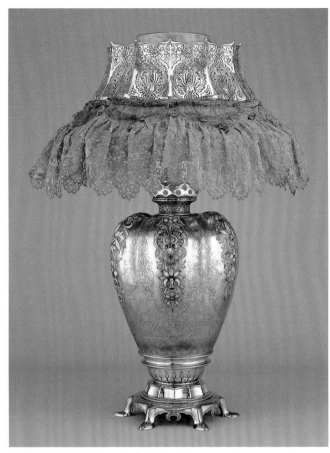

FIGURE 1.15. Edward C. Moore/Tiffany & Co., "*Orchid Vase*" *Lamp*, 1889 and 1891 (cat. no. 58).

FIGURE 1.16. Interior of the Hearst mansion in Washington, D.C., after 1894.

Eccentricities also occurred at Phoebe's estate called Wyntoon, in Northern California, which was designed by Bernard Maybeck (1862–1957), an architect who was decidedly unconventional.[34] This, coupled with the fact that the estate was deep in the woods and far from the concerns of Washington's social hierarchy, probably allowed free rein for both client and creator. The hacienda that she built later at Pleasanton, where George Hearst's Thoroughbred ranch was located (about forty miles southeast of San Francisco), was more restrained, with the exception of the music room (fig. 1.17).[35]

Phoebe Hearst had a decisive influence on her son. She taught him at home herself for as much time as he spent in school. When he was ten years old, she took him to Europe. Their tour was grand indeed: it lasted eighteen months. They saw Dublin, Glasgow, and Edinburgh before reaching London. Then there were Antwerp, Baden-Baden, Dresden, Munich, and Vienna, followed by Milan, Venice, Verona, Florence, and Rome. Her son was attracted to carved wood sculptures,[36] and she reported to her husband: "He frequently

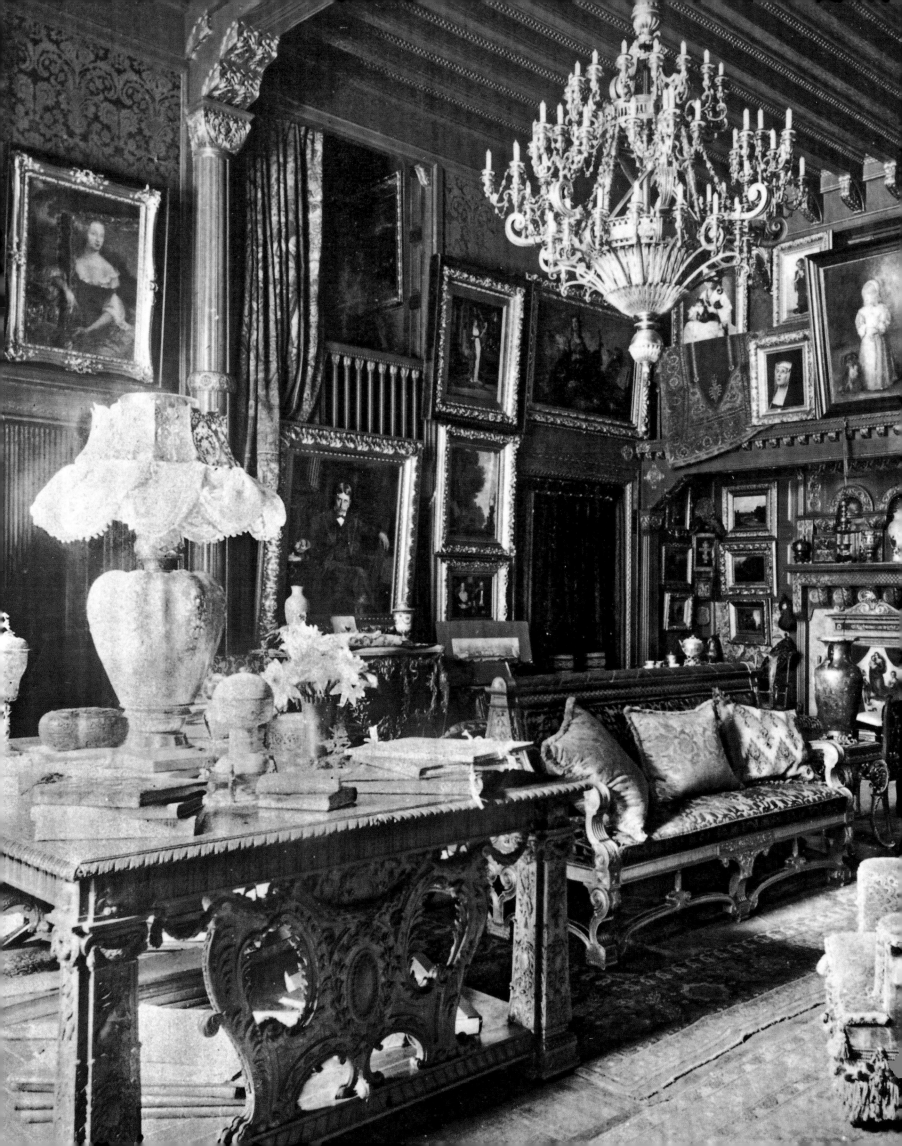

surprises me in his expressions concerning the best pictures.... I am very proud of his advancement in German."[37] Phoebe had already mastered French. By the time they reached the climax of their trip, Paris, in April 1874, her child could manage in that language too.[38]

Phoebe felt compelled to visit some museums twice. She realized that she had to learn the specifics of the history of art: "I am more enthusiastic about [paintings] than I ever supposed I would be," she wrote to her husband.[39] For his part, little Willie was entranced by Venetian glass, castles, illustrated books, and porcelain. How could anyone not have delighted in such a wonderful adventure? His mother probably never mentioned the severe financial crisis of 1873, which preoccupied the indulgent George Hearst at home.

Hearst's mother doted on him, but she was a taskmaster.[40] Fifty years later, when the managing director of Hearst's British subsidiary asked him how he came to know so much about European art, he explained "that his mother first began to bring him over on these educational tours when he was a very small boy...and at the beginning he was bored and impatient as a small boy naturally would be. But his mother was determined that he should learn about the art treasures of Europe so she persisted with these tours, and gradually came knowledge, and with knowledge enjoyment, that increased over the years."[41]

In 1879 mother and son returned to Europe with a tutor. They went to Rome and Orvieto, where they acquired what Phoebe Hearst called "relics" from an Etruscan site.[42] It is easy to assume from her remark about Willie wanting "all I could carry away" that the objects were south Italian vases, with additional small bronzes or jewelry. In Paris the adolescent misbehavior was such that the beleaguered tutor quietly rejoiced when the stay was truncated. Young Will Hearst was now headed for the misery of a Yankee winter at St. Paul's School in New Hampshire, to prepare to fulfill his mother's dream of having her son go to Harvard.

Hearst's record at the university was uneven, by turns either a joyous social romp or dismal scholastic captivity punctuated by suspension and brought to a close when the faculty refused to let him continue. A Harvard degree was not in his future. Neither was mining, which he gamely experienced for a brief interval to please his father.[43] In his sophomore year, however, as business manager of Harvard's satirical magazine the *Lampoon*, Hearst was brilliant. He expanded its circulation and tripled its advertising revenue, turning it into a profitable enterprise.[44]

When Hearst was twenty-four, he cajoled his father into giving him control of the *San Francisco Examiner*, which George Hearst had financed to promote his own political ambitions.[45] At virtually the same time, Hearst agreed to jettison the sweetheart his mother despised. This is where the Hearst publications began. Almost instantaneously he transformed the *Examiner*.[46] Visually his father's newspaper had all the appeal of today's telephone directory. The layout did not substantially differ from the broadsheets printed by Benjamin Franklin a hundred years earlier. Hearst reduced the number of columns, increased the size of the type, and made the headlines bolder. He expanded its circulation to outlying suburbs. Inspired by Joseph Pulitzer's sensational *World*, which he studied firsthand, Hearst adjusted the content too. Vivid, exaggerated descriptions bristled with excitement. He worked like a demon to make the paper succeed. By the end of 1890 he had turned a profit and earned his father's respect.[47]

George Hearst died the following year. With the exception of a hundred thousand acres in Mexico that he had already given to his son, he left his entire estate, including the *Examiner*, to his wife.[48] Apparently George Hearst recognized not only his boy's talent for newspaper publishing but also his expansive approach to spending his father's money.[49] This placed Hearst in an exasperating situation with regard to his mother. He could have struck out on his own, but instead he remained dependent on her decisions about financing his business. To judge from what must have been major expenditures on such luxuries as an elaborate trip to Europe in 1892, a powerful yacht, and a mansion in Sausalito, Phoebe humored him, and he was able to draw on family accounts.

Nonetheless, by the time he reached the age of thirty, Hearst had to establish some measure of independence. Being subordinate to the financial officer of the *Examiner* gnawed at him, and being tied to San Francisco was frustrating.[50] The real objective was to have a newspaper in New York, and he had come close in 1890, when he succeeded in persuading his father to bid for a paper there. In 1895 Hearst and his mother reached an agreement. He deeded his land in Mexico to her. She sold her share of the Anaconda mine to the Rothschild family, which provided her son with the money to buy the failing *New York Morning Journal*. He renamed it the *New York Journal*.[51]

Hearst transformed it as rapidly as he did the *Examiner*. The layout was overhauled. Typefaces were cobbled together

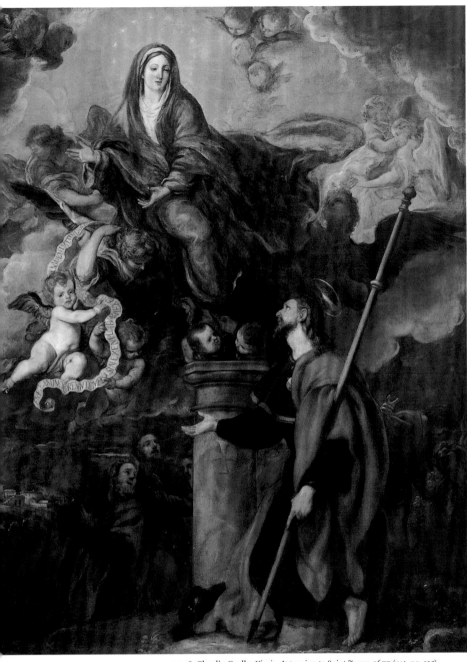

to make headlines big enough to be read from ten feet away. Stories were aimed at a popular audience interested in minor scandals, crime, the adventures of high society, and a variety of social concerns. These included direct election of the Senate, corruption, the purulence of political machines, and the privately owned monopolies that operated the equivalent of today's municipal utilities. Aggressive challenges to government and industrialists throbbed with vehemence. Hearst's jealousy of Theodore Roosevelt added to the bite. Intensified, sharpened color opened up like a rainbow. Contests and rewards attracted additional attention. Even comic strips became a topic of anticipation when Hearst hired the inventor of the "Yellow Kid" away from Pulitzer.[52] Illustrations of exceptional quality were included—sometimes they almost filled the front page—and they were provided by such recognized artists as Charles Dana Gibson and Frederic Remington, whose portrait appeared on the front page of the paper when he was dispatched to Cuba. Remington's assignment there shows how Hearst promoted the dazzling new newspaper itself as part of the news.

As loud as Hearst's headlines and his public life were, his home was relatively calm. According to early biographies, he lived in comparatively unpretentious but well-appointed quarters on Twenty-fifth Street in New York City from 1897 until 1900, when he bought a townhouse at 123 Lexington Avenue.[53] His opinions about art and decorating up to that time were outlined in two letters. In 1885 he pointed out to his father that a "representative of the Democratic party" should live in an "imposing but unassuming [house] as if it were at the same time sensible of the views of the occupants toward the people," asserting that the interior must not "display that arrogance of wealth that is so offensive to the people."[54] The symbolic appropriateness of the house is enhanced by the fact that in the same letter Hearst declared his intention to have a career in politics himself.

To his mother, however, he voiced a significantly more worldly inclination in January 1889. Touring Europe, he renewed an acquaintance with Leopoldo Ansiglioni, the academic sculptor whom Phoebe Hearst had commissioned to carve portrait busts of her and her son several years before.[55] Will wrote to his mother that he now would "never miss a gallery," offering pointed advice:

> If instead of buying a half a dozen fairly nice things, you would wait and buy one fine thing all would be well. As it is at present we have things scattered from

New York and Washington to San Francisco more than a house could hold and yet not among them a half a dozen things that are really superb.... In the different palaces of Italy several things are to be sold that are simply magnificent.... In the Pallavicini Palace, Genoa, is one of the finest Van Dykes.... In Pisa is a Guido Reni.... Ansiglioni says it is a great time to buy. The people are heavily taxed; the government is nearly bankrupt.... We could exchange all our alleged pictures—except for the four or five good ones—for two or three masterpieces.... In price they are the same but in value how different.... Get a Murillo or a Velasquez. Don't get four or five old masters that nobody has ever heard anything about.... Get a Murillo *and* a Velasquez if you can but get at least one good picture.[56]

These were very clever suggestions: Spanish and north Italian baroque paintings were not yet very much in vogue, and Italian provenances usually carried lower prices than British ones did.[57] The advice was evidently of little interest to Hearst's mother, and over the years Hearst took the opposite tack himself when buying paintings. The closest Phoebe Hearst came to the level that her son advocated in 1889 was with Claudio Coello's admirable *Virgin Appearing to Saint James* of 1677 (fig. 1.18). Hearst never owned anything by Velázquez. The closest he came to that ideal was with the *Departure of Saint Peter Nolasco* (fig. 1.19), painted by Francisco de Zurbarán and assistants.[58]

Instead Phoebe Hearst crowded her salon in Washington with tiny objects and incidental pictures that were woefully out of proportion to the few large paintings and tapestries nearby.[59] It might have been this waywardness that disappointed her son. The fortune was hers. She did not use it to buy masterpieces.

Hearst's finances in the late 1890s were somewhat discouraging. The *Journal*, despite its robust circulation, was losing money. Hearst was borrowing about $1 million a year from his mother.[60] He probably would not have bought much that was truly extravagant himself. Nevertheless he acquired Tiffany & Co.'s thirty-inch-high *Roman Punch Bowl* and the inventive silver *"Aztec" Calendar Plate* (fig. 1.20), which was created for the 1893 World's Columbian Exposition in Chicago. The paintings he bought around this time were essentially insignificant, with the exception of one of several versions of Luc-Olivier Merson's *Rest on the Flight to Egypt* (purchased in 1894) and Jean-Léon Gérôme's *Napoleon before*

Cairo (purchased in 1898).[61] He also bought a few examples of Spanish lusterware and probably the grand volute-krater by the Capodimonte Painter too.[62]

Hearst was off to Europe and Egypt in 1899.[63] From there he wrote exuberantly to his mother about his desire to redouble her involvement with archaeological excavations. The momentary impulse toward academic philanthropy was swept aside by politics when the Democratic Party asked him to start a newspaper in Chicago, which began publication in 1900, once Phoebe Hearst overcame her annoyance about his request that she pay for it.[64]

That year Hearst made another trip to Europe, which must have included the Exposition Universelle in Paris. A visit there is the only conceivable explanation for the presence of an extraordinary painting in his inventory: Jean Béraud's sensational *Deposition* of 1892 (fig. 1.21), which transposed the Crucifixion from a hill near Jerusalem to one overlooking Montmartre. Perhaps Béraud's depiction of ragged beggars who, in place of Roman soldiers, huddled at the foot of the cross appealed to Hearst's affinity for populist causes. He might have already seen the painting when it was exhibited in the World's Columbian Exposition. The *Deposition* was part of a series in which Béraud depicted various episodes from the life of Christ as though they were

occurring amid the decadence of contemporary Parisian society. The provocative painting was mentioned in the press no fewer than forty-three times from the day it was first exhibited, in 1892, until it was last believed to have been publicly shown, in 1900.[65] No other painting like this appeared in Hearst's collection: he owned academic pictures of easier subjects, with only a few other nods to the art of social conscience. In fact there were not many paintings like Béraud's anywhere.

It is generally assumed that Phoebe Hearst's penchant for antiquity carried over to her son.[66] Yet, except for the episode involving the "relics" at Orvieto mentioned earlier, and possibly some acquisitions in 1899 (see cat. no. 93), he appears not to have acquired any works of ancient art that were indisputably traceable until March 1901, when he bought a felicitous selection of more than twenty-five Greek vases at two auctions. These were the sales of the dealer Henry de Morgan's stock in New York and the collection of Alfred Bourguignon in Paris. Informative descriptions and illustrations promoted the vases in the catalogues. Hearst is said to have relied on the advice of the expert Fernand Robert for the auction in Paris, but Robert's role is unclear.[67]

In any case the interest of these early acquisitions warrants mentioning some of them individually. A few vases remained at San Simeon (for example, the majestic black-glazed Gnathian hydria and a red-figured kalpis with a depiction on its shoulders of women spinning).[68] Others stayed in the Hearst family, and others were dispersed, notably to the Metropolitan Museum of Art. Among those now in the museum's collection are a hydria attributed to the Erbach Painter,[69] a situla attributed to the Lycurgus Painter,[70] an exquisite neck-amphora attributed to the Pig Painter,[71] a small black-figured neck-amphora with Death and Sleep carrying the body of Sarpedon,[72] and an exceedingly rare black-figured tumbler with animated revelers from about 540 BC.[73]

Hearst bought about eight modestly scaled vases from the sale of de Morgan's collection.[74] The majority were intact or in near-perfect condition. Some remained at San Simeon (a red-figured kylix with an ephebe riding a horse, no. 368: "The style of this vase is of the best period of art"; a black-figured skyphos with sphinxes and warriors, no. 177: "From the Forman collection … in brilliant glaze"; and a "skyphos" [in reality an oinochoe] in the form of an African's head, from the collection of Julien Gréau, "fine style," no. 161). Two black-figured amphorae were among the sixty-five

vases bought by the Metropolitan in 1956 (no. 191 ["Very primitive style … a battle scene of great action and decorative effect…. The other scene may be Ulysses recognized by his dog…. In perfect condition"] and no. 192, a panel amphora with Herakles killing the Nemean lion ["The vase is perfect, with the exception of the foot, mended"]). They are likely the ones that Bothmer attributed to the Princeton Painter and assigned to Group E, respectively. Three others were sold: no. 150, an oinochoe in the form of a female bust, "very rare shape"; no. 158, a skyphos with Herakles and the "herd of Geryon…. The glaze is brilliant; the vase intact"; and no. 162, a pyxis with five women on the cover and ivy leaves on the body, formerly in the Forman collection. The pyxis was "delicate. Very rare and in perfect condition."[75] It is now in the Tampa Museum of Art.[76]

One salient detail that can be associated with 1901 in the chronology of Hearst's collecting is an entry carried over that year from Duveen Bros.' "old ledger" for a seventeenth-century Flemish figure of the Madonna and Child.[77] It establishes the length of Hearst's relationship with the dealer, which would last until Joseph Duveen's death in 1939.[78]

In terms of Hearst's secular chronology, however, the year 1901 was a dismal one. The assassination of President McKinley in September made real the viciousness of what was thrown about abstractly in Hearst's *Journal*, and Hearst became completely identified with the event. To undo that ghastly association, he changed the name of the newspaper to the *American* and subdued his public behavior.[79] Formalizing his engagement to a conspicuously beautiful brunette showgirl, Millicent Willson, was part of this effort. Election to the House of Representatives in 1902 was the proximate objective, which he achieved twice.[80] The ultimate prize was the presidency, which he failed to attain twice: first he was passed over for the Democratic nomination in 1904, and then he lost as an independent four years later.[81] Hearst's populist convictions regarding the average laborer and unions were too defiant for the Democratic Party of that era to digest. Stories about presumed Rothschild intervention in American finance concocted by his own staffers backfired explosively against him.[82] Hearst's campaign for mayor of New York in 1905 was confounded by fraudulent irregularities. His seesawing attitude toward the political machine of Tammany Hall undermined legitimate support, even though his campaign cleansed New York City's government temporarily of that filth in 1909. Hearst became the target of ridicule and

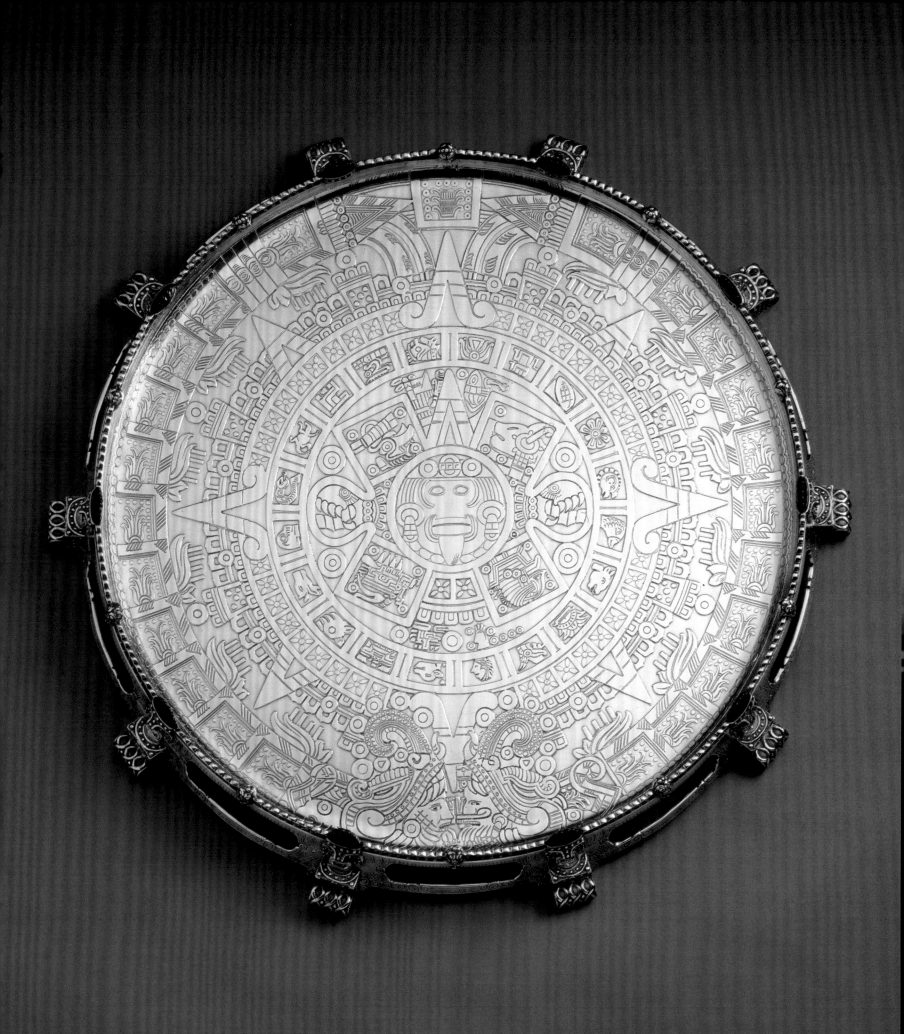

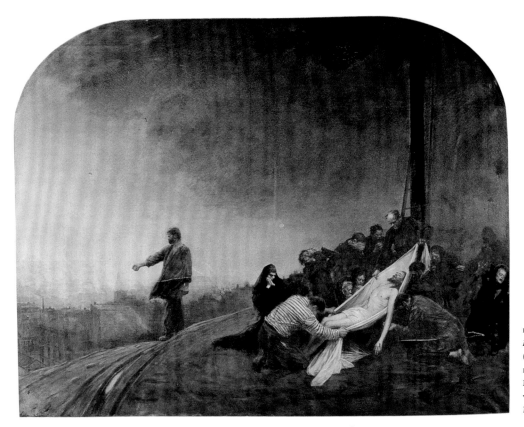

FIGURE I.21. Jean Béraud (French, 1849–1936); *Deposition*, 1892; oil on canvas; 45⅛ x 57⅛ in. (114.6 x 145 cm); present location unknown.

FIGURE I.22. *September*, from the Medallion Months series; Brussels, 1525–28; silk and wool; 177¾ x 166¾ in. (451.5 x 423.5 cm); Minneapolis Institute of Arts (inv. no. 38.40).

suspicion in competing newspapers across the country,[83] and Roosevelt made no secret of the fact that he believed Hearst to be a hypocritical demagogue who was fomenting social conflict.[84]

After Hearst appeared to have bowed out from politics in 1906, following his defeat in the campaign for governor of New York,[85] there was much speculation about his future. One appraisal, titled "The Significance of Mr. Hearst," was printed in the British periodical *Fortnightly*. The author, Sydney Brooks, who had interviewed Hearst, pointed out that Hearst's papers were always "doing things," like taking on the monopolistic suppliers of ice for refrigeration and starting soup kitchens. "Some of the things are worth doing. That is a fact which the stupidity of Mr. Hearst's enemies…has yet to recognize." Brooks believed that *Collier's* weakened its own case against Hearst by mentioning what he actually accomplished, such as "forcing the Central and Union Railroads to pay the £24,000,000 they owed to the government." In addition, "Mr. Hearst secured a model Children's Hospital for San Francisco, and he built the Greek Theatre of the University of California—one of the most successful classic repertories in America." Brooks cautioned, however, that Hearst's own reports of his triumphs were very exaggerated.[86]

Hearst paid more than the top union wage, with salaries "unique in the history of journalism," Brooks continued. He instituted an eight-hour workday for his employees. In asserting that "Mr. Hearst's political campaigns are practically self-supporting. They pay their way in the increased circulation of his journals," Brooks erred (as he did in several other details), but he echoed what must have been prevailing beliefs at the time. Hearst is described as the "rallying point for disaffection and unrest." After citing the "unbridled vehemence and maliciousness" of the attacks on McKinley, Brooks averred that Hearst was as different from his papers as possible: "They are blatant,…he is… impeccably quiet, measured, and decorous. He struck me as a man of power…and serene, with a certain dry wit…. Mr. Hearst is somewhat of a surprise."[87]

Brooks added: "For a multi-millionaire he scarcely has any friends among the rich, and to 'Society' he is wholly indifferent, he lives in an unpretentious house in an unfashionable quarter." The unfashionable neighborhood was, by coincidence, near where J. P. Morgan lived.[88] Morgan had just been elected president of the board of trustees of the Metropolitan Museum of Art. Hearst could not have become significantly involved with the museum at the time because he was not yet rich or experienced enough for the board as

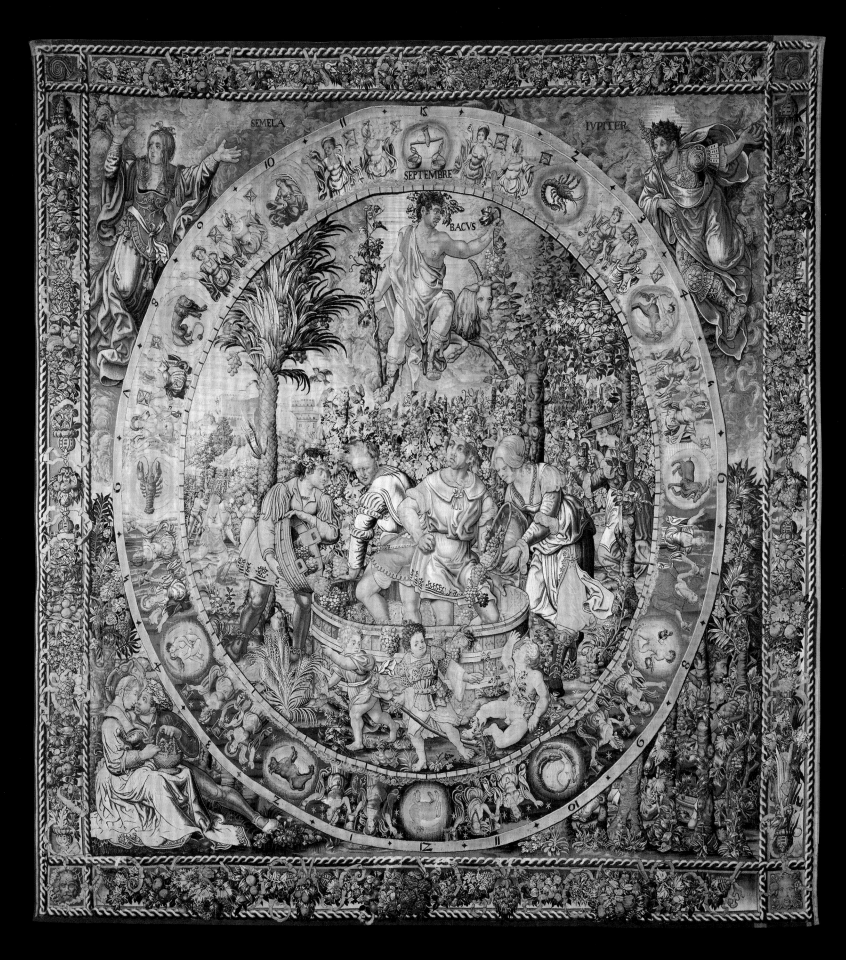

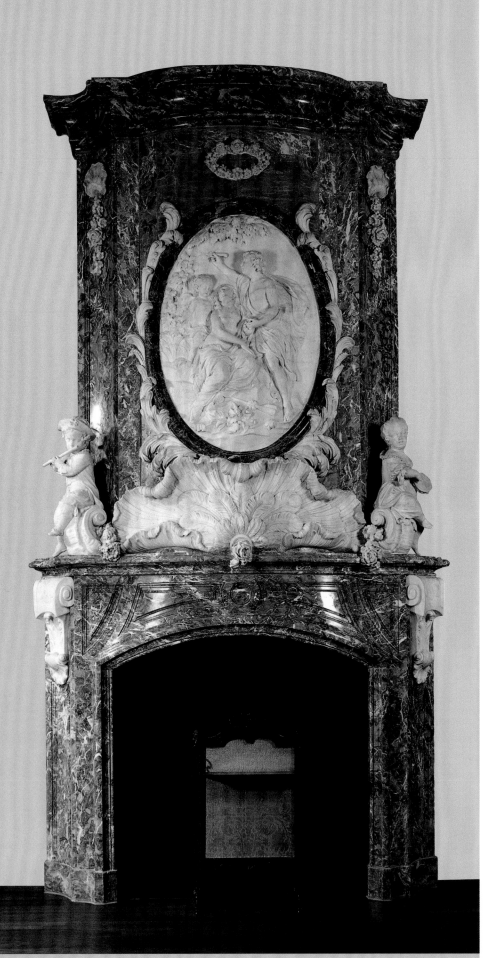

FIGURE 1.23. Jean-Baptiste Xavery (Dutch, 1697–1742); *Chimney Piece with Medallion of Paris and Oenone*, 1739; polychrome marble; 181½ x 99¼ x 5½ in. (461 x 252.1 x 14 cm); Rijksmuseum, Amsterdam (inv. no. BK-1995-3).

it was transformed under Morgan's leadership. The fulminations in his newspapers about the supposed thievery of monopolistic industrialists would hardly have endeared him to the elite group that included Frick, John G. Johnson, and Henry Walters, but it is tempting to believe that the museum's growing ambitions set an example for Hearst at that time.[89]

A description from 1905 offers a glimpse into one room in his townhouse.[90] The walls were painted dark green and decorated with fleurs-de-lis, imitating the château of Blois. The importance of the unnamed paintings ("costly") that were stacked on the floor was probably exaggerated. Conventional nineteenth-century bronzes and porcelains appear, along with a mummy case, a suit of armor, "deer antlers for chandeliers," Delft ware, and old glass. It is tempting to believe that the chandeliers were Lusterweibchen (literally, "chandelier maids"), the charming hybrids that resemble mermaids, with antlers spreading out in place of their tails. Hearst nourished an intense affection for these Bavarian and Franconian lighting fixtures. A "Tudor bed with bulbous supports" was also in the townhouse.[91] Neither the Greek vases nor the sumptuous allegorical tapestry of the month of September, which Hearst purchased in 1903 (fig. 1.22), was mentioned, however.

Hearst apparently made no noteworthy acquisitions of art in 1906. There was an earthquake in San Francisco, which leveled the city. Nothing was left of the Examiner Building except its shell. A number of Phoebe Hearst's possessions stored there were reduced to ashes. The University of California became a refugee camp. Hearst wrote to his mother, who was in Paris: "We are not as badly off as most people so we have no right to complain.... The paper loses disastrously. The insurance will partly restore the plant but the income is wiped out.... When you see poor old San Francisco it seems as if you had come back to earth after thousands of years and were seeing the places you had lived in during a previous existence."[92]

A natural disaster of this magnitude could not overwhelm Hearst's energy and determination. He had to find printing presses to replace the ones that were destroyed. One of his sons recounted: "He discovered them in Salt Lake City, and paid twice their worth. The unassembled parts were loaded onto two railroad cars and attached to a San Francisco–bound train; Chicago mechanics were rushed by train to San Francisco to assemble them. Pop had done it all between lunch and dinner in New York. Within days of the quake, the *Examiner* was publishing again. Grandma cheered."[93]

The following year Hearst returned to Duveen. In April he bought some ruby-backed Chinese plates, objects for which he seemed to develop a continuous appetite. Three weeks after he bought the plates, he added four "old carved wood Spanish columns, one pair of fine old carved cassones [*sic*]," and the major purchase, "four old Flemish Renaissance 16th century tapestries with borders."[94] The bill came to $25,000. Now the scale and quality of the works of art he bought really began to rise.

Hearst may have bought directly from the Stanford White auction of 1907 an ornate carved ceiling that incorporated a colorful Adoration of the Shepherds as its central motif.[95] In 1909 he purchased the elaborate polychrome marble chimneypiece of 1739 by Jean-Baptiste Xavery (fig. 1.23) at auction in Amsterdam.[96] These might have been acquired in view of a move to a much grander residence. Hearst bought from Duveen throughout 1908: "four very fine genuine old tapestry cushions armorial designs [possibly those in fig. 6.2]; a collection of 15 genuine old Oriental plates of the Kangste [illeg., i.e., Kangxi] dynasty etc.; four old painted carved panels in gilt wood frames; one carved wood shield with arms of Colonna and Orsini family in high relief; one carved and gilt walnut armchair frame in the Renaissance style covered in tapestry; one old 16th century doorknocker."[97] He visited Duveen once a week for three weeks in November. He was billed for the repair and "touching up gilding" of the four panels and for the repair and lining of the tapestries.[98]

Hearst's address, given in the Duveen ledgers for 1908, was 135 East Twenty-eighth Street. This was the townhouse at Lexington Avenue. In 1909 Duveen listed him at Eighty-sixth Street at Riverside Drive.[99] Here Hearst created a gigantic apartment that overlooked the Hudson River. His life was rapidly expanding along palatial lines. His network of newspapers and the syndication of his wire and photographic services blossomed. In 1910 he gained a foothold in Europe with the purchase of *Nash's* magazine in England.[100] To his first magazine, *Cosmopolitan*, purchased in 1905, he added *Good Housekeeping*, in 1911, and *Harper's Bazaar*, in 1912.[101] In 1913 he was producing newsreels. Next came an agreement to distribute and coproduce feature films with Pathé in 1914. Animated cartoons followed in 1915.

After his mother died in 1919 (her will was probated in 1923) and virtually all the fortune finally passed into his control, Hearst established a movie production company, Cosmopolitan Studios, in New York.[102] As he assembled the

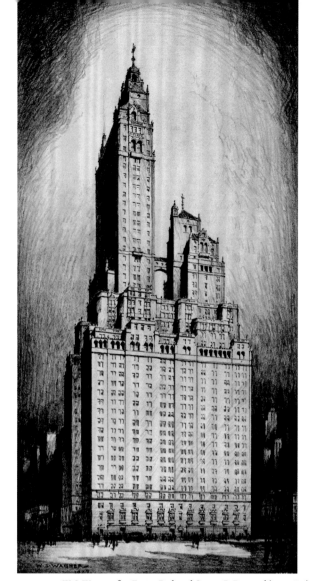

FIGURE 1.24. W. S. Wagner after Emery Roth and George B. Post, architects; *Project for the Warwick Hotel*, 1927; charcoal or black crayon on paper; approx. 12 x 6 in. (30.5 x 15.2 cm); New York Historical Society (inv. no. PRO53/9/1).

properties essential for film production and the growth of his publishing enterprises, his commercial real estate holdings billowed across Manhattan. They ranged from whole blocks in semi-industrial areas to the Cosmopolitan Theater, remodeled by the Viennese designer Joseph Urban, and the visionary plans for a skyscraper called the Warwick Hotel (fig. 1.24) across from it (see chapter 4). He proceeded, in a decade, to conceive or extensively renovate five other extraordinary residences: a castle on the central coast of California (begun 1919), a mansion on the beach in Los Angeles (begun c. 1925), a medieval fortress in Wales (bought in 1926), an estate on Long Island (bought in late 1927), and a Bavarian-style enclave in Northern California (begun late 1929). He orchestrated their style and amassed the furnishings and collections that they housed simultaneously. It was a unique and breathtaking phenomenon. He started with his home in New York.

Notes

1. Hearst also had knowledge of French and German and was familiar with Latin and Greek.

2. Suggested by a remark by one of the workers at San Simeon, quoted by Nancy Loe, *Hearst Castle: An Interpretive History of W. R. Hearst's San Simeon Estate* (Santa Barbara, Calif.: Companion Press, 1994), 48.

3. A red-figured pyxis from Hearst's collection is in the University of Canterbury, Christchurch, New Zealand, and a black-figured amphora is in the Israel Museum, Jerusalem. Hearst objects can probably also be found in collections in South America. Many Hearst objects were bought by the dealer Nicholas de Koenigsberg and his daughter Paula. Their Le Passe gallery had a significant operation in Argentina, so Hearst objects likely remain there. Thus there are probably Hearst objects on five continents.

4. W. A. Swanberg deserves credit for pointing out that previous authors erred in their negative judgments against Hearst in this regard (*Citizen Hearst: A Biography of William Randolph Hearst* [New York: Scribner's, 1961], 466). Hearst did own a lot. When he moved his possessions from Lincoln Storage in New York to his new warehouse in the Bronx, the registrar reported to him on February 16, 1928, that he had "already transported and stored…3500 cases weighing from 200 up to 1000 pounds each" (William Randolph Hearst Papers, Special Collections, Bancroft Library, University of California, Berkeley, 39:7).

5. "Hearst," *Fortune*, October 1935, 44, 54, quoted by David Nasaw, "Earthly Delights," *New Yorker*, March 23, 1998, 71; Aline Louchheim, "Mr. Hearst and Art," *New York Times*, August 26, 1951 (this estimate was surely an exaggeration that corresponded to popular assumptions of the time); René Brimo, *L'évolution du goût aux États-Unis* (Paris: James Fortune, 1938), 96–97 (see also 93–95, 140, 142, 144–45).

6. Mary Levkoff, "The Little-Known American Provenance of Some Well-Known European Sculptures," in *La sculpture en occident: Études offertes à Jean-René Gaborit*, ed. G. Bresc-Bautier (Dijon: Éditions Faton, 2007), 300–301.

7. Emily B. Neff, *John Singleton Copley in England*, exh. cat. (London: M. Holberton; Houston: Museum of Fine Arts, 1995), no. 3.

8. Timothy B. Schroder, *The Gilbert Collection of Gold and Silver* (Los Angeles: Los Angeles County Museum of Art, 1988), no. 166; for other Hearst objects in the Gilbert Collection, see nos. 11, 58, 139.

9. Dietrich von Bothmer, "Greek Vases from the Hearst Collection," *Metropolitan Museum of Art Bulletin*, n.s., 15 (March 1957): 167. The number 450 must be judged in historical perspective. It pales beside the eighteenth-century collection of Sir William Hamilton, the British envoy to Naples (beginning 1764), who owned more than 1,500 such vessels. Thomas Hope purchased (1801) about 750 vases that had belonged to Hamilton. The export of vases excavated in Italy was supposed to have stopped in 1909, when the Italian government passed a law declaring that any antiquity unearthed from Italian soil belonged to Italy.

10. Sandra Barghini's memo (July 28, 1992) in Hearst Castle files relates that Bothmer first worked with Charles C. Rounds, the registrar of the Hearst warehouse in the Bronx, "with initial interest in the maiolica collection. Rounds suggested the acquisition of Greek vases." Another memo by Barghini (September 30, 1988) notes that the Metropolitan's initial focus had been the maiolica. (Bothmer's prime interest was Greek vases.) He "worked out of the black notebooks in the New York warehouse to choose a selection. In some cases, there were no photos, and he chose by description only." In 1941 the Metropolitan bought Hearst's black-figured panel amphora of Herakles killing the Nemean lion from one of his sales; see Gisela Richter, "Two Early Greek Vases," *Metropolitan Museum of Art Bulletin* 36 (September 1941): 187–90. The renowned volute-krater was in the Thomas Clarke sale of 1899 (lot 424), where it was bought by the dealer Michel van Gelder. He either was Hearst's agent or sold it directly to him.

11. Guy Delmarcel, *Wandtapijten*, vol. 1, *Middeleeuwen en vroege Renaissance* (Brussels: Koninklijke Musea voor Kunst en Geschiedenis, 1977), 11, figs. 30–36. Also known as the Seven Deadly Sins series, as in Charissa Bremer-David, "French & Company and American Collections of Tapestries, 1907–1959," *Studies in the Decorative Arts* 11 (Fall–Winter 2003-4): 49–50.

12. Donald LaRocca, "Carl Otto Kretzschmar von Kienbusch and the Collecting of Arms and Armor in America," *Philadelphia Museum of Art Bulletin* 81 (Winter 1985): 8, 11, 13, 14.

13. Jennifer Pittman, "The Silver Legacy of William Randolph Hearst," *Silver Society of Canada* 4 (Fall 2001): 10, 11.

14. Marion Davies, *The Times We Had: Life with William Randolph Hearst* (New York and Indianapolis: Bobbs-Merrill, 1975), 132.

15. On the importance of these tapestries, see Bremer-David, "French & Company."

16. Loe, *Hearst Castle*, 15, possibly relying on the *Fortune* article from 1935 (see note 5 above).

17. William Randolph Hearst Jr. with Jack Casserly, *The Hearsts: Father and Son* (Niwot, Colo.: Roberts Rinehart, 1991), 7; Judith Robinson, *The Hearsts: An American Dynasty* (San Francisco: Telegraph Hill Press, 1991), 33–35, 40.

18. Ibid., 35, 39.

19. Ibid., 105.

20. Nancy E. Loe, *William Randolph Hearst: An Illustrated Biography*, 2nd ed. (Bishop, Calif.: Companion Press, 2005), 16–17, citing Michael Cieply, "The Loded Hearst," *Westways* 73, no. 6 (1981): 78. Loe (ibid., 18) astutely characterized this, using today's corporate terminology, as "vertical integration."

21. Robinson, *American Dynasty*, 101. David Nasaw remarked that the presence of copper was known, but only Hearst and his partners had the means to locate it (*The Chief: The Life of William Randolph Hearst* [New York: Houghton Mifflin, 2000], 24).

22. Loe, *William Randolph Hearst*, 16–17; Hearst Jr., *The Hearsts*, 8; Robinson, *American Dynasty*, 105.

23. Robinson, *American Dynasty*, 80–81, 181–84.

24. Ibid., 40. Lawsuits continued into 1873 (ibid., 133).

25. Sally B. Woodbridge, *Bernard Maybeck: Visionary Architect* (New York: Abbeville, 1992), 76–77.

26. Robinson, *American Dynasty*, 251. For Phoebe's support of the study of anthropology and archaeology at Berkeley, see "The Museum of Anthropology of the University of California," *Science* 34 (December 1911): 794. At the time it was "the largest single contribution to the furtherance of anthropology ever made in America."

27. Phoebe gave a complete library to Lead in 1894, and one to Anaconda in 1904. Her kindergarten at Lead, staffed by teachers trained by her school in Washington, introduced "immigrant children to the English language and American culture" (Richard H. Peterson, "The Spirit of Giving: The Educational Philanthropy of Western Mining Leaders, 1870-1900," *Pacific Historical Review* 53 [August 1984]: 329-30). Watson Parker notes that the strike in 1909 failed because the employees were well treated. The Hearst company store "competed with but never superseded…smaller…businesses" (review of Joseph H. Cash, *Working the Homestake* [Ames: Iowa State University Press, 1973], in *Journal of American History* 60 [March 1974]: 1146). There was a hospital, free land for houses, schools, and the library. Mitchell Bishop observes that her philanthropies in some cases compensated for the aftereffects of her husband's business: "There was no questioning of colonial enterprise even if it involved taking land from Native Americans and destroying and polluting the landscape to extract wealth" ("Phoebe Hearst, 1842–1919, Philanthropist" [unpublished paper for UCLA Department of Information Studies, September 5, 2002], 15). There seems to be no evidence of efforts on Phoebe's part to benefit Native Americans then. See also Alexandra Nickliss, "Phoebe Apperson Hearst's 'Gospel of Wealth,'" *Pacific Historical Review* 71 (November 2002): 575–605.

28. See J. Nilsen Laurvik, ed., *Catalogue Mrs. Phoebe A. Hearst Loan Collection* (San Francisco: San Francisco Art Association, 1917). Many of her rare manuscripts are in the library of the University of California, Berkeley (see Melvyl catalog, http://melvyl.cdlib.org).

29. Their sale during her lifetime possibly coincided with reductions in donations to her charities in 1904 (see Robinson, *American Dynasty*, 339-40) and the building of her castle at Wyntoon in 1903. For the tapestries, see Candace Adelson and Sheila Ffolliott, *Images of a Queen's Power: The Artemisia Tapestries*, exh. cat. (Minneapolis: Minneapolis Institute of Arts, 1993), 38. Phoebe also owned tapestries that her son kept. They are listed in the Hearst Castle inventory: "Château Gardens" and "Landscape with Temple" (a pair); "Boreas Abducting Orythea"; "Sleigh Ride," attributed to Jean-Baptiste Le Prince (later sold to Mr. Ruby Black); and an "Alexander" Gobelins tapestry, which was in the music room (presumably at her California hacienda, not Washington).

30. Robinson (*American Dynasty*, 223), relying on newspaper accounts of the time, lists the names Corot, Reynolds, Rousseau, Watteau, Millet, Romney, van Dyck, and Copley and a miniature by David. The house was demolished decades ago. Hearst kept the painting attributed to Reynolds and eventually installed it in his wife's estate on Long Island (see chapter 6); it was later sold. Phoebe also owned a painting by Albert Bierstadt, but its location then and now is untraced.

31. Ibid., 35.

32. John Loring, *Magnificent Tiffany Silver* (New York: Harry N. Abrams, 2001), 81.

33. The portrait of Hearst is in Hearst Castle. The portrait of Phoebe Hearst's parents is in a private collection.

34. Woodbridge, *Bernard Maybeck*.

35. Native American baskets were stuck in the same rafters from which a chandelier and a Japanese lantern were suspended. A bust that might be a copy of Antonio Rossellino's *Portrait of a Lady* (c. 1460, Berlin, Staatliche Museen) was set in front of a late seventeenth-century Flemish tapestry; paintings were stacked to the ceiling, and carpets and other textiles abounded. A Gobelins tapestry of Alexander the Great, inherited by Hearst from his mother, mentioned above, is described in the Hearst Castle inventory as having been in a music room; this was presumably the one at the hacienda, as the decoration of the mansion in Washington was long since dismantled. Phoebe moved to her hacienda in 1897 (Robinson, *American Dynasty*, 254). Her penchant for German enameled-glass beakers (humpen), shown in photographs of her seated before a mantelpiece decorated with them at the hacienda (Loe, *Hearst Castle*, 52), was shared by her son, who collected them enthusiastically (see cat. nos. 65–69).

36. Loe, *William Randolph Hearst*, 15.

37. Robinson, *American Dynasty*, 120–30. The letter is quoted on 130.

38. Ibid., 134.

39. Ibid., 124, 131.

40. Nasaw, *The Chief*, 20–21: Phoebe arranged the crowded itineraries for each city visited, as well as schedules of study. She also took her son to Switzerland and Holland.

41. Related by Alice Head, *It Could Never Have Happened* (London: W. Heinemann, 1939), 116.

42. Robinson, *American Dynasty*, 154, 156 (for the tutor).

43. Ibid., 198–99.

44. Nasaw, *The Chief*, 33.

45. Loe (*William Randolph Hearst*, 21) states that George Hearst gained ownership in 1880 "in lieu of repayment of the loans" that he had extended in its support. According to Nasaw (*The Chief*, 40), he bought it because it was the only Democratic paper in San Francisco and thus a key to political influence. Cf. Robinson, *American Dynasty*, 169.

46. Nasaw, *The Chief*, 54–55) quotes a long letter from Hearst to his father (1885) in which Hearst advises that the "changes be made not by degrees but at once so the improvement will be very marked [to] attract…attention."

47. Robinson, *American Dynasty*, 220; Robinson notes that by 1889 Will Hearst had an office in New York. He persuaded his father to erect a building in San Francisco to house the newspaper (ibid., 219). George Hearst respected his son's work at the *World* and looked to him for help (ibid., 196–97).

48. Nasaw, *The Chief*, 60, for the land in Mexico.

49. Robinson, *American Dynasty*, 238.

50. Ibid., 240 (for the trip to Europe), 244–45.

51. Nasaw, *The Chief*, 96–98, 100; Robinson, *American Dynasty*, 250 (for Babicora).

52. Nasaw, *The Chief*, 110; Loe, *William Randolph Hearst*, 42–46. It is well known that the character's name gave rise to the term *yellow journalism*, referring to sensationalist or scandal-mongering news coverage.

53. Taylor Coffman, *Hearst as Collector: The First Fifty Years, 1873–1923* (Summerland, Calif.: Coastal Heritage Press, 2003), 25, citing Cora Older and John Winkler (1927): his first residence in New York was "beautifully decorated with tapestries, bronzes, and paintings"; when he moved to Twenty-fifth Street, "he ripped out the interior and…put in beamed ceilings, tiled floors, rare mantels, and furnished the rooms with antique furniture and tapestries." Robinson (*American Dynasty*, 252) says that Hearst was on a "buying spree" in Europe in 1895, but she uncharacteristically provides no documentation for this.

54. Robinson, *American Dynasty*, 194.

55. Coffman, *Hearst as Collector*, 11–12. Ansiglioni's portrait bust of Phoebe Hearst is in the Phoebe Hearst Museum at Berkeley; the portrait of her son (attributed to Jean-Léon Gérôme in Hearst Castle inventory) is in a private collection. She also had an example of Ansiglioni's statue *Flora*, which appears in a photograph of the house in Washington, D.C.

56. Ibid., 16–17. Nasaw (*The Chief*, 86) also quotes this letter but with different elisions. The letter suggests Hearst's lack of confidence in his mother's taste.

57. Italian High Renaissance paintings were significantly more desirable then. Raphael's popularity was at its summit in modern times (see John Pope-Hennessy, *Raphael* [New York: New York University Press, 1970], 9). Bernard Berenson remarked that a "second-rate picture that has belonged to any English nobleman" was easier to sell in America "than a first-rate one that has belonged to a great name in the Italian nobility" (quoted by Samuel N. Behrman, *Duveen* [Boston: Little, Brown, 1972], 82).

58. For the pictures attributed to Murillo, see *Art Objects and Furnishings from the William Randolph Hearst Collection* ([New York]: Hammer Galleries, 1941), 23. For the Zurbarán, see Jeannine Baticle, *Zurbarán*, exh. cat. (New York: Metropolitan Museum of Art, 1987), no. 7. Myron Laskin kindly brought the Zurbarán to the author's attention.

59. Hearst kept the tapestry of the duke of Marlborough battling the Turks, which is now at Hearst Castle (Coffman, *Hearst as Collector*, 19). He kept some other works of art that belonged to his mother as well, notably a Spanish silver standard (cat. no. 55), the painting by Coello, a painting of a lady with a lamb (by a follower of Peter Lely), and a *Mystic Marriage of Saint Catherine* (c. 1650), all at Hearst Castle. See Burton Fredericksen, *Handbook of the Paintings in the Hearst San Simeon State Historical Monument* (n.p.: Delphinian Publications in cooperation with the California Department of Parks and Recreation, 1977). Julia Morgan wrote to Chris MacGregor, Hearst's registrar: "At the time the Hacienda was dismantled, Mr. Hearst selected out three lots of paintings, portraits, etc. One lot he sent to New York, one lot by van to Wyntoon, and one lot by van to San Simeon" (August 22, 1933, Julia Morgan Papers, Special Collections, Robert E. Kennedy Library, California Polytechnic State University, San Luis Obispo, V-B-46-09).

60. Robinson (*American Dynasty*, 326) estimates that from 1891 to about 1901 she provided about $10 million to him. According to Nasaw (*The Chief*, 159), who cites testimony regarding her estate, by 1902 Phoebe had lent him $2 million to improve the newspapers in New York and Chicago. She forgave the debt. Hearst testified that she believed that he was entitled to half of George Hearst's estate.

61. For the punch bowl, see John M. Blades and John Loring, *Tiffany at the World's Columbian Exposition* (Palm Beach, Fla.: Henry Morrison Flagler Museum, 2006), 45, 125. He also owned Gérôme's *Oedipus*, which depicts Napoléon before the Sphinx. Both are at Hearst Castle. For the other paintings (e.g., those by Jean-Baptiste Isabey and Adolf Schreyer, and *Boy in Scarlet* by Paul Moreelse), see Coffman, *Hearst as Collector*, 26.

62. The Hearst Castle inventory cites ceramics purchased at auction in New York on February 24, 1898, and February 19, 1899. Coffman (ibid., 25) notes that Hearst bought Spanish ceramics in 1898. An annotated catalogue of the Thomas Clarke sale in 1899 shows that the vase was sold to the dealer Michel van Gelder. The provenance in the Metropolitan Museum of Art lists no owner other than Hearst after Clarke.

63. Loe, *Hearst Castle*, 50; Nasaw, *The Chief*, 152.

64. Nasaw, *The Chief*, 153–55.

65. *The William Randolph Hearst Collection: Photographs and Acquisition Records* (New York: Clearwater Publishing, [1987?]), microfiche card 598. See Patrick Offenstadt, *Jean Béraud, 1849–1935: The Belle Epoque, a Dream of Times Gone By: Catalogue Raisonné* (Cologne: Taschen, 1999), no. 358. The painting was mentioned in the press five times in 1900. No further mention occurs after this date.

66. Robinson (*American Dynasty*, 305) estimates that Phoebe Hearst donated about sixty thousand objects to the museum at the University of California, Berkeley. In 1992 it was renamed in her honor.

67. Coffman (*Hearst as Collector*, 27) states that Robert was Hearst's proxy at the sale, which occurred over three days, March 18–20, 1901. According to the Hearst Castle inventory, Hearst bought at least eight vases from Robert on March 25, 1901, while at least fifteen other vases are listed as having been bought directly at the auction on March 18, 1901. A couple of vases came from the Thomas Clarke sale, February 1, 1901, as noted by Coffman. Robert was also one of Isabella Stewart Gardner's agents.

68. Lot 68 was described in the auction catalogue as "une des plus belles pièces de ce genre," with its "brillant vernis noir," and as having been published by Helbig in 1873. The intact kalpis had a lengthy description as lot 32.

69. Marjorie Milne, "Three Attic Red-Figured Vases in New York," *American Journal of Archaeology* 66 (July 1962): 306. Another related hydria discussed in this article also came from Hearst.

70. Andrew Oliver Jr., "The Lycurgus Painter," *Metropolitan Museum of Art Bulletin*, n.s., 21 (Summer 1962): 25–30. The situla was lot 58, described as "absolument remarquable" and made in imitation of a bronze situla. The face painted under the foot ("détail unique") was reproduced in a line drawing in the catalogue.

71. Bourguignon sale cat. (*Collection d'antiquités…*), Hôtel Drouot, Paris, March 18, 1901, no. 31: "dessein délicieux…conservation irréprochable." Illus. in Bothmer, "Greek Vases," 177.

72. Bourguignon sale cat., no. 19, illus. in the text with a line drawing and described as Eos carrying away the body of Memnon, which is on the other side. Illus. in Bothmer, "Greek Vases," 172.

73. Bourguignon sale cat., no. 46; illus. in Bothmer, "Greek Vases," 165. The tumbler is glazed on the inside with two perfect rings left in reserve. The information provided

here was pieced together by matching up illustrations in Bothmer's article with those in the auction catalogues and descriptions in the Hearst Castle inventory. There are other ancient Greek and Roman works of art from Hearst in the Metropolitan beyond the sixty-five vases.

74. A few cards were missing from the Hearst Castle inventory, so the total cannot be exact.

75. Illus. in Bothmer, "Greek Vases," 169. The battle of Herakles with four hoplites described in de Morgan's catalogue is identified by Bothmer as Herakles and Geryon.

76. Inv. no. 86.07; Beazley Archive Pottery Database, Oxford University online database, vase no. 250105, http://www.beazley.ox.ac.uk/databases/pottery.htm.

77. New York sales, 1901–10, Duveen Archive, Getty Research Institute (hereafter referred to as GRI), box 5. Carolyn Miner found this document. Behrman (*Duveen*, 60) notes that 1901 was the year in which Joseph Duveen "made his real début as an art dealer" when he paid the highest price for a painting at auction in England. Joseph arrived in New York in 1886, when he was seventeen years old (ibid., 57). (Hearst bought some tankards from Duveen Bros.' London house in 1900, notes Christine Brennan, in "William Randolph Hearst and the Art Market: A Study of Hearst's Purchases from the Brummer Gallery" [paper for Bard Graduate College, 2007], citing Edward Fowles, *Memories of Duveen Brothers* [London: Times Books, 1976], 7.)

78. Some researchers delight in the fact that Duveen's list of code names to his clients gives Hearst's as "Hasty," but these codes were not adopted until 1935. Before that, Hearst's code name was the conventional "William" (as in Duveen cable, May 13, 1929, Duveen Archive, GRI).

79. Nasaw (*The Chief*, 156-61) gives an excellent account of this transformation.

80. They married in 1903, when she turned twenty-one. Millicent and her sister had accompanied Hearst in his Cuban adventure in 1898, and they went to Europe and Egypt with him in 1899 (Nasaw, *The Chief*, 137, 152). Phoebe Hearst did not attend the wedding. Her gift of "a set of magnificent emeralds" to the bride is mentioned in an article covering their marriage ("William R. Hearst Married," *New York Times*, April 29, 1903). For Hearst's election to the House, see Nasaw, *The Chief*, 168.

81. Loe, *Hearst Castle*, 55-57. Phoebe Hearst provided $1 million for the 1904 campaign, according to Robinson, *American Dynasty*, 338.

82. Nasaw, *The Chief*, 179-80.

83. The *Los Angeles Times* (January 26, 1904), for example, published a sarcastic article with a limerick that alluded to Hearst buying his political support.

84. Nasaw, *The Chief*, 210. The transfer of ownership of the monopolies (utilities) to the government, as Hearst proposed, was equated with nationalization. According to his son, Hearst was "his own brand of capitalist. As he defined it, 'The prosperity of the businessman depends on the prosperity of the people,'" (Hearst Jr., *The Hearsts*, 50). In an address on Labor Day in 1907 Hearst stated: "In this country there is no class of men that work with their hands while another class work with their brains.... We have no aristocracy save that of intellect and industry.... Let us all regard one another as fellow working men.... The man who digs the precious metal from the earth is worth his wage. The man who tells him where to find it deserves his profit, too. The great financial promoters, organizers, executives of America are worthy of recognition and reward.... Through many an anxious day and many a wakeful night these men have planned and prosecuted the great enterprises which...have given employment to millions of men. Let them have a liberal share of that wealth...as long as it is honestly acquired through enterprises that benefit the whole community.... Labor unions are valuable...to the whole community.... I plead for equal laws for all, for equal rights for all, for equal justice for all" (in *Selections from the Writings and Speeches of William Randolph Hearst*, ed. E. F. Tompkins [San Francisco: San Francisco Examiner, 1948], 357-61).

85. Nasaw, *The Chief*, 212.

86. Sydney Brooks, "The Significance of Mr. Hearst," *Fortnightly* 88 (December 1907): 919-31. Part of Brooks's article seems to have been adapted from an article by Charles E. Russell of the *Chicago American*, "William Randolph Hearst," *Harper's Weekly*, May 21, 1904, 790. There are some glaring errors in Brooks's article, for example, about Hearst's presumed lack of outside interests.

87. This was not a performance designed for an interviewer. William Randolph Hearst Jr. wrote that his father "was a very calm, logical person.... He often made his points with humor.... [He] kept this quotation from George Washington among his most important private papers: 'To persevere in one's duty and be silent is the best answer to calumny'" (Hearst Jr., 63).

88. Neither Hearst nor Morgan was interested in what Calvin Tomkins called the "competitive piles" of ersatz Renaissance palaces that lined Fifth Avenue north of Forty-second Street, or in Newport vacations. Neither inherited his full fortune until

he was almost sixty years old. Both had parents who collected art, and both were exposed to European (and specifically Germanic) culture early in their lives, although Morgan was raised in Europe and had full academic training at the University of Göttingen. Morgan belonged to an older generation than Hearst. He too bought massive quantities of art, but the high concentration of major masterpieces overshadowed the fact that at times he bought whole collections of thousands of objects (for example, the Garland collection of Chinese porcelains and the Hoentschel collections of decorative arts and medieval art). Through Morgan's influence the Metropolitan was set on a course of excellence that resulted in its greatness today. See Calvin Tomkins, *Merchants and Masterpieces: The Story of the Metropolitan Museum of Art* (New York: E. P. Dutton, 1973), 95-100. Hearst bought numerous works of art from Morgan's collection and apparently bought only one whole collection (the Rothschild maiolica).

89. Ibid., 100.

90. Coffman, *Hearst as Collector*, 30. A frequently published photograph of Hearst seated before a mantelpiece with a row of humpen on it does not depict the townhouse (see Victoria Kastner, *Hearst Castle: The Biography of a Country House* [New York: Harry N. Abrams, 2000], 48). The mantelpiece was in Phoebe Hearst's hacienda (see Loe, *Hearst Castle*, 52). Another photograph of Hearst (private collection) in front of the same mantelpiece shows the windows of the hacienda, made of leaded "bottle-end" glass, in the background. They are mentioned in Sara Boutelle, *Julia Morgan, Architect* (New York: Abbeville, 1995), 172.

91. Purchased in December 1901 from W. and A. Thornton-Smith. Chinese porcelains and Staffordshire pottery were also probably there (Hearst Corporation papers).

92. Robinson, *American Dynasty*, 346.

93. Hearst Jr., *The Hearsts*, 16.

94. New York sales, 1901–10, Duveen Archive, GRI, box 5. These were not the tapestries now in Detroit, bought in 1922, or the Redemption series, bought in 1921 (Duveen Client Summary Book 1910-1959, Duveen Archive, Metropolitan Museum of Art [hereafter referred to as MMA], reel 420). Coffman (*Hearst as Collector*, 32), quoting Cora Older's biography of Hearst, recounts that Hearst's "recently acquired tapestries" were installed in a space in his apartment at the Clarendon that was created by the removal of several partitions. The Duveen tapestries must be these.

95. Coffman (*Hearst as Collector*, 31) says that Hearst bought the ceiling directly at the auction; other sources suggest that it was purchased later from French & Company. Now in Hearst Castle, it is attributed to Joachim Wtewael or Abraham Bloemart (see dust jacket and Kastner, *Hearst Castle*, 49).

96. *Hearst Collection*, microfiche card 432, lot 191, art. 1-29. The complexity of the ensemble is suggested by the twenty-nine elements referred to in the inventory number. Two freestanding putti are situated on the mantel; the central motif above them, an oval relief, is more than four feet high. See "Recent Acquisitions at the Rijksmuseum" (supplement), *Burlington Magazine* 138 (November 1996), no. XVI. Frits Scholten kindly confirmed this information.

97. One of the armorial cushions might be in the Minneapolis Institute of Arts, inv. no. 39.15 (ex-collection Hearst). Made around 1740, it is more than two feet square and heavily worked with silver. Candace Adelson explains the importance of these costly armorial cushions, which were made for elected officials and guilds in the Netherlands (*European Tapestry in the Minneapolis Institute of Arts* [Minneapolis: Minneapolis Institute of Arts, 1994], 379-80).

98. New York sales, 1901–10, Duveen Archive, GRI, box 5. Many of the larger objects might have been stored at Phoebe Hearst's hacienda. Hearst wrote in mid-September 1919 to his architect Julia Morgan that "some of them have been there for a long time—columns &c" (Loe, *Hearst Castle*, 9). Warehouses in New York, Washington, and San Francisco also stored Phoebe's possessions (Robinson, *American Dynasty*, 244), as did the Examiner Building.

99. Purchases in 1909 from Duveen included a rose tapestry settee, marquise, and banquette; a carved inlaid table; and cushions and armchairs. Hearst possibly bought in 1910 from Duveen a picture by Nicolas de Largillière and a pair of Boulle cabinets.

100. Nasaw, *The Chief*, 345; Robinson, *American Dynasty*, 349: he also purchased a London paper called the *Daily Budget* in 1911.

101. Nasaw, *The Chief*, 190: Hearst's innovation was that until he arrived on the scene "newspaper publishers did not publish magazines." For the other magazines, see ibid., 227.

102. Ibid., 233-37, 280.

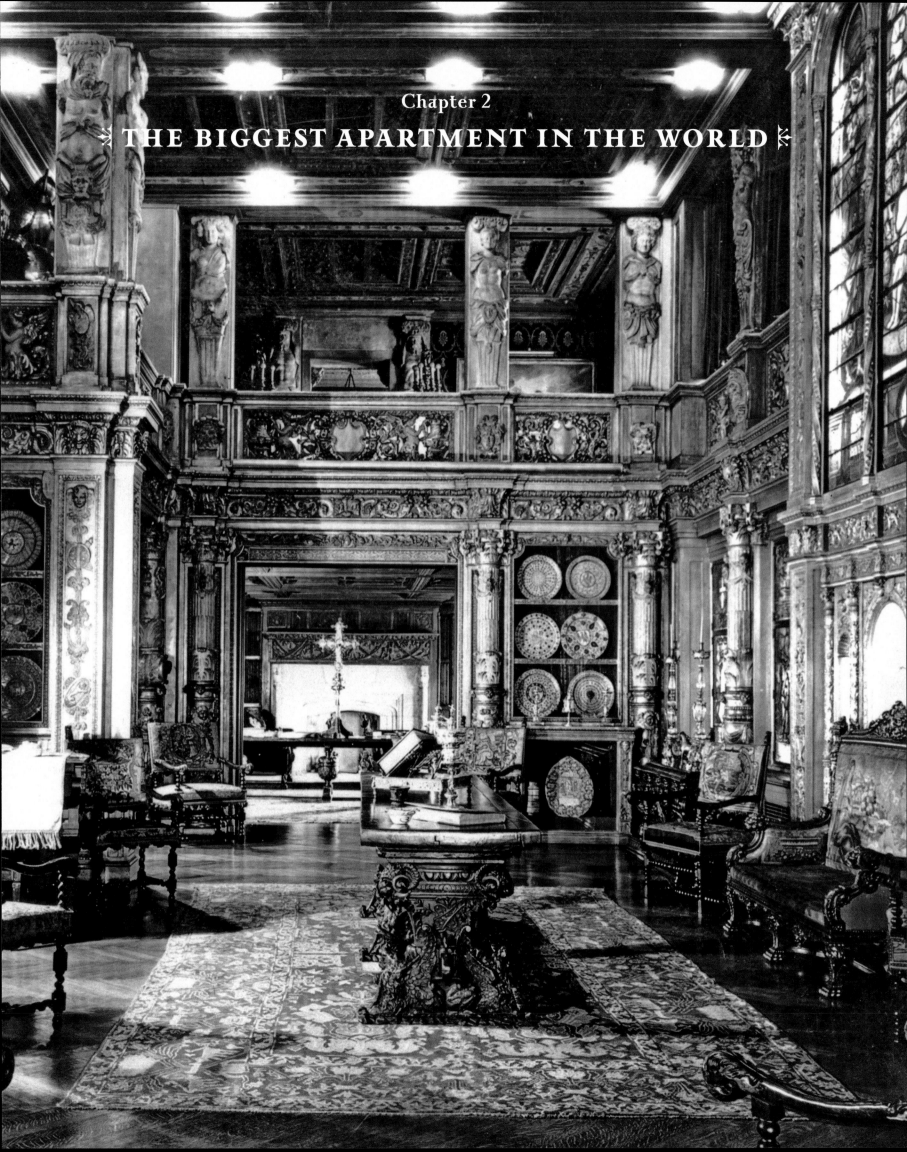

Chapter 2

❧ THE BIGGEST APARTMENT IN THE WORLD ❦

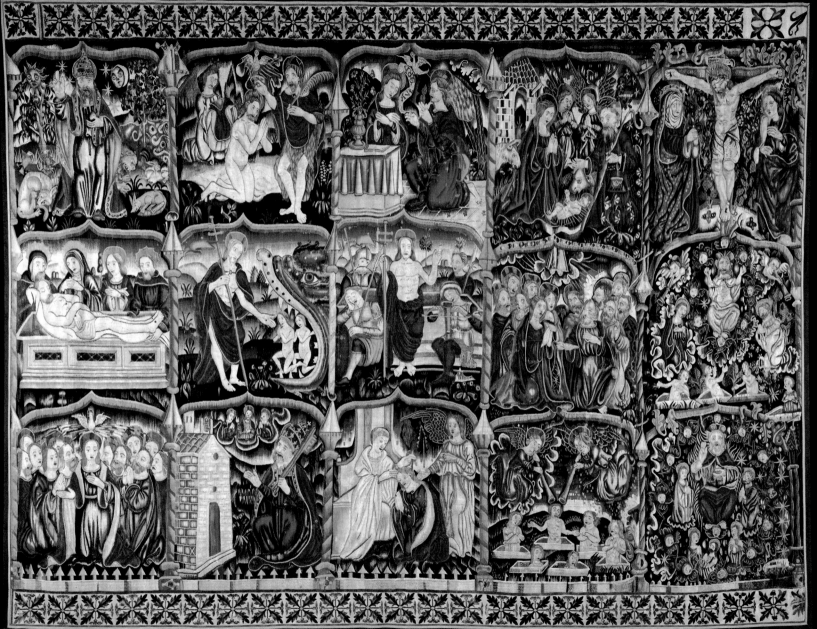

Approximately a year after the birth of his second son, in 1908,[1] Hearst moved his family to a luxurious new rental apartment building at 137 Riverside Drive called the Clarendon, designed by Charles Birge.[2] It covered half a city block. Each floor was divided into two residences. The Hearsts had the top three floors—in other words, six apartments. "That was Pop's response to Mother's request for more room," recalled William Randolph Hearst Jr. "It was like a royal palace. The lowest of the three floors was a dining room and a big-domed living room. Pop often used one end of the large living room as an office. The top two floors were made into a banquet hall for parties and a ballroom for dancing. The ballroom had a balcony at each end.... Mom and Pop...lived on the middle floor."[3] The elevation that overlooked the Hudson River was 102 feet long, with 100 feet facing Eighty-sixth Street. Hearst's real estate agent, Martin Huberth, estimated that the total square footage was about three-quarters of an acre, excluding the roof garden.[4]

A few years later, in 1913, Hearst decided to add the two floors below to the three he already occupied. "The owner wouldn't allow Pop to expand our apartment, so my father bought the entire building for about $1,000,000. He had much of it redecorated," continued his son. The "redecoration" included the demolition of two of the floors and raising a ceiling through a steep, copper-clad mansard roof. The resulting space was thirty-five feet high.[5] "When all the work was finished, some people said we owned the largest private apartment in New York and likely the world." The children lived downstairs. Their parents "were concerned about all the valuable paintings, statuary, and armor."[6]

Thanks to the fact that Hearst was a newspaperman who understood the potential of syndication, his home in the Clarendon was fairly well documented in photographs.[7] The *Apostles' Creed* tapestry (fig. 2.2), which had once been in the Cathedral of Toledo, is in one view (fig. 2.3),[8] while the *Vendange* tapestry, bought at auction in 1911, and a cassone purchased from one of the Seligmans figured in

Overleaf: FIGURE 2.1. An interior in Hearst's apartment in the Clarendon, New York, before 1929, showing the collection of Spanish lusterware. FIGURE 2.2. *The Apostles' Creed*, Europe, c. 1550–1600 (cat. no. 35). FIGURE 2.3. An interior in Hearst's apartment in the Clarendon, with the *Apostles' Creed* tapestry at the left. The sixteenth-century Italian trestle table is in the Los Angeles County Museum of Art (inv. no. 46.10.2).

a room lined with meticulously carved linenfold paneling that came from Gwydyr Castle in Wales.[9] A young architect, Thaddeus Joy, described what the quintuplex looked like on March 9, 1923:

> Mr. Hearst's house is amazingly rich. He has four floors of a large appartment [*sic*] house (the topmost floors). I saw but the principal rooms of the 10th and eleventh, the lower two floors. They are well executed but it seems to me what might have been truly stunning effects of vistas and connections have just been missed. The furniture is not altogether suitable.... [An arrow points to a cross section.] The ceiling of the central room (Recpt. Hall) is an antique & the other two upper ceiling [*sic*] are made to match.... His colored windows show... a glory through the medium of glass that nothing else would do. One upper room is a museum of treasures of archeology—pottery, small bas reliefs, statuettes & jewelry from ancient Greece and—South America! with a few scattered gothic carvings. George Thompson [the valet] calls it the "Greek Room."[10]

The cross section that Joy sketched corresponds in its proportions and arrangement to the room where Hearst displayed his collection of Spanish lusterware (fig. 2.1).[11] It was the most ornate room in the Clarendon that was photographed. In the distance, before a large fireplace, a large processional cross (probably fig. 2.4) stood on a refectory table. The mezzanine above it must have been the balcony of the "Spanish Gallery," where two suits of modern horse armor were displayed.[12] Andirons with bronzes after Tiziano Aspetti are in front of the fireplace.

To the right was the stained-glass *Creation* window (1533) by Valentin Bousch, from the priory church of Saint-Firmin at Flavigny-sur-Moselle, France.[13] Its unusually dense and modulated color scheme must have created a spectacular effect. Whether or not it was among the stained-glass panels that, as early as 1910, already attracted the attention of a Dr. Schmitz (no doubt Hermann Schmitz of the Kunstgewerbemuseum in Berlin), who asked through an intermediary at the Metropolitan Museum of Art if he could see Hearst's glass, is unknown. Hearst replied regretfully to the scholar's colleague at the Metropolitan that "the greater part of my things" had been packed in anticipation of Hearst's departure for Europe the next day.[14] The colleague was Wilhelm (later William) Valentiner, who had been engaged by the Metropolitan Museum as a curator of decorative art.

The lusterware was one of the few segments of Hearst's collection that favorably impressed the dealer Germain Seligman when he saw it in 1913.[15] Of course a great number of these ceramics had come from his father, Jacques Seligmann, in addition to the ones Hearst bought at auction and elsewhere. Eventually this collection comprised almost three hundred objects.[16] After Hearst's death ninety-seven of them were purchased by the Metropolitan Museum of Art, the Detroit Institute of Arts acquired about five others, and about a dozen others were bought by Doris Duke for her museum of Islamic art in Hawaii.

Hearst had specific reasons for his choices in this and other areas, but he rarely explained them. His orders to Duveen about the purchase ("without fail") of three Spanish lusterware chargers at two auctions in Paris were so absolute that Duveen told his Paris gallery: "positively buy them whatever they may fetch." Hearst and Duveen prevailed, securing two plates against three other dealers for about $33,900 at one auction. "The purchase has made a great sensation, it was reproduced in all the French newspapers," Duveen's Paris branch reported. The third object was a small plate that Hearst wanted just as adamantly. Everyone remained baffled by Hearst's single-mindedness. When the small plate was obtained for $1,500, Duveen's Paris branch wired New York a comment tinged with umbrage: it was a "small and unimportant piece, and we cannot find your interest therein."[17]

Sometimes Hearst's interest in very modest items was more obvious. His Delft, Staffordshire, and Liverpool ceramics—like souvenirs of high quality—depicted historic scenes, locations that were familiar to him, and subjects that appealed to his patriotism. He had several examples of Liverpool pitchers with George Washington's portrait and at least five examples of a Staffordshire plate known as "The Tyrant's Foe." It reproduced the text of the First Amendment to the U.S. Constitution, with a reference to freedom of the press in the center (fig. 2.5).[18]

Hearst did not need to justify his choices to anyone, and he could proceed without explanation through almost incomprehensible negotiations with his dealers. To cite but a single episode related to Spanish lusterware, his proposals to Duveen in 1911, when he agreed to pay off his debt to the dealer in installments of $5,000 a month, would have unraveled a normal person.[19] Duveen was made of stronger stuff. Hearst apparently was interested in a bowl and ewer. Perhaps instead of Hearst paying for them outright, Hearst's

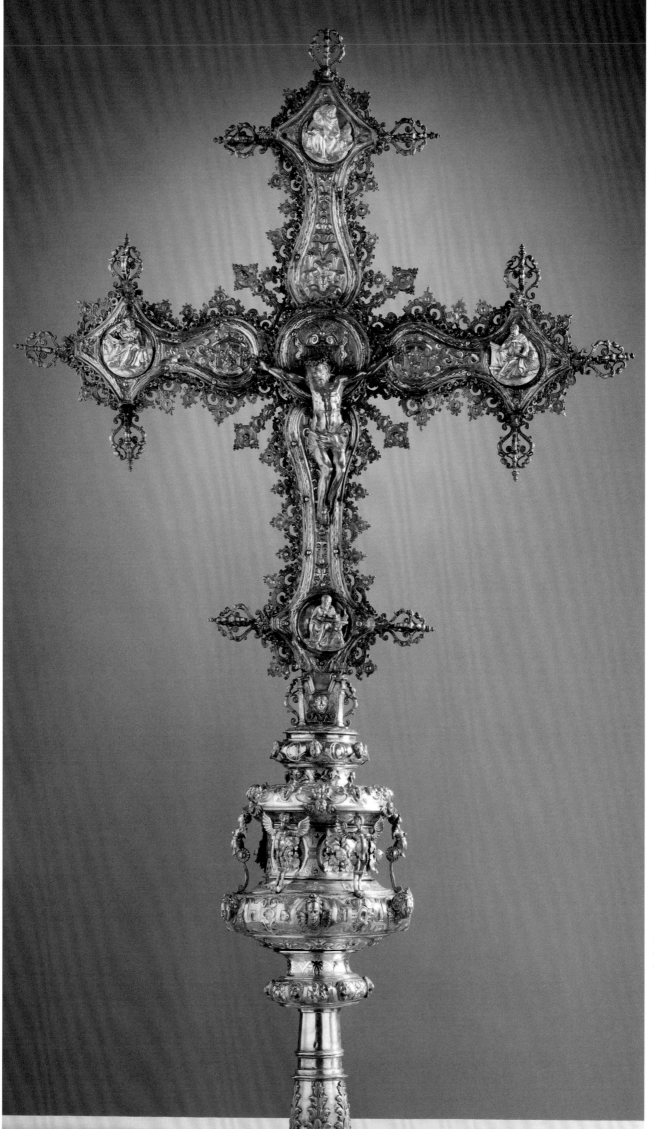

FIGURE 2.4. *Processional
Cross*, Spain (Burgos),
c. 1550 (cat. no. 47).

Parisian agent, Gerard d'Aquin, asked if Duveen's other client (Robert Lehman?) would buy the bowl and ewer and exchange them for a tapestry that Hearst had bought from Duveen, even though "Mr. Hearst does feel he can pay more for the bowl and ewer," d'Aquin wrote, but "in the interest of further business it may be well to accept Mr. Hearst's offer of $40,000."[20] More than six months later Hearst had still not come to see the ewer (probably fig. 2.7). "I have had so much annoyance with strikes the last few days," he wrote, "that my mind was not on art objects."[21]

Strikes at home were just an irritant in comparison with the calamity that lay ahead in Europe. The assassination of the Austrian archduke Franz Ferdinand in 1914 revitalized old alliances and led to horrific carnage. To Hearst, it was essential that the United States stay out of the conflict. He saw no contradiction in waging a war to oust a European power from the Americas, or to protect the interests of the United States in its own hemisphere, while insisting that the United States not become involved in the European hemisphere.

Now, as a result of the murder of a useless aristocrat, other useless aristocrats were sending innocent people to their deaths, Hearst maintained. In a signed editorial he wrote:

> It is a war between states that should be living in peace…and even in governmental accord, as 'The United States of Europe.'… It is a war in which the proportion of civilized human beings on the planet will be greatly reduced, and [their] contribution to human progress…irretrievably lost. It is a war in which the accumulated treasures of centuries are being destroyed, treasures not merely of money but of art and architecture which can never be replaced, and whose refining and elevating and civilizing influence will forever be ended in the world…. It is a disaster to the civilization of which we Americans are part possessors…. The war is attributable to the survival in Europe of mediaeval institutions long outgrown by modern society, to the prosecution of imperial policies in the selfish interest of greedy hereditary dynasties…. No country exalts…the man who holds up another…and takes his…pocketbook from him as "indemnity." No country applauds…the man who hides in the night and from mean motives of revenge destroys a tenement with a bomb, killing and maiming innocent women and children. In modern society, men such as these are regarded as criminals.[22]

The fact that Hearst published stories from Germany's point of view in addition to Great Britain's, while also defying England's censorship laws and suggesting, incredibly, that British citizens be deported from the United States so that they could fight their war, made him a pariah.[23] His newspapers were boycotted.

Nevertheless the Hearst Corporation of 1917 was estimated to have been worth about $35 million.[24] That year marks the beginning of a long relationship with the dealer Mitchell Samuels, the principal of French & Company.[25] Otherwise Hearst's collecting was curtailed until after the armistice. Then it took off with a bang. His mother's estate was probated in 1923. He was sixty years old. Tapestries, armor, paintings, furniture, and every form of decorative art came in a flood from every possible source.

Hearst bought not only some important Limoges enamels that had been in the J. Pierpont Morgan collection (fig. 2.6, cat. nos. 60, 61, 63)[26] but also the magnificent Rothschild collection of maiolica.[27] Dozens of purchases of arms and armor were made when the renowned Beardmore and Morgan Williams collections were auctioned in 1921. It is likely that Bashford Dean, the curator of arms and armor at the Metropolitan, gave his opinions on some of the lots.[28] Hearst wanted Duveen to handle the bidding for him at the auctions. When he sent the list to Duveen, Hearst finally recorded an explanatory remark about his preferences and motives: "No. 159 I am willing to pay more for, but a single, small piece like this is of no such value to me as a good suit of armor, as I want this material for decoration largely; but of course I want fine decoration."[29]

Somewhere in the Clarendon were a Spanish ceiling "too valuable to lose" and a copy of Canova's *Pauline Borghese*.[30] An important Chippendale commode was in Hearst's grand library, which stretched down four pairs of projecting bays.[31] Hearst bought a portrait of Mrs. Baldwin by Sir Joshua Reynolds (fig. 6.8) in 1920,[32] as well as Gérôme's *King Candaules* (1859; fig. 2.8), a painting that was enormously popular in its day.[33] It joined one of Hearst's other paintings by Gérôme, *Oedipus* (1867–68), purchased in 1913.[34] Several eighteenth-century French paintings (including ones by Jacques-Louis David [fig. 8.2], Jean-Baptiste Greuze, and Jean-Honoré Fragonard[35] and others attributed then to Jean-Marc Nattier[36] and Élisabeth Vigée-Lebrun) would enter Hearst's collection over the next few years. Their presence shows both Millicent Hearst's taste and the influence of the dealer Félix Wildenstein.[37] Millicent did not shrink

FIGURE 2.7. *Pitcher*, Spain (Valencia, probably Manises), c. 1400–1450 (cat. no. 73).

from more emotionally demanding subjects: she asked that the *Ecce Homo* tapestry, which Hearst bought from French & Company, be installed in the Clarendon's Spanish Gallery.[38]

By late April 1924 Hearst owed Duveen $976,000, of which $500,000 was paid on the dealer's request.[39] The remaining debt did not deter Hearst from securing twenty-eight lots at the auction of the historic Swaythling silver in May (figs. 2.9, 2.10).[40] In June the big acquisition was machinery that printed images and text of unprecedented clarity and precision.[41]

Birge provided a design for the installation of early panel paintings in an "Italian Room" in 1925.[42] The Bateman *Mercury* (now in the Los Angeles County Museum of Art) was in the Clarendon too, along with Egyptian antiquities.[43] Many of the interiors were fitted with Tudor and Jacobean

FIGURE 2.8. Jean-Léon Gérôme (French, 1824–1904); *King Candaules (Le roi Candaule)*, 1859; oil on canvas; 26½ x 39 in. (67.3 x 99.1 cm); Museo de Arte de Ponce (inv. no. 63.0353).

paneling and magnificent plaster ceilings. Cabinets, carved tables, Elizabethan canopy beds, stained-glass windows, and Persian and Turkish carpets furnished rooms in which seventeenth- and eighteenth-century silver sconces twinkled on the walls. Hearst installed offices on the ground floor of the building in 1926.[44] A paneled room attributed to Grinling Gibbons was added to the Clarendon before 1929.[45]

The glory of the quintuplex, however, was the breathtaking armory (fig. 2.11), in which two dozen superb suits of armor stood along the walls.[46] Through six tapestries from the Redemption of Man series, purchased from Duveen in 1921 (cat. no. 33), the story of the metaphysical salvation of humankind through Christ was unfurled.[47] Above them, stained-glass clerestory windows rose toward the vaulted ceiling. One end of the gallery was hung with the tapestry *The Martyrdom of Saint Paul* (cat. no. 31); a pair of extraordinarily large dinanderie torchères flanked the mantelpiece (fig. 6.4).

In 1932 the concept of the Clarendon's tapestry-lined armory reappeared as a design for an addition to the estate that Hearst had begun in 1919 near the village of San Simeon in California. It was the greatest individual residential construction project undertaken up to that time in the United States. By the time the Clarendon was photographed in 1929, that estate too was substantially built.

Notes
1. William Randolph Hearst Jr. (*The Hearsts*, 24) wrote that they moved in about a year after he was born, i.e., around 1909. Nasaw (*The Chief*, 193) says that Hearst signed the lease in 1905, which is approximately when the building began to be erected. Perhaps Hearst had an option on the space before the building was ready. According to the *New York Times* (Frank Crane, "Hearst Apartment on 'Drive' Vacated," January 21, 1940), "The house was built shortly before 1906 by Mr. [Robert E.] Dowling," and then Ronald H. Macdonald bought it from Dowling in 1906. It opened in 1908 (Christopher Gray, "Hearst's Opulent Quintuplex," *New York Times*, May 1, 1994). Hearst bought the Clarendon in July 1913.
2. Gray, "Hearst's Opulent Quintuplex."
3. Hearst Jr., *The Hearsts*, 24.
4. Swanberg, *Citizen Hearst*, 55.

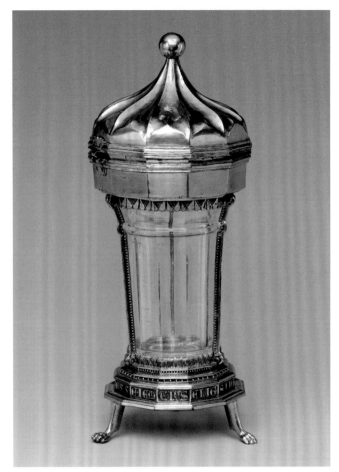

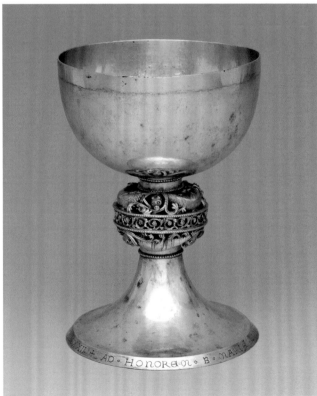

5. Swanberg (ibid., 289) comments that Hearst basically masterminded the new plans himself, "with the nominal help of an architect." See also Gray, "Hearst's Opulent Quintuplex."

6. Hearst Jr., *The Hearsts*, 24. Another renovation at the Clarendon, in 1925, would be extensive enough to cause the Hearsts to move temporarily to their apartment in the Ritz Hotel (Head, *It Could Never*, 79), which Hearst owned.

7. The photographs (New York Historical Society, coll. PR-026, box 9, folder 205) were shot by Mattie Edwards Hewitt for two articles that appeared in the June and October 1929 issues of Hearst's *International Studio* magazine. Other views by other photographers are in the Library of Congress (Biographical File—Hearst).

8. Hearst bought it from Duveen in 1925 for $40,000 (see Duveen Client Summary Book 1910–1959, reel 420, and correspondence, November 20, 1928, with an account of purchases of that day, Duveen Archive, GRI). It must have been one of Hearst's favorites. He bought it back from the liquidation of 1941, according to Coffman (*Hearst as Collector*, 266); see chapter 10 in this volume.

9. See "English Panelled Rooms in America," *International Studio* 93 (June 1929): 48. For the tapestry, cf. Coffman, *Hearst as Collector*, 49. The cassone (ex-collection comte de Gosselin, bought March 19, 1928) is in a photograph in the Seligman Archive (Archives of American Art, Washington, D.C.). The incorporation of historic paneled rooms into the Clarendon might not have occurred until the renovation of 1925 or after, when Hearst was rapidly building up a stock of paneling from dozens of historic properties. Hearst might have been finishing the rooms in the Clarendon while he was simultaneously renovating his castle in Wales and arranging a mansion for Marion Davies in Santa Monica, California.

10. Joy to Morgan, Morgan Papers. Hearst apparently was interested by Greek vases in a sale around May 14, 1914, when his "political secretary," Lawrence O'Reilly, reported to him (Hearst was in Atlanta) that they conformed "to drawings in original book of Hamilton collection sold in 1801" and were in good condition but repainted (Hearst Papers, 9:10, personal correspondence).

11. Some of the chargers are in the Metropolitan Museum of Art. They are misidentified as silver salvers by Elizabeth Hawes, in *New York, New York: How the Apartment House Transformed the Life of the City (1869–1930)* (New York: Knopf, 1993), 240, carried over by Nasaw, *The Chief*, 231.

12. Notes from illustrated binder given to Hearst Castle by a friend of Marion Davies. It contains records for: "Suit of armor for man and horse, 16th century. All new. Engraved throughout.... Note: Ex balcony, Spanish Gallery at 137 Riverside Dr." and "Suit of armor for man and horse. Maximilian. Engraved in [illeg.] throughout. Partly modern.... Note: ex balcony, Spanish Gallery, 137 Riverside Dr."

13. Ariane Isler-de Jongh, "A Stained-Glass Window from Flavigny-sur-Moselle," *Metropolitan Museum of Art Journal* 33 (1998): 153–67. Some elements of this window are in the Metropolitan, as is the window of *The Flood and Moses with the Tablets of the Law* (purchased 1917); Hearst's window was in a private collection in Canada following its sale in spring 2007 at Maynard's. Professor Isler-de Jongh said that the owner told her that Hearst had bought the window in Sens (personal communication to the author, 2007).

14. Valentiner Papers, Archives of American Art microfilm, Huntington Library, roll 2142, corresp: series II.

15. Germain Seligman, *Merchants of Art, 1880–1960: Eighty Years of Professional Collecting* (New York: Appleton-Century-Crofts, 1961), 86, and Brimo, *L'évolution du goût*. The taste for these ceramics was also strong in France and England.

16. Coffman (*Hearst as Collector*, 207) counted 280 examples of Spanish lusterware ceramics. With the exception of the Peyta Collection (approximately one hundred items; see *Hearst Collection*, microfiche cards 325–56), which Hearst bought en bloc, the majority were bought individually or in twos or threes. A purchase of ten at one time is recorded (ibid.). For the collection in the Metropolitan, see cat. nos. 72–80 and *Masterpieces of Fifty Centuries* (New York: Metropolitan Museum of Art and Dutton, 1970), no. 132. A huge (almost 20 inches in diameter) *brasero* said to have belonged to Hearst was on the Paris art market around 1990 for about $100,000.

17. See Duveen correspondence, November–December 10, 1926, Duveen Archive, GRI. The small plate was sold at the Hôtel Drouot on December 3, 1926 (lot 106). The two others were auctioned by Georges Petit on December 6 and 7, 1926 (both are in the Metropolitan Museum of Art, inv. no. 56.171.127–28).

18. Among the early (before 1919) acquisitions were three Liverpool pitchers with the portrait of Washington, two Masonic jars with an allegory of architecture, a Staffordshire plate with the Park Theater in New York, and a view of the Capitol (all Hearst Corporation papers). The "Tyrant's Foe" plate was called the "First Amendment" plate in the auction of September 8, 1913 (Bronx warehouse [Southern

FIGURE 2.9. *Covered Beaker*, Austria and Italy, c. 1325–60 (cat. no. 41)
FIGURE 2.10. *Chalice*, Northern Europe, 1222 (cat. no. 40)

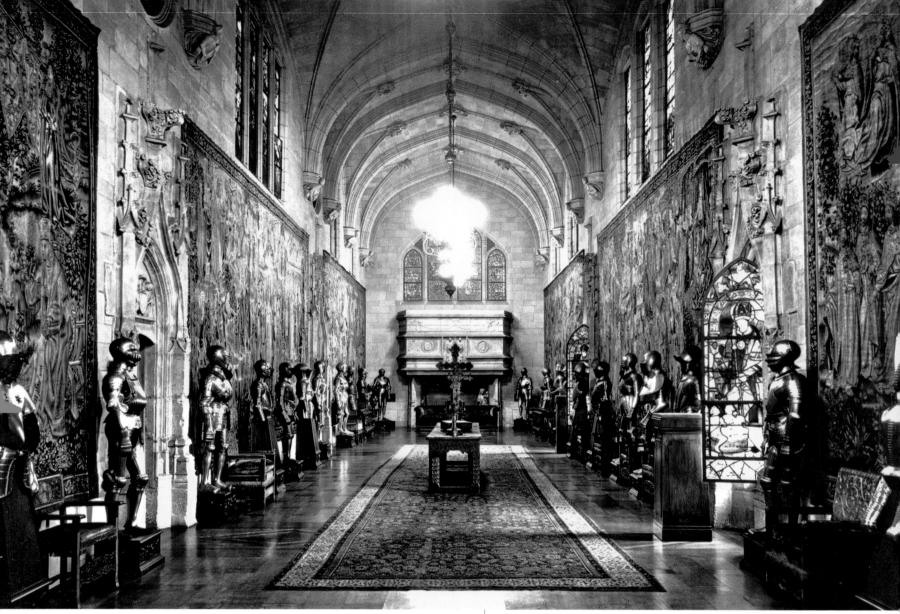

FIGURE 2.11. View of the armory in Hearst's apartment in the Clarendon, c. 1929.

FIGURE 2.12. *Combat of the Virtues and Vices* (detail), from the Redemption of Man series, Southern Netherlands (Brussels), 1500–1515 (cat. no. 33).

Boulevard, hereafter cited as SB], lot 995, art. 140). It was also called "The People's Friend" (SB lot 998, arts. 3, 15).

19. A letter from Duveen to Hearst (December 29, 1915, Duveen Archive, GRI) refers to this agreement, reached in 1911. The letter from 1915 recounts Duveen's proposal to buy back from Hearst for $75,000 two cassoni that Hearst purchased from him for $20,000. At the time Hearst owed Duveen $86,000. The sale of the cassoni would virtually liquidate the debt, Duveen pointed out, but Hearst countered by offering him $25,000 and the two cassoni, so he could keep $50,000. Then Duveen countered by offering to pay Hearst $37,500 in cash and apply $37,500 to the debt. Hearst commented: "I am anxious to do anything reasonable to please Mr. Duveen, and so I suggest that we split the difference between $37,500 and $50,000, and that he give me $43,750" (Hearst to O'Reilly, undated, Duveen Archive, GRI).

20. Duveen to d'Aquin (almost illegible) and d'Aquin to Duveen, September 30, 1911 (more legible), Duveen Archive, GRI.

21. Hearst to Duveen, May 29, 1912, Duveen Archive, GRI. In fact Hearst bought two matched ewers and basins from Duveen, one in 1911 and the other in 1912 (probably Metropolitan Museum of Art, inv. no. 56.171.146; ex-collection earl of Spencer; see Duveen Client Summary Book 1894–1918, Metropolitan Museum of Art, microfilm, Duveen Archive, GRI, reel 420). Hearst Castle inventory mentions a ewer (18¼ in. tall) from Duveen, purchased for $20,000 on November 23, 1912.

22. William Randolph Hearst, "The War of Kings" (September 3, 1914), in *Selections from the Writings and Speeches of William Randolph Hearst*, ed. E. F. Tompkins (San Francisco: San Francisco Examiner, 1948), 566–70.

23. Nasaw, *The Chief*, 244–47; Hearst's letter about censorship was published in the *Washington Post*, March 27, 1917 (reprinted in Hearst, *Selections from the Writings*, 297–98). Once the United States entered the war, however, he agreed with its rules of censorship (June 25, 1918).

24. Thomas Navin, "The Five Hundred Largest American Industrials in 1917," *Business History Review* 44 (Autumn 1970): 374.

25. Bremer-David, "French & Company," 49.

26. The Duveen Client Summary Book 1910–1959 G–H (Metropolitan Museum of Art, microfilm, Duveen Archive, GRI, reel 420) shows that in 1915 he bought an oval platter with Moses Crossing the Red Sea (ex-collection Kann). Apparently there were no purchases until 1919: the Calendar Plates by Martial Courteys (cat. no. 63), a plate with the Sacrifice of Abraham, a plate with the Temptation in the Garden of Eden, and a large oval platter of Abraham with the "Kings of Sodom" by Pierre Courteys, all ex-collection Mannheim, Morgan.

27. Proposed in 1921; bought 1923. See Duveen-Hearst correspondence, May 12, 1921; June 14, 1921; May 13, 1923, Duveen Archive, GRI. Duveen arranged to have the maiolica displayed at the Metropolitan.

28. Hearst gave $500 to the Metropolitan to help defray some of the curator Bashford Dean's expenses for the "recent collecting expedition to London" on May 30, 1921

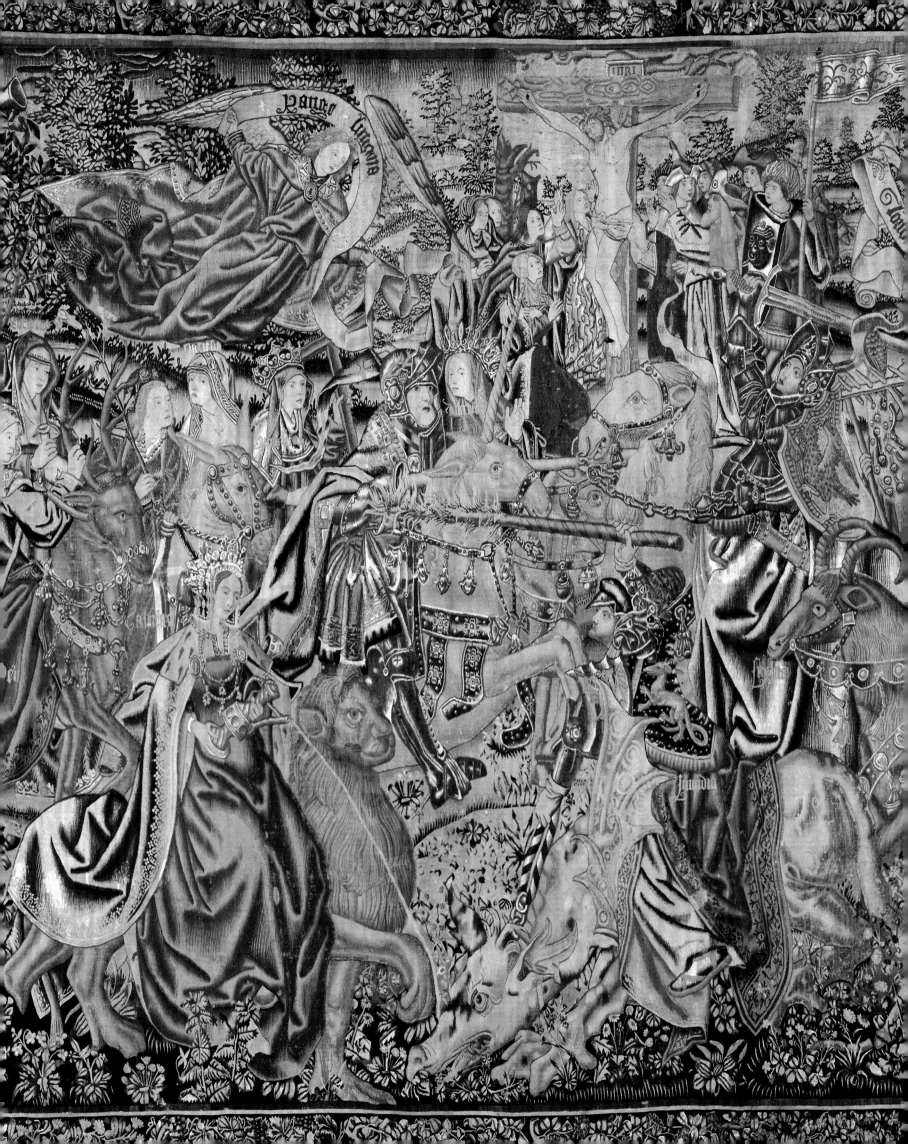

(correspondence in Department of Arms and Armor files, Metropolitan Museum of Art). Duveen might have suggested this. Dean and Hearst continued a working relationship through about May 1923, when Hearst began to consider hiring Dean's new staffer, Raymond Bartel, to work for him part-time (letter from Hearst, May 25, 1923, Department of Arms and Armor files).

29. Hearst to Duveen, June 24, 1921, Duveen Archive, GRI. Of the fifty-four items Hearst purchased from the Beardmore sale, only seven were his top choices; the majority of the rest were his third choices (Hearst-Duveen correspondence, July 5, 1921, Duveen Archive, GRI). Hearst bought from major collections: Morgan Williams, Beardmore, Whawell, and Meyricks.

30. The ceiling was possibly bought from French & Company. Mitchell Samuels reported to Julia Morgan that they were trying to locate it "in the apartment," presumably to send it to San Simeon (May 26, 1923, Morgan Papers). According to the inventory at Hearst Castle, the copy of *Pauline Borghese* (bought April 7, 1921) went to San Simeon from the Clarendon. It was sold in 1963.

31. Acquired in 1921 at auction in London (Townshend sale, June 24); now in the Philadelphia Museum of Art, inv. no. 41-73-1 (*Philadelphia Museum of Art Bulletin* 39 [January 1944]: 45).

32. Bought April 15, 1920, at the McCormick auction in New York. Reynolds's portrait of Miss Warren was purchased two years after that (see chapter 6). Probably in 1922 Hearst bought from John Levy Galleries the double portrait of "The Misses Prosser" by Francis Cotes (Frick Collection archive).

33. Purchased at auction in New York, January 29, 1920; Gerald Ackerman, *The Life and Work of Jean-Léon Gérôme* (London: Sotheby's Publications, 1986), 204.

34. Fredericksen, *Handbook*, no. 55.

35. The painting known as *Portrait of Mlle Marie-Catherine Colombe* is in a view of the library (present location unknown); Jean-Pierre Cuzin, *Jean-Honoré Fragonard: Life and Work: Complete Catalogue of the Oil Paintings* (New York: Abrams, 1988), no. 221.

36. The portrait, called *Mme Sophie de France as a Vestal*, was purchased from Félix Wildenstein on May 12, 1928, as a picture by Nattier. It is now in the Detroit Institute of Arts, but there is no consensus about the attribution.

37. Many of the interiors at Millicent's estate (see chapter 6) had a definite French flavor. She bought French eighteenth-century terra-cottas after Hearst died: for example, two well-known groups by Joseph Chinard (now in the Detroit Institute of Arts and Los Angeles County Museum of Art). See *European Works of Art*, sale cat., Parke Bernet, New York, November 29, 1975, nos. 91, 92. Hearst bought several paintings from Wildenstein (including *Danaë* by Greuze in the Metropolitan Museum of Art, David's *Vestal* [fig. 8.2], and allegories of War and Peace attributed to Jean-Jacques Lagrenée). See Daniel Wildenstein and Yves Stavridès, *Marchands d'art* (Paris: Plon, 1999), 33–36: Hearst "was, in a sense, my grandfather.... He was *the* biggest client of our New York gallery" (author's translation). Wildenstein makes a play on words alluding to Hearst's size.

38. This was in 1931 (MacGregor to Hearst, Hearst Papers, 39:23). The tapestry (ex-collection Morgan) is now in the Berkeley Art Museum, inv. no. 1957.1.

39. Duveen to Hearst, April 24, 1924, Duveen Archive, GRI.

40. The total cost was more than £40,000 (Duveen to Hearst, May 12, 1924, Duveen Archive, GRI).

41. Duveen to Hearst, June 24, 1924, Duveen Archive, GRI.

42. It was to house six large paintings with some smaller ones mixed in (August 28, 1925, Duveen Archive, GRI). This might be the "Italian Room 12th floor north" mentioned in a letter of November 9, 1926 (Hearst Papers, 38:9).

43. Los Angeles County Museum of Art, inv. no. 48.24.15 (not Hearst's Lansdowne *Mercury*, which is now in the Metropolitan). Hearst's registrar wrote to Hearst's secretary: "Please tell Chief we have life-size Hermes sculpture purchased from Brummer in place at apt" (cable of September 30, 1927, Hearst Papers, 39:4). The statue was bought in 1926 (Hearst Papers, 40:23).

44. Memo to Duveen, November 26, 1926, Duveen Archive. Despite Hearst's general lack of interest in landscapes, he did buy two gigantic (144 x 240 in.) landscapes by Hubert Robert at auction in May 1925, at the Gramont sale in Paris (Duveen memo, May 25, 1926, Duveen Archive, GRI). They might now be in a private collection in South America (opinion provided by Joseph Baillio).

45. "English Panelled Rooms," 46-47. Some elements of the Denham suite (c. 1700, George I walnut settee and chairs, with open "flying" brackets) were illustrated in them. Hearst bought the furniture (ex-collection Leverhulme) in 1926 (see Hearst sale, Parke-Bernet, January 5–7, 1939). The settee alone was recently sold at auction for $204,000 (Sotheby's, New York, April 5, 2006, lot 423).

46. Individual purchases included a Gothic battle-ax (Bartel said, "we needed one for your collection"), bought on January 21, 1927, at the Grassi sale. Hearst's registrar, Chris MacGregor, told him that Brummer, "whom I asked to aid me in purchasing the things said it was one of the crookedest sales he ever attended" (Hearst Papers, 38:50). Hearst said he was "always interested in decorative halberds," but he was afraid that Bartel was "too technical and only considers the rarity of various objects" (February 25, 1927, Hearst Papers, 38:51). On February 28, 1927, Hearst advised: "You will have to pay liberal prices for good things.... You can't always hope to get bargains" (Hearst Papers, 38:51). His hopes for an executioner's sword, however, were dashed a few days later: "I have made three attempts to buy an executioner's sword and each time have gone beyond the appraised value...and always some other fellow has paid twice the liberal limit that I put on it" (March 3, 1927, Hearst Papers, 38:51). This correspondence likely refers to the armory in the Clarendon, since the one at Saint Donat's had not yet been set up (unless Hearst was already planning for it).

47. "Early Flemish Tapestries in the Collection of William Randolph Hearst, Esq." (unsigned editorial note based on an analysis by Dr. Phyllis Ackerman), *Connoisseur* 105 (June 1940): 187–88. Duveen invoiced Hearst for four of them on January 27, 1921; the two others may have been the ones mentioned on February 3, 1922. Four came from the Cathedral of Toledo, and the others came from the duke of Berwick and Alba. Four are now in the Fine Arts Museums of San Francisco; one is in the Museum of Fine Arts, Boston; and a reduced duplicate is in the Art Institute of Chicago. The tapestry *Paris and Helen* (also known as *The Knight's Vow*), which is illustrated in the 1940 *Connoisseur* article (193), is now in the collection of Boston University (as is an unrelated tapestry, *Avarice*). He owned three panels from the Four Cardinal Virtues series (two are in the Fine Arts Museums of San Francisco; the third is in the Carnegie Museum of Art). The current location of his *Athena Giving Weapons to Perseus*, which was at Saint Donat's, is unknown (see chapter 5).

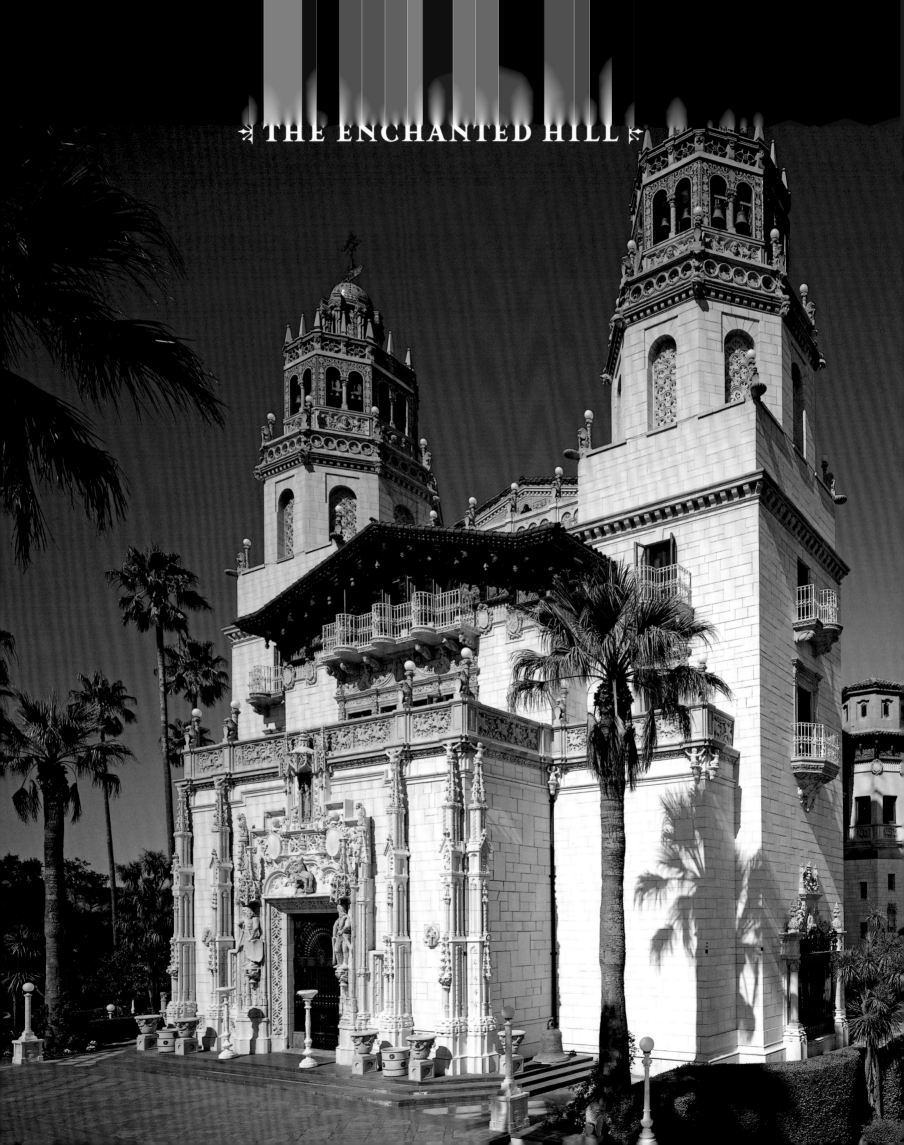

⊰ THE ENCHANTED HILL ⊱

On March 31, 1919, Hearst reached the hacienda at Pleasanton, California, where his mother lay dying from a pulmonary infection caused by the epidemic influenza of that year.[1] Before Phoebe Hearst passed away on April 13, he met with the architect Julia Morgan in San Francisco to discuss plans for building a bungalow on a sixteen-hundred-foot-high peak that his family owned on the central coast of California.[2]

The site was part of approximately 50,000 acres that Hearst's father bought there in 1865.[3] The ranch produced fruit, leather, and beef for trade with Portuguese whalers who docked at the small harbor in the inlet. George Hearst bought up the shares of the tiny port, and around 1868–70 he extended a new pier into the ocean at the little hamlet of San Simeon.[4] He also built a depot at its foot to store merchandise. With the exception of a stately white clapboard ranch house that he eventually built almost a mile inland, he made few improvements in the area. Several local inhabitants assumed that he was simply holding the land for his little boy, who developed an overwhelming passion for the site while still a youth.[5] Eventually the holdings at San Simeon grew to about 240,000 acres through the consolidation of additional properties.[6] The magnificent spread was bigger than Washington, D.C. Across the south and west, its hilltops offered panoramas of the earth's largest physical body, the Pacific Ocean. The sloping green views to the east were edged by rocky heights with massive outcroppings. The little gray cone of an extinct volcano popped up on the horizon to the north.

Hearst was already familiar with Morgan's work. He had commissioned a new building for the *Los Angeles Examiner* from her in 1915.[7] Phoebe Hearst had noticed the young Morgan at Berkeley, where she was the only female student in the civil-engineering program. Morgan studied with Bernard Maybeck and became the first woman not only to gain admission to the École des Beaux-Arts in Paris but also to earn a degree in architecture there. From about 1903 to 1910 she was responsible for the completion of, and additions to, Phoebe Hearst's hacienda. By the time Hearst commissioned her to work for him on a project at San Simeon, she was an experienced and very successful architect.

One of Morgan's associates recalled that initial conversation between client and architect in April 1919. For years Hearst and his family had gone camping in the hills. Hearst now wanted something permanent. At first some "bungalow books" that he had seen suggested what he thought was a Japanese-Swiss kind of architecture.[8] This likely referred to the Craftsman-style houses of Southern California, which were epitomized by the Gamble House in Pasadena (1909). It could easily be mistaken for a blend of the low gabled roofs, overhanging eaves, and protruding rafters of Japanese structures like the shrines at Ise with elements of the traditional Alpine chalet. The modest California bungalow was quite contemporary in 1919: one book on bungalows was reprinted three times between 1910 and 1920.[9]

Before the year was out, the scheme for what is now popularly called Hearst Castle had changed dramatically. It became a complex of three cottages arranged in a crescent facing the spectacular views downhill.[10] They would be dominated by a main building above them, and their style, Hearst decided, had to be in keeping with California's Spanish heritage. He disliked the "Baroc."[11] The other choices were the Renaissance, the austere style of the late eighteenth-century missions established along the coast of California by the Franciscan Order, or the frothy counterfeit Spanish vocabulary of the Panama-California Exposition of 1915 in San Diego.[12] He sent pictures of Spanish Renaissance buildings to Morgan. They included "the patio from Bergos [*sic*] which, by the way, I own but cannot get out of Spain."[13] Morgan counseled against the style of the exposition and agreed that the Mission style was "too primitive."[14] On New Year's Eve 1919 Hearst wrote a long letter to Morgan. Returning to the Renaissance, he referred to the plateresque style associated with Spanish architecture of the transitional period around 1500, which was characterized by crisply carved stone ornament resembling strips of silversmith's work (*platería*) applied to plain masonry walls.[15] The Moorish presence in Spain had to be acknowledged too.[16] In March 1920 Hearst approved Morgan's drawings for the cottages.

The client reported to the architect on November 10, 1919, that he was "working on the interior decoration" and might "have a suggestion to send…in a few days." He had promised in September that he would "try to get stuff to

Overleaf: FIGURE 3.1. The facade of Casa Grande, the main building on the Enchanted Hill at San Simeon (Hearst Castle).
FIGURE 3.2. Ceiling (Italy, c. 1600?) in the Refectory, Casa Grande, Hearst Castle (detail). Purchased through Luigi Gallandt, Rome, May 13, 1924. The ceiling is 68 feet (20.7 m) long and about 28 feet (8.5 m) across.

57

STUDY FOR ASSEMBLY ROOM
FOR MR WILLIAM R HEARST
SAN SIMEON
JULIA MORGAN ARCHT
SCALE ¼" ONE FOOT

STUDY FOR LOWER HALL OF HOUSE A FOR
MR WILLIAM RANDOLPH HEARST — SCALE AT WALL ½"=1'0" — JULIA MORGAN ARCHITECT

suit in a decorative way," and he kept his word in December (possibly in 1920), when he "bought some stuff at sales."[17] His thoughts about the interiors included passing references to Stanford White, as well as a suggestion that Morgan talk to Charles Birge about the work he had done for Hearst at the Clarendon in New York. If Hearst understood that by recommending this he was overstepping the bounds of professional courtesy, perhaps the closing "Violet [*sic*] Le Duc Hearst" acknowledged his presumptuousness.[18] In any case, Morgan's beautiful elevations for the interiors of the first cottage sufficed (fig. 3.4). No further collaboration from anyone but Hearst himself was recommended after that.

Of course Hearst was full of suggestions. He gave specific instructions about coordinating the colors of flowers to the buildings, the choice of fruit trees, and everything else about the gardens, including the fragrance and Millicent's preferences. He had fantastic concepts for a Chinese pavilion, an aviary, a Tudor house, and a labyrinth with wild animals. For a Moorish hothouse that he imagined to be made of green Tiffany glass edged with gilded iron ribs,

Hearst drew his own sketches.[19] On the more practical side, he conceived the estate's emblematic lampposts of janiform herms. He advised Morgan to have other lamps made of columns fitted with alabaster globes. Carved by Italian sculptors, they were as delicate as fifteenth-century Florentine reliefs (cat. no. 14).[20] The idea for the mosaics with the signs of the zodiac for the indoor pool (1928–35) also came from Hearst.[21]

The chronology of the complex at San Simeon has been recounted frequently.[22] The three cottages, which blossomed into luxurious guesthouses, were begun first for the sake of financial expediency. They were followed by the main house, called Casa Grande, which grew into the shape of a lobster with its claws pointing east. Its great Assembly Room (figs. 1.12, 3.3) was ready early in 1926,[23] and the idea for the main library above it was determined around that time. The Refectory was laid out at a perpendicular from the Assembly Room toward the east in 1926–27. The vaulted Moorish ceiling originally preferred for the Refectory could not be realized with the material at hand, so Hearst proposed in

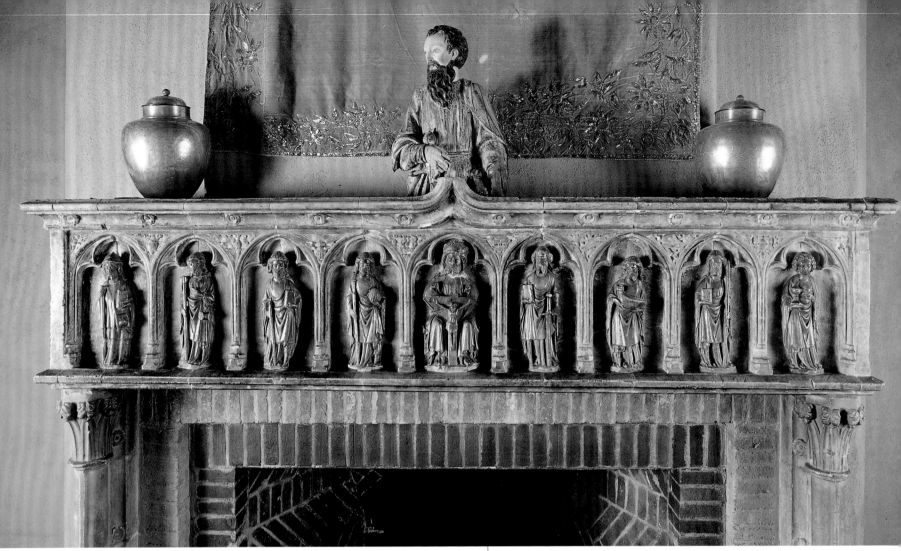

FIGURE 3.6. *Altarpiece of the Trinity with Saints*, England(?), c. 1350–1400; alabaster; approx. 28 x 82¼ in. (71.1 x 208.9 cm); Hearst Castle, San Simeon, California (inv. no. 529-9-5157). The altarpiece is incorporated into a mantelpiece in one of the "Cloister" bedrooms, Casa Grande.

its place a magnificent flat ceiling from the Renaissance that was carved in relief with gigantic full-length figures of saints (fig. 3.2).[24]

The main portal of Casa Grande was inspired by a gateway in Seville,[25] and a tower of the Cathedral of Ronda was multiplied by two to frame the facade: Hearst and Morgan both had a predilection for symmetry (see fig. 3.5).[26] Despite these references to stylistic antecedents, the building was not a fastidious revival like Biltmore, the Vanderbilt estate near Asheville, North Carolina (1895), which was a frigid imitation of a late fifteenth-century château with a misplaced spiral staircase derived from the sixteenth-century one at Blois. Nor was Casa Grande a West Coast variant of the ponderous "beach houses" of Newport, Rhode Island. It was, however, more ambitiously opulent than James Deering's delicate Vizcaya in Miami (1914–16).[27]

If a comparison to anything must be made, then perhaps the best parallel is the castles of King Ludwig II of Bavaria (1845–1886)—Neuschwanstein, Linderhof, and Herrenchiemsee—which referred to three different historic prototypes and were set in dreamlike landscapes.[28] La Cuesta Encantada ("the enchanted hill"), as Hearst formally called his ranch by 1925, was an original invention.[29] Morgan's disciplined genius, which was reinforced by rigorous professional training, adapted elements from a religious vernacular to a set piece in a residential estate that resembles a village of fabulous luxury in Renaissance Spain.[30] She realized Hearst's vision. His son commented, "He did it with something not even a fortune could buy: his imagination."[31]

While Morgan toiled in 1921 with four-mule teams to prepare the hillside for construction, Hearst, in anticipation of what the buildings would comprise, bought elements that would provide the decor. About 95 percent of the objects were acquired after the project commenced.[32] As early as 1921 Morgan and Hearst discussed the need for keeping a systematic inventory of all the material and objects that had

FIGURE 3.7. Jan van de Velde III, *Still Life with Glass*, c. 1650 (cat. no. 134).

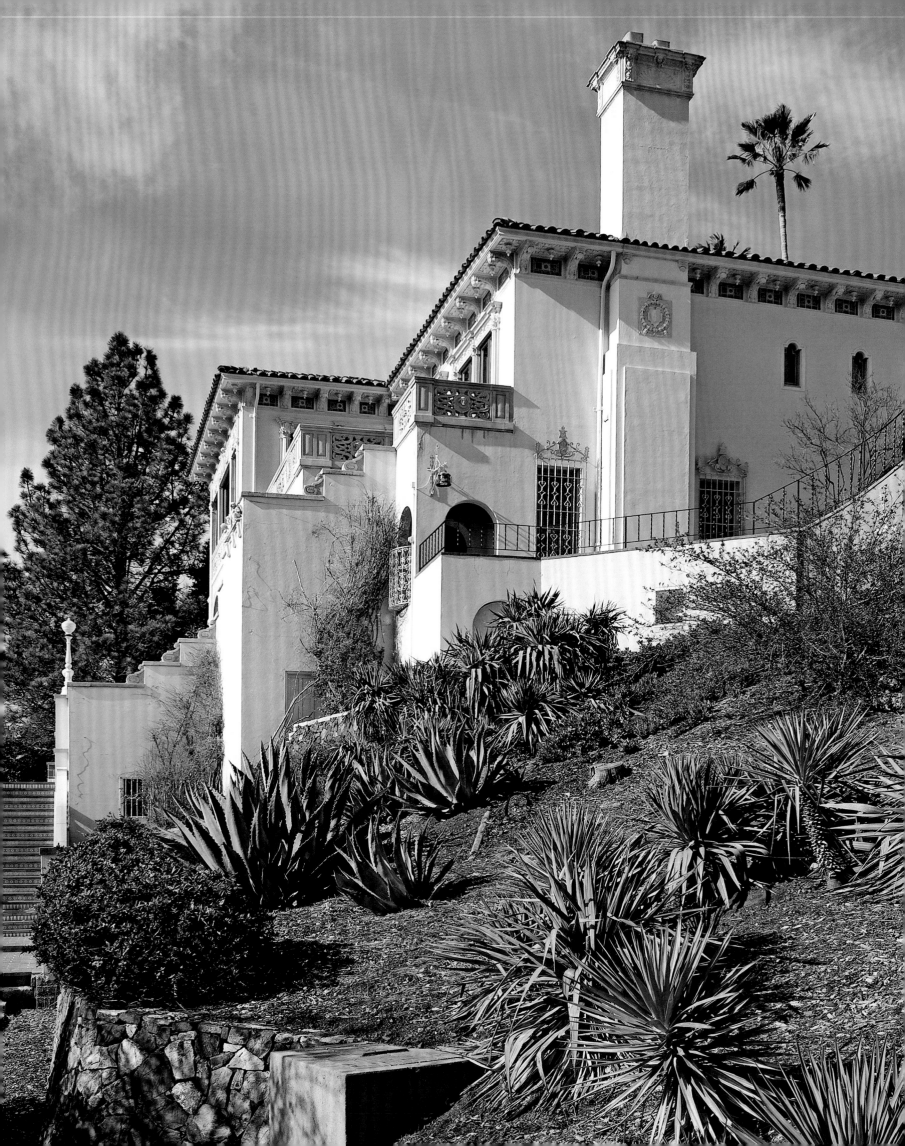

not yet been installed. Everything that arrived in New York would be photographed in duplicate, and another warehouse was proposed near the one that Hearst's father built.[33]

Although bulk auctions of Spanish and Italian collections provided many of the furnishings, textiles, and sculptures (and a few paintings) in the 1920s, they supplied but a fraction of what went to the Enchanted Hill.[34] From the outset a wide variety of objects were purchased individually or stood out in the large masses that were bought. Two hundred running feet of Islamic tiles from French & Company were considered.[35] There were, for example, a Dutch still-life painting (the only one identifiable in Hearst's collections, fig. 3.7) that was bought at auction and sent almost immediately from New York in March 1920; an exceedingly rare fourteenth-century alabaster altarpiece (fig. 3.6) that was purchased from Joseph Duveen's brother Charles in London; two ancient Roman herms from the Hope collection,[36] and a black velvet banner of Adam and Eve praying to the Virgin for intercession with God (fig. 3.9). The banner, with its exquisite asymmetry, was tried out at the Clarendon for two weeks before it was dispatched to California.

Many of the paintings at San Simeon were bought at auction before Hearst had to curtail expenditures on construction late in the winter of 1929–30, when he began to realize the consequences of the stock market crash.[37] A number of unexpectedly distinctive pictures are encountered on the Enchanted Hill, but overall the paintings are not the most significant works of art at the castle either artistically or historically, especially when considered in relation to the tapestries, the sculptures by Thorvaldsen and Canova, and the antiquities. Sumptuous embroidered textiles were more opulent alternatives to paintings for decorating the walls. What appears to be a high concentration of paintings of the Madonna and Child throughout the complex can be explained by Hearst's relative lack of interest in landscape painting; as for still lifes, he evidently was captivated by the reality of the goldsmith's art itself and not by an illusion of it. Generally speaking, Hearst's preferences were for human images, whether they were portraits, or paintings of the Madonna and Child, the saints, and the Crucifixion—subjects that dominated Renaissance art. Despite the well-known identification of the period with the rebirth of classical antiquity, subjects drawn from it are few in comparison to those of Christian themes. In any case, the Virgin's benevolence had universal appeal.[38]

Morgan conjured the buildings to house these objects from a combination of steel-reinforced concrete, historic elements, and her own designs inspired by them. The complex progressed visibly by the summer of 1924. "There is no effort to make the buildings themselves other than modern," she wrote, as the masterful severity of the south elevation of Casa del Mar makes clear (fig. 3.8).[39] For help in securing the historic elements that Hearst required, Morgan recommended Mildred Stapley Byne, a curator, and her husband, Arthur, who in January 1920 worked for the "Hispanic Museum," Archer Huntington's collection of Spanish art and related library in New York.[40] Morgan knew of them from her years in Paris. As Mildred wrote to Morgan in 1914, they provided photographs of Spanish architecture to the Hispanic Society (the formal name of the "Hispanic Museum"), the Metropolitan Museum of Art, Harvard University, Massachusetts Institute of Technology, and the Avery Architectural Library of Columbia University.[41]

Morgan described the project at San Simeon and pointed out its advantage: "Having different buildings allows the use of very varied treatments."[42] Hearst asked Morgan to invite Mildred Byne "to act as agent for us.... Probably we could do much better from her than from the average antiquary."[43] Hearst was also approached by the sculptor George Gray Barnard, who was amassing a panoply of architectural elements in France, but Hearst found his prices too high.[44] Instead he bought a number of architectural elements (including ceilings) from French & Company and the periodically devious Lucien Demotte. William Permain (a dealer who remained a constant but occasionally disappointing agent for Hearst); Raymond Bartel; and Hearst's chief correspondent for European affairs, Karl von Wiegand, also scouted for appropriate architectural merchandise. To judge from a census of about ninety ceilings drawn up in 1931, Arthur Byne provided about a third of the historic ceilings, predominantly Spanish, that Hearst collected up to that time, including the one in his own bedroom in Casa Grande.[45]

Not until late in 1926 did the Spanish government controlled by Miguel Primo de Rivera adopt laws protecting national patrimony.[46] Spain had remained neutral in World War I, so it did not suffer the physical depredations of that conflict. After the war ended, its economy expanded, and modernization became the order of the day. The sale of historic property may have been an aspect of this. Arthur Byne became a key agent for many transactions. There were several clients for whom he exchanged Spain's patrimony

FIGURE 3.8. Casa del Mar (House A) from the south, with the chimney raised as Hearst wished (see cat. no. 4).

for cash, but Hearst was the most important.[47] Hearst's frequent telegrams to Morgan about Byne read like orders issued to a contractor. Byne's prowess impressed Hearst. In 1924 he asked Byne how he accomplished what he did, and Byne answered that it was the "fruit of twenty years' investigation."[48] It was also the fruit of creativity. For example, to supply large mantelpieces, which were hard to find, Byne would "generally look for an old sarcophagus and then pick up some columns and on top of these build a hood, perhaps working in an escutcheon," he explained to Morgan.[49] Hearst was a willing but not naive client. He commented about one mantelpiece, "I know it is partly made up but it is effective."[50]

Byne soon experienced Hearst's lack of attentiveness about paying for what he bought. Copies of Byne's histrionic telegrams and abusive letters, neatly typed on elegantly engraved stationery, arrived in a continual stream at Morgan's office. Hearst probably assumed that any member of his army of employees had already seen to the bills that stacked up, not only those with Byne's name on them but those of packers, shippers, and customs brokers too. In Spain, however, he had no credit, Byne pointed out.[51] Morgan responded in 1925: "Mr. Hearst accepts your dictum—cash or nothing."[52] With the unpredictability of Hearst's revenues after 1929, the uncertainties surrounding the imposition of an income tax in 1932, and the devaluation of the dollar in 1933, the understanding was periodically swept aside.[53] Just as Duveen did, but with less unctuousness, Byne persisted in offering Hearst new material for sale while haranguing him about payment for the old. Hearst bought more from Byne during the difficult 1930s but apparently used a greater portion of what was purchased from him in the 1920s. Hearst's optimism might have accounted for this disparity.

The successful visual integration of so many historic features at San Simeon obscures the tribulations that lie behind their acquisition, recounted in detail in Byne's correspondence. He was a respected Hispanist scholar, but his letters reveal that he could be a cynical privateer who profited not only from the Spanish dictatorship, which honored him, but also from the civil war that erupted after Primo de Rivera's resignation in January 1930 and the departure of King Alphonso XII in 1931. Byne often resorted to bribery to accomplish his objectives.[54] He usually managed his contributions adroitly, but he would lose his investment when a bishop or colonel whose favorable inclination toward his activities had come at a steep price was stripped of his

authority to sell a church or export part of a monastery and was replaced by an officer with whom Byne had to recommence his patronage from scratch.[55] The policies on every side changed unpredictably over the years.[56] Property owners were eager to liquidate what they could, and the government wanted to provide the opportunities for employment that came with the dismantling of historic buildings.[57] In some cases villagers did not want to lose familiar monuments. In other cases the monuments were simply pretexts for extortion: "The district where the Monastery is situated is completely Bolshevik; all surrounding estates and properties have been taken over by the peasants.... It is not that the local agitators are interested in preserving a monument," Byne explained, but he had to "pay such tribute as to render the whole operation impossible." He "tried to buy off the leaders but it was money thrown away."[58]

The Vatican opposed its lieutenants who tried to sell everything (e.g., cloisters and refectories) but the churches themselves. At times these structures were declared by the government to be the property of the state to be sold, or they were nationalized and protected as patrimony.[59] At one point there was no authority from which to obtain permission.[60] Sometimes the concept of patrimony was not even considered, as in 1935, when the Bank of Spain decided to demolish the Convent of Santa Fe in Toledo and erect an office building in its place. Byne offered its fifteenth-century refectory to Hearst instead.[61]

Byne upbraided Hearst about the dire financial straits and life-threatening situations that his delays in payment created,[62] but when Byne died in a car crash in 1935, he was described as one of the wealthiest Americans in Spain.[63] In retrospect, his activities might also be considered in light of the disasters of May 1931, when numerous churches were set ablaze.[64] His exports may have spared some historic elements from the systematic destruction of Church property and art during that explosive time. The property of certain religious orders was to be nationalized for educational or charitable uses. Byne's offer in November 1931 of the cloister and facade of the monastery of Alcantara (which he owned) to the Spanish government in exchange for releasing the vaulted ceilings for export to Hearst was a rational compromise.[65]

Of the thirty grandiose carved, polychromed, and tiled ceilings that contribute with such distinction to the atmosphere of Hearst Castle, more came from Arthur Byne than from any other source. His most important feat, however,

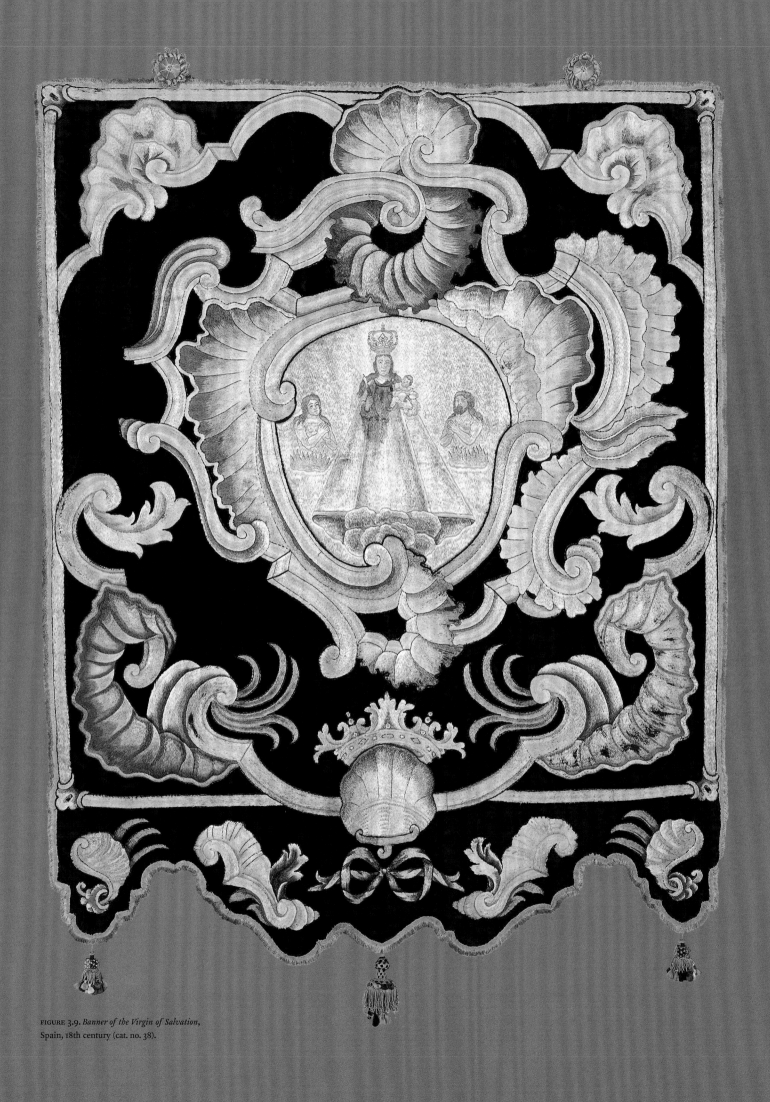

FIGURE 3.9. *Banner of the Virgin of Salvation*, Spain, 18th century (cat. no. 38).

FIGURE 3.10. Julia Morgan, *Longitudinal Section for Tapestry Room*, 1932 (cat. no. 13).

...NDY.

...NAL & SECTION &
...STRY ROOM.

...ABST SAN SIMEON CALIF.
...AN ARCHT.
NOV.28-32
...(FT)

OPEN

had nothing to do with a ceiling. It involved the gigantic choir screen from the Cathedral of Valladolid (fig. 1.7), Spain's capital before Madrid. On March 12 and April 25, 1929, he reported to Morgan that he had located "the grille [that] formerly enclosed the choir but in a 'reform'…ten or twelve years ago the grille was taken down and piled up in the crypt." It was forty feet high, fifty feet wide, and cost $17,000. "I just bought it," he added. "It is unique." Byne was so confident about its significance that he paid for it himself and decided to ship it to New York at his own expense. Two days after reading Byne's letter, Hearst agreed to acquire it.[66] In 1957, when the grille was inaugurated at the Metropolitan Museum of Art, *Time* magazine reported, "What saved the reja from the scrapheap was the omnivorous taste of the late William Randolph Hearst."[67]

Hearst wanted to incorporate the screen into a huge neo-Gothic castle he envisaged in Northern California in 1930 (see chapter 7), but the cost was prohibitive. In 1932 the screen was considered for San Simeon as part of a proposed wing that would have connected the two eastward-stretching arms that reached out from the Refectory, thereby enclosing the terrace on the eastern side of Casa Grande (cat. no. 13). The interior of the wing, which was never built, would have echoed the plan of the armory at the Clarendon (fig. 3.10).

Limitations imposed by financial realities never clouded Hearst's delight over the results of his efforts. Probably on June 2, 1926, he held a party at San Simeon for "those wild movie people," as Hearst called them in his congratulatory letter to Morgan, who was among the guests. He apologetically wrote that they "prevented me from talking to you as much as I wanted to…. Nevertheless the movie folk…said it was the most wonderful place in the world and that the most extravagant dream of a movie picture set fell far short of this reality. They all wanted to make a picture there but they are NOT going to be allowed to do it…. P.S. I started this out as a telegram but it is too long so I am making it a note."[68]

San Simeon was becoming more important to Hearst than he had expected. He was spending more time in California, and he wanted to raise the quality of art that was housed at the Enchanted Hill. In 1927 he said that he might think of it as a museum.[69] It was attracting attention. August Thyssen wanted to see it, and so did Arthur Upham Pope, the curator of Islamic art at the Art Institute of Chicago.[70] Hearst poured money into it at an alarming rate, continuing at full throttle even when one of his lawyers admonished

him, "The entire history of your corporation shows an informal method of withdrawal of funds."[71] An old trust fund that had been set up by George Hearst had supplied the ready cash for Morgan's payroll, construction, and various purchases. By July 1927 it was spent.[72] Still Hearst pressed ahead.

For a "gymnasium"—probably the Roman Pool, which was begun in 1928—Hearst decided to commission marble copies of six famous classical sculptures (the Doryphorus, Hermes of Andros, Lansdowne Hercules, two Amazons, and Hermes with the Infant Dionysus), with two more in mind. "If we cannot find the right thing in a classic statue we can find a modern one," he decided.[73] The irony was that a little over a year later, while the new sculptures were being made, Hearst was alerted to the fact that the renowned Lansdowne collection was going to be sold.[74] Negotiations for some of its treasures were not easy,[75] but Hearst secured five ancient Roman sculptures from it.[76] The Lansdowne Throne, Artemis, Athlete, Bust of the Athena of Velletri (all Los Angeles County Museum of Art), and Mercury (Metropolitan Museum of Art) all arrived at San Simeon before the neoclassical prize included in the auction, the Lansdowne *Venus Italica* by Canova (fig. 1.13).[77] (Hearst required a second set of photographs of the sculpture before deciding to pursue it.)[78] Although the Roman Pool (p. 9) offered a historically appropriate setting for the ancient sculptures, its chronic humidity likely precluded installing them there. Hearst had seven important classical statues, as well as the Stowe Vase (also Los Angeles County Museum of Art) and a Muse sarcophagus. They would have been just right for a gallery of Roman art, but he did not establish one. His preference for installing the ancient sculptures seems not to have been recorded, but the Canova was set in the Assembly Room. A year later Hearst acquired Thorvaldsen's *Venus Vincitrice*, a statue of the goddess holding the apple that was her prize for victory in the Judgment of Paris (fig 3.11).[79] This was the sculpture illustrated as the frontispiece of Eugène Plon's monograph on the artist.

Hearst's collection now displayed a paradigmatic comparison between Canova's work and that of his younger competitor Thorvaldsen. This synoptic confrontation embodied a lively philosophical debate that, ever since the day Thorvaldsen arrived in Rome and presented a challenge to Canova's vision of classicism, pitted the preference of French and Italian critics for Canova against that of German and Scandinavian scholars for Thorvaldsen.[80] There was

FIGURE 3.11. Bertel Thorvaldsen (Denmark, also active Rome, 1770–1844); *Venus Vincitrice*, 1818–24; marble; 68 × 26½ in. (172.7 × 67.3 cm); Hearst Castle, San Simeon, California (inv. no. 529-9-6281). This is the version of the sculpture commissioned from Thorvaldsen by Lord Lucan.

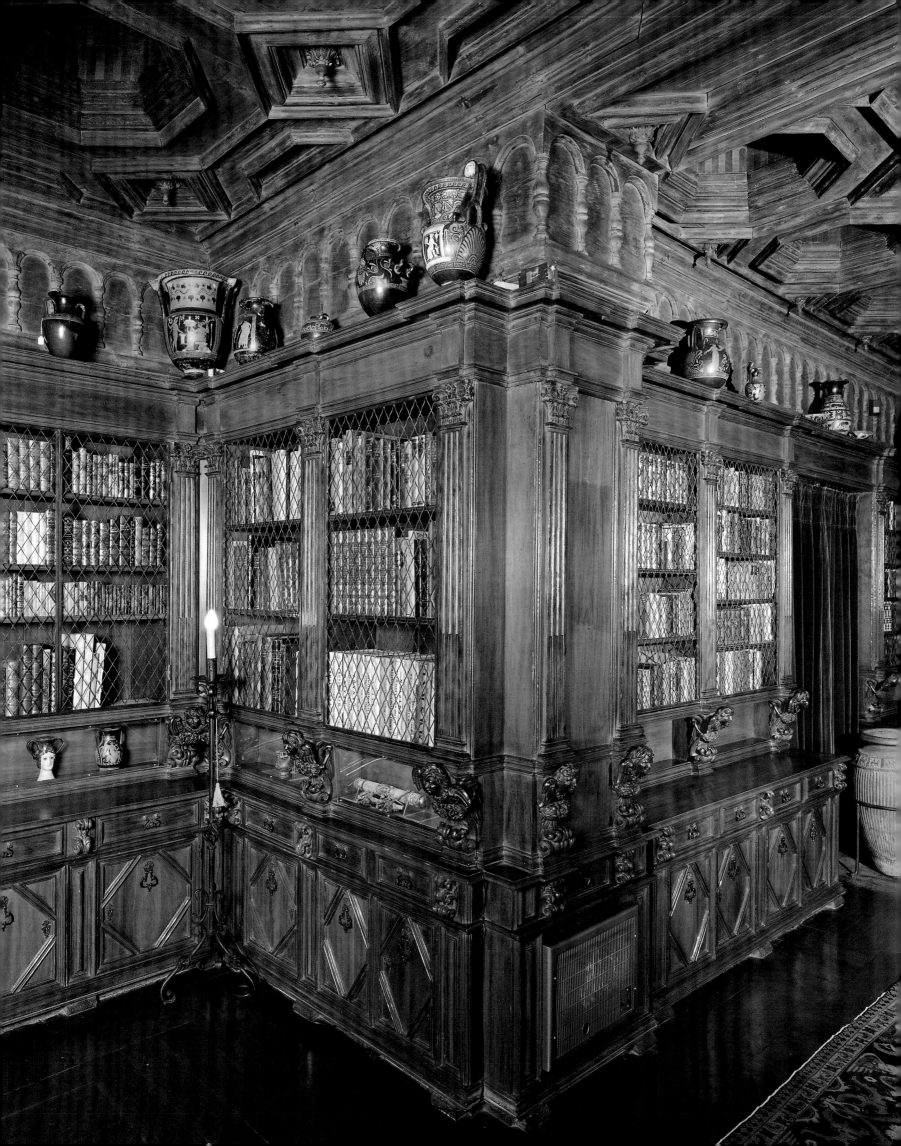

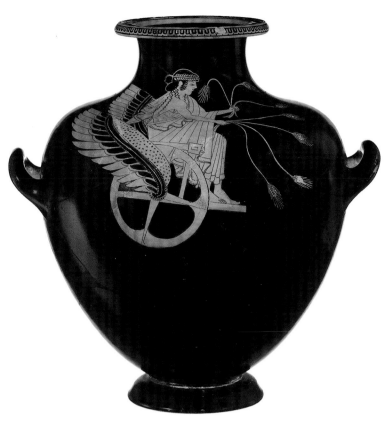

FIGURE 3.12. A corner in the main library, Hearst Castle.
FIGURE 3.13. Attributed to the Troilos Painter, Red-Figured Kalpis (Water Jar),
c. 490–480 BC (cat. no. 98).

FIGURE 3.14. Kantharos, south Italian, possibly Apulian, c. 325–200 BC; terra-cotta with
gilding; approx. 6¼ x 5½ in. (15.9 x 14 cm) measured across handles; Hearst Castle,
San Simeon, California (inv. no. 529-9-647).

little wonder that Hearst insisted to Duveen late in 1932:
"I really want to show you what I have done on my little
hilltop. The art objects may not be quite up to the Duveen
standard, but they are good enough for a ranch, and the
general effect is scrumptious."[81] Thorvaldsen's presence
in the Assembly Room became even more imposing in
1937, when Hearst bought the grand allegorical roundels
of civic virtues that the sculptor carved for Eugène de
Beauharnais.[82]

Hearst added another prize, the Hope Athena (fig. 9.10),
which was the first sculpture in Thomas Hope's catalogue
of his storied collection and the finest known example of
the type.[83] It was displayed in the Assembly Room with the
Canova and the Thorvaldsen, but its companion sculpture—
the Hope Hygieia (p. 7), which had been excavated along-
side the Athena in Ostia around 1797 and was acquired by
Hearst in 1936—inexplicably did not join it there.

Greek and south Italian vases formed the other
significant collection of ancient treasures at San Simeon.
Even while Hearst added to the collection at the Clarendon
(for example, with the ancient Greek gold jewelry from the

Schiller collection, which he bought in June 1929), he was
also adding vases at San Simeon. In 1929 Brummer sent
nearly two dozen vases, probably those purchased from
the Torr collection.[84] Among them was the refined red-
figured kalpis with Triptolemos flying in his chariot around
the shoulder (fig. 3.13). Although Hearst ordered most of
his maiolica—and presumably much of his collection of
Spanish lusterware—sent to San Simeon from the Clarendon,
these objects were overwhelmed by the massive scale of
the main library.[85] In 1936 Morgan reported that she had
"placed the Spanish and Italian maiolica collections in the
study," which must have meant the Gothic Study, but photo-
graphs from Hearst Castle archives do show some examples
set experimentally on the bookcases of the main library.[86]
The Renaissance ceramics simply did not have the physical
mass or the intellectual depth required by the monumental
bookcases and heavily coffered Renaissance ceiling of the
main library (fig. 3.12).

Over time, through individual purchases and the
liquidation of famed holdings such as the Holford (1927)
and Revelstoke (1935) collections, Hearst added significant

classical treasures to the Enchanted Hill: they ranged from a grand amphora attributed to the Dipylon Painter to a pair of exquisite rare gilded kantharoi (fig. 3.14). The name vase of the Durham Painter, for example, came from the collection of Mrs. Hunt in Kent, one of twenty-two of her vases that were sold to Hearst. Spink's, Fischer, the American Art Association, and Sotheby's were all sources for Hearst.[87] The vases really mattered to him. When financial catastrophe loomed in 1937 and the Clarendon began to be dismantled, Hearst's secretary wired the registrar on March 4: "When will Greek vases arrive here. Chief inquires almost every day." The Chief also asked for Gisela Richter's *Red-Figured Athenian Vases in the Metropolitan Museum of Art*.[88]

The method of display in the library was the most classic presentation that Hearst achieved. Although it did not allow easy scrutiny of the vases, it followed exactly in the tradition of the illustrious Italian connoisseurs Giuseppe Valletta and the duca di Noia,[89] and it drew the attention of alert specialists like a magnet. Not until forty years after Hearst's death, when J. Paul Getty's bequest funded a new museum, was a collection of comparable significance developed west of Pennsylvania. Hearst demonstrated one of his most rational and methodical exercises of wealth and power through the acquisition of his vases.

Notes

1. Robinson, *American Dynasty*, 379. It is commonly believed (e.g., Kastner, *Hearst Castle*, 22n5) that Hearst sold the hacienda because it became less important to him than San Simeon, but in fact he was bound to sell it to comply with Phoebe Hearst's stipulation of 1917 (Robinson, *American Dynasty*, 381). He must have kept it or some of its property until about 1927 because references to it still occurred then (Hearst Papers, 42:61). Phoebe was annoyed that her son preferred San Simeon, but she was vexed when, in 1894, he started to build the hacienda on her land at Pleasanton without her permission (Robinson, *American Dynasty*, 382, 248). See also Boutelle, *Julia Morgan*, 172–73. In 1969 most of the hacienda was destroyed by fire.
2. Thomas Aidala, *Hearst Castle, San Simeon* (New York: Hudson Hills Press, 1981), 39.
3. Ibid.; Hearst Jr., *The Hearsts*, 68.
4. Robinson, *American Dynasty*, 84 (1865, for permission to build a wharf), 90 (1870, construction of new wharf).
5. Ibid., 89, 383. Hearst recalled: "My father brought me to San Simeon as a boy. I had to come up the slope hanging on to the tail of a pony. We lived in a cabin on this spot and I could see forever. That's the West—forever" (quoted in Hearst Jr., *The Hearsts*, 69).
6. Calculated from Swanberg, *Citizen Hearst*, 493. In 1940 the U.S. government acquired 164,000 acres that became Fort Hunter Liggett. One of Hearst's descendants explained (personal communication to author, January 2007) that George Hearst had systematically purchased many small properties along the shore and razed the structures on them, provoking some enmity. By clearing the coastline of the numerous shanties that disfigured it, he created the "untouched" stretch of land that visitors see today. Some of the negotiations are recounted by Robinson, *American Dynasty*, 85–91. His son planted thousands of trees that cover parts of the hillsides and the peninsula.
7. Boutelle, *Julia Morgan*, 174–75; for Morgan's education, see 23–29.
8. Nasaw, *The Chief*, 287–88. Robert Judson Clark refers to Charles Sumner Greene and Henry Mather Greene's "adaptions of the low-gabled Alpine chalet…and then the articulated structures of Japan.…After 1910…the California bungalow [was] now advertised by publishers of bungalow books and magazines" ("The Pacific Coast," in *The Arts and Crafts Movement in America, 1876–1916*, ed. Robert Judson

Clark [Princeton: Art Museum, Princeton University, 1972], 83). It is a pleasure to acknowledge here, after many years, Professor Clark's teaching.
9. Marcus Whiffen, *American Architecture since 1780: Guide to the Styles* (Cambridge, Mass.: MIT Press, 1969), 209–11, 220.
10. At first designated Houses A, B, and C, they were later formally named Casa del Mar, Casa del Monte, and Casa del Sol.
11. Hearst to Morgan, December 10, 1919 (and December 27, 1919): "The Gothic and Renaissance of Spain are so very much more interesting than the Baroc stuff of the 18th century." He explicitly specified the Spanish style (Hearst to Morgan, January 13, 1920, and February 3, 1920, all Morgan Papers).
12. Robert Pavlik, "Something a Little Different," *California History* 71 (March 1, 1992): 467–72, gives an excellent analysis of the architecture of the fair. Hearst dismissed the inspiration in a message to Morgan: "Our definite decision in favor of the [Renaissance] makes it unnecessary to go into the San Diego Exposition stuff at all" (January 14, 1920, Morgan Papers).
13. Hearst to Morgan, December 30, 1919, Morgan Papers.
14. Morgan to Hearst, January 8, 1920, Morgan Papers.
15. Hearst to Morgan, December 31, 1919, Morgan Papers.
16. Hearst asked Morgan for "a little more Moorish character" for House C (February 6, 1920). See also Hearst to Morgan; December 10, 1919, February 9 and August 26, 1920; all Morgan Papers.
17. Hearst to Morgan; November 10, 1919; December 10 and 30, 1919; April 4, 1920; and possibly December 1920; all Morgan Papers.
18. For Stanford White, see Kastner, *Hearst Castle*, 47–50, and Hearst to Morgan, April 4, 1920, Morgan Papers. For Hearst's recommendation that Morgan talk to Birge, see Hearst to Morgan, c. August 25 or 26, [1920?], Morgan Papers. In 1923 Morgan sent her young draftsman Thaddeus Joy to visit Hearst's apartment in New York (see chapter 2).
19. The silhouette resembled the Taj Mahal. "Having nothing to do on the train I made a stab at the greenhouse," he wrote to Morgan (c. March 10, 1927). Hearst's time on transcontinental trains was usually filled with his staff and work (Head, *It Could Never*, 91–92).
20. Hearst to Morgan, July 25, 1927, Hearst Papers: "What do you think of large alabaster bowls on top of columns." Another version of the letter (Hearst Papers, 42:66) might date from February 1931. On September 17, 1927 (Hearst Papers, 42:58), he sent Morgan his suggestion "that we take those caryatids from one of the Roman villas, where they are holding some kind of cup or globe on top of their heads, and make some kind of cast-stone models out of these and put lights in place of the vase." He was probably referring to the Villa of Hadrian at Tivoli. Hearst specified the number and placement of the lamps. On September 17, 1927 (Hearst Papers, 42:58, Hearst-Morgan correspondence), MacGregor reported to Hearst, "alabaster globes on way." Three cases reached Los Angeles by August 12, 1929 (Hearst Papers, 41:1, Barham Insurance). In 1930 thirty more globes arrived (Hearst Papers, 41:1, Barham Insurance, May 5, 1930), as well as twenty carved marble standards.
21. Hearst to Morgan (September 2, 1929, Hearst Papers, 39:51): "Why not mosaic the ceiling of indoor swimming pool. Use blue glass mosaic studded with gold stars and beams with designs figures or signs of Zodiac or such. Wouldn't that be more striking than present plan." Cf. Kastner, *Hearst Castle*, 172–73. Hearst's message was scribbled on the back of a reply to Alice Head about paneling at Saint Donat's. On July 15, 1928, he wrote to Morgan to ask her to use the idea for the tiles at Marion Davies's mansion in Santa Monica for San Simeon: "the border of fishes with gold similar to the beach house" (Morgan Papers).
22. The history is well told by Thomas Aidala, Nancy E. Loe, and Victoria Kastner (see selected bibliography).
23. The ceiling, which came from the Palazzo Martinengo, was acquired by Hearst very early, in 1909, from Galeries Heilbronner in Paris (Coffman, *Hearst as Collector*, 38).
24. Hearst to Morgan, April 26, 1926. The flatness of the ceiling has been criticized with regard to the Gothic character of the room (Kastner, *Hearst Castle*, 112). Generally Hearst preferred flat ceilings (Hearst to Morgan, October 25, 1919). On April 27, 1926, Morgan agreed that it was more suitable in scale than the Moorish ceilings that they had considered (all Morgan Papers).
25. Illustrated in Kastner, *Hearst Castle*, 36–37. The teak gable might be a holdover from the initial idea for a bungalow.
26. Hearst to Morgan, May 22, 1922, Morgan Papers: "I like the equal towers because they balance the frame of those middle terraces." Morgan's training at the École des Beaux-Arts underscored the preference for symmetry. This background is also reflected in several details throughout the complex, for example, the seraphim on the chimneys of House A (cat. no. 4, fig. 3.8). The prototypes for these range from fifteenth-century

Florence to late sixteenth-century Germany; one, attributed to Germain Pilon, coincidentally is in the collection of the École des Beaux-Arts (illus. in G. Bresc-Bautier, ed., *Germain Pilon et les sculpteurs français de la Renaissance* [Paris: La documentation française, 1993], 29).

27. Hearst did not exhibit any signs of concern about his social status. When his son asked him why he built the estate at San Simeon, he replied, "I just wanted to. Period. I loved the place" (Hearst Jr., *The Hearsts*, 70). Hearst had the means to combine two loves—the exhilarating expanse of the frontier and the rich sophistication of art—and that is what he did.

28. Hans Rall and Michael Petzet, *König Ludwig II* (Munich: Schnell & Steiner, 1968). Neuschwanstein (begun 1869) was neo-Gothic, Linderhof (begun 1874) was neo-rococo, and Herrenchiemsee (begun 1878) was inspired by Versailles.

29. "Cuesta Encantada" appears on Hearst's engraved stationery in January 1925. He did not call Casa Grande a castle. He referred to the property as "the ranch."

30. The Villa Rotonda, designed by Palladio, was notable in the sixteenth century for its dome, a form that was previously associated in European architecture only with Roman temples. It was an isolated example. Religious (i.e., Christian) architecture was rarely adapted for domestic applications, but Hearst and Morgan were probably not concerned about "appropriateness."

31. Hearst Jr., *The Hearsts*, 70.

32. Kastner (*Hearst Castle*, 56) points out that "less than five per cent of the estate's art collection was purchased prior to 1919." Comparatively little had been stockpiled or brought from Phoebe Hearst's hacienda. A few specific objects (e.g., eight large Spanish silver candlesticks mentioned on March 12, 1930) were transferred from the Clarendon.

33. Correspondence between Morgan and Hearst; July 17, 18, and 22, 1921; Morgan Papers; MacGregor advised Hearst to have his own warehouse in New York (June 1926, Hearst Papers).

34. The collections included those of Emil Pares (1919), Pedro Ruiz, Luis Ruiz (several sales), Raimondo Ruiz (1920 and 1921), Tolentino (1920, 1922, 1923, 1925), and Almenas (1927). More than 250 objects at San Simeon came from Raimondo Ruiz (Sandra Barghini, "Spanish Collections at Hearst Castle" [lecture, Los Angeles County Museum of Art, June 12, 1994]). For Almenas, see Maria Jose Martínez Ruiz, "Luces y sombras...," *Goya*, nos. 307–8 (July–October 2005): 281–94. The collection of the Italian dealer Ercole Canessa was sold in 1924. Of the Tolentino sale in 1923, which took place in San Francisco, Hearst asked Morgan on March 19 to vet the lots: "If any of all those Tolentino things mentioned are defective or uninteresting please let me know quickly we will only get the good things" (Morgan Papers). French & Company provided at least 378 works of art now at the castle (Bremer-David, "French & Company," 49).

35. Hearst to Morgan, March 27, 1921, Morgan Papers.

36. Hearst to Morgan, February 7, 1921, Morgan Papers: "two Hermes [*sic*]...from Lord Hope's collection" that he wanted to be installed at House A.

37. Hearst to Morgan, January 9, 1930: "I am not going to do much building on the ranch this year and not going to do what we expected...at Wyntoon." A few weeks later Hearst wrote to Morgan that he "did not want to spend much until business improves" (January 29, 1930, both Morgan Papers).

38. Among the paintings are a small Crucifixion on copper in one of the Cloister bedrooms, a large Crucifixion in the Assembly Room, and small panels with scenes from the Passion in the North Gothic Bedroom. On August 28, 1932, Hearst asked for four of his nineteenth-century academic paintings to be sent to San Simeon (Hearst to MacGregor, Hearst Papers, 39:32): "Mersons Flight into Egypt, Geromes Napoleon before Sphinx and Gerome's Napoleon overlooking Cairo and Geromes King Candaules." The number of paintings of the Madonna has led to speculation about whether they refer to Hearst's mother, but there seems to be no basis for this. The presence of Phoebe Hearst's Orchid Lamp in the Assembly Room has also been interpreted this way, but the lamp is not centrally placed in the room.

39. Morgan to M. Byne, May 17, 1924, Morgan Papers. Hearst contributed to the design by insisting on the dominant central bay.

40. Morgan to Hearst, January 5, 1920, Morgan Papers.

41. M. Byne to Morgan; April 28, May 11, and June 9, 1914; Morgan Papers.

42. Morgan to M. Byne, September 19, 1921, Morgan Papers.

43. Included in Morgan to M. and A. Byne, November 18, 1921, Morgan Papers.

44. Hearst to Lawrence O'Reilly, December 27, 1921, Hearst Papers, 9:10 (personal correspondence). Barnard's enterprise in purveying large-scale architectural ensembles became serious around 1906. It makes a fascinating parallel to Hearst's projects, which included the idea, mentioned in August 1925, of buying a cloister for a museum he wanted to build for the University of California (Morgan to A. Byne, August 25, 1925, Morgan Papers). Barnard's collections were purchased by John D. Rockefeller, who

gave them to the Metropolitan Museum of Art to establish the Cloisters; the gift was announced in June 1925. Barnard had also promoted the idea of a museum of medieval art and architecture in Chicago, San Francisco, and Los Angeles (Palos Verdes). See J. L. Schrader, "The Cloisters and the Abbaye," *Metropolitan Museum of Art Bulletin*, n.s., 37 (Summer 1979): 34–36.

45. List dated May 1, 1931, Morgan Papers. Thirty-five came from Byne.

46. Barghini, "Spanish Collections," 7; Spain passed a law against "further exportation of works of art or ruins" ("Hearst Importing a Spanish Cloister," *New York Times*, December 14, 1926).

47. Mildred Byne explained to Morgan (October 1, 1921) that her "husband...made arrangements with several decorators [in New York] to send them complete Spanish interiors or separate pieces. We intended doing this only in a casual way, but...we were almost overwhelmed with orders." Addison Mizner was one of their clients (A. Byne to Morgan, October 4, 1923). Arthur Byne wrote to Morgan that he made reproductions too, "as we now undertake to completely furnish houses in the Spanish manner and obviously there are not enough antiques for all [the] modern requirements" (August 28, 1924, all Morgan Papers).

48. A. Byne to Hearst, December 29, 1930, Morgan Papers.

49. A. Byne to Morgan, October 25, 1924, Morgan Papers.

50. Hearst to MacGregor, October 7, 1929, Hearst Papers, 39:15. Cf. Hearst's order to MacGregor from about September 30, 1929, to send "two second-rate" cassoni from the Clarendon to San Simeon (Hearst Papers, 39:5).

51. Byne to Morgan, June 5, 1924, Morgan Papers.

52. March 14, 1925, Morgan Papers.

53. Morgan wrote to Byne on April 30, 1932: "The situation here is so uncertain...as to what income taxes will develop.... Things have been very difficult for the richest as well as the poorest." Uncertainty discourages investment. A second crash did occur, in 1932. The new tax is believed to have triggered it. Between March and September 1933 the dollar depreciated by about 33 percent, Byne calculated (Byne to Morgan, September 17, 1933). He could no longer quote prices in dollars. On June 1, 1933, he wrote: "If the Senate and House are determined to have a fifty-cent dollar then...the [ceiling] must be abandoned.... It is when using the dollar abroad that the seriousness of depreciated money is instantly demonstrated." By August 8, 1934, Morgan reported to Byne that she was "coming back to a normal existence," presumably because Hearst's finances were stabilizing momentarily (all Morgan Papers).

54. Byne called them "subsidiary commissions of legal and illegal nature" (A. Byne to Morgan, September 14, 1925, Morgan Papers). After the collapse of Primo de Rivera's government, Byne also had to pay the villagers to let him pass (Byne to Morgan, November 28, 1932, Morgan Papers).

55. For example, on October 10, 1926, Byne explained to Hearst that the revolt of the artillery had led to the dismissal of certain officers. The owner of the monastery in question was an artillery general in favor of the government, and Byne had "depended on his influence." On June 1, 1933, Byne reported, "There are no end of disturbances and killings." There was a new governor every month, and with each he had to start over, "sacrificing whatever money I have put down" (both Morgan Papers). The *Encyclopedia Britannica* (1947 ed., s.v. "Spain") mentions that there were twenty-six different governments between June 1931 and November 1935.

56. Byne wrote to Hearst (February 16, 1932): "The present Socialistic government in Spain is bitterly opposed to letting any church property get out of the country." There were efforts to safeguard Spain's patrimony: "Under the Republic the Church is forbidden to sell," Byne reported to Morgan on May 12, 1932. The government had just bought a ceiling for more than Byne had wanted from Hearst, who had let his option on the purchase expire. On May 19, 1934, Byne proposed a late fifteenth-century gilded ceiling from the castle of Curiel de los Ajos (Valladolid) to Hearst ("more than a ceiling...an illuminated document on a large scale"). The National Museum of Architecture wanted to buy it, but the government did not have the means to pay for it (all Morgan Papers).

57. Byne to Morgan, October 29, 1923, about a ceiling from Toledo: "With a threatened revolution I found the owner in a much more reasonable mood; in fact rather anxious to sell." On July 29, 1933, referring to a small plateresque facade from Ubeda that became available, Byne explained that it had been removed by a Sevillian noble: "All his lands confiscated" (all Morgan Papers).

58. Byne to Hearst, March 23, 1933, Morgan Papers.

59. On September 14, 1925, he wrote to Morgan: "Nor is the question of getting State permission so serious; it is that the villages...rise up and through the press carry on a campaign against you." On May 15, 1930, he wrote to Hearst about "representatives of the Church, either wholly ignorant or wholly unscrupulous (or both)." The next day

he wrote to Hearst: "Since the new government has come into power there has been a determined effort to curb the sale of art objects by the Spanish Bishops.... The State is not powerful enough to enforce this law directly but is doing it indirectly through the Vatican.... The Bishops...claim they are free to sell what they choose." (A similar debate arose about some Gothic choir stalls, as Byne reported on October 23, 1930: "The Spanish State and the Vatican are still wrangling over these.") To Morgan on May 16, 1930, he wrote: "The government is trying to prevent the Church from selling its art unless authorized by the civil authorities. This action has aroused the ire of the Bishops and some refused to sell anything as a result and others are for clearing out everything of value while they can." On July 18, 1930, Byne wrote to Hearst: "We have a perfect fanatic as Minister of Bellas Artes in Spain and he has been...declaring everything a national monument [but] the country has not the means to sustain all these buildings. However in October we have elections (the first in seven years!) and everybody is looking forward to great changes." He wrote to Hearst on June 19, 1931: "The Minister of Labor regards the work [of dismantling a building] as a solution to the unemployment problem in the district where the monastery is.... He is of such importance in the present government that the whole department of Fine Arts has been swept aside." On November 5, 1930, Byne proposed a Romanesque portal to Hearst. He mentioned that it had been published in Arthur Kingsley Porter's *Spanish Romanesque Sculpture*. The cardinal archbishop of Burgos ordered it sold, but the state "raised a terrific howl" about it (all Morgan Papers).

60. Byne tried to renew his application for export of the monastery of Alcantara but reported on June 10, 1933, "the government collapsed" (Morgan Papers).

61. Byne to Hearst, April 25, 1935. Cf. letter from Byne to Morgan, May 31, 1929: Byne had part of a Gothic castle, which "was dismantled by the Government so that the dimensioned stone might be used for the construction of a great bridge nearby." He predicted that Fiske Kimball, director of the Philadelphia Museum of Art, would be trying to acquire the material. Byne's report to Morgan on December 15, 1921, about the sixteenth-century house of Gonzalo de Cordova, general of Ferdinand the Catholic, offers insights into the salvage of historic properties. The house was going to be demolished for a theater, and Byne's initial investigations uncovered nothing extraordinary until the demolition began. Only then were the original Renaissance ceilings, which had been covered by modern plastering, revealed (all Morgan Papers).

62. Some velvet was sent back to Spain, and Byne was stuck with a $750 customs bill. Furious, he wrote, "I am sweating blood in Spain, transporting a whole Monastery in the midst of revolution and anarchy all for Mr. Hearst's sake I am in no mood to listen to any such tomfollery [sic] as this" (Byne to Morgan, June 16, 1931).

63. "Arthur Byne Dies in Spain," *New York Times*, July 17, 1935.

64. On "the disgraceful fruit" of the conflict between desires for improvement and attitudes associated with the monarchy and the Church, see Juan Antonio Sánchez López, "La imagen-símbolo destruida: La publicística en torno al tema del crucificado de Pedro de Mena tras los sucesos de 1931 en Málaga," in *Pedro de Mena y su época: Simposio nacional* ([Málaga]: Junta de Andalucía, 1990), 447–48. See also Byne to Hearst, May 20, 1931, Morgan Papers.

65. Byne to Morgan, November 22, 1931, Morgan Papers: he wrote that the property would become a school.

66. See correspondence between Byne and Hearst; April 25, May 11, and May 13, 1929; all Morgan Papers. It weighed more than thirty thousand pounds. See Jesus Urrea, "A New Date for the Choir Screen from Valladolid," *Metropolitan Museum of Art Journal* 13 (1978): 143.

67. *Time*, November 25, 1957, 102.

68. Hearst to Morgan, June [2?], 1926. Morgan replied on June 3, 1926: "I liked and enjoyed the movey [sic] people. They are artists, and alive. It was a pleasure also to see the way those who did not go swimming went around absorbedly taking in the detail." She understood that it was not possible to review details "when people all want you. It was a beautiful party" (both Morgan Papers).

69. Hearst to Morgan, February 19, 1927. In September, however, he postponed the idea of the museum for the University of California because he "just bought some papers in Pittsburgh and it has left [him] pretty well exhausted for ready cash" (Hearst to Morgan, September 15, 1927, Morgan Papers).

70. On October 8, 1927, Millicent wrote to Hearst that August Thyssen wanted to see the ranch (copy of note, Morgan Papers). On April 1, 1927, Pope asked for permission to visit (Hearst Papers, 9:20). Hearst's personal secretary, Col. J. Willicombe, added that this would be allowed even if Hearst was not there, which was very unusual, according to Willicombe (February 2, 1940, Hearst Papers, 36:[7?]). Hearst had an "infallible" rule, "which was never broken, not to allow people to come to San Simeon in case of his absence." There are six significant Islamic tiled panels at Hearst Castle and two mihrabs.

71. John Neylan to Hearst, May 7, 1927, Hearst Papers, carton 9.

72. Neylan to Hearst, July 12, 1927, Hearst Papers, carton 9. The fund had $700,000.

73. Overall the inventory of Hearst Castle lists sixteen copies of classical sculptures; some of these are in the garden. Hearst's request for the copies is in a long memo to Thaddeus Joy (July 14, 1928, Morgan Papers) written before Hearst left for Europe; he explained their placement, with an option for a "modern one" on July 15, 1928; on February 19, 1930, he was informed that five of the eight copies were ready, but the three remaining were delayed because "permission to make casts" was pending, which suggests that the sculptures had not been copied in marble before (all Morgan Papers).

74. Head to Hearst, July 27, 1929, Hearst Papers, 37:27.

75. Not everything was sold directly at the Lansdowne auction on March 5, 1930, in London. Hearst tried to buy the Hercules (lot 34) and the Victorious Youth (lot 60) separately (Head to Hearst, March 11, 1930, and Hearst to McPeake, March 21, 1930, Hearst Papers 37:34). On July 31, 1933, Head told Hearst that Lansdowne would not sell the Hercules when she wrote to him about the Hope collection (Hearst Papers, 37:39).

76. Messages from March 6, 1930, and March 11, 1930 (Hearst Papers, 40:23). Brummer was the agent. In 1926 he also sold the Gallo-Roman mosaics from Villelaure to Hearst (Hearst Papers, 40:23), one now in the Los Angeles County Museum of Art, the other in the J. Paul Getty Museum.

77. Head to Hearst, April 5, 1930, Hearst Papers, 37:34.

78. Hearst to Head(?), October 21, 1929, Hearst Papers, 37:31. Hearst rarely bought anything of value at auction if he did not have a good idea of what it looked like unless there were compelling historical factors in the object's favor.

79. Levkoff, "Little-Known American Provenance," 297.

80. A summary is provided by Jörgen B. Hartmann, "Canova e Thorvaldsen," in *Colloqui del Sodalizio* 2 (1951-52/1953-54 [published 1956]): 71–89.

81. Hearst to Duveen, November 15, 1932, Duveen Archive, just after Hearst acknowledged his awareness of outstanding debts in his account with Duveen.

82. Levkoff, "Little-Known American Provenance," 297-98; purchased at the auction of Victor Rothschild's collection in 1937.

83. Geoffrey Waywell, *The Lever and Hope Sculptures* (Berlin: Gebrüder Mann, 1986), 44 (fig. 2), 67-68. Hearst bought the sculpture from Brummer, not from the auction, because the catalogue reached him too late (Brummer to Hearst, March 11, 1930, Hearst Papers, 40:23). A letter from Head to Willicombe refers to the arms and helmet that were added when the sculpture was restored around 1800 (December 13, 1933, Hearst Papers, 37:42). Hearst was sophisticated enough to safeguard these; they are at the Los Angeles County Museum of Art. Hearst did buy at the auction the renowned Erickstanebrae fibula (Los Angeles County Museum of Art); see Hearst to McPeake, July 27, 1933, Hearst Papers, 37:39.

84. Brummer handled the acquisition for him (Hearst Papers, 40:23, 37:51).

85. Hearst asked for the maiolica at the Clarendon to be sent to San Simeon (May 3, 1932, Hearst Papers, 39:29), but his Rothschild maiolica remained on view at the Metropolitan. He reminded his registrar that some examples had been found in the "clothes closet on the eleventh floor." He mentioned the Spanish ceramics and the maiolica again on June 5 (Hearst Papers, 39:31), in particular the Spanish plates that were "loose" (i.e., probably the ones that were not already installed in the room that Thaddeus Joy described in 1923).

86. Morgan to Hearst, February 14, 1936, Morgan Papers.

87. Hearst asked Brummer to buy all vases illustrated in the Holford sale catalogue (July 13, 1927, Hearst Papers, 37:19). The Torr sale was July 2, 1929 (mentioned in Hearst Papers, 37:51), with twenty-one vases for Hearst; the Revelstoke (i.e., Baring) sale in 1935 provided fifty-two vases to Hearst. Goldschmidt might have been the intermediary for twenty-two vases from Mrs. Hunt's collection. Spink's sold nine vases from the Lloyd collection to Hearst in 1936; other sources included sales at Christie's around May 7, 1936, and Sotheby's around April 11, 1934. The Hearst Castle inventory lists the provenances. A number of these vases were dispersed by Parke-Bernet on April 5, 1963.

88. Hearst Papers, 39:36. There were two separate messages that day—one about the vases, the other about Richter's book.

89. Lucilla Burn, "Words and Pictures: Greek Vases and Their Classification," in *Enlightenment: Discovering the World in the Eighteenth Century*, ed. Kim Sloan and Andrew Burnett (London: British Museum Press, 2003), 142; see also Mary Levkoff, "Hearst and the Antique," *Apollo* 167 (October 2008), forthcoming.

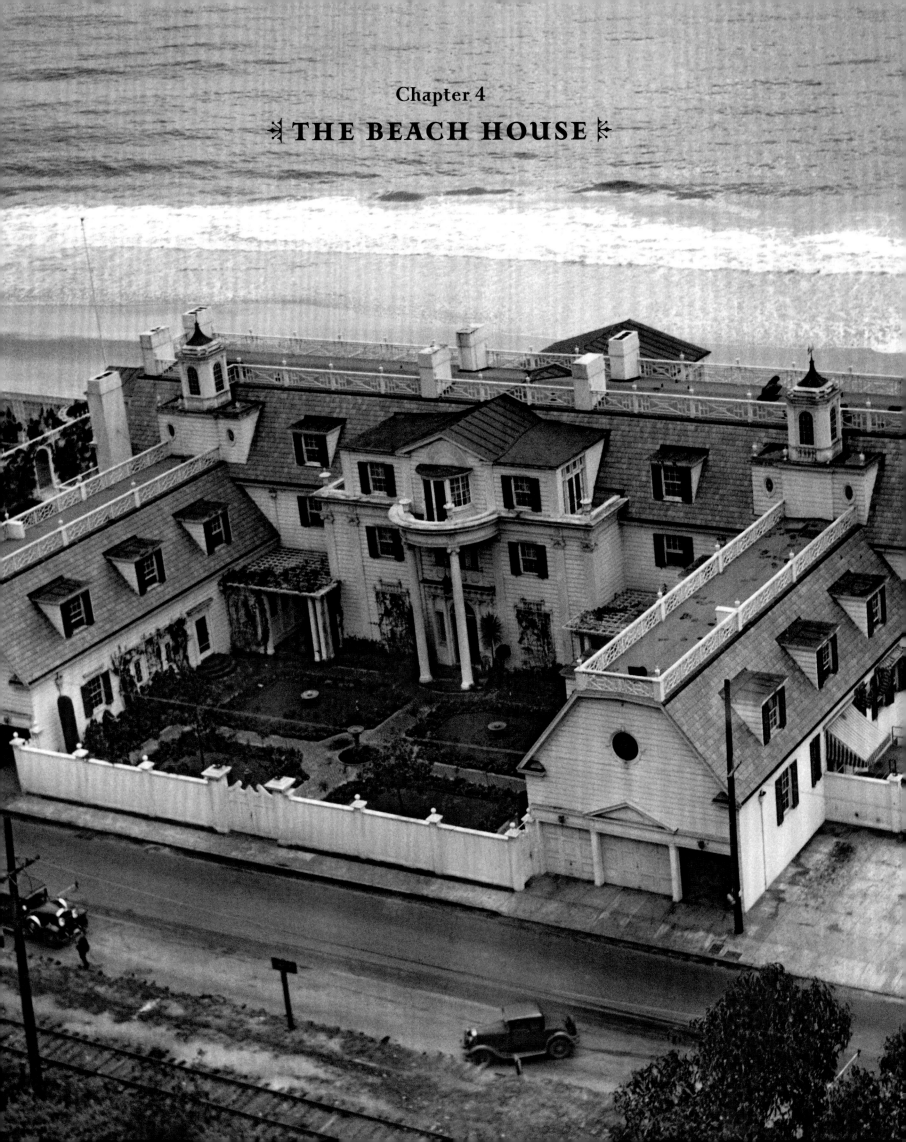

Chapter 4
⊹ **THE BEACH HOUSE** ⊹

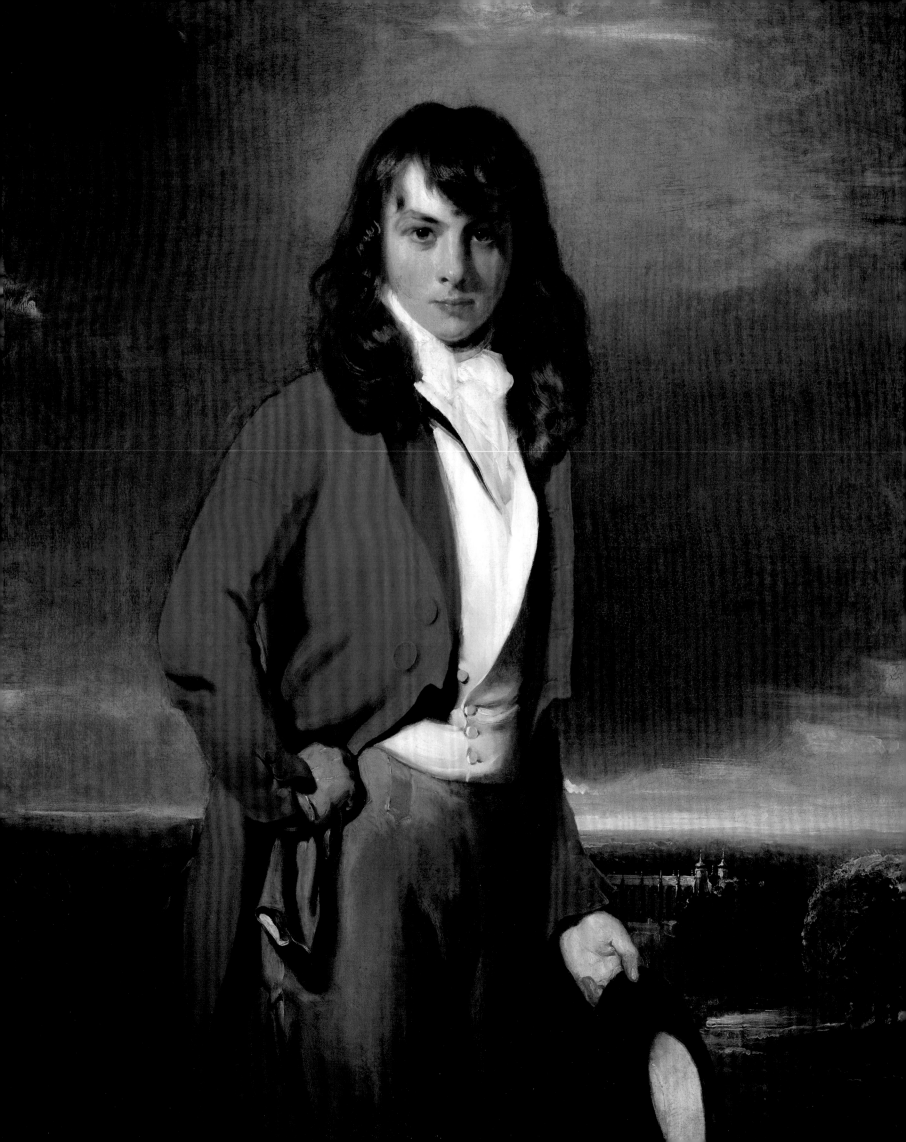

Marion Davies (fig. 4.3) was the stage name of Marion Douras, a lissome blond who was the daughter of a New York magistrate. She was a chorus girl at the Ziegfeld Follies when Hearst noticed her late in 1915 or in 1916. Davies was "gaminesque…a genuinely unselfish person…and inspired mimic," wrote Alice Head, who was the managing director of Hearst's British subsidiary.[1] Hearst's infatuation with her became an enduring affection and caused his estrangement from his wife. Davies's career as a comedienne and producer has been eclipsed by her role in Hearst's life, but Hearst's own history in motion pictures, aside from the controversy that arose over *Citizen Kane*, was considerable. No worthwhile account of his passion for visual art can neglect his participation in developing this new medium.

Hearst's innovative distribution agreements and "synergies" among his various enterprises are well known. He extended his business of syndicating still photographs through the International News Service to encompass the production and distribution of photographic images that moved. They were called newsreels.[2] Conversely, some of the newsreels became famous when their best individual frames were extracted and used as stills.[3]

Hearst also wanted to produce elegant feature films that would be "an alternative to the cheap slapstick reel that had become so ubiquitous," as the general manager of his film company, Cosmopolitan Studios, explained.[4] To accomplish this, he recruited the Viennese designer Joseph Urban as his art director in 1920.[5] Thanks to Hearst's patronage, Urban's legacy continues to influence the visual language of cinema. "I want to make pictures that are moving compositions in the same sense that a great painting is an immobile composition," said the designer, who instructed his American assistants to watch *The Cabinet of Dr. Caligari* (1920) to put his point across.[6] The influential Urban, whose American reputation was made by the sophisticated colors he combined for the stage sets of the Boston Opera and the Ziegfeld Follies, transformed the black-and-white medium of film by manipulating the contrasts of dark and light as a painter would.[7] His unyielding prohibition against wanton historical inaccuracies in set design imposed a rare discipline on Hearst.[8] Hearst also commissioned him to conceive the

FIGURE 4.3. Marion Davies in her mansion, with *Portrait of Arthur Atherley as an Etonian* (cat. no. 143) on the wall behind her.

streamlined, modern Cosmopolitan Theater in New York, which was across the street from Hearst's Warwick Hotel.[9]

In 1925 Hearst decided to close Cosmopolitan Studios in New York and establish a joint venture with Metro-Goldwyn-Mayer in Los Angeles instead. His news service was responsible for "the first photograph transmitted across the continent by telephone," which recorded "Miss Davies' actual appearance on the lot under her new contract to make pictures for Metro-Goldwyn-Mayer."[10] More than ever, Hearst's attention turned to California and Marion Davies.

Partly through the generous salary Hearst paid her, partly through her intelligence in heeding good advice about investments, and partly through her own talent and professionalism, Davies became very wealthy in her own right.[11] She owned a considerable property on the beach in Santa Monica. She explained: "I had bought some land

Overleaf: FIGURE 4.1. The central block of Marion Davies's mansion in Santa Monica, with the garden forecourt designed by Hearst.
FIGURE 4.2. Sir Thomas Lawrence, *Portrait of Arthur Atherley as an Etonian*, c. 1791 (cat. no. 143).

from Will Rogers, so there was my house and another guest house and then a lawn of about 60 feet on the right. On the left were two extra houses and the staff house....W. R. liked the beach house, but that was when the architects came in again. More additions were added on."[12]

The original mansion was pieced together from the initial five houses in a Georgian style by William Flannery, a set designer in Los Angeles,[13] but in June 1926 Hearst turned to Julia Morgan for advice: "When we come to the decoration of the interior of the beach house, in order to prevent too much similarity in the ten bedrooms,...might we have on the top floor, for example, one Dutch bedroom, one French, etc. Of course the majority would be straight Colonial,... on the second floor we use interesting papers with white wainscoting...on the top floor...a little different type of treatment, all in the 18th century period, however."[14] The costly wallpaper, manufactured by Zuber, depicted American landscapes and horse racing in Europe.[15] A week later he recommended a doorknob with George Washington's bust: "I would like to use some patriotic stuff of this character."[16]

A barrage of communications regarding English and American paintings early in the winter of 1927 must be related to the Beach House. "Knoedler had a portrait of George Washington but sold it although I went in reasonably soon after they wrote to me," Hearst told his registrar. Knoedler and Company had obtained another, and Hearst thought he might try to acquire it but added, "Maybe you should try to get a Washington portrait somewhere else."[17] From Knoedler he still wanted a portrait of an admiral and a painting of a young lady in white, but he asked the registrar to see if he could get a better price for them.[18] A portrait attributed to Thomas Sully of Peyton Randolph, the first president of the Continental Congress (1774–75), was shipped to Hearst at the end of January.[19]

The house was originally scheduled for occupancy in mid-April 1927, but Flannery reported that it would not be ready until July.[20] Hearst was infuriated by the delay. Work carried on through October and beyond that for another year, primarily because of the building's poor foundations.[21] On the last day of October 1927 Hearst bought twelve hundred orchids—the entire stock of Fred Hills Nursery—for more than what two luxury automobiles cost at the time.[22]

Throughout the autumn Hearst's correspondence was sprinkled with instructions about acquiring colonial and other eighteenth-century furnishings. His secretary wrote to the registrar: "Tell [Mitchell] Samuels Chief asks him

express to Los Angeles the two Horace Vernet ship tapestries. Chief says he may use or return them." The message continued with requests for prices and many notes on Georgian and colonial beds.[23] Hearst also asked Alice Head for "Welsh dresser for plates rugs etc." and more chairs and "long tables...two very fine Queen Anne or Georgian dining tables, four pedestal tables would do or earlier ones better. Want to put them end to end for large dinner so they must match in size be similar in general character." He recommended that she ask Charles [of London], Partridges, and Stair for them.[24] An exhausting number of hooked rugs were bought at auction in October,[25] and toward the end of December, Hearst wrote to the registrar: "Please ship all colonial furniture, hook rugs, lighting fixtures recently bought. Farr [a dealer in London] to get painting to match marine picture. Buy two Chippendale gilt mirrors from Partridges $4000 or less."[26]

There was a swimming pool squeezed into the margin between the portico of the west facade and the sea. Its floor was bordered with a whimsical mosaic of goldfish designed by Morgan, and a white marble bridge, with a profile that vaguely recalled the Rialto Bridge in Venice (1588), spanned its middle. The mosaic and the marble stairs with curved rails were completed before the swimming pools at San Simeon, which included similar elements.[27] Davies's "Rathskeller," lined with Tudor paneling, opened onto the pool.[28]

Why Hearst favored American colonial revival for the building remains open to speculation. The Georgian style of the mansion (to say nothing of its size) was thoroughly incongruous on a California beach. It made a significant statement about Hearst and Davies's status in Los Angeles. Perhaps the reference to American colonial history lent it an aura of gentility, but in any case, by the late 1920s Georgian architecture was simply becoming more fashionable than the Spanish revival of the past decade.[29] Around September 1927 Hearst's own British edition of *Good Housekeeping* was planning to print a circular to include in one of its issues. Reading a proposal about it then, Hearst might have recalled the unruly decoration of his mother's parlors. It was titled "The Horsehair Sofa Is in the Attic": "...and with it the fruit under glass, the what-nots and many other hideosity [*sic*], as well as the stuffy ideas that tolerated them. In their place, in the countless charming homes throughout the country, there are delightful pieces of furniture, colorful draperies and an atmosphere of good taste the gay nineties could not boast." The cause was the

magazines that "went into the home, not merely to entertain, but to serve.... Chief among them is Good Housekeeping." Letters asked *"its help and guidance in making the home a more attractive place to live."* The insert was illustrated with a faultlessly arranged "colonial bedroom executed in and by the Good Housekeeping studio," as the caption stated.[30]

Hearst was certainly not opposed to the style: at one point he considered erecting a Georgian pavilion at San Simeon. The lavish Beach House was graced with paneling from Cassiobury Park (attributed to Grinling Gibbons) and Burton Hall. Eighteenth-century marble mantelpieces could be found throughout the mansion, and two small tapestries were on the second floor.[31] One might recall Hearst's sarcastic critique of the mismatched decoration that he saw at a dinner at the White House in 1905, during Theodore Roosevelt's presidency. He wrote to his mother about "the Italian renaissance woodwork and...gothic tapestry, all of which is so appropriate in a public building in America, a country which drew the inspiration of its Republican idea and also of its architecture from the classic times...and has no association in spirit or history with medieval Europe."[32]

The timing of Hearst's purchases of several paintings in 1927–28 suggests that he acquired them specifically for Davies's estate. The eighteenth century prevailed in the most important rooms: the formal dining room, with paintings of George III and Queen Charlotte from Reynolds's studio, as well as tables arranged the way Hearst had described them to Alice Head;[33] the Marine Room (fig. 4.4), with a group portrait by Arthur William Devis (fig. 4.5);[34] and the music room (fig. 4.6), with Fragonard's *Winter* (fig. 4.7).[35] At the same time, Hearst rejected other paintings by Fragonard as "too purely decorative."[36]

The most magnificent space was the eighteenth-century Gold Room (fig. 4.8). It compared reasonably well with the ballroom of the Rothschild Palace in London, which would be dismantled in 1937. (At the auction of the contents of the palace, Hearst bought the Thorvaldsen roundels, which he then set into the walls at San Simeon's Assembly Room.)[37] Over the mantelpiece at one end of the Gold Room, *Pastoral Secrets* by François Boucher (fig. 4.9), painted for the Hôtel de Matignon and bought from Wildenstein in 1928, was installed. In 1931 the Gold Room was described as having four pictures by Boucher (see p. 83). Davies did own two overdoors by Boucher (figs. 4.10, 4.11), possibly the ones that Hearst admired at the Wildenstein gallery in Paris in 1929.[38] Perhaps her Fragonard, which was believed to be a portrait

of Marie-Thérèse Colombe and was purchased by Hearst in 1923, was mistaken for a Boucher.[39]

A fashion plate of Davies modeling a gown by Lucien Lelong records the location in the Gold Room of her most important painting (fig. 4.3). It was the romantic *Portrait of Arthur Atherley* by Sir Thomas Lawrence (fig. 4.2). Davies recounted how she had chosen this painting and bargained with Duveen for it herself. He insisted that the portrait would one day be considered as significant as Lawrence's *Pinkie*. Duveen had sold *Pinkie* the year before to Henry E. Huntington, and he wanted an exorbitant $600,000 for *Arthur Atherley*. He refrained from mentioning two factors that contributed to *Pinkie*'s value: unlike *Arthur Atherley*, it was a full-length portrait, and it was paired by Huntington with the most important British painting in the United States, *The Blue Boy* by Thomas Gainsborough. Duveen told Davies that Mrs. Dodge had offered more money for it than she had. She responded: "Mr. Hearst will be so sorry. I don't think he'll buy anything here anymore." Hearst was billed $140,000 for the painting in 1928.[40]

Hearst must have bought most, if not all, of the paintings for Davies. Maybe it is more accurate to say that he paid for them. There seems to be no documentation about whether Davies personally selected other pictures the way she did *Arthur Atherley*. Ultimately much of their property was commingled: auction catalogues of the furnishings of the Beach House list properties from one year to the next interchangeably as Davies's or Hearst's. It is reasonable to believe that the choice of virtually everything was his; even so, the furnishings of the Beach House did not have the refinement of Anna Thompson Dodge's focused collection in Detroit.

A favored spot in the Beach House for photographing guests at Davies's frequent costume parties was where *The Smoker* by David Teniers the Younger, now in the Los Angeles County Museum of Art, could be found. In the Informal Living Room a concealed screen could be raised from the floor to show movies.[41] A painting of a bearded man by Govaert Flinck (cat. no. 133) was in this room. Hearst might have paid about $150,000 for this picture; it was the price commanded by the attribution to Rembrandt.[42]

A useful description of the Beach House was recorded by William Valentiner in 1931, twenty years after he had written to Hearst about the stained glass in the Clarendon (see chapter 2). Valentiner had advanced to become the director of the Detroit Institute of Arts. The entry in his diary for January 15 recounts:

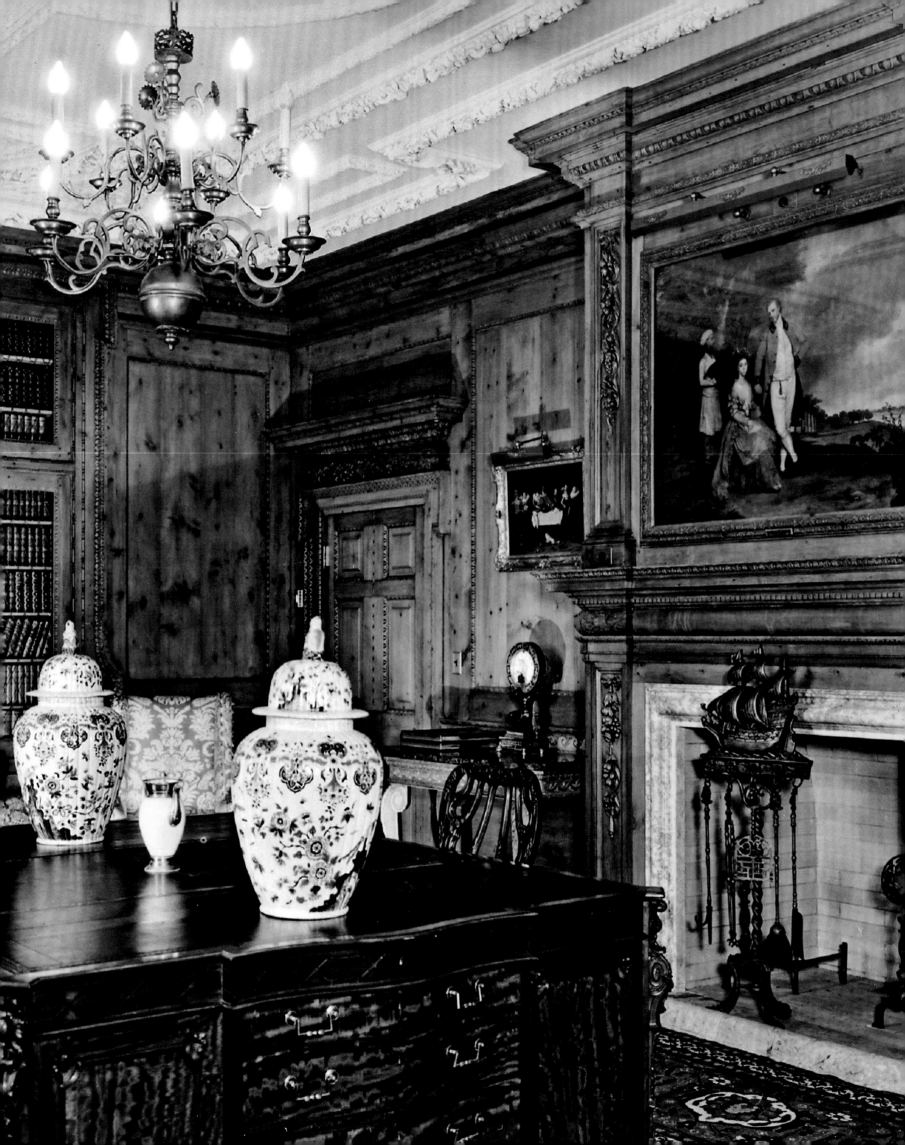

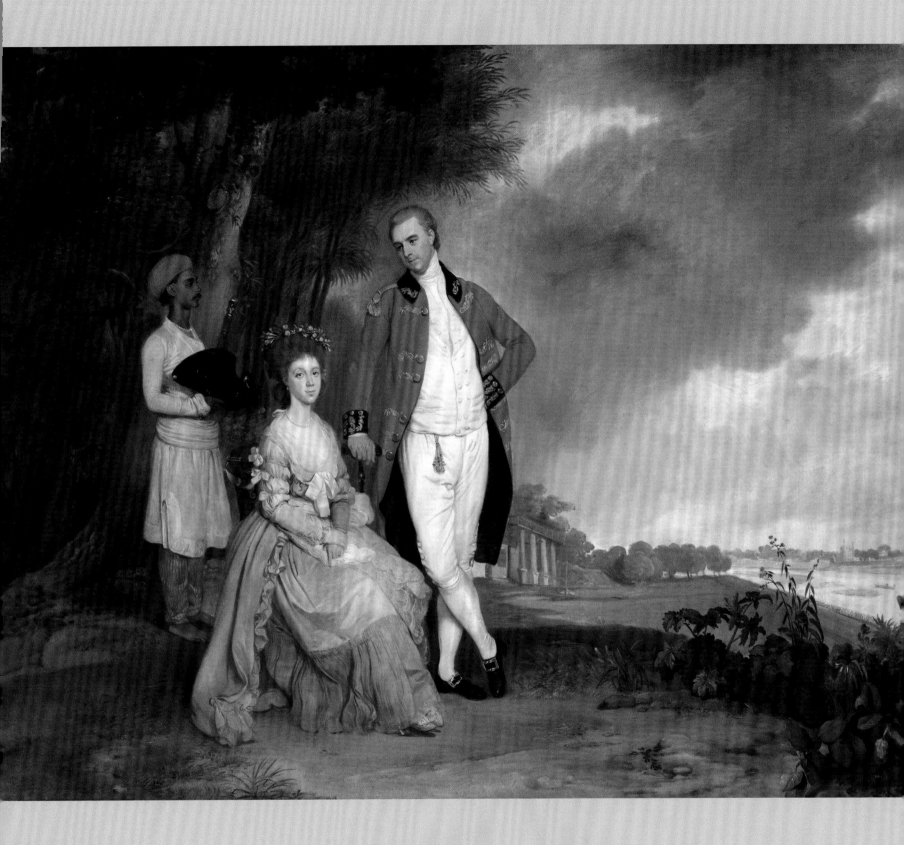

FIGURE 4.4. The Marine Room in Davies's mansion. The painting over the mantel is the group portrait by Devis (cat. no. 142).

FIGURE 4.5. Arthur William Devis, *The Hon. William Monson and His Wife, Anne Debonnaire, with a Servant,* c. 1786 (cat. no. 142).

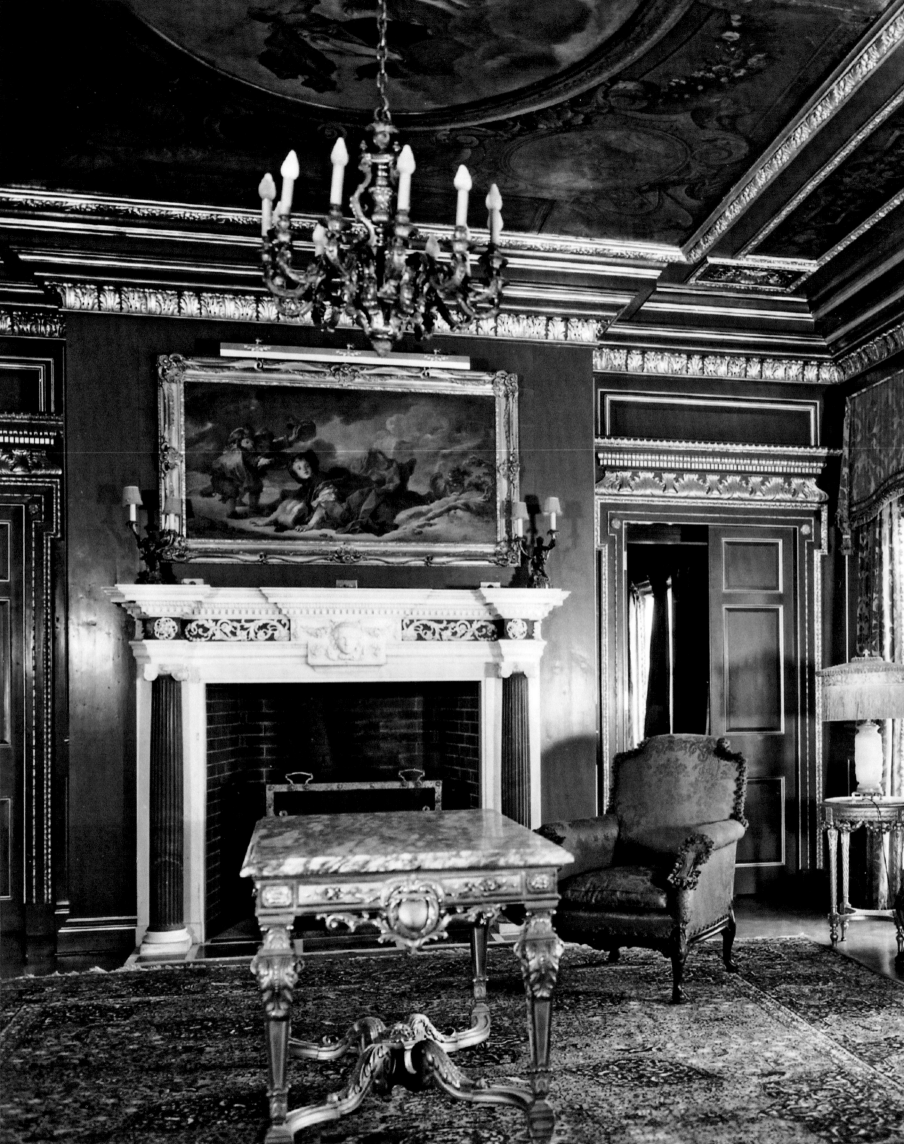

FIGURE 4.6. The music room in Davies's mansion, with *Winter* by Fragonard (cat. no. 139) over the mantelpiece.

FIGURE 4.7. Jean-Honoré Fragonard, *Winter*, c. 1752–55 (cat. no. 139).

For lunch in another house, built by Hearst for Marion Davies, a long-stretched white building in the Colonial style, galleries of small columns and climbing flowers are building a fence around the garden, in which center there is a large swimming pool…and [above,] the reception-rooms, in English style, only one in French style with four good pictures by Boucher [the Gold Room?], a library with pictures by Rembrandt, Franz Hals, etc. It is possible to show a film here, when a button is pressed there appears on the wall a canvas in a precious frame, at the same time two doors open up as on a cuckoo-clock, the film can be heard through the big hall. Charming are the bedrooms, the enormous windows are made each of one large window-pane and with the ocean in the background it is like being on a boat. Friendly light-colored walls, gay curtains, and dark blue Chinese carpets fitting in astonishingly well with everything else.…White vases with lovely flowers, white orchids, and in the diningroom loads of English silverware.[43]

In January 1932 Hearst was preoccupied with the safety of the paintings. He asked Julia Morgan how to fireproof the Beach House: "Miss Davies has over half a million dollars' worth of pictures in it, and perhaps half a million dollars' worth of other valuables."[44]

Despite the quantities of correspondence in which Hearst briefly mentioned his opinions about specific works of art, there is scant documentation from Hearst himself of the personal feelings that otherwise were eloquently expressed through the ensembles he conceived. For this reason, Marion Davies takes on a piquant significance in Hearst's history as a collector. She was eager to learn from him, and she loyally shared his interests.[45] She was the witness who explained the character of the trips he led to Europe "every summer for eight years," taking anywhere from twelve to twenty guests on a complex and carefully planned itinerary. They were difficult to control. According to Davies, "his big annoyance" was people who left the historical tour to amuse themselves elsewhere. He "always maintained that if people wanted to have fun, they could do it in New York. He thought that if you went to Europe, you had to see Europe and understand educationally what the history was. There was no time for any jollities or frivolities in Europe.… He was trying to teach us something."[46]

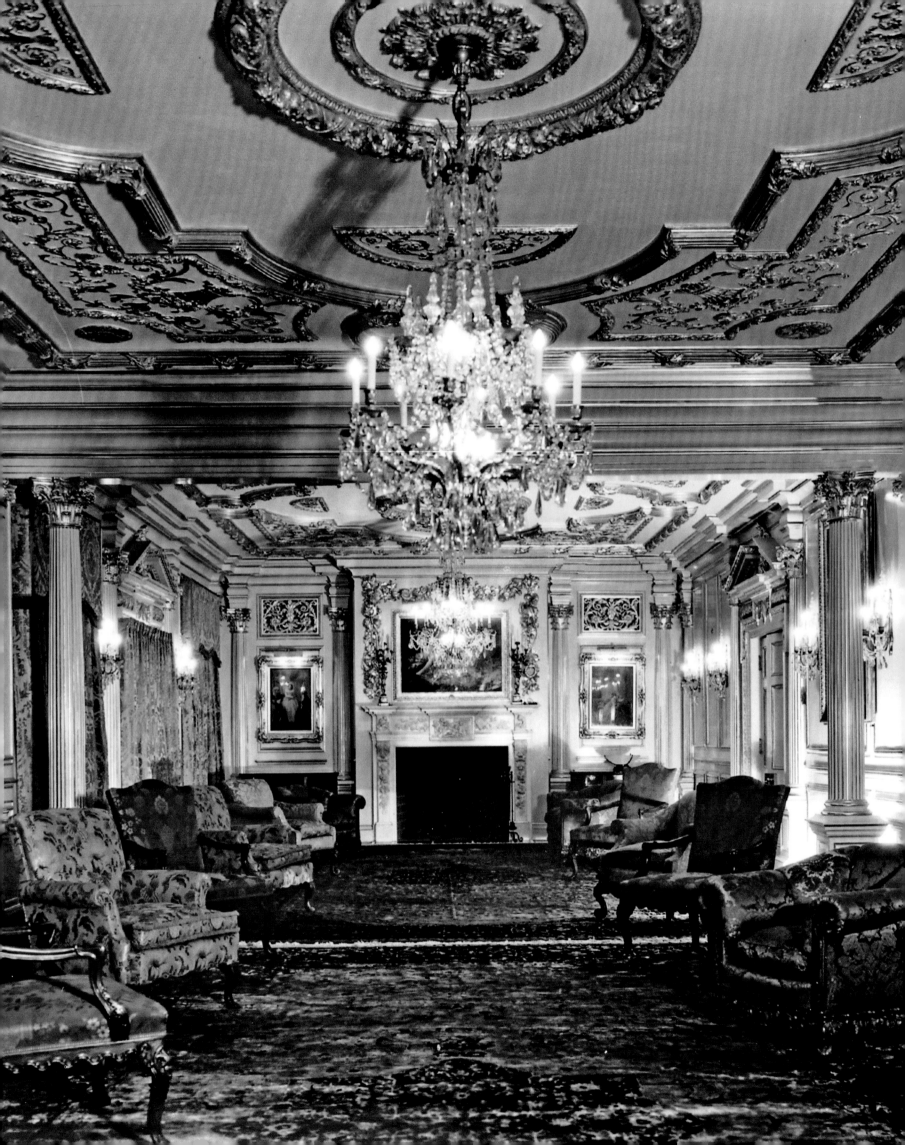

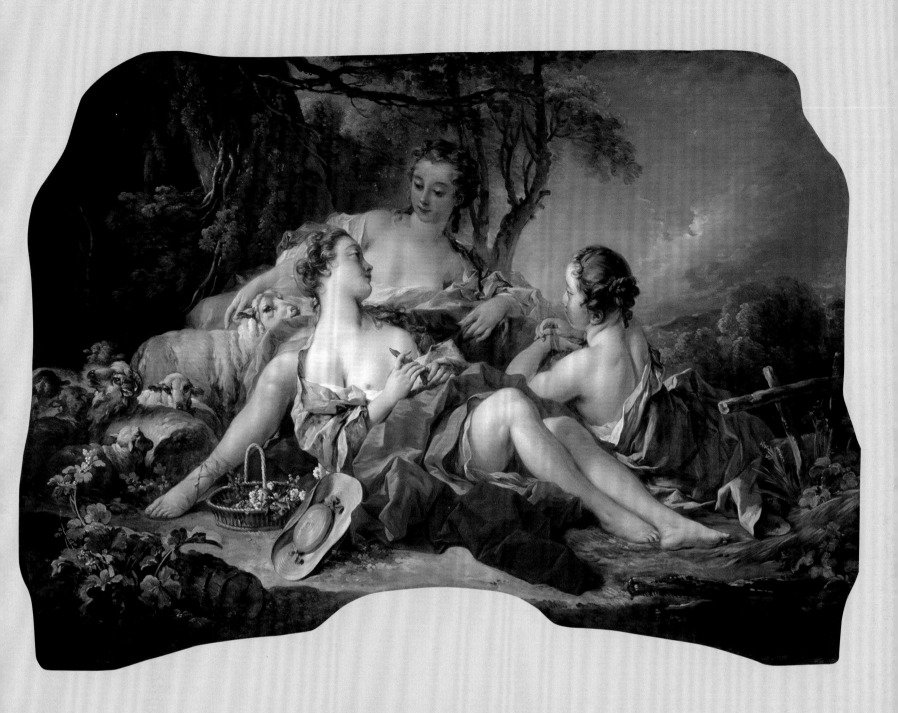

FIGURE 4.8. The Gold Room in Davies's mansion, with eighteenth-century Venetian paneling. The painting *Pastoral Secrets* by François Boucher can be discerned over the mantelpiece.

FIGURE 4.9. François Boucher (French, 1703–1770); *Pastoral Secrets*, c. 1745; oil on canvas; 37 x 52 in. (94 x 132.1 cm); Los Angeles County Museum of Art, Gift of Hearst Magazines (inv. no. 47.29.1).

FIGURE 4.10. François Boucher, *Venus and Mercury Instructing Cupid*, 1738 (cat. no. 136).

Notes

1. Head, *It Could Never*, 96–97. When Head asked Hearst if his mother had been worried about him in the Spanish-American War, "he murmured: 'Not half so worried as she was about me and the Follies!'"

2. Nasaw, *The Chief*, 234. An archive of twenty-seven million feet of Hearst newsreels covering the years 1914 to 1967—together with story synopses, subject index, and associated promotional material—was donated by the Hearst Corporation to UCLA.

3. Blaine Bartell, senior preservationist of newsreels at UCLA's Film and Television Archive, explained the importance of the newsreels to the author (2005): they recorded not only historic events but also precious images of the everyday lives of ordinary people. The most famous and influential single frame, shot by Wong Hai-sheng ("Newsreel" Wong), showed a derelict baby crying on a platform in the Shanghai South railroad station after Japan bombed it in 1937. Hearst footage also recorded Frida Kahlo greeting Leon Trotsky and his wife in Mexico.

4. Quoted in Matthew Wilson Smith, "Joseph Urban and the Birth of American Film Design," in *Architect of Dreams: The Theatrical Vision of Joseph Urban*, exh. cat., ed. Arnold Aronson (New York: Miriam and Ira D. Wallach Art Gallery, Columbia University, 2000), 49.

5. Louis Pizzitola, *Hearst over Hollywood* (New York: Columbia University Press, 2002), 187; see also Randolph Carter and Robert Reed Cole, *Joseph Urban: Architecture, Theater, Opera, Film* (New York: Abbeville, 1992), 30–34.

6. Quoted in Smith, "Joseph Urban," 52.

7. Carter and Cole, *Joseph Urban*, 71–73, 99. Urban received the commission for the "Color and Protection" pavilion at the 1933 Chicago World's Fair, which was realized after he died. "The masterful handling of these colors, directed by the late Joseph Urban, created an expanse of color never seen anywhere," according to the brochure for the pavilion (Joseph Urban Papers, Rare Book and Manuscript Library, Columbia University, folder 33:7; Tara Craig kindly assisted with consultation).

8. Urban's daughter recalled: "Urban reminded Hearst that he was hired to oversee the artistic perfection of the film and could not tolerate such a conglomeration of furniture. Hearst capitulated" (quoted in Carter and Cole, *Joseph Urban*, 149). Urban sought curator Bashford Dean's advice on modern armor for *When Knighthood Was in Flower* (1922). Dean was mortified when his name appeared in the credits as a property master (correspondence in Department of Arms and Armor files, Metropolitan

Museum of Art). Hearst wrote to Urban about *The Young Diana* (1922): "I just dropped in to tell you how wonderful the snow carnival is. It is the most beautiful thing I have ever seen.... It will make the picture a sensation. Very many thanks" (Hearst to Urban, Urban Papers, box 27, folder 9).

9. The property for both was bought in 1925 ("Hearst to Build Four Big Buildings," *New York Times*, June 13, 1925); the cornerstone was laid in 1926 ("Hearst and Ziegfeld in Big Theater Deal," *New York Times*, January 6, 1925; also "Ziegfeld Theatre's Cornerstone Laid," *New York Times*, December 10, 1926). See also Steven Ruttenbaum, *Mansions in the Clouds: The Skyscraper Palazzi of Emery Roth* (New York: Balsam Press, 1986), 113. The Warwick was established as an apartment-hotel, and Hearst had a luxurious apartment there. In January 1927 he was looking for Jacobean paneling for the apartment. He intended to have Mitchell Samuels oversee its decoration rather than Charles Birge (Hearst to MacGregor, January 18, 1927, Hearst Papers, 38:50). As for the theater, Hearst explained to Urban that he wanted "conspicuous architectural character...something too that reflected the public character of our publications" (Hearst to Urban, April 4, 1927, Hearst Papers, 10:18).

10. Caption on photograph in Marion Davies Papers, Margaret Herrick Library, Academy of Motion Picture Arts and Sciences, Beverly Hills, California, file MPGP 7848. It was sent from San Francisco to New York.

11. Her estate was valued at about $20 million in 1963 (Davies, *Times We Had*, unpaged [introduction]).

12. Ibid., 101. Hearst and Davies referred to the property as the Beach House. After Davies sold the complex in 1946, it was transformed into a luxurious hotel called Ocean House. The renovated rooms in the hotel were photographed for *Architectural Digest* 12, no. 2 [1949]. Most of the original mansion was demolished in the 1950s. Later additions were severely damaged in the 1994 Northridge earthquake (information provided by Ho Nguyen of Santa Monica Historical Society and Christie McAvoy, Historic Resources Group). The rehabilitation of the site is being carried out by Frederick Fisher and Partners as this book goes to press.

13. Howard Heyn, "Marion Davies' Beach House Becomes Hotel," *Los Angeles Examiner*, October 16, 1949, reprinted in Moule and Polyzoides, Architects and Urbanists, *Oceanhouse, America's Most Beautiful Hotel*, brochure (Pasadena, Calif., July 1, 1999); Taylor Coffman, *The Builders behind the Castles: George Loorz and the F. C. Stolte Co.* (San Luis Obispo, Calif.: San Luis Obispo Historical Society, 1990), 6.

FIGURE 4.11. François Boucher, *Cupid Wounding Psyche*, 1741 (cat. no. 137).

14. Hearst to Morgan, June 15, 1926, Morgan Papers. This description belies Anne Edwards's flawed assertion that "Ocean House [*sic*] had little continuity in décor" ("Marion Davies' Ocean House," *Architectural Digest*, April 1994, 173; carried over in Nasaw, *The Chief*, 364).

15. Heyn, "Marion Davies' Beach House."

16. Hearst to Morgan, June 22, 1926, Morgan Papers.

17. Hearst to MacGregor, January 18, 1927, Hearst Papers, 38:50. This is an instance in which Hearst's desire for a picture was determined by its subject alone. Another example involved a portrait of Emma Hamilton: on July 30, 1926 (when the Davenport collection was auctioned), he wrote to Duveen: "Please let me have Lady Hamilton. I have always wanted one and Huntington has one." Duveen replied (August 4, 1926) that he had promised to show the [Davenport] painting to Mellon first but he was "now negotiating another Romney Lady Hamilton so you will surely have one or other" (Duveen Archives, GRI).

18. Hearst to MacGregor, January 18, 1927, Hearst Papers, 38:50. The next day MacGregor reported about three paintings by Reynolds: "McCormick [looked at them and said] all three genuine.... Highmore picture very beautiful." On January 20, apparently in anticipation of a shipment, Hearst asked, "Where is the Reynolds painting of man in red coat, and have you any record of price and when and where purchased." In another message of the same day, he said that he would "always pay cash when we get a real bargain."

19. Communications between Hearst, his secretary, and the registrar, January 21-28, 1927, Hearst Papers, 38:50. Hearst was buying furniture from the Grassi auction and giving orders about the renovation of his apartment in the Warwick Hotel at the same time.

20. Message of April 7, 1927, Hearst Papers, 43:40: "Miss Davies moves in on the 15th. Do taproom and reception room at once." The message was likely intended for Flannery. Around January 1927 Flannery reported that he had to hire more draftsmen for Davies's house in Beverly Hills and for her children's "clinic at Sawtelle, both projects of Chiefs," according to the telegram. The huge Mission-style clinic was in West Los Angeles. Flannery said that the Beach House would not be ready before July 1927; Hearst was "outraged" (Hearst Papers, 43:40). The German paneling intended for one part of the house had been held up by the German government, so Hearst instructed the designer to use wallpaper instead. "We can get other attractive Colonial paper for

the rest," Hearst added on July 22, 1927. The Beach House had a vault for storing the valuable Zuber wallpaper; there was also "Chinese Chippendale" wallpaper.

21. Morgan's expertise as an engineer was needed. She explained the problems to Hearst on July 19, 1928 (Morgan Papers). The piles were not deep enough. "Flannery is a good draughtsman but is not a very experienced architect," she wrote, "and is nothing of an engineer."

22. The bill for the orchids amounted to more than $4,000 (Morgan Papers). A frequently reproduced postcard of Marion Davies playing ball on the beach in front of the house may be a composite image that was manufactured when the mansion was turned into a hotel, judging from the breadth of the beach (cf. Hearst Papers, 43:42). Hearst sent Morgan his simple axial design for the front garden with his choice of flowers on August 4, 1927, and it is exactly this design that appears in figure 4.1.

23. Willicombe to MacGregor, September 7, 1927, Hearst Papers, 39:5.

24. Hearst to MacGregor (to ask Head), September 17, 1927, Hearst Papers, 39:5.

25. Hearst Papers, 39:5, referring to a sale around October 12, 1927, at Anderson Galleries in New York. Additional rugs might have been bought in January 1928; more came around December 5, 1928, from a sale at Anderson Galleries (Hearst Papers, 39:7).

26. Hearst to MacGregor, c. December 30, 1927, Hearst Papers, 39:6.

27. Morgan received a long message from Hearst on July 15, 1928, before he left to see his castle in Wales. He had an idea for the tiles for the indoor pool at San Simeon. They were to be blue and gold, "the border of fishes with gold similar to the beach house." On November 22, 1928, he asked for marble stairs for the San Simeon pool to be like the ones at Santa Monica: "They are very successful," he commented. The foundation continued to be a problem, no doubt because of the proximity of the ocean. Hearst asked Morgan on June 2, 1930: "Please hold up everything at the Beach House until the pool the part of the pavement that is sinking and the marble front are all fixed." The pool (with its mosaic) still exists and will be restored when the site is inaugurated as a public beach facility in 2008.

28. Davies, *Times We Had*, 164: The paneling came from an inn in Surrey. Was this the Elizabethan room purchased from Charles of London from Acton Surgey, "one of finest" in existence (message of October 3, 1927, Hearst Papers, 39:6)? The mantelpiece with the story of Rebecca and Isaac was dated 1642, according to *Oceanhouse*, 6. On April 23, 1928, Hearst ordered his registrar to buy various tables "and the Elizabethan stone fireplace for the taproom and other things we need" (Hearst Papers, 39:7).

Davies said she turned the bar into a soda fountain after Aimee Semple McPherson denounced her for having a bar in her house (*Times We Had*, 164).

29. The dealer Michael Hall, who knew Davies, explained that it was simply a matter of fashion (personal communication to the author, 2003). According to Henry-Russell Hitchcock, the Spanish colonial style prevailed until about 1925: the influence of the 1915 Panama-California Exposition in San Diego was so strong that it "turned most local [i.e., California] architects away from innovation for almost twenty years" (*Architecture: Nineteenth and Twentieth Centuries* [Harmondsworth: Penguin, 1975], 450).

30. It is included in a memo to Hearst from C. H. Hathaway of around September 29, 1927 (Hearst Papers, 36:7).

31. The *Oceanhouse* brochure mentions the mantelpieces. There were two small tapestries in the east center and west center bedrooms (inventory binder at Hearst Castle, ex-collection Marion Davies, 6438). Charles of London provided the paneling in the Rathskeller. Hearst asked his registrar about the possibility of using his paneling from Hamilton Palace (he owned almost all the paneling from the demolished palace; November 18, 1926, Hearst Papers, 38:49).

32. Quoted in Robinson, *American Dynasty*, 335.

33. The paintings were purchased from French & Company in 1928, donated to the Los Angeles County Museum of Art in 1947, and later deaccessioned. According to Heyn ("Marion Davies' Beach House"), the paneling came from Burton Hall, Ireland, c. 1749.

34. The paneling was either from Cassiobury Park (by Grinling Gibbons) or from the Georgian country house of the duchess of Northumberland. It is not clear from Heyn's description (ibid.) which room is being discussed. The painting was sold by Leggatt to Permain for Hearst in 1928. The Marine Room was being redone in 1929, to judge from a message from Thaddeus Joy to Hearst about the drawing for the guesthouse: "The sea wall for the guesthouse must go in before the house is started and the piles must be shipped from Washington.... Change in the Marine Room is progressing" (July 19, 1929, Hearst Papers, 42:63).

35. It might have been purchased slightly earlier, in 1926.

36. Message from March 22, 1928, Hearst Papers, 39:7. All the while Hearst was also buying works of art for San Simeon. Simultaneously he was closing his apartment at the Warwick, and his registrar was moving everything out of the rented storage at the Lincoln warehouse in Manhattan to the new storage in the Bronx.

37. *The Magnificent Contents of 148 Piccadilly* (Victor Rothschild sale), sale cat., Sotheby's, London, April 19, 1937.

38. Hearst to Joseph Stransky (manager of Paris branch of Wildenstein), October 8, 1929, Hearst Papers, 40:53: "I like the Bouchers but they are only overdoors and must be many feet high to get proper effect." Stransky persevered, mentioning that they were signed and dated 1741. One of the overdoors in the Los Angeles County Museum of Art's collection (cat. no. 137) is signed and dated 1741; the other is signed and dated 1738. Hearst had asked Stransky (July 8, 1929) to list his available paintings by French artists who were of interest to Hearst.

39. The Fragonard (ex-collection Salomon) was sold to the Los Angeles County Museum of Art and later deaccessioned. It is now in a private collection in London. See Cuzin, *Fragonard: Life and Work*, no. 223.

40. Invoice for several paintings, November 20, 1928, Duveen correspondence. It was purchased in London when Hearst went to inspect progress on the renovation of his castle in Wales (see chapter 5). Davies's account comes from *Times We Had*, 119–21.

41. Davies, *Times We Had*, 164.

42. December 31, 1929, Hearst Papers, 39:17: Hearst's "Rembrandt" (cat. no. 133) and *Girl with Gloves*, then attributed to Hals, were to be sent west. Cf. the description of the room given by Valentiner (note 43 below).

43. Valentiner Papers, Archives of American Art, reel 2140, frame 770, p. 44. Amy Walsh generously brought this material to the author's attention. The modernity of the large plate glass is notable because it must have been quite different from the smaller panes produced in the eighteenth century. On January 14 Valentiner had been invited to lunch with Davies on the MGM lot: "in her charming bungalow, which Hearst had had built for her...arranged in the best taste: white-washed walls, not much furniture, a big fireplace, the furniture mostly antique" (ibid., reel 2140, frame 769).

44. Hearst to Morgan, September 25, 1932, Hearst Papers, 43:6. Hearst had additional English paintings at the Clarendon, to judge from a message to MacGregor (c. May 20, 1928, Hearst Papers, 39:7): "Get photos taken of all English pictures I own that you have in storage. Do not bother with those...at apartment. I want to get as many pictures out of storage as possible and would like to hang them in apartment even if overcrowd[ed]. I think pictures can be better taken care of if hanging where can be seen and easily treated when necessary."

45. For example, she accompanied him to visit the collection of Grenville Winthrop. See Stephan Wolohojian, ed., *A Private Passion: Nineteenth-Century Paintings and Drawings from the Grenville L. Winthrop Collection*, exh. cat. (New York: Metropolitan Museum of Art; New Haven: Yale University Press, 2003), 43.

46. Davies, *Times We Had*, 115–16. Cf. Head, *It Could Never*, 116–17, who corroborated the report of Hearst's seriousness on most of these trips, including a test at dinner on the sights of the day. At Bad Nauheim he "engaged a German instructor for us, so that we could learn to speak the language more fluently.... On these trips Mr. Hearst is just like a boy let out of school.... He jokes with the boatmen and the itinerant musicians, does a little yodelling...and buys wooden animals and carved inkstands...and tells us in the most interesting way the history of all the places that we visit" (143-44).

Chapter 5
⊰ SAINT DONAT'S ⊱

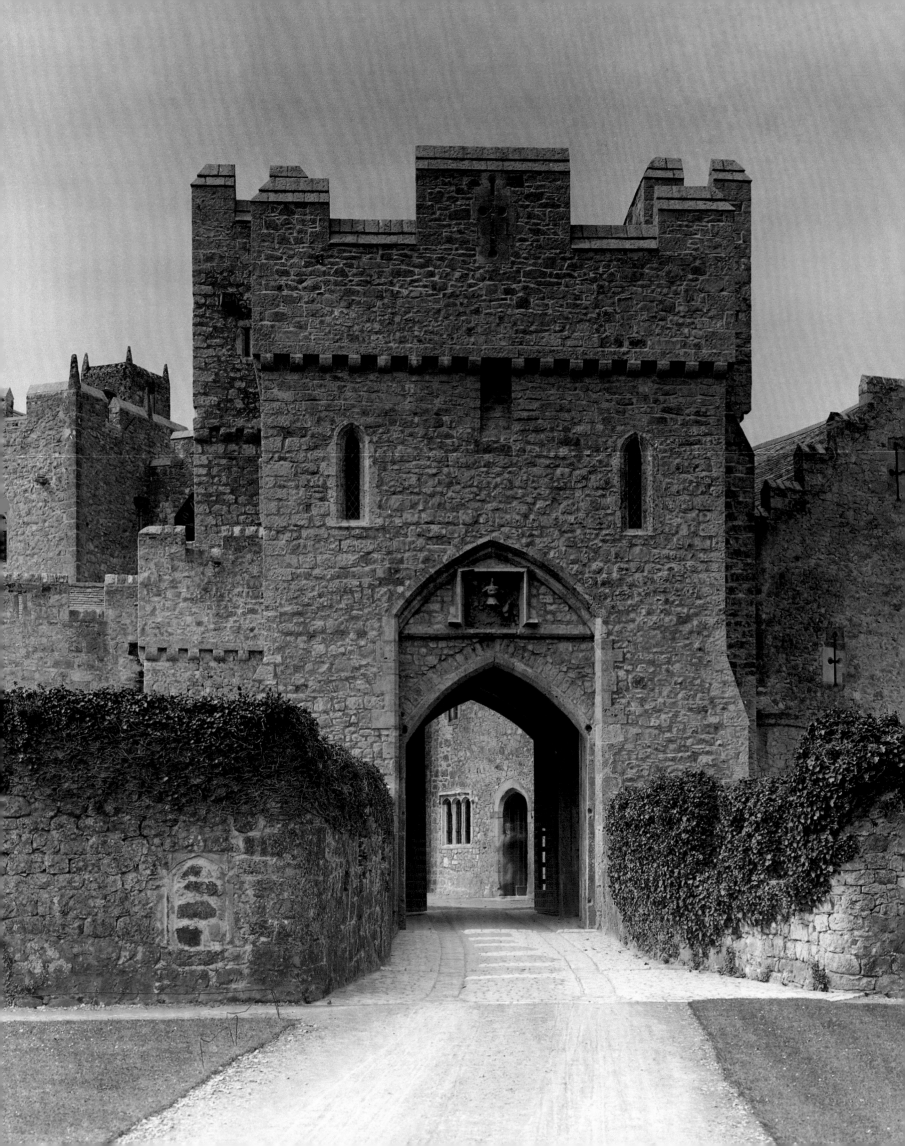

I n April 1925 Hearst was thinking about leasing a castle in Great Britain.[1] Two were available: Saint Donat's, in Wales, and Leeds Castle, both of which were featured in *Country Life* that month. The managing director of Hearst's National Magazine Company in London, Alice Head, investigated.[2] As for Leeds, "there was not a bath in the place," but Saint Donat's was in "good repair," she reported. On August 13, 1925, Hearst wired a different idea to Head: "Want buy castle in England please find which ones available." The only one he mentioned was Saint Donat's. Head recounted: "I like to do as my employer wishes, so I bought it.... For various reasons I thought it wiser to buy the Castle in the name of the National Magazine Company, and Mr. Hearst fully concurred."[3] The transaction was completed on October 8, 1925, and almost immediately Hearst wired: "Must buy many things for Saint Donat's."[4]

The castle and the magazine *Connoisseur* were acquired "out of current years' profits" of *Nash's* and the British edition of *Good Housekeeping*, Head related. *Good Housekeeping* was a juggernaut. "Not only was the magazine different in appearance from any other…English women's magazine, but its contents were revolutionary. It printed authoritative articles on the 'burning subjects of the day,'" she wrote.[5] In 1926 *Good Housekeeping* "carried more advertising in the classification of furnishings and decoration than any other monthly publication in the women's field."[6] The fact that the castle's renovation and maintenance were to be financed by the National Magazine Company under Head's authority probably accounted for the relative restraint with which the project was handled.

Saint Donat's dated mostly from the sixteenth century, but considerable vestiges of the earlier Norman structure (c. 1200) were preserved too, along with sections from the early fourteenth and late fifteenth centuries. The castle had been renovated with some modern conveniences, including electricity and three bathrooms. The temperate Alice Head was not quite petrified by her misgivings about the project. She prepared herself by adopting "the Hearst outlook upon life" and thinking of it as "a lark."[7]

For a castle, Saint Donat's was a manageable size. Views photographed toward its southern elevation are deceptive and make it seem forbidding and much larger than it is. The property could support limited farming, and a picturesque vignette of a tiny church and its adjacent cemetery added to its charm. A ghost and a pirate kidnapping rounded out the castle's lore.[8] In all it exemplified what one imagines a castle ought to be, for at first glance it seems much older than a Renaissance structure.[9]

Then there was the view. The broad terraces that extended down the slope from the castle to the shore of the Bristol Channel represented a nearly unique survival of a Tudor terraced garden.[10] On the third terrace a group of "Queen's Beasts" sculptures installed around 1900 punctuated the sequence of five. The terraces led to a pebbly coast flanked by miniature limestone palisades the color of milk and honey. At low tide the sea gave way to shallow, clear pools of endless variety.[11] The golden shoreline curved compactly around the southern and western horizons to create an oval bay of twinkling water worthy of any scene invented by the mystic artist Samuel Palmer. Hearst must have been in raptures when he finally saw it in September 1928.[12]

Basic improvements were carried out for two years before Hearst visited the property himself. The architect was Sir Charles Allom, whom Duveen had recommended earlier to Henry Clay Frick: Sir Charles was Duveen's collaborator on the installation of Frick's masterpieces on Fifth Avenue. Allom's prior experience included the renovation of Buckingham Palace.[13] By the end of 1928 his suggestions were sent to Hearst.[14]

In early January 1929 Hearst responded: "Am outlining ideas on ground plan and returning it. Under these circumstances believe expenditure justified."[15] He had rotated the main axis of the new dining room lengthwise, cut it into a drawing room and a dining room, put a bedroom over it, and transformed the existing dining room into a library. Then he ordered that the servants' quarters be moved to the stables and garages and asked for more bedrooms and baths. Great care had to be given to the elevations, he remarked: "The character and composition of the exteriors require very thoughtful consideration." Everything must "add to the picturesqueness of the place"—even the garages.[16] His plans provided for about forty bedrooms, he calculated, "which I think are sufficient."[17] Finally in March Hearst approved Allom's plans but added a thought about the wing at the

Overleaf: FIGURE 5.1. Aerial view of Saint Donat's Castle, c. 1930–34, with swimming pool at lower edge.
FIGURE 5.2. Saint Donat's Castle, outer gatehouse (c. 1300).

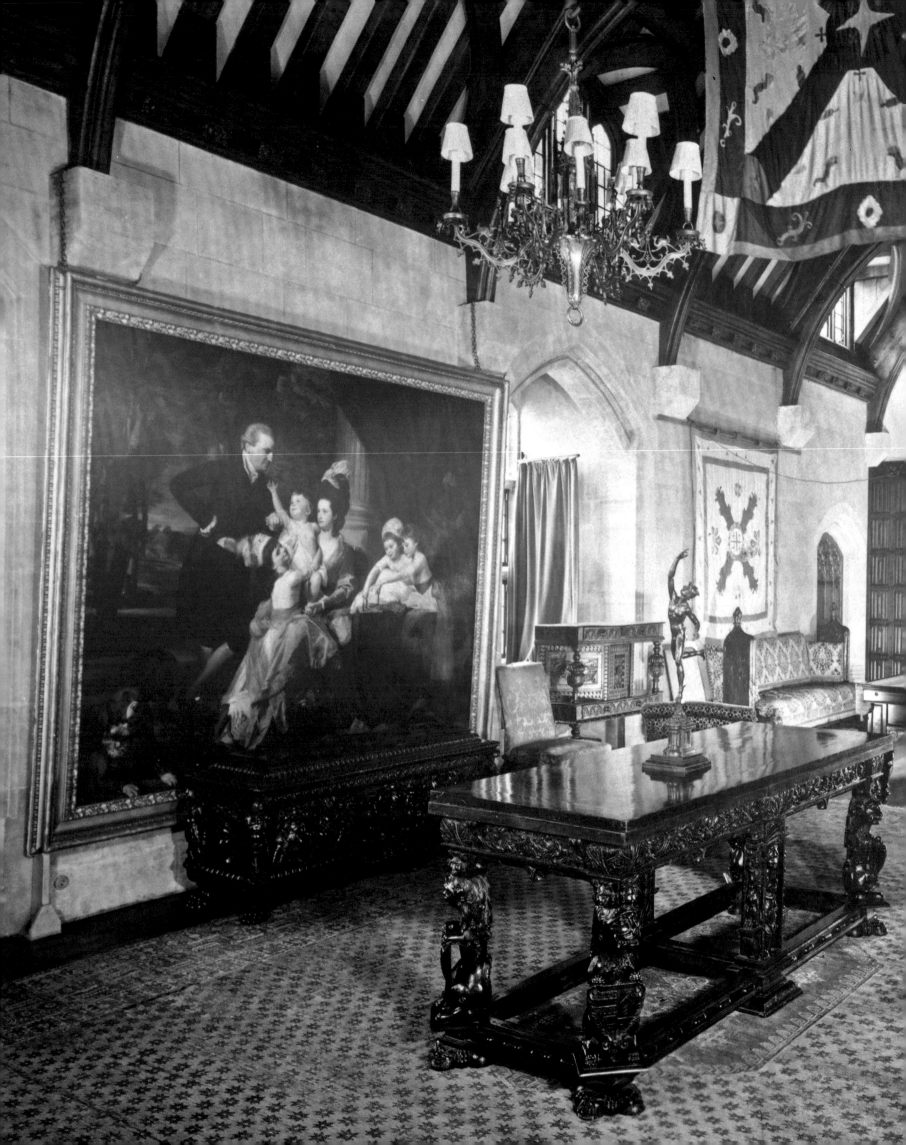

FIGURE 5.3. Library of Saint Donat's castle, with Copley's *Portrait of Sir William Pepperell and His Family* and a bronze after Giambologna.

FIGURE 5.4. John Singleton Copley (American, 1738–1815); *Portrait of Sir William Pepperell and His Family*, 1778; oil on canvas; 90 x 108 in. (228.6 x 274.3 cm); North Carolina Museum of Art (inv. no. 52.9.8).

entrance: "[It] should have some defensive or offensive motive and some formidable character to justify its advanced location in a fortress. What does Sir Charles think."[18]

By June a hundred men were at work on the site, Head reported.[19] A 150-foot-long swimming pool was excavated where the old jousting field had been, at the foot of the terraces overlooking the shore.[20] In July Hearst warned Head not to use marble for the pool because it was "a little too refined for character of the castle." He preferred dark green tile. In the same letter he advised her "always to add old things" instead of fabricating something new.[21]

The transfer and incorporation of historic architectural elements at Saint Donat's proceeded calmly, in contrast with the fevered pitch of Arthur Byne's efforts to move similar material to San Simeon. The challenges of transplanting monasteries from the chaotic battlefields of Spain to California were enormous, while most of what was to be incorporated at Saint Donat's originated in the British Isles and remained there, with the exception of historic wood paneling that Hearst had bought in Great Britain and shipped to New York, only to send it back across the Atlantic to Wales.[22] San Simeon was being built from scratch in a remote, mountainous region, and Saint Donat's was essentially a renovation, albeit an ambitious one.[23]

Nevertheless the removal of historic structures did not go uncontested. Head reported in June 1929 that the Ancient Monuments Society was making a "fearful howl" about the dismantling of Bradenstoke Priory.[24] Six weeks later, during what she called a "harassing time," Her Majesty's Office of Works, the prime minister, and the House of Commons issued demands for legislation to protect historic structures.[25] There was some progress by October: although the Society for the Protection of Ancient Buildings had vigorously protested the removal of Bradenstoke from England to Wales,[26] it addressed a letter to the *Times* of London praising Hearst for his work at Saint Donat's and shaming Great Britain for not doing more to preserve its own heritage.[27]

Hearst's relocation of Bradenstoke's muscular wood vaulting to Saint Donat's was one of his most spectacular feats in collecting architecture. Despite his hesitation over the cost of building a new hall along the southern flank of Saint Donat's just to sustain Bradenstoke's ceiling and roof—he even suggested that Bradenstoke might be sent to the United States instead—Hearst regained his nerve and proceeded.[28] The rot was cured, and the vaults were invisibly reinforced with steel. The installation of the ceiling from Saint Botolph's, the Boston parish church in Lincolnshire, was another triumph for him. The intricately groined ceiling, replete with bosses carved in the form of smiling faces, was sold to Hearst to finance the restoration of the church itself.[29] The ceiling was destined for the banqueting hall, the east end of which was defined by a lacy Gothic choir screen originally created for a church in southwest England. It "was found built into the wall of a house in Bridgwater [*sic*], Somerset" when Hearst salvaged it.[30]

In September 1929, however, Hearst, concerned about the interior elevations, ordered the work stopped until he could see the castle himself. He intended to compare illustrations of historic British buildings. "Need ancient atmosphere at St. Donat's," his telegram to Head ordered.[31] The plans for the great hall that supported the Bradenstoke vaulting were to be adjusted to accommodate the tapestries that Hearst might choose for it, as were the walls in the dining room and the placement of the windows.[32]

Hearst may have conceived one element of the decoration almost immediately: a banqueting hall lined with "portraits of stately men" seems to have been on his mind in 1925.[33] During 1925, however, the Clarendon was also being renovated. A new idea for an enlarged Beach House may have been concocted at the same time, so it is impossible to state with certainty that this scheme pertained to Saint Donat's. Similarly, it is difficult to assign a destination to the silver that was the subject of a flurry of instructions in June 1929 about auctions in July. Hearst made a rare comment about having enough silver on July 8, even though he sent a hasty additional order nine days later.[34] In 1930 he salvaged the remains of Hornby Castle for potential incorporation at Saint Donat's.[35]

It was probably in 1931 that Allom asked Head for measurements of tapestries, if stained glass was already available, and if there was an expert who could set up Hearst's armor. The tapestries that were proposed to Allom were probably the four Virtues now in the Detroit Institute of Arts (see cat. no. 32), perhaps for the Great Hall with the vaulting from Bradenstoke, or two pairs of tapestries as an alternative: the untraced Prodigal Son tapestries and the *Triumph of Strength* and *Triumph of Justice* (both Fine Arts Museums of San Francisco).[36]

Only one tapestry that was sent to Saint Donat's in 1931 was purchased that year (*The Queen's Reception*, ex-collection Heilbronner, bought from French & Company on June 22).

FIGURE 5.5. Frederick Sandys (British, 1829–1904); *La Belle Yseult*, 1862; oil on canvas;
9 5/16 x 7 5/8 in. (23.7 x 19.3 cm); The Makins Collection, Washington, D.C.

FIGURE 5.6. Partial view of the armory at Saint Donat's castle, looking toward the
library. *Portrait of a Woman, Possibly Frances Cotton* (cat. no. 130) is above the billiard
table; the tournament armor of Emperor Maximilian I, c. 1500 (Royal Armouries,
Leeds) is installed in front of the central pier.

FIGURE 5.7. Attributed to Robert Peake, *Portrait of a Woman, Possibly Frances Cotton
of Boughton Castle, Northamptonshire,* c. 1605–15 (cat. no. 130).

Hearst already owned all the others: *The Marriage of Aeneas and Lavinia* (from the Canessa sale of July 25, 1924); *Charity* (bought from Wildenstein on April 2, 1926); the small *Seasons* tapestries that had been in Hearst's townhouse on Lexington Avenue; and *Athena Giving Weapons to Perseus*, which found a home in the Banqueting Hall, above the silver buffet.[37] It was bought at the Heilbronner sale on June 22, 1921, and came to Hearst via French & Company.[38] The inventory of the silver must have been separated or damaged or was incomplete. An idea of what this important collection included can be obtained from a series of articles published in *Connoisseur* when the sale of Hearst's collection was promoted in 1938.[39] Saint Donat's was probably the home of Hearst's mother-of-pearl French Renaissance casket (p. 12).

The luxurious furniture that Hearst provided for Saint Donat's dated mostly to the late sixteenth and the seventeenth centuries, forming a coherent chronological decor, which echoed the fact that the castle had been almost continuously inhabited. Lacquer, tortoiseshell, and Indo-Portuguese inlaid cabinets on stands were focal points in Hearst's and Marion Davies's suites and elsewhere. There were a few Gothic accents and several cassoni; Chippendale chairs were sent from New York, and six George II mahogany chairs, bought from French & Company in 1930, were added. Nottingham alabasters were mentioned among the contents, along with five figure-brasses (three of them "cut out of sheets of metal") purchased in 1932 from the Spanish Gallery in London.[40]

Hearst's inclination toward portraits is manifest among the paintings that can be identified at Saint Donat's. On September 26, 1927, he asked Head to find six to eight fifteenth- and sixteenth-century "full length...decorative pictures," approximately seven to eight feet high, preferably in pairs. His inquiry to Head on October 25, 1929, about wanting four full-length English portraits "not of very first quality as to cost too much" might refer to either Saint Donat's or a plan for the Beach House, but portraits do predominate in photographs of the castle.[41] Ranging in date from the late sixteenth century to about 1900, the significant ones that decorated the castle were all British. Lawrence's *Portrait of Lady Jane Long* (Huntington Gallery) was there, as were at least four other British paintings bought in July 1934: Johann Zoffany's *Sayer Family*, a Peter Lely, George Frederick Watts's *Amber Necklace*, and John Singleton Copley's *Portrait of Sir William Pepperell and His Family* (see fig. 5.4).[42] The Copley took on a certain poignancy in an American collection

housed in Great Britain. Pepperell had been a royalist in the American colonies and returned to England brokenhearted. Frederick Sandys's *La Belle Yseult* was in the Banqueting Hall at one point;[43] it was illustrated on the cover of *Connoisseur* in January 1939 (fig. 5.5). The exquisite late Elizabethan portrait with an inscription that identifies the sitter as Elizabeth Jefferys, wife of Edward, Lord Montagu (fig. 5.7), was in the gallery outside the library (fig. 5.6).[44]

The preferred location for the only secured identified sculptured portrait—a noblewoman in an expertly rendered costume from about 1635 (fig. 5.8), which Hearst bought in 1936—is unknown: the inventories mention it in three different settings, which may reflect the changing circumstances of the castle during wartime.[45]

Saint Donat's also housed antiquities. There were Egyptian scarabs, wood figures, and stone sculptures. Among the ancient Roman works of art were an alabastron on a tripod from Caesarea, a bronze oinochoe, two Roman candelabra, and a janiform herm of comic and tragic masks.[46] According to Dietrich von Bothmer, there were about 150 Greek vases at the castle too.[47] They have not yet been found in photographs of the interiors, but if they were at Saint Donat's, they were surely among the roughly 450 vases that were later united at San Simeon. Hearst's taste for classical art extended to neoclassical sculpture as well, and in this regard he was upholding the tradition of early nineteenth-century British connoisseurs who collected the former while commissioning the latter. Thus Thorvaldsen's first version of *Hebe* (fig. 5.10) was not out of place among the works of art at Saint Donat's (fig. 5.9).[48] Hearst bought *Hebe* in 1934. He had considered adding Lord Ashburton's *Mercury* by Thorvaldsen, which was offered for sale in 1933.[49]

"I believe you have some armor stored away," was the delicate wording of Sir Charles Allom's inquiry to Head about the most important collection at Saint Donat's.[50] Over the difficult years of 1929–32, and beyond that juncture, Hearst and Raymond Bartel persevered in assembling one of the two greatest private collections of its short-lived time. In 1929 Bartel was purchasing the Dieterbach armor for Hearst;[51] on April 20, 1931, it was armor from the collection of Count Wilczek at Castle Kreuzenheim. The next day Hearst asked: "Is fine Gothic armor...with good marks still available?.... Think Bartel should go abroad again now to try to buy Gothic suits of Grafenegg, Ratibur [i.e., from the dukes of Ratibor at Schloss Grafenegg], and to inspect Kahlert offerings."[52]

FIGURE 5.8. Attributed to Giuliano Finelli (Italy, active Rome, 1601–1653); *Portrait of a Lady, Possibly Maria Cerri Capranica*, c. 1637–43; marble; 35 7/16 x 24 1/8 x 11 1/2 in. (90 x 61.3 x 29.2 cm); J. Paul Getty Museum, Los Angeles (inv. no. 2000.72).

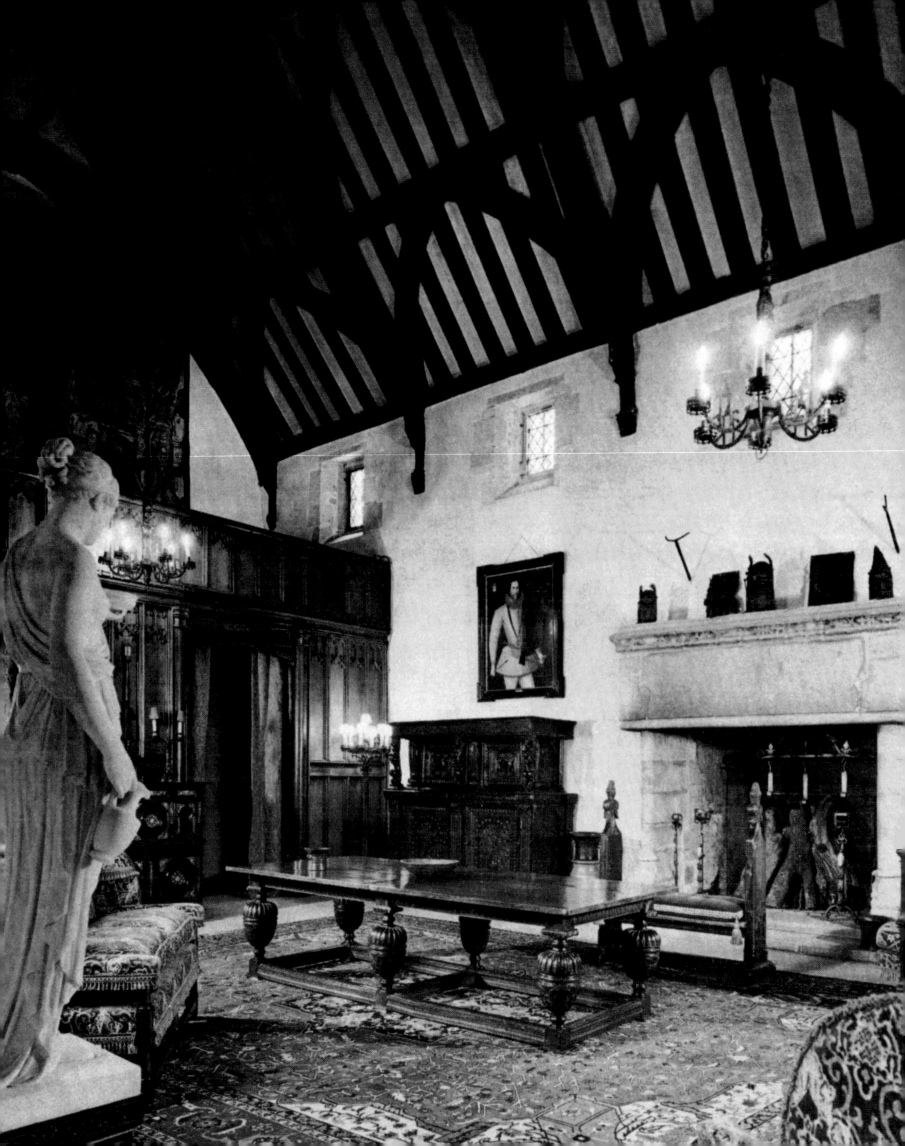

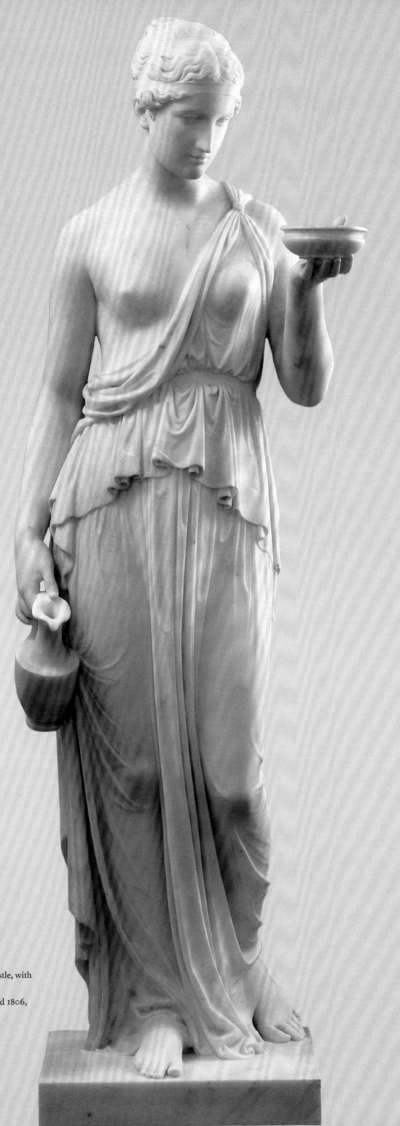

FIGURE 5.9. The Great Hall of Saint Donat's Castle, with Thorvaldsen's *Hebe* (cat. no. 124) at the left.
FIGURE 5.10. Bertel Thorvaldsen, *Hebe*, conceived 1806, carved 1819–23 (cat. no. 124).

In July 1931 Hearst acquired two brass cannons from a sale at Christie's, which were delivered to Saint Donat's in 1932.[53] On September 7, 1932, Hearst invested in the blued suit of armor from Duke Julius of Braunschweig (ex-collection Graf von Dessau),[54] but important news came with James Robinson's report from Berlin: "Completed negotiations [for permission] to sell and guarantee delivery complete armor #18 see Churburger's Rüstkammer.... Cable me immed. your instructions.... Will bring purchase with me."[55] Hearst alone was allowed by Count Trapp to buy armor from the castle at Churburg at that time.[56] The jewel of the collection at Saint Donat's was the "Avant" armor (Milanese, c. 1440), so named because the word *avant* ("forward" in French) was engraved around the armholes (fig. 5.11). It was the earliest and finest of two surviving examples of near-complete field armor of its time and is now in the Kelvingrove Museum, Glasgow. Hearst also owned the other harness, the armor of Schott von Hellingen (private collection, United States).

Hearst's armor collection at Saint Donat's existed for less than a decade. Even so, it was densely populated with significant objects that eventually found their way to other renowned collections, in particular the Kienbusch Collection at the Philadelphia Museum of Art and the British Royal Armouries. And Hearst did fill the lacuna that had so vexed him: an executioner's sword.[57] He also achieved his objective, stated simply on July 1, 1929: that he and Alice Head "could make the castle unique if it is done to the limit."[58]

Notes

1. Head to Nicholson, April 29, 1925 (referring to *Country Life*, April 4, 1925); Head to Nicholson, May 21, 1925; Head to Hearst, May 29, 1925; Head to Hearst, June 3, 1925; Head to Hearst, August 12, 1925. All Hearst Corporation papers, box 5, folder 1.
2. Head, *It Could Never*, 65.
3. Ibid., 85. Ownership of the castle was a crucial question when Hearst's financial crisis occurred in 1937. Hearst must have recalled the name of a previous owner of the castle, Morgan Williams, who had an exceptional collection of armor there. Hearst bought from the auction of this collection in 1921. See chapter 2.
4. Hearst to McPeake Jr., October 20, 1925, Hearst Corporation papers.
5. Head, *It Could Never*, 59, 60, 68. *Good Housekeeping* was launched in 1922.
6. Report to Hearst (Hearst Papers, 36:5).
7. Head, *It Could Never*, 86.
8. Alan Hall, personal communication with the author, October 2004; see also his *St Donat's Castle: A Guide and Brief History* (n.p.: Atlantic College, 2002), 19.
9. The family most closely identified with it was the Stradlings. Sir Edward (1529–1609), an illustrious humanist (ibid., 20–21), created the famous garden. See Elisabeth Whittle, "The Tudor Gardens of St Donat's Castle, Glamorgan, South Wales," *Garden History* 27 (Summer 1999): 121–22.
10. Ibid., 111. Whittle quotes an interview with Hearst referring to the castles at Caernarfon and Conwy, which he saw in 1891. See Enfys McMurry, *Hearst's Other Castle* (Bridgend, Wales: Seren, 1999), 28.
11. This description reflects the author's experience, 2004. Head, however, commented on the muddiness and "shingly" coast (*It Could Never*, 122).
12. McMurry, *Hearst's Other Castle*, 16.

FIGURE 5.11. *"Avant" Armor*, Milan, c. 1440; steel; approx. 68 in. (172.7 cm) high; Kelvingrove Museum, Glasgow (inv. no. 1939.65e).

13. Behrman, *Duveen*, 40.

14. Head to Hearst, December 7, 1928, Hearst Papers, 37:21.

15. Hearst to McPeake Jr., January 9, 1929, Hearst Papers, 37:22.

16. Hearst to Head, January 13, 1929, and Hearst to McPeake Jr., January 10, 1929, Hearst Papers, 37:22.

17. Hearst to Head, January 16, 1929, Hearst Papers, 37:22.

18. Hearst to McPeake Jr., March 3, 1929, Hearst Papers, 37:24.

19. Head to Hearst, June 18, 1929, Hearst Papers, 37:26.

20. McMurry, *Hearst's Other Castle*, 55. On November 25, 1928, Hearst asked Julia Morgan to cable Thaddeus Joy to ask him to visit Saint Donat's (Morgan Papers). Part of Joy's mission was to purchase works of art (Morgan to Hearst, September 5, 1929, Morgan Papers).

21. Hearst to Head, July 1, 1929, Hearst Papers, 37:27. The pool at the castle today is a new one.

22. On July 1, 1929, Hearst told Head that certain things could be sent from New York but that she should try to use items that were in Britain (Hearst Papers, 37:27). On the return of historic elements to the castle, see Howard C. Jones, "W. R. Hearst and St. Donat's," in *The Story of St. Donat's Castle and Atlantic College*, ed. Roy Denning (Cowbridge, U.K.: D. Brown & Sons, 1983), 75. Allom asked for paneling to be sent from the warehouse in New York as follows: Ellenhall, Tong Hall, Sandwich, Albyn's, linenfold, Elizabethan. "Have copied old windows in dining room and library bay," he telegraphed. "Impossible to find sufficient windows or ceiling in market for such big surface without some copying.... Please buy nothing more but old beams and corbels for present to enable [construction to] proceed for housing existing rooms." The enthusiastic Hearst had asked his London staff (McPeake Jr.) on January 13, 1929, to tell his scout Permain to look "for great Gothic screen and great stairway...need fine early panelings and ceilings, and splendid fireplaces." He noted that "really great things" were difficult to find and required effort. He wanted "exceptional pieces of furniture and silver," adding "I have enough pictures and tapestries" (Hearst Papers, 37:22). On August 8, 1927, after a mantelpiece was sold to someone else, Hearst wanted to sack Permain because he did not visit "leading dealers regularly.... He doesn't find things" (Hearst Papers, 37:20).

23. Water and electricity had to be supplied to San Simeon; they were available at Saint Donat's but had to be augmented.

24. Head to Hearst, June 6, 1929, Hearst Papers, 37:26.

25. Head to Hearst, July 22, 1929, Hearst Papers, 37:27.

26. Hall, *St Donat's Castle*, 12. Hearst bought Bradenstoke and was paying taxes on it (message dated September 13, 1929, Hearst Papers, 37:30).

27. October 6, 1929, Hearst Papers, 37:31. Hearst's inquiry to McPeake Jr. about neighborhood charity perhaps reflected his sensitivity to the complaints. In early November 1929 he wrote: "I would like to do something for neighborhood schools near St. Donat's" (Hearst Papers, 37:31). He ordered a halt to construction until economic conditions improved (Hearst to McPeake Jr., November 12, 1929, Hearst Papers, 37:32), but he wanted to buy more silver at auction (Hearst to McPeake Jr., November 14, 1929, Hearst Papers, 37:32).

28. Hearst to McPeake Jr., early January 1929, Hearst Papers, 37:22. Hearst also had a "big English mantel removed from Refectory at San Simeon" and ordered it sent to Saint Donat's "for the great hall of Bradenstoke" (Hearst to Morgan, September 3, 1929, Morgan Papers).

29. McMurry, *Hearst's Other Castle*, 35–36.

30. Alan Hall, letter to the author, February 2, 2005. A Hearst ceiling now in the Burrell Collection in Glasgow "came with the same provenance," Hall added. The fact that these were already for sale exposes some flaws in the reasoning of John Harris, in "How Citizen Kane Bought Up Britain," *Country Life*, June 14, 2007, 118–21.

31. Hearst to Head, September 26, 1929, Hearst Papers, 37:30. He added that he wanted her to focus on the magazines. Perhaps this referred to a message to Hearst from general manager Thomas White (July 5, 1929) that mentioned "your fire red ink babies": *International Studio*, *Druggist*, *Field*, *American Architect*, and *Aromatics* (Hearst Papers, carton 36).

32. Hearst to McPeake Jr., November 19, 1929, Hearst Papers, 37:32: For Bradenstoke, there was a tapestry approximately twelve by twenty or fourteen by twenty-eight feet. "I have narrower Gothic tapestry available for dining room when I know exact dimensions." Head had asked for the size so she could place the windows (October 31, 1929, Hearst Papers, 37:31). Hearst's *Perseus* tapestry was chosen for the Refectory. Samuels mentioned a "Perseus and Andromeda" tapestry to Hearst on January 29, 1927 (Hearst Papers, 40:32).

FIGURE 5.12. *Composite Field Armor*, Northern Italy, 1440–80 (cat. no. 19).

33. Telegram from Hearst, probably from 1925, Hearst Corporation papers. He also mentioned "large decorative portraits for English hall" (box 5, folder 7).

34. Willicombe to Head, June 18, 1929, referring to silver advertised in *Country Life* (March 2, 1929, and March 9, 1929), then Hearst to McPeake Jr., June 27, 1929, about a sale at Sotheby's on July 3. The other letters are from Hearst to McPeake Jr., one of them asking for the Irish silver in Sotheby's sale, on July 18, 1929 (all Hearst Papers, 37:27).

35. McMurry, *Hearst's Other Castle*, 56; see 37–40 for the paneling and mantelpieces incorporated at Saint Donat's.

36. Hearst Papers, 37:35. MacGregor listed on April 30, [1931?]: one pair *Prodigal Son*, one pair *Triumph of Strength* and *Triumph of Justice* (Hearst also owned a third panel, *Triumph of Hope*, now in the Carnegie Institute, Pittsburgh). They were fourteen by eighteen feet. MacGregor referred to a set of four tapestries, the measurements of which correspond to the Detroit Virtues. For the Triumph tapestries, see Geneviève Souchal, "The Triumph of the Seven Virtues: Reconstruction of a Brussels Series (ca. 1520–1535)," and Guy Delmarcel, "The Triumph of the Seven Virtues and Related Brussels Tapestries of the Early Renaissance," both in *Acts of the Tapestry Symposium, November 1976* (San Francisco: Fine Arts Museums of San Francisco, 1979), 103–53, 155–69.

37. Illus. McMurry, *Hearst's Other Castle*, 63, and Delmarcel, "Triumph of the Seven Virtues," 159, fig. 4.

38. Hearst Corporation papers.

39. On the silver, see Charles R. Beard, "Silver from St. Donat's Castle," *Connoisseur*, December 1938, 288–95. The London auction catalogues give an imprecise view because they also include silver that was sent from New York to London for sale.

40. Hearst Corporation papers, box 4, folder 2. On incised brass plates used on British tombs, see Paul Binski, "Monumental Brasses," in *The Age of Chivalry*, exh. cat., ed. Jonathan Alexander and Paul Binski (London: Royal Academy of Arts, 1987), 171–73.

41. Hearst to Head, September 26, 1927, Hearst Papers, 37:20; Hearst to Head, October 25, 1929, Hearst Papers, 37:31. He also asked about Italian, Spanish, and Flemish paintings from the fifteenth, sixteenth, or early seventeenth century.

42. The painting by Watts is mentioned in Hearst Corporation papers.

43. Hearst Corporation papers.

44. Hearst Corporation papers (inventory of 1946). The Sayer portrait was sold at Sotheby's, New York, May 27, 2004, lot 242 (deaccessioned by the Kimbell Art Museum).

45. The provenance of the sculpture before 1953 was unknown to the Getty Museum at the time of acquisition, but the bust was promoted in *Connoisseur* in March 1939 (165), where it was said to be destined for auction in April 1939. The sculpture was instead sold to the dealer Mary Bellis. See Levkoff, "Little-Known American Provenance," 295.

46. Hearst Corporation papers (inventory of 1946).

47. Dietrich von Bothmer, conversation with the author, 2005.

48. Levkoff, "Little-Known American Provenance," 297.

49. Message from Hearst, December 22, 1933, about Lord Ashburton's sculpture, which was advertised in the December 1933 issue of *Connoisseur* (p. xxx). Hearst wanted to know the price. He commented, "Looks like fine piece" (Hearst Papers, 37:42). Also included in the advertisement was Thorvaldsen's other, fully draped version of *Hebe*, which apparently was of no interest to Hearst.

50. Message from April 15, probably 1930 or 1931, to judge from the context, Hearst Papers, 37:35.

51. Christine Schrader referred to this, August 20, 1929, Hearst Papers, 39:50.

52. Both communications to MacGregor, Hearst Papers, 39:18. The Ratibor armor was auctioned in 1936.

53. Hearst Corporation papers.

54. Purchased at auction (Fischer, Lucerne), it dated from about 1568–89 (inventory compiled by Harrison K. Bird Jr., Hearst Corporation papers).

55. MacGregor relayed Robinson's report to Hearst (September 3, 1932, Hearst Papers, 39:32). In November Hearst hesitated briefly about buying more armor "in these dull times" (Hearst Papers, 39:33), but in December he still inquired about horse armor from "Mr. M," most likely Clarence Mackay (Hearst Papers, 39:34). In 1933 he purchased several items from Sotheby's auction on May 26, including a set of German eviscerating instruments dated 1581 (Hearst Corporation papers).

56. Tobias Capwell, personal communication with author, December 2005. Capwell also kindly confirmed the date of the Avant armor.

57. The seventeenth-century sword was sold to the dealer Mary Bellis (Hearst Corporation papers).

58. Hearst to Head, July 1, 1929, Hearst Papers, 37:27. When parts of Hearst's collection were liquidated in 1938, Sir William Burrell purchased nearly a hundred objects that had been at Saint Donat's. These included tapestries, armor, stained glass, furniture, and architectural elements. They are now part of the Burrell Collection of the Glasgow Museums.

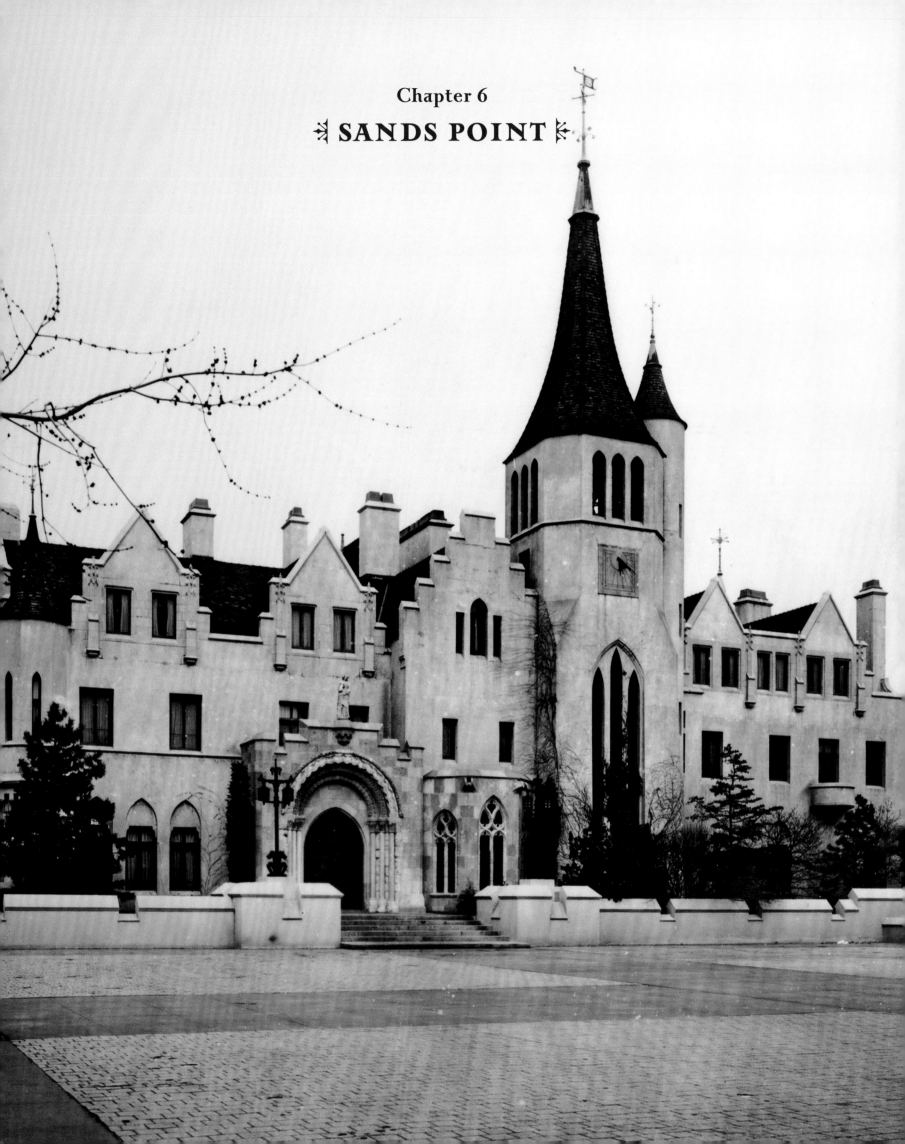

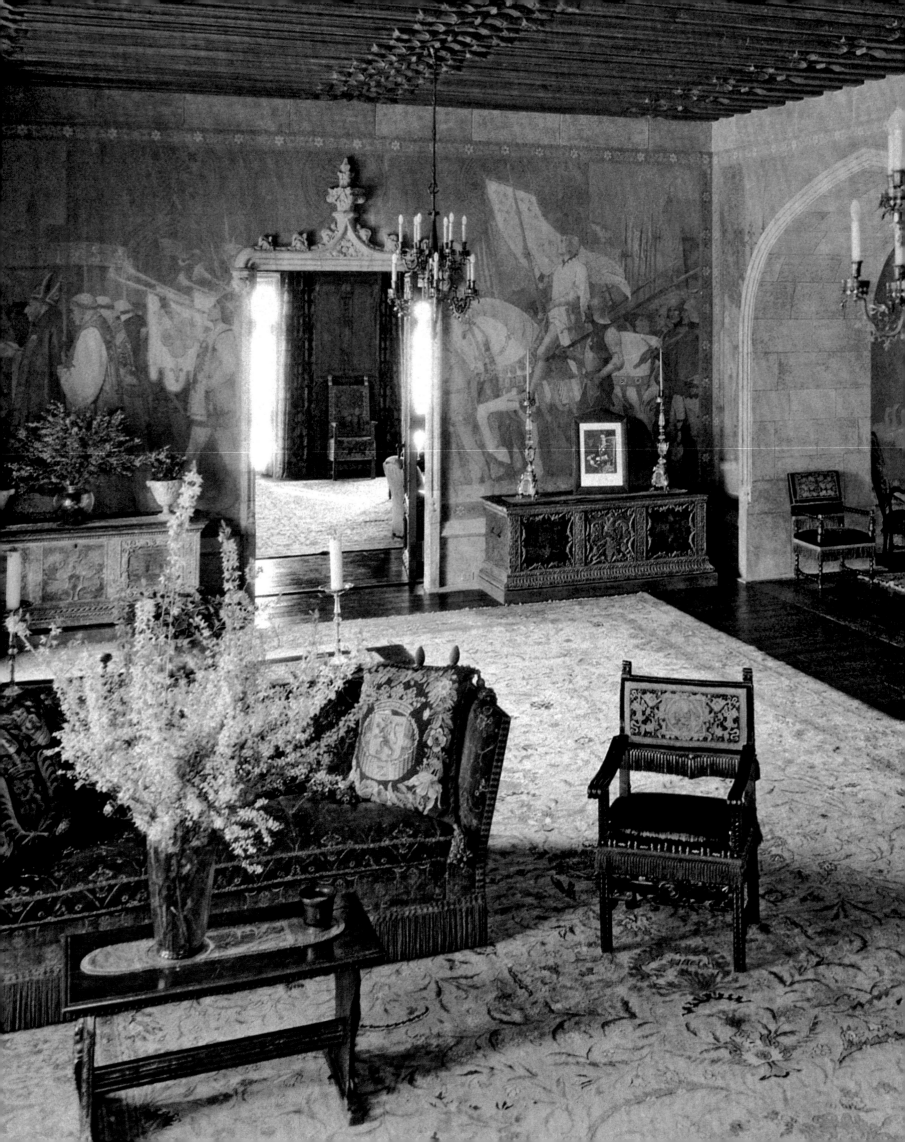

At about the same time that the decoration of Marion Davies's estate was nearing completion and the renovation of Saint Donat's was advancing, Hearst bought a castle for his wife at Sands Point, on the north shore of Long Island, in an enclave where some of America's wealthiest families had beachfront properties.[1] The title passed to him late in 1927,[2] a few months after he floated serial gold debentures for $10 million to be paid annually (guaranteed unconditionally by Hearst personally) at $1 million a year from 1929 to 1938. His timing could not have been worse. In March 1927, however, the prospectus prepared by the accounting firm of Haskins and Sells offered a sunny view: "The Hearst Organization is the largest publishing business in the world, with a gross business for 1926 of approximately $180,000,000." The statement added that "one or more Hearst publications can be found in approximately 10,000,000 homes and are read by one in every three families in the United States." The company was responsible for "more than 12% of the country's daily publication of newspapers."[3] Still, Duveen noted in January of that year that Hearst was overextended. In any case, Hearst recovered and bought van Dyck's portrait of Queen Henrietta Maria from him in May 1928 (see fig. 1.5).[4]

Millicent Hearst's place in New York society was bolstered by her philanthropies, in particular the Free Milk Fund for Babies, which she established in 1922. In October 1929 she made an ambitious gesture by organizing a benefit exhibition of early Netherlandish paintings at the Kleinberger Gallery in New York.[5] Her husband's liaison with Marion Davies did not diminish Millicent Hearst's social standing. It is easy to assume that when Hearst purchased the castle he was compensating his wife for having to tolerate the existence of a rival and that the estate was to be her stronghold.[6]

The castle, designed by Richard Howland Hunt in a style that loosely referred to late fifteenth-century French prototypes, was erected by Alva Vanderbilt Belmont on eighteen acres that the widowed Mrs. Belmont bought in 1915. The mansion stood almost directly on the beach, and an esplanade as big as the huge building itself stretched in front of the opposite elevation; a walled swimming pool projected from the flank of the castle between the beach and the grand forecourt. The property inspired the fictional mansion in F. Scott Fitzgerald's *Great Gatsby*.

The estate was called Beacon Towers; an alternate name, Saint Joan's Castle, was derived from the murals of Joan of Arc that decorated its interior.[7] They referred to Belmont's prominent role in the women's suffrage movement, associating her crusade with the deeds of the French maiden. In October 1927, having decided to move to France, she sold the property to Hearst. It was the most important estate on Long Island. In his letters Hearst called it Sands Point.

Hearst had the roof raised, and gables were added on the upper floor, which resulted in a better visual coordination with the verticality of the spindly towers.[8] Hearst seems to have delegated oversight of the renovation primarily to his New York architect, Charles Birge, but the interiors were carried out primarily by French & Company.[9] To the main entrance Hearst applied the 176 blocks that made up a massive Romanesque portal from the *chapelle abbatiale* of Bulles-sur-Oise, supplied to him by Joseph Brummer in 1924.[10] It made the neatly dressed twentieth-century masonry walls look like paper in comparison. A Gothic bay was added beside the Romanesque portal.[11] Most of the work was ready within a year, but in the spring of 1929 Hearst sacrificed some of the progress at San Simeon to expedite the completion of his wife's estate.[12]

Hearst proposed taking the panoramic wallpaper stored in the vaults of the Beach House and hanging it in his wife's castle, writing to Birge on April 17, 1929: "I intend to put the American Revolution paper in the main hall, the paper I have at the Beach and the South American paper in the two first-floor bedrooms and the Italian landscape and the other landscape in the top two bedrooms." He asked if there was any "leftover paper of The Hunt," noting that the stock of wallpaper at the Beach House included six sheets of "Chinese Chippendale" paper.[13]

On the ground floor and in some of the bedrooms on the top floor, the neo-Gothic style of the castle at Sands Point was improved when Hearst (as well as Birge and Mitchell Samuels) marshaled a variety of architectural elements that had been acquired over the decade.[14] With these, the baronial atmosphere of the mansion was reinforced, although some items (small ceilings in particular) had to be found

Overleaf: FIGURE 6.1. Forecourt of Hearst's modern castle at Sands Point, Long Island, with the Romanesque portal that he added to its main entrance.
FIGURE 6.2. View of the Great Hall, Sands Point, with the historic armorial cushions from the Netherlands (c. 1740) on the sofa (see p. 39).

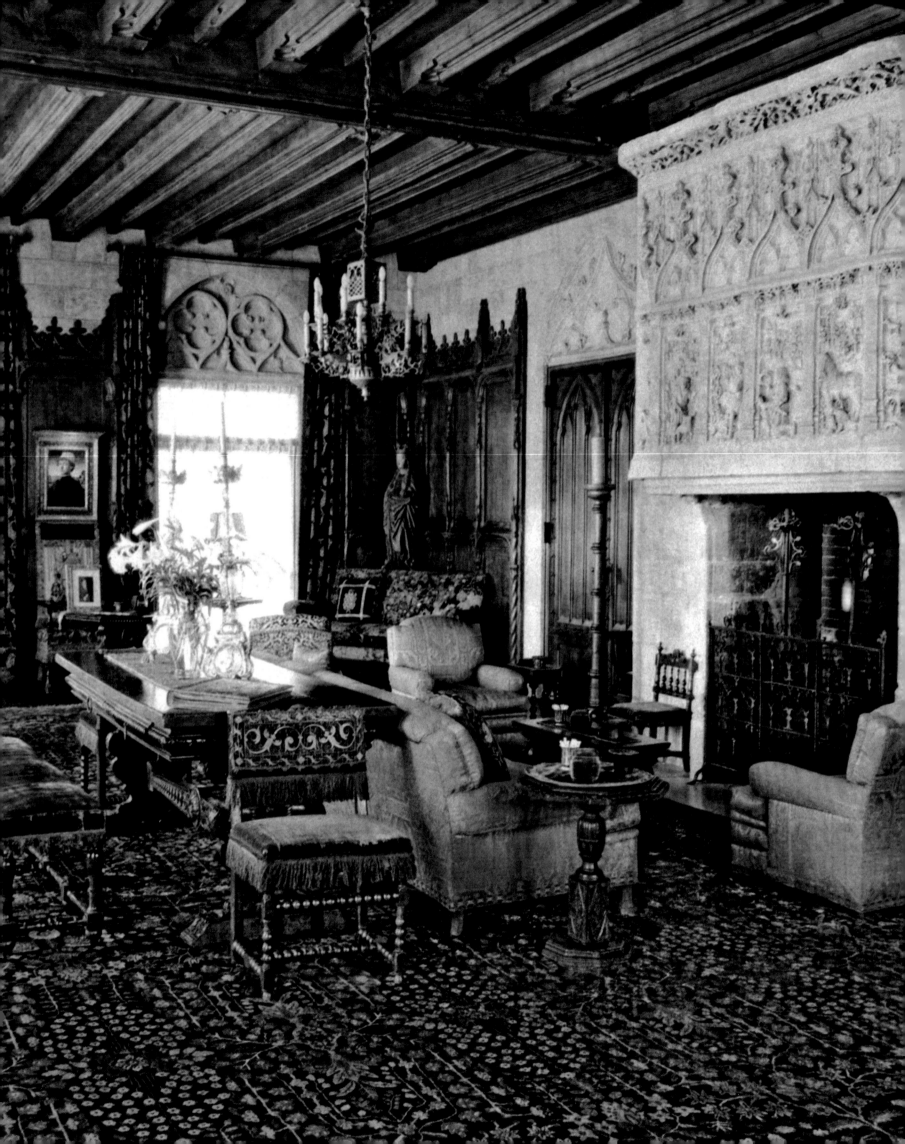

specially for the refurbishment.[15] Paneling from Ipswich Hall was incorporated to Hearst's later chagrin, when he wanted to use it at Saint Donat's instead.[16]

In the Great Hall (fig. 6.2) some of the paintings of Joan of Arc were retained in favor of the scenic wallpaper Hearst had first proposed. Two or three suits of armor made real the images in the murals. The beamed ceiling, bought in 1928, came from Munich, and at least two of Hearst's four valuable Dutch eighteenth-century armorial cushions added some softness.[17] The living room (fig. 6.3) was lined with sixteenth-century paneling from Hamilton Palace, which was sold to Hearst by French & Company in 1924; the ceiling, bought in 1927, came from Wels, Austria; and the exquisite late fifteenth-century French mantelpiece was purchased from Demotte in 1928.[18] A pair of tall (approx. six feet high), very rare dinanderie torchères, acquired from Brummer in 1924, stood beside it (fig. 6.4).[19] They were likely the ones that had been in the armory at the Clarendon. In the background between the windows was a fifteenth-century Italian portrait that Hearst bought from Duveen in September 1928, within a week of his purchase of the portrait of Arthur Atherley for Davies (see fig. 4.2).[20] The price of the Italian picture ($110,000), compared with that of the Lawrence ($140,000), should have alerted Hearst to the fact that its attribution to Botticelli was shaky. By Duveen's own logic, which was reported in Hearst's publications, a price that modest was a sign that something was amiss.[21]

In other rooms Millicent's taste for French eighteenth-century art prevailed. The most important of these was her La Fontaine Room (fig. 6.5), conceived by the Parisian firm Jansen and coordinated with Birge. This may have been one of Henri Samuel's earliest projects in his long career as a designer, which began with Jansen. Jansen supplied a mantelpiece, the mirrored overmantel, corner tables, a console table, and a suite of Louis XVI furniture upholstered with vignettes from La Fontaine's fables.[22] The walls were upholstered with silk that had belonged to Pauline Borghese. Despite its relatively low ceiling, this grand reception room could still accommodate a twenty-three-foot-wide Beauvais tapestry woven on the designs of Jean-Baptiste Le Prince (fig. 6.6).[23] It was *The Repast under the Tent* (fig. 6.6) from the Russian Games series. Boucher's oval painting *Venus Disarming Cupid* (cat. no. 138) was on the opposite wall.[24]

Millicent's consistent preference for the art of eighteenth-century France continued in the Marie-Antoinette Room,

where an eighteenth-century *lit à la polonaise* was the focal point.[25] In the French Princess Room the tapestry *Pastoral Love*, from the series Les beaux pastorales, designed by Boucher, was hung.[26] One view of this room includes chairs from the La Fontaine suite and shows what must be Millicent's terra-cotta *Bather* or her *Bacchante*, both attributed to Joseph-Charles Marin, positioned before a window. On a mantelpiece beside it stood a bronze reduction of Jean-Antoine Houdon's *La frileuse*, reputedly from the collection of Sophie Arnould, one of the sculptor's most important clients.[27]

FIGURE 6.3. View of the living room, Sands Point, with one of the tall torchères beside the chimneypiece.
FIGURE 6.4. *Pair of Torchères*, c. 1400 (cat. no. 42).

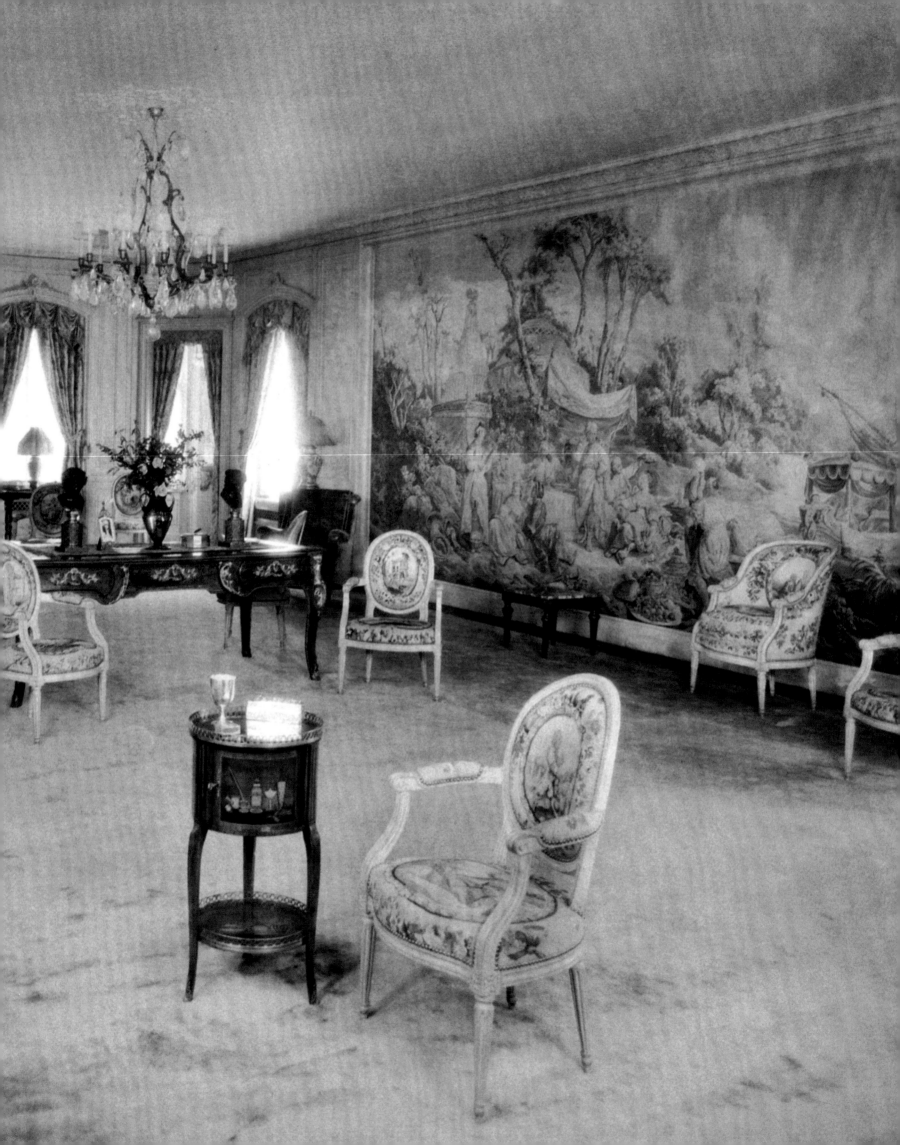

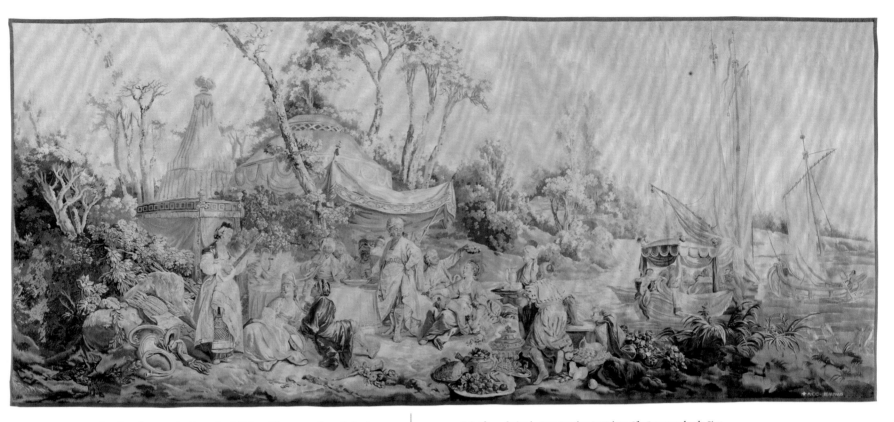

FIGURE 6.5. View of La Fontaine Room, Sands Point, with tapestry after a design by Le Prince (cat. no. 39).

FIGURE 6.6. After a design by Jean-Baptiste Le Prince, *The Repast under the Tent*, c. 1770–80 (cat. no. 39).

The art of the British Isles could not be suppressed, however. The "Bed Room no. 2" was lined with George I paneling from the duchess's suite of Hamilton Palace and furnished with some of the chairs from the Denham suite, which Hearst must have moved from the Clarendon.[28] A magnificent lacquered cabinet-on-stand likely was in the same room or nearby.[29] On one wall a copy of Thomas Gainsborough's *Girl with Pigs* (original in Castle Howard) was installed facing one of Reynolds's sumptuously exotic portraits of Mrs. Baldwin (fig. 6.8).[30] Reynolds's *Portrait of a Woman, Possibly Elizabeth Warren* (fig. 6.7) was also at Sands Point, as was a picture then known as *Mme Adélaïde*, which had belonged to Phoebe Hearst.[31]

Toward the end of March 1929 Hearst considered installing his greatest painting, the van Dyck that he had purchased just ten months before, at Sands Point. His plan for the dining room, which was enriched by sixteenth-century paneling from Hamilton Palace, included "four consoles and the mirrors," which he felt "would be very stunning. I should say that they ought to be used two on each side leaving the East end for the van Dyck picture."[32] This could only have been the portrait of Henrietta Maria.

Within five years, when Hearst's debts were massed against him and his income was taxed to the hilt, he tried to persuade Duveen to take back the painting.[33] Duveen could do nothing for him. The picture was consigned to Knoedler for sale in 1938, and then, in 1941, it was sent to Gimbels for the liquidation of nearly half of Hearst's collection. One of the previews of the sale was by ticket only, to benefit Millicent's milk fund. Not until after Hearst's death was the painting finally sold, to S. H. Kress. We do not know if Hearst ever saw the rhapsodic article by Sacheverell Sitwell, published in the fateful month of December 1941, in which his painting was singled out as one of van Dyck's seven "most characteristic" portraits. Sitwell evoked van Dyck's renditions of the "most beautiful style in male dress there ever has been. Nothing more Romantic than the full Cavalier costume could be imagined.... The plumed hats of the Cavaliers, their laced collars, and their high boots" distinguished the seven paintings. The last one mentioned by Sitwell was "the portrait of Henrietta Maria in a hunting-dress, with a dwarf at her side."[34]

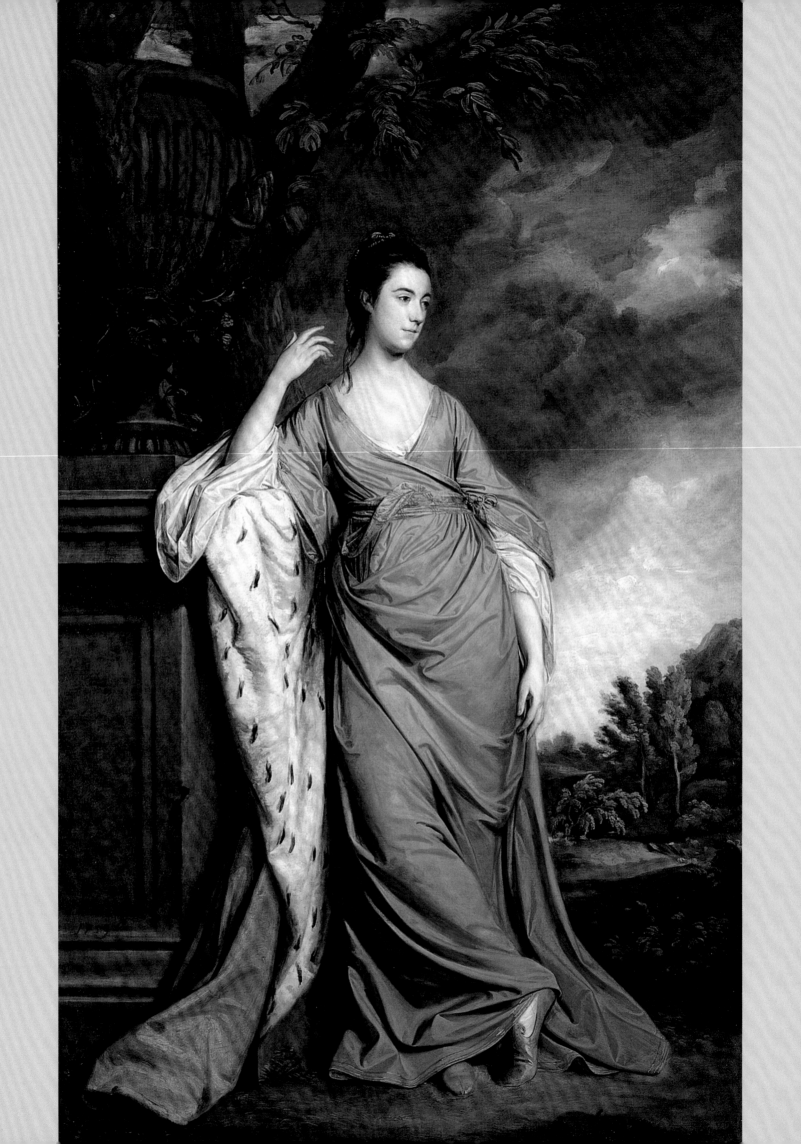

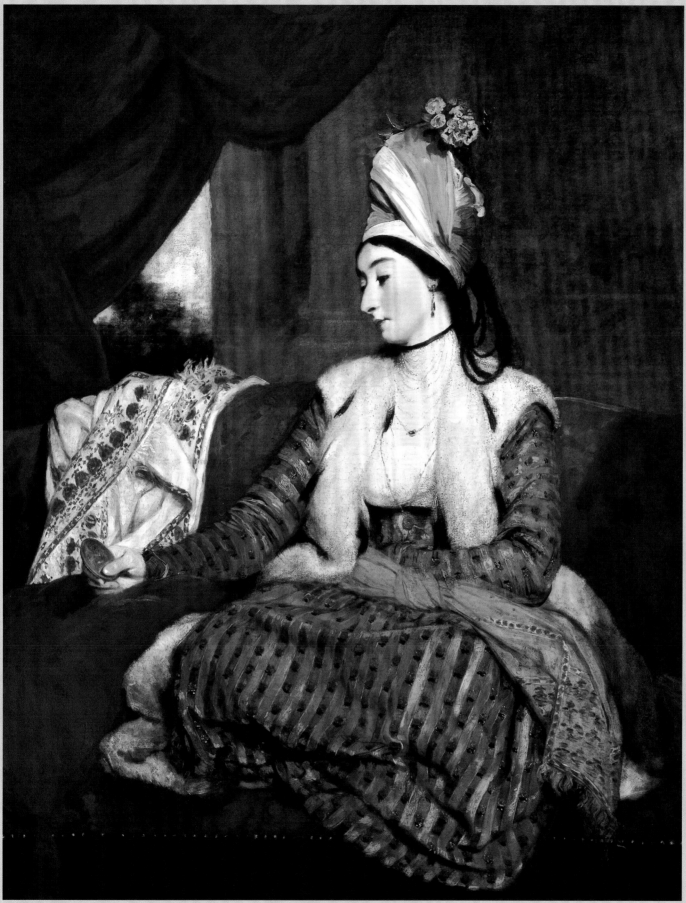

FIGURE 6.7. Sir Joshua Reynolds, *Portrait of a Woman, Possibly Elizabeth Warren*,
1758–59 (cat. no. 140).

FIGURE 6.8. Sir Joshua Reynolds, *Portrait of Mrs. Baldwin*, 1782 (cat. no. 141).

Notes

1. It is on the peninsula just east of Great Neck. Two other neo-Gothic estates were there besides the one Hearst bought: Hempstead House, which belonged to Daniel Guggenheim, and Falaise, built in 1923 for Harry Guggenheim, the founder of *Newsday*. The castle cost $400,000 (according to "Sands Point Lighthouse," Lighthouses of New York State, http://longislandlighthouses.com/sandspt.htm).

2. Nasaw, *The Chief*, 366, for the date of purchase; for the personal guarantee, see note 3 below.

3. Statement for the International Magazine Company, March 1, 1927, Hearst Papers, 36:5. A careful reading shows that the finances were not solid. The debt was to be secured by all the outstanding capital stock, except directors' capital share, of the International Magazine Company, and the first mortgages of real estate in New York City, which were valued at $2.7 million. The net value of the property exceeded $20 million. The net assets included goodwill and circulation, for "the financial success of a newspaper or magazine depends primarily upon the good will of its subscribers," explained the prospectus.

4. Duveen's New York branch to Duveen, en route to California, January 8, 1927, Duveen Archive: "Client has been overcommitting himself temporarily and financial sides are ascertaining position and supervising spending as happened a few years ago." The painting cost $80,000 (bought from Duveen by May 13, 1928).

5. The event was scheduled for October 26, 1929 (correspondence between M. Hearst and Duveen, August 7, 1929, and September 6, 1929). Mellon and Rockefeller agreed to lend; Millicent asked for loans from Duveen. This correspondence locates Millicent on vacation at San Simeon in mid-September.

6. The mansion's "big Gothic Hall and rooms and halls adjoining" could accommodate the Redemption tapestries, which Millicent wanted for the dinner she planned for the vice president of the United States in 1931 (MacGregor to Willicombe, September 28, 1931, Hearst Papers, 39:21). Hearst once said to his attorney John Neylan: "Millicent is my wife.... I know I'm the villain of the piece" (quoted in Swanberg, *Citizen Hearst*, 383).

7. The basic information about the property is drawn from Robert B. King and Charles O. McLean, *The Vanderbilt Homes* (New York: Rizzoli, 1989), 164–67; Monica Randall, *The Mansions of Long Island's Gold Coast* (New York: Rizzoli, 1987), 10 (illus.); Richard Chafee, "Mrs. O. H. P. Belmont Residence," in *Long Island Country Houses and Their Architects, 1860–1940*, ed. Robert E. Mackay, Anthony K. Baker, and Carol A. Traynor (New York: Society for the Preservation of Long Island Antiquities in association with W. W. Norton, 1997), 231–32; and Augusta O. Patterson, "A Gothic Castle on Sands Point," *Town and Country*, May 1932, 24–31.

8. King and McLean, *Vanderbilt Homes*, 167; the change can be seen if one compares the photograph in Randall, *Mansions*, with the illustrations in *Town and Country*.

9. Reply from Hearst to Christine Schrader, the registrar's secretary, about items of furniture being delivered to Sands Point when "Birge wants them" (August 19, 1929, Hearst Papers, 39:50); a message from Hearst in 1928 to Birge records that Hearst wanted larger dormers on the north side and a "Gothic statue" over the entrance (Hearst Papers, 43:45).

10. *Hearst Collection*, microfiche card 535. The description is on card 534.

11. See Library of Congress photograph of the landward elevation, digital ID no. cph-3a34985 (reproduction no. LC-USZ62-34493).

12. Hearst asked Morgan to "go easy at San Simeon in May because Mrs. Hearst has lots to do at Sands Point" (Hearst to Morgan, April 18, 1929, Morgan Papers).

13. Hearst to Birge, April 17, 1929, Hearst Papers, 43:45. Known photographs of Sands Point do not show any rooms with these wallpapers.

14. A photograph shows one of the upper bedrooms with the dormers created by Hearst and Birge (*Hearst Collection*, microfiche card 535). In addition, Hearst still considered actively collecting for Sands Point, buying the Calhoun Constitutional Sideboard, for example, which he indicated "should go to Sands Point" (June 15, 1929, Hearst Papers, 39:48); see also Hearst to MacGregor, November 24, 1931, Hearst Papers, 39:23.

15. On August 19, 1929, Schrader wrote to Hearst that she would ask Brummer to look for small ceilings (Hearst Papers, 39:50).

16. Hearst's registrar reported to him on April 4, 1932, that the paneling from Ipswich that Hearst wanted sent to Wales had been erected at Sands Point instead (Hearst Papers, 39:28).

17. The ceiling was acquired from Brummer in summer 1928 (*Hearst Collection*, microfiche card 533; see also card 534 for another view). For the cushion, see Adelson, *European Tapestry*, no. 23.

18. Sixteenth-century paneling from Hamilton Palace was in the dining room, and mantelpieces from Hamilton Palace were also installed at Sands Point. The ceiling

was purchased from Otto Ebner (November 14, 1927). See *Hearst Collection*, microfiche cards 532, 533.

19. See Brennan, "Hearst and the Art Market," 38. Although Duveen looms large in this narrative, Brennan (31) notes that Hearst bought more than two hundred works of medieval art from Brummer. This tally does not include Hearst's numerous purchases from Brummer of Egyptian, Greek, Roman, and Byzantine objects.

20. The painting (ex-collection Wemys) was noted among selections from Duveen's Paris branch on September 11, 1928; the invoice of September 17, 1928, from London included *Arthur Atherley* (both Duveen Archive).

21. For the attribution, see André Chastel and Gabriele Mandel, *Tout l'oeuvre peint de Botticelli* (Paris: Flammarion, 1968), no. 19. A lawsuit was filed against Duveen for having asserted that a version of *La belle ferronière* with a doubtful attribution to Leonardo da Vinci was a copy. An editorial in the March 1929 issue of *International Studio* (8) mentioned that Duveen had argued that the painting would be worth $3 million if it were really by Leonardo, and as the writer asserted, it "could not be offered for sale at a quarter of a million dollars"—the asking price for the copy—"even by a lunatic."

22. Message asking if a mantel and mirror from Jansen that were at the warehouse would be all right for Sands Point (Schrader to Hearst, August 19, 1929, Hearst Papers, 39:50). Hearst replied: "Deliver them to Sands Point when Birge wants them." There is another communication about a mantel and a mirror, and a "mantel-mirror," console table, and some corner tables for a reception room at Sands Point, which must be the La Fontaine Room. "I do not know whether Birge would like them," Hearst commented on August 29, 1929 (Hearst Papers, 39:50). There is a reference to a payment "for Jansen room" on February 11, 1930 (Schrader to Willicombe, Hearst Papers, 39:47).

23. Shown in *Hearst Collection*, microfiche card 532.

24. Hearst bought it on November 8, 1926, from Wildenstein (ibid., microfiche card 96).

25. Room mentioned in Hearst Corporation papers (Furniture, vol. 3).

26. Mentioned as being in the Princess Room at Sands Point by C. C. Rounds in a message to Willicombe suggesting it as a possible gift to the Los Angeles County Museum (December 13, 1937, Hearst Papers, 40:57). It previously belonged to Morgan and then to Boni de Castellane and was approximately eleven by eleven feet.

27. *Hearst Collection*, microfiche card 537. Size (51.5 cm) and provenance given in catalogue of sale of Mrs. Hearst's estate, Parke-Bernet, New York, November 29, 1975, no. 59, at a time when the significance of Arnould's patronage of Houdon was not as well understood as it is today. Cf. Anne Poulet and Guilhem Scherf, eds., *Houdon, sculpteur des Lumières*, exh. cat. (Versailles: Musée national du château de Versailles, 2004), nos. 8, 9, 40. The *Bacchante* (location unknown) also figured in the 1975 sale; the *Bather* is in a private collection (see sale cat., Sotheby's, New York, May 22, 2001, lot 77).

28. The date of acquisition of this paneling is given as 1927, as opposed to the year 1924 for the sixteenth-century paneling, but both were from French & Company (*Hearst Collection*, microfiche card 533). The Denham suite is identified by its distinctive open flying brackets. For a full description, see sale cat., Sotheby's, New York, April 5, 2006, lot 423.

29. Both the Denham suite and the cabinet were bought for Hearst by Partridge's from the 1926 auction of the Leverhulme collection. The cabinet was mentioned in Hearst Corporation papers (Furniture, vol. 3) as being at Sands Point.

30. Purchased on April 15, 1920, at the American Art Association auction of the Philip McCormick sale for $2,100; the other version (Lansdowne, now Compton Verney) was engraved by S. W. Reynolds and is mentioned in the description in Hearst Corporation papers.

31. Records for "Mme Adélaïde" indicate that it was acquired from Phoebe Hearst (Hearst Corporation papers). Millicent owned it for the rest of her life; it was sold at the auction of her estate on January 22–23, 1976 (Parke-Bernet, New York, lot 1).

32. Hearst asked MacGregor to discuss consoles and mirrors for the dining room with Samuels (March 30, 1929, Hearst Papers, 39:9). He asked for a layout and if all the furniture could be used. Hearst had a picture that was erroneously attributed to van Dyck, but logically the choice must have been *Queen Henrietta Maria*. Swanberg (*Citizen Hearst*, 486) states that the price of the painting was $375,000, which was almost as much as Hearst paid for Sands Point. Duveen's records show a price of $80,000. The higher value was probably the appraisal made for the liquidation of 1938–42. The officers of the Frick Collection considered buying the van Dyck (see Center for History of Collecting in America archive, Frick Collection, Central Files, 1937—Art for Sale). A van Dyck is mentioned at Sands Point on July 24, 1937.

33. Hearst to Duveen, March 16, 1934, Duveen Archive.

34. Sacheverell Sitwell, "Van Dyck: An Appreciation," *Burlington Magazine* 79 (December 1941): 174, 177.

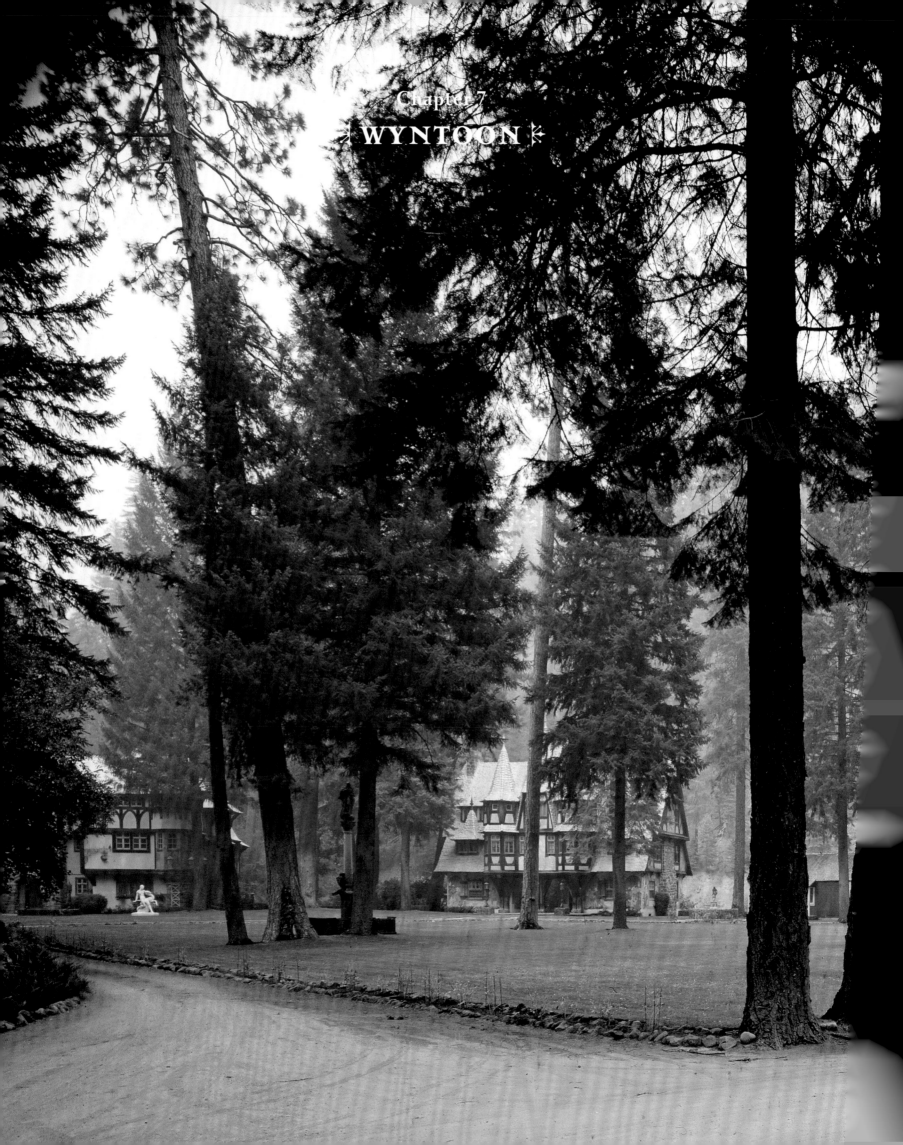

Chapter 7

⊰ WYNTOON ⊱

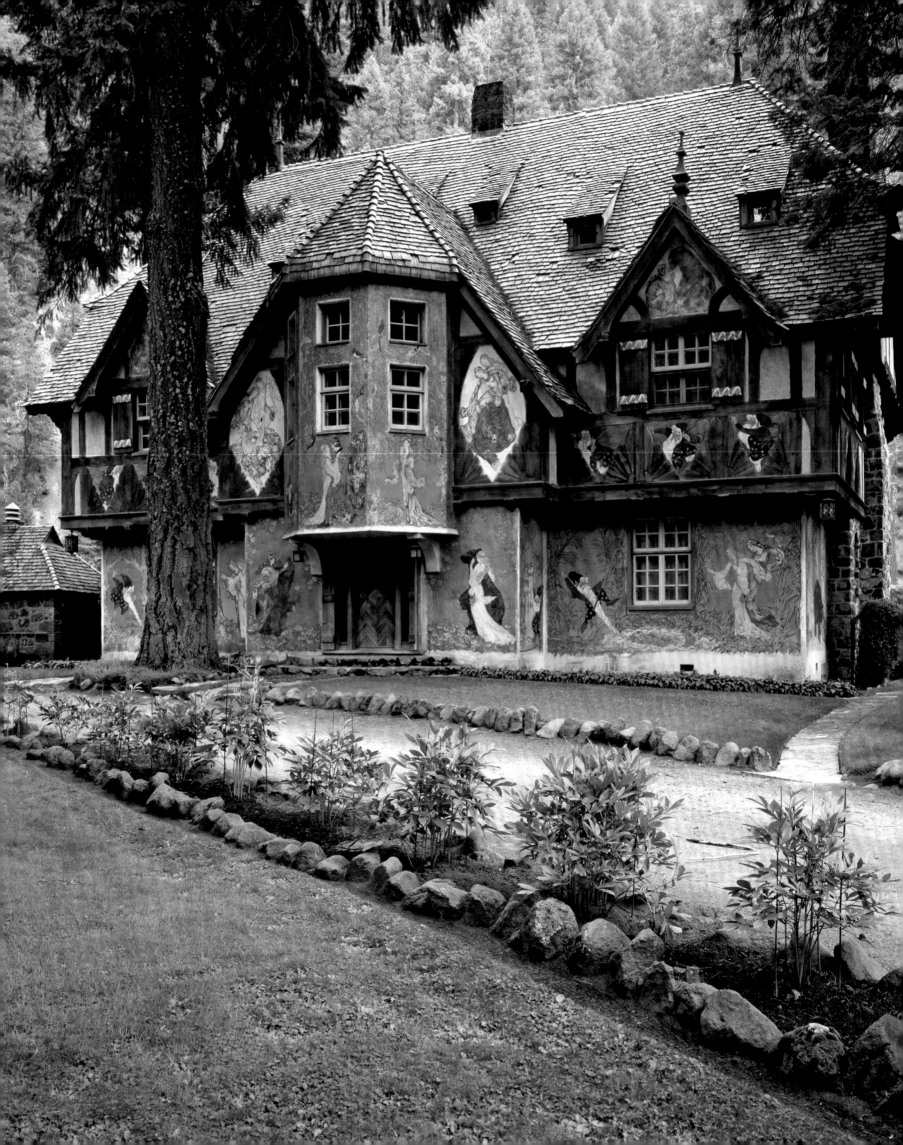

❧ WYNTOON ❧

The estate called Wyntoon, near Mount Shasta, was established on land that had belonged to Charles Wheeler, Phoebe Hearst's lawyer. The name stemmed from the Native American tribe called the Wintu.[1] The area that surrounded Shasta Lake and the village of Muir was a vacation spot for residents of San Francisco. The majestic, isolated, and volcanic height of Mount Shasta dominates the region spiritually and physically, with the icy water from its glaciers feeding a narrow, swift river that races through miles of forest. Glimpsed through clearings in the surrounding wooded slopes, the heavenly white cone of the mountain seems to float disembodied above the earth. Phoebe Hearst

commissioned Bernard Maybeck to build a castle for her on a flat overlooking the riverbank. To her son's chagrin, she bequeathed the property to her niece Anne Apperson, but Hearst bought it from his cousin in 1925.[2] In 1934 he purchased the rest of Wheeler's acreage, which included a stone and timber Adirondack-style retreat about a half-mile walk south of his mother's.[3] In all, Hearst owned sixty thousand acres there.

When his mother's castle burned in the winter of 1929–30, Hearst began planning a new one.[4] Bernard Maybeck was originally approached for the commission, but Julia Morgan became the primary architect. The neo-Gothic

Overleaf: FIGURE 7.1. Partial view of the village at Wyntoon.
FIGURE 7.2. Bear House, Wyntoon.
FIGURE 7.3. German glass from Hearst's collection (cat. nos. 65–69).

fortress was intended to sprawl along the river.[5] The vast- ness of Hearst's unrealized concept is reflected in the fact that he and Morgan in April 1930 decided to incorporate a Gothic cloister within it as a library. Their project demon- strated how his mind meshed the huge architectural ele- ments that he collected. A vaulted ceiling over the side aisles would create the "book alcoves," as Morgan explained to Arthur Byne, who was in the midst of "mining" (to use his word) the fortified monastery of Alcantara, which had been wrecked by the gunpowder stored in it by the Spanish army, for material.[6] Morgan wrote that Hearst and she were going to use Byne's "immense grille…in the new building at Wyntoon…a quite extraordinary project." This was their first recorded idea for the enormous choir screen from the Cathedral of Valladolid (see fig. 1.7).[7]

Next Hearst decided to add the refectory from Bradenstoke, to divide "the church from Byne" into "two great halls," create a living room from Byne's chapel, and make an entry from the chapter house.[8] Three fifteenth- century ceilings (one Swiss, one Tyrolean, one Spanish) were bought for Wyntoon at this juncture.[9] Hearst also wanted to create an armory at Wyntoon—his third after the ones at the Clarendon and Saint Donat's. It was going to be a hundred feet long.[10] Hearst's plan incorporated a minimum of forty bedrooms in a seven-story castle.[11]

Hearst described his vision of a great hall to Morgan in May 1931: "We enter at a porch between two formidable towers, and go…from the vestibule to the left to the small entrance door of the hall." There would be "two tapestries in the central part of the hall on each side—four tapestries in all,…and windows above the tapestries…with a great massive table in the middle, and four great divans underneath the tapestries. Over the fireplace we will put the big primi- tive."[12] It is easy to imagine that the "primitive" Hearst envi- sioned was his early fifteenth-century Aragonese altarpiece of Saint George (fig. 7.4). It was slightly bigger than the largest altarpiece at San Simeon, the altarpiece of Saint Martin.[13] The central panel depicted the chivalric, dragon- slaying hero wearing armor rendered in glimmering silver leaf, so it was ideally suited to the spirit of the complex.

The contraction of Hearst's finances in 1932, however, kept him from building this castle, just as it stifled the idea of an almost identical gallery that Morgan conceived for him at San Simeon around the same time.[14] A more reason- ably sized building called the Gables was erected on the site; it too eventually fell victim to fire, in 1945.[15]

Apparently on Morgan's suggestion, Hearst proceeded instead to construct an ensemble of houses on the river far- ther north, where a guest cottage was already located. This one was renovated in a Federal style,[16] but the new cottages, which really are small mansions, were built in a romanti- cized, late Gothic German idiom (fig. 7.2) that was perfectly consonant with the surrounding forest. Hearst's penchant for Gothic art has been attributed to an enduring allegiance to his mother's taste, but Phoebe Hearst did not collect much that was medieval. The real legacy was her fondness for Bavaria's velvety green hills, picturesque villages, and steep mountaintops draped with snow.[17] Hearst wanted his readers to appreciate the beauty of Bavaria and the Tyrol. In August 1929 he asked Karl von Wiegand, his European director and chief correspondent, to find photographs of Germany and Austria so that Hearst could produce picture "tours" of them in his publications.[18] Around 1926 he contemplated buying a castle in southern Austria, and short of that, in 1929, he issued an order that, when transmitted by Wiegand, read like an advertisement: "Chief desires Gothic or Romanesque chapel 75' x 100' long, 28' x 40' wide arches with keystones. Richly carved, must be genuine."[19]

Hearst's knowledge of Austria and Germany is manifest in his recommendations to Morgan, whose tour of Europe he underwrote late in 1934. He suggested that she visit Innsbruck, Munich, Nuremberg, Cologne, Nordlingen, Augsburg, Dinkelspühl ("as picturesque as Nuremberg and Rothenburg," he explained), then perhaps Würzburg, Frankfurt, Bingen, Nauheim, Giesing, and Koblenz.[20]

Morgan designed three grand houses around a dappled lawn to create a sumptuous fairyland village. One of the houses was for Hearst; the two others were for his guests. Altogether they incorporated more than twenty-five bed- rooms and several sitting rooms and living rooms. A Maybeckian tower was added at the bridge over the river, and a chalet for the staff was constructed out of sight. The three main dwellings were capped by silvery green-tiled pinnacled roofs that blended visually into the forest, where the tall pine trees stood like guardians against the cares of the outside world. The tranquillity of the setting is ineffable. It was here that Hearst composed "Song of the River," a lilting meditation that compared the cycle of life to the melting water of the glaciers, which eventually returned to the heavens, only to fall to earth again as snow.

Instead of the simple motifs of the "air painting" (*Luftmalerei*) that traditionally decorated the exteriors of

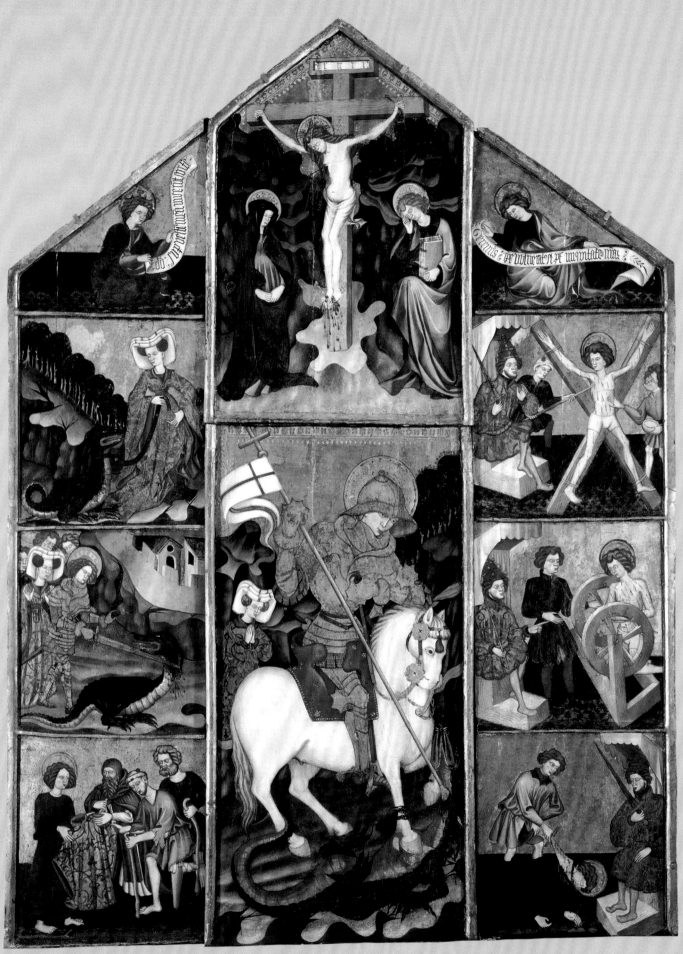

FIGURE 7.4. *Altarpiece with Scenes from the Life of Saint George*, Spain (Aragon), c. 1425;
tempera, gold, and silver leaf on panel; 98 x 74 in. (248.9 x 187.9 cm); Los Angeles
County Museum of Art, William Randolph Hearst Collection (inv. no. 50.28.8).

more modest Bavarian houses, the half-timbered expanses of the ones at Wyntoon were covered with elaborate narrative scenes commissioned from Willy Pogany (cat. nos. 15–17), a noted illustrator of Hungarian origin. The subjects of some of Pogany's paintings were determined by the name that Hearst and Morgan (with Marion Davies?) selected for the house used by Hearst by 1933, Brown Bear.[21] Pogany himself may have suggested the name for the largest house, Sleeping Beauty (later known as Angel House), since that was the subject of one of his murals at the Children's Theater in New York; the middle house became known as Cinderella House. Even the dark wood shutters were ornamented. Their painted trim was inspired by the leaves in the surrounding forest. Pogany finished two of the houses before the winter of 1936–37.[22]

The interiors revealed Morgan's creativity yet again. The soaring wood vaults of the peaked ceilings were knitted together in marvelously complex arrangements. The houses were paneled throughout in unstained oiled pine. In every room a new medieval vocabulary for the beams and borders was invented to merge late Gothic arabesques with a kind of art nouveau flourish that sprang from the unplumbed resources of Morgan's imagination. Hearst sent her a clipping to give her an idea of what he wanted for the kitchen, where he stipulated yellow or green tiles but not blue ones: they were "too Dutch."[23] Hearst acquired about a dozen traditional Germanic ceramic stoves, both antique and custom-ordered, to provide heat. The gigantic hammered hinges on the wood doors were inspired by medieval examples.[24] Stone mantelpieces ranged from one that incorporated a Tuscan fifteenth-century relief to others from Germany from about 1600. A colorful glazed terra-cotta mantelpiece (c. 1630) with allegorical images of the Seasons, purchased from Seligman in 1932, was the focal point in the main salon of Bear House, as it came to be called.[25] Hearst was not exclusively focused on historicizing architecture, however: he sent a clipping to Morgan in September 1931 with photographs of an Aztec revival art deco building, Frank Lloyd Wright's Millard House (1923), and Erich Mendelsohn's Einstein Tower (1919–21). The tower was marked with an X.[26]

Hearst put his German enameled glass humpen, collected over the years, at Wyntoon (fig. 7.3). In the mid-1930s he added at least three dozen more humpen, most of which dated from the seventeenth century. Wyntoon's art was decidedly Germanic and much less heterogeneous than San Simeon's. Franconian and Ulmish sixteenth-century

polychromed wood statues, Rheinish fourteenth-century reliquary busts,[27] and modern paintings by Franz von Stuck and Adolf Hengeler, whose work Hearst clearly appreciated, were destined for Wyntoon.[28] Of everything that he acquired specifically for Wyntoon, however, the most arresting objects were the thirty or so Lusterweibchen that he bought from 1929 through 1936 (fig. 7.5).[29]

Lusterweibchen are the Northern Renaissance equivalent of Italian versions of ancient Roman oil lamps that looked like sirens holding candles or oil reservoirs in their fists.[30] They were suspended from the ceiling. Every few months for seven years, Hearst acquired one of these distinctive Germanic chandeliers. They were composed of the upper torsos of polychromed wood figures, usually female; below their midsection a pair of antlers were attached like the tail of a siren. The lights were held in their fists or set among the points of the antlers, which were valued as trophies for their size. At least two of Hearst's Lusterweibchen were in the form of mermaids, with coiling green or silvered tails in addition to the antlers; one stupendous example was nearly six feet long. The collection he formed for Wyntoon might be unique, as there are almost no more fifteenth- or sixteenth-century examples on the market. It is valid to assert that the Lusterweibchen constitute the most original of all Hearst's collections.

Wyntoon figured in a turning point in Hearst's life. The estate was the setting against which a lengthy article about him was published in *Fortune* magazine in 1935. The article assessed the extent of his empire and estimated his wealth. His corporation was about to reorganize from ninety different companies into a more consolidated enterprise.[31] Hearst had weathered the initial crisis of 1929 despite a serious drop in advertising revenues in 1930,[32] but the new taxes levied in 1932 snuffed out hope for an imminent nationwide recovery. Various entities of Hearst's empire had earlier issued $60 million in bonds; his consolidated publications issued $50 million more in stock in 1930. In addition to this, there were $50 million in mortgages.[33]

Hearst secretly issued private notes to Duveen to cover his indebtedness (at $500,000 they were a fraction of what was due in taxes, mortgages, and the serial debenture issued in 1927); the men agreed that the notes would be locked in Duveen's vault.[34] Hearst's competitor in collecting armor, Clarence Mackay, was on the ropes too: Duveen asked Hearst if he would be interested in buying part of Mackay's collection. Hearst replied: "Of course I would be if we ever

FIGURE 7.5. A Lusterweibchen suspended from a ceiling at Wyntoon.

get out of this damned depression but there is no use in my having interest…while this continues. My main effort just now is to pay for what I have already bought and you have personal knowledge in that."[35]

Governments desperate for revenues increased taxes again in 1935. The federal government took 75 percent, and California took another 15 percent.[36] Many of Hearst's assets—art and real estate—were illiquid in a depression. By the mid-1930s a precipitous drop in circulation of Hearst publications took on an ominous dimension. Just like van Dyck's portrait of Queen Henrietta Maria, Wyntoon symbolized the opposite poles of Hearst's life: fantasy and disaster. As it turned out, part of the fantasy survived.

Notes

1. Robinson says that Edward Clark, Phoebe's cousin, invented the name (*American Dynasty*, 333). For a description of the building, see Woodbridge, *Bernard Maybeck*, 80–84.

2. Robinson, *American Dynasty*, 381.

3. "Hearst," *Fortune*, October 1935, 50.

4. The fire occurred by January 29, 1930, when mentioned in a letter from Hearst to Morgan (Morgan Papers). Hearst wanted to "perfect the plans for…the new castle." An earlier message (August 21, 1928, Morgan Papers) from Morgan about progress of work might refer to the swimming pool. Before the fire Hearst removed tapestries from Wyntoon for repair. One of them was a "Polish sleigh scene" (Hearst to Morgan, November 29, 1929, Morgan Papers; probably the *Sleigh Ride*, designed by J. B. Le Prince, mentioned in Hearst Castle inventory, ex-collection Phoebe Hearst), and another was the *Rabbit Hunt* bought from Demotte, probably the one now in the Fine Arts Museums of San Francisco (October 29, 1929, Hearst Papers, 39:15). On October 27, 1929, he also asked for his "whole collection of pewter" to be sent to Wyntoon (Hearst Papers, 39:15).

5. Drawings for it are in the Morgan Papers. Robert Blunk, the architect commissioned by the Hearst Corporation to complete the last cottage at Wyntoon, described

the idea in a lecture given for the Library Associates Dinner at California Polytechnic State University, January 11, 1991: "From its lower gate on the river, it was to rise eight or nine stories in an irregular and utterly fantastic aggregation of arches, peaked roofs, towers, and ramparts." Mr. Blunk provided a typescript of his lecture to the author; a copy is in Special Collections, Robert E. Kennedy Library, California Polytechnic State University.

6. Morgan to Byne, December 27, 1930, Morgan Papers: "the room to take the form of a church with nave and side aisles." Byne wrote to Morgan on April 1 and 23, 1930, that the monastery's historical interest "did not keep the Spanish army officials from storing powder there, explosions of which finished the destruction caused in the Peninsular war" (Morgan Papers).

7. Morgan to Byne, May 20, 1930, Morgan Papers. Byne had proposed the grille to Morgan on May 13, 1929 (Morgan to Hearst: "sounds incredible but Byne's grille is main nave grille from Valladolid Cathedral" [Morgan Papers]).

8. Hearst to Morgan, January 23, 1931, Hearst Papers, 42:65.

9. The Swiss and Tyrolean ceilings were purchased from Helbing in January. Wainscoting (more than thirty feet long each) and doors were included (listed in Morgan's inventory of ceilings dated May 1, 1931, Morgan Papers). A fourth ceiling (German) was also probably bought for Wyntoon (see correspondence between Hearst and Morgan, November 4, 1933, Morgan Papers).

10. Hearst to Morgan, January 23, 1931, Hearst Papers, 42:65. In an undated message (Hearst Papers, 42:65), Hearst suggested that "the armory with the cloisters attached be transferred to the library side and Bynes refectory now our library be made the armory and entrance hall.... This interchange gives us alcoves in the library as we wanted. It also provides a hundred and four foot wooden ceiling [also purchased from Byne, named "Longceil" in his telegrams] for the central portion of the library.... This makes a more genial and livable library. Bynes refectory is cold and better suited for an entrance hall and armory." The ceiling was a fifteenth-century Spanish ceiling with "painted frieze showing heraldic shields, and signature of maker."

11. Hearst to Morgan, January 21, 1931, Hearst Papers, 42:65.

12. Hearst to Morgan, May 27, 1931, Hearst Papers, 42:69.

13. The Saint George altarpiece was purchased in 1920 at the Pedro Ruiz auction. For the altarpiece of Saint Martin, see Fredericksen, *Handbook*, no. 63, illus. in Loe, *Interpretive History*, 87.

14. A message from Hearst to Morgan discussed the gallery at San Simeon (April 26, 1932, Morgan Papers). On September 2, 1933, Hearst wrote to Morgan about the names for the cottages that he then decided to build at Wyntoon (Morgan Papers).

15. Boutelle, *Julia Morgan*, 250. Hearst still added three grand wings to Charles Wheeler's lodge.

16. The scenic wallpaper is the most distinctive aspect of the decoration.

17. In 1885 she said that she wanted to go to Munich for "at least one year" (Nasaw, *The Chief*, 48). Around 1886 she said, "How I should love to go to Germany" (Robinson, *American Dynasty*, 202).

18. Hearst to Wiegand, August 30, 1929, Hearst Papers, 12:17: "So many of our people go to London and Paris...and do not go to really beautiful spots that they do not know anything about.... I want our people when they go abroad to see Germany and Austria and get a thorough knowledge of those countries."

19. Wiegand to New York office, April 21, 1929, Hearst Papers, 12:17. For the castle, see Wiegand's correspondence of December 14, 1926 (Hearst Papers, 12:16), which refers to Gothic ceilings, balconies, windows, and doors from a Tyrolean castle; a message from November 12, 1926, seems to refer to the fifteenth-century castle of Wehrburg (midway between Meran and Bolzano). It had forty rooms and a twelfth-century tower and was "magnificently situated." Castle Theireck, near Reichenhall, was also mentioned. Perhaps Byne's monastery was substituted for it in 1930.

20. Hearst to Morgan, October 26, 1934, and January 14, 1935, Morgan Papers. In the latter he said she should "not hurry home" because "interiors at Wyntoon have all been worked out and it will be a long time before the wood is carved and ready."

21. Hearst to Morgan, August 19, 1933, Morgan Papers: he advises using names that are "already familiar," for example, River House/River Cottage, Turrets/Hunter's Cottage, and Brown Bear Cottage. He refers to the names Gables, Angel House, and Pinnacles too. Angel House became the name of the largest (unfinished until recently) house. Davies's opinions might also have been taken into account. On September 18, 1935, Hearst apologized to Morgan about having left her at Wyntoon while Davies and Pogany flew back to Los Angeles: "Miss Davies and Mr. Pogany were so anxious to get to Los Angeles before the studio closed. Miss Davies should have reported on Monday, but I held her over to discuss things with you and Mr. Pogany." See names in messages cited in note 22 below.

22. Work had to be curtailed, Hearst wrote to Morgan (November 13, 1936, Morgan Papers), because "taxes were becoming confiscatory." Morgan said she would finish Angel House. (This name came from the proximity to Angel Creek.) There is a reference to Sleeping Beauty House. Morgan reported that Pogany completed frescoes on Brown Bear and the front of Cinderella; the sides of Cinderella were blocked out. It was too cold to continue (Morgan to Hearst, November 11, 1936, Morgan Papers). Brown Bear was ready for Pogany in August 1936, when he examined the plaster.

23. Hearst scribbled the order at the bottom of an article about a kitchen in Pennsylvania (unidentified clipping [possibly from *American Architect*], September 1935, Morgan Papers).

24. Illustrated in Boutelle, *Julia Morgan*, 216-31, and Sally Woodbridge, "Wyntoon," *Architectural Digest*, January 1988, 97-103, 156. Gothic hinges of this type are in the Cloisters, Metropolitan Museum of Art.

25. Photograph (with date) in Jacques Seligmann & Co. records, series 2 (Collector's Files), Archives of American Art, Smithsonian Institution, Washington, D.C. Only three seasons are represented. Also in "Hearst," *Fortune*, 51.

26. Hearst to Morgan, September 24, 1931, with unidentified clipping (possibly from *Architectural Review*), September 1931, Morgan Papers. Similarly, not all the purchases in 1930 were for Wyntoon. For example, the Sansovino relief was purchased that year but did not go to Wyntoon.

27. Five of them were purchased from Goldschmidt around 1935 (Hearst Castle inventory).

28. Hearst asked Wiegand (Hearst Papers, 12:16) on August 14, 1926: "What was price of Stuck's Amazon which we got permission from Museum to duplicate." Then Willicombe told Wiegand that Hearst asked the price of "Judith painting exhibited at Glas Palast Munich." An art deco painting by Émile Aubry, *The Voice of Pan* (purchased from the artist sometime between September 1, 1936, and January 19, 1937), was also sent to Wyntoon (Hearst Papers, 39:36; instruction sent to MacGregor on January 25, 1937).

29. The Hearst Castle inventory mentions Lusterweibchen purchased from 1929 to 1936. The dealers were Böhler ("Judith," bought December 31, 1929); Seligmann, Rey; Goldschmidt; Otto Ebner (a mermaid, 1932); Arnold Seligmann; Brummer; Hugo Helbing (1930, from town hall of Nabburg [sic]). The one bought on December 7, 1933, was seventy inches long. The average price for each was about $2,000. There was one in Santa Monica (presumably in the Rathskeller of the Beach House; it was sold to Michael Hall). Three came with historic provenances (castle of Biebrich, prince of Isenberg, and Hohenzollern-Sigmaringen). Ebner sold a beautiful example with six lights (one held in the hand) to Hearst on May 16, 1932 (mentioned in Hearst Papers, 39:23); another came from a sale in Frankfurt on May 3, 1932 (Hearst Papers, 39:28).

30. See the etching by Piranesi from his *Vasi, candelabri, cippi*, illus. in Jonathan Bourne and Vanessa Brett, *Lighting in the Domestic Interior* (London: Sotheby's, 1991), fig. 14. Cf. the chandelier in the form of a dragon, designed by Albrecht Dürer, illus. in *Gothic and Renaissance Art in Nuremberg, 1300-1550*, exh. cat. (New York: Metropolitan Museum of Art, 1986), nos. 149, 150. The origin of Lusterweibchen has not been clearly determined, but they must be derived from classical oil lamps in the form of sirens, onto which were grafted, centuries later, trophies of antlers.

31. "Hearst," *Fortune*, 55. Swanberg (*Citizen Hearst*, 474) commented that the writers were "to confer with Hearst," so they had fallen "prey to deceiving appearances."

32. White to Hearst, March 6, 1930, Hearst Papers, carton 36 (International Magazine Company): "nationwide depression and uncertainty about new taxation has paralyzed all advertising." In 1932 operating profit was down about 35 percent; *American Architect* was hit because there was no construction. The balance sheet for December 1932-February 1933 was a blaze of red ink, but it showed improvement from 1931.

33. Swanberg, *Citizen Hearst*, 417, 484.

34. December 10 and 15, 1932, Duveen Archive.

35. October 29, 1932, Duveen Archive. Hearst was not alone; the banker Jules Bache also owed substantially to Duveen, who was himself in difficulty. "The banks have put a question-mark after all of these men today," Duveen commented (August 3, 1932, Duveen Archive). At about the same time Mitchell Samuels told Duveen that he had $200,000 in Hearst stock and could not do anything with it. The stock was partial payment for his work on Sands Point (Hearst Papers, 43:2). On April 20, 1931, Hearst told his registrar, "I will not buy anything that I cannot pay for next year and I wish [Paul Byk, one of Seligmann's associates] would not tempt me." A day later Hearst bought doorways from Byk (Hearst Papers, 39:18).

36. Swanberg, *Citizen Hearst*, 475; Kastner, *Hearst Castle*, 179.

Chapter 8

✢ CRISIS ✢

Overleaf: FIGURE 8.1. Abraham Gessner, *Globe Cup* (detail), c. 1600 (cat. no. 50).

FIGURE 8.2. Jacques-Louis David (French, 1748–1825); *The Vestal*, 1787; oil on canvas; 31 ⅞ x 25 ¼ in. (81 x 61.1 cm); private collection.

Surviving the financial crises of 1929 and 1932 put Hearst on an illusory footing of stability. His opposition to the tax of 1932 was not mollified by the fact that he absorbed its shock. In a series of editorials he argued that it would push capital into tax-exempt securities rather than investment in production. This would reduce consumption and cause the economy to stagnate. It would "divide our… people into two conflicting extremes of Communism and Fascism." The elevated income tax was despotic, and officials in Washington were "disciples of Lenin and Stalin" and Bolsheviks.[1] A variety of factors—among them Hearst's aversion to Franklin Roosevelt's policies, his condemnations of Joseph Stalin and the Soviet Union, the comparative restraint of his newspapers' early reporting about Adolf Hitler, and a story about the agreement to let the Nazi government subscribe to his news service—led Hearst's critics to brand him as pro-Hitler and a fascist.[2]

Hearst believed that Hitler could be contained and that communism caused fascism. This, combined with communism's mendacious allure, posed a greater threat to freedom.[3] In a radio address on January 5, 1935, denouncing Soviet tyranny and the widespread starvation that it caused, Hearst warned against providing aid to Russia because it would ultimately go to "a gang of criminal Communists who are robbing innocent farmers."[4] For this stance, as well as intemperate language against Roosevelt and the reversal of his early general support for labor unions, Hearst earned a boycott of his publications, movies, newsreels, and theaters that made the boycott of 1906 seem like a carnival.[5] "Radicals Assail Hearst," reported the *New York Times* on February 4, 1935. The leaders of the rally claimed that he wanted "to pave the way for 'Fascist reaction'; to outlaw radical working-class parties;…to destroy academic freedom…and in other ways to 'crush' labor." On February 26, 1935, the *Times* reported, "More than 15,000 persons gathered…to protest, with the Friends of the Soviet Union, against the collapse of debt negotiations." Madison Square Garden was "hung with red streamers proclaiming the Soviet cause and condemning Hearst." The speakers declared that the Soviet Union had "proved itself the only nation in the world which stood for peace and progress."[6] Stalin's savagery (for example, the fact that nearly 25 percent of the population of Georgia was

being slaughtered or sent to prison camps) went unmentioned;[7] instead the participants in the rally sought donations to pay for literature with which to "bombard" Hearst's buildings.

Hearst began to understand that he was not invulnerable. A message from his publisher Albert Kobler, to whom he occasionally turned for opinions about art, alluded to this in May 1936. Kobler wrote: "You wish to dispose of some of the articles now in the warehouse. List amounts to cost of $5.8 million, may be possible to get something like it. Tapestries may bring more." He recommended selling them abroad.[8] Among the items on the list were a Gothic crystal beaker and cover (fig. 2.9), a chalice dated 1222 (fig. 2.10); *Jupiter and Danae* by Greuze (all Metropolitan Museum of Art); an altarpiece of Saint Catherine (fig. 8.3); *The Vestal* by Jacques-Louis David (fig. 8.2); and two huge landscapes by Hubert Robert, *La Cascade* and *Pont sur le torrent* (both private collection). Among the tapestries were the Redemption series, *The Martyrdom of Saint Paul* (cat. no. 31), *The Apostles' Creed* (fig. 2.2), and *Fortitude* and *Justice* (Fine Arts Museums of San Francisco).

Hearst probably never saw the income of his corporation as separate from his own, except, perhaps, for some of the National Magazine Company's outlays for Saint Donat's. While he brilliantly swelled his inheritance of $30 million to $200 million, he spent almost all the annual profits of $15 million.[9] To be sure, a good part was reinvested, for example, in building radio towers or buying additional newspapers, but this was often at steep prices; his movies rarely generated what they cost. What was spent on works of art (including the salvage of monasteries) topped off the expense of constructing and maintaining six grand residences, even if Marion Davies paid for herself in Santa Monica. There were subsidiary outposts—Hearst's apartments in the Warwick or the Ritz; a hacienda northeast of San Simeon near the town of Jolon; and Millicent's luxurious pied-à-terre in the Sherry Hotel.[10] San Simeon was to finance itself in the future through poultry, beef, and dairy farming, but these were long-term enterprises that could not quickly provide a significant return on investment. Hearst was a generous man and a joyous spender. Orson Welles's fictional Kane might have been scripted to say that he "always

FIGURE 8.3. Donato d'Arezzo and Gregorio d'Arezzo, *Saint Catherine of Alexandria and Twelve Scenes from Her Life*, c. 1330 (cat. no. 128)

gagged on that silver spoon," but for Hearst there was only the boundless glee with which he immersed himself in his golden fortune.

An arrangement was in fact set up with what became a Hearst subsidiary established in the early 1920s, the International Studio Art Corporation, to balance Hearst's personal property against what belonged to the corporation.[11] It is suggested by a brief communication from Hearst in June 1936 about sending some furniture to storage because he needed "this intake there to offset some of the...things which we are taking out."[12] By the time Christmas arrived, the efforts to refinance his bonds were coming up against a wall of bad publicity, ill will, and stolid prudence. There was limited reason for any financier to believe that Hearst would soon be able to repay a new round of loans in the sorry economic conditions of the 1930s. His debt schedule had $39 million coming due in a year.[13] Banks were more desperate for intake than the warehouse was.

The paneling was being removed from the Clarendon, but even this did not quell Hearst's single-minded zeal for treasures that fortuitously became available.[14] In April 1937

he acquired eleven objects, among them the splendid parcel-gilt *Globe Cup* by Abraham Gessner (fig. 8.1) and the *Covered "Grapes" Cup with Bacchus* by Hans Keller (cat. no. 51) at the Rothschild auction in London.[15] Hell-bent, Hearst squeezed through the last great purchase of this chapter in his life: Thorvaldsen's four huge allegorical marble roundels of civic virtues, which add so much to the grandeur of San Simeon (fig. 8.4). Yet Hearst was no hypocrite. He directed his managers to keep as many employees on the payroll as possible at the same time.[16]

Hearst's credit was "shattered" in August 1937, according to his attorney John Francis Neylan.[17] How swiftly his finances began to crumble can be judged from the fact that, within a month of buying the roundels, he was called to New York to discuss the survival of his corporation. Various attempts were made, mainly by his confidant Joseph P. Kennedy, to renegotiate his obligations through schemes that Neylan denounced as "utterly unsound." Neylan warned Hearst that they would deliver his empire "into the hands of the coterie in Washington most eager to destroy" him. Among Hearst's "unproductive assets" he identified the

FIGURE 8.4. Bertel Thorvaldsen (Danish, 1770–1844); *Minerva Endowing Mankind, Sculptured by Prometheus, with a Soul*, 1807–22; marble; diameter 62 in. (157.5 cm), including frame. Hearst Castle, San Simeon, California (inv. no. 529-9-2058). This sculpture is an allegory of wisdom, one of the four virtues necessary for good government. The design was originally commissioned for Cristiansborg, the royal palace of Denmark. The other roundels are allegories of health, strength, and justice.

collections and insisted that they be liquidated to offset the debts. This, he believed, was what induced Hearst to replace him with another lawyer, Clarence Shearn, who in 1925 had made a name for himself with obnoxious behavior toward Joseph Widener in a lawsuit about the Rembrandts that Widener acquired from Prince Felix Youssoupoff.[18] Shearn was now a judge and gave the impression that he was well placed in financial circles. As trustee, he essentially controlled the corporation.[19]

Hearst was put on a budget without recourse. The collections were reappraised. He could retain about one-third to one-half.[20] Careful notations in some inventory books show that he selected item by item. The rest became an asset of the corporation to be sold in the pitched effort to meet financial obligations. Mortgages on the Clarendon and Sands Point would be foreclosed. The radical amputation extended to radio stations and newspapers, which were also sold, merged, or shuttered—including the *New York American*, one of Hearst's sentimental mainstays. On that occasion Bernard Baruch wrote to him: "Win, lose, or draw, I never heard you complain.... Whatever you decide to do I hope that success will perch on your banner."[21]

Word leaked out in the spring of 1937 that the collections were being scrutinized. The *New Yorker* asked for permission to do an article about the warehouse in the Bronx, and Hearst refused with a capitalized *NO*.[22] His intuition was correct. When a story did appear in the magazine in 1941, the writer's fake ingenuousness oozed from every paragraph and made a contemptible mockery of what Hearst had accomplished.[23]

In October 1937 the *New York Times* informed its readers that Hearst was the owner of the "property of a gentleman" on Parke-Bernet's docket of auctions for December.[24] In the scramble to restore liquidity, works of art were consigned to a number of other dealers too. Hearst asked if the profit from the newsreels could be used to pay off debts related to acquisitions of art, as well as Bartel's salary, and whether the tapestries should be sold separately by Duveen's branch in Paris.[25] Hiram Parke (of Parke-Bernet) showed equal amounts of pragmatism and probity when he solicited Duveen's help in securing more consignments from Hearst. He believed that the auctions would be harmed if the objects were "hawked all over New York" and that it was better to keep the categories intact. Among the first designated for the block were Hearst's impressive collections of rare American books and autographs. Parke told Duveen that there were also about two hundred insignificant American paintings accumulated over the previous two decades.[26] For the public record, the purpose was estate planning. About two-thirds of the collection would be dispersed by sale or by gift to unidentified museums; auctions were initially ruled out. Overall responsibility for the disposal was assigned to Parish-Watson & Co. Museums that expressed an interest in purchasing significant works of art would be given special consideration. By July 1937 the officers of the Frick Collection were confidentially offered a selection.[27]

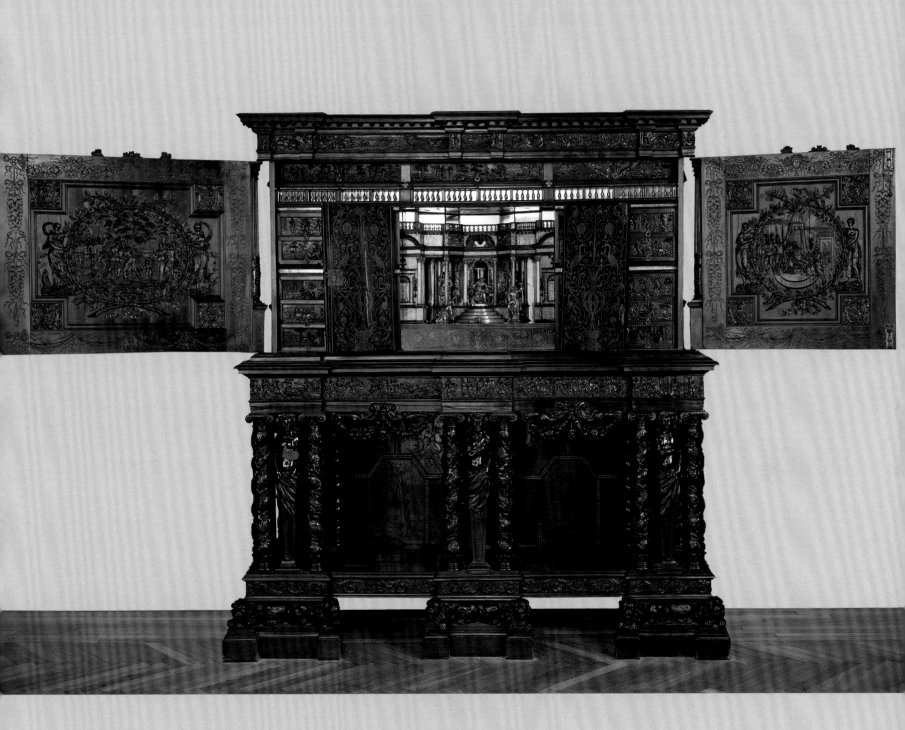

FIGURE 8.5. Daniel Garnier (French, c. 1667–1699); *Chandelier*, 1691–97; silver with iron core; 27 x 33 in. (68.5 x 83.8 cm); Colonial Williamsburg (inv. no. 1938-42). This heavy (approx. 721 oz. [20.4 kg]) chandelier was made for William III.

FIGURE 8.6. Attributed to Pierre Gole, *Cabinet on a Stand*, c. 1650 (cat. no. 88).

This is how, in 1938, Colonial Williamsburg obtained, through the generosity of John D. Rockefeller Jr., about two dozen examples of superb Georgian silver (fig. 8.5), as well as Chippendale chairs and Elizabethan beds.[28] Thorvaldsens Museum's direct acquisition of the statue of Hebe in May of that year is another example of preferential treatment.[29] One exception was the ebony cabinet that had been on loan to "the museum in San Francisco" (fig. 8.6), which Hearst wanted at San Simeon.[30] Charles C. Rounds, who signed as "chief accountant" at the International Studio Art Corporation,[31] oversaw the details and eventually determined appropriate destinations for many of the most important works of art. Rounds compensated, however slightly, for Parish-Watson's blunders, one of which involved pulling tapestries from Duveen prematurely for sales that never materialized. Besides possibly offending Duveen, who at that miserable time was "one of the very few dealers who have clients for expensive tapestries," Hearst fumed, Parish-Watson "greatly cheapened them and us.... [He] advertises like a bargain basement sale." Hearst continued, "I am heartbroken that we were ever compelled to have dealings with such a man." He figured that Parish-Watson had lost the corporation more in value than he earned through actual sales. "I am terribly distressed, and believe I am much damaged, by his methods," he added. Parish-Watson was removed.[32]

Hearst, "slightly battered but still in the ring," as he described himself to his son, had a ready champion in the *Connoisseur*, which ran a series of articles not only to promote the sales but also to explain the overall interest of the collections of silver, armor, furniture, and early Flemish tapestries.[33] These remain fundamental references for Hearst's collections, particularly with regard to the contents of Saint Donat's.[34] The diversity of methods used for the liquidation from 1938 to 1942 reflects the desperation of the times. One attorney told Hearst in January 1940 that "only the sale of antiques" would cover future tax.[35] "The auction market is so unsettled," Rounds explained to Hearst on March 2, 1940, that a series of exhibitions in department stores in Chicago, Saint Louis, Seattle, and perhaps Pittsburgh was recommended to dispose of another tier of manuscripts, autographs, furniture, and porcelain.[36]

On February 1, 1940, Karl von Wiegand filed a report from Shanghai: Germany was going to attack Great Britain in eight weeks. "Japan very quietly but intensively is preparing to meet that situation," he wrote. "It has been forgotten that Japan and not Germany invented the Blitzkrieg." Germany would make a "titanic blow" against Great Britain before American aid could arrive, his informant predicted. Wiegand referred to a general breakdown in civilization. China was supplying Germany, and there was famine in Spain. He concluded, "Question: is this OK for Sunday?" Hearst commented: "Very interesting and rather alarming. It seems authoritative. I advise making Sunday feature keeping it to two columns."[37]

Unexpectedly the National Magazine Company reported "splendid" profits in February.[38] Hearst was elated: at last some good news! Then Germany launched its attack. Hearst knew that conditions in London were going to worsen and that Saint Donat's might be bombed. The collections there were stored or removed, and the castle was temporarily made available for recuperating British soldiers.[39] Dreadful challenges were on the horizon.

Dispatches from Hearst's staff at the National Magazine Company described events as they unfolded. On September 16, 1940, J. Y. McPeake Jr. wrote: "A German airplane lies 250 yards from our office. Two were shot down in three minutes. Thanks for support. Most exciting since Armada." On September 26 T. J. Buttikofer reported that the art director for Amalgamated Press died in an air raid. McPeake moved to London because commuting was too perilous. Then he was bombed out of his apartment. He camped at the office: "Things are getting very tough." On October 11 McPeake asked for permission to allow rest for some staff at Saint Donat's. On November 18 Richard Berlin relayed a story from a friend of Buttikofer in Switzerland, where Germany controlled all imports and exports: "Our only way out of Switzerland is by autocar from Geneva to Barcelona and from there by air to Lisbon. That is if the Spaniards don't join the war. I cannot describe to you what it feels like... [even in Switzerland] we feel the iron rule of the Germans." On December 10 McPeake wrote: "We will have to put up with fifteen hours of bombing per night for the next three or four months." On January 26, 1941, Hearst sent condolences to Cary Grant "on death of relatives who lost their lives in the Nazi bombing." On April 16 McPeake reported: "savage air raid...an ordeal" [beyond September's].... Every kind of bomb and missile was used." In the countryside, after a father and son were bombed twice, they tried to rescue four waitresses in a pub that was bombed. They could save only one. The others were "caught in the debris." McPeake stood firm: "These terror attacks will fail." On August 7 McPeake's pregnant wife had labor induced so

that the baby could be delivered "before full moon, which Luftwaffe prefers."[40]

Meanwhile in the United States, banks complained that the sales of Hearst's collections were not generating proceeds fast enough.[41] In April 1941 plans were formulated to consign thousands of works of art and historical documents to Gimbels and Saks department stores in an exercise that the impresario Armand Hammer had previously tried with success.[42] By November the fifth floor of Gimbels was remodeled to accommodate the collections, which were marketed for more than a year with a crassness that was appalling even by today's standards. The poor quality of the catalogue obscured the beauty of such paintings as the processional cross attributed to the Master of Santa Chiara (fig. 8.7), which figured in the sale.

When Japan attacked Pearl Harbor, Hearst feared that the coastline of California would be next. He and Davies moved to Wyntoon. Although he was opposed to involvement in European conflicts, he had long advocated strengthening defense in the Pacific. Now he accepted the fact that the United States must join the struggle and threw his editorial force into the effort. Just about the time his collections were being flogged as "Bargains in Nattiers and Gas Stoves," around August 1942, the Bank of America agreed to extend its loans.[43] In the year of the Bataan Death March, the public's hunger for wartime news and a leap in advertising paradoxically began to resuscitate the Hearst Corporation.

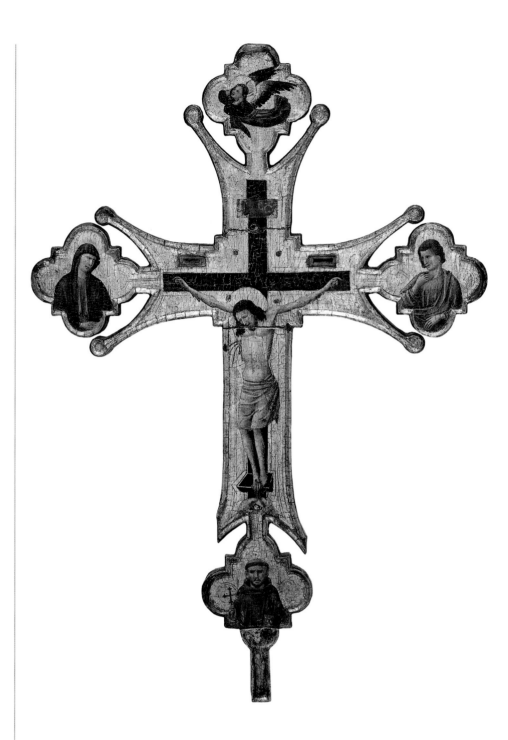

FIGURE 8.7. Attributed to the Master of Santa Chiara (Italian, c. 1255–c. 1320); *Processional Cross*, c. 1320; oil and gilding on canvas on wood; 24⅛ x 17⅜ in. (61.3 x 44.1 cm); Cleveland Museum of Art (inv. no. 1943.280).

Notes

1. The quotations are from his radio address of June 4, 1932, and his editorial of March 26, 1932 (reprinted in Hearst, *Writings and Speeches*, 516–17, 519–20); for the other editorials, see ibid., 515–38.

2. Nasaw, *The Chief*, 489. Hearst initially cautioned his editors against "incendiary" stories about Hitler. One of these may have been a report filed by Wiegand in April 1934: "Hitler...has had a near breakdown. In his last cabinet meeting he...ranted, shrieked, then broke down, wept, and sobbed hysterically" over Germany's deteriorating economy. The head of the biggest German bank told Wiegand that if boycotts continued and credit was refused, "the financial situation promises to wreck Hitler before the end of the year." This was "probably the most daring message out of Germany...under present [censorship]," Wiegand wrote to Edmond Coblentz, editorial director of the Hearst newspapers, demanding to know why it was not used (April 8 and 11, 1934, Hearst Papers, 12:19). Wiegand first said it was for editorial information, not for publication.

3. Hearst, *Writings and Speeches*, 141–43; see also 181–83.

4. Reprinted in Hearst, *Writings and Speeches*, 112–20.

5. Nasaw, *The Chief*, 505–7, 518–21, 533. Swanberg believed the 1906 boycott was worse (*Citizen Hearst*, 471). Cf. Pizzitola, *Hearst over Hollywood*, 344–48. Hitler disgusted Hearst; see his editorial of December 18, 1935, referring to the "incredible persecution of Jewry" by Hitler's government, which "impregnates the world again with a poison" (*Writings and Speeches*, 498). Hearst stated in an editorial on November 16, 1938, "Not since the Spanish Inquisition has history known such a chapter of horrors as the one which the Nazi regime is...writing now" (*Writings and Speeches*, 33–35). Hearst interviewed Hitler in 1934 (Pizzitola, *Hearst over Hollywood*, 308–15) and perhaps naively believed that he could influence Hitler just as Auguste Rodin had hoped to persuade

Pope Benedict XV to condemn Germany's invasion of Belgium in the previous world war. See also Hearst's warning to Hitler in June 1940 ("The Lemmings," reprinted in *Writings and Speeches*, 672–73).

6. Cf. Hearst's editorial of July 22, 1943 (*Writings and Speeches*, 651–54): "Russia… intends to absorb Latvia, Lithuania, and Estonia…Poland and Finland. She intends to encroach in the Balkans. She intends to dominate Europe.…There is no freedom in Russia's concept of government."

7. Cf. Melik Kaylan, "A Monument to the Terror," *Wall Street Journal*, September 4, 2007: seventy-two thousand people shot and two hundred thousand deported, of a population of four million.

8. Kobler to Hearst, May 26, 1936, Hearst Papers, 40:10. For the David painting, see Joseph Baillio, in *The Arts of France: From François I^er to Napoléon I^er* (New York: Wildenstein, 2005), 310–12, no. 136.

9. Hearst did spend his own funds for some construction at Saint Donat's (Willicombe to McPeake Jr., December 17, 1940, Hearst Papers, 37:41). This estimate of the value of the corporation was given after Hearst died. See the brilliant obituary "Hearst Journalism," *Life*, August 27, 1951, 22: "In all respects he was a fabulous man—such as the U.S. had never produced before and never will produce again." For the income, see Hearst Jr., *The Hearsts*, 58.

10. Plans for a huge hacienda in Mexico and a hotel or mansion near the Grand Canyon were abandoned. The Mission-style hacienda at Jolon (designed by Julia Morgan; see Boutelle, *Julia Morgan*, 232–33) was maintained on a limited basis until the land was sold to the federal government in 1940.

11. Nasaw, *The Chief*, 301. The warehouse was bought in 1927.

12. Hearst to Morgan, June 8, 1936, Morgan Papers. Cf. Hearst's inquiry from March 8(?), 1938: "What was value of arms and other material Bartel selected from warehouse that must be charged to me and should not be excessive" (Hearst Papers, 39:36).

13. Nasaw, *The Chief*, 530–32; see also 424–32, on the stock issue of 1930 and how the crucial dividend schedule would affect Hearst.

14. Hearst to MacGregor, February 6, 1937, Hearst Papers, 39:36.

15. Hearst Papers, 40:35 (Goldschmidt folder), referring to Rothschild auction in London, April 26 and 28, 1937. Hearst bought lots 75, 129, 185, 196, 206, 213, 225, 227, 228, 260, and 272.

16. See Hearst Jr., *The Hearsts*, 123, regarding his father's order "to maintain the highest possible degree of employment" (July 15, 1937).

17. Hearst Papers, carton 9 (Legal and Financial: Neylan).

18. Behrman, *Duveen*, 16–22.

19. Nasaw, *The Chief*, 538–40; W. R. Hearst Jr., who despised Shearn, noted that "seventeen banks imposed a trusteeship" when $35 million in a new series of bonds failed to be authorized (*The Hearsts*, 58). Hearst's competitor in the Los Angeles market, Harry Chandler, held a $600,000 note on San Simeon through the Bank of America. According to Hearst Jr. (ibid.), Neylan said that Shearn wanted Chandler to call the loan, but he extended it. The two competing publishers had a mutual appreciation, to judge from Hearst's gift to Chandler of a dachshund (Camilla Chandler, personal communication to the author, 1995).

20. Some writers say that he kept half; Thomas C. Linn reported that he would keep a third ("Hearst to Disperse Vast Art Holdings," *New York Times*, March 2, 1938). A new census of the collection was prepared (August 18, 1938, Hearst Papers, 39:37). Morgan was to tabulate everything at Wyntoon, San Simeon, and the West Coast warehouses and what was lent to the museums in San Francisco. Lawyer Geoffrey Konta would tabulate the contents of the Clarendon, Sands Point, and the Bronx warehouse and what was on loan to the Metropolitan. Then a handful of dealers provided current appraisals.

21. Baruch to Hearst, July 12, 1937, Hearst Papers, box 5, personal correspondence.

22. Messages between Hearst and MacGregor, May 15 and 19, 1937, Hearst Papers, 39:36.

23. Geoffrey Hellman, "Monastery for Sale," *New Yorker*, February 1, 1941. For example, a sale to a "British shipping magnate" was mentioned without explanation that the buyer was either of two illustrious Scottish collectors: Sir William Burrell or Robert Scott, both of whose collections now form part of the Glasgow Museums.

24. "Hearst Silver to Be Sold," *New York Times*, October 11, 1937; see also Nasaw, *The Chief*, 539.

25. September 1, 1937, Hearst Papers, 40:27 (Duveen folder); Hearst to "Mr. Cutler"(?), May 19, 1937, Hearst Papers, 40:4.

26. Messages from Duveen's New York office to Duveen in Nassau, January 31, 1938, and February 4, 1938, Duveen Archive.

27. Linn, "Hearst to Disperse Vast Art Holdings." For the Frick offer, see correspondence in Frick Collection archives, Central Files, 1937—Art for Sale, July 15–August 3, 1937.

28. "Rockefeller Buys Rare Hearst Silverware; Williamsburg Shrine to Get $100,000 Items," *New York Times*, April 29, 1938. John D. Davis calls the acquisition Williamsburg's "most important purchase of period silver" (*English Silver at Williamsburg* [Williamsburg, Va.: Colonial Williamsburg Foundation, 1976], 5). The Hearst silver is so crucial to the renovated display at Williamsburg that it was not lent for this exhibition. In addition, dozens of Hearst's early American artifacts and pieces of furniture went to the Henry Ford Museum.

29. Correspondence in Thorvaldsens Museum, kindly provided by William Gelius. The sales were announced in the international press, including Denmark's *Ekstrabladet*.

30. Charles C. Rounds to Willicombe, December 27, 1938, Hearst Papers, 39:37. Hearst gave the cabinet to San Francisco in 1947. It is worth noting that, according to J. Edward Gerald, Hearst Consolidated Publications had no profit *before* taxes in 1938 (see graph in Edwin Emery, "William Randolph Hearst: A Tentative Appraisal," *Journalism Quarterly* 28 [fall 1951]: 437).

31. Rounds to Duveen, March 7, 1938, Duveen Archive.

32. Hearst Papers, 40:27 (Duveen folder); this undated message must relate to a message from Duveen in New York to Duveen's gallery in Paris (August 8, 1939, Duveen Archive): "Parish-Watson has been removed from the Hearst organization, as they are very dissatisfied with his management."

33. Hearst Jr., *The Hearsts*, 124. See the articles by Charles Beard in the bibliography of this volume. There were auctions of the silver in New York and London in late 1938 and early 1939; fine armor was sent to Switzerland; fine furniture was consigned to Mallett's in London.

34. Contrast Hearst's complaint to Richard Berlin (December 29, 1940, Hearst Papers, box 36) that his newspapers reported badly on the sales in department stores. It "revives rumors of the bankruptcy of the institution." He advised an "inquiry into the value of our remaining antiques" and reminded his executives that "in dealing with an object of art you are dealing with an elusive thing.… A created value…depends largely upon their rarity, scarcity, and difficulty of securing them."

35. Konta to Hearst, April 1940, Hearst Papers, 44:34.

36. Correspondence of January–March 1940, Hearst Papers, 39:38. Hearst disapproved of the venue of department stores (see note 34 above).

37. Wiegand to Hearst (with Hearst's handwritten comments), February 1, 1940, Hearst Papers, 12:20.

38. Hearst to Berlin, February 13, 1940 Hearst Papers, 36:7(?).

39. Hearst to Head, 1939 or 1940(?), Hearst Papers, 37:44; Head to Hearst, March 7, 1940, carton 36.

40. All messages selected from Hearst Papers, carton 36, except Hearst to Cary Grant, January 26, 1941, Hearst Papers, 10:28.

41. Berlin to Hearst, January 3, 1941, Hearst Papers, carton 36.

42. Newspapers announced the sale in December 1940; on March 22, 1941, the *New York Times* announced a preliminary private benefit auction ("Art Sales Winning Large Public Here"); Clarence Mackay also consigned objects to Gimbels (Hearst Papers, 40:34). Hearst pulled his maiolica from the event (April 11, 1941, Hearst Papers, 39:40). See also, with caution, Jack Alexander, "Cellini to Hearst to Klotz," *Saturday Evening Post*, November 1, 1941, 16–17, 84, 86–89. Numerous errors and a facetious tone mar this deplorable article.

43. Hearst-Berlin correspondence, c. August 4, 1942, Hearst Papers, carton 36.

Chapter 9

⊰ RENAISSANCE ⊱

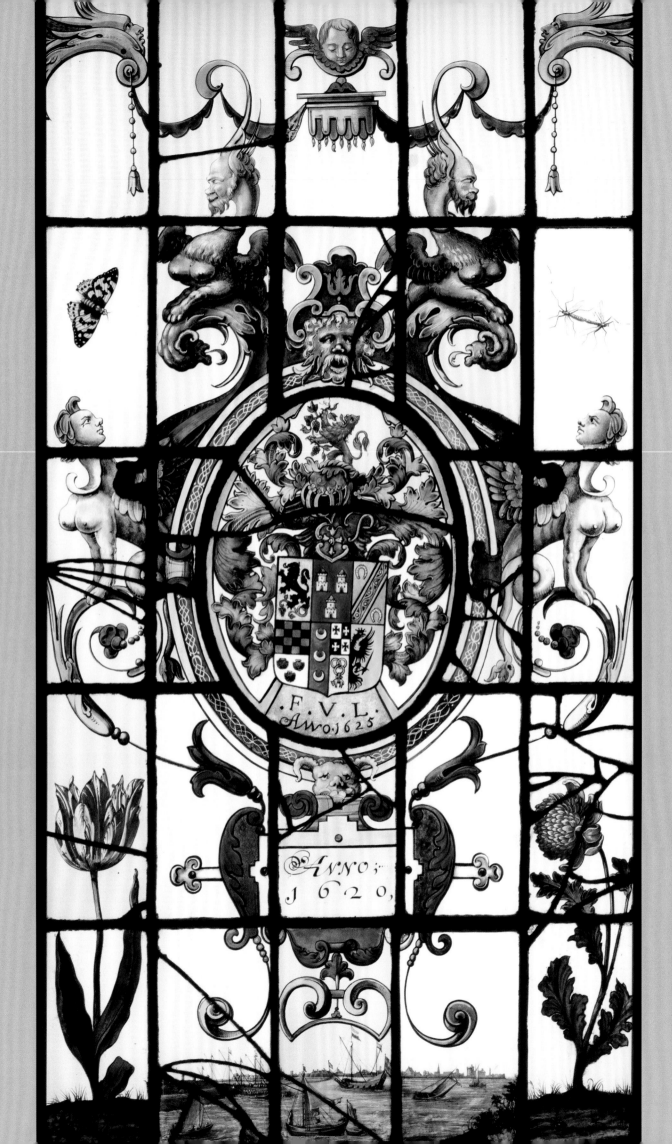

A standard biography of Hearst, or of any noteworthy individual, must finally reach a denouement, which usually consists of an exposition about a gradual decline and its inevitable conclusion. In Hearst's case, biographies would recount how he emerged, as he approached his eightieth birthday, from the grinding siege that threatened his corporation, how he rebounded with its resurgence, and how he returned to San Simeon, where construction on the north wing of Casa Grande was resumed, even though the revetment and part of the south wing would be left unfinished. Next, Hearst's cardiac troubles in the spring of 1947 would be cited as the cause of his having to quit the Enchanted Hill for a mansion that Davies bought in a luxurious enclave of Los Angeles County called Beverly Hills, so that medical care could be obtained immediately in an emergency. Last, the debilitation and loneliness of the frail old tycoon would bring the story toward its end in August 1951. Hearst, however, is not a normal subject. He had a little surprise in store for anyone who wrote about the last few years of his life.

When William Randolph Hearst Jr. looked back at the crisis of 1937–42, he observed: "If Pop was upset by all the turmoil, he never showed it. It was only money, he said, not life or death."[1] Hearst's attention was still trained on his newspapers, and there were other small distractions. The *New York Times* had alluded to one of them in 1938 with a vague comment about possible donations to museums,[2] but none of the three with which Hearst had developed long relationships, primarily as a lender—the Metropolitan Museum of Art, the California Palace of the Legion of Honor, and the de Young Museum (the latter two in San Francisco)—was an immediate beneficiary. At that time there was no reason for anyone to imagine that Hearst would instead essentially lay the foundation of what became the foremost encyclopedic museum west of the Mississippi.

In 1942, perhaps because he was at Wyntoon, Hearst decided to donate a collection that had once been stored there to the Los Angeles County Museum of History, Science, and Art, which had opened in 1913 without a single work of art or the means to acquire one. Although the fledgling institution was mentioned when Hearst's collections underwent a preliminary triage in 1937, nothing came of it.[3]

Hearst's Navajo textiles (fig. 9.3), which had been offered to the Museum of the American Indian in New York in 1938, became the first of his gifts to the unexpected recipient.[4]

Many of Hearst's Navajo blankets were particularly valued because they were in excellent condition, thanks to the fact that they had been bought from Mexicans who acquired them through barter after the Civil War. They reflect Hearst's passion for the American frontier. His interest in them was surely sparked by his mother, who bought some at the Columbian Exposition in 1893; in 1901 Hearst mentioned blankets that he and his mother purchased on the train that passed through Albuquerque.[5] Hearst acquired almost two hundred of them; of these the vast majority came from Herman Schweizer, the manager of the Indian Department of the Fred Harvey Company of the Santa Fe railroad, who purveyed them professionally.[6] In 1932, with Hearst's approval, Julia Morgan sent them to the hacienda at Jolon, but she had to apologize to Hearst when he found them there five years later, "being further antiqued," as he put it, on the floor. The housekeeper at Jolon "was paralyzed when I told her how much the fine ones cost," he wrote.[7] When the land around Jolon was sold to the federal government in 1940, the blankets were removed to Wyntoon, and Hearst apparently wanted them next at San Simeon. In all, the textiles were appraised at $66,858. They were followed by stained glass and more than two hundred German glass vessels. The stained glass was worth almost $50,000, and the humpen were appraised at about $17,000.

Hearst enjoyed some encouragement from one of Arnold Seligmann's associates, Paul Byk.[8] In September 1944 Byk visited Los Angeles and wrote that Roland McKinney, who had been appointed director of the Los Angeles museum six years before, had "done the most extraordinary museum job in America.... Years and years ago...there was no art to be found. Today it is different.... Your gift of stained glass is superb.... Maybe one day this nucleus of medieval art may be complemented with some statuary and tapestries," he wrote. Davies's paintings had been removed from the Beach House and were displayed at the museum too. Byk remarked that they were "superb and each picture speaks for itself."[9] In January 1945 the optimistic McKinney wrote to Hearst about his hopes for postwar expansion of the art section of

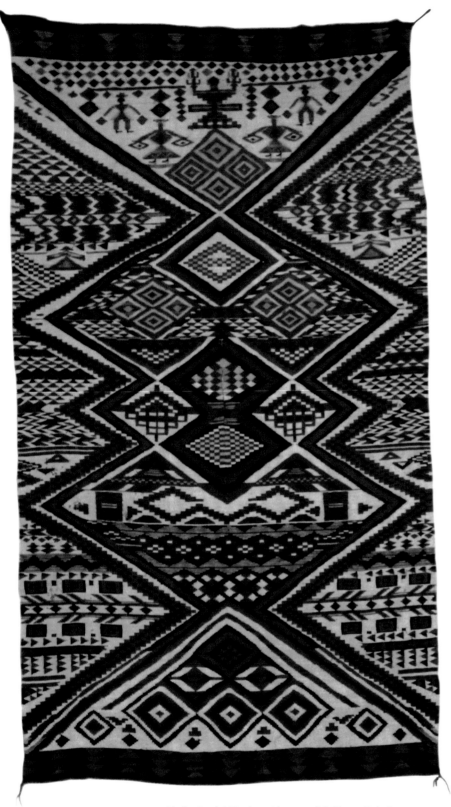

FIGURE 9.3. *Blanket (Poncho)*, Navajo, c. 1865–75; wool; 85 13/16 x 49 5/16 in. (217.9 x 125.2 cm); Natural History Museum of Los Angeles County (inv. no. A.5141.42-126).

the museum, which until then had been overshadowed by taxidermy groups and paleontological finds.[10]

In response McKinney received a sophisticated inquiry, brilliant in its brevity: Hearst wanted to know what the museum needed. McKinney's broad outline of everything from classical antiquity, Asia, and "material from the Byzantine to Baroque" exposed the baleful limitations of the institution.[11] Hearst made some lovely gifts, among them a view of the Spanish Steps by Childe Hassam and a very rare Spanish medieval silver pyx (fig. 9.4). Charles C. Rounds came to visit soon afterward, but McKinney's tenure did not last long beyond that. In 1946 he was replaced by James Breasted Jr.

Hearst revived his activity as a collector after the war ended. He acquired a Bacchic sarcophagus that was conspicuous for having been documented in the Renaissance (fig. 9.5) as well as two cassoni.[12] At two different junctures in 1946 the Greek vases that made up the collections of Marshall Brooks (May 14) and Viscount Cowdray (December 2) were auctioned. Brooks's country estate at Tarporley gave its name to one vase painter (see fig. 9.6), and Lady Cowdray was known for her remarkable taste (moreover, her husband's profile in the oil industry was so high that the Rockefellers had to buy his interest in Mexico to avoid competing with him).[13] Hearst seized the opportunity and bought about forty vases at the sales. He also bought two rare Peruvian armorial banners (fig. 9.8), which were hung in the north wing of Casa Grande in 1946.

Once Hearst left San Simeon in 1947, probably no one believed that he would log any further accomplishments beyond his eighty-three years. Then a soul mate unexpectedly materialized on his doorstep. It was William Valentiner, who arrived in Los Angeles (to him, "the furthest point of western civilization") after reaching the obligatory retirement age as director of the Detroit Institute of Arts.[14] The Los Angeles County Museum had appointed him consulting director for the art division. An irrepressible polymath who spread himself too thinly—publishing on everything from terra-cottas by Ghiberti to paintings by Rembrandt, with expertises on cassoni that were real and Cellini cups that were not, and an article about Jacques-Louis David thrown in for good measure—the German-born Valentiner was Hearst's kindred spirit. He quickly renewed their acquaintance.

Valentiner had visited San Simeon early in January 1931 and found it an "unexpected joy." Describing the hilltop then as "the village of the Holy Grail," he recalled how the

limousine (lent by Edsel Ford) "stopped in front of the marble, piled-up fairytale castle." It had "what everybody dreams of: old art combined with modern comfort," he wrote. In comparison Huntington's estate in San Marino, California, disappointed him. An entry in his diary records his preference for the idiosyncratic character of San Simeon's interiors: "Jan. 14 [1931]. [Huntington's] is really a wonderful collection, of English masterworks of the 18th century, but the whole thing is so very impersonal, built of no personality. It really was built by an art-dealer [i.e., Duveen].... The effect is much stronger...when a strong personality with a passion to collect is the creator of an art-collection, like Hearst for instance."[15]

As Valentiner was leaving him, Hearst asked if there was anything he wanted to acquire for the museum. Valentiner "was astounded," he wrote later, "as no wealthy collector had ever asked me such a question" during the forty years that he had worked in museums. He had to think quickly. Spontaneously he mentioned an Annunciation group by Andrea della Robbia that was on loan from Adolph Loewi, a dealer who opened a branch of his Venetian operation in Los Angeles. Hearst said he would try to find the money for it. A week went by in silence, and then the president of the Hearst Corporation made an impromptu visit to the museum. After another week Hearst's son David delivered a check for $50,000 to pay for the sculptures.[16] Hearst then contributed $100,000 of his own for further acquisitions, and his newspaper reported an additional grant of $250,000. With these funds Valentiner purchased, among many other things, a Tang dynasty ceramic camel, etchings by Giovanni Battista Piranesi, the spectacular gilded terracotta portrait of Pope Alexander VIII by Domenico Guidi, and paintings by José Leonardo and Hans Bol.[17]

"He was exceedingly kind," Valentiner wrote. He believed that Hearst's purchases for himself at that time were modest, perhaps when judged against what he had amassed in his heyday, but in 1947 Hearst bought thirty-two pieces of armor, including a Venetian mail shirt.[18] Paintings by Salvator Rosa followed. Valentiner recalled: "Although he hardly ever left the house he was still amazingly active...in the art world.... He could never go to the museum, since his health was slowly failing, [but] he was still interested in the public auctions in London and New York.... His nurse told me once that his constant interest in these sales and in the development of our museum actually kept him alive."[19] Even though Hearst was courted by other directors, he

FIGURE 9.4. *Standing Pyx*, Spain (Barcelona), c. 1400 (cat. no. 43).

FIGURE 9.5. Sarcophagus with Dionysos and His Followers, Roman, c. AD 230–40 (cat. no. 111).

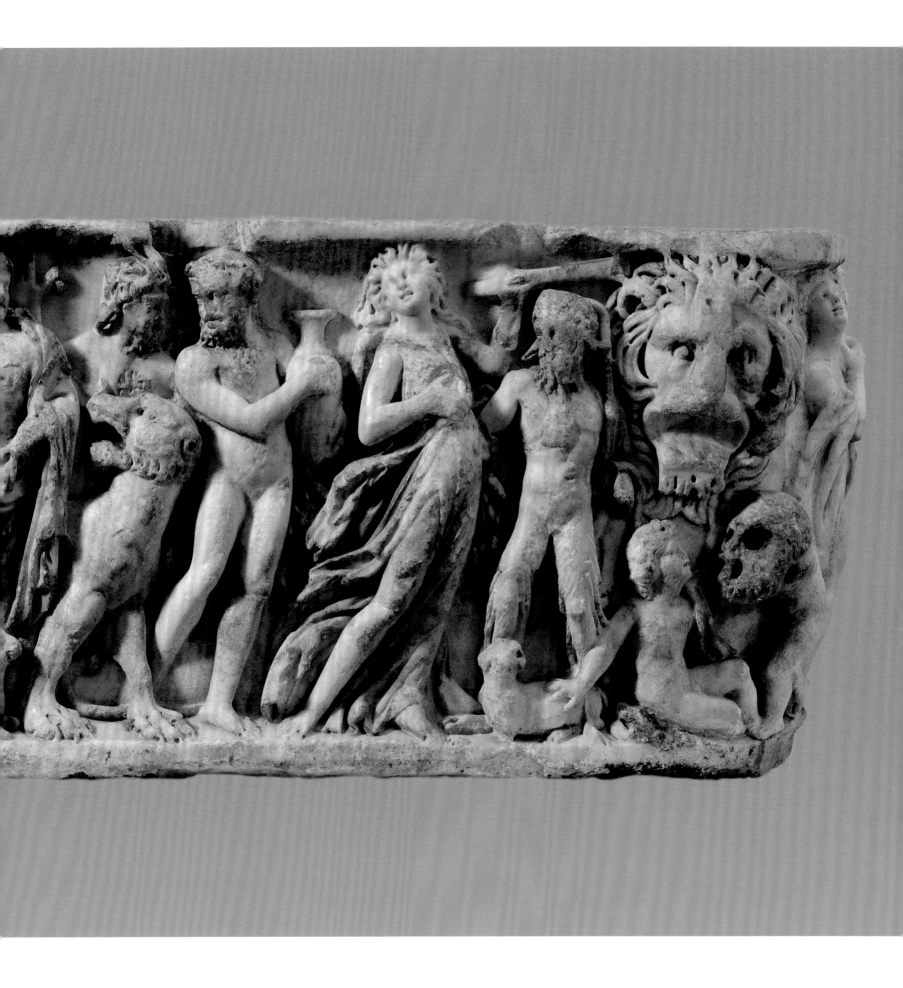

FIGURE 9.6. Attributed to the Tarporley Painter, Red-Figured Bell-Krater (Wine Bowl), c. 400–390 BC (cat. no. 101).

FIGURE 9.7. Attributed to the Michigan Painter, Black-Figured Stamnos (Wine Bowl), c. 500 BC (cat. no. 97).

focused on Los Angeles.[20] It is to his credit as a philanthropist that he gave where the need was greatest.

In all, Hearst donated, either from his own collections or through direct purchase for the museum, about nine hundred objects. Among these gifts was a contribution of $850,000 from Hearst Magazines to pay Davies for nineteen paintings from the Beach House, including funds for the refurbishment of the galleries in which they would be displayed. One of the museum's early trustees recounted how she "witnessed, amazed, the outpouring of princely Hearst gifts" that Valentiner brought to the museum month after month.[21]

They reveal Hearst's eclecticism in all its eye-popping glory. There were effigies of knights from Spain, ancient Near Eastern cylinder seals, the renowned Erickstanebrae Fibula, pre-Columbian gold, the sandals of an African king, medieval altarpieces from France, Egyptian antiquities, and all the Greek vases that Hearst bought for himself in 1946 (e.g., cat. nos. 94, 96, 97, 99, 101–5). A treasury of thirty Limoges enamels (e.g., cat. nos. 59–63) was assembled from Hearst's personal collection. The Buonafede altarpiece of the Nativity came too. In 1948 and 1949 Hearst bought up several

examples of maiolica and about three dozen paintings at auction in London and gave them all to the museum in 1949. Sculptures that were already in place at the Enchanted Hill were removed and sent to Los Angeles: among them were the renowned Hope Athena (fig. 9.10), a gilded bronze bust that had once belonged to Georges Hoentschel (fig. 9.9), and a sixteenth-century painted terra-cotta sculpture of the Madonna and Child that Valentiner surely recalled from his days in Berlin.[22] Only a collector of Hearst's scope could have provided gifts of such breadth.[23] On May 5, 1950, Rounds wrote to Valentiner about Hearst's vigorous interest: "Mr. Hearst wants to make additional gifts to the museum but I am in somewhat of a quandary as to the type of objects to suggest to him."[24] It was as though Hearst, reborn in the last five years of his life, decided to embark on furnishing a seventh residence.

Three of the original six had been dismantled: the Clarendon, Sands Point, and the Beach House. The Hearst Corporation preserved Wyntoon privately. Many of the fittings of Saint Donat's were sold to Sir William Burrell, who bequeathed them in 1944 to the city of Glasgow, which

FIGURE 9.8. *Armorial Banner,* Peru, c. 1580 (cat. no. 36).

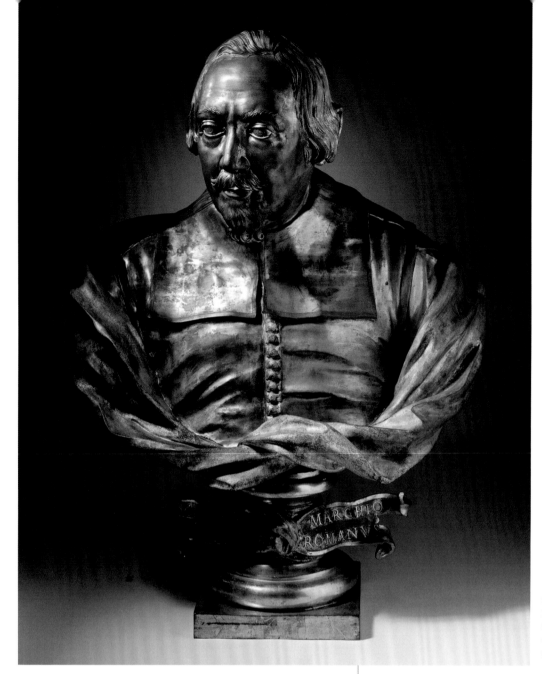

FIGURE 9.9. Attributed to Pietro Paolo Naldini, *Bust of Bartolomeo Ruspoli (d. 1681)*, 1670–80 (cat. no. 117).
FIGURE 9.10. The Hope Athena, Roman, mid-2nd century AD (cat. no. 109).

established a museum in his name. In 1960 the castle was finally sold to Antonin Bresse, a French benefactor, who gave it to the founders of the United World Colleges.

There remained the Enchanted Hill. Hearst wanted to offer it to the University of California, possibly to fulfill a promise he made to his mother a year before she died, that he would build a museum for her collections at Berkeley.[25] He believed that "a museum was an artistic achievement to be shared with others," explained his son. "That is precisely what the great galleries of Europe had taught him. He was saying that we would use the place for a while,... but one day it would belong to the American people.... He believed in giving them a good show in a breathtaking American setting—an enchanted castle and gardens created in the grand European manner."[26] The university, however, could

not cope with a property of such size and complexity. As an alternative, the Hearst Corporation's officers decided to offer the Enchanted Hill to California. The corporation retained the sixty thousand surrounding acres, which were preserved as a working ranch. When the castle opened to the public in 1958, the response was sensational. The Hearst Corporation and Foundations also donated or sold hundreds of works of art to museums across the United States. Hearst had invested a fortune to bring them from abroad. The fact that more than a million visitors to the two largest repositories of his collections—the Hearst San Simeon State Historical Monument and the Los Angeles County Museum of Art—every year delight in his treasures testifies to his accomplishments. Hearst probably would have been pleased by the result.

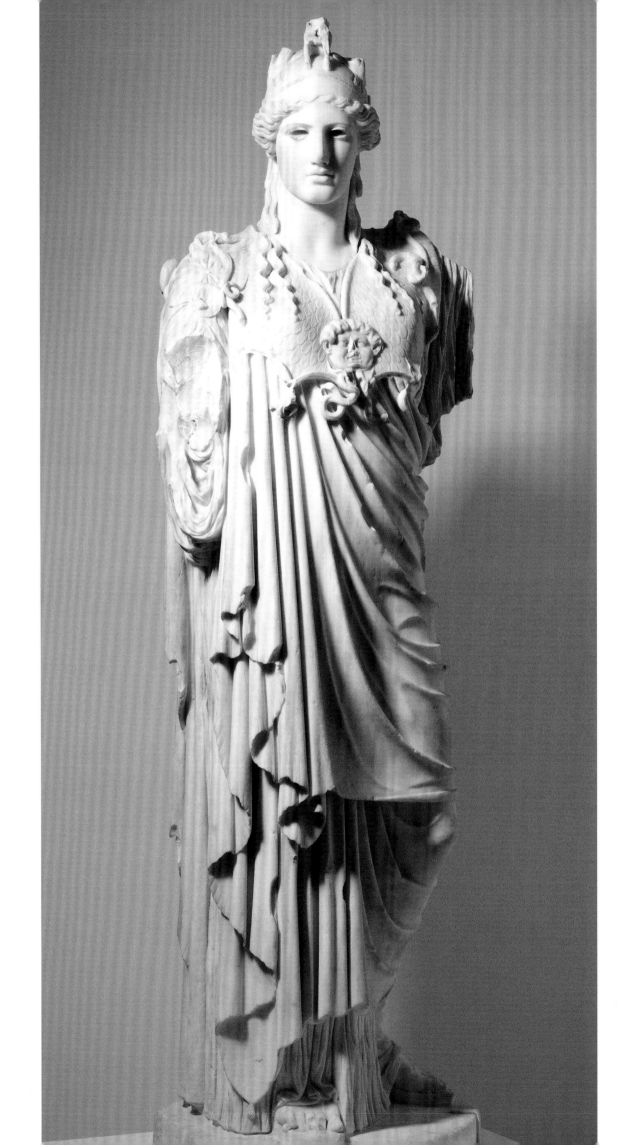

Notes

1. Hearst Jr., *The Hearsts*, 60. Hearst's empire was cut to 40 percent by his estimate; he still owned sixteen dailies, with circulation of five million, and eight magazines. Revenue was approximately $50 million (probably c. 1945). Licensing and syndication added more. Swanberg (*Citizen Hearst*, 488) commented, "That Hearst did not die of chagrin in 1938 or 1939 was a miracle of fortitude."

2. Linn, "Hearst to Disperse Vast Art Holdings."

3. Rounds to Willicombe, December 13, 1937, Hearst Papers, 40:57, about a list of tapestries, possibly for the Los Angeles County Museum, that included the Beauvais tapestry "Pastoral Love, by Boucher" (ex-collection Morhan, Boni de Castellane, bought from French & Co., April 2, 1924). The portrait of a bearded man (cat. no. 133), then attributed to Rembrandt, seems also to have been considered at that juncture.

4. On the offer to the Museum of the American Indian, see correspondence of February 27, 1938, Hearst Papers, 39:38. Many of Hearst's textiles duplicated what was already in that collection.

5. Registrarial archives, Natural History Museum of Los Angeles County.

6. Nancy Blomberg, *Navajo Textiles: The William Randolph Hearst Collection* (Tucson: University of Arizona Press, 1988), 12 (mentions 158 of a total of 186 textiles).

7. Morgan to Hearst, August(?) 1932; Morgan to Hearst, then Hearst to Morgan, May 12, 1937; request to Morgan to send to San Simeon four Gothic windows, one Spanish ceiling, and collection of Indian blankets, sent from Wyntoon, June 29, 1940, all Morgan Papers. A hand-tinted interior view of Jolon shows a blanket hung on a banister (Morgan Papers), but Hearst disapproved of that treatment too. The photograph is reproduced in Kastner, *Hearst Castle*, 159, and Boutelle, *Julia Morgan*, 233.

8. Byk to Hearst, July 9, 1941, Hearst Papers, 40:20: "Our [Paris] place…has been Aryanized and a lot of our valuable antiques have been taken over by the Germans.… Our London place has been bombed."

9. Byk to Hearst, September 19, 1944, Hearst Papers, 40:20. According to Taylor Coffman (personal communication to the author, 2005 or 2006), Hearst might have known McKinney from when he was director of the Baltimore Museum of Art.

10. Summarized in Levkoff, "Little-Known American Provenance."

11. McKinney to Hearst via Rounds, March 29, 1945, registrarial records, Los Angeles County Museum of Art. See Mary Levkoff, "William Randolph Hearst's Gifts of European Sculptures to the Los Angeles County Museum of Art," *Sculpture Journal* 4 (2000): 162. The museum did benefit from gifts of American art, Asian textiles, and a handful of European paintings from other donors.

12. The sarcophagus was in the Whitney auction in February 1946. Hearst bought it from Brummer. It was listed in the inventory kept at Hearst Castle. A fifteenth-century cassone was bought from the Straus sale at Parke-Bernet on October 13, 1945; the other was bought at auction through French & Company around January 23, 1947, and sent in May to Beverly Hills. Both were later donated to the Fine Arts Museums of San Francisco (Hearst Castle inventory).

13. Robert Middlemas, *The Master Builders* (London: Hutchison, 1963), 163–69, 176–77. On December 2, 1946, McPeake Jr. sent photographs of thirteen vases purchased at Sotheby's to the office at Wyntoon (Hearst Papers, 45:27). Hearst also bought a painting of the Madonna and Child by Bouguereau at auction on October 24, 1946. A picture by Lawrence Alma-Tadema was among these postwar acquisitions.

14. Margaret Sterne, *The Passionate Eye: The Life of William R. Valentiner* (Detroit: Wayne State University Press, 1980), 306.

15. Valentiner Papers, Archives of American Art, Smithsonian Institution, reel 2140, frames 768–69, pp. 42–43. Amy Walsh kindly brought this reference to the author's attention.

16. Sterne, *Passionate Eye*, 316.

17. Valentiner also purchased sculptures and paintings of lesser quality and doubtful authenticity with Hearst funds. Over time these purchases became confused with objects that Hearst had actually owned and contributed to the formation of negative opinions about his judgment as a collector.

18. Hearst bought armor at auction in London on December 4, 1947 (Hearst Corporation papers), and on November 5, 1948 (Hearst Corporation papers).

19. Quoted in Sterne, *Passionate Eye*, 315.

20. For example, David Finley, the director of the National Gallery of Art, wanted to talk to Hearst in July 1947 (message to Hearst on May 22, 1947, Hearst Papers, 45:27). James Rorimer of the Metropolitan visited him in 1941 and the warehouses later (foreword, *Metropolitan Museum of Art Bulletin*, n.s., 15 [March 1957]: unpaged).

21. Caroline Liebig, "The First Twenty Years," *Los Angeles County Museum Quarterly* 16, no. 2 (1960): 8.

22. See Levkoff, "Hearst's Gifts," 167–68. Among other sculptures removed from the castle to benefit Los Angeles (listed in the inventory called the Forney notebooks at Hearst Castle) are a fragment of seraphim (from an altar attributed to Antonio Rossellino, from the Canessa sale, March 29, 1930), which was in the Assembly Room, as was the Hope Athena and a Roman bust that was believed to be a portrait of the Empress Faustina (ex-collection Fritz August von Kaulbach, bought in October 1929). A colossal Egyptian head (cat. no. 92) and a basalt squatting scribe (bought from Christie's, May 20, 1930; donated 1948) were in the main library, as was the gilded bronze bust. A sculpture of the Madonna and Child, believed to be Burgundian (purchased from Demotte, June 1933; exhibited at the Institute of French Art in New York in 1928, in Seattle's exhibition of Gothic sculpture in 1931, and in San Diego in 1932), came out of the Gothic Suite library.

23. "Even you as a munificent donor could hardly realize the extent of the transformation of the art galleries which your gifts have brought about," wrote the president of the museum to Hearst in 1950 (registrarial archives, Los Angeles County Museum of Art). An objective commentary appears in an obituary for Albert Barnes and Hearst, who died within a few weeks of each other: Hearst's donations "fertilize soil virtually virgin when it comes to experience of the classics.… Barnes and Hearst leave no collectors of equal stature" (Alfred Frankfurter, "Grandeur and Double Exit: Hearst and Barnes," *Art News* 50 [October 1951]: 13).

24. Registrarial archives, Los Angeles County Museum of Art. See Levkoff, "Hearst's Gifts," 166.

25. Hearst Jr., *The Hearsts*, 85. The census of Hearst philanthropies undertaken for the Hearst Corporation by Mildred Hamilton notes that Hearst had first considered donating the castle to the Franciscan Order. According to Robinson (*American Dynasty*, 377, 416n10), in 1918 Phoebe canceled his debts to her. In return she expected him to "pay me $300,000, which I want…to construct a building to house my collections at Berkeley. I want you to consider that a serious business obligation and agree to pay that and pay it." Hearst erected a gymnasium at Berkeley in her memory, but the gallery that was planned as part of it was never built. On the building, see Kenneth H. Cardwell, *Bernard Maybeck: Artisan, Architect, Artist* (Santa Barbara, Calif.: Peregrine Smith, 1977), 198–202. The dedicatory plaque at San Simeon reads, "La Cuesta Encantada presented to the State of California in 1958 by the Hearst Corporation in memory of William Randolph Hearst who created this Enchanted Hill, and of his mother, Phoebe Apperson Hearst, who inspired it."

26. Hearst Jr., *The Hearsts*, 76. Hearst alluded to this in an interview in 1946 when he commented that his own enjoyment of his collections was not as important as the enjoyment that others could obtain from them; he also pointed out that not everyone could travel abroad (quoted by Kastner, *Hearst Castle*, 221).

Note to the Reader

The works of art in the exhibition are representative of the breadth and quality of Hearst's collections, primarily of European works of art. Many extraordinary objects were not available for loan, however: they were either too costly to transport, or they were too significant to the museums where they are housed to be removed. As explained in the introduction, Hearst's pre-Columbian, African, Islamic, and Asian objects were outside the scope of what could reasonably be presented, while his art from the United States would constitute another exhibition on its own.

In addition to works of art formerly owned by Hearst, the catalogue also includes a selection of architectural drawings and accessories in order to underscore Hearst's patronage of living artists and architects and to give a sense of the character and history of the residences that he conceived.

Works that are not in the exhibition are indicated by the symbol ∙.

Provenance
Provenances of objects are as complete as possible. When a logical chronological gap occurs in a provenance, it is not emphasized or noted. If a brief gap in history might suggest that Hearst bought an object very early, however, the gap in information is noted where appropriate.

Bibliography
The bibliographies for the objects are limited to three or four publications, generally the most recent or those that provide further bibliography, and include only those publications in which the object is mentioned. Additional sources are listed in notes.

Exhibition History
An exhibition history is given for each object that is known to have been included in a special exhibition. If there is an exhibition catalogue, the catalogue number is given wherever possible. For works of art with extensive exhibition histories, only a selection is included.

Credit Lines
For objects in the collection of the Los Angeles County Museum of Art for which the Hearst Foundation is listed as the donor, we have tried to clarify whether the object was originally bought by Hearst and then transferred to the foundation. In some cases we do not know whether Hearst truly owned the object or whether it was instead purchased by the museum with funds provided by the foundation.

Archival Sources
The following archival sources are cited in abbreviated form in the entries:

Duveen Archive, GRI
Duveen Archive, Getty Research Institute, Los Angeles. Included in microfilm are additional Duveen documents housed in the Duveen Archive at the Metropolitan Museum of Art.

Hearst Castle inventory
This is also called the Pacific Coast inventory. The inventory at Hearst Castle is a synoptic version of Hearst's more detailed inventory of what was held on the West Coast, for example, in the warehouses at San Simeon or at Wyntoon.

Hearst Corporation papers
Documents belonging to the Hearst Corporation.

Hearst Papers
William Randolph Hearst Papers, Special Collections, Bancroft Library, University of California, Berkeley.

Morgan Papers
Julia Morgan Papers, Special Collections, Robert E. Kennedy Library, California Polytechnic State University, San Luis Obispo.

Authors
The authors of the catalogue entries are identified by their initials as follows:

Christine E. Brennan	CEB
Martin G. Chapman	MGC
Andrew J. Clark	AJC
Jens Daehner	JD
Brian D. Gallagher	BDG
Wolfram Koeppe	WK
Linda Komaroff	LK
Mary L. Levkoff	MLL
Nancy E. Loe	NEL
J.-Patrice Marandel	JPM
Thomas Michie	TM
Carolyn H. Miner	CHM
Stuart W. Pyhrr	SWP
Thom Richardson	TR
Graeme Rimer	GR
Jana Seely	JS
Jon L. Seydl	JLS
Nancy Thomas	NT

Above: Scene of the Rape of Ganymede, detail of
Wheellock Sporting Gun, made by Nicolas Keucks,
Germany (Rhineland), c. 1620 (cat. no. 26).
Page 145: *Armor* (detail), Italy (Milan), c. 1600–1610
(cat. no. 25).

I

Julia Morgan, AIA (American, 1872–1957)

ELEVATION OF CASA GRANDE AND GUESTHOUSES, c. 1919

Pencil and colored pencil on tracing paper
18 x 18 in. (45.7 x 45.7 cm)
Kennedy Library, California Polytechnic State University
(80-13-403)
Page 59

Provenance: Julia Morgan Estate; donated to California Polytechnic State
University, 1980.

This early annotated sketch of Casa Grande and three sur-
rounding guesthouses reflects the long-distance collaboration
between Hearst and architect Julia Morgan. Given her thriv-
ing architectural practice in San Francisco, Morgan usually
worked at San Simeon on weekends. Frequent telegrams,
letters, and drawings sent between architect and client docu-
ment the design process and their inspirations.

"We are building for him a sort of village on a mountain-
top overlooking the sea and ranges and ranges of mountains,
miles from any railway, and housing…his collections as
well as his family. Having different buildings allows the use
of very varied treatments; as does the fact that all garden
work is on steep hillsides, requiring endless steps and ter-
racing," Morgan wrote to art dealer Arthur Byne in 1921
(September 19, 1921, Morgan Papers). NEL

2

Julia Morgan, AIA (American, 1872–1957)

STUDY FOR FOUNTAIN, HOUSE C, 1921

Pencil on tracing paper
11 x 9 in. (27.9 x 22.8 cm)
Kennedy Library, California Polytechnic State University
(80-13-585)

Provenance: Julia Morgan Estate; donated to California Polytechnic State
University, 1980.

Late in 1921 Julia Morgan drew this preliminary sketch
for the fountain on the terrace of House C, or Casa del Sol.
Hearst wrote to Morgan, "I think the fountain of the lion
spitting into the tank (to phrase it poetically) is best placed

on the center of the stairs opposite the court of C"
(December 9, 1921, Morgan Papers).

The fountain was assembled from carved marble and
limestone and eventually completed with a bronze copy of
Donatello's *David*. Hearst approved, writing that it was
"something conspicuous and useful and attractive too in the
middle of the blank space to the west that we always feel
needs filling up" (Hearst to Morgan, August 14, 1926,
Morgan Papers). NEL

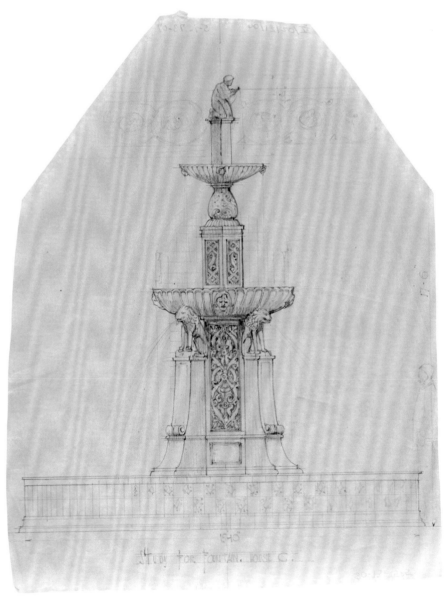

2

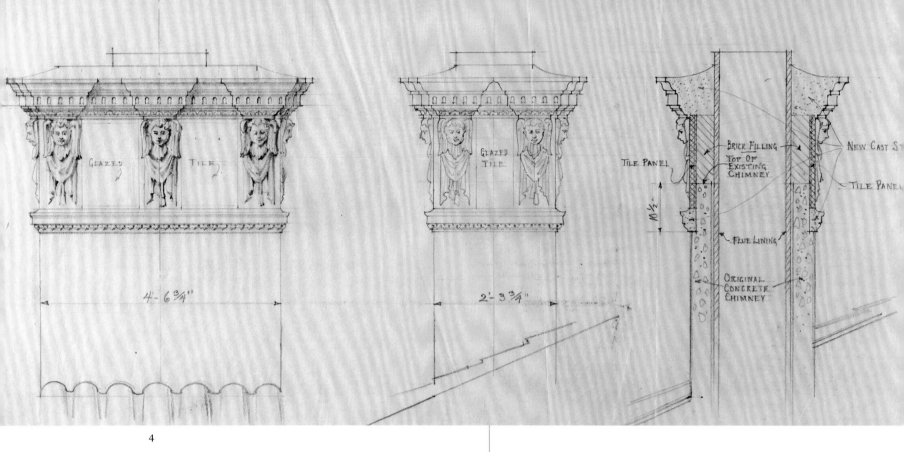

4

3

Julia Morgan, AIA (American, 1872–1957)
STUDY FOR LOWER HALL OF HOUSE A, c. 1922

Pencil and colored pencil on tracing paper
13 x 20 in. (33 x 50.8 cm)
Kennedy Library, California Polytechnic State University
(80-13-472)
Page 58

Provenance: Julia Morgan Estate; donated to California Polytechnic State University, 1980.

Morgan and her staff made hundreds of preliminary sketches like this one so that Hearst could envision and approve of the placement of his many works of art throughout the estate. Eager to occupy the buildings from the moment the first spadeful of earth was turned, Hearst believed that smaller structures could be completed more rapidly. As a result, the earliest construction efforts were devoted to Casa del Mar, or House A, which Hearst and his family would occupy, and its two companions, Casa del Monte and Casa del Sol (Houses B and C, respectively). NEL

4

Julia Morgan, AIA (American, 1872–1957)
DECORATIVE DETAIL FOR CHIMNEY, HOUSES A AND B, 1923

Pencil on tracing paper
9 x 18 in. (22.8 x 45.7 cm)
Kennedy Library, California Polytechnic State University
(80-13-443)

Provenance: Julia Morgan Estate; donated to California Polytechnic State University, 1980.

This sketch illustrates the seraphim on the exteriors of the chimneys on the first two guesthouses. Julia Morgan's classical training in architecture at the École des Beaux-Arts in Paris, her background as a civil engineer, and her considerable experience in using reinforced concrete made her ideally suited to the enormous tasks Hearst proposed. The first building under construction at San Simeon, House A, was Hearst's residence at the estate while the main building was being built. NEL

5

Julia Morgan, AIA (American, 1872–1957)
STUDY FOR ASSEMBLY ROOM, c. 1924

Pencil and colored pencil on paper
20 x 18 in. (50.8 x 45.7 cm)
Kennedy Library, California Polytechnic State University
(5-I-FF55-02)
Page 58

Provenance: Julia Morgan Estate; donated to California Polytechnic State
University, 1980.

In 1925 the twenty-five-hundred-square-foot Assembly Room, which illustrator Ludwig Bemelmans described as "half of Grand Central Station," was nearing completion. This sketch illustrates one of the settings Morgan designed for Hearst's collection of tapestries, which the publisher delighted in telling guests were merely an early form of newspaper. He enjoyed slipping quietly into the Assembly Room from a disguised door to the left of the fireplace, startling guests who had gathered for cocktails before dinner. NEL

6

Julia Morgan, AIA (American, 1872–1957)
STUDY FOR TILE, c. 1925

Pencil on paper
16 x 13 in. (40.6 x 33 cm)
Kennedy Library, California Polytechnic State University
(80-13-535)

7

Julia Morgan, AIA (American, 1872–1957)
STUDY FOR TILE, H-34, c. 1925

Pencil on paper
14 x 12 in. (35.6 x 30.5 cm)
Kennedy Library, California Polytechnic State University
(80-13-539)

Provenance: Julia Morgan Estate; donated to California Polytechnic State
University, 1980.

Julia Morgan sent these iterative sketches for decorative tiles for the master bedroom of House A to William Bragdon of California Faience to begin the work of casting, glazing, and firing the custom-designed pieces.

The exquisite tiles used lavishly at San Simeon are an important though often overlooked element in the

6

7

8

ensemble. Designed by Morgan to complement antique tiles in Hearst's collection, they enhance floors, walls, stair risers, soffits, friezes, and patios, as well as the esplanade and twin bell towers at the estate. NEL

8

Julia Morgan, AIA (American, 1872–1957)
STUDY FOR TILE WITH SEAHORSES (NUMBERED "H31-H30"), c. 1925

Pencil on paper
11 x 18 (27.9 x 45.7 cm)
Kennedy Library, California Polytechnic State University
(80-13-532)

9

Julia Morgan, AIA (American, 1872–1957)
TILING FOR FLOOR IN MR. HEARST'S BEDROOM, c. 1925

Pencil and colored pencil on paper
11 x 21 in. (27.9 x 53.3 cm)
Kennedy Library, California Polytechnic State University
(80-13-503)

Provenance: Julia Morgan Estate; donated to California Polytechnic State University, 1980.

Bibliography: Robert C. Pavlik, "The Tile Art of San Simeon: A Social and Cultural Perspective," *Tile Heritage* 4 (Winter 1997): 3-11.

For the floor of Hearst's master bedroom in House A, Julia Morgan conceived lozenge-shaped tiles featuring sea creatures, in keeping with the aquatic design elements of Casa del Mar. Early in the design process she selected California Faience to produce most of the decorative tiles at San Simeon. Founded by William Bragdon, California Faience was an influential participant in the Arts and Crafts movement, pioneering the production of art pottery in the Bay Area. In addition to the work at San Simeon, Bragdon's firm produced tiles for other Morgan commissions, including San Francisco's Fairmont Hotel and the Berkeley Women's City Club.

Two other Bay Area tile firms supplied materials for San Simeon: Gladding, McBean & Company produced terra-cotta pavers for the terraces, and decorative tile used in the kitchen was crafted by Solon & Schemmel. NEL

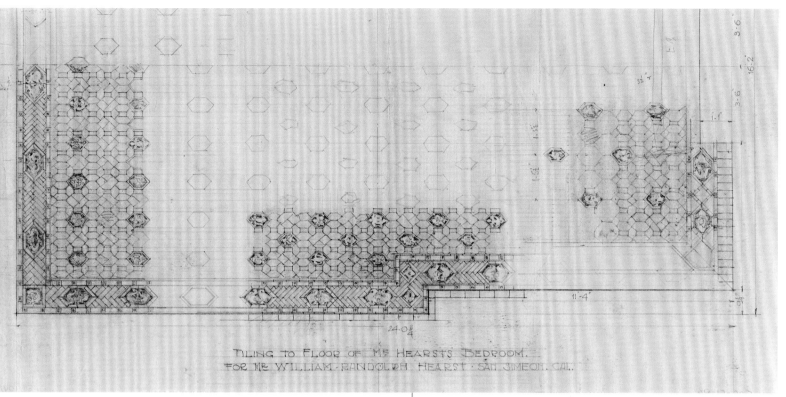

9

10

Julia Morgan, AIA (American, 1872–1957)
STUDY FOR TILING FOR TOWER OF MAIN BUILDING, 1927

Pencil and colored pencil on tracing paper
36 x 19 in. (91.4 x 48.3 cm)
Kennedy Library, California Polytechnic State University
(FF54-07)

Provenance: Julia Morgan Estate; donated to California Polytechnic State University, 1980.

This sketch illustrates the details of the cupola and tile placement on the bell towers. Julia Morgan redesigned Casa Grande's towers to accommodate Hearst's request for a carillon and new guest rooms. The original pencil-shaped finials inspired by the Cathedral of Ronda in Spain were removed, and the former towers were enclosed to create the Celestial Suite bedrooms. Above each suite, Morgan directed the placement of the carillon bells and practical twenty-five-thousand-gallon water tanks.

 "Mr. William Randolph Hearst is building a country estate in California," Morgan wrote, "the site being on top of a mountain about 1800 feet above the sea, and commanding the coast for miles, as well as range after range of mountains.... He would like a carillon of the Belgian type of about 25 to 35 bells, sweet in tone, wide in range.... As the bells are to serve a decorative, as well as musical purpose, they are to be hung in the openings of the towers" (Morgan to Michiels Brothers Foundry, October 8, 1921, Morgan Papers). NEL

11

Julia Morgan, AIA (American, 1872–1957)
ART GALLERY FOR MR. HEARST, December 1930

Pencil on paper
25½ x 34⅜ in. (64.8 x 87.2 cm)
Hearst Castle/California State Parks (inv. no. 2.4.4.4.6)

Provenance: Julia Morgan(?).

This drawing might be for the rotunda east of the main patio of Casa Grande, which is mentioned briefly in correspondence between Hearst and Julia Morgan in April 1932 in which a long gallery (cat. no. 12) connecting the north and south wings was discussed as an alternative (Morgan Papers). This drawing could easily be a cross section of the gallery's central element. Two previous messages exchanged between

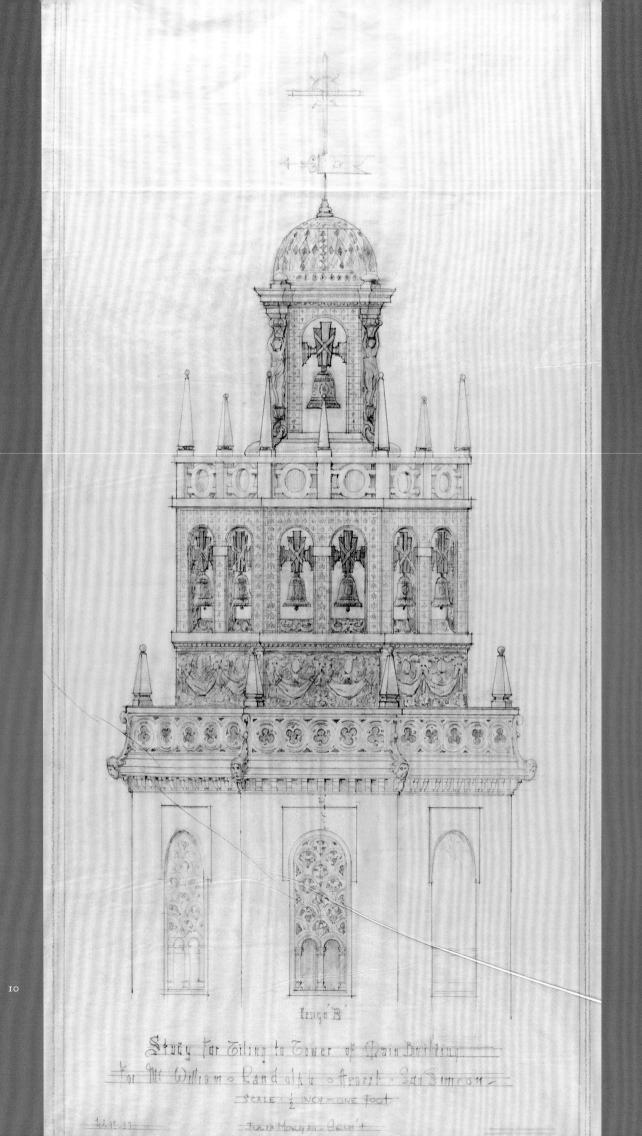

Design 'B'

Study for Tiling to Tower of Main Building

For Mr William · Randolph · Hearst · San Simeon

Scale ½ inch = one foot

Julia Morgan · Arch't

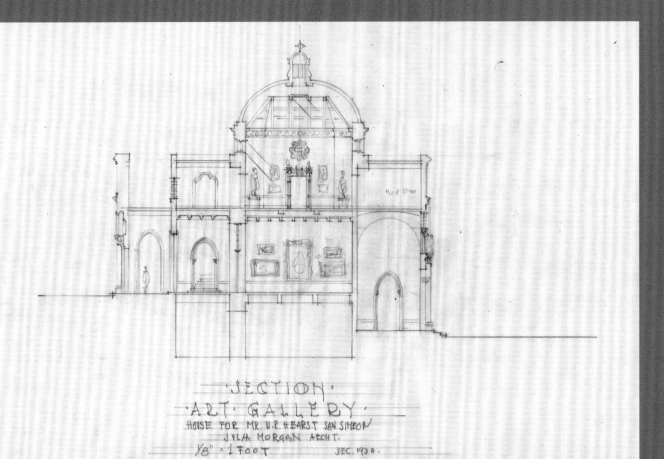

·SECTION·
·ART· GALLERY·
HOVSE FOR MR. W.R. HEARST SAN SIMEON
JVLIA MORGAN ARCHT.
⅛" = 1 FOOT DEC. 1930.

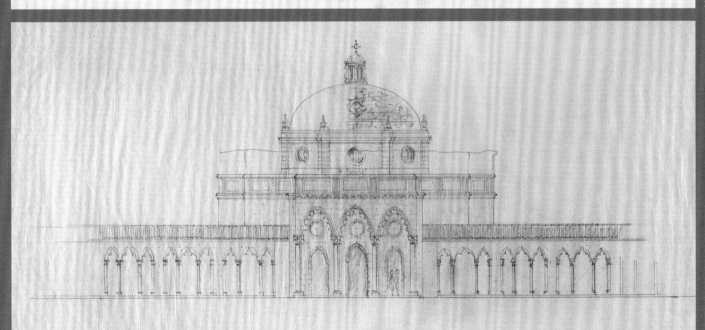

·PATIO· ELEVATION·=·
·ART· GALLERY·
HOVSE FOR MR. W.R. HEARST ·SAN SIMEON CALIF.·
JVLIA MORGAN ARCHT.
SCALE ⅛" = 1 FOOT.
DEC. 1930

Hearst and Morgan must be related to it: on March 19, 1930, Morgan referred to Hearst's sketch of a "picture gallery," and on March 21 Hearst asked Morgan if she would "approve of the art gallery" (Morgan Papers).

Although Hearst did eventually refer to San Simeon as a museum, he apparently did not consider any arrangements (other than this one) that resembled the formal installations of paintings and sculptures customary in public museums—that is, without integrating them with furniture, textiles, and other decorative arts.

An element of fantasy is embodied here in the attachment of a single bedroom to the second floor. In a collector's vision of an ideal lodging, he might awake to an ensemble of masterpieces housed in a building resembling a centrally planned Italian High Renaissance chapel. Hearst could have thought of this as a rotunda. MLL

12

Julia Morgan, AIA (American, 1872–1957)
PATIO ELEVATION, ART GALLERY, 1930

Pencil and colored pencil on paper
21 x 30 in. (53.3 x 76.2 cm)
Kennedy Library, California Polytechnic State University
(5-I-FF55-01)

Provenance: Julia Morgan Estate; donated to California Polytechnic State University, 1980.

This elevation illustrates Morgan's plan to enclose the courtyard at the rear of Casa Grande by adding a fourth wing that would serve as an art gallery. Conceived in 1930, just as Hearst's income began to decline, the structure was never built. Morgan drew numerous other plans for additions that Hearst desired, including two more guesthouses, a zoo complex, a ballroom, a banquet hall, a polo field, a croquet lawn, and a topiary maze. In 1926 he effused: "Perhaps we might have a temple here, or an Alhambra tower, or a Moorish pavillon [sic], or Chinese tea garden, or something that would be effective and enjoyable.... We can walk over the grounds and plan out these things. I am merely making these notes as reminders" (Hearst to Morgan, August 14, 1926, Morgan Papers). NEL

13

Julia Morgan, AIA (American, 1872–1957)
LONGITUDINAL SECTION FOR TAPESTRY ROOM,
November 28, 1932

Pencil and colored pencil on paper
67 5/16 x 29 3/16 in. (170.9 x 74.2 cm)
Hearst Castle/California State Parks (inv. no. 2.4.4.4.08)
Pages 66–67

Provenance: Julia Morgan(?).

This drawing records an idea developed by Hearst and Julia Morgan for the interior of the fourth wing of Casa Grande (see cat. no. 12). It would have been even grander than Hearst's armory at the Clarendon. Hearst suggested to Morgan (April 26, 1932, Morgan Papers) a hall 150 feet long, lined with eight "great Gothic tapestries," four on each side. The choir screen from the Cathedral of Valladolid would be opposite the entrance, with a high Moorish ceiling at the center. When the hall was not in use for entertaining, it would house "collections in cases in the middle" and armor, Hearst added. He had bought thirty-eight items of Turkish, Indian, and Persian arms and armor at Anderson Gallery's auction on May 14, 1921. They would have been ideal for this plan.

In September 1932 Hearst informed Morgan that he had finally acquired two horse armors, thereby fulfilling her vision: "You always drew the big hall...with two horse-armors.... There is no reason now why we should not go ahead...of course in due time—when [they] have been paid for." The wing was never built. MLL

14

Romanelli Brothers or M. Montani, Florence
ALABASTER LAMP COVERS WITH VARIOUS DESIGNS
(DAISY DESIGN, RIBBON DESIGN, AND GROTESQUE
MASK DESIGN), c. 1927

Alabaster
Height: 11 in. (27.9 cm); diameter: 21 in. (53.3 cm)
Hearst Castle/California State Parks (inv. nos. 529-9-4790, 529-9-4879, 529-9-4935)

Provenance: Commissioned by William Randolph Hearst, prior to 1930.

Bibliography: Hearst Castle Archives, Hearst San Simeon State Historical Monument/CA State Parks; Morgan Papers; Hearst Papers.

Marble lamp standards topped by translucent carved alabaster shades illuminated San Simeon's walkways, terraces, and pools. They were commissioned from two Florentine firms, Romanelli Brothers and M. Montani, prior to 1930. While some of the lamps were provided from the companies' stock patterns, others were executed from designs created by Julia Morgan and her staff.

Lamp covers of different shapes—hand carved with diverse patterns that included daisies, ribbons, and grotesque masks—were apparently not restricted to a single location; historic photographs, taken at various times, show them in different areas of the gardens.

An incident concerning the lamps reveals Hearst's close attention to detail in the operation of his estate. Weather extremes necessitated removal of the fragile alabaster covers seasonally. When staff failed to move the globes to safety in anticipation of a storm, Hearst's correspondence described his displeasure over the resulting damage and his determination that the oversight not be repeated. JS

15

Willy Pogany (Hungarian, active in the United States, 1882-1955)
THE MUSICIANS PLAY, c. 1935-36

Charcoal on wove paper
115 x 72 in. (292.1 x 182.9 cm)
Inscribed on reverse: 58 / Musicians
Hearst Corporation

16

Willy Pogany (Hungarian, active in the United States, 1882-1955)
GNOME WITH BAG OVER SHOULDER (HOLDING ON TO LEFT CORNER OF BUILDING), c. 1935-36

Charcoal with red conté crayon on wove paper
56 x 62 in. (142.2 x 157.5 cm)
Inscribed on reverse: #18 / use sand paper / Gnome Middle
Hearst Corporation

14

15

17

Willy Pogany (Hungarian, active in the United States, 1882–1955)
BEAR BEING HUGGED BY MAIDEN IN FLOWING GOWN, c. 1935–36

Charcoal with red conté crayon on wove paper
72 x 60 in. (182.9 x 152.4 cm)
Inscribed on reverse *#15 / House Peak / Maiden & Bear White Dress / use sand paper*
Hearst Corporation

These drawings are full-scale cartoons for frescoes created by Willy Pogany for two of the cottages at Wyntoon. A noted illustrator of Hungarian origin, Pogany arrived in the United States in 1914, after two years in Paris and ten in London. His lavish illustrations frequently appeared in Hearst's *American Weekly* magazine, and his murals for the Children's Theater in New York were published in Hearst's *International Studio* in October 1925. According to Pogany's obituaries in the *New York Times* (July 31, 1955) and *Time* magazine (August 8, 1955), he also created murals for the Ziegfeld Theater and the Ritz Tower in New York. Hearst was therefore personally familiar with his work when he commissioned the frescoes. Pogany had also decorated a ceiling in John and Mable Ringling's house in Sarasota. His success continued in Los Angeles with work for Walt Disney.

The paintings must have been planned by September 1935, when Hearst apologized to Julia Morgan about having left her behind at Wyntoon: "Miss [Marion] Davies and Mr. Pogany were so anxious to get to Los Angeles before the studio closed. Miss Davies should have reported on Monday, but I held her over to discuss things with you and Mr. Pogany." Brown Bear House was ready to be painted in August 1936, when Pogany examined the plaster. On November 13, 1936, Morgan reported to Hearst that Pogany had completed the frescoes on Brown Bear House and the front of Cinderella House and had blocked out the sides of Cinderella House but that it was too cold to continue (Morgan Papers). The frescoes are but a single aspect of Hearst's wide-ranging patronage of living artists, most of whom were engaged to illustrate his magazines and newspapers. MLL

16

17

18

Mail Shirt and Aventail for a Basinet
Germany, mid-14th century

Iron, copper alloy
Height as mounted: 42 3/16 in. (107 cm); shirt, riveted link diameter: 1/2 in. (1.26 cm), welded link diameter: 1/2 in. (1.26 cm), weight: 23 lb. 6 oz. (10.61 kg); aventail link diameter outside: 1/2 in. (1.23 mm), weight: 7 lb. 1 oz. (3.21 kg)
• Royal Armouries, Leeds (inv. no. III.1279–80)

Provenance: Dr. Fritsch, Lucerne; sold privately to William Randolph Hearst via Raymond Bartel, June 1935; purchased by the Tower Armouries with the aid of the National Art Collections Fund and the Pilgrim Trust, 1952.

Bibliography: E. Martin Burgess, "The Mail Shirt from the Hearst Collection," *Antiquaries Journal* 38 (July–October 1958): 197–204.

This mail shirt and aventail are traditionally associated with Rudolf IV of Hapsburg, Duke of Austria, Carinthia, and Ferrette (1339–1365). The hip-length mail shirt, or habergeon, is constructed of alternate rows of riveted and welded rings, the riveted links closed by wedge-shaped rivets. As such it is one of a very few examples of European mail datable to the fourteenth century. The cuffs are bordered by three rows of copper alloy links closed by wedge-shaped iron rivets, and the lower edge by two rows. A collar of heavy fifteenth-century riveted mail has been added to the neck; the shirt probably did not originally have a collar, and this supports a pre-1350 date for it. The aventail is of mail of all-riveted construction, the links fastened by wedge-shaped rivets. The mail is bordered by two rows of copper alloy links. The basinet with which it is displayed is a modern restoration.
TR

19

Composite Field Armor
Northern Italy (Milan and Brescia) and Austria (Mulhau), 1440–80

Steel, leather
Height as mounted: 69 1/8 in. (175 cm); weight: 41 lb. 1 oz. (18.65 kg)

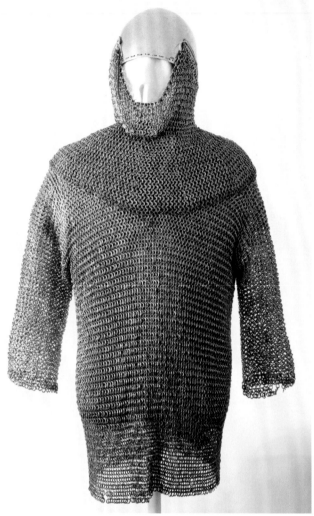

18

Sallet stamped with marks attributed to Giano Vimercati of Brescia; bevor stamped with the cross-keys mark attributed to Giovanni Negroli of Milan; breastplate stamped with the mark attributed to "Zoan" Giovanni da Castello of Milan; cuisses stamped on their upper plates by a Master ZA, possibly Ambrogio Zapellis of Milan; greaves stamped by an unidentified Milanese Master OI; pauldrons stamped with the triple marks of an unidentified Milanese Master IO.
• Royal Armouries, Leeds (inv. nos. II.168, III.1354)
Page 103

Provenance: Armory of the Trapp family at Schloss Churburg; offered for sale, Galerie Fischer, Lucerne, May 13, 1936, lot 82; sold privately to William Randolph Hearst via Raymond Bartel, June 1, 1936; purchased by the Tower Armouries with the aid of the National Art Collections Fund and the Pilgrim Trust, 1952.[1]

Bibliography: Mario Scalini, *L'armeria Trapp di Castel Coira* (Udine: Magnus, 1996), 45–46, 71–72, pl. II.20; Oswald Graf Trapp, *The Armoury of the Castle of Churburg*, trans. James G. Mann (London: Methuen, 1929), 62–65, no. A23, pls. XXVIIIb, XXIX, XXXVIIIb.

The armorers of northern Italy, especially Milan, held a predominant place in the manufacture of armor in the mid-fifteenth century, and even as far north as England armor "of the touch of Milan" was a byword in excellence. This armor gives a good impression of the export armors made for the German-speaking Tyrol, but its components are mixed, and it is unlikely that they were worn together during the time of their use. The composite assembly is nevertheless a good illustration of Italian export armor of the period and is typical of Hearst's taste for medieval armor.

The armory of the Counts Trapp at Schloss Churburg in the Italian Tyrol is legendary in the field of medieval armor studies. Preserved there since the time of its use, with scarcely any modification, is the finest group of medieval European armor in private hands in the world. Although the collection has survived until the present day largely intact, a few pieces were sold after 1930, and the majority of these are now in the collection of the Royal Armouries, purchased from the Hearst collection. TR

Notes

1. The German leg defenses that had been associated with the armor as acquired were exchanged with Count Trapp in 1957 for the Italian leg defenses that now form part of it. The arm defenses were acquired from the collection of E. Valentine, who purchased them about 1957 as part of another composite armor in London. The late fifteenth-century German mail shirt displayed with the armor was purchased from the collection of Sir Edward Barry with the aid of the National Art Collections Fund, 1965.

20

ARMOR IN THE GOTHIC STYLE

Germany (Augsburg), c. 1485 and later

Steel, copper alloy, leather
Height as mounted: 70 ⅝ in. (179.4 cm)
The Detroit Institute of Arts, Gift of the Hearst Foundation, 1953 (inv. no. 53.193)

Provenance: Princes Hohenzollern-Sigmaringen, Schloss Sigmaringen, Bavaria; sold to Arnold Seligmann, Rey & Co., New York, 1929; sold to William Randolph Hearst, New York, 1930; presented to the Detroit Institute of Arts by the Hearst Foundation, 1953.

Bibliography: Ortwin Gamber, "Der Turnierharnisch Kaiser Maximilians I, und das Thunsche Skizzenbuch," *Jahrbuch der Kunsthistorischen Sammlungen in Wien* 53 (1957): 43, 48, figs. 51–53; Francis W. Robinson, *A Selection from the William Randolph Hearst Collection of Arms and Armor in the Detroit Institute of Arts* (Detroit: Detroit Institute of Arts, 1954), 6–7.

20

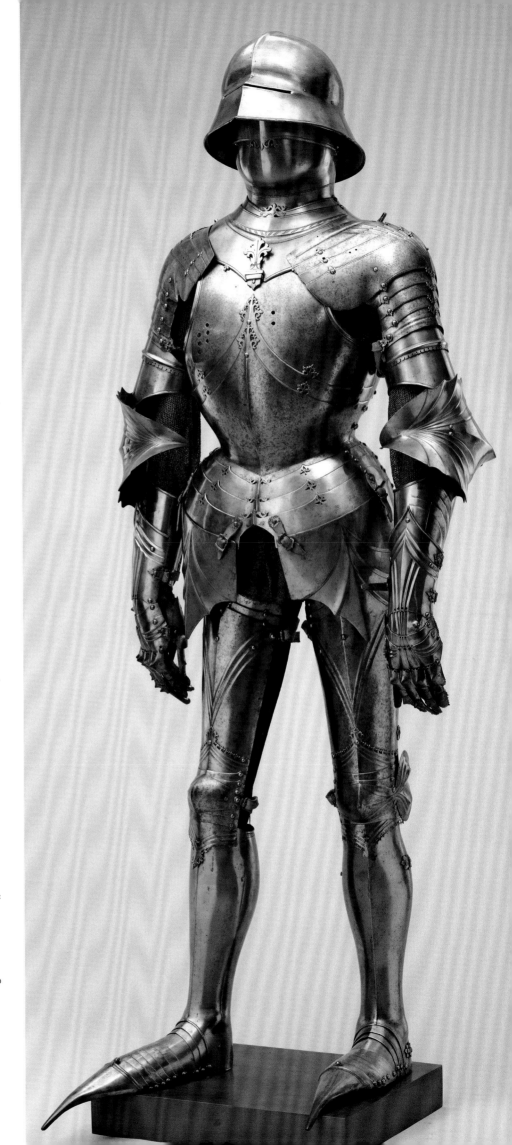

"Gothic armor," a term loosely applied in the past to any European harness made before 1500, was the greatest prize for any serious armor collector. To the romantic it symbolized an age of chivalry and the last flowering of knighthood; to the connoisseur it was the purest form of armor, in which technical and aesthetic considerations were in perfect balance. Complete and homogeneous late medieval armors are extremely rare, even in national museums, while the majority of those appearing on the art market tend to be composite at best and fake at worst. Among twentieth-century collectors, Hearst had the best luck in acquiring genuine "Gothic" armor, including this important, though restored, example.

The armor comes from the Hohenzollern armory at Sigmaringen Castle in Bavaria, a largely nineteenth-century collection, and was secured for Hearst by the dealer Arnold Seligmann (with intense competition from Joseph Duveen) in 1929 for $60,000. The genuine elements comprise the breast and backplate, both shoulder defenses (pauldrons), and thigh defenses (cuisses), most of which bear the mark of Lorenz Helmschmid of Augsburg, the finest German armorer of his generation. They are thought to form part of a specialized armor (*Rennzeug*) for the joust with sharp lances that was probably made around 1485 for the future emperor Maximilian I (1459–1519, r. 1508–19). With their gracefully shaped plates articulated with cusps and sprays of ridges and their edges decoratively pierced, these elements are masterpieces of the armorer's art. The remaining skillfully restored parts are the work of a Munich armorer around 1870. SWP

21

SHAFFRON

Germany, c. 1510–20

Steel

Height: 25½ in. (64.5 cm); width: 12³⁄₁₆ in. (31 cm);
weight: 7 lb. 4 oz. (3.29 kg)
• Royal Armouries, Leeds (inv. no. VI.368)

Provenance: Dukes of Ratibor, Schloss Grafenegg; sale, Galerie Fischer, Lucerne, May 2, 1934, lot 90 (associated with a composite Maximilian armor and modern horse armor); sold to William Randolph Hearst via Raymond Bartel, November 27, 1935; purchased by the Tower Armouries with the aid of the National Art Collections Fund and the Pilgrim Trust, 1952.

This head defense for a horse is decorated with the fluting characteristic of the Maximilian style of armor popular in the German lands in the early sixteenth century. The escutcheon is etched with a man drawing a cart in which there is a lute. Above is a scroll inscribed "Ein Lauten auf einem Kar fier die Nar" (A fool transports a lute on a cart). The original source of the engraving has not been identified, but it closely resembles the style and content of illustrations for Sebastian Brant's *Narrenschiff* (*The Ship of Fools*), published in 1494, attributed to Albrecht Dürer and others.

Grafenegg Castle has a particular importance in the history of arms and armor because parts of the collection there were from the Imperial Arsenal in Vienna, given by Charles VI to Count Breuner and passed by marriage to the dukes of Ratibor. TR

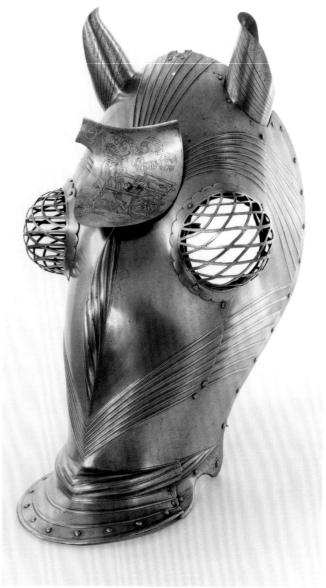

21

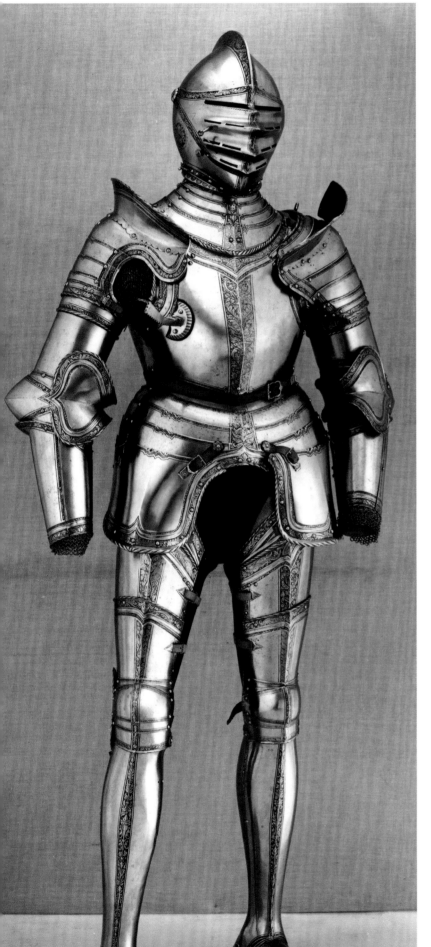

Probably Jörg Seusenhofer (Austrian, fl. 1526–80)

FIELD ARMOR

Austria (Innsbruck), dated 1549

Steel, leather

Height as mounted: 69½ in. (176 cm); weight: 45 lb. 5 oz. (20.57 kg)

Dated in a cartouche etched at the right of the helmet comb

• Royal Armouries, Leeds (inv. no. II.169)

Provenance: Prince Charles of Prussia, Zeughaus, Berlin; sale, Sotheby's, London, July 2, 1936, lot 134 ("from a public museum"); sold to William Randolph Hearst; purchased by the Tower Armouries with the aid of the National Art Collections Fund and the Pilgrim Trust, 1952.

Exhibitions: *Die Innsbrucker Plattnerkunst*, Tiroler Landesmuseum, Innsbruck, 1954, no. 102.

Bibliography: James G. Mann, "The Etched Decoration of Armour: A Study in Classification," *Proceedings of the British Academy* 27 (1940): 17–45, pl. xvb (p. 21); A. V. B. Norman, *Wallace Collection Catalogues: European Arms and Armour Supplement* (London: Wallace Collection, 1986), 108, no. A409.

This full armor for the field is typical of the fine mid-sixteenth-century products of the court armory of Innsbruck, established by Maximilian I. It is of hardened but not fully quenched steel, etched but not gilded, with narrow bands decorated with grotesque monsters and classical trophies of arms amid scrolling foliage on a granulated ground. The decoration on the band at the center of the breastplate and the left cuisse, or thigh defense, includes the device of a serpent twined around an anchor, associated with the Poppenberger family of Regensburg. The same date and similar decoration appear on a saddle in the Wallace Collection, London (inv. no. A409), in association with the fire steel badge of the Schurff family, and it has been suggested that the armor and saddle were made together for Wilhelm I Schurff (1484–1556), one of the executors of the will of Maximilian I. The etching is in the manner of Leonhard Meurl, who worked on the finest Innsbruck products of this period but who died in 1547.[1] TR

Notes

1. The backplate is from another armor, added to complete the arrangement, as were a pair of associated gauntlets, which were removed from the armor before 1952. The solid tassets were restored for Hearst by Raymond Bartel (Bartel to Sir James Mann, February 10, 1942, Royal Armouries archive), replacing the modern articulated tassets on the armor in 1936. The helmet has an associated but contemporary bellows visor, probably from a great basinet for the foot combat.

23

ARMOR FOR THE TILT
Germany (Augsburg), c. 1580

Steel, copper alloy, leather, paint
Height as mounted: 71 ⅜ in. (181.3 cm)
The Detroit Institute of Arts, Gift of the William Randolph
Hearst Foundation, 1953 (inv. no. 53.196)

Provenance: Archibald Kennedy, thirteenth earl of Cassilis, Baron Ailsa, Culzean
Castle, Ayrshire, Scotland; Jean-Baptiste and Louis Carrand, Paris; Frederick Spitzer,
Paris; his sale, Galerie Georges Petit, Paris, June 10–14, 1895, lot 6; William Randolph
Hearst, New York; presented to the Detroit Institute of Arts by the Hearst Foundation,
1953.

Exhibitions: L'Exposition historique du Trocadéro, Palais du Trocadéro, Paris, 1878 (see
Breban, Livret-guide); The Art of the Armorer, Flint Institute of Arts, Flint, Michigan,
1967–68, no. 8.

Bibliography: Philibert Breban, Livret-guide du visiteur à l'Exposition historique du
Trocadéro (Paris: E. Dentu, 1878), 53; Émile Molinier, ed., La collection Spitzer (Paris:
Maison Quantin, 1893), vol. 6, 2, no. 6, illus. p. 3; Francis W. Robinson, A Selection from
the William Randolph Hearst Collection of Arms and Armor in the Detroit Institute of Arts
(Detroit: Detroit Institute of Arts, 1954), 18–19.

This armor was designed for use in the tilt, an equestrian
contest fought between two armored combatants who rode
at each other, left side to left side, their blunted lances aimed
across a separating wooden barrier (the "tilt"), with the pur-
pose of splintering lances against the opponent or unseating
him. The armor's smooth, deflecting surfaces and its solid
construction helped to ensure the wearer's safety. The helmet,
for example, is bolted rigid to the breast and backplates to
prevent whiplash and has a narrow vision slit and ventilation
holes located only on the protected right side; the concave
tilt shield at the left shoulder is also bolted to the torso, and
the vulnerable left arm has a reinforcing plate at the elbow.
The harmonious integration of these essential features of
defense with aesthetic considerations—the armor's sleek
lines and elegant proportions—exemplifies the art of the
European armorer.

 The harness is stamped with the marks of the famous
south German armor-making center of Augsburg (the
pinecone and pearled A marks) and assembly or series
marks (crescents and dots), but it unfortunately lacks a
maker's mark.

 This is thought to be one of a series of similar tilt har-
nesses removed from Munich by Napoléon's troops in 1800.
Many of the armors ended up soon afterward on the English
art market, where they were acquired by collectors inspired
by the Gothic revival and Sir Walter Scott's tales of chivalry.

The Detroit armor is unique in having painted on the shield
the arms of one of its later owners, the young Scottish Earl
of Cassilis (1816–1870), who, in the guise of the Knight of
the Dolphin (and apparently wearing a different armor),
participated in the famous romantic (and rain-drenched)
Eglington Tournament in 1839. SWP

24

ARMOR FOR THE TILT IN THE SAXON FASHION
Germany (Annaberg or Dresden), c. 1590

Steel, leather
Height as mounted: 68 ⅞ in. (174.9 cm)
The Detroit Institute of Arts, Gift of the William Randolph
Hearst Foundation, 1953 (inv. no. 53.197)

Provenance: Armory of the prince-electors and kings of Saxony, Dresden, until 1920s;
sold to William Randolph Hearst, New York, 1925; presented to the Detroit Institute
of Arts by the Hearst Foundation, 1953.

Exhibitions: Loan Exhibition of European Arms and Armor, Brooklyn Museum, 1933,
no. 10; The Art of the Armorer, Flint Institute of Arts, Flint, Michigan, 1967–68, no. 9.

Bibliography: Max von Ehrenthal, Führer durch das Königliche Historische Museum zu
Dresden, 3rd ed. (Dresden: Wilhelm Baensch, 1899), 42–44; Francis W. Robinson, A
Selection from the William Randolph Hearst Collection of Arms and Armor in the Detroit
Institute of Arts (Detroit: Detroit Institute of Arts, 1954), 22–23.

Since the Middle Ages tournaments provided knights, men-
at-arms, and courtiers the opportunity to test their martial
skills in mock combats. The major spectator sport of the age
of chivalry, the tournament often served as political propa-
ganda, a visible demonstration of the wealth, power, and
magnificence of the event's sponsor. This was particularly
true of the Renaissance and baroque tournaments held by
the prince-electors of Saxony in Dresden, which were unri-
valed in splendor. The Detroit armor, which comes from the
Dresden armory, witnessed many of these spectacles.

 This example is one of three dozen nearly identical tilt
armors that were made for court use by local Saxon armorers
in the late sixteenth century. The Saxon examples are readily
distinguished from contemporaneous south German tilt
armors (e.g., cat. no. 23) by their helmet, a late form of sallet
covering only the upper part of the face, which necessitated
a separate bolted-on chin defense (bevor). These armors
remained in use into the eighteenth century, and many have
painted inside the backplate the name of the latter-day
knights who wore them. The Detroit armor bears the name
of Count Hans Caspar Lesgewang, a courtier who in the
1720s administered the important mining regions of Saxony.

23, 24

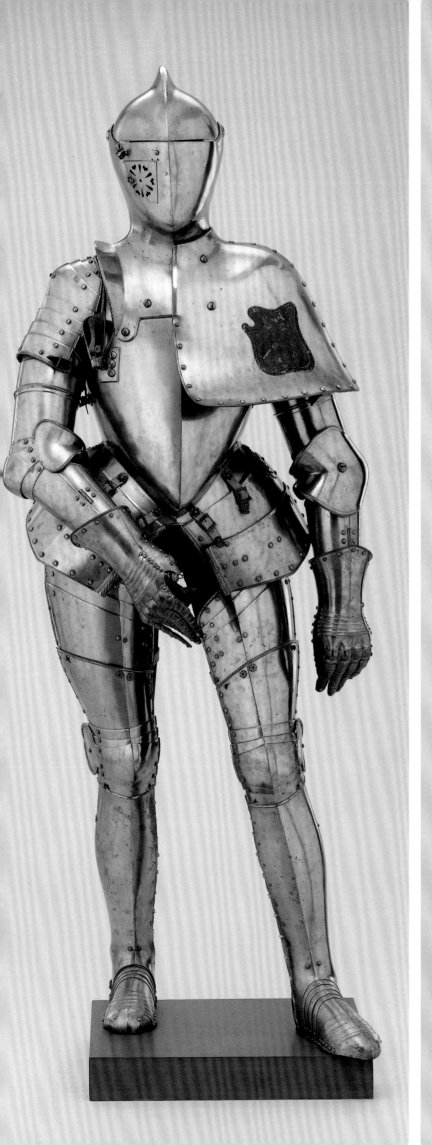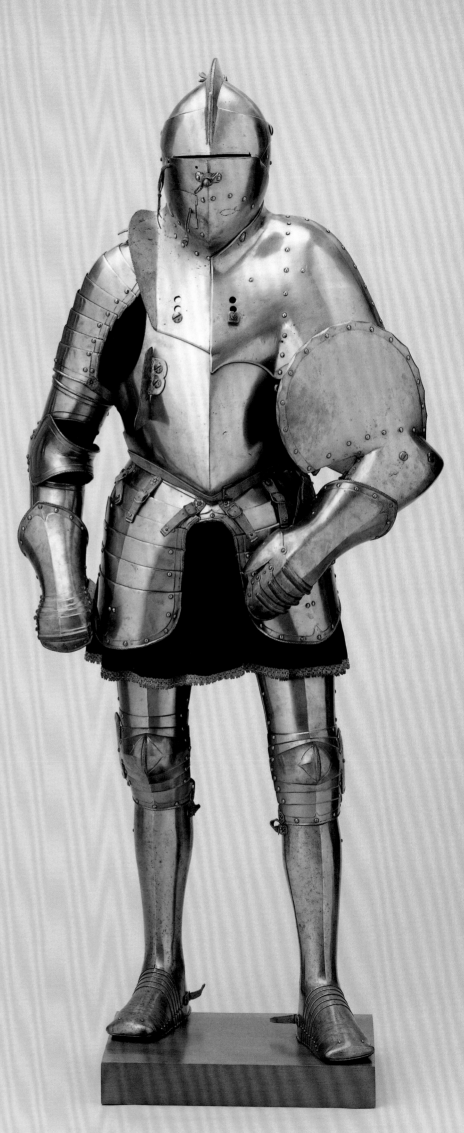

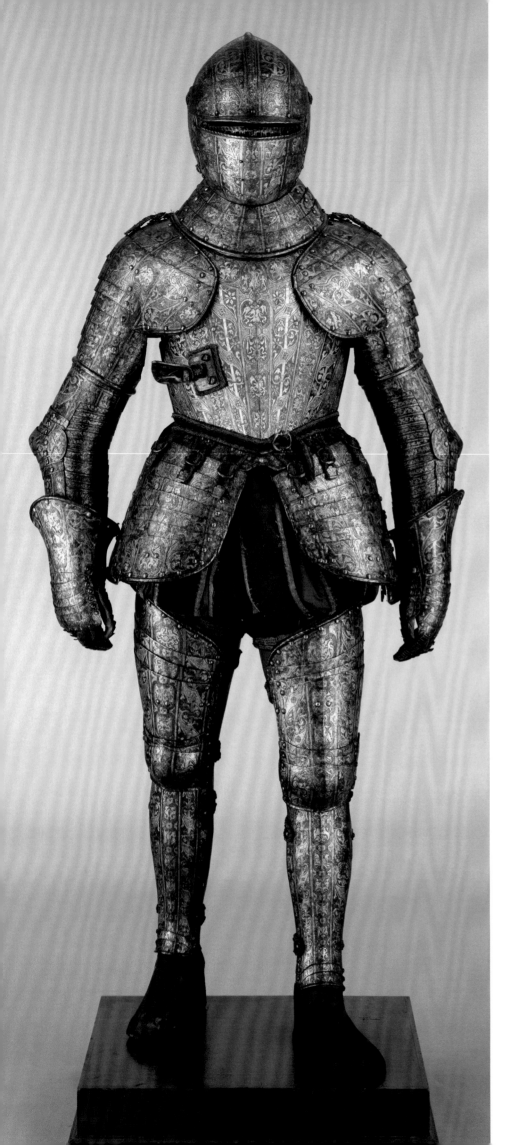

Following World War I a number of these armors were sold from the Dresden Historical Museum and were eagerly acquired by American collectors. In 1925 Hearst's major rivals, Clarence Mackay and the Metropolitan Museum of Art, each bought two examples; that year Hearst himself, who would eventually own four of them, acquired this example. SWP

25

ARMOR
Italy (Milan), c. 1600–1610

Steel, gold, silver, textile, leather
Height as mounted: 62½ in. (159 cm); weight: 42 lb. 6 oz.
(19.25 kg)
The Metropolitan Museum of Art, Fletcher Fund, 1938
(inv. no. 38.148.1)

Provenance: Princes Khevenhüller, Schloss Hoch-Osterwitz, Carinthia, Austria; Counts Giech, Schloss Thurnau, near Bayreuth, Germany, until 1923; sold to Anton and Hans Schedelmann, Munich, 1923; sold to William Randolph Hearst, New York, 1924; acquired by the Metropolitan Museum of Art, 1938.

Exhibitions: *Loan Exhibition of European Arms and Armor*, Brooklyn Museum, 1933, no. 12; *Loan Exhibition of Medieval and Renaissance Arms and Armor from the Metropolitan Museum of Art*, Los Angeles County Museum, California Palace of the Legion of Honor, San Francisco, and Carnegie Institute, Pittsburgh, 1953–54, no. 11.

Bibliography: L. G. Boccia and E. T. Coelho, *L'arte dell'armatura in Italia* (Milan: Bramante Editrice, 1967), 463–64, 480–81, pl. 424; Stephen V. Grancsay, "A Young Prince's Enriched Armor," *Metropolitan Museum of Art Bulletin* 34 (November 1939): 260–63; Hans Schedelmann, "Ein Rückblick auf den Waffenmarkt des letzten halben Jahrhunderts," *Waffen- und Kostümkunde*, 3rd ser., 15 (1973): 25, no. 4, 27, fig. 4.

Among Hearst's finest armors, this example is notable for its completeness, magnificent decoration, and superb condition. The armor retains its matching shaffron (defense for the horse's head) and rear saddle plates (the front ones are missing), not exhibited.

The surfaces are covered with dense ornament, including classical and allegorical figures, foliage, and distinctive S-shaped cartouches, the motifs chiseled, punched, and delicately damascened in gold and silver. This exacting decorative technique, more time-consuming and costly than traditional armor etching, is characteristic of a small group of Milanese parade armors made at the end of the sixteenth century. The most complete of these is a tournament armor for man and horse made for Archduke Albert, regent of the Netherlands, perhaps in connection with his ceremonial entry into Brussels in 1599.

Constructed as a traditional heavy cavalry armor, including a lance rest, this harness was probably intended more

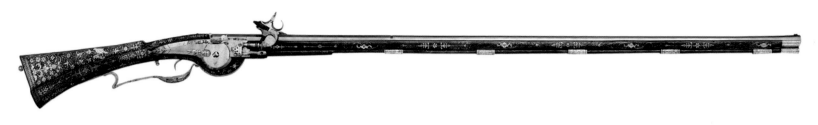

26

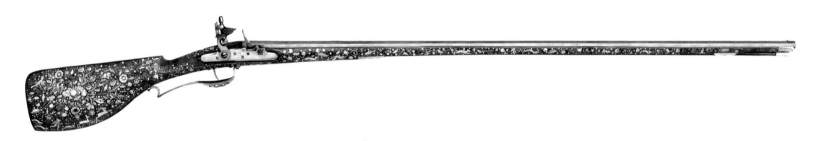

27

for show than for practical use. The armor's small size suggests that it was made for a young man, perhaps a member of the noble Khevenhüller family, from which it, together with two other armors, passed by marriage in the seventeenth century to the Counts Giech in Franconia. All three armors were acquired privately by Hearst in 1924, this example for $15,000, and were displayed in his New York apartment (see fig. 2.11). SWP

26

Wheellock Sporting Gun
Made by Nicolas Keucks
Germany (Rhineland), c. 1620

Overall length: 59 3/16 in. (150 cm); barrel length: 46 11/16 in. (118.2 cm); caliber: 0.5 in. (12.5 mm)
Engraved on the barrel: *Nicolas Keucks*
• Royal Armouries, Leeds (inv. no. XII.1551)

Provenance: Emil Buchel, Spandau; sold to William Randolph Hearst through Raymond Bartel by November 1934; purchased by the Tower Armouries with the aid of the National Art Collections Fund and the Pilgrim Trust, 1952.

Exhibitions: *Treasures from the Tower in the Kremlin*, State Museum of the Moscow Kremlin, 1997, no. 64.

Bibliography: Graeme Rimer, *Wheellock Firearms of the Royal Armouries* (Leeds: Royal Armouries Museum, 2001), 42–49.

This gun is a superb combination of function and design; it mixes the austere with the ornate and the practical with the

exquisite. It has a plain, unmarked lock and an octagonal barrel. The stock has a slender shoulder butt and is inlaid in silver with stylized flowers and foliage. Between the side nails is a scene representing the Rape of Ganymede (see p. 146). Little is known of the maker, who was believed to have worked in the Rhineland during the period 1620–30. The very high quality and medium of the stock decoration relate the gun to a group of other firearms, all of which are thought to have been made in the Rhineland or Lorraine. In this group the decoration of the old German school, characterized by the use of inlaid stag horn, is replaced by the newly emerging French fashion for inlays of silver wire and panels. The decoration is strongly influenced by designs by French artists Michel Le Blon, published in 1611, and Theodore de Bry. GR, TR

27

Flintlock Sporting Gun
Decorated by Jean Conrad Tornier
Germany (Alsace), dated 1646

Overall length: 59 1/2 in. (150.8 cm); barrel length: 44 in. (111.8 cm); caliber: 0.39 in. (1.0 mm)
Lock stamped with the mark of a shield with *FK* above two stars and a flower, attributed to the Solothurn gunmaker Franz Kruter; barrel stamped *IS* for the unknown maker and dated
• Royal Armouries, Leeds (inv. no. XII.1549)

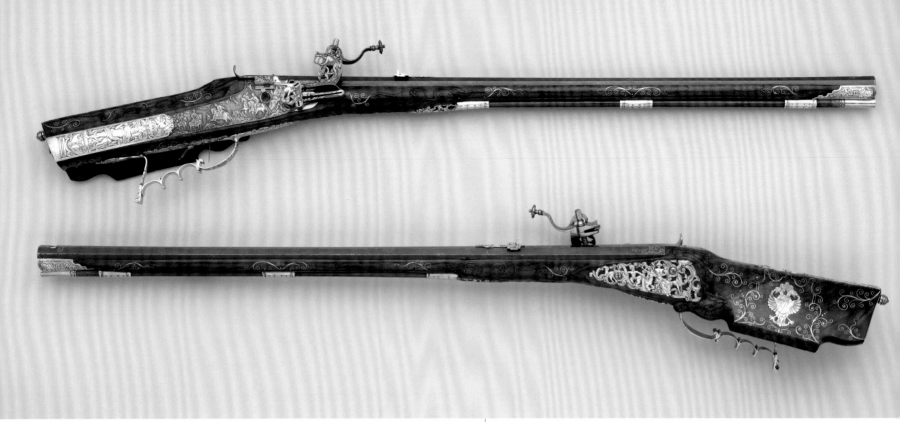

Provenance: Viennese collector; sale, Sotheby's, July 2, 1936, lot 89; sold to William Randolph Hearst; purchased by the Tower Armouries with the aid of the National Art Collections Fund and the Pilgrim Trust, 1952.

Exhibitions: *Treasures from the Tower of London*, Sainsbury Centre, Norwich, 1982, pp. 78–79

Bibliography: A. N. Kennard, "Jean Conrad Tornier," *Burlington Magazine* 77 (October 1940): 127–28; Hans Schedelmann, "Jean Conrad Tornier, an Alsatian Gunstock-Maker," *Journal of the Arms and Armour Society* 2 (December 1958): 261–70.

The wooden stock has a deep-bellied butt and is inlaid with plain, yellow-stained, and green-stained stag horn with intricate designs of bunches of flowers and fruit interspersed with birds and animals and hunting scenes. The rich decoration of the stock is attributed to Jean Conrad Tornier of Alsace, who signed a wooden casket of the same design in the Wallace Collection, London. It was inspired by designs by the engraver, art dealer, diplomat, and possible Rosicrucian Michel Le Blon (1587–1656), a German from Frankfurt am Main who moved to the Netherlands to study engraving under Theodore de Bry and worked in Amsterdam, London, and Stockholm. TR, GR

28

PAIR OF WHEELLOCK RIFLES OF EMPEROR LEOPOLD I
Made by Caspar Neireiter (recorded 1667–c. 1730)
Bohemia (Prague), c. 1690–1700

Steel, wood, silver, gold, copper alloy
Overall length: 43 ⅜ in. (110.2 cm); barrel length: 32 ⅛ in. (81.5 cm); caliber: 0.53 in. (14 mm)
Inlaid in gold along the top of each barrel: *Neireiter A Prag*
The Metropolitan Museum of Art, Purchase, Joseph Pulitzer Bequest, 1950 (inv. no. 50.203.1, 2)

Provenance: Emperor Leopold I (1640–1705, r. 1658–1705); Imperial Gewehrkammer, Vienna, 1785; Princes Thun-Hohenstein, Schloss Tetschen, Bohemia; their sale, Dorotheum, Vienna, October 24–26, 1933, lot 50 (one of pair); sold to William Randolph Hearst, Saint Donat's Castle, Wales; his sale, Galerie Fischer, Zurich, May 10, 1939, lot 88; sold to Hans Schedelmann, Vienna; sold to Kunsthistorisches Museum, Vienna, July 26, 1941; Galerie Fischer, Lucerne, June 15, 1950, lot 1640; sold to Leopold Blumka, New York; acquired by the Metropolitan Museum of Art, 1950.

Exhibitions: *Loan Exhibition of Medieval and Renaissance Arms and Armor from the Metropolitan Museum of Art*, Washington County Museum of Art, Hagerstown, Maryland, and Newark Museum, Newark, New Jersey, 1955, no. 96.

Bibliography: Hans Schedelmann, *Die Wiener Büchsenmacher und Büchsenschäker* (Berlin: Walter de Gruyter & Co., 1944), 60 (inv. no. 42).

Distinguished by their opulent silver mounts and original ornament, this matched pair of hunting rifles exemplifies the sophisticated design and craftsmanship practiced by central European gunmakers in the late baroque period. Each

rifle is inlaid in silver on the cheekpiece with the double-headed eagle of the Holy Roman Empire, on whose breast is displayed the double-tailed lion of Bohemia. The same lion appears on a shield beneath the raised figure of Zeus/Jupiter on the silver patchbox cover on the opposite side. The arms are those of Emperor Leopold I (r. 1658–1705), who also reigned as king of Bohemia from 1656. The rifles were made to order by the leading Bohemian gunmaker, Caspar Neireiter.

Recorded in an inventory of the imperial hunting cabinet in Vienna in 1785, the rifles passed into the possession of the Bohemian Counts Thun-Hohenstein, whose collection was sold in 1933. Hearst's armorer, Raymond Bartel, acquired one of the pair at auction and reunited it with its mate, apparently still in Thun possession, after the sale. They subsequently entered the armory at Saint Donat's Castle, Wales, where the majority of Hearst's purchases of the 1930s were displayed. SWP

29

HUNTING SWORD
Part of the hunting suite of Ernst August (1688–1748), Grand Duke of Saxe-Weimar-Eisenach
Hilt: Germany, c. 1740; blade: Europe, c. 1620

Copper alloy, steel
Overall length: 37.6 in. (95.5 cm); blade length: 32.2 in. (81.8 cm); weight: 1 lb. 9 oz. (.71 kg)
• Royal Armouries, Leeds (inv. no. IX.954)

Provenance: Grand dukes of Saxe-Weimar-Eisenach, Schloss Ettersburg, Saxony; sold anonymously (probably by the dealer Hal Furmage, liquidating the stock of Cyril Andrade) in London; sale, Sotheby's, London, July 26, 1935, lot 43 (with a saddle and pair of pistols from the same source); sold to William Randolph Hearst via Raymond Bartel; purchased by the Tower Armouries with the aid of the National Art Collections Fund and the Pilgrim Trust, 1952.

Made for Ernst August (1688–1748), Grand Duke of Saxe-Weimar-Eisenach, this sword formed part of the ducal armory, preserved at Ettersburg Castle until 1927, when a substantial part was sold through the auction house Galerie Fischer of Lucerne. The collection percolated through auction rooms in the following decade. The hilt of this sword has a gilt brass grip and knuckle guard, pierced and chiseled with rococo scrollwork and shell patterns, with the pommel in the form of a grotesque beast. The decoration incorporates the monogram of Ernst August. Many of the guns in the Ettersburg collection were decorated with the initials of the grand dukes for whom they were made. Specialized hunting swords developed in the seventeenth century, originally for dispatching wounded game. They were usually short swords, often with curved blades like the contemporary infantry hanger (deriving its name ultimately from the Turkish *hancer*, a curved dagger) and elaborate decorative hilts, serving as both status symbols and functional weapons. TR

30

SMALLSWORD
Probably Germany, c. 1750–60

Hard stone, gold, silver, copper alloy, steel
Overall length: 36 5/8 in. (93 cm)
Inscribed at the base of the blade: *De la fabrique de la marque au Raisin à Sohlingen* and *Crepin Marchand fourbisseur Rue St. Honoré à Paris*
The Metropolitan Museum of Art, Rogers Fund, 1984 (inv. no. 1984.349)

29

Provenance: Prince Alexej Ivanovitj Sachovskojs, Saint Petersburg; Count Theodor Keller, Saint Petersburg; Count Alexander Keller, Saint Petersburg; his sale, Bukowski, Stockholm, March 5, 1920, lot 159; sold to Baron de Geer, Sweden; his sale, Bukowski, Stockholm, March 3–4, 1926, lot 490; sold to Major Theodore Jakobsson, Stockholm; his sale, Sotheby's, London, May 10–11, 1932, lot 166; sold to William Randolph Hearst, Saint Donat's, Wales; Phillips, Son & Neale, London, July 7, 1982, lot 109; Howard Ricketts, London; acquired by the Metropolitan Museum of Art, 1984.

Bibliography: Stuart W. Pyhrr, "Smallsword," in *Notable Acquisitions, 1984–1985* (New York: Metropolitan Museum of Art, 1985), 16.

Smallswords were the indispensable sidearm worn by fashionable gentlemen throughout Europe from the mid-seventeenth to the late eighteenth century. Like the snuffbox, the smallsword hilt was regarded as an essential element of masculine jewelry and was often rendered in the finest materials, displaying the most fashionable ornament, its opulence limited only by the owner's wealth and taste. Hard-stone hilts are exceedingly rare, owing no doubt to the difficult technique and fragile material. This outstanding example employs mottled pale green chrysoprase and black marble set into a gold cagework of fluid rococo scrolls, the black panels further embellished with flowers in varicolored gold, silver, and copper. Although the blade bears a Parisian cutler's name, the hilt is probably German, its materials and workmanship reminiscent of some of Frederick the Great of Prussia's prized hard-stone snuffboxes of mid-eighteenth-century Berlin manufacture.

Despite their graceful form and wealth of ornament, smallswords were not widely appreciated by arms collectors, who typically preferred robust medieval swords and Renaissance rapiers that were more in keeping with period and character of their armor holdings. Hearst nevertheless owned a handful of eighteenth-century smallswords, of which this was undoubtedly his finest. SWP

31

THE MARTYRDOM OF SAINT PAUL, from the
Life of Saint Peter series
France or the Franco-Flemish territories, c. 1460

Wool, silk, and metal-wrapped thread
9 ft. 4⅝ in. x 6 ft. 8¾ in. (286 x 205 cm)
Museum of Fine Arts, Boston, Francis Bartlett Donation
of 1912 (inv. no. 38.758)

Provenance: Cathedral of Saint Peter, Beauvais, France, until 1793; collection of
M. Mansard of Voisinlieu, who returned it to the cathedral in 1844; in 1906 it was
given back to representatives of the Mansard family in compliance with their
petition; Arnold Seligmann, Rey & Co., New York; William Randolph Hearst; Arnold
Seligmann, Rey & Co.; acquired by the Museum of Fine Arts, Boston, 1938.

Exhibitions: *A Medieval Tapestry in Sharp Focus*, Museum of Fine Arts, Boston, 1977;
From Fiber to Fine Art, Museum of Fine Arts, Boston, 1980, no. 10.

Bibliography: Adolph S. Cavallo, *Tapestries of Europe and of Colonial Peru in the
Museum of Fine Arts, Boston* (Boston: Museum of Fine Arts, 1967), vol. 1, 51-55;
Gertrude Townsend, "The Martyrdom of Saint Paul: A Fifteenth-Century Tapestry,"
Bulletin of the Museum of Fine Arts, Boston 36 (1938): 64-72.

The moment of Saint Paul's martyrdom is vividly represented
in this composition, with the executioner still standing over
the saint's kneeling body and Paul's severed head lying, eyes
blindfolded, in the lower right corner. It rests above one of
the three springs that were said to have appeared where the
saint's head touched the ground. Behind the foreground
figures stand two groups of witnesses: Nero, clad in golden
brocade robes, with his courtiers, on the left, and Christians,
on the right. Above them all, God the Father receives the
saint's soul.

This panel is one of at least eleven that make up the
Life of Saint Peter series. The series was apparently woven
only once, although opinion has differed as to whether that
was in France or Flanders. Some experts have suggested
that the compositions of the eleven tapestries may be after
the designs of Robert Campin. The coats of arms seen here
are those of Guillaume de Hellande (bishop of Beauvais,
1444-62), who commissioned the set in 1460 to give to the
Beauvais Cathedral. BDG

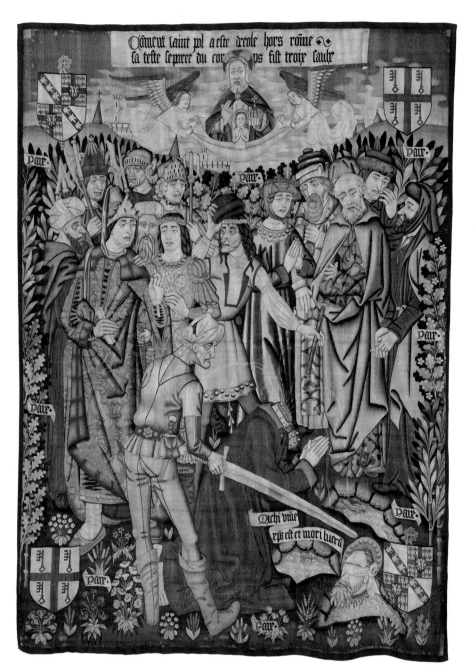

31

32

FORTITUDE

Southern Netherlands (probably Brussels), c. 1500–1510

Wool and silk
12 ft. 8 in. x 21 ft. 8 in. (386 x 660 cm)
Detroit Institute of Arts, Gift of the William Randolph
Hearst Foundation (inv. no. 55.521)
Page 25

Provenance: Antoinette de Montmorency-Luxembourg; Baron Félix d'Hunolstein; Duveen Brothers, New York; William Randolph Hearst, New York, 1922; presented to the Detroit Institute of Arts, 1955.

Exhibitions: Musée des Arts Décoratifs, Paris, 1880, no. 5; *Art Objects and Furnishings from the William Randolph Hearst Collection*, Hammer Galleries, New York, 1941, nos. 183–84; *Tapisseries bruxelloises de la pré-Renaissance*, Musées Royaux d'Art et d'Histoire, Brussels, 1976, p. 100; *Woven Splendor: Five Centuries of European Tapestry in the Detroit Institute of Arts*, Detroit Institute of Arts, 1996, no. 6.

Bibliography: "Early Flemish Tapestries in the Collection of William Randolph Hearst, Esq.: Editorial Note Based on an Analysis by Dr. Phyllis Ackerman," *Connoisseur* 105 (June 1940): 187–94, 210; Helen Comstock, "Tapestries from the Hearst Collection in American Museums," *Connoisseur Year Book*, 1956, 40–46, 134; Adele Weibel and Francis W. Robinson, "Four Late Gothic Allegorical Tapestries," *Bulletin of the Detroit Institute of Arts* 36, no. 3 (1956–57): 60–63.

The central figure in this tapestry is Fortitude, identified by an inscription and by her attribute, the lion resting at her feet. One of the Seven Virtues, she is enthroned and surrounded by numerous attendants, including Boldness and Gluttony on the lower left, Charlemagne and Hercules on the lower right, and other, unidentified figures. The tapestry's other sections similarly depict allegorical or biblical figures with others. The full meaning of these individual scenes and how they relate to one another has remained impenetrable, although they were likely borrowed from contemporary street theater, particularly morality and mystery plays.

Fortitude is related to three other tapestries—*Charity*, *Wrath*, and *Pride*—formerly owned by Hearst and now in Detroit, and the four were almost certainly part of a Virtues and Vices series. Given the large size of the Detroit tapestries, it seems unlikely that the complete set included all fourteen Virtues and Vices, but the exact number of tapestries in it is unknown. *Fortitude*, together with *Combat of the Virtues and Vices* and *Spring* (cat. nos. 33, 34), exemplifies the particularly strong group of Late Gothic and Renaissance tapestries once owned by Hearst that feature allegorical themes. BDG

33

COMBAT OF THE VIRTUES AND VICES, from the Redemption of Man series

Southern Netherlands (Brussels), 1500–1515

Wool and silk
13 ft. 8 in. x 26 ft. 2 in. (417 x 798 cm)
Fine Arts Museums of San Francisco, Gift of the William Randolph Hearst Foundation (inv. no. 54.14.4)
Page 53 (detail)

Provenance: Cathedral of Toledo, Spain, 1890; Goldschmidt Frères, 1905; Duveen Brothers, New York; William Randolph Hearst, 1921; presented to the Fine Arts Museums of San Francisco, 1954.

Exhibitions: *Exposition de l'histoire de la tapisserie*, Union central des beaux-arts appliqués à l'industrie, Paris, 1876; *Exposition d'art ancien bruxellois*, Brussels, 1905; Golden Gate International Exposition, San Francisco, 1939; *Art Objects and Furnishings from the William Randolph Hearst Collection*, Hammer Galleries, New York, 1941, no. 592-15; *Five Centuries of Tapestry from the Fine Arts Museums of San Francisco*, California Palace of the Legion of Honor, San Francisco, 1976, no. 12.

Bibliography: Anna Gray Bennett, *Five Centuries of Tapestries from the Fine Arts Museums of San Francisco*, rev. ed. (San Francisco: Fine Arts Museums and Chronicle Books, 1992), 68–71; "Early Flemish Tapestries in the Collection of William Randolph Hearst, Esq.: Editorial Note Based on an Analysis by Dr. Phyllis Ackerman," *Connoisseur* 105 (June 1940): 187–94, 210; D. T. B. Wood, "Tapestries of the Seven Deadly Sins," pts. 1 and 2, *Burlington Magazine* 20 (January 1912): 215–16, (February 1912): 278.

The seventh of ten panels in a Redemption of Man series, *Combat of the Virtues and Vices* represents humankind's internal moral struggle as an actual battle between the Virtues and Vices, a theme that can be traced back to the fourth-century poem *Psychomachia* by Prudentius. The tapestry's chief protagonist is the Christian knight, wearing armor and riding a unicorn, a symbol of Christ. He leads the Virtues—Temperance, Devotion to God, Chastity, and others—to victory. Pride, riding a white camel, heads the legion of Vices; among those identifiable by their attributes

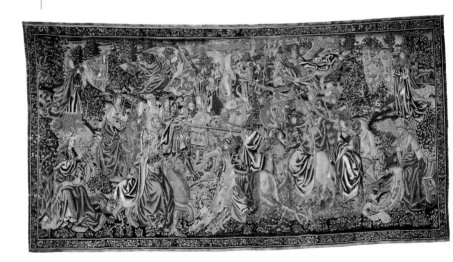

33

or inscriptions are Envy, Avarice, and Luxury. The Virtues' moment of victory corresponds directly to Christ's Crucifixion, depicted in the upper center of the composition.

Approximately six sets of the Redemption of Man series were woven in the early 1500s, although only about thirty panels or partial panels still survive, dispersed among collections in Europe and the United States. One of the largest concentrations is in the Fine Arts Museums of San Francisco, which own four, all formerly in the Hearst collection. *Combat of the Virtues and Vices* features the most elaborate and complex composition of the group. BDG

34

SPRING, from the Twelve Ages of Man series
Southern Netherlands (Brussels), designed c. 1520–23, woven c. 1525–28

Wool and silk
13 ft. 7 in. x 23 ft. 8 in. (414 x 721 cm)
The Metropolitan Museum of Art, New York, Gift of the Hearst Foundation, in memory of William Randolph Hearst (inv. no. 53.221.1)
Page 25

Provenance: French & Co., 1933; William Randolph Hearst, 1934; presented to the Metropolitan Museum of Art, 1953.

Exhibitions: *Art Objects and Furnishings from the William Randolph Hearst Collection,* Hammer Galleries, New York, 1941, no. 1141-3.

Bibliography: Helen Comstock, "Tapestries from the Hearst Collection in American Museums," *Connoisseur Year Book*, 1956, 40–46, 134; Edith A. Standen, "The Twelve Ages of Man," *Bulletin of the Metropolitan Museum of Art* 12 (April 1954): 241–48; Standen, "The Twelve Ages of Man: A Further Study of a Set of Early Sixteenth-Century Flemish Tapestries," *Metropolitan Museum Journal* 2 (1969): 127–68; Standen, *European Post-Medieval Tapestries and Related Hangings in the Metropolitan Museum of Art* (New York: Metropolitan Museum of Art, 1985), vol. 1, 24–30.

Spring is one of four tapestries that make up the Twelve Ages of Man series, which were donated to the Metropolitan Museum of Art after Hearst's death. He purchased the series in its entirety from French & Company; they were among the forty tapestries that he acquired from the dealer.

Each tapestry in the series illustrates three ages in the life of man and is divided into three vertical sections. Each section also represents a month, which can be identified by the zodiac signs and figures in the roundels located at the top of the section: *Spring* consists, somewhat confusingly, of January, February, and March. Finally, each section includes a story from a biblical or classical source that illustrates a quality characteristic of the particular age. The

entire composition is presided over by the central figure of Venus, the goddess long associated with the season.

Edith A. Standen ("Twelve Ages of Man" [1969]) attributed the series' erudite iconographic program to Jerome van Busleyden, or Hieronymus Buslidius (c. 1470–1517), a humanist and ecclesiastical member of Margaret of Austria's Grand Council. She also attributed the tapestries' manufacture to Brussels, based on the quality of the weaving, but there is no evidence for a specific workshop. BDG

35

THE APOSTLES' CREED
Europe, c. 1550–1600

Wool
11 ft. 11½ in. x 15 ft. 10 in. (364.5 x 482.6 cm)
The Metropolitan Museum of Art, New York, Gift of the Hearst Foundation, Inc., 1960 (inv. no. 60.182)
Page 44

Provenance: Said to have come from a church near Barcelona, Spain, date unknown; marqués de Sambola, Gerona, Spain; Jacques Seligmann, Paris, by 1912; sold to J. Pierpont Morgan, New York, 1912-16; French & Co., New York, until 1923; William Randolph Hearst, New York and San Simeon, California, 1923-51; Hearst Foundation, Inc., 1951-60; presented to the Metropolitan Museum of Art, 1960.

Exhibitions: *Tapisseries gothiques appartenant à M. J. Pierpont Morgan exposées au bénéfice des Amis du Louvre,* Galerie Jacques Seligmann, Paris, 1912, no. XI; *Loan Exhibition of the J. Pierpont Morgan Collection,* Metropolitan Museum of Art, New York, 1914; *An Exhibition of Gothic Tapestries of France and Flanders,* Art Institute of Chicago, 1920, no. 12; *Cinq siècles d'art,* Exposition Universelle et Internationale, Brussels, 1935, no. 685; *The Middle Ages: Treasures from the Cloisters and the Metropolitan Museum of Art,* Los Angeles County Museum of Art and Art Institute of Chicago, 1970, no. 113.

Bibliography: Adolfo Salvatore Cavallo, *Medieval Tapestries in the Metropolitan Museum of Art* (New York: Metropolitan Museum of Art, 1993), 608-16; Seymour de Ricci, *Catalogue of Twenty Renaissance Tapestries from the J. Pierpont Morgan Collection* (Paris: Typographie P. Renouard, 1913), 44-48; William H. Forsyth, "A 'Credo' Tapestry: A Pictorial Interpretation of the Apostles' Creed," *Metropolitan Museum of Art Bulletin*, n.s., 21 (March 1963): 240-51.

The surprising jewel-like tones of red, yellow, green, ultramarine blue, and bright white are attributed to this tapestry's excellent state of preservation as well as the taste of the weavers. It translates the dogma defined in the Apostles' Creed into a visual narrative set within fifteen rectangular compartments arranged in three horizontal rows. During the medieval period it was believed that each of the twelve apostles was inspired at the Pentecost to speak one article of this creed, the text of which was illustrated with twelve or more scenes (Cavallo, *Medieval Tapestries*, 611).

Although other examples of the creed worked in tapestry exist, the style of this one is unique in the medium. Most

scholars have noted that the tapestry has a provincial character, and it is likely that fifteenth-century woodcut sheets and books illustrating the creed served as its inspiration. In addition, the composition of scenes such as the Entombment and Resurrection have been linked to formulas developed in Renaissance Italy. Such disparate sources render attempts at localization difficult.

William Randolph Hearst's interest in collecting tapestries was no doubt influenced by his mother, Phoebe Hearst, who assembled an important collection of tapestries. This tapestry's putative provenance from a church near Barcelona may have particularly interested Hearst, who had a penchant for Spanish art. Its later association with the legendary financier and collector J. Pierpont Morgan may also have drawn Hearst to acquire it.

<div align="right">CEB</div>

36

ARMORIAL BANNER
Peru, c. 1580

Wool
88 x 82 in. (223.5 x 208.3 cm)
Hearst Castle/California State Parks (inv. no. 529-9-6550)
Page 141

Provenance: Helen Hay Whitney, New York; her sale, Parke-Bernet Galleries, New York, February 6–7, 1946, lot 418; sold to William Randolph Hearst.

Bibliography: Anna Gray Bennett, *Five Centuries of Tapestry from the Fine Arts Museums of San Francisco*, rev. ed. (San Francisco: Fine Arts Museums of San Francisco and Chronicle Books, 1992), 294 (for the banner in San Francisco).

This Spanish colonial tapestry from Peru is one of a pair displayed in Hearst Castle's North Wing, site of the estate's most recent construction, and an area of Casa Grande that closely melds Spanish and Islamic elements in its art and architecture.

Itself the result of combined cultures—the format of Old World Europe, manipulated with a New World Peruvian flair—this tapestry has a mirror image in the collection of the Fine Arts Museums of San Francisco. The banners depict the heraldic shield of Don Luis Jerónimo Fernández Cabrera y Bobadilla, Count of Chinchón, who was viceroy of Peru (1629–39).

Black outlines accentuate the red, gold, tan, and white sections of alpaca wool that portray towers, eagles, a goat, and the lions and castles that are the insignia, respectively, of León and Castile. Surrounding blue foliage recalls the energetic swirling patterns of Islamic design.

<div align="right">JS</div>

37

THE SIEGE OF DOESBURG, from the Conquests of Louis XIV series
France (probably Beauvais Tapestry Manufactory or the Béhagle family workshop, Paris [probably under the direction of Philippe Béhagle (French, 1641–1705), 1692–1705, or during the term of his widow and son, 1705–11])

Wool, silk, and metal-wrapped threads
15 ft. 5¼ in. x 10 ft. 1 in. (471 x 307 cm)
• The Speed Art Museum, Louisville, Gift from the Preston Pope Satterwhite Collection (inv. no. 1947.25)

Provenance: Count Heinrich von Brühl, Saxony; Lord Amherst of Hackney, Didlington Hall, Norfolk; Christie, Manson & Woods, London, 1908; Spanish Art Gallery; French & Co., New York; William Randolph Hearst, 1927; returned to French & Co., 1940; Preston Pope Satterwhite, 1941; presented to the Speed Art Museum, 1947.

Exhibitions: *Appaloosa: The Spotted Horse in Art and History*, Amon Carter Museum of Western Art, Fort Worth, 1963, pp. 58–59; *Glorious Horsemen: Equestrian Art in Europe, 1500–1800*, Museum of Fine Arts, Springfield, Massachusetts, and J. B. Speed Art Museum, Louisville, Kentucky, 1981, p. 124.

Bibliography: "Arts of the Period of Louis XIV: As Represented in the Satterwhite Collection," *Connoisseur* 126 (August 1950): 55–60; Charissa Bremer-David, "French & Company and American Collections of Tapestries, 1907–1959," *Studies in the Decorative Arts* 11 (Fall–Winter 2003–4): 38–68; Alice Zrebiec and Scott Erbes, *Conquest and Glory: Tapestries Devoted to Louis XIV in the Collection of the Speed Art Museum* (Louisville, Ky.: Speed Art Museum, 2000), 24–25.

Part of a Conquests of Louis XIV series, *The Siege of Doesburg* documents a specific battle in the Dutch War, which Louis waged between 1672 and 1678. The king, sumptuously attired and seated on horseback in the panel's foreground, points with his military baton toward the battle behind him. Plumes of smoke in the distance indicate that the city of Doesburg is burning. The composition relates to an engraving of around 1686 by Sébastien Leclerc commemorating the same battle, although some experts believe that Adam Frans van der Meulen and Jean-Baptiste Martin may have created the actual designs for the Conquests series. The coat of arms on the tapestry is that of Count Brühl (German, 1700–1763), who acquired it at some point after it was woven.

Hearst purchased the present panel, along with another tapestry from the series, in 1927 from French & Company, but returned them in 1940, perhaps because of his financial difficulties. Two other tapestries are related to this example: one, made for the comte de Toulouse (1678–1737), now at Versailles and the other formerly in the collection of Principe Don Marcantonio Doria d'Angri.

<div align="right">BDG</div>

<div align="right">37</div>

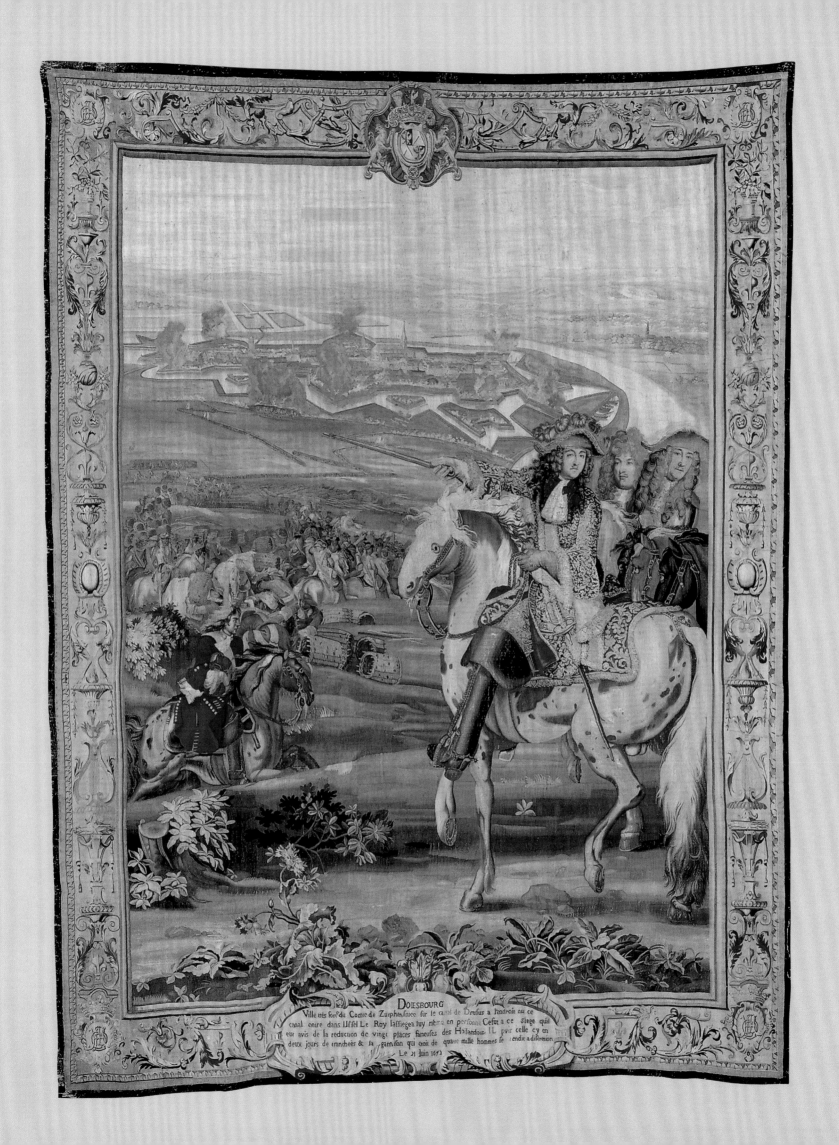

38

BANNER OF THE VIRGIN OF SALVATION
Spain, 18th century

Embroidered velvet
47 x 40 in. (119.4 x 101.6 cm)
Hearst Castle/California State Parks (inv. no. 529-9-4513)
Page 65

Provenance: Joseph Dabissi; his sale, American Art Association, New York, March 21–24, 1923; sold to William Randolph Hearst, March 22, 1923.

Examples of Spanish needlework decorate many of San Simeon's walls. On this banner a central cartouche is set amid the rococo asymmetry of scrolling patterns and shell-like designs embroidered on black velvet. The deceptively simple narrative scene it contains delivers a sophisticated commentary on complex Christian principles.

The Virgin Mary, regally crowned and robed, with scepter in hand, holds the infant Christ. Flanking them are Adam and Eve, engulfed to the waist in flames, with hands poised in supplication. The first man and woman, condemned to the fires of hell, seek salvation by appealing to the Virgin to intercede with Jesus on their behalf.

Mary fills the role of the new Eve, bringing eternal life into the world via Jesus, who becomes the new Adam. Their spiritual perfection allows them to eradicate the sin introduced by Adam and Eve, redeeming them—and wicked humankind—from eternal punishment in a theological quid pro quo. JS

39

After a design by Jean-Baptiste Le Prince (French, 1734–1781)
THE REPAST UNDER THE TENT, from the Russian Games series
France (Beauvais Tapestry Manufactory), c. 1770–80

Wool and silk
9 ft. 8½ in. x 23 ft. (295.9 x 701 cm)
Los Angeles County Museum of Art, William Randolph Hearst Collection (inv. no. 48.5.2)
Page 111

Provenance: William Randolph Hearst; presented to the Los Angeles County Museum, 1948.

Bibliography: Hubert Delesalle, "Les tapisseries des 'Jeux Russiens,'" *Bulletin de la Société de l'Histoire de l'Art Français*, 1941–44, 127; Edith Standen, "Some Exotic Subjects," *Apollo* 114 (July 1981): 44–54 (for the Metropolitan Museum version).

A pupil of François Boucher, Jean-Baptiste Le Prince achieved fame for his Eastern subjects, including *chinoiseries, turqueries,* and depictions of Russian themes based on his extensive travels through Russia and Siberia between 1758 and 1764. A prolific draftsman and innovative printmaker whose production was widely distributed, Le Prince also exhibited paintings at the Paris Salon, where three of the large cartoons for his suite of tapestries called Les jeux russiens (The Russian Games) were shown in 1767. Regardless of their seductiveness, originality, and somewhat accurate description of exotic details, they were harshly received by Denis Diderot, the most demanding critic of the time. Diderot's harsh judgment did not damage Le Prince's reputation: his Jeux russiens were woven many times between 1770 and 1780, attesting to their immense success.

One would be hard-pressed to find in Le Prince's elegant composition an accurate rendition of a Russian subject. If anything, the scene is more "oriental" or Turkish than Russian, with the sultanlike figure smoking his hookah under the dais. Some figures are borrowed from his mentor Boucher; others are wearing exotic costumes based on actual ethnic garments Le Prince could have sketched in Russia.

The provenance of the Hearst tapestry is not known. Like a similar tapestry in the Metropolitan Museum of Art, New York, it bears the initials *A.C.C.* for André-Charlemagne Charron, head of the Beauvais Manufactory from 1753 until 1780, which provides a terminus ante quem. JPM

METALWORK

40

CHALICE

Northern Europe (possibly valley of the Meuse), 1222

Silver and silver gilt

Height: 7 ½ in. (19.1 cm); diameter: 5 ⅜ in. (13.7 cm)

Inscribed on the foot of the chalice: *AD HONOREM B. MARIE VIRGINIS F. BERTINUS ME FECIT Ao MCCXXII*

The Metropolitan Museum of Art, The Cloisters Collection, 1947 (47.101.30)

Page 51

Provenance: Martin Hecksher, Vienna, 1898; his sale, Christie's, London, May 4, 1898, lot 257; sold to S. Durlacher, London; Sir Samuel Montagu (1832–1911), first Baron Swaythling, London, from at least 1901; his sale, Christie's, London, May 6, 1924, lot 71; sold to Crichton Brothers, London, 1924, for William Randolph Hearst; William Randolph Hearst, New York and San Simeon, California, 1924; Parish-Watson & Co., New York, until 1938; Brummer Gallery, Paris and New York, 1938–47; acquired by the Metropolitan Museum of Art, 1947.

Exhibitions: *Exhibition of a Collection of Silversmiths' Work of European Origin*, Burlington Fine Arts Club, London, 1901, pl. II, fig. 2 (ill.), p. 65, case H, no. I; *Arts of the Middle Ages*, Museum of Fine Arts, Boston, 1940, no. 221; *The Year 1200: A Centennial Exhibition*, Metropolitan Museum of Art, New York, 1970, no. 127; *Ornamenta Ecclesiae: Kunst und Künstler der Romantik*, Schnütgen-Museum in the Josef-Haubrich-Kunsthalle, Cologne, 1985, no. C 37; *Dekorativno-prikladnoe iskusstvo ot pozdnei antichnosti do pozdnei gotiki iz sobranii Muzeia Metropoliten, Niu Iork, I Khudzhestvennogo Instututa, Chikago*, Moscow and Leningrad, 1990, no. 26.

Bibliography: Robert Didier and Jacques Toussaint, *Autour de Hugo d'Oignies* (Namur: Société archéologique de Namur, 2003), 114, 150–51; E. Alfred Jones, "Some Old Foreign Silver in the Collection of Mr. William Randolph Hearst," *Connoisseur* 86 (July–December 1930): 220–21.

A Latin inscription around the edge of the foot of the chalice reads, "In honor of the Blessed Virgin Brother Bertinus made this in the year 1222," thereby providing a rare example of medieval goldsmiths' work with a documented maker and date of manufacture. This elegantly rendered chalice consists of a hemispherical cup with gilded interior, a central knop decorated with six writhing and intertwined dragons separated by a band of scrolling foliage, and a circular foot. Areas of gilded silver surrounded by beaded bands clearly separate the cup and base, while a thin band of gilding at the lip of the cup and around the edge of the foot provides a link between the two sections of the chalice.

Without additional information about Brother Bertinus, it is impossible to determine a precise localization for this chalice. Although its proportions are related to examples produced in the area of the Meuse Valley, it has also been suggested that the lively animal and plant decoration on the knop resembles that of metalwork produced in the Limousin region of France (see entry by Barbara Drake Boehm, in *Dekorativno-prikladnoe iskusstvo*, 59).

The chalice is one of three works in silver that William Randolph Hearst acquired from the noted collection assembled by Sir Samuel Montagu, first Baron Swaythling, which also included a covered beaker (cat no. 41) and a flagon (cat. no. 48). Hearst owned a number of medieval chalices, several of which are illustrated in the 1941 sale catalogue of works from his collection held at Gimbels department store. CEB

41

COVERED BEAKER

Mounts: Austria (Vienna?), c. 1350–60

Vessel: Italy (Venice), 1325–50

Silver gilt, rock crystal, and translucent enamels

Height: 8 ½ in. (21 cm)

Inscribed around the base:
··*WER/HIE·V/S·/DR/INCE/ET·W/INDE/R·MV/EZZ/E·IEM/ER·S/ELIG/SIN*

The Metropolitan Museum of Art, The Cloisters Collection, 1989 (1989.293)

Page 51

Provenance: Hollingworth Magniac, Colworth, England; his sale, Christie's, London, July 2–4, 1892, lot 642; Thomas Gibson Carmichael, Castle Craig, by at least 1901; his sale, Christie's, London, May 12, 1902, lot 87; sold to Harding, London; Sir Samuel Montagu (1832–1911), first Baron Swaythling, London; his sale, Christie's, London, May 6, 1924, lot 69; sold to Crichton Brothers, London, 1924, for William Randolph Hearst; William Randolph Hearst, New York and San Simeon, California (International Studio Corporation), 1924–40; sold to Brummer Gallery, Paris and New York, 1947–49; sold to Ruth and Leopold Blumka, New York, 1949–89; acquired by the Metropolitan Museum of Art, 1989.

Exhibitions: *Exhibition of a Collection of Silversmiths' Work of European Origin*, Burlington Fine Arts Club, London, 1901, pl. VIII, fig. 2, p. 143, case M, no. 9; *Mirror of the Medieval World*, Metropolitan Museum of Art, New York, 1998, no. 183.

Bibliography: Peter Barnet and Nancy Wu, *The Cloisters: Medieval Art and Architecture* (New York: Metropolitan Museum of Art; New Haven: Yale University Press, 2005), 101; Carl Johan Lamm, *Mittelalterliche Gläser und Steinschnittarbeiten aus dem Nahen Osten* (Berlin: Dietrich Reimer–Ernst Vohsen, 1930), vol. 1, 233–34, vol. 2, pl. 84, no. 15.

A twelve-sided rock crystal vessel is the central feature of this rare covered beaker. Both the gilded silver base and the cover echo the twelve-sided nature of the hard-stone container, serving to unify the ensemble. Decorating its base, in alternating panels of green and blue translucent enamel, is a verse in a German dialect that reads: "He who drinks wine from me, ever shall happy be." Except where adapted to liturgical use, precious medieval secular metalwork survives only rarely. This beaker, with its insistently worldly inscription, is thus remarkable.

The attribution is based on three nearly identical crystal vessels located at Amiens Cathedral, the Mainfränkisches Museum in Würzburg, and the Kunsthistorisches Museum in Vienna, all of which were likely produced in the same workshop. In addition, the mounts are comparable with those of a group of vessels commissioned between 1335 and 1339 by Duke Otto, the son of Archduke Albrecht II of Austria for the monastery of Klosterneuberg (Timothy B. Husband, "Covered Beaker," in *Mirror of the Medieval World*, 156).

Like the chalice by Brother Bertinus (cat. no. 40), this covered beaker belonged to several illustrious European collectors. Indeed, both works were acquired together by Hearst in 1924 through Crichton Brothers of London and New York, a well-known goldsmiths firm that also collected works of art and acted as a purchasing agent for important collectors. CEB

42

Pair of Torchères
Flanders (Dinant), c. 1400

Brass (dinanderie)
Height: 72 in. (182.9 cm); diameter: 18 ½ in. (47 cm)
Both incised with the letters *SE* on the base
Lent by Mr. and Mrs. Anthony Blumka
Page 109

Provenance: Parish-Watson, New York; sold to Hearst; sold to Joseph Brummer, 1938; his estate sale, Parke-Bernet, New York, fourth session, April 23, 1949, lot 801; sold to Leopold and Ruth Blumka; by descent to Anthony Blumka.

Dinanderie takes its name from the town of Dinant, on the Meuse River. From around 1200 to 1466, when Philip the Good invaded it, Dinant was renowned for the brass objects produced there. They ranged from aquamaniles and pricket candlesticks to lecterns.

For their size alone, these torchères are extraordinary creations of late dinanderie and must be the "fifteenth-century brass candlesticks" mentioned by David Nasaw.[1] Their exceptional height and rarity validate Hearst's fury at the oversight that resulted in their sale to the dealer Joseph Brummer during the liquidation of his collections. Hearst tried to buy them back, but Brummer, who had profited handsomely from Hearst's business over the years, would not sell them back unless Hearst agreed to pay Brummer's full price. MLL

Notes
1. David Nasaw, *The Chief: The Life of William Randolph Hearst* (New York: Houghton Mifflin, 2000), 542.

43

Standing Pyx
Spain (Barcelona), c. 1400

Silver, silver gilt, enamels
Height: 13 in. (33 cm); width: 7 in. (17.8 cm)
Los Angeles County Museum of Art, William Randolph Hearst Collection (inv. no. 46.4.7)
Page 137

Provenance: William Randolph Hearst; presented to the Los Angeles County Museum, January 1946.

Bibliography: Elizabeth Bradford Smith, ed., *Medieval Art in America: Patterns of Collecting, 1800–1940* (University Park: Palmer Museum of Art, Pennsylvania State University, 1996); Wilhelm R. Valentiner, "Acquisitions of the Art Division of the Los Angeles County Museum, 1946–1950," *Bulletin of the Art Division, Los Angeles County Museum* 3 (Summer 1950): 23.

In the Christian church, the pyx holds the consecrated bread used in the celebration of Holy Communion. This example made in Barcelona relates to others produced throughout Catalonia. Its surface is enriched with sixteen quatrefoils of basse-taille enamel, a technique of firing glass paste over engraved metal. Their subjects include four apostles on the lid and four prophets on the sides of the coffer. Armorial panels on the lid and foot suggest that this pyx may have been used in a private chapel. It is a rare survival of Spanish Gothic silver, but unfortunately its source is not known.
TM

44

Attributed to Hans Greiff (German, active Ingolstadt, 1470–90)
Footed Beaker with Cover, c. 1480–90

Silver, parcel-gilt, enamel
Height: 12 ⅜ in. (31.4 cm)

leading goldsmith and the most likely maker of this beaker. It was commissioned as a trophy by a marksmen's fraternity (*Schützenbruderschaft*), which had been granted a city charter in 1445 and whose patron was Saint Sebastian, the figure on the finial of the cup. Enamel shields fastened to the three feet are suitably emblazoned with the arms of the city of Ingolstadt (a rampant panther), a shotgun (*Luntengewehr*), and a crossbow. The cup's distinctive form recalls a knotty tree trunk, stripped of branches and complete with simulated bark. Its spiral shape may have been inspired by a celebrated late Gothic column of similar form, the "Schöne Säule," which stands in the mortuarium of the cathedral in nearby Eichstätt. TM

45

Pierre Mangot (French, active Paris, 1520–40)
CASKET
Portuguese India (Gujarat), with French mounts, 1532–33

Mother-of-pearl, silver gilt, emeralds, agates, and garnets on wood carcass
11 ½ x 16 x 14 in. (29 x 40 x 26 cm)
Paris, Musée du Louvre, département des Objets d'art (inv. no. OA 11936)
Page 12

Bibliography: Annemarie Jordan-Gschwend, "Ma meilleur soeur: Leonor of Austria, Queen of Portugal and France (1498–1558)," in *Royal Inventories of Charles V and the Imperial Family*, ed. Fernando Checa (Los Angeles: Getty Foundation, in press); Gérard Mabille, "Une nouvelle oeuvre de la Renaissance au Louvre," *Revue du Louvre et des Musées de France* 50 (October 2000): 13–14; Michael Snodin and Malcolm Baker, "William Beckford's Silver II," *Burlington Magazine* 122 (December 1980): 820–31, 833–34.

This masterpiece is one of the most important works of art that belonged to Hearst. Jordan-Gschwend's research ("Ma meilleur soeur") shows how the mother-of-pearl box would be acquired by Francis I through the Portuguese contacts of his second wife, Eleonora of Portugal; it was then fitted in Paris with silver-gilt mounts and jewels by the king's goldsmith, Pierre Mangot. Francis I brought several Italian artists (including Leonardo da Vinci) to his court in France. His taste for exotic objects from China, India, and the Middle East was manifest in the cabinets of rarities he established at

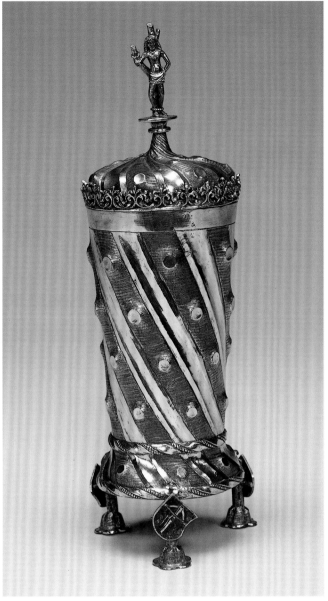

44

Toledo Museum of Art; gift of Florence Scott Libby (inv. no. 1961.13)

Bibliography: Roger M. Berkowitz, "Objects of Precious Metal," *Museum News: The Toledo Museum of Art*, n.s., 13 (Spring 1970): 10.

This covered beaker is one of five sold in 1813 by the municipal council of Ingolstadt, a Bavarian city on the Danube between Munich and Nuremberg. Hans Greiff was the city's

the Louvre and his château of Fontainebleau. This casket—
decorated with classically inspired colonnettes, busts, and
acanthus leaves—merges these aspects of the Renaissance
king's interests.

French goldsmiths' work from the Renaissance is very
rare, much of it having been melted down over the centuries.
This was not the only French Renaissance object that Hearst
owned. He also had a pair of crystal candlesticks (Toledo
Museum of Art), similar to the candlesticks from the treasury
of the Order of the Holy Spirit, which are in the Louvre.
MLL

46

Possibly John Veitch (Scottish, c. 1517–1550)
THE METHUEN CUP
Scotland (Edinburgh), c. 1530

Silver gilt, rock crystal
Height: 7 in. (17.7 cm)
Los Angeles County Museum of Art, Gift of the Hearst
Foundation (inv. no. 49.14.6a–b)

Provenance: By descent to Field Marshall Paul Sanford Methuen (1845–1932), third
Baron Methuen, Corsham Court, Wiltshire; sale, Christie's, London, February 25, 1920,
lot 87; sold to Crichton Brothers, London; William Randolph Hearst; possibly sold to
Joseph Brummer, New York, c. 1940; sale, Parke-Bernet, New York, April 20–23, 1949,
lot 433; William Randolph Hearst; presented to the Los Angeles County Museum,
July 1949.

Exhibitions: *Wine: Celebration and Ceremony*, Cooper-Hewitt Museum, New York,
1985; *Silver: Made in Scotland*, National Museums of Scotland, Edinburgh, 2008,
pp. 3–4, no. 1.2.

Bibliography: H. Avray Tipping, "English Silver Plate Belonging to Field-Marshall
Lord Methuen, G.C.B.," *Country Life*, February 14, 1920, 197–99; Francis C. Eeles,
"The Methuen Cup: A Piece of Sixteenth-Century Scottish Plate," *Proceedings of the
Society of Antiquaries of Scotland* 55 (1921): 285; Gregor Norman-Wilcox, "The Methuen
Cup," *Bulletin of the Art Division, Los Angeles County Museum* 13, no. 3 (1961): 10–15;
Ian Finlay, *Scottish Gold and Silver* (London: Chatto & Windus, 1956), 64–65, pl. 26, A.

This is one of the earliest known examples of Scottish silver.
Made of silver gilt with a rock crystal stem and finial, the
cup is engraved with verse in Broad Scott (an early dialect)
that indicates its secular use. Priscilla Bawcutt (letter dated
August 11, 2000, in object file, LACMA) has identified the first
quatrain of the verse as an earlier version of a moral poem
in the Bannatyne Manuscript (c. 1568). The cup may have
survived the widespread melting of silver throughout
Scotland at the time of the Reformation because the
Methuen family moved from Scotland to England shortly
after it was made.

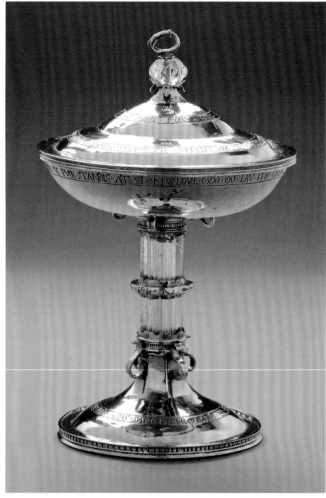

46

Hearst sold this cup during his financial crisis of 1938
but was in a position to repurchase it in 1949, following the
revival of his fortunes during the war years. TM

47

PROCESSIONAL CROSS
Spain (Burgos), c. 1550

Silver, silver gilt over wooden core
42½ x 25½ in. (107.9 x 64 cm)
Los Angeles County Museum of Art, William Randolph
Hearst Collection (inv. no. 49.19.2)
Page 47

Provenance: William Randolph Hearst; presented to the Los Angeles County
Museum, August 1949.

The ritual of leading church processions with a silver or
gold cross decorated on both sides is as old as Christianity
itself. Symbols of office, crosses preceded clergy whenever

they traveled beyond the sanctuary, especially in processions that passed through the streets on religious holidays. Processional crosses are therefore typically larger and more elaborate than those placed on altars.

On this and other Spanish crosses of the sixteenth century, the dazzling outline of cast and reticulated ornament is in the style known as *gotico florido* (flowering gothic). At the ends of each baluster-shaped arm, finials extend from gilt plaques with saints and evangelists. The elaborate surface belies the underlying construction of thin silver sheets applied over a simple wooden core. This cross was fitted at a later date, probably around 1550–75, with a base ornamented in full mannerist style.

Hearst owned at least three other Spanish silver processional crosses, including one said to have come from the Cathedral of Saragossa. In 1925 he purchased two others in the course of one week, one from William Permain in London and the other from French & Company in New York. They were all likely displayed in his quintuplex in Manhattan. This one might be recorded in a photograph of his collection of Valencian lusterware. TM

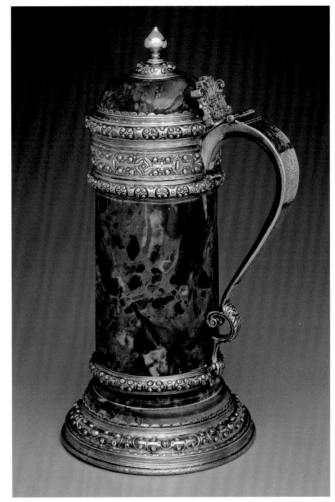

48

48

FLAGON

Probably Germany, c. 1560/70

Marble, silver gilt
Height: 9 ⅝ in. (24.5 cm); diameter: 4 ¾ in. (12.1 cm)
Museum of Fine Arts, Boston. Theodora Wilbour Fund in Memory of Charlotte Beebe Wilbour (inv. no. 49.476)

Provenance: Torkington collection, Great Stukeley Hall, Huntingdon, England, until about 1852 or later;[1] anonymous sale ("property of a gentleman"), Christie's, London, June 13, 1907, lot 66; sold to Foster; Sir Samuel Montagu (1832–1911), first Baron Swaythling, London, acquired between 1907 and 1911; his sale, Christie's, London, May 6, 1924, lot 124; sold to Crichton Brothers, London; sold to William Randolph Hearst, New York, May 30, 1924; sold to Brummer Gallery, New York (stock no. N6020), July 28, 1944; Brummer sale, Parke-Bernet Galleries, New York, April 22, 1949, lot 453; acquired by the Museum of Fine Arts, Boston, 1949.

Exhibitions: *The Virtuoso Craftsman: Northern European Design in the Sixteenth Century*, Worcester Art Museum, Worcester, Massachusetts, 1969, no. 64; *The Triumph of Humanism: A Visual Survey of the Decorative Arts of the Renaissance*, Fine Arts Museums of San Francisco, 1977–78, no. 63.

Bibliography: Ellenor M. Alcorn, *English Silver in the Museum of Fine Arts, Boston* (Boston: Museum of Fine Arts, 1993), vol. I, no. 4.

Although this flagon was previously thought to be English, its bold, rich ornamentation suggests that it is more likely German. Other mounted pieces, such as the Strasbourg rock crystal tankard in the Gilbert Collection, also display more highly embossed mounts, worked in higher relief, and with more precision than is usually found on English pieces of this time.[2] On the English flagon also in the Museum of Fine Arts (cat. no. 53), for example, the ornament on the mounts is less prominent and is stamped rather than embossed. The marble body of the flagon is an unusual feature. The marble may be ancient, quarried in Asia Minor and then sent to Rome, where it was excavated during the Renaissance and prized for its decorative value. MGC

Notes
1. An undated note from Captain Charles Torkington (1847–1919) in the curatorial file states: "It has been in my family for a great number of years. It was removed from Great Stukeley Hall, Huntingdon about the year 1852 by my mother when the house was dismantled." It is not known whether it left the family's possession at that time.
2. Timothy Schroder, *The Gilbert Collection of Gold and Silver* (Los Angeles: Los Angeles County Museum of Art, 1988), no. 133.

Bibliography: Christina Esteras Martín, "Platería virreinal novohispana: Siglos XVI–XIX," in *El arte de la platería mexicana: 500 años*, ed. Lucía García-Noriega y Nito (Mexico City: Centro Cultural de Arte Contemporáneo, 1989), 152–55, no. 15; Hugh Tait, *Catalogue of the Waddesdon Bequest in the British Museum*, vol. 1, *The Jewels* (London: British Museum Publications, 1988), 233–36.

Acquired by Hearst as Spanish, this chalice is now widely regarded as the most important example of silverwork from sixteenth-century Mexico. Its size, the quality of its execution, and the rich combination of pre-Hispanic materials and techniques, such as carved rock crystal and feather mosaic, are extraordinary. The octagonal rock crystal knop, complete with ionic capitals, contains niches with reliefs of the Apostles carved in boxwood and backed with hummingbird feathers. On the foot, chased medallions alternate with rock crystal covering other boxwood carvings with scenes from the Passion, two of which retain their backgrounds of hummingbird feathers, which were regarded as sacred by the Aztecs and traditionally reserved for nobles, priests, and warriors. Rock crystal was also sacred in pre-Hispanic Mexico. The use of feathers instead of the colored enamels favored in Europe makes this chalice an unusual example of Spanish design that incorporates native traditions. It is also one of two known silver objects with an engraved profile of a Spanish soldier (concealed under the stem).

Lionel "Spanish" Harris was London's leading dealer and importer of Spanish art. Hearst was a frequent customer in the 1920s, although it is not known when he acquired this chalice.

TM

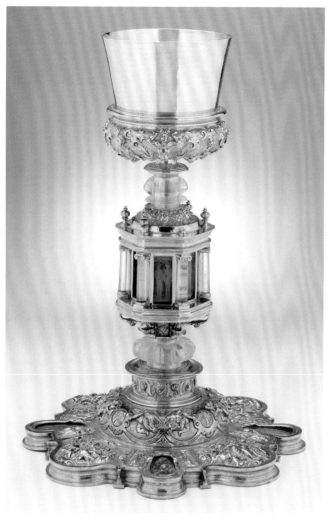

49

49

CHALICE

Mexico (Mexico City), c. 1575

Silver gilt, rock crystal, boxwood, hummingbird feathers
Height: 13 in. (33 cm); diameter: 9½ in. (23.5 cm)
Los Angeles County Museum of Art, William Randolph
Hearst Collection (inv. no. 48.24.20)

Provenance: Acquired in Spain by Lionel Harris, London; sold to William Randolph Hearst; shipped from the Bronx warehouse and presented to the Los Angeles County Museum, June 1948.

Exhibitions: *Mexico: Splendors of Thirty Centuries/ México: Esplendores de treinta siglos*, Metropolitan Museum of Art, New York; San Antonio Museum of Art, San Antonio, Texas; Los Angeles County Museum of Art; Museo de Arte Contemporáneo de Monterrey, Monterrey, Mexico; Antiguo Colegio de San Ildefonso, Mexico City, 1990–93, no. 170; *El oro y la plata de las Indias en la época de los Austrias*, Fundación ICO, Madrid, 1999, no. 208; *Aztecs*, Royal Academy of Arts, London, 2002–3, no. 327; *Tesoros/Treasures/Tesouros: The Arts of Latin America, 1492–1820*, Philadelphia Museum of Art; Antiguo Colegio de San Ildefonso, Mexico City; Los Angeles County Museum of Art, 2006–7, no. III-4.

50

Abraham Gessner (Swiss, 1552–1613)

GLOBE CUP, c. 1600

Silver, silver gilt
Height: 23½ in. (59.7 cm)
Los Angeles County Museum of Art, William Randolph
Hearst Collection (inv. no. 51.13.9)

Provenance: Baron Mayer Carl von Rothschild (1820–1886), Frankfurt; by descent to Emma Louisa Rothschild (1844–1935); by descent to Sir Nathaniel Mayer Victor (1910–1990), third Baron Rothschild, London; his sale, London, Sotheby's, April 28, 1937, lot 272; sold to Goldschmidt Galleries, New York, for William Randolph Hearst; shipped from the San Simeon warehouse and presented to the Los Angeles County Museum, December 1950.

Exhibitions: *Encompassing the Globe: Portugal and the World in the Sixteenth and Seventeenth Centuries*, Freer-Sackler Gallery, Washington, D.C., 2007.

Few Renaissance objects present a richer combination of artistic, scientific, and mechanical genius than this standing cup in the form of Atlas upholding terrestrial and celestial globes. Two cups form the globe and are joined at the equator. Once the celestial globe is removed from its calibrated frame (for predicting the location of constellations at different times of year), the upper half forms a second cup with an elaborately scrolled stem. The engraved map was a novelty, based on the Petrus Plancius world map of 1590, which was informed by recent Portuguese and Dutch exploration of the globe, notably in Asia. Around the base of the cup are more traditional vignettes of the four continents, thus combining the most up-to-date cartography with the traditional mythological view of the world.

Zurich goldsmith Abraham Gessner evidently made a specialty of globe cups, since more than a dozen examples by him are known; this is one of the most spectacular. Their ingenuity and precious materials made them ideal objects for princely cabinets of curiosities, where man-made and natural wonders were displayed together for education and amusement.

The early history of this cup is not known. By the late nineteenth century it formed part of the collection of Baron Mayer Carl von Rothschild of Frankfurt. Hearst purchased it, together with other European silver (e.g., cat. no. 51) and sculpture, when the third Baron Rothschild sold the contents of 148 Piccadilly at auction, one of the last great sales before the outbreak of World War II. TM

51

Hans Keller (German, active 1582–1609)
Covered "Grapes" Cup with Bacchus
Nuremberg, c. 1600

Silver gilt
Height: 29 ¼ in. (74 cm)
The Walters Art Museum, Baltimore (inv. no. 57.1870)

Provenance: In France in the early 18th century; in Russia, 1736; Sir Nathaniel Mayer Victor (1910–1990), third Baron Rothschild, London; his sale, Sotheby's, London, April 29, 1937; William Randolph Hearst; acquired by the Walters Art Gallery, 1957.

Bibliography: Ann Gabhart, *Treasures and Rarities: Renaissance, Mannerist, and Baroque* (Baltimore: Walters Art Gallery, 1971), 24–25; Hans Weihrauch, "Italienische Bronzen als Vorbilder deutscher Goldschmiedekunst," in *Studien zur Geschichte der europäische Plastik: Festschrift für Theodor Müller*, ed. Kurt Martin (Munich: Hirmer, 1965), 273–75.

This stupendous object, also known informally as a pineapple cup, is nearly three feet high and can hold more than three liquid quarts. The seven-inch-high figure of the wine god

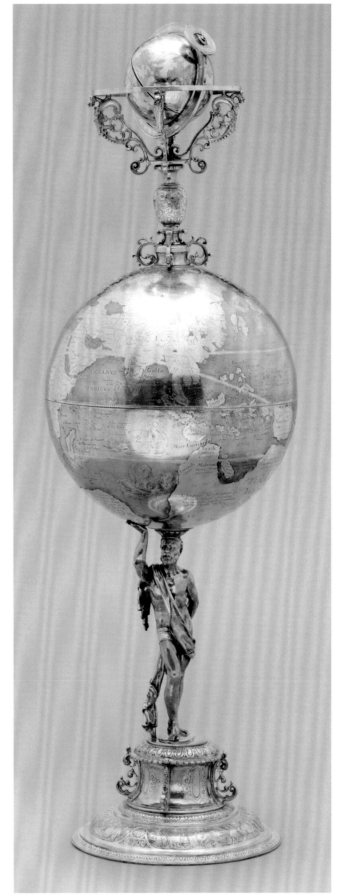

50

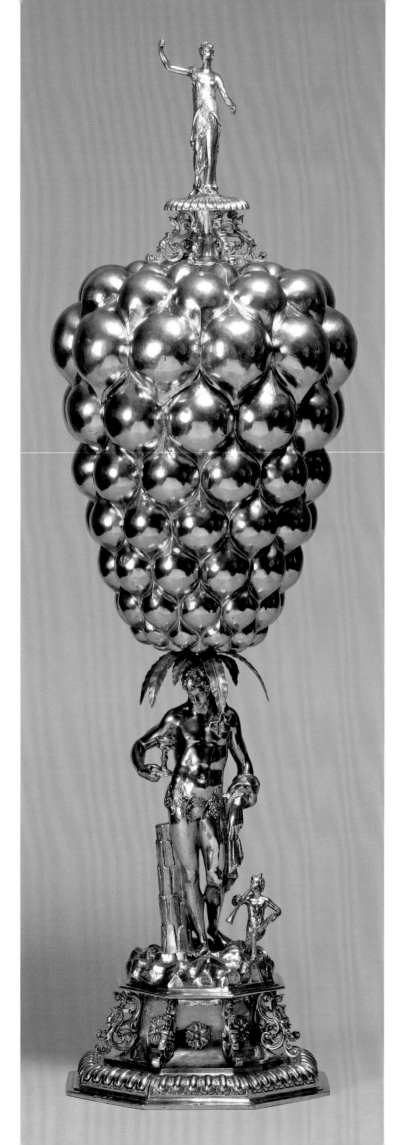

Bacchus is the equivalent of a freestanding statuette. It is loosely derived from the Belvedere Antinous, a renowned ancient Roman statue that inspired a multitude of small bronzes in the Renaissance. Weihrauch ("Italienische Bronzen") notes that its adaptation in this cup demonstrates the liberties mannerist goldsmiths took when they applied figures that were not originally designed as supports to their compositions. This cup is one of eleven objects that Hearst bought at the auction of Rothschild silver in London in April 1937. It bears a price in francs on the foot and a mark that locates it in Russia in 1736. MLL

52

Attributed to Edward Rowland (English, active London, c. 1600)

THE BOSTON SALT

England (London), 1600

Silver gilt

Height: 12 in. (30.5 cm)

Los Angeles County Museum of Art, William Randolph Hearst Collection (inv. no. 49.19.8a–c)

Provenance: Town of Boston, Lincolnshire; sale, Boston Guildhall, June 1, 1837; William Randolph Hearst; presented to the Los Angeles County Museum, August 1949.

Exhibition: *Three Centuries of English Silver*, Los Angeles County Museum, 1950, no. 11.

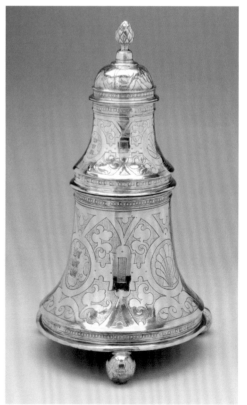

52

Silver standing salts were among the most potent symbols of status and authority in Elizabethan and Jacobean England. Bell-shaped double salts, of which about thirty examples are known, were less costly than architectural or chased cylindrical forms and were considered common by the early seventeenth century. By the 1620s open "trencher" salts had replaced them on fashionable tables and sideboards.

The Boston salt is one of the largest bell salts known and one of four that Hearst owned; the other three were sold from Saint Donat's Castle in 1938. Its base is engraved with the arms of the town of Boston, in Lincolnshire, where it formed part of the corporation plate used at civic banquets. In 1837, following passage of the Municipal Corporations Act (1835), the borough council voted to sell the town's historic silver. In 1929 and again in 1934 Hearst purchased other Boston silver: two of the four ceremonial maces that had been dispersed in 1837.

Double salts comprise three stacked tiers: a smaller salt dish that fits on top of the larger base and a pierced cover, or "sprinkle," that served as a caster for pepper or other dry spice. (The pineapple finial on this example is a later replacement.) When disassembled, the larger salt dish remained in front of the host while the smaller salt and caster stood elsewhere on the table. TM

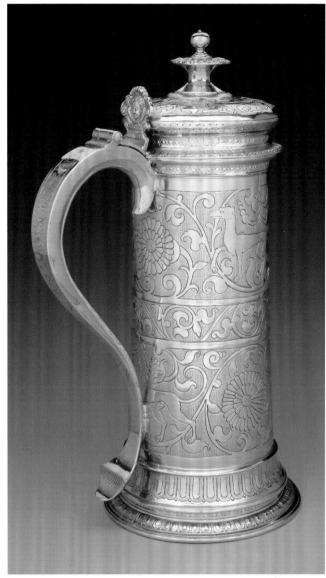

53

53

FLAGON

England (London), 1607/8 (probably John Acton, silversmith)

Silver gilt
Height: 12 in. (30.4 cm); diameter of foot: 5⁵⁄₁₆ in. (13.5 cm)
Marks: date letter *K,* lion passant, leopard's head crowned; maker's mark *IA*
Scratched on base, *39 00; XXXIX oz half...*
Museum of Fine Arts, Boston. Theodora Wilbour Fund in Memory of Charlotte Beebe Wilbour (inv. no. 56.1184)

Provenance: Sold anonymously, Christie's, London, May 18, 1898, lot 138; sold to Wells; Earl of Kilmorey (probably Francis Charles, third Earl, 1842–1915); Earl of Kilmorey estate sale, Christie's, London, July 13, 1926, lot 95; sold to Walter H. Willson, Ltd., London; Mrs. F. H. Cook; her sale, Sotheby's, London, June 14, 1934, lot 151; sold to William Permain, London, for William Randolph Hearst, Saint Donat's Castle, Wales; his sale, Christie's, London, December 14, 1938, lot 96; sold to Sotheby; James Robinson, New York, 1946; Thomas Lumley, Ltd., London, 1956; acquired by the Museum of Fine Arts, Boston, 1956.

Exhibitions: *The Stuart Legacy: English Art, 1603–1714,* Birmingham Museum of Art, Birmingham, Alabama, 1990, no. 102.

Bibliography: Ellenor M. Alcorn, *English Silver in the Museum of Fine Arts, Boston* (Boston: Museum of Fine Arts, 1993), vol. 1, no. 23; Philippa Glanville, *Silver in Tudor and Early Stuart England* (London: Victoria & Albert Museum, 1990), 266–69;

Gerald Taylor, "Some London Platemakers' Marks, 1558–1624," *Proceedings of the Silver Society* 3, no. 4 (1984): 97–100.

Intended as serving vessels for beer or wine, large, straight-sided flagons were made in England for both domestic and church use. Although most surviving examples have been found in churches, they may have been made originally as household plate then given later to churches, where they were used for the Communion. The form of this flagon—with its bun-shaped lid, scrolled handle, and stamped egg-and-dart ornament—is conventional for the date, but the decoration of the sides is remarkable for its precision. The scrolling foliage enclosing greyhounds, bunches of grapes, and stylized flowers (possibly derived from Asian porcelain) is executed

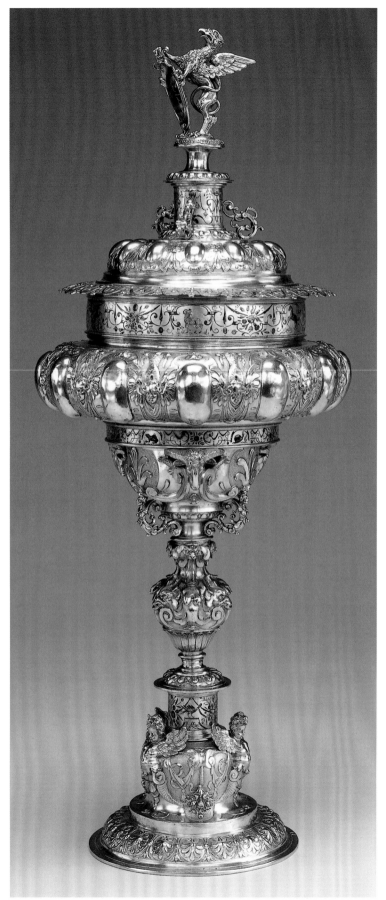

in a peculiarly English technique known as flat chasing, whereby the lines are hammered out with the edge of a punch rather than engraved. This decoration is clearly and boldly delineated in comparison with other examples of the period and with unusually regular punching in the background. The silversmith of this flagon has been identified as John Acton, who worked from a shop in Lombard Street, London, and supplied silver to the king. MGC

54

Hans Jacob I Bachmann, goldsmith (German, c. 1565–1613)
Attributed to David Altenstetter, enameler (German, active in Augsburg, 1570–1617)
STANDING CUP WITH COVER, c. 1608–13

Silver gilt, enamel
Height: 22 in. (55.9 cm)
Toledo Museum of Art; purchased with funds from the Florence Scott Libby Bequest in memory of her father, Maurice A. Scott (inv. no. 1956.63)

Provenance: According to tradition, Cathedral of Tarazona, Spain; Munich art market; William Randolph Hearst (from 1910); Rosenberg & Stiebel, New York; acquired by the Toledo Museum of Art, 1956.

Exhibitions: *German Drawings and Related Objects*, Toledo Museum of Art (lent by Rosenberg & Stiebel, New York), 1956.

Bibliography: "Accessions of American and Canadian Museums, October–December 1957," *Art Quarterly* 21 (Spring 1958): 92, illus. 88; Roger M. Berkowitz, "Objects of Precious Metal," *Museum News: Toledo Museum of Art*, n.s., 13 (Spring 1970): 11; John F. Hayward, *Virtuoso Goldsmiths and the Triumph of Mannerism, 1540–1620* (London: Sotheby Parke Bernet Publications, 1976), 382, pl. 471.

Monumental standing cups are among the most ambitious and spectacular secular objects created by German goldsmiths in the sixteenth and seventeenth centuries. Made in large numbers, they are a distinctively German form that remained popular through the nineteenth century. The griffin finial on this monumental cup holds the shield of the town of Greifenburg, in Bavaria. It may have formed part of the municipal plate displayed at civic banquets or possibly was commissioned for presentation to a visiting dignitary.

The elaborate form and decoration of this cup comprise the full repertory of the goldsmith's art: chasing and repoussé, engraving, and casting. In addition, bands of enamel recall the work of David Altenstetter, a specialist in enamel work, and may have been executed in his workshop. Hans Jacob I Bachmann was well known in court circles. An automaton by him was included in the Kunst- und Wunderkammer of Emperor Rudolf II of Prague. TM

54

55

SILVER ECCLESIASTICAL BANNER WITH PASCHAL LAMB
AND MONSTRANCE
Spain, c. 1680–90

Silver, silver gilt, brass, wood
Banner: 18¾ x 18 in. (47.6 x 45.7 cm); overall height: 115 in.
(292.1 cm)
Hearst Castle/California State Parks (inv. no. 529-9-6338)

Provenance: Phoebe Apperson Hearst; by descent to William Randolph Hearst, 1919.

Exhibitions: *Mrs. Phoebe A. Hearst Loan Collection*, Palace of Fine Arts, San Francisco, 1915–17, no. 640.

Bibliography: Victoria Kastner and Jana Seely, "San Simeon's Collection of Ceremonial Objects," *Magazine Antiques* 161 (April 2002): 141–42; Jana Seely, "Ceremonial Silver at Hearst Castle," *Silver Magazine* 27 (March–April 1995): 31, 34.

William Randolph Hearst and his mother, Phoebe Apperson Hearst, were instrumental in organizing the 1915 Panama-Pacific International Exposition in San Francisco. World's fairs often influenced the cultural climate of their venues, and in the case of San Francisco, the 1915 exposition's focus on the fine arts inspired the city to retain one of the "temporary" buildings constructed for the fair as a permanent gallery, the Palace of Fine Arts.

In 1916 Mrs. Hearst lent objects from her own collection to promote the gallery. The exhibition included tapestries, drawings, furniture, glass, and this silver processional banner. Each side of the banner is chased with scrolling foliage and embellished with gilt floral medallions. One side features a haloed lamb bearing a banner: the Paschal Lamb, symbolic of the resurrection of Jesus. The reverse depicts a monstrance, the receptacle for display of the consecrated host of the communion service. These primary motifs suggest a ceremonial link with the celebration of the Lord's Supper. JS

55

56

56

David Willaume (French, active in England, 1678–1741)
WINE COOLER, 1710

Silver
17¾ x 31 x 18 in. (45.1 x 78.7 x 45.7 cm)
Engraved *TRIA JUNCTA IN UNO* and *SPECTEMUR AGENDO*
Hearst Castle/California State Parks (inv. no. 529-9-6333)

Provenance: Duke of Leeds; his sale, London, June 10, 1920, lot 50; Sotheby's, London, March 19, 1931; sold to William Permain; sold to William Randolph Hearst, London, April 30, 1931.

Bibliography: Victoria Kastner, *Hearst Castle: The Biography of a Country House* (New York: Harry N. Abrams, 2000), 52; Jana Seely and Keri Collins, *Faces of Hearst Castle* (San Simeon, Calif.: Hearst Castle Press, 2007), 38–39.

As Hearst Castle's only dining room, the Refectory was the logical place to display silver serving pieces. At dinner, candlelight reflected off the surfaces of the silver bowls, plates, and platters that were displayed en masse on long tables used as sideboards.

One focal point was this large wine cooler created in London by the Huguenot silversmith David Willaume. The oval basin decorated with bold gadroon borders and a band of shells and husks is bracketed by heavy cast griffin heads overlooking scrolled-ring handles. The body is engraved with the arms of Edward Hussey, Baron Beaulieu.

Such coolers were made to hold bottles of wine packed in ice but were also occasionally used for washing plates and dishes, a perhaps prodigal gesture considering the substantial monetary value represented by the impressive amount of silver required for their manufacture. This one weighs 501.1 ounces (14.2 kg). Hearst owned several of these grandiose silver vessels, all with prestigious provenances.

JS

57

Paulding Farnham(?)/Tiffany & Co.
"Aztec" Calendar Plate, c. 1893

Silver, agate
21 x 21 x 2 in. (53.3 x 53.3 x 5.1 cm)
Brooklyn Museum, Modernism Benefit Fund (inv.
no. 87.182)
Page 35

Provenance: Tiffany & Co. silver display, World's Columbian Exposition, Chicago,
1893; sold to William Randolph Hearst; American Heritage Society; sale, Sotheby
Parke Bernet, New York, November 6–8, 1975; sale, Sotheby's, January 28, 1988, lot
1029; acquired by the Brooklyn Museum.

Exhibitions: World's Columbian Exposition, Chicago, 1893; *Converging Cultures:
Art and Identity in Spanish America*, Brooklyn Museum and Phoenix Art Museum,
1996–97; *Tiffany Retrospective: Designs from Tiffany & Co., 1837–1999*, Art
International, Tokyo, and Exhibition International, New York, New York, 1999.

Bibliography: John Loring, *Magnificent Tiffany Silver* (New York: Harry N. Abrams,
2001), 217.

Tiffany & Co. created this silver tray as part of its display
for the 1893 Chicago World's Fair, known as the World's
Columbian Exposition. It may have been purchased there
by William Randolph Hearst, who shared with his mother,
Phoebe Apperson Hearst, a keen appreciation for the art
of ancient cultures. Phoebe Hearst fueled her interest in art
and anthropology by funding archaeological expeditions
to Peru, Mexico, Italy, Greece, and Egypt.

Edward C. Moore, head of Tiffany design, also admired
ancient art. He assembled an important collection of metal-
work from Egypt, Persia, Turkey, and India, as well as glass
and ceramics from Persia and Arabia; these objects, along
with a library of resource materials, were made available
for Tiffany designers to study. This tray demonstrates the
way Tiffany designers, especially those who worked with
Moore, used arts of other cultures as sources of inspiration.
The silver version interpreted, rather than copied, the
renowned Aztec stone calendar from Tenochtitlan, Mexico
(Museo Nacional de Antropología, Mexico City), which is
about eleven feet in diameter and weighs almost twenty-five
tons. It dates from about 1490. Hearst also owned the tea
set (Dallas Museum of Art) and salt and pepper shakers
(Brooklyn Museum) inspired by this Aztec design. JS

58

Edward C. Moore/Tiffany & Co.
"Orchid Vase" Lamp, 1889 (vase) and 1891 (lamp)

Silver, enamel, glass
Overall height: 45 in. (114.3 cm); overall diameter: 21 in.
(53.3 cm)
Vase: height: 25 in. (63.5 cm); diameter: 17 in. (43.2 cm)
Hearst Castle/California State Parks (inv. nos. 529-9-6239,
529-9-9009)
Page 28

Provenance: Tiffany & Co., New York, 1889; sold to Phoebe Apperson Hearst;
by descent to William Randolph Hearst, 1919.

Exhibitions: Tiffany & Co. silver display, Exposition Universelle, Paris, 1889.

Bibliography: John Loring, *Magnificent Tiffany Silver* (New York: Harry N. Abrams,
2001), 180–81; Jennifer Pittman, "The Silver Legacy of William Randolph Hearst,"
Silver Society of Canada 4 (Fall 2001): 6–12; Jana Seely, "Found, but Not Lost: Hearst
Castle's Tiffany & Co. Lamp," *Silver Magazine* 33, no. 3 (2001): 20–25.

The "Orchid Vase" was designed by Edward C. Moore as a
showpiece for Tiffany & Co.'s award-winning silver display
at the 1889 Exposition Universelle in Paris. Phoebe Apperson
Hearst purchased the vase and later commissioned Tiffany's
to refit it as a lamp for the mansion that she and her hus-
band bought in Washington, D.C., during his terms in the
U.S. Senate. After inheriting the lamp, her son, William
Randolph Hearst, insisted that it occupy pride of place in
the Assembly Room at his San Simeon estate, where it is
the only Victorian decoration in evidence.

More than thirty varieties of orchids cascade in enamel
down the sides of the vase. Their realism is emphasized by
nuanced color and detailed enameling. All nonenameled
surfaces are etched in patterns that were described at the
time of manufacture as "Saracenic" or Islamic in inspiration.
Because the vase was raised from a single sheet of silver,
no solder or seam lines mar the delicacy of the patterns.
JS

ENAMELS

59

The Master of the Aeneid (France, active c. 1520–40)
PLAQUE: NAVAL GAMES IN HONOR OF ANCHISES
France (Limoges), c. 1525–30

Enamel, gold and silver foil, copper
8 13/16 x 7 7/8 in. (22.3 x 20 cm)
Los Angeles County Museum of Art, William Randolph
Hearst Collection (inv. no. 51.13.2)

Provenance: Probably Hollingworth Magniac, Colworth, Bedfordshire; sale, London,
July 2, 1892, lot 511 or 528; possibly J. and S. Goldschmidt, Frankfurt; Jules Porgès, Paris
(by 1912); Thomas Fortune Ryan (1851–1928), New York; sale, American Art Association/
Anderson Galleries, New York, November 23–25, 1933, lot 388b; Arnold Seligmann,
Rey & Co., New York; sold to William Randolph Hearst, 1936(?); shipped from the
San Simeon warehouse and presented to the Los Angeles County Museum, 1951.

Bibliography: Sophie Baratte, "La série de plaques du maître de l'Énéide," in *Études
d'histoire de l'art offertes à Jacques Thirion*, ed. Alain Erlande-Brandenburg and Jean-
Michiel Linaud (Paris: École des Chartes, 2001), 134, 143, no. 45; Susan L. Caroselli,
The Painted Enamels of Limoges (Los Angeles: Los Angeles County Museum of Art,
1993), no. 4; Jean-Joseph Marquet de Vasselot, "Une suite d'émaux limousins à sujets
tirés de l'Énéide," *Bulletin de la Société de l'histoire de l'art français*, 1912, 40, no. 30.

Eighty-two plaques with scenes from Virgil's *Aeneid* are
known today, all of them different and evidently by the
same unknown artist working in Limoges around 1525–30.
They constitute the largest series of Renaissance enamels

59

known. They are also unusual in illustrating a classical text
rather than religious subjects. It is likely that they were a
private commission originally designed to be set into the
woodwork of a small room, or *studiolo*, of a learned patron.

This plaque depicts events described in book 5 of the
Aeneid. Having landed in Sicily at Dardanus, the Trojans
organized a boat race to commemorate the first anniversary
of the death of Anchises, the father of Aeneas. The design
sources for this and the other plaques in the series are the
woodcut illustrations in the 1502 edition of the *Aeneid* pub-
lished in Strasbourg by Johann Grüninger.

Hearst owned three plaques by the Master of the Aeneid;
two were gifts to the Los Angeles County Museum in 1951.
The third, also from the T. F. Ryan collection and purchased
from Seligmann in 1936, was sold at auction (Hammer
Galleries, New York, March 25, 1941, lot 141), where it was
purchased by Brummer Galleries. Ryan was an important
collector of Medieval and Renaissance art; he was president
of the board of trustees of the Metropolitan Museum of Art
and one of Auguste Rodin's patrons. TM

60

Pierre Reymond (French, c. 1513–after 1584)
TAZZA: SCENE FROM THE BOOK OF PROVERBS
France (Limoges), 1558

Enamel, copper
Height: 3 1/2 in. (8.9 cm); diameter: 8 15/16 in. (22.7 cm)
Los Angeles County Museum of Art, William Randolph
Hearst Collection (inv. no. 48.2.12)

Provenance: Baron Roger; sale, 1841, lot 194; Adrien-Joseph Rattier, Paris; sale,
Paris, March 21–24, 1859, lot 150; de Blacas [Louis de Blacas d'Aulps, duc de Blacas
(1815–66)?]; Charles Mannheim (1833–1910), Paris; J. Pierpont Morgan (1837–1913),
New York; Duveen Brothers, New York; sold to William Randolph Hearst; presented
to the Los Angeles County Museum, January 12, 1948.

Bibliography: Susan L. Caroselli, *The Painted Enamels of Limoges* (Los Angeles:
Los Angeles County Museum of Art, 1993), no. 9; Émile Molinier, *Collection Charles
Mannheim: Objets d'art* (Paris: E. Moreau, 1898), no. 182.

This shallow footed bowl, or tazza, and its mate (also in the
Hearst collection) illustrate scenes from the Old Testament
book of Proverbs. A tablet in the lower right identifies the
subject, *ORNAMENTVM AVREUM IN NARE PORCI PROVERBIS
XI* (A gold ornament in a pig's snout, Proverbs 11), a portion
of the proverb "Like a gold ring in a pig's snout is a beauti-
ful woman without good sense." The pig is prominent in
the foreground, but there is no foolish woman in sight, only
dancing peasants in the middle distance.

The stand is dated 1558 opposite an unidentified coat of arms. The underside is richly decorated with mannerist strapwork and oval cartouches containing reclining nudes that Susan Caroselli (*Painted Enamels*) relates to Jacques Androuet du Cerceau's 1556 design for the ceiling decoration of the Galerie d'Ulysse at Fontainebleau.

No other Limoges enamels decorated with scenes from the book of Proverbs are known, and no print source for this composition has come to light. The tazza's rarity, the quality of execution, and the presence of a coat of arms all suggest a private commission. TM

61

Pierre Reymond (French, c. 1513–after 1584)
EWER STAND WITH SCENES FROM THE BOOK OF GENESIS
France (Limoges), c. 1558

Enamel on copper
Diameter: 18¾ in. (47.6 cm)
Los Angeles County Museum of Art, William Randolph
Hearst Collection (inv. no. 48.2.19)

Provenance: Possibly Debruge Duménil collection, Paris, by 1846; sale, Hôtel des Ventes, Paris, January 23, 1850, lot 709; possibly Prince Peter Soltykoff, Paris; sale, Hôtel Drouot, Paris, April 8–May 1, 1861, lot 481; possibly Seillière collection, Paris; Maurice Kann (d. 1906), Paris, by 1889; probably Duveen Brothers, New York; J. Pierpont Morgan (1837–1913), New York; Duveen Brothers, New York; William Randolph Hearst; presented to the Los Angeles County Museum, January 12, 1948.

Exhibitions: Possibly Exposition Universelle, Paris, 1878; *Exposition rétrospective de l'art français au Trocadéro*, Palais du Trocadéro, Paris, 1889, no. 1108.

Bibliography: Susan L. Caroselli, *The Painted Enamels of Limoges* (Los Angeles: Los Angeles County Museum of Art, 1993), no. 11; possibly Jules Labarte, *Description des objets d'art qui composent la collection Debruge-Duménil* (Paris: Victor Didron, 1847), no. 709; possibly Edmond du Sommerard, *Les arts au moyen-age en ce qui concerne principalement le palais romain de Paris l'Hôtel de Cluny*, vol. 5 (Paris: Hôtel de Cluny, 1846), 400, ser. 7, pl. XXVIII.

This ewer stand is one of approximately fifteen similarly decorated known stands that were produced in the workshop of Pierre Reymond, whose products are often marked, as this one is, with the initials *P.R.* Susan Caroselli (*Painted Enamels*) has pointed out that several different Limoges workshops produced ewers, whereas the majority of stands come from Reymond's shop. This suggests that the two items were not always made as a pair.

The stand illustrates scenes from the first four chapters of the book of Genesis set against a landscape inhabited by real and mythical beasts. The figures are faithful copies of a series of engravings by Lucas van Leyden depicting the Creation and Fall of Man (1529). The black outlines around

60, 61, 62

the major figures suggest the use of pricked tracings to transfer these images from the prints onto copper.

This is one of several Limoges enamel plates and vessels from the collection of J. Pierpont Morgan that Hearst acquired from Duveen between 1915 and 1919. Hearst also owned a second ewer stand by Reymond, now in the Milwaukee Art Museum. TM

62

Jean de Court (French, active 1553–85)
OVAL PLATTER: DESTRUCTION OF THE HOSTS OF PHARAOH
France (Limoges), c. 1560–70

Enamel, copper
15 13/$_{16}$ x 20 ¾ in. (40.2 x 52.7 cm)
Los Angeles County Museum of Art, William Randolph Hearst Collection (inv. no. 48.2.16)

Provenance: Baron Achille Seillière, Paris; sale, Paris, Galerie Georges Petit, March 5–10, 1890, lot 215; Maurice Kann (d. 1906), Paris; Duveen Brothers, New York; William Randolph Hearst, 1915; presented to the Los Angeles County Museum, 1948.

Exhibitions: Probably *Special Loan Exhibition of Enamels on Metal*, South Kensington Museum, London, 1874; *Exposition de l'Union centrale des arts décoratifs*, Union centrale des arts décoratifs, Paris, 1884.

Bibliography: Susan L. Caroselli, *The Painted Enamels of Limoges* (Los Angeles: Los Angeles County Museum of Art, 1993), no. 27; Philippe Verdier, *The Frick Collection: An Illustrated Catalogue*, vol. 8, *Limoges Painted Enamels, Oriental Rugs, and English Silver* (New York: Frick Collection, 1977), 160n3.

The dense composition on this platter is characteristic of the enamels produced in the atelier of Jean de Court, a court painter at Fontainebleau who also maintained an enamel workshop at Limoges. This scene depicts Moses parting the Red Sea, shown as a wall of water about to engulf the pharaoh, in a horse-drawn chariot, and his army. Behind Moses, God appears in the form of a swan-shaped pillar of cloud in the distance.

Susan Caroselli (*Painted Enamels*) identified the source for this design as an engraving by Bernard Solomon published in Claude Paradin's *Quadrins historiques de la Bible* (Lyons, 1553). Reymond adapted the print to create a far more dramatic composition, further enhanced by the skillful painting of drapery on the left side and dramatic shading of flesh tones in the figures and horses on the right.

The underside and the border decoration of this platter are nearly identical to those of another platter by de Court in the Hearst collection, which displays an entirely different subject, the Rape of Europa. This suggests that successful designs were often interchangeable on products of the de Court workshop. TM

63

Martial Courteys (French, active 1544–c. 1581)
TWELVE PLATES: THE LABORS OF THE MONTHS
France (Limoges), c. 1565–75

Enamel, copper
Diameter: 8 in. (20.3 cm) each
Los Angeles County Museum of Art, William Randolph Hearst Collection (inv. nos. 48.2.11.1–.12)

Provenance: George Guy Greville (1818–1893), fourth Earl of Warwick; sale, Christie's, London, July 17, 1896, lot 22; Charles Mannheim (1833–1910), Paris; J. Pierpont Morgan (1837–1913), New York; Duveen Brothers, New York; sold to William Randolph Hearst, 1919; presented to the Los Angeles County Museum, January 1948.

Exhibition: *Special Loan Exhibition of Enamels on Metal*, South Kensington Museum, London, 1874, nos. 747–58.

Bibliography: Susan L. Caroselli, *The Painted Enamels of Limoges* (Los Angeles: Los Angeles County Museum of Art, 1993), nos. 29–40; Émile Molinier, *Collection Charles Mannheim: Objets d'art* (Paris: E. Moreau, 1898), nos. 191–202.

Martial Courteys was a second-generation enameler, the middle son of Pierre Courteys, whose work is also represented in the Hearst collection. Enamels by Courteys are very rare, and this is the only known complete set of calendar plates by him. They were adapted from engravings by Étienne Delaune, and all but the January plate incorporate the artist's initials, M.C., within a cartouche at the top and the name of the month at the bottom. The underside of each plate is painted with the appropriate zodiacal sign. Susan Caroselli (*Painted Enamels*) proposed that these plates were probably painted by Courteys himself, since the quality of the painting is equal to or better than that of the finest work signed by him.

Hearst rarely acquired collections en bloc, although Italian maiolica from the Morgan and Adolphe de Rothschild collections and Limoges enamels from the Morgan collection were exceptions. Duveen's client account book records the sale of these plates and other enamels between 1915 and 1919, the same years he was selling the majority of Morgan's Limoges enamels to Henry Clay Frick. These calendar plates still bear Morgan's red catalog numbers (P.M. 773–74, 778, 951, 955, 957–58, 983, 986–88, 909). TM

GLASS

64

LAMP
Egypt or Syria, mid-14th century

Glass, free-blown and tooled, applied handles, enameled
and gilded
14⅞ x 11½ in. (37.5 x 29.2 cm)
Los Angeles County Museum of Art, William Randolph
Hearst Collection (inv. no. 50.28.4)

Provenance: Lucien Sauphar; his sale, Galerie Charpentier, Paris, March 17, 1936; sold
to Arnold Seligmann, Rey & Co., Paris; sold to William Randolph Hearst; presented to
the Los Angeles County Museum, 1950.

Exhibitions: *The Arts of Fire: Islamic Influences on Glass and Ceramics of the Italian
Renaissance*, J. Paul Getty Museum, Los Angeles, 2004, pp. 86–87, pl. 6.

This oil lamp was specifically commissioned for a building
in Cairo, either the mosque or the *khanaqah* (Sufi hospice)
of the Amir Shaykhu al-Nasiri, whose name is inscribed on
the lower section of the object, while his heraldic device,
a cup within a medallion, is repeated on the neck and foot.
The Arabic inscription on the lamp's neck quotes from a
famous verse in the Qur'an (24:35), in which the light of
God is likened to the light from an oil lamp.

Glassware of this type, which was produced primarily
between 1300 and 1400, owes its strong appeal to the tech-
nical virtuosity involved in its production. Polychrome
enamels and gilding were applied cold and then carefully
fixed in a low-temperature kiln. Examples of enameled
glass from the Mamluk period in Syria and Egypt (1250–1517)
found their way to Europe as early as the fourteenth cen-
tury, but in the mid-nineteenth century a popular taste for
this glass blossomed in Europe. Its popularity also inspired
glassmakers in France, Italy, and Austria to imitate Mamluk
glass. In fact, at the same time that Hearst acquired this
lamp, he also purchased a late nineteenth-century Austrian
imitation. LK

65

BOTTLE WITH THE ARMS OF THE HOLY ROMAN EMPIRE
Bohemia, 1572

Blown glass, enamels
13½ x 4½ x 4½ in. (34.3 x 11.4 x 11.4 cm)
Los Angeles County Museum of Art, William Randolph
Hearst Collection (inv. no. 48.24.146a–b)
Page 117

Provenance: William Randolph Hearst; presented to the Los Angeles County
Museum, October 1948.

Bibliography: Gregor Norman-Wilcox, "Early German Glasses," *Bulletin of the Art
Division, Los Angeles County Museum* 2 (Spring 1949): 3–11; Axel von Saldern, *German
Enameled Glass* (Corning: Corning Museum of Glass, 1965), 63–64, fig. 51.

66

GOBLET WITH STAG HUNT
Bohemia, 1594

Blown glass, enamels
Height: 10¼ in. (26 cm); diameter (rim): 3½ in. (8.9 cm);
diameter (base): 3⅝ in. (9.2 cm)
Los Angeles County Museum of Art, William Randolph
Hearst Collection (inv. no. 48.24.231)
Page 117

Provenance: Frederic Spitzer (1815–1890), Paris; probably sold at auction, Paris, 1893;
William Randolph Hearst; presented to the Los Angeles County Museum, October 1948.

67

BOTTLE WITH THE CRUCIFIXION
German, 1620

Blown glass, enamels
Height: 15 in. (38.1 cm)
Los Angeles County Museum of Art, William Randolph
Hearst Collection (inv. no. 48.24.149)
Page 117

Provenance: William Randolph Hearst, by 1903; presented to the Los Angeles County
Museum, October 1948.

64

68

ELECTORS BEAKER (KURFÜRSTENHUMPEN)
Germany (probably Franconia), 1667

Blown glass, enamels
Height: 9 ⅞ in. (25.1 cm); diameter (base): 5 ⅝ in. (14.3 cm)
Los Angeles County Museum of Art, William Randolph
Hearst Collection (inv. no. 48.24.160)
Page 117

Provenance: Julius Campe Jr. (d. 1909), Hamburg; William Randolph Hearst, 1910; presented to the Los Angeles County Museum, October 1948.

In 1948 Hearst presented more than two hundred examples of German glass to the Los Angeles County Museum. They range in date from the late sixteenth century to the nineteenth century and included enameled and etched glass from Germany, Bohemia, and Silesia. The enameled glass comprised all the major shapes and styles of decoration: Reichsadler- and Kurfürstenhumpen (imperial eagle and electors beakers), Passglasses and Willkommglasses, court cellar glasses, and vessels decorated with biblical scenes, armorial crests, mottoes and images of trade guilds, and hunt scenes.

Among the earliest examples is the Reichsadler bottle of unusual rectangular shape, dated 1572. The early stepped cup decorated with a hunt scene and the 1667 electors beaker were among Hearst's first acquisitions of glass. He purchased the goblet in 1893 in Paris at the auction of the celebrated collection of Viennese dealer-collector Frederic Spitzer. The beaker was part of a group of forty-three glasses from the collection of Hamburg publisher Julius Campe that Hearst purchased at auction in Paris in 1910. The bottle with the Crucifixion and figures of an elector and Martin Luther has confounded experts, who regard it as either a unique rarity or an outright fake.

Hearst inherited his taste for German glass from his mother, Phoebe Hearst, who collected humpen. Beginning in the 1890s and continuing over the course of the next fifty years, he assembled his own extensive collection of German glass, primarily through purchases at auctions in Germany and in Paris, Amsterdam, London, and New York. It was among his earliest collecting interests, and examples of German glass were also among the last works of art he purchased before his death. TM

69

HOFKELLEREI PASSGLAS (BEAKER)
Germany (Saxony), 1701

Blown glass, enamel, gilding
Height: 13 ¾ in. (34.9 cm); overall diameter: 7 ¼ in. (18.4 cm)
Los Angeles County Museum of Art, William Randolph
Hearst Collection (inv. no. 48.24.221)
Page 117

Provenance: Karl Thewalt, Cologne; sale, Kunsthaus Lempertz, Cologne, November 4–14, 1903, lot 432; probably Phoebe Apperson Hearst (d. 1919); by descent to William Randolph Hearst; presented to the Los Angeles County Museum, October 1948.

Bibliography: Gregor Norman-Wilcox, "Early German Glasses," *Los Angeles County Museum, Bulletin of the Art Division* 2 (Spring 1949): 5; Axel von Saldern, *German Enameled Glass: The Edwin J. Beinecke Collection and Related Pieces* (Corning, N.Y.: Corning Museum of Glass, 1965), 207.

This unusually large Passglas is decorated with a view of the fortress of Voigtsberg and bears Latin and German inscriptions recalling the region's earliest history under Decimus Claudius Drusus (38–9 BCE), the Roman governor (in German, *Vogt*) of Gaul. Opposite the landscape is the coat of arms of Saxony-Poland and the date 1701. Modern Voigtland forms the southwest corner of Saxony, whose rulers and various castles are commemorated on a small number of seventeenth- and early eighteenth-century Hofkellerei glasses. These were intended for communal drinking, with each person's draft indicated by a gilt line.

This glass evidently belonged to Phoebe Apperson Hearst, who placed it at the center of a display of German enameled glass on a mantelpiece in her hacienda at Pleasanton. By 1948, when Hearst presented more than two hundred examples of early German glass to the Los Angeles County Museum, they were shipped from Wyntoon. Much of the collection had already been dispersed, with a number of important pieces sold to Edwin J. Beinecke in 1940 (now in the Corning Museum of Glass).
TM

70

TWO WINDOWS WITH THE STORY OF ESTHER
The Netherlands, 1620s

Colorless glass, grisaille, enamels, silver stain
38 x 24 in. (96.5 x 61 cm)
Los Angeles County Museum of Art, William Randolph
Hearst Collection (inv. no. 45.21.52–.53)

Provenance: Hamburger Frères, Paris; sold to William Randolph Hearst, April 24, 1913; shipped from the Bronx warehouse and presented to the Los Angeles County Museum, September 1943.

Bibliography: Madeline H. Caviness et al., *Stained Glass before 1700 in American Collections: Midwestern and Western States*, Corpus Vitrearum Checklist 3 (Washington, D.C.: National Gallery of Art, 1985), 16–20; Timothy B. Husband, *Stained Glass before 1700 in American Collections: Silver-Stained Roundels and Unipartite Panels*, Corpus Vitrearum Checklist 4 (Washington, D.C.: National Gallery of Art, 1991); James Normile, "The William Randolph Hearst Collection of Medieval and Renaissance Stained and Painted Glass," *Stained Glass* 41 (Summer 1946): 39-44.

These windows, part of a larger set, are fine examples of the Dutch tradition of placing a monochromatic panel within a larger field of colorless glass. The central panels are reversed versions of 1563 engravings by Philip Galle after Maerten van Heemskerck (Hollstein 250, 255).

The Old Testament book of Esther relates the story of Queen Esther, who risked her life by disobeying royal protocol in order to save the Jewish people from being put to death by the king's chief minister, Haman. The subject may have appealed to Dutch patrons as analogous to the founding of the Netherlands, a tiny Protestant nation that had recently gained autonomy from the Catholic empire of Spain.

One window shows King Ahasuerus (Xerxes) giving his ring, the ultimate seal of authority, to Haman. The other shows the climax of the story as Esther exposes Haman's treacherous plot of mass murder and begs the king to spare the lives of Jewish people in his empire. Visible in the distance are the gallows on which Haman, rather than Esther, is then put to death.

Between 1910 and 1930 Hearst assembled a vast collection of stained and painted glass. Before 1914 he purchased mainly from European dealers such as Hugo Helbing and A. S. Drey in Munich, Hamburger Frères in Paris, and Frederick Muller in Amsterdam. The pace of Hearst's glass acquisitions peaked in the 1920s, when he relied primarily on Arnold Seligmann, Rey & Co., Brummer Galleries, and French & Company in New York. He also bought actively at the auction of the James Garland collection (1924). The bulk of Hearst's stained glass was dispersed at auctions in the 1930s and sold through Gimbels in the 1940s. Much of what remained was given to the Los Angeles County Museum.

TM

71

ARMORIAL WINDOW
The Netherlands, 1620 and 1625

Colorless glass, grisaille, enamels, silver stain
33 ¼ x 17 ¾ in. (84.4 x 45.1 cm)
Los Angeles County Museum of Art, William Randolph
Hearst Collection (inv. no. 45.21.57)
Page 134

Provenance: William Randolph Hearst; shipped from the Bronx warehouse and presented to the Los Angeles County Museum, December 1943.

Bibliography: Madeline H. Caviness et al., *Stained Glass before 1700 in American Collections: Midwestern and Western States*, Corpus Vitrearum Checklist 3 (Washington, D.C.: National Gallery of Art, 1985), 76; James Normile, "The William Randolph Hearst Collection of Medieval and Renaissance Stained and Painted Glass," *Los Angeles County Museum Quarterly* 4 (Fall–Winter 1945): 9.

This window is part of a set of six heraldic panels. The initials of an owner, F.V.L., and the date 1625 were evidently added five years after it was made, and the coat of arms was also updated at that time. The most colorful details are the flowers in the lower corners: a tulip and a chrysanthemum. The chrysanthemum, native to China and introduced to Japan around the eighth century, was first imported to Europe in the seventeenth century, when Dutch merchants established trade with both countries. The red and white tulip resembles the *Semper Augustus*, the rarest of bulbs at the center of the Dutch tulip mania in the 1630s. It is appropriate that these two flowers, emblems of trade and finance, frame a seascape with ships in a harbor. This is the only panel in the group with a painted seascape.

TM

Haman die hooch van ... Aſsveero was verheeven
Sijnde een geſsvooren Vijſſant vande Jooden
Hij Creech Coninck... ... Heeſt haeſt geſchreeven
Jn Alle ʒʒeʃten Om ... Haer te Dooden
· 1 · 6 · 2 · 0 ·

Abraham Lieven ſ8 ʒvaloy en
Everitgen Pieterſ Zijn Huijſv.

CERAMICS

72

DEEP DISH
Decorated with tree of life, palmettes, pseudo-Kufic script, and stylized motifs; reverse with large fleur-de-lis
Spain (Valencia, probably Manises), c. 1400–1450

Earthenware, tin-glazed, painted in blue and brown luster
Diameter: 17¾ in. (45.1 cm)
The Metropolitan Museum of Art, New York, The Cloisters
Collection, 1956 (inv. no. 56.171.162)

Provenance: Arnold Seligmann, Rey & Co., Paris and New York; sold to William Randolph Hearst, March 22, 1915.

Exhibitions: *Islam and the Medieval West*, University Art Gallery, State University of New York, Binghamton, 1975, no. 84.

Bibliography: Timothy Husband, "Valencian Lusterware of the Fifteenth Century: Notes and Documents," *Bulletin of the Metropolitan Museum of Art*, n.s., 29 (Summer 1970): 22; *The Islamic World* (New York: Metropolitan Museum of Art, 1987), 64–65; Richard H. Randall Jr., "Lusterware of Spain," *Bulletin of the Metropolitan Museum of Art*, n.s., 15 (June 1957): 213–21.

73

PITCHER
Decorated with pseudo-Kufic script and stylized geometric forms
Spain (Valencia, probably Manises), c. 1400–1450

Earthenware, tin-glazed, painted in blue and brown luster
Height: 18⅜ in. (46.7 cm)
The Metropolitan Museum of Art, New York, The Cloisters
Collection, 1956 (inv. no. 56.171.146)
Page 49

Provenance: Frederick Spencer, fourth Earl Spencer(?), Althorp, Northampton, England; Joseph Duveen; sold to William Randolph Hearst, November 23, 1912.

Exhibitions: *Fine European Earthenware*, Saint Petersburg Museum of Fine Arts, Saint Petersburg, Florida, 1973; *The Secular Spirit: Life and Art at the End of the Middle Ages*, Cloisters, Metropolitan Museum of Art, New York, 1975, no. 43.

Bibliography: Juan Ainaud de Lasarte, *Ars Hispaniae*, vol. 10, *Ceramica y vidrio* (Madrid: Editorial Plus-Ultra, 1952), 42; Randall, "Lusterware of Spain," 213–21.

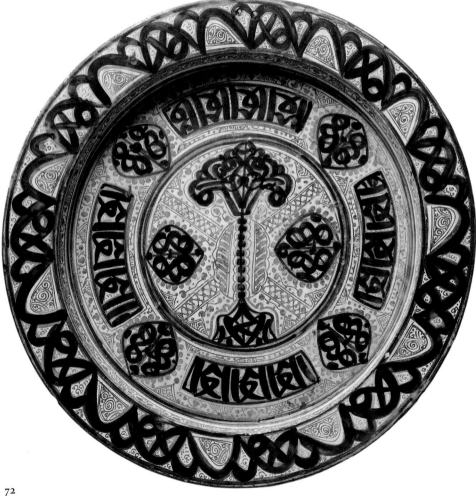

72

74

DISH

Decorated with hound and stylized floral decoration

Spain (Valencia, probably Manises), c. 1400–1450

Earthenware, tin-glazed and painted in blue and brown luster

Diameter: 13 ¾ in. (34.9 cm)

The Metropolitan Museum of Art, New York, The Cloisters Collection, 1956 (inv. no. 56.171.115)

Provenance: Arnold Seligmann, Rey & Co., Paris and New York; sold to William Randolph Hearst, June 13, 1922.

Exhibitions: *Monsters, Gargoyles, and Dragons: Animals in the Middle Ages*, Mount Holyoke College, South Hadley, Massachusetts, 1977, no. 35.

75

DEEP DISH

Decorated with acacia tendrils and blossoms, crowns, and monogram *IM*

Spain (Valencia, probably Manises), c. 1430–60

Earthenware, tin-glazed and painted in blue and brown luster

Diameter: 18 ¾ in. (47.2 cm)

The Metropolitan Museum of Art, New York, The Cloisters Collection, 1956 (inv. no. 56.171.154)

Provenance: William Randolph Hearst.

Exhibitions: *Fine European Earthenware*, Saint Petersburg Museum of Fine Arts, Saint Petersburg, Florida, 1973; *The Secular Spirit: Life and Art at the End of the Middle Ages*, Cloisters, Metropolitan Museum of Art, New York, 1975, no. 74; *Images of the Plague: The Black Death in Biology, Arts, Literature, and Learning*, University Art Gallery, State University of New York, Binghamton, 1977.

Bibliography: Husband, "Valencian Lusterware," 28; Randall, "Lusterware of Spain," 213–21.

76

DISH

With patterned spur decoration and central rampant lion within shield

Spain (Valencia, probably Manises), c. 1430–60

Earthenware, tin-glazed and painted in blue and brown luster

Diameter: 18 ¼ in. (46.4 cm)

The Metropolitan Museum of Art, New York, The Cloisters Collection, 1956 (inv. no. 56.171.131)

Provenance: William Permain, London; sold to William Randolph Hearst, December 31, 1921.

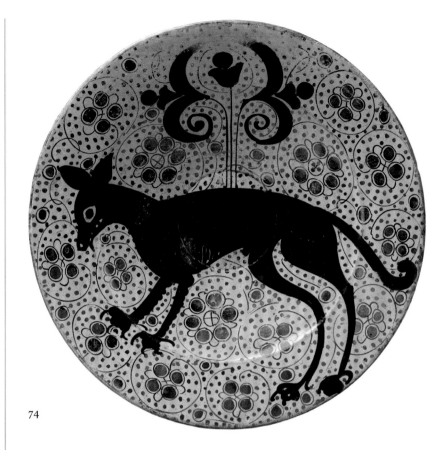

74

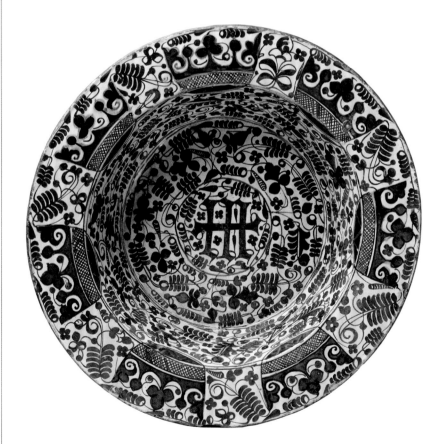

75

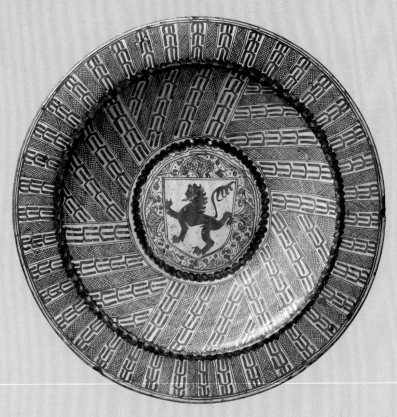

76

77

78

79

77

DISH

Decorated with unidentified coat of arms and ivy leaves with sgraffito veining, mimosa, and other flowers
Spain (Valencia, probably Manises), c. 1430–70

Earthenware, tin-glazed and painted in blue and brown luster
Diameter: 18 in. (45.7 cm)
The Metropolitan Museum of Art, New York, The Cloisters Collection, 1956 (inv. no. 56.171.102)

Provenance: Ernest Odiot, Paris; his sale, Hôtel Drouot, April 27–28, 1889, no. 76; Rudolph Lepke, Berlin; William Randolph Hearst, June 26, 1911 (?).

78

DISH

Decorated with unidentified shield containing an antelope and ivy leaf decoration
Spain (Valencia, probably Manises), c. 1430–70

Earthenware, tin-glazed and painted in brown luster
Diameter: 17 ¾ in. (45.1 cm)
The Metropolitan Museum of Art, New York, The Cloisters Collection, 1956 (inv. no. 56.171.137)

Provenance: Arnold Seligmann, Rey & Co., Paris and New York; sold to William Randolph Hearst, April 1, 1916.

Bibliography: Richard Randall Jr., *A Cloisters Bestiary* (New York: Metropolitan Museum of Art, 1960), 19; Jack L. Schrader, "A Medieval Bestiary," *Bulletin of the Metropolitan Museum of Art*, n.s., 44 (Summer 1986): 16.

79

DEEP DISH

With central shield containing an eagle and decorated with leaves and flowers; reverse decorated with heraldic eagle among acacia blossoms
Spain (Valencia, probably Manises), c. 1450–70

Earthenware, tin-glazed and painted in blue and brown luster
Diameter: 18 ⅝ in. (47.3 cm)
The Metropolitan Museum of Art, New York, The Cloisters Collection, 1956 (inv. no. 56.171.151)

Provenance: Ercole Canessa, New York; sold to William Randolph Hearst, March 9, 1926.

Bibliography: Randall, "Lusterware of Spain," 213–21.

80

DISH

Decorated with molded petal motifs, tree of life, and dot and stalk decoration; raised central with coat of arms, perhaps the counts of Villahermosa, Aragon
Spain (Valencia, probably Manises), late 15th–early 16th century

Earthenware, tin-glazed and painted in brown luster
Diameter: 17 ⅜ in. (44.2 cm)
The Metropolitan Museum of Art, New York, The Cloisters Collection, 1956 (inv. no. 56.171.121)

Provenance: William Randolph Hearst.

Exhibitions: *Songs of Glory: Medieval Art from 900–1500*, Oklahoma Museum of Art, Oklahoma City, 1985, no. 125.

Bibliography: Alberto and Arturo Garcia Carraffa, *Enciclopedia heráldica y genealógica hispano-americana* (Madrid: [Neuva Imprenta Radio], 1919–56), vol. 7, 232–37, no. 1789.

80

Characterized by a unique glazing process that simulates the metallic finish of precious metals and a distinctive palette of varying shades of brown luster, frequently in combination with a rich cobalt blue paint, the type of pottery from Spain known as Valencian lusterware was the finest and most highly prized glazed pottery of the fifteenth century. Indeed, written documentation and the appearance of these wares in paintings of non-Spanish origin attest to their widespread appeal and their export to an extremely large international market. While it is believed that the technique gradually spread to southern Spain from North Africa, by the end of the fourteenth century the region of Valencia, on the eastern coast of the country, rich in potter's clays, became the leading center of Spanish lusterware production. Although it is traditionally associated with the workshops of Manises, surviving documentation provides evidence that workshops existed throughout the region.[1]

Fifteenth-century Valencian lusterware is often referred to as Hispano-Moresque pottery, and these nine examples clearly illustrate the confluence of Islamic techniques and decorative elements with Gothic motifs. Both the deep dish with tree of life and the large pitcher, which are dated to the first half of the fifteenth century, are strongly Islamic in character, with pseudo-Kufic script, trees of life, and stylized zigzag and geometric decoration. Other dishes decorated with floral and vegetal motifs reflect a combination of Islamic and Gothic elements, such as the deep dish decorated with acacia blossoms and tendrils, crowns, and the monogram *IM*, possibly referring to Jesus Maria.[2] Coats of arms as well as more simplified heraldic images such as eagles and hounds also decorate many of these dishes. Only one of the works bears a coat of arms that can be identified, however. The dish with molded petal motifs and stylized dot and stalk decoration contains the arms of Castile and Léon dimidiating the pales of Aragon, thereby providing evidence to date its manufacture to 1479 or later and making it the latest of this group (Susan Romanelli, in *Songs of Glory*, 316). Frequently decorated on the reverse with simple concentric circles and bands of stylized flowers, many of the finest pieces are also embellished with large, beautifully rendered heraldic images.[3] In the absence of identifiable arms or a sealed archaeological context, the material is difficult to date precisely, and it is generally classified according to the style of decoration.

Lustered pottery from Spain became highly collectible, particularly during the nineteenth century, and Hearst began acquiring examples in the 1890s, relatively early in his collecting career.[4] In assembling an important collection of fifteenth-century Spanish lusterware, he made acquisitions from noted European and American dealers, including Arnold Seligmann, William Permain, and Ercole Canessa. At least two of the nine works currently under discussion previously belonged to illustrious nineteenth-century collectors such as Ernest Odiot (cat. no. 77) and a member of the noted Spencer family of Althorp (cat. no. 73). These nine dishes are representative of the nearly one hundred such examples acquired by the Metropolitan Museum from the Hearst Foundation in 1956. All were prominently displayed in Hearst's home in New York. CEB

Notes
1. Anthony Ray, *Spanish Pottery, 1248–1898, with a Catalogue of the Collection in the Victoria & Albert Museum* (London: V&A Publications, 2000), 58.
2. Contemporary examples with Hebrew inscriptions also survive, further highlighting the widespread popularity of this pottery.
3. Cat. nos. 77 and 79 are decorated with eagles on the reverse, while cat. no. 72 is decorated with a fleur-de-lis.
4. *The William Randolph Hearst Collection: Photographs and Acquisition Records* (New York: Clearwater Publishing, [1987?]), 1.

81

DISH WITH A BATTLE SCENE
Italy (Deruta), c. 1500–1510

Tin-glazed earthenware
Diameter: 19 ¾ in. (50.2 cm)
Los Angeles County Museum of Art, William Randolph Hearst Collection (inv. no. 50.9.7)

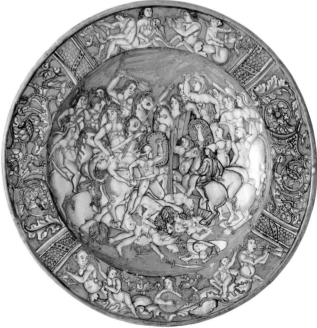

81

Provenance: Alexander Barker (d. c. 1874), London (by 1868); Sir Francis Cook (1817–1901), Doughty House, Richmond Hill, Surrey, c. 1870; by descent to Wyndham F. Cook (d. 1905); by descent to Humphrey W. Cook; sale, London, Christie's, July 7–10, 1925, lot 38; sold to William Permain, London; sold to William Randolph Hearst, October 22, 1925; shipped from San Simeon and presented to the Los Angeles County Museum, February 1950.

Exhibitions: *National Exhibition of Works of Art*, Leeds, 1868, no. 1046.

Bibliography: John Fleming, "Art Dealing in the Risorgimento II," *Burlington Magazine* 121 (August 1979): 505–6; Timothy Wilson, "Il ruolo de Deruta nello sviluppo della maiolica istoriata," in *La ceramica umbra al tempo di Perugino*, exh. cat., ed. Giulio Busti and Franco Cocchi (Cinisello Balsamo: Silvana, 2004), 41–42, fig. 8.

This large display plate (*piatto da pompa*) is the earliest example of *istoriato* (historiated) ware in Hearst's collection at the Los Angeles County Museum of Art. The tangle of horses and bodies recalls images of the destruction of Troy or the Roman battle of Cannae, both popular subjects on later maiolica, although a precise source for this image has not been identified. In addition to the awkward draftsmanship, the complexity of the design suggests an early effort to adapt a rectangular design, probably a woodcut, to the round, concave surface of a dish.

A label from the 1868 loan exhibition at Leeds identifies its first recorded owner, Alexander Barker, portions of whose collection were also lent to the Victoria and Albert Museum. Barker was a dealer and decorator who worked closely with Baron Amschel Mayer Rothschild to display his princely collections at Mentmore. The plate was subsequently owned by Sir Francis Cook, whose celebrated art collection, displayed at Doughty House in Richmond, was among the most notable private holdings of the nineteenth century.

TM

82

DISPLAY PLATE (PIATTO DA POMPA) WITH MEDICI ARMS
Italy (Deruta), c. 1530

Tin-glazed earthenware
Diameter: 16 in. (40.6 cm)
Los Angeles County Museum of Art, William Randolph Hearst Collection (inv. no. 50.9.27)

Provenance: Walter M. de Zoete, Layer Breton, Colchester; sale, London, Sotheby's, April 1, 1935, lot 224, sold to William Randolph Hearst; shipped from San Simeon and presented to the Los Angeles County Museum, February 1950.

Bibliography: Gian Carlo Bojani, ed., *La ceramica di Deruta dal XIII al XVIII secolo* (Perugia: Volumnia Editrice, 1994); Timothy Wilson, "Renaissance Ceramics," in *Western Decorative Arts*, by Rudolph Distelberger et al., pt. 1 (Washington, D.C.: National Gallery of Art; [New York]: Cambridge University Press, 1993).

82

The imposing shield, crossed keys, and papal tiara represent the coat of arms of a Medici pope, either Leo X (r. 1513–21) or Clement VII (r. 1523–34). A second dish (Écouen, Musée national de la Renaissance) with nearly identical decoration, dated 1531, points to the reign of Clement VII for this design. Such plates were possibly commissioned by the pope to be presented as gifts, although, as Wilson ("Renaissance Ceramics") asserts, they are more likely to have been purchased and displayed by lay owners as proclamations of loyalty or simply to commemorate the pope's reign.

This is one of more than twenty Deruta display plates that Hearst acquired between 1912 and 1935. He purchased the majority of them in the 1920s from Arnold Seligmann, Rey & Company in New York and others from various dealers and at auction in Munich, London, and New York. Hearst displayed them in the Gothic Study at San Simeon ("Museum Gifts and Loans," Hearst Papers, 40:58). TM

83

83

Francesco Xanto Avelli (Italian, c. 1486–c. 1542)

PLATE FROM THE PUCCI SERVICE: "PALINURUS FALLING
OVERBOARD"

Italy (Urbino), 1532

Tin-glazed earthenware

Diameter: 11 ⅜ in. (28 cm)

Los Angeles County Museum of Art, William Randolph
Hearst Collection (inv. no. 50.9.28)

Provenance: Andrew Fountaine IV (1808–1873), Narford Hall, Norfolk; sale, Christie's,
London, June 16–19, 1884, lot 306; Walter M. de Zoete (d. 1935), Layer Breton,
Colchester, England; sale, Sotheby's, London, April 1, 1935, lot 260; William Randolph
Hearst; shipped from San Simeon and presented to the Los Angeles County Museum,
February 1950.

Bibliography: J. V. G. Mallett et al., *Xanto: Pottery-Painter, Poet of the Italian Renaissance*
(London: Wallace Collection, 2007), 195, no. 181; Andrew Moore, "The Fountaine
Collection of Maiolica," *Burlington Magazine* 130 (June 1988): 435–67; Julia Triolo,
"Francesco Xanto Avelli's Pucci Service (1532–1533): A Catalogue," *Faenza: Bolletino
del Museo Internazionale delle Ceramiche di Faenza* 74, nos. 4–6 (1998): 237, no. 5.

The thirty-seven known pieces of *istoriato* maiolica with the
arms of the Pucci family of Florence constitute one of the
largest surviving dinner services from Renaissance Italy.
Xanto signed and dated nearly every piece and typically
added inscriptions identifying their subjects and literary
sources, including Ovid's *Metamorphoses*, Ariosto's *Orlando
Furioso*, and Virgil's *Aeneid*.

This plate depicts an episode from the *Aeneid* (5.835–71)
in which Palinurus, the pilot of Aeneas's ship, falls over-
board clutching the tiller. As shown by Xanto, Aeneas wears
a plumed turban and points aft to Palinurus, frozen in mid-
fall, after he has been put to sleep by a god shaking "a bough
dripping with Lethe's dew" (i.e., sleep) over his head.

Xanto continually borrowed elements from prints, often
inverting them, changing figures' identities, and recombining
them to create original compositions. As Julia Triolo ("Xanto
Avelli's Pucci Service") has shown, the bearded figure of
Palinurus is taken from a print by Giovanni Jacopo Caraglio

after Rosso Fiorentino, Aeneas comes from an engraving by Marco Dente after Baccio Bandinelli, and the god of sleep is based on an engraving probably after Raphael. TM

84

Possibly the Workshop of Maestro Giorgio Andreoli, Gubbio
SPICE DISH
Italy (Faenza[?], luster-painted in Gubbio), c. 1560

Tin-glazed earthenware with luster decoration
2⅞ x 7¾ in. (7.3 x 19.7 cm)
Los Angeles County Museum of Art, William Randolph Hearst Collection (inv. no. 50.9.1)

Provenance: According to tradition, Miss Walters Cacciola, Taormina, Sicily; Cesare Canessa (d. 1922) and Ercole Canessa (d. 1929), New York, Paris, and Naples; sale, American Art Association, New York, January 25, 1924, lot 93; William Randolph Hearst; presented to the Los Angeles County Museum, February 1950.

Exhibition: *The Arts of Fire: Islamic Influences on the Italian Renaissance*, J. Paul Getty Museum, Los Angeles, 2004, p. 118, pl. 22.

John Mallett (notes dated June 7, 1993, in object file, LACMA) has proposed that this spice dish, long attributed to Faenza, was probably made in the workshop of Maestro Giorgio Andreoli, the leading potter in Gubbio who specialized in gold and ruby metallic lusters. The function of this rare form of tableware remains uncertain. Previously thought to be an egg dish, it is more likely a serving dish for spices, much like an open saltcellar in the British Museum also attributed to Maestro Giorgio. The dense surface decoration is clearly inspired by Islamic ornament, probably by way of the Valencian lusterware widely imported to Italy from Spain since the fifteenth century. The dish's shield shape with paneled sides also relates to Spanish silver-gilt spice plates from the second quarter of the sixteenth century.

84

The Canessa brothers were famous dealers of antiquities, coins, and European paintings. After showing portions of their collection at the Panama-Pacific International Exposition in 1915, they were unable to find buyers and liquidated hundreds of items in a series of auctions held in New York. Hearst displayed the spice dish with other Italian maiolica in the Gothic Study at San Simeon ("Museum Gifts and Loans," Hearst Papers, 40:58). TM

85

Attributed to the Fontana Workshop (Urbino, active c. 1520–76)
THREE DEEP DISHES FROM THE SALVIATI SERVICE
Italy, c. 1560–70

Tin-glazed earthenware
Diameter: 10¾ in. (27.3 cm) each
Los Angeles County Museum of Art, William Randolph Hearst Collection (inv. no. 50.9.16.1–.3)

Provenance: Arnold Seligmann, Rey & Co., New York; sold to William Randolph Hearst, August 3, 1931; shipped from San Simeon and presented to the Los Angeles County Museum, February 1950.

These plates belong to the only maiolica service decorated with pure landscapes that cover the entire surface, a type of decoration identified by Cipriano Piccolpasso (c. 1557) as *paesi* (literally, "countries"). Now dispersed, this extensive service originally comprised dishes, plates, and other vessels bearing the coat of arms used by the Salviati, one of the most prominent families of Florence. The style of the landscapes—particularly the fortified towers, half-timbering, and thatched roofs on imaginary buildings—has led some scholars to point to the influence of Northern Renaissance artists such as Augustin Hirschvogel and Hanns Lautensack, although similar buildings appear in prints and drawings by Domenico Campagnola, Titian, and other Venetian masters.

There is general agreement that these plates were produced by the Fontana workshop in Urbino. John Mallett has ascribed them to Orazio Fontana, who in 1565 left the workshop of his father, Guido Durantino, and continued to produce *istoriato* wares independently until his death, probably in 1571.[1] TM

Notes
1. J. V. G. Mallett, "In Botega di Maestro Guido Durantino in Urbino," *Burlington Magazine* 129 (May 1987): 294.

85

86

Enoch Wood and Sons (English, fl. 1818–46)
PLATE, "HARVARD COLLEGE"
England (Burslem, Staffordshire), c. 1830–40

Earthenware, transfer-printed decoration
Diameter: 10¾ in. (27.3 cm)
Los Angeles County Museum of Art, Gift of the Hearst
Corporation (inv. no. 50.28.17)

87

PLATE, "THE TYRANT'S FOE, THE PEOPLE'S FRIEND"
England (probably Staffordshire), c. 1840

Earthenware, transfer-printed decoration
Diameter: 10½ in. (26.7 cm)
Los Angeles County Museum of Art, Gift of the Hearst
Corporation (inv. no. 50.28.23)
Page 48

Provenance: William Randolph Hearst; shipped from the Bronx warehouse and
presented to the Los Angeles County Museum, June 1950.

In the late nineteenth century, collectors of Americana eagerly
sought examples of transfer-printed earthenware produced
in the 1830s and 1840s by several Staffordshire factories for
export to the United States. Popular subjects included views
of American cities and historical monuments, as well as
patriotic and political themes.[1] Dinner and tea wares were
often issued in series, fueling a craze for collecting "old blue"
that continues today. Hearst shared the taste of his genera-
tion, and beginning around 1910 and continuing through-
out the 1930s, he assembled extensive collections of English
transfer-printed earthenware, creamware, and lusterware.
He was active at every major auction of Americana in the
1920s and 1930s, where quantities of English pottery typi-
cally accompanied colonial American furniture. The examples
featured here obviously reminded Hearst of his own life,
first at Harvard College and later as a newspaperman.
Staffordshire plates with both these designs were featured
in the pioneering book *China Collecting in America*.[2]

The view of Harvard Yard is based on an 1828 drawing
by Andrew Jackson Davis. Issued as a lithograph in London
in 1830, it was the earliest view of Harvard in the new print
medium and appeared almost immediately on ceramics.
Similar Staffordshire plates were introduced to the Harvard
Commons during the presidency of Josiah Quincy (1829–45)
and may have been familiar to Hearst as an undergraduate.[3]

86

The antislavery plate, "The Tyrant's Foe," is one of several versions that Hearst owned. It commemorates Elijah P. Lovejoy (1802–1837), editor of a newspaper in Alton, Illinois, who faced down an angry pro-slavery mob after they had thrown his printing presses into the Mississippi River on three occasions. Killed while defending freedom of the press and of speech, Lovejoy became a martyr for the abolitionist cause, which was originally supported by the sale of these plates. TM

Notes
1. See Ellouise Baker Larsen, *American Historical Views on Staffordshire China*, 3rd ed. (New York: Dover, 1975).
2. Alice Morse Earle, *China Collecting in America* (New York: Charles Scribner's Sons, 1892).
3. See Hamilton Vaughan Bail, *Views of Harvard: A Pictorial Record to 1860* (Cambridge, Mass.: Harvard University Press, 1949).

FURNITURE

88

Attributed to Pierre Gole (Dutch, active in France, c. 1620–1685)
CABINET ON A STAND
France (Paris), c. 1650

Ebony; pine; interior with rosewood, tulipwood, oak, stained ivory, gilt bronze, mirror
91½ x 86½ x 30 in. (232.4 x 219.7 x 76.2 cm)
Fine Arts Museums of San Francisco (inv. no. 47.20.2)
Page 129

Provenance: Adolphe de Rothschild, Naples, Paris, and Geneva; C. and E. Canessa; their sale, American Art Association, New York, January 25-26, 1924; William Randolph Hearst; presented to the De Young Museum, December 29, 1947.

Bibliography: Theodoor H. Lunsingh Scheurleer, *Pierre Gole, ébéniste de Louis XIV* (Dijon: Faton, 2005), 67-72.

Although this impressive ebony cabinet depicting the ancient kings of Israel and scenes from the Old Testament has been attributed to Jean Macé over the years, it was recently identified as the work of Pierre Gole, cabinetmaker to Louis XIV. The Dutch-born Gole worked in Paris from about 1640, specializing in large ebony cabinets for members of the French court. Theodoor H. Lunsingh Scheurleer suggests that this one may have been made for the queen mother and regent Anne of Austria (1601-1666), based on its richness of finish and its iconography of kingship. The cabinet contains many drawers and compartments, the fronts of which are meticulously carved in costly, lustrous ebony and lined with exotic tulipwood. The cabinet was designed for a collector; it was intended to house works of art, documents, and precious items.

The central compartment inside the cabinet, flanked by ivory columns and lined in mirrors, is arranged to resemble a theater. It depicts the Judgment of Solomon, which is enacted by gilt-bronze figures. Solomon's wisdom reiterates the theme of kingly virtues, and heroes of the Old Testament appear throughout the panels of the cabinet. On the exterior, between the Corinthian columns, are the Old Testament heroes: the figures of David with the head of Goliath, flanked by Judith with the head of Holofernes, and Jael with spike and mallet for killing Sisera. The doors are carved in low relief with panels depicting kings: Saul, first king of Israel, is on the left, while Solomon, who is often seen as the greatest king of Israel, is shown receiving the queen of

Sheba on the right. The remaining drawer fronts and panels also show scenes from the Old Testament. Readily identifiable on the left middle drawer is Moses in the Bulrushes. Moses Striking the Rock is on the right middle drawer, and the Crossing of the Red Sea is on the top frieze.

This cabinet was probably acquired by Hearst soon after its sale in New York in 1924.　　　　　　　MGC

89

Attributed to the Master with the Ornamented Background
(active 1660s–1680s)
Collector's Cabinet
Bohemia (Eger [now Chêb, Czech Republic]), c. 1660–70
(stand possibly 1830–40 or later)

Carcass in fir, beech, and various fruitwoods; relief marquetry and veneer: maple, walnut, walnut-burr wood, ebony and ebonized fruitwood, plum wood, pear wood, linden, partly colored with stain
73½ x 38 x 13 in. (186 x 96.5 x 33.5 cm) (with stand)
44⅝ x 38 x 12¾ in. (113.3 x 96.5 x 32.5 cm) (cabinet only)
Lent anonymously in memory of Dr. Irmgard von Lemmers-Danforth and Mrs. Hildegard Pletsch, Wetzlar

Provenance: Geheimrat Ottmar Strauss, Cologne, until 1934; sale, Hugo Helbing, Frankfurt am Main, November 8, 1934, no. 267, pl. 8; sold to J. & S. Goldschmidt for William Randolph Hearst; sold to Meier & Frank, September 13, 1940; sale, Christie's, London, March 11, 1976, lot 81; sold to Dr. Arthur Kauffmann for Dr. Irmgard Freiin von Lemmers-Danforth (1892–1984), Wetzlar; part of the Lemmers-Danforth collection until deaccessioned by the town of Wetzlar in 2004; offered for sale, Sotheby's, London, October 28, 2004, lot 340; sale, Sotheby's, Amsterdam, December 21, 2005, lot 295; later sold to the current owner.

Bibliography: Wolfram Koeppe, *Die Lemmers-Danforth Sammlung Wetzlar: Europäische Wohnkultur aus Renaissance und Barock* (Heidelberg: Ed. Braus, 1992), 235–37, no. M139; Jochen Voight, *Reliefintarsien aus Eger für die Kunstkammern Europas* (Halle an der Saale: Stekovics, 1999; Leipzig: Grassi Museum 1999), 283–84, no.I.34.

The top of this cabinet is embellished with a stylized allusion to then-reigning emperor Leopold I (r. 1658–1705) with a laurel crown. Bucolic or courtly scenes are inlaid on the fronts of the drawers and doors that conceal secret compartments. The large panel in the center illustrates the "good life and spending" of the Prodigal Son (Luke 15.13–14), framed by the richly dressed figures of the Four Seasons, partly after etchings by Wenzel Hollar (1606–1677).[1]

Eger work combines heterogeneous materials such as various woods into unified decorative or narrative compositions, achieving a painterly effect similar to that of hard-stone panels. The technique may have been influenced by the hard-stone carvers working in nearby Prague.[2]

On the day of the Christie's auction in 1976 at which this cabinet was sold to London art agent Dr. Arthur Kauffmann on behalf of Dr. Irmgard Freiin von Lemmers-Danforth, Kauffmann wrote to von Lemmers-Danforth: "It amuses me that I had this object in my hands before. When I auctioned off [as auctioneer] the collection of Geheimrat Ottmar Strauss (1934!), the cabinet was lot 267 and was illustrated on plate 38. It was acquired by Goldschmidt for the newspaper king Hearst."[3]　　　　　　　WK

1. Koeppe, *Lemmers-Danforth Sammlung*, 237; for collector's cabinets, see ibid., 225–67, and Voight, *Reliefintarsien*, 273–84; for cabinets made by the Master with the Ornamented Background, see Georg Laue, ed., *Möbel für die Kunstkammern Europas: Kabinettschränke und Prunkkassetten* (Munich, 2008).
2. Koeppe, *Lemmers-Danforth Sammlung*, 236–37; *Art of the Royal Court: Treasures in Pietre Dure from the Palaces of Europe*, exh. cat. (New York: Metropolitan Museum of Art, 2008), no. 53.
3. Letter in author's archive; see also Koeppe, *Lemmers-Danforth Sammlung Wetzlar*, 267.

89

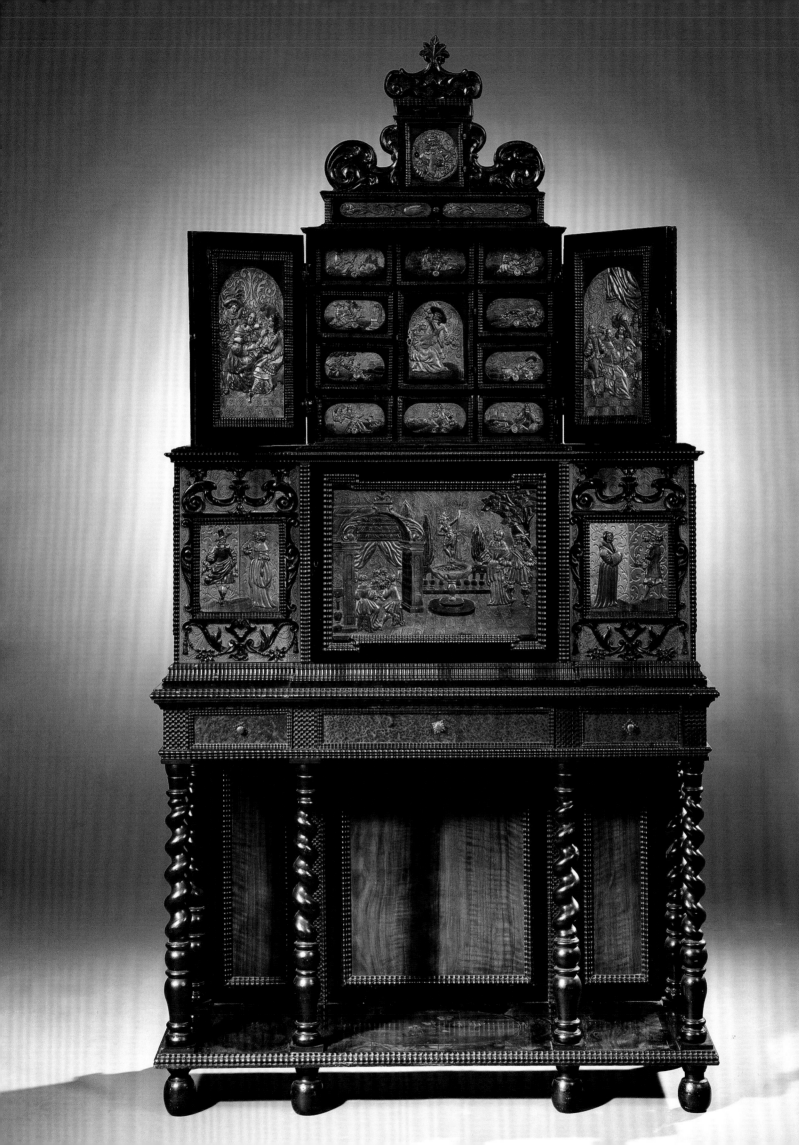

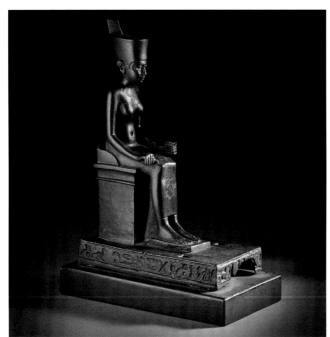

90

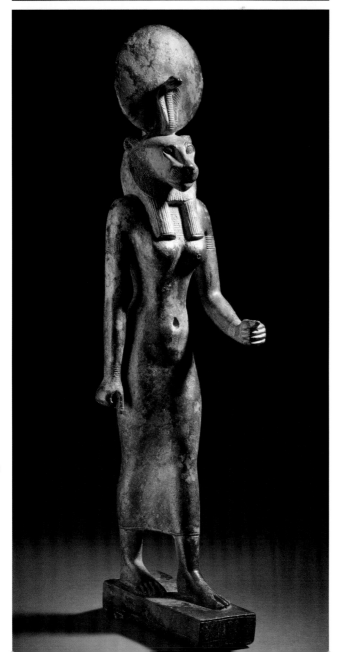

91

EGYPTIAN ART

90

SEATED FIGURE OF THE GODDESS NEITH
Egypt, Late Period (711–323 BCE)

Bronze with gold
4 ⁷⁄₁₆ x 2 ³⁄₈ x 6 ½ in. (11.2 x 6 x 16.5 cm)
Los Angeles County Museum of Art, Gift of the William
Randolph Hearst Foundation (inv. no. 50.14.1)

Provenance: William Randolph Hearst Foundation; presented to the Los Angeles
County Museum, 1950.

Exhibitions: *Age of the Pharaohs: Egyptian Art from American Collections*, Los Angeles
County Museum of Art, 1974, no. 68.

Bibliography: James H. Breasted Jr., "Three Egyptian Small Bronzes," *Los Angeles
County Museum: Bulletin of the Art Division* 3 (Winter 1951): 6.

This seated bronze female figure represents the ancient
Egyptian goddess Neith, patron of hunting and warfare. The
goddess was known from predynastic times, and her early
cult center was located at Sais, in the western Nile Delta. She
wears the flat-topped headdress known as the red crown,
which was emblematic of the northern portion of the coun-
try. Her close-fitting sheath is hardly visible, with the excep-
tion of the clearly indicated hemline at her ankles. The thin
sheets of beaten gold covering the whites of her eyes pro-
vide the figure's only ornamentation, strongly contrasting
with the dark bronze surface. This figure from the Hearst
collection is largely intact and well preserved, retaining
its original and somewhat unusual pillar-shaped throne and
a base inscribed for its first owner, Hor Khonsu. NT

91

WADJET
Egypt, 26th Dynasty (664–525 BCE) or later

Bronze
15 x 2½ x 4⅛ in. (38 x 6.4 x 10.5 cm)
Los Angeles County Museum of Art, William Randolph
Hearst Collection (inv. no. 50.37.14)

Provenance: Lionel Edwards; sale, Parke Bernet, New York, June 5, 1945, lot 52; sold
to William Randolph Hearst; presented to the Los Angeles County Museum, 1950.

Exhibitions: *Age of the Pharaohs: Egyptian Art from American Collections*, Los Angeles County Museum of Art, 1974, no. 75 (identified as Sekhmet); *In the Tomb of Nefertari: Conservation of the Wall Paintings*, J. Paul Getty Museum, Malibu, California, 1992–93, no. 29.

Bibliography: Lorna Price, *Masterpieces from the Los Angeles County Museum of Art Collection* (Los Angeles: Los Angeles County Museum of Art, 1988), 26.

This elegant striding bronze figure represents the goddess Wadjet, protector of the king and tutelary deity of Lower Egypt. One of several ancient Egyptian goddesses depicted with the head of a lioness, Wadjet is identified in this example by the dedicatory inscription on the rectangular base. While numerous Late Period Egyptian bronzes are preserved in Egypt and in collections worldwide, this example is particularly fine. The narrow-waisted human figure is treated in an exceptionally refined and supple manner, with the contours of the breasts, abdomen, and thighs visible beneath the thin garment. Incised details such as the patterning of the lion's mane, broad collar, armbands, and bracelets are carefully rendered. The sun disk and uraeus headdress are intact, while the handheld attributes, probably an ankh and papyrus scepter, are now lost. It is possible that Hearst was attracted to this lioness image, as a full statue and three fragments of a similar deity are incorporated into an outdoor fountain that remains in situ at San Simeon. NT

92

ROYAL HEAD, POSSIBLY KING NECTANEBO I
Egypt, reign of Nectanebo I (380–363 BCE)

Quartzite
18 ½ x 11 ¹³⁄₁₆ x 16 ¹⁵⁄₁₆ in. (47 x 30 x 43 cm)
Incised with the letter *R* on the proper left side of head
Los Angeles County Museum of Art, William Randolph Hearst Collection (inv. no. 49.23.7)

Provenance: Sale, Brummer Gallery, New York, May 10, 1929; sold to William Randolph Hearst; presented to the Los Angeles County Museum, 1949.

Exhibitions: *Age of the Pharaohs: Egyptian Art from American Collections*, Los Angeles County Museum of Art, 1974, no. 76.

Bibliography: J. Breasted Jr., "Notes on Some Recent Acquisitions of the Earlier Periods," *Los Angeles County Museum: Bulletin of the Art Division* 3 (Winter 1951): 2, no. 1; Jack A. Josephson, *Egyptian Royal Sculpture of the Late Period, 400–246 B.C.* (Mainz: Philipp von Zabern, 1997), 25n181, pl. 1.9b; Nancy Thomas, "Transformation of a Royal Head: Notes on a Portrait of Nectanebo I," (for forthcoming festschrift).

This monumental stone head most likely represents Nectanebo I, a king from the last dynasty of native Egyptian rule, Dynasty 30. During the fifteen-year period of his reign (380–365 BCE), artists from the royal workshops produced

92

colossal representations of the king for temples, including more than seven hundred statues of the king as a sphinx, placed along processional avenues. Uninscribed, the king can be identified by his royal headdress, here an unpleated *nemes* with a broken yet recognizable uraeus, and the treatment of his facial features: pronounced almond-shaped eyes with extended folds formed by the overlap of the upper lid; straight eyebrows, running parallel to the band of the *nemes* for most of their length; and an arching smile. The carefully executed drill holes at the corners of the mouth are a strong defining characteristic of portraiture of the period. Hearst purchased this massive head in 1929 and placed it on display with other antiquities in the library at San Simeon in the mid-1930s. In 1949 William R. Valentiner, representing the Los Angeles County Museum, selected the head from a number of Hearst objects at San Simeon, and it was accessioned by the museum later that year. NT

93

94

GREEK AND SOUTH ITALIAN VASES

93

BLACK-FIGURED HYDRIA (WATER JAR), known as the
HEARST HYDRIA
Attributed to the Ptoon Painter by J. D. Beazley
Athens, c. 560–550 BC

Terra-cotta
Height: 15 15/16 in. (40.5 cm); diameter (body): 14 in. (35.6 cm)
The Metropolitan Museum of Art, Fletcher Fund, 1956 (inv.
no. 56.171.28)

Provenance: Said to be from Kamiros, Rhodes, Greece; Thomas Benedict Clarke,
New York; his sale, American Art Galleries, New York, February 15–18, 1899, pt. 2,
no. 345; William Randolph Hearst; Hearst Corporation; acquired by the Metropolitan
Museum of Art, 1956.

Exhibitions: *A Loan Collection of American Landscapes Together with Greek Terra-cotta
Figures and Vases*, Union League Club, New York, 1890, no. 2.

Bibliography: J. D. Beazley, *Attic Black-figure Vase-painters* (Oxford: Clarendon Press,
1956), 84, no. 4; Beazley Archive Pottery Database, Oxford University online database,
vase no. 300778, http://www.beazley.ox.ac.uk/databases/pottery.htm; H. R. W.
Smith, "The Hearst Hydria: An Attic Footnote to Corinthian History," *University of
California Publications in Classical Archaeology* 1, no. 10 (1929–44): 241–90.

Hearst was probably attracted to this hydria because of its
unusual shape and decoration. On the upper half a unique
and puzzling scene is depicted: men clad in striped garments
and holding spears are flanked by oversized cocks, lotus
buds, and sirens. By contrast, the image below is common
and uncomplicated: a row of panthers, goats, and swans.

The eccentricities of this vase were explained by H. R. W.
Smith in 1944. On the one hand, the prominence of the
animals on the hydria, as well as their incised details, links
the vase to Corinthian vase painting. On the other hand,
the floral ornaments and the men are Athenian, in both
their appearance and the manner of their depiction. The
round shape is also Athenian and is closely comparable to
some black-figured hydriai attributed to the Tyrrhenian
Group.[1] The Ptoon Painter takes his name from Mount
Ptoon in Boeotia, Greece, where another vase attributed
to him was found.

This vase may have been purchased by Hearst at the
Clarke sale in 1899, and if so, it was one of the first Greek
vases he acquired. AJC

Notes
1. Leiden, Rijksmuseum van Oudheden, inv. no. PC 47; Paris, Cabinet des Médailles,
no. 253; Paris, Musée du Louvre, inv. no. E 694; and New York, Metropolitan Museum
of Art, inv. no. 1983.11.2 (Beazley Archive Pottery Database, vase nos. 31025–28;
Beazley, *Attic Black-figure Vase-painters*, 104, nos. 126–29).

94

BLACK-FIGURED HYDRIA (WATER JAR)

Attributed to the Manner of the Antimenes Painter by J. D. Beazley

Athens, c. 530–520 BC

Terra-cotta

Height: 14⅞ in. (37.7 cm); diameter (body): 10⅞ in. (27.5 cm)

Los Angeles County Museum of Art, William Randolph Hearst Collection (inv. no. 50.8.5)

Provenance: Marshall Brooks (1855–1944); his sale, Sotheby's, London, December 2, 1946, no. 41; sold to William Randolph Hearst; presented to the Los Angeles County Museum, 1950.

Bibliography: Judith Barringer, *The Hunt in Ancient Greece* (Baltimore: Johns Hopkins University Press, 2001), 66, no. 86, table 2; J. D. Beazley, *Attic Black-figure Vase-painters* (Oxford: Clarendon Press, 1956), 277, no. 6; Beazley Archive Pottery Database, Oxford University online database, vase no. 320168, http://www.beazley.ox.ac.uk/databases/pottery.htm; Pamela M. Packard and Paul A. Clement, *The Los Angeles County Museum of Art*, fasc. 1, Corpus Vasorum Antiquorum, USA fasc. 18 (Berkeley: University of California Press, 1977), 19–20 (with additional bibliography), pls. 17–18.

The precisely drawn pictures on this hydria exemplify the elegance of the black-figure technique, which depends on the painter's ability to delineate the silhouettes of the figures and patterns, and then incise their details through the black glaze (before firing).

The staid character of the chariot scenes, ubiquitous in black-figure, contrasts with the very active deer hunt, an uncommon subject seen almost exclusively as subsidiary pictures on hydriai of this type. Paradoxically, although hydriai were used mainly by women—and many do depict women carrying such water jars or filling them at the fountain house—male imagery is represented much more frequently.

The Antimenes Painter was a major black-figure vase painter whose favorite shapes were the neck-amphora (storage jar) and the hydria. On this vase the drawing of the horses, as well as the representation of a deer hunt, are characteristically Antimenean stylistic elements. AJC

95

BLACK-FIGURED OINOCHOE (WINE PITCHER)

Attributed to the Bizoumis Painter by Andrew J. Clark

Athens, c. 520–500 BC

Terra-cotta

Height (to mouth): 8¼ in. (20.9 cm); diameter (body): 5 in. (12.6 cm)

Collection of Dr. Dimitri and Mrs. Leah Bizoumis, Los Angeles

Provenance: Spink & Son, London, 1936; sold to William Randolph Hearst; his sale, Parke-Bernet, New York, April 5, 1963, no. 49; Russell B. Aitken; his sale, Christie's, New York, June 11, 2003, no. 104.

Bibliography: Dietrich von Bothmer, *Amazons in Greek Art* (Oxford: Clarendon Press, 1957), 43, no. 52; Andrew J. Clark, "Attic Black-figured Olpai and Oinochoai" (PhD diss., New York University, 1992), 873, no. 2037.

On this oinochoe, Herakles, the most famous of all Greek heroes, battles an Amazon, a member of the legendary tribe of female warriors. Extending his outsize left arm to grasp his opponent, he is about to dispatch her with the club he wields in his right hand. Amazons figure importantly in Greek mythology, and on Athenian vases they are frequently shown fighting Herakles or in combat with Greek warriors. In the Trojan War they fought on the side of the Trojans.

This vase is by the same artist as another oinochoe in the Bizoumis collection, of which only the lower half is preserved, which depicts Herakles fighting the brigand Kyknos, a son of the war god Ares.[1] An unpublished small neck-amphora once in an American private collection, decorated on the front with Herakles fighting an Amazon, is also by the same hand.[2] In honor of the present owner of the oinochoe formerly in the Hearst collection, this artist may be named the Bizoumis Painter. AJC

Notes

1. Formerly in the Museum of Fine Arts, Boston (inv. no. Res. 41.54); sold by the museum, Sotheby's, New York, June 12, 2001, 159, no. 275; Clark, "Attic Black-figured Olpai and Oinochoai," 879, no. 2066.

2. At one time in a private collection in Syracuse; present whereabouts unknown. On the reverse, two maenads; on both sides of the neck, one hanging palmette between two vertical ones; ibid., mentioned 873, under no. 2037.

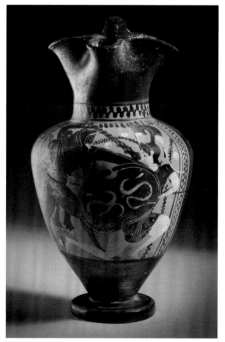

95

96

BLACK-FIGURED NECK-AMPHORA
(STORAGE JAR)
Attributed to the Edinburgh Painter, or to an artist very
near him, by J. D. Beazley
Athens, c. 510–500 BC

Terra-cotta
Height: 18 in. (45.7 cm); diameter (body): 11¾ in. (29.8 cm)
Los Angeles County Museum of Art, William Randolph
Hearst Collection (inv. no. 50.8.19)

Provenance: Marshall Brooks (1855-1944); his sale, Sotheby's, London, May 14, 1946,
no. 15, pl. 1; sold to William Randolph Hearst; presented to the Los Angeles County
Museum, 1950.

Bibliography: J. D. Beazley, *Attic Black-figure Vase-painters* (Oxford: Clarendon Press,
1956), 479, no. 4; Beazley Archive Pottery Database, Oxford University online data-
base, vase no. 303408, http://www.beazley.ox.ac.uk/databases/pottery.htm; Pamela
M. Packard and Paul A. Clement, *The Los Angeles County Museum of Art*, fasc. 1, Corpus
Vasorum Antiquorum, USA fasc. 18 (Berkeley: University of California Press, 1977),
13-15 (with additional bibliography), pl. 11.

The picture on the front of this neck-amphora depicts three
of the most popular figures in Athenian vase painting—the
hero Herakles, the goddess Athena, and the messenger god
Hermes—engaged in the most daring of all Herakles' labors,
his descent to the Underworld, the realm of the dead, to
capture the monstrous hound Cerberus, who guarded its
gates. Herakles, so often depicted as a fully bearded adult,
is still an adolescent here, just beginning to grow whiskers
along his jawline, and seems rather satisfied with his own
accomplishment.

The reverse depicts a scene of domestic tranquillity, the
homecoming of a warrior, a frequent theme in black-figure
vase painting. The youth standing behind the warrior looks
back in the direction of Herakles on the other side, as if both
events—the supernatural and the commonplace—somehow
are unfolding simultaneously and in close proximity.

Neck-amphorae by the Edinburgh Painter, principally a
painter of lekythoi (oil bottles), are usually small rather than
of standard size like this vase. The drawing here most closely
resembles the style of the painter himself in the figure of
Hermes, the heads of Cerberus, and the playful dog on the
reverse. AJC

96

97

BLACK-FIGURED STAMNOS (WINE BOWL)

Attributed to the Michigan Painter by Barbara Philippaki

Athens, c. 500 BC

Terra-cotta

Height: 13 ⅜ in. (34.1 cm); diameter (body): 11 in. (28 cm)

Los Angeles County Museum of Art, William Randolph

Hearst Collection (inv. no. 50.8.2)

Page 140

Provenance: B. Hertz; Joseph Mayer; his sale, Sotheby's, London, February 7, 1859, no. 182; William H. Forman, Pippbrook House, Dorking, Surrey, England; his sale, Sotheby's, London, June 19, 1899, no. 317; Sir John Evans; his sale, Sotheby's, London, July 29, 1946, no. 167; sold to William Randolph Hearst; presented to the Los Angeles County Museum, 1950.

Bibliography: J. D. Beazley, *Attic Black-figure Vase-painters* (Oxford: Clarendon Press, 1956), 343, no. 1.; Beazley Archive Pottery Database, Oxford University online database, vase no. 301903, http://www.beazley.ox.ac.uk/databases/pottery.htm; Pamela M. Packard and Paul A. Clement, *The Los Angeles County Museum of Art*, fasc. 1, Corpus Vasorum Antiquorum, USA fasc. 18 (Berkeley: University of California Press, 1977), 16-18 (with additional bibliography), pls. 14-15; Barbara Philippaki, *The Attic Stamnos* (Oxford: Clarendon Press, 1967), 13, 23, 46n4, pl. 8.

The stamnos, a kind of storage jar, was often used as a bowl in which wine and water were mixed and from which the diluted wine was served. That surely was the purpose of this vase, on which men and women are depicted dancing, music making, and feasting—festivities that were undoubtedly accompanied by wine.

In the upper scene a woman dips her oinochoe (wine pitcher) into another type of wine mixing bowl, a krater. To her right a man holding what could be a very full drinking cup moves off to join his dancing companions. The main picture focuses on a man and woman reclining on a couch, in front of which is a table laden with white loaves of bread and strips of meat. The wine god Dionysos, an unseen presence at the party, is symbolized by the ivy leaves around the neck of the vase and the grapevines under the handles.

The Michigan Painter was the leading painter of black-figured stamnoi, and the figures that decorate this vase are not only especially lively but also form a remarkably large crowd, comprising twenty-eight men and women. The painter is named for a small neck-amphora in the Kelsey Museum of Archaeology at the University of Michigan, Ann Arbor.

AJC

98

RED-FIGURED KALPIS (WATER JAR)

Attributed to the Troilos Painter by J. D. Beazley

Athens, c. 490–480 BC

Terra-cotta

Height: 14 1/16 in. (35.7 cm); diameter (body): 13 ½ in. (34.3 cm)

The Metropolitan Museum of Art, Fletcher Fund, 1956 (inv. no. 56.171.53)

Page 71

Provenance: From the Etruscan cemetery at Vulci, Italy; Lucien Bonaparte, Prince of Canino; his sale, Paris, April 4, 1843, no. 15;[1] William Williams Hope, Rushton Hall, Northamptonshire, England; his sale, Christie's, London, June 14-16, 1849, no. 63 (annotated as purchased by "Campanari," presumably the art dealer Domenico Campanari); William Henry Forman, Pippbrook House, Dorking, Surrey, England; his sale, Sotheby's, London, June 19-22, 1899, first portion, no. 338; Cecil Torr, Wreyland, Devon, England; his sale, Sotheby's, London, July 2, 1929, no. 32; sold to William Randolph Hearst; Hearst Corporation; acquired by the Metropolitan Museum of Art, 1956.

Bibliography: J. D. Beazley, *Attic Red-figure Vase-painters*, 2d ed. (Oxford: Clarendon Press, 1963), 297, no. 14; Beazley Archive Pottery Database, Oxford University online database, vase no. 203081, http://www.beazley.ox.ac.uk/databases/pottery.htm; Gerda Schwarz, "Triptolemos," in *Lexicon Iconographicum Mythologiae Classicae*, vol. 8, pt. 1 (Zurich: Artemis, 1997), 62, no. 85.

In a black "sky," a youth holding stalks of wheat is aloft in a winged chariot. He is Triptolemos, a prince of Eleusis, who was given the chariot and the grain by the goddess Demeter. He then set out to disseminate the wheat and knowledge of its cultivation to humankind.

Of the more than twenty vases attributed to the Troilos Painter, the Hearst vase is the only one decorated so minimally, with just a single figural element, Triptolemos in his chariot, and one ornamental embellishment, an egg-and-dart design around the mouth. The simplicity of its decoration makes this kalpis one of the most visually striking vases among the sixty-five that were purchased from the Hearst Corporation in 1956 by the Metropolitan Museum of Art.

The Troilos Painter is named for the scene on a kalpis in the British Museum, London, depicting the Trojan prince Troilos and his sister Polyxena.

AJC

Notes

1. *Notice d'une collection de vases antiques en terre peinte provenant des fouilles faites en Etrurie par feu M. le Prince de Canino*; authorship of the catalogue attributed to J. J. Dubois.

99

RED-FIGURED AMPHORA (STORAGE JAR)
Attributed to the Deepdene Painter (his name vase) by
J. D. Beazley
Athens, c. 470–460 BC

Terra-cotta
Height: 18 in. (45.7 cm); diameter (body): 10 ¾ in. (27.3 cm)
Los Angeles County Museum of Art, William Randolph
Hearst Collection (inv. no. 50.8.21)

Provenance: Sir William Hamilton (1730–1803), Naples, late 18th century; Thomas
Hope (1769–1831); by descent to Henry Francis Hope Pelham Clinton (1866–1941),
1884; his sale, Christie's, London, July 23, 1917, no. 71, Marshall Brooks (1855–1944);
his sale, Sotheby's, London, May 14, 1946, no. 43, pl. 2; sold to William Randolph
Hearst; presented to the Los Angeles County Museum, 1950.

Bibliography: J. D. Beazley, "An Amphora by the Berlin Painter," *Antike Kunst* 4,
no. 2 (1961): 57, no. 6 (on Athena and Herakles, see 55–58); J. D. Beazley, *Attic Red-
figure Vase-painters*, 2nd ed. (Oxford: Clarendon Press, 1963), 500, no. 28; Beazley
Archive Pottery Database, Oxford University online database, vase no. 205127,
http://www.beazley.ox.ac.uk/databases/pottery.htm; Pamela M. Packard and Paul A.
Clement, *The Los Angeles County Museum of Art*, fasc. 1, Corpus Vasorum Antiquorum,
USA fasc. 18 (Berkeley: University of California Press, 1977), 24–25 (with additional
bibliography), pl. 23.

Among the many heroes aided by Athena, her favorite by
far was Herakles, and their relationship as depicted on
vases sometimes takes on the character of a friendship: the
two shake hands or, as on this amphora, the goddess serves
wine to the hero. The encounter perhaps takes place after
Herakles' earthly demise and during his subsequent life as
an immortal among the gods on Mount Olympus. Athena
fills his kantharos, the type of wine cup preferred by
Dionysos, the wine god, who is shown on the other side
of this vase holding his kantharos and being served either
by a maenad, one of his female followers, or by his mortal
bride, Ariadne.

Only about twenty Athenian vases are known to
depict Athena serving wine to Herakles, and the Hearst
amphora is best compared with the most splendid among
them, a red-figured amphora by the Berlin Painter in the
Antikenmuseum, Basel.[1]

The Deepdene Painter, mainly a painter of stamnoi
(wine bowls), takes his name from Deepdene (demolished
1969), the country home of the collector Thomas Hope
(1769–1831) in Surrey, England. AJC

Notes

1. Basel, Antikenmuseum, inv. no. KA 418 (Beazley Archive Pottery Database, vase
no. 275090; Beazley, "Amphora by the Berlin Painter," 49–67; Beazley, *Attic Red-figure
Vase-painters*, 1634 no. 1 bis).

100

The god Eros, son of the love goddess Aphrodite, personifies desire. On this oinochoe the youthful, impassive god rides a fallow deer (*Dama dama*), probably a fawn. Much of the surface of the deer's body is abraded, as are the legs and wings of Eros. Although fewer than ten examples of this subject are known in Athenian vase painting, Polion seems to have favored it; a vase attributed to him in the Ashmolean Museum, Oxford, is decorated with a nearly identical image.[1]

On vases, deer sometimes appear in scenes with Aphrodite or Dionysos, the wine god. Deer also were depicted in vase paintings as "love gifts," presents given by an older man to a youth.[2] The specific meaning of the present image is, however, unknown.

Polion, whose name is known from his signature on only one of the vases by his hand, was a painter mainly of kraters and oinochoai, vases used for mixing and pouring wine.

AJC

Notes

1. The vase is a lekythos (oil bottle) (Ashmolean Museum, inv. no. 1957.31; Beazley Archive Pottery Database, vase no. 215545; Beazley, *Attic Red-figure Vase-painters*, 1172, no. 19). For this subject on south Italian vases, see Konrad Schauenburg, "Eros und Reh auf Kantharos in Kieler Antikensammlung," *Jahrbuch des Deutschen Archäologischen Instituts* 108 (1993): 221–53 (esp. 233–42).

2. Gundel Koch-Harnack, *Knabenliebe und Tiergeschenke: Ihre Bedeutung in päderastischen Erziehungssystem Athens* (Berlin: Gebr. Mann, 1983), 119–24.

101

Red-Figured Bell-Krater (Wine Bowl)

Attributed to the Tarporley Painter (his name vase) by
Noël Moon
South Italy, c. 400–390 BC

Terra-cotta
Height: 14 ⅞ in. (37.5 cm); diameter (body): 10 ½ in. (26.7 cm)
Los Angeles County Museum of Art, William Randolph
Hearst Collection (inv. no. 50.8.29)
Page 140

Provenance: Sir William Hamilton (1730–1803), Naples, late 18th century; Thomas Hope (1769–1831); by descent to Henry Francis Hope Pelham Clinton (1866–1941), 1884; his sale, Christie's, London, July 23, 1917, no. 109; Marshall Brooks (1855–1944); his sale, Sotheby's, London, May 14, 1946, no. 60, pl. 4; sold to William Randolph Hearst; presented to the Los Angeles County Museum, 1950.

Bibliography: Beazley Archive Pottery Database, Oxford University online database, vase no. 1001496, http://www.beazley.ox.ac.uk/databases/pottery.htm; Pamela M. Packard and Paul A. Clement, *The Los Angeles County Museum of Art*, fasc. 1, Corpus Vasorum Antiquorum, USA fasc. 18 (Berkeley: University of California Press, 1977), 44–45 (with additional bibliography), pl. 40; A. D. Trendall and Alexander Cambitoglou, *The Red-figured Vases of Apulia* (Oxford: Clarendon Press, 1978), 47, no. 10.

Diluted wine was served from kraters of different shapes. On the front of this vase, a satyr witnesses the crowning of

100

Red-Figured Oinochoe (Wine Pitcher)

Attributed to Polion by J. D. Beazley
Athens, c. 430–420 BC

Terra-cotta
Height: 9 ⅜ in. (23.8 cm); diameter (body): 3 ¾ in. (9.5 cm)
The Metropolitan Museum of Art, Fletcher Fund, 1956 (inv. no. 56.171.57)

Provenance: From the Etruscan cemetery at Spina, Italy; Count Dino Spetia di Radione; his sale, Sotheby's, London, December 13, 1928, no. 107; unknown collector; his or her sale, Sotheby's, London, July 2, 1929, no. 53; sold to William Randolph Hearst; Hearst Corporation; acquired by the Metropolitan Museum of Art, 1956.

Bibliography: J. D. Beazley, *Attic Red-figure Vase-painters*, 2nd ed. (Oxford: Clarendon Press, 1963), 1172, no. 16; Beazley Archive Pottery Database, Oxford University online database, vase no. 215542, http://www.beazley.ox.ac.uk/databases/pottery.htm; Antoine Hermary, "Eros," in *Lexicon Iconographicum Mythologiae Classicae*, vol. 3, pt. 1 (Zurich: Artemis, 1986), 872, no. 225.

the wine god Dionysos by a maenad. In south Italian vase painting, the youthful vigor of Dionysos symbolizes his potency as a force of nature, a power underscored by the staves carried by the three figures, made from the giant fennel plant (*Ferula communis*, or narthex). Dionysos and the satyr carry fennel stalks topped with pinecones (*thyrsoi*), and the maenad shoulders a fennel stalk in flower. The seeds of the pinecone, the fennel's blossoms, and the sizable stalks themselves are all emblematic of fertility. The three clothed youths on the other side of the bell-krater almost certainly have no specific connection with the Dionysiac scene. Groups of two or three such youths routinely appear on the reverses of a wide variety of south Italian vase shapes.

The Tarporley Painter, one of the earliest Apulian vase painters, was named after this vase, which was formerly owned by Marshall Brooks, who lived in Tarporley, Cheshire, England. Another bell-krater by this painter with a Dionysiac theme, now on loan to the Metropolitan Museum of Art, was also once in the Hearst collection (L.1988.81.4, on loan from Jan Mitchell; Trendall and Cambitoglou, *Red-Figured Vases*, 46, no. 2, pl. 13).

<div align="right">AJC</div>

102

RED-FIGURED BOTTLE
Attributed to the CA Painter by J. D. Beazley
South Italy (Cumae), c. 350–340 BC

Terra-cotta
Height: 7⅞ in. (20 cm); diameter (body): 4¼ in. (10.9 cm)
Los Angeles County Museum of Art, William Randolph
Hearst Collection (inv. no. 50.8.26)

Provenance: Thomas Hope (1769–1831); by descent to Henry Francis Hope Pelham Clinton (1866–1941), 1884; his sale, Christie's, London, July 23, 1917, no. 250a; Weetman Dickinson Pearson, first Viscount Cowdray (1856–1927); by descent to third Viscount Cowdray; his sale, Sotheby's, London, December 2, 1946, no. 61; sold to William Randolph Hearst; presented to the Los Angeles County Museum, 1950.

Bibliography: Beazley Archive Pottery Database, Oxford University online database, vase no. 1001508, http://www.beazley.ox.ac.uk/databases/pottery.htm; Oscar Broneer, "Eros and Aphrodite on the North Slope of the Acropolis," *Hesperia* 1 (1932): 55; Pamela M. Packard and Paul A. Clement, *The Los Angeles County Museum of Art*, fasc. 1, Corpus Vasorum Antiquorum, USA fasc. 18 (Berkeley: University of California Press, 1977), 53–54 (with additional bibliography), pl. 50; A. D. Trendall, *The Red-figured Vases of Lucania, Campania, and Sicily* (Oxford: Clarendon Press, 1967), 451, 459, 460, no. 64.

The mother and child depicted on this bottle kiss and engage in a mutual embrace. Seated on a fawn-skin-covered chair, the mother is the love goddess Aphrodite. Her son is the winged and eternally boyish god Eros. Two women and a girl holding up a mirror observe the affectionate pair.

That this may be something more than merely a charming picture is indicated by the thymiaterion (incense burner) behind Aphrodite's chair. Its presence suggests that the scene is religious in character. More than seventy-five years ago, Oscar Broneer ingeniously proposed that the picture might have been inspired by depictions of a secret ceremony for Aphrodite conducted in Athens by two maidens, the Arrephoroi, at the goddess's outdoor sanctuary, said to be "in the Gardens." Very recently, however, both the association of the goddess with that ceremony and its location have been challenged.[1]

The CA Painter frequently represented ritual scenes with women bringing offerings, and his work belongs to the first phase of vase painting at Cumae. As A. D. Trendall noted, this is the earliest known Cumaean example of the bottle shape.

<div align="right">AJC</div>

Notes
1. Robert Simms, "Erechtheus and the Arrephoria" (online abstract of a paper presented at the annual meeting of the American Philological Society, Boston, January 6–9, 2005, http://www.apaclassics.org/AnnualMeeting/05mtg/abstracts/SIMMS.html).

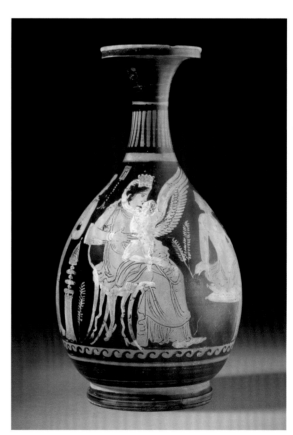

102

103

104

103

RED-FIGURED BELL-KRATER (WINE BOWL)

Attributed to Python by Carl Watzinger

South Italy (Paestum), c. 340–335 BC

Terra-cotta

Height: 15 in. (38.2 cm); diameter (body): 9½ in. (24.1 cm)

Los Angeles County Museum of Art, William Randolph

Hearst Collection (inv. no. 50.8.30)

Provenance: Thomas Hope (1769–1831); by descent to Henry Francis Hope Pelham Clinton (1866–1941), 1884; his sale, Christie's, London, July 23, 1917, no. 137b; Weetman Dickinson Pearson, first Viscount Cowdray (1856–1927); by descent to third Viscount Cowdray; his sale, Sotheby's, London, December 2, 1946, no. 64; sold to William Randolph Hearst; presented to the Los Angeles County Museum, 1950.

Exhibitions: *The Art of South Italy: Vases from Magna Graecia*, Virginia Museum of Fine Arts, Richmond; Philbrook Art Center, Tulsa; Detroit Institute of Arts, 1982–83, no. 106.

Bibliography: Beazley Archive Pottery Database, Oxford University online database, vase no. 1001509, http://www.beazley.ox.ac.uk/databases/pottery.htm; Pamela M. Packard and Paul A. Clement, *The Los Angeles County Museum of Art*, fasc. 1, Corpus Vasorum Antiquorum, USA fasc. 18 (Berkeley: University of California Press, 1977), 54–55 (with additional bibliography), pl. 51; A. D. Trendall, *The Red-figured Vases of Paestum* (London: British School at Rome, 1987), 160, no. 290, pl. 105e–f.

Asteas and Python, who signed some of their vases, are the only two south Italian vase painters known by their real names. They were contemporaries working in Paestum from about 360 to 330 BC. The two Paestan bell-kraters once owned by Hearst (this one and cat. no. 104) are unsigned works by Python, one of the most accomplished of all south Italian vase painters.

On south Italian vases the wine god Dionysos is almost invariably depicted as a long-haired, athletic young man. On the front of this vase the god advances across uneven terrain at night, his way illuminated by the torch carried by a small, old white-haired satyr, who hurries along with a full wine-skin slung over his shoulder. They are on their way to a drinking party, and in anticipation of their arrival, Dionysos holds out his cup. Below the satyr is a small altar.

Flanking the pictures front and back are slender half-palmettes, ornamental hallmarks of the Paestan style of vase painting. The two clothed youths on the reverse are standard too, as are the heavy dot-stripe borders on their garments.

AJC

104

RED-FIGURED BELL-KRATER (WINE BOWL)
Attributed to Python by Carl Watzinger
South Italy (Paestum), c. 340–330 BC

Terra-cotta
Height: 15 ¼ in. (38.8 cm); diameter (body): 9 ⅝ in. (24.3 cm)
Los Angeles County Museum of Art, William Randolph
Hearst Collection (inv. no. 50.8.40)

Provenance: Sir William Hamilton (1730–1803), Naples, late 18th century; Thomas Hope (1769–1831); by descent to Henry Francis Hope Pelham Clinton (1866–1941), 1884; his sale, Christie's, London, July 23, 1917, no. 137a; Weetman Dickinson Pearson, first Viscount Cowdray (1856–1927); by descent to third Viscount Cowdray; his sale, Sotheby's, London, December 2, 1946, no. 63; sold to William Randolph Hearst; presented to the Los Angeles County Museum, 1950.

Exhibitions: *The Art of South Italy: Vases from Magna Graecia*, Virginia Museum of Fine Arts, Richmond; Philbrook Art Center, Tulsa; Detroit Institute of Arts, 1982–83, no. 107.

Bibliography: Beazley Archive Pottery Database, Oxford University online database, vase no. 1001510, http://www.beazley.ox.ac.uk/databases/pottery.htm; Pamela M. Packard and Paul A. Clement, *The Los Angeles County Museum of Art*, fasc. 1, Corpus Vasorum Antiquorum, USA fasc. 18 (Berkeley: University of California Press, 1977), 55–56 (with additional bibliography), pl. 52; A. D. Trendall, *The Red-figured Vases of Paestum* (London: British School at Rome, 1987), 160, no. 291.

From the time that they were acquired by Thomas Hope, the two bell-kraters by Python that belonged to Hearst (this one and cat. no. 103) have been in the same collections, and given their many similarities, not only is it likely that they are close in date, but it is also conceivable that they were buried together in antiquity.

On this vase a centaur is depicted traveling in the company of a diminutive satyr. The torch held by the centaur indicates that the scene takes place at night. Centaurs are part human and part horse, and more often than not, they are depicted as uncouth beings. This centaur appears distinctly human, however, and it may be that he is either Chiron, the wise centaur who tutored the hero Achilles, or Pholos, another civilized centaur. Whoever he may be, the centaur's torch and the presence of a satyr suggest that they are going to a nocturnal Dionysiac revel. Except for Chiron and Pholos, centaurs were notorious drunks who could not hold their liquor.

For the floral decoration and the figures on the reverse, see cat. no. 103. AJC

105

RED-FIGURED NECK-AMPHORA (STORAGE JAR)
Attributed to the Ixion Painter by J. D. Beazley
South Italy (Capua), c. 330–310 BC

Terra-cotta, perhaps originally with gilding on raised areas
Height (as restored): 26 ⅜ in. (67 cm); diameter (body):
9 ⅛ in. (23.1 cm)
Los Angeles County Museum of Art, William Randolph
Hearst Collection (inv. no. 50.8.16)

Provenance: Said to be from Polignano, South Italy (now considered doubtful); Giovanni Carafa, Duke of Noia, Naples, 1760s or earlier; Museo Nazionale di Capodimonte, Naples; James Edwards, London; Thomas Hope (1769–1831); by descent to Henry Francis Hope Pelham Clinton (1866–1941), 1884; his sale, Christie's, London, July 23, 1917, no. 119; Weetman Dickinson Pearson, first Viscount Cowdray (1856–1927); by descent to third Viscount Cowdray; his sale, Sotheby's, London, December 2, 1946, no. 66; sold to William Randolph Hearst; presented to the Los Angeles County Museum, 1950.

Bibliography: Beazley Archive Pottery Database, Oxford University online database, vase no. 1001505, http://www.beazley.ox.ac.uk/databases/pottery.htm; Dietrich von Bothmer and Martine Denoyelle, "Naturalisme et illusion: *Les Vases grecs et étrusques*, une oeuvre d'Alexandre-Isidore Leroy de Barde (1777–1828)," *Revue du Louvre* 52 (April 2002): 37, 38, fig. 5; Pamela M. Packard and Paul A. Clement, *The Los Angeles County Museum of Art*, fasc. 1, Corpus Vasorum Antiquorum, USA fasc. 18 (Berkeley: University of California Press, 1977), 50–52 (with additional bibliography), pls. 46–47; A. D. Trendall, *The Red-figured Vases of Lucania, Campania, and Sicily* (Oxford: Clarendon Press, 1967), 335, 337, 339, no. 799.

The fact that this neck-amphora once belonged to one of the first collectors of Greek vases, Giovanni Carafa, the Duke of Noia, may have influenced Hearst's decision to purchase it. It was first mentioned by the German scholar Johann Joachim Winckelmann in the second edition of his renowned *History of the Art of Antiquity* (Vienna, 1776), in which he described it as "the most beautiful and at the same time the most scholarly piece."[1]

Winckelmann asserted that the exceptional multilevel battle of fourteen warriors on the front depicted one of the climactic moments in the Trojan War, the fight over the corpse of Patroclus, one of the Greek heroes. Given the lack of inscriptions to identify the figures, Winckelmann's interpretation cannot be proved, but at the same time, his idea cannot be bettered. The subject of the scene on the reverse—four women, a youth, and Eros—remains elusive as well, although it has been suggested that its meaning has something to do with a wedding.

The Ixion Painter depicted a wider range of subjects than any other Campanian vase painter. AJC

Notes
1. Johann Joachim Winckelmann, *Geschichte der Kunst des Alterthums*, Schriften und Nachlass Johann Joachim Winckelmann, vol. 4, pt. 1, ed. Adolf H. Borbein et al. (Mainz: Phillip von Zabern, 2002), 191.

105

106

JANIFORM HERM WITH PANISKOS AND PANISKE
Roman, first century BC–first century AD

Bronze with silver gilding
Height: 7½ in. (19.1 cm)
Los Angeles County Museum of Art, William Randolph
Hearst Collection (inv. no. 51.18.9)

Provenance: Castellani sale, Rome, 1884, no. 277 or 278; Arnold Seligmann, Rey & Co., until 1933; sold to William Randolph Hearst; presented to the Los Angeles County Museum, 1951.

Exhibitions: *Master Bronzes from the Classical World*, Fogg Art Museum, Cambridge, Massachusetts, City Art Museums of St. Louis, Los Angeles County Museum of Art, 1967–68, no. 294; *The Villa of the Mysteries in Pompeii: Ancient Ritual, Modern Muse*, Kelsey Museum of Archeology and University of Michigan Museum of Art, Ann Arbor, 2000, no. 65.

This spirited sculpture of the youthful, silver-eyed Pan on one side and his female counterpart on the other is one of seven bronze examples of the same model, all of which are believed to have come from an excavation around Pompeii (probably Torre del Greco) in the second half of the nineteenth century. They are now divided among the collections of the Los Angeles County Museum of Art; the Victoria and Albert Museum, London; the Staatliche Museen, Berlin; the

106

Musée du Petit Palais, Paris; and the Museo Archeologico Nazionale, Naples. Two of the bronzes were sold from the Castellani collection in 1884.

The squared termination and the hollowed interior of the bronzes indicate that the herms were decorative fixtures in an interior architectural program of a Roman villa, most likely finials on a fence. CHM

107

THE LANSDOWNE ARTEMIS

Roman, 1st century AD

Marble
Height: 70 in. (178 cm)
Los Angeles County Museum of Art, William Randolph
Hearst Collection (inv. no. 49.23.5a)

Provenance: William Petty Fitzmaurice, second Earl of Shelburne (later first Marquess of Lansdowne), Great Britain, after 1771; sold to John, second Marquess of Lansdowne, 1805; his sale, London, 1810, lot 30 ("Juno"?): sold to Henry, third Marquess of Lansdowne; by descent to Henry William Edmund, sixth Marquess of Lansdowne, 1927; his sale, Christie's, March 5, 1930, lot 24, ill.; sold to Joseph Brummer, New York; sold to William Randolph Hearst, March 6, 1930; presented to the Los Angeles County Museum, 1949.

Bibliography: Adolf Michaelis, *Ancient Marbles in Britain* (Cambridge: Cambridge University Press, 1882), 455–56, no. 67; Charles Picard, *Manuel d'archéologie grecque: La sculpture*, vol. 3.1 (Paris: Picard, 1948), 63, 123n2, figs. 14, 38; L. Kahil, in *Lexicon Iconographicum Mythologiae Classicae*, vol. 2 (Zurich: Artemis, 1984), 636, s.v. Artemis, no. 128.

Artemis (or Diana), goddess of the hunt, is recognizable by the strap of the quiver that was once attached to the figure's back. The statue belongs to the minority of images that show Artemis in long garments rather than a knee-length hunting outfit. Here she wears the typical dress of a high-classical goddess, the belted peplos with overfold (*apoptygma*). No other exact replicas of this figure are known, so it may be a Roman adaptation of a Greek image created in the 440s BC that represented Artemis, probably holding a scepter in her raised right hand and an offering dish in her outstretched left. Although an attractive torso, the figure was fully restored before entering the Lansdowne collection and was still in that state when Hearst donated it to the Los Angeles County Museum, including both arms and an ancient head of Apollo.

When the renowned Lansdowne marbles were sold in 1930, there was enormous interest from major museums, such as the Metropolitan Museum of Art in New York and the Ny Carlsberg Glyptotek in Copenhagen. In addition to the *Venus Italica* by Antonio Canova (cat. no. 123), Hearst

108

acquired at least four more Lansdowne sculptures, including the throne, the bust of Athena (cat. no. 108), the "Boxer" restored by Bartolomeo Cavaceppi (all Los Angeles County Museum of Art), and the Hermes (Metropolitan Museum of Art, gift of the William Randolph Hearst Foundation).

JD

108

THE LANSDOWNE BUST OF ATHENA

Roman, c. AD 140–50 (head)

Attributed to Bartolomeo Cavaceppi (1716–1799), c. 1760–70 (bust)

Marble

42 x 33 x 19 in. (107 x 83.8 x 48.3 cm)

Los Angeles County Museum of Art, William Randolph Hearst Collection (inv. no. 49.23.1)

Provenance: Gavin Hamilton, after 1760;[1] sold to William Petty Fitzmaurice, second Earl of Shelburne (later first Marquess of Lansdowne), 1772; sold to John, second Marquess of Lansdowne, 1805; his sale, London, 1810, lot 66; sold to Henry, third Marquess of Lansdowne; by descent to Henry William Edmund, sixth Marquess of Lansdowne, 1927; his sale, Christie's, March 5, 1930, lot 64, ill.; sold to Joseph Brummer, New York; sold to William Randolph Hearst, March 11, 1930; presented to the Los Angeles County Museum, 1949.

Bibliography: Evelyn Harrison, "Alkamenes I," *American Journal of Archaeology* 81 (1977): 150–75 (for a list of ancient replicas, see 175–78); Seymour Howard, "The Lansdowne Bust of the Athena of Velletri," *Bulletin of the Art Division, Los Angeles County Museum* 17, no. 1 (1965): 3–15; reprinted with an addendum, in Howard, *Antiquity Restored: Essays on the Afterlife of the Antique* (Vienna: IRSA, 1990), 130–41; Adolf Michaelis, *Ancient Marbles in Britain* (Cambridge: Cambridge University Press, 1882), 469, no. 93.

The goddess Athena wears a snake-lined aegis emblazoned with a gorgoneion and a mantle, while a Corinthian helmet topped by another snake is pushed up high on her head. This over-life-size bust reflects the dilemma in the attribution of antique works from European eighteenth-century collections. At least four authors have contributed to its creation. A Greek artist of the second half of the fifth century BC conceived the original image of the so-called Velletri Athena, a full-length statue, which is lost but survives in the form of Roman copies such as this one, made in the second century AD. Only the head and right shoulder of the sculpture are ancient, however; most of the bust and the restoration of other details are the work of a neoclassical sculptor of the 1760s, possibly Bartolomeo Cavaceppi in Rome. The sculpture was modified by "conservation" treatment in the 1970s that stripped it of minor restorations such as the nose, snakes, and helmet parts but left the modern bust intact.

Formerly at Lansdowne House in London—built by Robert Adam in 1768 and demolished in 1930—the bust was first displayed there in the Blue Drawing Room and later in the Sculpture Gallery, together with the Artemis (cat. no. 107). An abbreviated version of a high-classical image, the Lansdowne Athena would have appealed to Hearst for its universal, timeless value; it epitomizes neoclassical taste.

JD

Notes

1. For the supposed findspot "at Roma Vecchia," see Richard Neudecker, *Die Skulpturenausstattung römischer Villen in Italien* (Mainz: Philipp von Zabern, 1988), 208n13.

109

THE HOPE ATHENA

Roman, mid-2nd century AD

Marble

Height: 86 in. (218 cm)

Los Angeles County Museum of Art, William Randolph Hearst Collection (inv. no. 51.18.12)

Page 143

Provenance: Found by Robert Fagan at Tor Boacciana in Ostia in 1797 (together with the Hygieia [cat. no. 110]); sold to Thomas Hope (1769–1831); by descent to Henry Francis Hope Pelham Clinton (1866–1941), 1884; his sale, Christie's, July 23–24, 1917, lot 258, pl. and frontispiece; sold to Weetman Dickinson Pearson, first Viscount Cowdray (1856–1927); his sale, Sotheby's, July 27, 1933, lot 127, pl. 6 (bought in); sold to William Randolph Hearst, probably by August 1, 1933; presented to the Los Angeles County Museum, 1951.

Exhibitions: On loan to the J. Paul Getty Museum, Malibu, California, 1973–87.

Bibliography: Detlev Kreikenbom, in *Die Geschichte der antiken Bildhauerkunst*, vol. 2, *Klassische Plastik*, ed. Peter C. Bol (Mainz: Philipp von Zabern, 2004), 204–7, text figs. 76 a–d; Adolf Preyß, "Athena Hope und Pallas Albani-Farnese," *Jahrbuch des Deutschen Archäologischen Instituts* 27 (1912): 88–128, figs. 1–4, pls. 9–11; Geoffrey B. Waywell, *The Lever and Hope Sculptures* (Berlin: Gebr. Mann, 1986), 67–68, no. 1, fig. 9, pl. 46 (with earlier bibliography).

Dressed in a chiton and sumptuous mantle, her chest protected by an aegis, Athena may once have looked at a small figure of Nike on her right hand while supporting her left arm on a lance. She stands in the purest classical contrapposto, but since the forms of her body are entirely concealed under the garments, this is conveyed by the system of drapery folds. The helmeted head, once crowned by a sphinx and two griffins, was carved separately. The Hope Athena gives her name to a sculptural type that is based on a Greek work of 430–420 BC and relates to the famous Athena Parthenos by Pheidias.

The Athena was excavated together with the Hygieia (cat. no. 110) in Ostia, the ancient port of Rome, and the two

statues were sold together at the Hope collection sale in 1917. They were numbers one and two, respectively, in Hope's catalogue of his own collection. Hearst acquired them later, at separate sales in the 1930s, thus reuniting two works of art that were probably displayed together in antiquity. He was definitely aware of their Hope provenance, if not their ancient context, since he also purchased a significant number of Greek vases that came from that English collection (see cat. nos. 99, 101–5). The Hope Athena and Hope Hygieia are clearly the most important and best-preserved Roman sculptures from Hearst's collection. At one point the Athena was displayed in the Assembly Room at San Simeon's Casa Grande, together with Antonio Canova's *Venus Italica* (cat. no. 123). Hearst parted with the Athena only at the very end, donating her in 1951, the year of his death. JD

110

THE HOPE HYGIEIA
Roman, mid-2nd century AD

Marble

75 x 25 x 18 in. (190 x 64 x 46 cm)

Los Angeles County Museum of Art, William Randolph Hearst Collection (inv. no. 50.33.23)

Page 7

Provenance: Found by Robert Fagan at Tor Boacciana in Ostia in 1797 (together with the Athena [cat. no. 109]); sold to Thomas Hope (1769–1831); by descent to Henry Francis Hope Pelham Clinton (1866–1941), 1884; his sale, Christie's, July 23–24, 1917, lot 252, pl. xvi; sold to Alfred Mond, first Baron Melchett (1868–1930); his sale, Christie's, April 23, 1936, lot 80; sold to William Permain, presumably as agent for Hearst; William Randolph Hearst; presented to the Los Angeles County Museum, 1950.

Exhibitions: On loan to the J. Paul Getty Museum, Malibu, California, 1973–87, 2006–8; *The Hope Hygieia: Restoring a Statue's History*, Getty Villa, Malibu, 2008.

Bibliography: Wolfram Geominy, in *Die Geschichte der antiken Bildhauerkunst II: Klassische Plastik*, ed. Peter C. Bol (Mainz: Philipp von Zabern, 2004), 299–300, pls. 268–73; Iphigeneia Leventi, *Hygieia in Classical Greek Art*, Archaiognosia, supp. 2 (Athens: University of Athens, 2003), 86–96, 158–68, no. St 9, pls. 61–64; Geoffrey B. Waywell, *The Lever and Hope Sculptures* (Berlin: Gebr. Mann, 1986), 68–69, no. 2, fig. 10, pl. 47 (with earlier bibliography).

Hygieia, daughter of the healer god Asklepios, is represented feeding a large serpent from a dish in her hand. This is the best-preserved ancient copy of a lost Greek statue of the fourth century BC—a type hence named after the Hope Hygieia—and was carved in the mid-second century AD, during the Antonine period. As with the Hope Athena (cat. no. 109), Hygieia's eye sockets are hollow, indicating that her eyes were originally inlaid in a different polychrome material, such as colored stone or glass.

When Hearst donated the statue to the Los Angeles County Museum, its appearance was essentially the same as it was when it entered Thomas Hope's collection 150 years earlier. The original marble restorations of around 1800—including the right arm, left hand, nose, eyes, and parts of the snake—were removed in the 1970s but reintegrated in preparation for the present exhibition. JD

111

SARCOPHAGUS WITH DIONYSOS AND HIS FOLLOWERS
Roman, c. AD 230–40

Marble

Length: 84 in. (214 cm); height: 25 in. (64 cm); depth: 25 in. (64 cm)

Los Angeles County Museum of Art, William Randolph Hearst Collection (inv. no. 50.37.11)

Pages 138–39

Provenance: From Rome; first recorded in a drawing by Pisanello (Oxford), before 1455; "monte Cavallo" (=Quirinal), 1570s (drawing by P. Jacques); between Castel Gandolfo and Albano (Galeria di Sopra), 1891 (C. Robert); Joseph Brummer, New York; sold to William Randolph Hearst, 1946; presented to the Los Angeles County Museum, 1950.

Bibliography: Friedrich Matz, *Die dionysischen Sarkophage*, vol. 1 (Berlin: Gebr. Mann, 1968), 158–59, no. 51, pls. 62.1, 63.1–2, Beilage 22.1–2; Jutta Stroszeck, *Löwen-Sarkophage* (Berlin: Gebr. Mann, 1998), 23 (with n81), 97, 107, no. 30; Henning Wrede and Richard Harprath, *Der Codex Coburgensis: Das erste systematische Archäologiebuch* (Coburg: Kunstsammlungen der Veste Coburg, 1986), 96, no. 103, fig. 53 and cover (16th-century drawing).

The oval, tub-shaped sarcophagus is made to resemble a wine trough, with the lion heads representing the spouts. The subject of the Bacchic *thiasos*, a procession of revelers—including Dionysos on his panther, satyrs, maenads, and goat-legged figures of Pan—is therefore particularly suitable and was one of the most popular in Roman mythological sarcophagi.

Sarcophagi were among the earliest antiquities known, collected, and recorded in the Renaissance, and this is one of them. Several drawings of the fifteenth and sixteenth centuries, including one in the Codex Coburgensis, show the Los Angeles sarcophagus before it suffered further damage and underwent extensive restoration in the seventeenth and eighteenth centuries.

No serious antiquarian's collection was complete without specimens of Roman funerary art. Apart from altars and grave reliefs, Hearst owned a number of sarcophagi. At least six others are still at San Simeon. JD

112

112

FEMALE RELIQUARY BUST
Flanders (Brussels or Brabant?), c. 1515–20

Polychromed and gilded wood
16½ x 15 x 7 in. (41.9 x 38.1 x 17.8 cm)
Los Angeles County Museum of Art, William Randolph
Hearst Collection (inv. no. 48.24.19)

Provenance: Louis Mohl; his sale, Hôtel Drouot, Paris, May 14, 1912; […]; William
Randolph Hearst; presented to the Los Angeles County Museum, 1948.

Bibliography: Mary L. Levkoff, "William Randolph Hearst's Gifts of European
Sculptures to the Los Angeles County Museum of Art," *Sculpture Journal* 4 (2000):
170nn55–60 (with relevant bibliography).

113

FEMALE RELIQUARY BUST (WITH LONG BRAIDS)
Flanders (Brussels or Brabant), c. 1520

Polychromed and gilded wood
Height (without base): 18¾ in. (47.6 cm); width: 17½ in.
(44.5 cm)
Height (base): 4¼ in. (10.8 cm)
Hearst Castle/California State Parks (inv. no. 529-9-931)

Provenance: Louis Mohl; his sale, Paris, May 14, 1912; [presumably sold to]
Raimondo Ruiz; his sale, Clarke's Gallery, New York, April 4–14, 1921; sold to
William Randolph Hearst.

114

FEMALE RELIQUARY BUST (WITH FLOWING LONG HAIR)
Flanders (Brussels or Brabant), c. 1520

Polychromed and gilded wood
Height (without base): 18¾ in. (47.6 cm); width: 16½ in.
(41.2 cm)
Height (base): 4 in. (10.2 cm)
Hearst Castle/California State Parks (inv. no. 529-9-932)

Provenance: Louis Mohl; his sale, Hôtel Drouot, Paris, May 14, 1912; [presumably
sold to] Raimondo Ruiz; his sale, Clarke's Gallery, New York, April 4–14, 1921; sold
to William Randolph Hearst.

These three sculptures belong to a coherent group of related
reliquary busts that can be found in the Metropolitan
Museum of Art, New York; the Museo de Arte Sacro de Álava,
Vitoria-Gasteiz, Spain; and the Staatliche Museen, Berlin.
Two busts in Vitoria came from that city's chapel of the

Eleven Hundred Virgins, which was founded by Hortuño Ibáñez de Aguirre, one of Charles V's counselors.[1] It is now generally accepted that the busts are not Spanish in origin and were brought to Spain from the Low Countries. Although they share general characteristics of slightly squinting eyes, headdresses typical of the years 1510 to 1525, and detailed costumes, the facial types are individualized enough to lead some specialists to believe that they might have been inspired by real people. The busts of a bishop (Berlin) and of Saint Albina (Vitoria) include a hand or hands.

The Los Angeles sculpture is smaller than the others, with a somewhat simpler costume, and is probably the best preserved of all, having never been restored. Photographs do not do it justice. The jeweled pendant, for example, was polychromed with a transparent glaze that can be distinguished only with a microscope; the irises are delicately shaded with blue and gray; and the lips are tinted with a transparent mulberry glaze. The Hearst Castle busts apparently were regilded and selectively repainted before Hearst acquired them. Their blouses, for example, were without doubt originally white. They were already attached to their bases when they were auctioned in 1912. The smaller bust was in New York when Hearst donated it to the Los Angeles County Museum. MLL

Notes

1. *Hispania—Austria: I re cattolici, Massimiliano I e gli inizi della Casa d'Austria in Spagna: Arte intorno al 1492*, exh. cat. (Innsbruck: Schloss Ambras; Milan: Electa, 1992), no. 72.

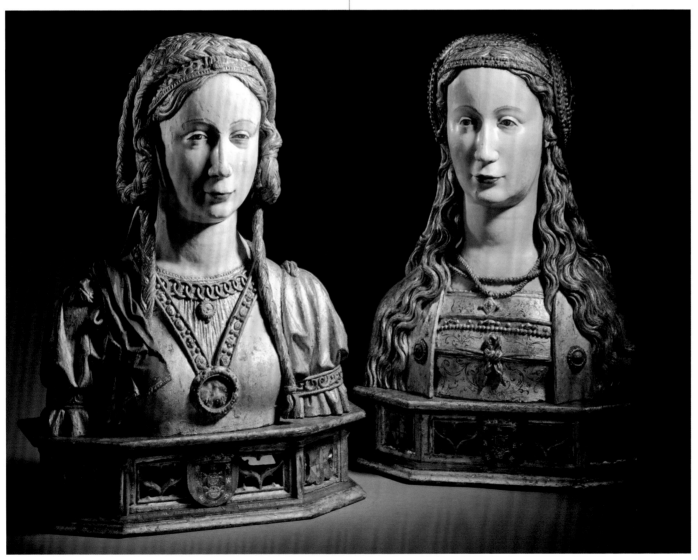

113, 114

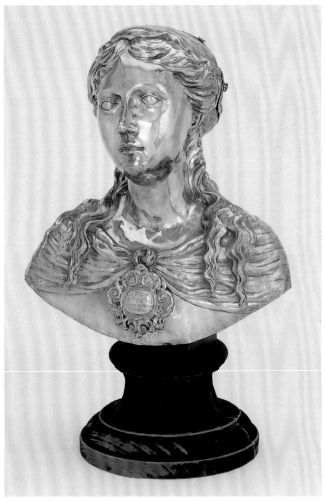

115

115
Reliquary Bust of a Young Woman
French or Flemish, 17th century

Silver
Height (without base): 18 in. (45.7 cm); width: 16 in. (40.6 cm)
Hearst Castle/California State Parks (inv. no. 529-9-6127)

Provenance: French & Co.; sold to William Randolph Hearst, 1923.

The inscription on the cartouche, which reads *capvt ex vna decim millivm virgin*, and the removable section on the back of the head suggest that this bust was sold to Hearst as a reliquary of Saint Ursula, the British princess who, according to legend, set out on a pilgrimage through Europe together with eleven thousand virgin ladies-in-waiting (some accounts give the number as eleven). She and her followers were supposedly massacred on their way to Cologne by the Huns, who were besieging the city.

The cartouche is of lesser quality and different style than the rest of the bust, and the aperture on the back of the head is an alteration. This suggests that the bust was conceived as a portrait and at a later date (probably in the late nineteenth or early twentieth century) and was fitted to look like a reliquary to meet the demand for medieval works of art at that time. Even so, a seventeenth-century silver bust of this size from France or Flanders is a rarity.
CHM

116
The Virgin Mary as a Young Girl
Spain (possibly Granada), c. 1630–80(?)

Polychromed wood, glass eyes
33 x 17½ x 12 in. (83.8 x 44.5 x 30.5 cm)
Hearst Castle, San Simeon, California (inv. no. 529-9-28)

Provenance: Pedro Ruiz & Sons, Madrid; Clarke's Gallery, New York; sold to William Randolph Hearst, May 1920.

Exhibitions: *Spanish Polychrome Sculpture, 1500–1800, in United States Collections*, Spanish Institute, New York; Meadows Museum, Southern Methodist University, Dallas; Los Angeles County Museum of Art, 1993–94, no. 32.

Bibliography: Jana Seely and Keri Collins, *Faces of Hearst Castle* (San Simeon, Calif.: Hearst Castle Press, 2007), 52–53.

The book held by the Virgin is inscribed with the words (Luke 1:46) with which Mary responded to the Archangel Gabriel when he announced that she would give birth to Jesus Christ. She is shown standing on clouds, which symbolize her immaculate conception.

The sculpture was first polychromed in classic *estofado*, a technique in which designs are etched through a layer of paint applied over a layer of gold leaf. By 1680, however, flowered white polychromy became more stylish. Spanish sculptures were frequently repainted in the new fashion, but the rich gold of the older *estofado* is still apparent in several areas of this sculpture. Decorative raised gesso or glass dots once accented the edges of the sleeves and the corners of the collar. The date of this perfectly realized sculpture—with its swaying drapery, graceful pose, and introspective gaze—is still debated. The split sleeves were popular from about 1585 to around 1615, but the straight-waisted laced bodice did not occur until much later in the century.
MLL

116

117

Attributed to Pietro Paolo Naldini (Italian, c. 1615–1691)
BUST OF BARTOLOMEO RUSPOLI (D. 1681), 1670–80

Gilt bronze
24 x 24 x 12 in. (61 x 61 x 30.5 cm) (without socle)
Height (with socle): 32 in. (81.3 cm)
Inscribed: *BARTHOLOMAEV/[?]VS [...?] MARCHIO/ ROMANUS*
Los Angeles County Museum of Art, William Randolph
Hearst Collection (inv. no. 51.18.5)
Page 142

Provenance: Georges Hoentschel, Paris; Canessa sale, American Art Galleries,
New York, January 25–26, 1924; William Randolph Hearst, San Simeon, California;
presented to the Los Angeles County Museum, 1951.

Exhibitions: *Baroque Portraiture in Italy: Works from North American Collections*,
Ringling Museum of Art, Sarasota, Florida, and Wadsworth Athenaeum, Hartford,
Connecticut, 1984–85, no. 19.

Bibliography: Mary Levkoff, "William Randolph Hearst's Gifts of European Sculptures
to the Los Angeles County Museum of Art," *Sculpture Journal* 4 (2000): 168; *Major
Themes in Baroque Art from Regional Collections* (Amherst, Mass.: Amherst College,
1974), no. 23; W. R. Valentiner, *Gothic and Renaissance Sculptures in the Collection of the
Los Angeles County Museum* (Los Angeles: Los Angeles County Museum, 1951), no. 70.

This bust was attributed to Camillo Rusconi by William R.
Valentiner, who selected it for the Los Angeles County
Museum from Hearst's collection at Hearst Castle, where
it had been displayed in the main library from 1934. The
attribution was based on the idea that the partially effaced
words on the scroll wrapped around the socle originally
read *RVSCONI*. The author of this portrait remains uncertain,
however. The scrollwork cartouche wrapped around the
socle is a unique and beautifully executed motif. The varied
surface textures suggest the hand of an accomplished sculp-
tor. Although there are no known works in bronze by Pietro
Paolo Naldini, Ursula Schlegel proposed an attribution
to him based on comparisons with his busts of Annibale
Carracci and Raphael (both executed for the Pantheon
and now in the Protomoteca, Rome). CHM

118

Jacques Buirette (French, 1631–1699)
THE RIVER NILE and THE RIVER TIBER, c. 1690
Bronze
7¾ x 17¾ x 8½ in. (19.7 x 45.1 x 21.6 cm)
Inscribed *B*
Hearst Castle/California State Parks (inv. nos. 529-9-1263, 529-9-1262)

Provenance: Anderson Galleries, New York, c. December 5, 1924; French & Co., New York, sold to William Randolph Hearst, San Simeon, May 13, 1925.

Bibliography: Francis Haskell and Nicholas Penny, *Taste and the Antique: The Lure of Classical Sculpture, 1500–1900* (New Haven: Yale University Press, 1981), 272–73, no. 65; Carolyn Miner, in *French Art of the Eighteenth Century at the Huntington*, ed. Shelley M. Bennett and Carolyn Sargentson (New Haven: Yale University Press, 2008), 460–61; François Souchal, *French Sculptors of the Seventeenth and Eighteenth Centuries: The Reign of Louis XIV: Illustrated Catalogue* (Oxford: Cassirer, 1977), vol. 1, 56.

These bronzes are reduced versions of two monumental ancient Roman sculptures excavated in 1512 and 1513 in Rome, which were traditionally called the Nile and the Tiber (the Nile is in the Vatican Museums, Vatican City, and the Tiber is in the Musée du Louvre, Paris). They have been reproduced in various sizes and media over the centuries.

Two pairs of the Nile and the Tiber are illustrated in engravings (c. 1710) of François Girardon's collection.[1] The larger pair is there attributed to Martin Carlier, and the Nile of the smaller pair, with similar measurements to the present Nile, is ascribed to Buirette. According to a posthumous inventory of the studio of Martin Desjardins (1637–1694), who was Buirette's pupil, Girardon owned two figures of river gods and two models of river gods "prêts à jeter en bronze" (ready for casting), which could well have been by Buirette. The present bronzes are attributed to Buirette because of their similarity in dimensions and appearance to the version in the engraving, as well as the initial *B* cast in the bronze.

CHM

Notes
1. N. Chevalier, after René Charpentier, *La Galerie du Sr. Girardon*, pls. 4, 6 (Bibliothèque nationale de France, Paris); see François Souchal, "La collection du sculpteur Girardon d'après son inventaire après décès," *Gazette des Beaux-Arts* 82 (July–August 1973): 1–98.

118

119

Claude Michel, called Clodion (French, 1733–1814)
RELIEF WITH DANCING MAENADS, 1765

Terra-cotta

11⅛ x 7⅞ in. (28.9 x 20 cm)

Signed and dated *Clodion/1765*

Malcolm Wiener

Page 14

Provenance: M. Morelle, Paris, purchased from the artist, May 3, 1786; sale, Vente Secrétan, Galerie Sedelmeyer, Paris, 1889; Raoul Cabany, Paris; Arnold Seligmann, Rey & Co.; sold to William Randolph Hearst, March 8, 1926; sold to Gimbels, 1942; Elizabeth Parke Firestone; sale, Christie's, New York, March 21–23, 1991, lot 849; Daniel Katz Gallery; sold to Malcolm Wiener.

Exhibitions: *Art in Rome in the Eighteenth Century*, Philadelphia Museum of Art and Houston Museum of Fine Arts, 2000, no. 125.

Bibliography: Stanislas Lami, *Dictionnaire des sculpteurs de l'école française au dix-huitième siècle*, vol. 2 (1911; reprint, Nendeln, Liechtenstein: Kraus, 1970), 157; Mary Levkoff, "The Little-Known American Provenance of Some Well-Known European Sculptures," in *La sculpture en occident: Études offertes a Jean-René Gaborit*, ed. G. Bresc-Bautier (Dijon: Éditions Faton, 2007), 301–2; Anne L. Poulet and Guilhem Scherf, *Clodion, 1738–1814*, exh. cat. (Paris: Musée du Louvre, 1992), 337, 443.

Clodion is recognized for his gently erotic evocations of classical subjects, and the present panel, one of his earliest known dated sculptures, is a consummate example inspired by the Borghese Dancers (Rome, 1st century AD, Musée du Louvre). In this masterful rendering of three women in the entourage of Bacchus, high and low relief are combined to create an illusion of much greater depth than the scant inch of terra-cotta that the composition occupies.

Terra-cotta sculpture has too often become synonymous with models or sketches, but many sculptors used the material for finished works of art in their own right, as the signature and date on this example imply.　　　CHM

120

Pierre Julien (French, 1731-1804)
HEAD OF A YOUNG GIRL, 1781

Terra-cotta on marble pedestal
Height: 18 in. (45.7 cm) with pedestal
Metropolitan Museum of Art, New York, Purchase,
C. Michael Paul Gift, 1978 (inv. no. 1978.1)

Provenance: Probably Paris Salon of 1779, no. 231; Wildenstein and Co., New York, until April 21, 1926; sold to William Randolph Hearst; sold to Gimbels, New York, March 25, 1941; acquired by the Metropolitan Museum of Art, 1978.

Exhibitions: *Playing with Fire: European Terracotta Models, 1740-1840*, Metropolitan Museum of Art, New York; Musée du Louvre, Paris; Nationalmuseum, Stockholm, pp. 273-75.

Bibliography: James David Draper, "Philippe Laurent Roland in the Metropolitan Museum of Art," *Metropolitan Museum Journal* 27 (1992): 129-47; Stanislas Lami, *Dictionnaire des sculpteurs de l'école française au dix-huitième siècle*, vol. 1 (1898; reprint, Nendeln, Liechtenstein: Kraus, 1970), 14; Guilhem Scherf, "Pierre Julien ou l'élégance néoclassique," *L'objet d'art*, no. 394 (October 2004): 56-65.

This bust is very likely the one described in the Paris Salon catalogue of 1779 as a "Head of a woman" with "a veil on her head and crowned with flowers, like the young girls dowered by the pope and the Sacred College in the Church of the Minerva in Rome." Once a year, at the Church of Santa Maria sopra Minerva in Rome, 350 impoverished women were offered a dowry from the Church either to marry or to become nuns. Those who chose the church wore flowers in their hair in the style of ancient Roman vestals. Here Julien combined the young girl's misgivings and fear with a seductive glance, so her choice seems ambiguous. When the sculptor exhibited the marble of the same model at the Salon of 1781, however, he no longer referred to it as *Head of a Woman*, but called it *Vestal*. CHM

121

Joseph-Charles Marin (French, 1759-1834) and workshop
ERIGONE or BACCHANTE, c. 1785

Terra-cotta
16 3/4 x 6 13/16 x 7 7/16 in. (42.6 x 17.3 x 18.9 cm)
Incised at the center of the back of base: *marin*
Henry E. Huntington Library, Art Galleries and Botanical Gardens (inv. no. 2003.6)

Provenance: Madame Christiane de Polès, Paris; her sale, Galerie Charpentier, Paris, November 17-18, 1936, lot 165; sold to Arnold Seligmann, Rey & Co., Paris; sold to William Randolph Hearst, New York, February 11, 1937; sold to Le Passe Gallery, 1941; J. Younger, Houston; Rosenberg & Stiebel, New York, by 1986; Daniel Katz Gallery; acquired by the Huntington, 2003.

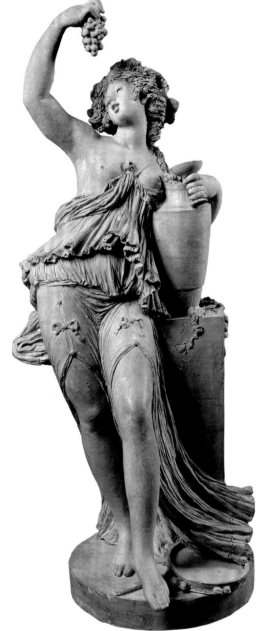

121

Exhibitions: *Art Objects and Furnishings from the William Randolph Hearst Collection*, Hammer Galleries, New York, 1941, no. 301.

Bibliography: Carolyn Miner, in *French Art of the Eighteenth Century at the Huntington*, ed. Shelley M. Bennett and Carolyn Sargentson (New Haven: Yale University Press, 2008), 503-5. M. Quinquenet, *Un élève de Clodion: Joseph-Charles Marin, 1759-1834* (Paris: Renée Lacoste, 1948); Guilhem Scherf, "Un 'élève de Clodion': Joseph-Charles Marin (1759-1834)," in *Clodion, 1738-1814*, ed. Anne Poulet and Guilhem Scherf (Paris: Réunion des Musées Nationaux, 1992), 405.

This terra-cotta figure is Marin's evocation of the ancient *topos* of the female followers of Bacchus, the Roman god of wine. Marin's career began in Clodion's (1738-1814) studio,

where he modeled figures in the manner of his master, from whose style he never truly progressed. This composition was inspired by Clodion's plaster *Erigone* for a niche in the château de Maisons-Laffitte. Comparison with two other terra-cottas by Marin helps to place it within his oeuvre. A *Bacchante* signed and dated 1784 is in the Thyssen-Bornemisza Collection, Madrid, and a signed *Head of a Bacchante* dated 1786 is in the Victoria and Albert Museum, London. CHM

122

Guillaume Boichot (French, 1735–1814)
HERCULES PERSONIFYING STRENGTH, C. 1800

Bronze (sand-cast)
35 x 17 x 27 in. (88.9 x 43.2 x 68.6 cm)
Los Angeles County Museum of Art, Gift of William Randolph Hearst (inv. no. 50.33.27)

Provenance: American Art Association, Anderson Galleries, New York, January 15, 1930; sold to Joseph Brummer; sold to Hearst, 1930; presented to the Los Angeles County Museum, 1950.

Exhibitions: *Neo-Classicism: Style and Motif*, Cleveland Museum of Art, 1964, no. 42.

Bibliography: F. H. Dowley, "Neo-classic Hercules, or La Force, by Guillaume Boichot," *Art Quarterly* 15, no. 1 (1952): 73–76; Mary L. Levkoff, "William Randolph Hearst's Gifts of European Sculptures to the Los Angeles County Museum of Art," *Sculpture Journal* 4 (2000): 167; Douglas Lewis, "The Progeny of Centaurs: An Early Work by Rude and Its Influence," *Antologia di belle arti*, nos. 48–51 (1994): 140–46.

In 1791 the Church of Saint-Geneviève, Paris, was converted into the Panthéon, a secular monument dedicated to the great men of France. Boichot was commissioned to create an allegorical plaster of Strength in the guise of Hercules for the building's portico. The plaster, destroyed during the Restoration, is known through the frontispiece of Friedrich Johann Lorenz Meyer's *Fragmente aus Paris in IVten Jahr der französischen Republik* (Hamburg, 1798) and through C. P. Landon's *Annales du Musée et de l'École moderne des beaux-arts* (1807). Boichot also exhibited a *demi-nature* (half-life-size) variant at the Paris Salon of 1795; it was donated to the Musée des Monuments Français (no. 554 of the catalogue of 1816; medium and present location unknown).

The present bronze differs from the Panthéon Hercules in two obvious ways: in the plaster Hercules rests his right arm on a tablet instead of a tree, and his pose (particularly the turn of the neck and chest) is oriented more toward the proper right side, which would have been appropriate for its location to the right of the entrance to the Panthéon. Therefore it is reasonable to believe that the Hearst bronze might reflect the one exhibited in 1795.

A cast of the Hearst bronze, stamped Crozatier, is in the British Royal Collection, Windsor. Charles Crozatier (1794–1855) was a bronze caster and sculptor in France, but there is no known record of any collaboration between him and Boichot. CHM

123

Antonio Canova (Italian, 1720–1822)
VENUS ITALICA, C. 1804–14

Marble
65 ³⁄₁₆ x 19 x 21 ½ in. (165.6 x 48.3 x 54.6 cm)
Hearst Castle/California State Parks (inv. no. 529-9-6248)
Page 27

Provenance: Commissioned from Antonio Canova by Count Andreas Kyrillovitsch Razoumovsky, 1806–7; delivered instead to Lucien Bonaparte, Prince of Canino and Musignano (1775–1841), by July 18, 1814; sold to Sir William (Fitzmaurice) Petty, second Earl of Shelburne and first Marquess of Lansdowne (1737–1805), 1816; by descent in the Lansdowne family; sold to William Permain; sale, Christie's, London, March 5, 1930, lot 120; sold to George L. Willson; William Randolph Hearst, San Simeon; transferred to the San Simeon Historical Monument, 1957.

Bibliography: Carlo Caruso and Katherine Hahn, "The Third Version of Canova's 'Venus,'" *Burlington Magazine* 135 (December 1993): 828; Hugh Honour, "Canova's Statues of Venus," *Burlington Magazine* 114 (October 1972): 658–71; D. Lewis, "The Clark Copy of Antonio Canova's 'Hope Venus,'" in *The William A. Clark Collection: An Exhibition Marking the Fiftieth Anniversary of the Installation of the Clark Collection at the Corcoran Gallery of Art*, exh. cat. (Washington, D.C.: Corcoran Gallery of Art, [1978]), 105–15; Carolyn Miner, in *Apollo*, November 2008 (forthcoming).

When Napoleon's armies invaded Italy, they seized the Medici Venus, a fully restored Hellenistic marble (1st century BC, Galleria degli Uffizi, Florence) and took it to Paris. Canova was commissioned to carve a replacement (1803), but because he did not make direct copies of antiquities, his Italian patron agreed to let him create a variant inspired by the looted antiquity. Canova's new composition was called the *Venus Italica*. In 1805 two unfinished statues of Venus were seen in Canova's studio in Rome: a true copy of the Medici Venus and a standing Venus emerging from the bath.

Ironically Napoleon paid for the Venus emerging from the bath, delivered on April 18, 1812, to the Uffizi (now Palazzo Pitti, Florence). There are two other documented versions of Canova's *Venus Italica*: one commissioned by Prince Ludwig of Bavaria before 1808 and delivered to Munich after August 1811 (Residenz, Munich) and another commissioned by Antonio Vighi in 1807 for Count Razoumovsky, which was instead offered by Canova in 1810 to Napoleon's brother, Lucien, Prince of Canino, as "the Venus sought by Razoumovsky and the King of Spain." By July 1814

122

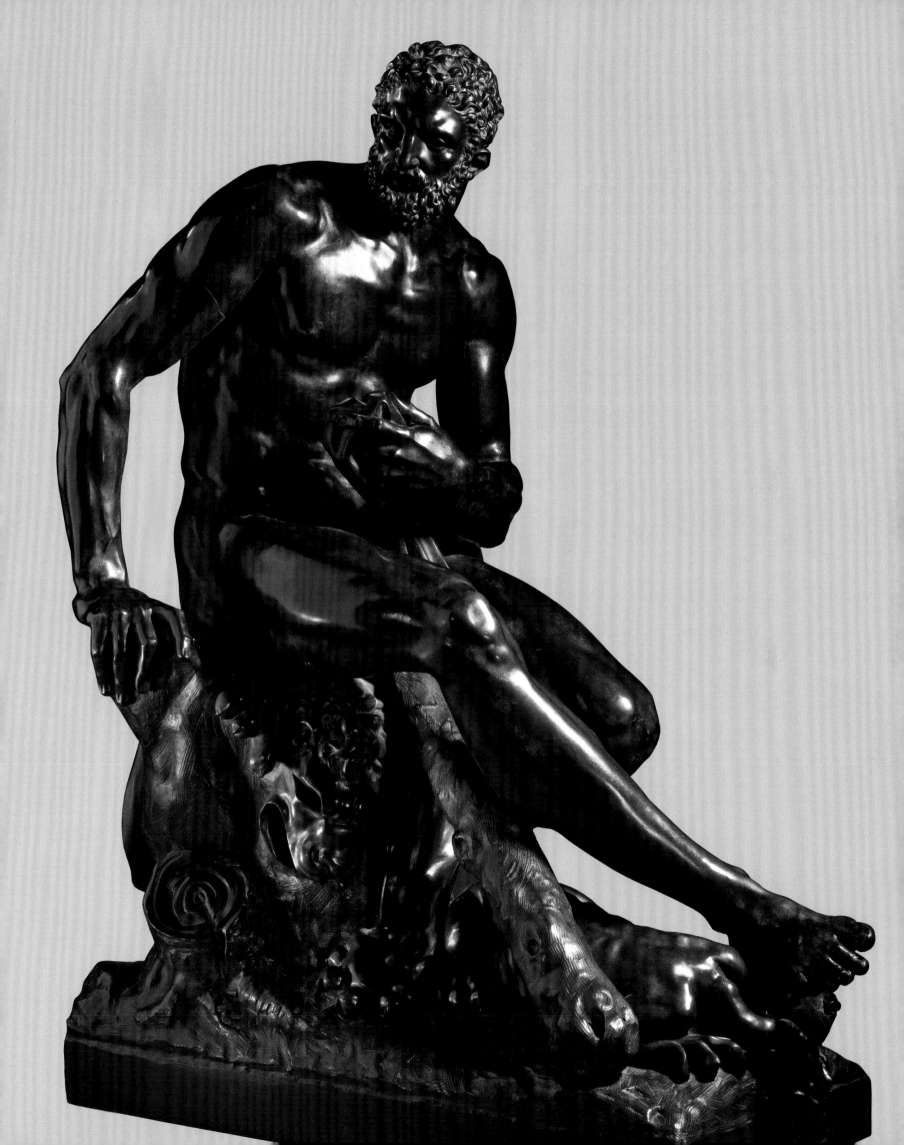

Lucien Bonaparte owned the third Venus. He sold it to Lord Lansdowne in 1816.

Hearst's purchase of the *Venus Italica* from the Lansdowne collection in 1930 challenges many misconceptions about him. In 1921—in a telegram (Duveen Archive, GRI) to Hearst discussing Canova's *Hope Venus* (now Corcoran Gallery, Washington, D.C.), a second version that varies significantly from the sculptor's original design—Mitchell Samuels wrote: "Your notation that it is somewhat like the one in Florence is remarkable," indicating that Hearst clearly knew not only Canova's *Venus Italica* but also the sculptor's slightly varying models. Despite the common assumption that Hearst was undiscerning, he did not purchase the *Hope Venus* but waited nine years to acquire Canova's original, and undoubtedly superior, Lansdowne version. CHM

124

Bertel Thorvaldsen (Danish, 1770–1844)
HEBE, conceived 1806, carved 1819–23

Marble
Height: 61½ in. (156.5 cm)
Thorvaldsens Museum, Copenhagen (inv. no. A 875)
Page 101

Provenance: Samuel Boddington, c. 1823; Fairfax Rhodes; his sale, Sotheby's, London, July 6, 1934; sold to William Randolph Hearst; acquired by Thorvaldsens Museum, Copenhagen, 1938.

Exhibitions: *Bertel Thorvaldsen, 1770–1844: Scultore danese a Roma*, Galleria Nazionale d'Arte Moderna, 1989–90, no. 6; *Künstlerleben in Rom: Bertel Thorvaldsen (1770–1844), der dänische Bildhauer und seine deutschen Freunde*, Germanisches Nationalmuseum, Nuremberg, and Schleswig-Holsteinisches Landesmuseum, Schloss Gottorf, Schleswig, 1991–92, no. 5.1.

Bibliography: Mary Levkoff, "The Little-Known American Provenance of Some Well-Known European Sculptures," in *La sculpture en occident: Études offertes a Jean-René Gaborit*, ed. G. Bresc-Bautier (Dijon: Éditions Faton, 2007), 297.

Thorvaldsen conceived this sculpture of Hebe, the Greek goddess of youth and wine bearer to Zeus, in 1806. Like Canova's *Venus Italica*, the *Hebe* was more original than a simple emulation of the antique. They are both their creators' attempts to improve on antique inspiration. Criticized for the hybrid, historically inaccurate costume, Thorvaldsen modeled a second version, with a more correct peplos and with the torso fully draped. It is also in Thorvaldsens Museum. CHM

125

SAINT BARBARA
France or Belgium(?), c. 1860–1910

Alabaster
47⅝ x 18³⁄₁₆ x 14½ in. (120.9 x 46.2 x 36.2 cm)
National Gallery of Art, Washington, D.C., Samuel H. Kress Collection (inv. no. 1952.5.102)
Page 13

Provenance: Reportedly in Portugal by 1911; Léouzon le Duc collection, Paris; Jacques Seligmann & Cie, Paris and New York, February 20, 1922; sold to Albert J. Kobler, November 1924; sold to William Randolph Hearst, August 22, 1930; sold to French & Co., April 18, 1940; sold to Dr. Preston Pope Satterwhite, before 1945; sold to French & Co., January 32, 1945; sold to the Samuel H. Kress Foundation, New York, November 29, 1949 (as Franco-Portuguese, c. 1510); gift by exchange to the National Gallery of Art, 1952.

Exhibitions: *Masterpieces of Art: European Paintings and Sculpture from 1300–1800*, New York World's Fair, 1939, no. 419 (as *St. Barbara, holding a Chalice with the Host*, from the school of Troyes [France]).

Bibliography: Mary Levkoff, "The Little-Known American Provenance of Some Well-Known European Sculptures," in *La sculpture en occident: Études offertes a Jean-René Gaborit*, ed. G. Bresc-Bautier (Dijon: Éditions Faton, 2007), 301; Ulrich Middeldorf, *Sculptures from the Samuel H. Kress Collection: European Schools XIV–XIX Century* (London: Phaidon, 1976), 122.

Albert Kobler, publisher of Hearst's *New York Mirror* and his occasional confidant in matters related to art, also had a luxurious apartment in Manhattan decorated in the Gothic style. Hearst probably referred to this statue when he wrote to his registrar on December 28, 1929, that Kobler had a statue of "Saint Agnes or some such saint bought from Jacques Seligmann. Would like that in Clarendon" (Hearst Papers, 39:17). Kobler probably acquired this statue as "The Queen of Spain as Saint Barbara," the title on Hearst's inventory card.

This sculpture was exhibited at the 1939 World's Fair as a masterpiece: Hearst was not alone in being deceived by it. Eventually the metallic carving, individualized expression, and brilliant state of preservation led some experts to doubt its authenticity. The statue is a virtuosic demonstration by a forger who let the taste of the late nineteenth century permeate his skillful historicism: the curling tendrils of hair in the back, which were probably inspired by Burgundian fifteenth-century sculptures, betray the sensibility of art nouveau style.

The geographic origin is difficult to identify. Alabaster was used more frequently in Belgium and Spain than in France, but the sharp precision and insistent decorative details are in keeping with the Portuguese origin that was first claimed for this sculpture. MLL

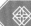 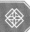

126

BIBLE

France (Paris), c. 1250–75

Tempera and gold leaf on parchment, leather binding
10 x 6½ in. (25.3 x 16.5 cm)
The Metropolitan Museum of Art, New York, Partial and
Promised Gift of John L. Feldman, in memory of his father,
Alvin Lindberg Feldman, 1997 (inv. no. 1997.320)

Provenance: From the Carthusian Abbey of Fontaine Notre-Dame (Bourg-Fontaine),
after 1325; Jean Budé (d. 1501), Paris; Guillaume Budé (d. 1540), Paris; President de
Saint-André; Jesuit Collège de Clermont, Paris (dispersed 1589–1610); Byron Holland;
Sir Sydney Cockerell, Cambridge; Sir Alfred Chester Beatty, London; his sale, Sotheby's,
London, May 9, 1933, lot 48; sold to William Permain, London; William Randolph
Hearst, New York and San Simeon, California, until 1944; sold to Brummer Gallery,
Paris and New York, 1944–48; sold to Joel and Maxine Spitz, Glencoe, Illinois, 1948;
Sotheby's, London, November 29, 1990, lot 98 (pp. 124–33); John L. Feldman,
Lakewood, Colorado, until 1997; acquired by the Metropolitan Museum of Art, 1997

Exhibitions: *Mirror of the Medieval World*, Metropolitan Museum of Art, New York,
1999, no. 137.

Bibliography: Seymour de Ricci and W. J. Wilson, *Census of Medieval and Renaissance
Manuscripts in the United States and Canada* (New York: H. W. Wilson, 1937), vol. 2,
1687, no. 1.

Created in Paris for Dominican use during the third quarter
of the thirteenth century, this beautifully decorated Bible
boasts eighty-one historiated initials. While it is stylistically
related to a group of Bibles produced in a university milieu,
made in fairly large numbers and for a wide range of clients,
the present example is more ambitious in both its size and
its ornamentation (Barbara Drake Boehm, "Bible," in *Mirror
of the Medieval World*, 115–16).

Several illustrious bibliophiles owned this Bible, includ-
ing perhaps the greatest of his time, Jean Budé, notary and
secretary to Louis XII (*Western Manuscripts and Miniatures*,
sale cat., Sotheby's, London, November 29, 1990, 124). Budé's
coat of arms was added beneath the Crucifixion scene in
the opening of the book of Genesis, which also features the
seven days of Creation in octofoils, the figure of a kneeling
Dominican, ivy leaf decoration, and two vignettes with
rabbits and hounds.

Hearst acquired the Bible from William Permain, a
London dealer who also acted as his private buyer in London.
Like the chalice and the covered beaker (cat. nos. 40, 41),
this manuscript was sold to the Brummer Gallery in the
years following Hearst's financial crisis. CEB

127

THE BEAUPRÉ ANTIPHONARY

Flanders, c. 1290, with later additions

Ink, paint, and gold on parchment
18¹⁵⁄₁₆ x 13⅝ in. (48.1 x 34.6 cm)
The Walters Art Museum, Baltimore; Gift of the William R.
Hearst Foundation, 1957 (inv. no. W.759–62)

Provenance: Volumes 1 and 2 made for Abbess Béatrix of Grammont and volume 3 for
contemporary prioress at Cistercian abbey of Saint Mary of Beaupré at Grimminge,
near Geeraardsbergen (Grammont), Belgium, until the French Revolution (abbey sold
1797); John Ruskin (d. 1900), England, c. 1850/53–1900; Arthur Severn (cousin of John
Ruskin) and Mrs. Severn, England, 1902 and 1904; Henry Yates Thompson, London,
1902 and 1904; his sale, Sotheby's, London, June 22, 1921, lot 67; sold to Bernard
Quaritch, London, 1921, for Sir Alfred Chester Beatty; Sir Alfred Chester Beatty, London,
1921–32; his sale, Sotheby's, London, June 7, 1932, lot 15; Spanish Art Gallery, London;
William Randolph Hearst, New York and San Simeon, California, until 1951; Hearst
Foundation, 1951–57; acquired by the Walters Art Gallery, Baltimore, 1957.

126

Exhibitions: *Exhibition of Illuminated Manuscripts*, Burlington Fine Arts Club, London, 1908, nos. 61, 62, pl. 54; *Treasures from Medieval France*, Cleveland Museum of Art, 1967, no. V2; *Die Kuenringer: Das Werden des Landes Niederösterreich*, Stift Zwettl, Zwettl, Austria, 1981, no. 465, fig. 31. (See Randall, *Medieval and Renaissance Manuscripts*, for complete bibliography and exhibition history.)

Bibliography: Lilian M. C. Randall, *Medieval and Renaissance Manuscripts in the Walters Art Gallery* (Baltimore and London: Johns Hopkins University Press, 1997), 26–56, and previous literature.

Containing the sung portions of the Divine Office, a cycle of prayers intoned at regular intervals during the day, this volume from an antiphonary is part of two three-volume sets created for the Abbey of Saint Mary of Beaupré. Including both movable and fixed feasts, the manuscript is embellished with eighteen exquisitely decorated historiated initials from Easter to the Assumption of the Virgin (August 15). The first depicts two scenes for Easter in an initial *A*. Jesus, rising from his tomb and flanked by censing angels, is presented in the lower portion of the letter, while the three Holy Women at Jesus' empty tomb, also flanked by angels, are rendered above. Donor figures, identified by inscriptions as members of the de Viane family, associate these rare volumes with the Convent of Saint Mary of Beaupré. Additionally, the third volume of the set contains a rare image of the scribe, Johannes, indicated by an accompanying inscription.

127

Currently bound in four volumes, which include additions from the fifteenth to the seventeenth centuries, the surviving set contains volumes from two sets made for the convent (Randall, *Medieval and Renaissance Manuscripts*, 54). The six volumes apparently became mismatched by the middle of the nineteenth century, when John Ruskin acquired the present set, while the other volumes were almost completely destroyed by fire at Sotheby's in London in 1865 (ibid.). In addition, it is mentioned in his diary in late 1853 and early 1854 that Ruskin removed a number of leaves from the set, which are now dispersed.[1] The large scale of the volumes, their lavishly illuminated pages, and their extraordinary history must have appealed to Hearst, who owned a number of medieval manuscripts. While some were sold at Gimbels in 1941 to alleviate financial hardship, this set reportedly remained in a vault at his magnificent residence at San Simeon until after his death. CEB

Notes
1. Dorothy F. Miner, "Since de Ricci: Western Illuminated Manuscripts Acquired since 1934: A Report in Two Parts," pt. 2, *Journal of the Walters Art Gallery* 31–32 (1968–69): 67.

128

Donato d'Arezzo (Italian, active 1315–c. 1340) and
Gregorio d'Arezzo (Italian, active 1315–c. 1340)
SAINT CATHERINE OF ALEXANDRIA AND TWELVE SCENES
FROM HER LIFE, c. 1330

Tempera and gold leaf on panel
39 3/8 x 71 1/8 x 4 in. (113.3 x 180.7 x 10.2 cm)
The J. Paul Getty Museum, Los Angeles (inv. no. 73.PB.69)
Page 126

Provenance: Possibly Galgano Saracini, Siena, by 1824; possibly by descent to Alessandro Saracini, Siena, by 1824; possibly by descent to Fabio di Carlo Corradino Chigi, Siena, by 1877; possibly by descent to Guido Chigi-Saracini, Siena, by 1906; sold to Luigi Grassi I, by 1923; sold to Wildenstein & Co. and André Seligmann, 1923; Achillito Chiesa, Milan; William Randolph Hearst, New York, by 1931; his sale, Gimbels, New York, May 1, 1941; sold to La Passe, Ltd. (Nicolas de Koenigsberg), Buenos Aires and New York; by descent to Paula Ch. de Koenigsberg, Buenos Aires, 1945; Luigi Grassi II, Florence, by 1970; acquired by the J. Paul Getty Museum, 1973.

Exhibitions: *Mostra Giottesca*, Palazzo degli Uffizi, Florence, 1937, no. 124; *Masterpieces of Art, 1939*, New York, 1940, no. 245; *Art Objects and Furnishings from the William Randolph Hearst Collection*, Hammer Galleries, New York, 1941, no. 1444-13; *Holy Image, Hallowed Ground: Icons from Sinai*, J. Paul Getty Museum, Los Angeles, 2006, no. 60.

Bibliography: Richard Offner, *The Fourteenth Century*, A Critical and Historical Corpus of Florentine Painting, sec. 3, vol. 1, by Richard Offner with Klara Steinweg, continued under the direction of Miklos Boskovits and Mina Gregori (Florence: Giunti Barbera, 1986), 9–10, 24, 28, 202–9.

The scant documentation regarding Saint Catherine of Alexandria casts doubt on whether the virgin-martyr ever existed, but her devotion was widespread in the Middle Ages and was celebrated with particular intensity in central Italy. The scenes surrounding the saint in this painting encapsulate the early trecento understanding of her story. At left, Catherine and her mother visit a hermit, who gives her a painting of the Virgin and Child, emphasizing the importance of religious images. Subsequent scenes depict Catherine's vision of the Virgin and Child, her baptism, her mystical marriage to Christ, her debate with pagan scholars in Rome, and the martyrdom of these scholars. Scenes at right show her jailing by the Roman emperor, the empress's conversion, Catherine's vision of Christ in prison, the miraculous destruction of the spiked wheel upon which she was to be killed, the martyrdom of soldiers she converted, and her beheading.

This painting is a dossal, a panel that stood on an altar, visible to the congregation while the priest celebrated Mass before them. Richard Offner, a noted expert on gold-ground paintings, asked Hearst to lend this altarpiece to the ambitious exhibition of paintings by Giotto and his contemporaries that took place in the difficult year of 1937. The painting was closely associated with Giotto when Hearst bought it.

JLS

129

Lorenzo Lotto (Italian, c. 1480–1556)
MADONNA AND CHILD WITH TWO DONORS, c. 1530–35

Oil on canvas
33 ¾ x 45 ½ in. (85.7 x 115.6 cm)
The J. Paul Getty Museum, Los Angeles (inv. no. 77.PA.110)
Page 15

Provenance: Possibly Paolo del Sera, Florence, by 1660; possibly sold to Cardinal Giovanni Carlo de' Medici, Florence, by 1663; Rospigliosi family, Rome, possibly by 1856; Robert Henry Benson and Evelyn Holford Benson, London and Buckhurst Park, Sussex, by 1905; sold to Duveen Brothers, London and New York, 1927; sold to William Randolph Hearst, New York, 1929; transferred to the Hearst Foundation, after 1941; sold to La Passe, Ltd. (Nicolas de Koenigsberg), Buenos Aires and New York, 1944; by descent to Paula Ch. de Koenigsberg, Buenos Aires, 1945; F. C. Stoop, Zurich; private collection; his or her sale, Christie's, London, December 2, 1977, lot 55; acquired by the J. Paul Getty Museum, 1977.

Exhibitions: Burlington Fine Arts Club, London, 1905; Burlington Fine Arts Club, London, 1914; *Loan Exhibition of the Benson Collection*, City of Manchester Art Galleries, Manchester, England, 1927, no. 51; *Art Objects and Furnishings from the William Randolph Hearst Collection*, Hammer Galleries, New York, 1941, no. 51-1; *The Golden Century of Venetian Painting*, Los Angeles County Museum of Art, 1979, no. 17; *The Age of Caravaggio*, Metropolitan Museum of Art, New York, and Museo Nazionale di Capodimonte, Naples, 1985, no. 6.

Bibliography: Peter Humphrey, *Lorenzo Lotto* (New Haven: Yale University Press, 1997), 131–32, 173n19.

The Madonna sits before a sumptuous green curtain, while the Christ child gestures at a pair of donors kneeling before them. An expansive landscape extends above the couple, seen through an open window, with reclining pastoral figures barely visible in the middle distance, and fig leaves—symbol of the Resurrection—dangle just outside the jamb.

The elongated figures and simple composition suggest that Lotto created this picture in the 1530s, when he was working in Venice. The presence of the donors, however, strongly suggests that he executed the painting for patrons in the Marches, who, in sharp contrast with Venetians, often asked to be included in domestically scaled religious pictures. Unusually for the artist, Lotto has adapted the Madonna and Child wholesale from a composition by Vincenzo Catena, *The Holy Family with Saint Anne* (present location unknown), a work Lotto may have had in his possession after settling the elder painter's estate in 1531. The veristic treatment of light and texture and the close connection of the figures place the human and divine in a convincing, unified space while subtly reinforcing the distinction between the spiritual and tangible worlds.

The Benson collection was one of the most prestigious of its time, and this provenance must have enhanced the painting's merit in Hearst's eyes.

JLS

130

Attributed to Robert Peake (English, c. 1551–1619)
PORTRAIT OF A WOMAN, POSSIBLY FRANCES COTTON OF BOUGHTON CASTLE, NORTHAMPTONSHIRE, c. 1605–15

Oil on canvas
29 ⅞ x 23 ⅛ in. (75.9 x 58.7 cm)
Yale Center for British Art, Paul Mellon Collection
(inv. no. B1974.3.31)
Page 97

Provenance: Wroxton Abbey, by descent through the Montagu family to the Lords North; North sale, Christie's, July 11, 1930; William Permain; E. H. Tipping; possibly sold May 24, 1933; William Randolph Hearst; [Mallett on approval, sold Sabin(?), 1956]; lent anonymously to Tate Gallery, 1970–72; Leggatt Brothers; Mr. and Mrs. Paul Mellon, March 1973; presented to Yale University Art Gallery, 1974.

The inscription reads, "Eliz[abeth], wife of Edw[ard] L[or]d Montagu of Boughton / Da[ughte]r of Sir John Jeffery / L[or]d Cheif [*sic*] Baron of the Exchequer." Edward Montagu (1562–1644) married Elizabeth Jeffery (c. 1568–1611) on September 21, 1585. After her death in 1611, he married Frances Cotton (c. 1564–1620). The sitter is currently identified as Frances Cotton despite the inscription, which, according

to Cassandra Albinson, appears to be in a later hand. The two women were born about the same time. The style of the costume suggests a date from about 1605 to almost 1615 at the latest. This may be either the deceased Elizabeth or a marriage portrait of Frances. The format recalls the oval miniatures popular in the Elizabethan period; it was already cut down to its present size when Hearst owned it.

The bewitching expression of the sitter and the red drapery play off against the combination of whites, bluish grays, and black diamonds that are at one with the icy character of English portraiture in its most mannered late phase. The styles of Robert Peake and Marcus Gheeraerts the Younger (to whom the painting was once attributed) inspired this beautiful image. MLL

131

Paul Vredeman de Vries (Flemish, 1567–after 1630)
INTERIOR OF A GOTHIC CHURCH, 1612

Oil on panel
31½ x 39 in. (61 x 78.7 cm)
Dated and inscribed on the tomb on the lower right:
1612 / PA[V?] VR.VRYS
Los Angeles County Museum of Art, Gift of William Randolph Hearst (inv. no. 49.17.5)
Pages 2–3

Provenance: S. Gist, London; Christie's, London, December 3, 1904, lot 16; Mrs. Lazarus, London; G. Ansley, London; sold, Christie's, London, May 28, 1948, lot 170, to Mallett for William Randolph Hearst; presented to the Los Angeles County Museum, 1949.

Exhibitions: *Dutch and Flemish Paintings of the Northern Renaissance*, La Jolla Museum of Art, La Jolla, California, 1964, no. 18 (as Pieter Neefs the Elder [*sic*]).

Inexplicably attributed at the time of its acquisition to Peeter Neeffs the Elder (c. 1578–1656) in spite of its prominent signature, this interior of a cathedral is by Paul Vredeman de Vries, an artist who—like his father, Hans—specialized in painting fanciful architectural subjects. Paul's most famous works are large compositions probably commissioned by Rudolf II in Prague, where Hans and Paul worked in 1596 (Vienna, Kunsthistorisches Museum). The Los Angeles panel, unlike the Vienna pictures, does not combine Italianate and Gothic motifs but represents instead the interior of a Gothic church loosely reminiscent of the Antwerp Cathedral.

It is likely that the figures were executed by another painter, a practice common to artists such as Vredeman de Vries, who specialized in the depiction of buildings. The

figures in many of his paintings were the work of Dirk de Quade van Ravesteyn (active c. 1576–1612).

To judge from the close timing of his purchase and donation of this painting, Hearst apparently bought it for the museum, not for himself, just as he did *Achilles Discovered among the Daughters of Lycomedes* by Jean Lemaire (inv. no. 49.17.16) and *Supper at Emmaus* by Filippo Tarchiani (inv. no. 49.17.13). *Interior of a Gothic Church* is included here as an example of Hearst's acquisitions on behalf of the Los Angeles County Museum. JPM

132

Anthony van Dyck (Flemish, 1599–1641)
PORTRAIT OF QUEEN HENRIETTA MARIA WITH SIR JEFFREY HUDSON, 1633

Oil on canvas
86¼ x 53 1/16 in. (219.1 x 134.8 cm)
National Gallery of Art, Samuel H. Kress Collection (inv. no. 1952.5.39)
Page 21

Provenance: Richard Newport, second Earl of Bradford; by descent to Henry Newport, third Earl of Bradford (1683–1734); thence by descent to Charles Henry Coote, seventh and last earl of Mountrath (d. 1802); Joseph Damer, first earl of Dorchester (d. 1798); by descent to Henry John Reuben Dawson-Damer, third earl of Portarlington (1822–1889); by exchange to Thomas George Baring, first earl of Northbrook (1826–1904), 1881; by inheritance to his son, Francis George Baring, first earl of Northbrook (1850–1929); sold to Duveen Brothers, London and New York, March 1927; sold to William Randolph Hearst, by 1929; consigned to M. Knoedler & Co., New York, 1938; returned to Hearst, 1939; his sale, Gimbels and Saks Fifth Avenue by Hammer Galleries, New York, 1941; consigned by Hearst Corporation to M. Knoedler & Co., New York, 1952; sold to the Samuel H. Kress Foundation, New York, September 1952; presented to the National Gallery of Art, 1952 (for complete provenance, see Wheelock, *Flemish Paintings*, or the National Gallery of Art Web site).

Exhibitions: *Anthony van Dyck*, National Gallery of Art, Washington, D.C., 1990, no. 67; *Van Dyck, 1599–1641*, Koninklijke Museum voor Schone Kunsten, Antwerp, and Royal Academy of Arts, London, 1999, no. 67; *Velázquez, Rubens y van Dyck: Pintores cortesanos del siglo XVII*, Museo Nacional del Prado, Madrid, 1999–2000, no. 10; *Great British Paintings from American Collections: Holbein to Hockney*, Yale Center for British Art, New Haven, and Huntington Library, Art Collections, and Botanical Gardens, San Marino, California, 2001–2, no. 3.

Bibliography: Susan J. Barnes, *Van Dyck: A Complete Catalogue of the Paintings* (New Haven: Published for the Paul Mellon Centre for Studies in British Art by Yale University Press, 2004), no. IV.119; Arthur K. Wheelock Jr., *Flemish Paintings of the Seventeenth Century* (Washington, D.C.: National Gallery of Art, 2005), 84–90.

Daughter of King Henri IV of France and Marie de Médicis, Henrietta Maria (1609–1669) wed Charles I of England in 1625 after his negotiations for the hand of the Infanta of Spain dissolved. Van Dyck painted this portrait of her a year after he arrived in England for the second time: in 1627 he had failed to secure any significant patronage there. Now triumphant, he was named the king's painter in 1633.

The queen was "a brave lady," according to contemporary sources.[1] Here she wears a costume with distinct masculine overtones: the dark, high-necked jacket with its lace collar is at once differentiated from the pale, low-necked gowns seen in other paintings of the queen (e.g., Windsor Castle, Dresden, and numerous miniatures). The extravagant black hat adds to the spirited character of the portrait by emphasizing a reference to costume appropriate for the outdoors. Van Dyck's genius for rendering fabric is deployed to brilliant effect here. In a breathtaking play of color and light worthy of the Venetian paintings that the artist saw in the early 1620s, the opalescent tones of the queen's complexion are enhanced by the shimmering lavender highlights of her deep blue gown. This was by far Hearst's greatest painting, and it is one of the most significant British portraits in the United States. MLL

Notes

1. Millia Davenport, *The Book of Costume* (New York: Crown Publishers, 1976), 574.

133

Attributed to Govaert Flinck (Dutch, 1615–1660)

PORTRAIT OF A BEARDED MAN, c. 1645–50

Oil on panel

25 ½ x 19 in. (63.5 x 48.2 cm) (oval)

Los Angeles County Museum of Art, Gift of Hearst Magazines (inv. no. 47.29.12)

Provenance: Jan Ingels, Amsterdam, 1654(?); Hyacinthe Rigaud, Paris, 1703(?); Lord Palmerston, London(?); W. Cowper Temple, Broadlands, prior to 1876; Charles Sedelmeyer, Paris; Charles Stewart Smith, before 1893–after 1916; Kleinberger, New York, 1923; William Randolph Hearst, before 1931; given to Marion Davies, Los Angeles, before 1944; acquired by the Los Angeles County Museum with funds provided by Hearst Magazines, Inc., 1947.

Exhibitions: Royal Academy, London, 1876, no. 239 (as Rembrandt); *A Loan Exhibition of Paintings by Old Dutch Masters in Connection with the Hudson-Fulton Celebration*, Metropolitan Museum of Art, New York, 1909, no. 80; *The Balch Collection and Old Masters from Los Angeles Collections*, Los Angeles County Museum, 1944, no. 40; *Loan Exhibition of Paintings by Frans Hals and Rembrandt*, Los Angeles County Museum, 1947, no. VIII (as Rembrandt); *Dutch and Flemish Paintings of the Northern Renaissance*, La Jolla Museum of Art, La Jolla, California, 1964, no. 24 (as Rembrandt).

Bibliography: Wilhelm von Bode, *The Complete Work of Rembrandt* (Paris: Charles Sedelmeyer, 1897–1906), vol. 1, no. 65, and vol. 2, no. 134; C. Hofstede de Groot, *A Catalogue Raisonné of the Works of the Most Eminent Dutch Painters of the Seventeenth Century* (London: Macmillan, 1908–28), vol. 6, no. 171; H. Gerson, *Rembrandt: Paintings* (Amsterdam: Meulenhoff International, 1968), no. 102.

A recent restoration of this painting has made barely legible the fake but old Rembrandt signature and date, and has eliminated the later addition of a cross to the right. Taking these later additions as original, most scholars until recently accepted this work as Rembrandt's and have described it

as a picture of John the Baptist. It is in fact a study of an unknown man by a follower of Rembrandt, most likely Govaert Flinck. The attribution to Flinck was suggested by John Walsh in 1981 and later by Arthur Wheelock and Ernst van de Wetering (information in LACMA curatorial files). This attribution was also cautiously endorsed by the Rembrandt Research Project (but with a date in the mid-1630s). It was more firmly embraced by J. W. von Moltke, author of a monograph on the artist, who suggested a date in the early 1650s.

The painting appears to have belonged to Hyacinthe Rigaud, the noted French portraitist. Dutch paintings of this type became increasingly popular among eighteenth-century French collectors and were much admired by artists like Fragonard, whose own "figures de fantaisie" show a clear debt to such expressive heads. JPM

133

134

Jan van de Velde III (Dutch, 1620–1662)
STILL LIFE WITH GLASS, c. 1650

Oil on panel
27 x 23 in. (68.6 x 58.4 cm)
Hearst Castle/California State Parks (inv. no. 529-9-6158)
Page 61

Provenance: Hendrik Willem Mesdag, The Hague; his sale, American Art Association, New York, March 8, 1920, lot 351; sold to William Randolph Hearst.

Bibliography: Burton B. Fredericksen, *Handbook of the Paintings in the Hearst San Simeon State Historical Monument* (n.p.: Delphinian Publications in cooperation with the California Department of Parks and Recreation, 1977), no. 84.

A peeled lemon, two partly dismembered crabs, a half walnut, a split pomegranate, a paper of tobacco, and a glass of frothing beer demonstrate the painter's virtuosity in depicting a variety of textures. As subjects in a still life, they—along with the accoutrements of eating, drinking, and smoking— serve to symbolize the transience of life.

Jan van de Velde was active in Haarlem, and he specialized in such small table scenes featuring food, drink, and associated vessels. The long clay pipe, the metal dish, and the tall goblet, or Passglas, which was used for drinking games, also appear in other still-life compositions by him, for example, the Ashmolean Museum's 1653 *Still Life with a Pipe Lighter*. This painting is located in the Doge's Suite of Casa Grande, where favored guests were housed in Hearst's era. What makes it particularly notable is that it has the distinction of being the only still life at San Simeon. JS

135

Claudio Coello (Spanish, 1642–1693)
VIRGIN APPEARING TO SAINT JAMES, 1677

Oil on canvas
76½ x 58¼ in. (194.3 x 148 cm)
Hearst Castle/California State Parks (inv. no. 529-9-6552)
Page 32

Provenance: Phoebe Apperson Hearst; by descent to William Randolph Hearst, prior to 1920.

Bibliography: Nina Ayala Mallory, *El Greco to Murillo: Spanish Painting in the Golden Age, 1556–1700* (New York: Harper Collins/Icon Editions, 1990), 287; Edward J. Sullivan, *Baroque Painting in Madrid: The Contribution of Claudio Coello, with a Catalogue Raisonné of His Works* (Columbia: University of Missouri Press, 1986), no. P62; Edward J. Sullivan and Nina A. Mallory, *Painting in Spain, 1650–1700, from North American Collections* (Princeton: Princeton University Press, 1982), 165.

Captured in a baroque maelstrom of turbulent clouds, agitated drapery, and expansive gesture, Saint James the Greater gazes up at the Virgin Mary. The tall staff in the saint's hand identifies him as a pilgrim, as does the cloak he wears and the scallop shells, one of which rests below his throat, with the other just visible on the hat that lies at the column's base; for centuries, pilgrims to his shrine at Santiago de Compostela have emulated this mode of dress.

The story depicted here is not related in the Bible but rather relies on folk tradition: Saint James, disheartened by his failure to spread Christianity through Spain, is miraculously visited at Zaragoza by the Virgin, who encourages him from atop a pillar.

Coello's reputation has long been overshadowed by the fame of his predecessor Diego Velázquez, but before the arrival of Luca Giordano in 1692, he was the foremost painter in Madrid during the reign of Charles II. JS

136

François Boucher (French, 1703–1770)
VENUS AND MERCURY INSTRUCTING CUPID, 1738

Oil on canvas
27½ x 60 in. (69.9 x 152.4 cm)
Inscribed at center, on scroll: *f. Boucher / 1738*
Los Angeles County Museum of Art, Gift of Hearst Magazines (inv. no. 47.29.10)
Page 86

137

François Boucher (French, 1703–1770)
CUPID WOUNDING PSYCHE, 1741

Oil on canvas
27 x 60 in. (68.6 x 152.4 cm)
Signed and dated: *F. Boucher 1741*
Los Angeles County Museum of Art, Gift of Hearst Magazines (inv. no. 47.29.19)
Page 87

Provenance: Françoise de Mailly, duchesse de Mazarin, Paris; Maréchal Lannes, duc de Montebello (1769–1809); his widow, duchesse de Montebello (at Hôtel de Broglie); Wildenstein; William Randolph Hearst; Marion Davies; acquired by the Los Angeles County Museum with funds provided by Hearst Magazines, Inc., 1947

Exhibitions: *Francois Boucher Rediscovered: The Conservation of Three Eighteenth-Century Works from the Permanent Collection*, Los Angeles County Museum of Art, 1997–98.

Bibliography: Georges Brunel, *Boucher* (Paris: Flammarion, 1986), 101, illus. 100; Melissa Hyde, *François Boucher and His Critics* (Los Angeles: Getty Research Institute, 2006), 50, fig. 2; Elma O'Donoghue and Virginia Rasmussen, "The Treatment of Two Overdoor Paintings by François Boucher," *AIC Paintings Specialty Group Postprints* (1996): 37–53 (illus.).

The history of these paintings was established in 1997, on the occasion of their extensive conservation. Conceived as pendants, they were commissioned to decorate the Hôtel de Mazarin, on the rue de Varenne in Paris. The *hôtel* belonged to Françoise de Mailly, duchesse de Mazarin (d. 1742), who in 1736 called upon the two greatest painters of the day for its decoration: Charles-Joseph Natoire (1700–1777) and François Boucher. Still young, the two painters were working for an increasing number of clients at the time. Both artists painted episodes from the story of Psyche, a theme then in favor because it allowed erotic license. Boucher's *Venus and Mercury Instructing Cupid* illustrates a subject borrowed from the Renaissance novel *Hypnerotomachia Poliphili* (1499), while *Cupid Wounding Psyche* is based on the more commonly treated telling of the myth by Apuleius in *The Golden Ass*. The two Boucher paintings—along with two others—were to be put over doors in the house's *salon de compagnie*, a room intended for informal entertainment.

Boucher's works for the Hôtel de Mazarin were known through a series of preparatory drawings in the Nationalmuseum, Stockholm. Although the subjects of these drawings relate to the Hearst paintings, their compositions are different. The recent conservation of the paintings and their analysis under X-radiography, however, revealed under the current compositions ones identical to the Stockholm drawings.

It is unknown when or why Boucher changed his concept. Other alterations to the pictures were carried out after his death. In 1807 the Hôtel de Mazarin, then the property of the duc de Montebello, was remodeled. The Boucher paintings were moved to the nearby Hôtel de Broglie, occupied by the widowed duchesse de Montebello. Photographs of the residence taken in the early years of the twentieth century show the paintings in place but enlarged to form rectangular overdoors. It was long assumed that they had been altered more recently, presumably by a dealer who thought that a rectangular format would be more palatable to the market, but in fact the paintings were altered decades before William Randolph Hearst purchased them. JPM

138

François Boucher (French, 1703–1770)
Venus Disarming Cupid, 1751

Oil on canvas
52 x 40 in. (142 x 114 cm)
Collection of Lynda and Stewart Resnick

Provenance: Marquise de Pompadour; marquis de Ménars; his sale, Paris, March 18, 1782, no. 20; sold to Vestris ("danseur"); Duterrage sale, Paris, December 20, 1790, no. 12; Rhone collection; Earl of Pembroke; his sale, Paris, June 1862, no. 4; Choupot collection; William Randolph Hearst; private collection, France; acquired by the present owners.

Exhibitions: *Masterworks of Five Centuries*, Golden Gate International Exposition, San Francisco, 1939, no. 110; *Seven Centuries of Painting*, Palace of the Legion of Honor, San Francisco, 1939–40, no. 190; *Three Masters of French Rococo: Boucher, Fragonard, Lancret*, Odakyu Grand Gallery, Tokyo; Daimaru Museum, Umeda-Osaka; Museum of Art, Hokkaido-Hakodate; Sogo Museum of Art, Yokohama, 1990, no. 19; *The Loves of the Gods: Mythological Painting from Watteau to David*, Galeries Nationales du Grand Palais, Paris; Philadelphia Museum of Art; Kimbell Art Museum, Fort Worth, 1991–92, no. 48.

Bibliography: Alexandre Ananoff and Daniel Wildenstein, *François Boucher* (Lausanne: Bibliothèque des arts, 1976), vol. 2, no. 375; *François Boucher: His Circle and Influence* (New York: Stair Sainty Matthiesen Gallery, 1987), 49; Edmond and Jules de Goncourt, *L'art du dix-huitième siècle* (Paris: A. Quantin, 1880–82), vol. I, 188–89.

This sumptuous composition ranks among the grandest representations of Venus and Cupid by Boucher. While the early history of the painting remains unclear—neither the residence for which it was commissioned nor the exact date of the commission is known (the painting is not signed or dated)—much can be deduced, as Colin Bailey did in the catalogue of the exhibition *Loves of the Gods*, from its appearance in the inventory of the marquise de Pompadour's collection made after her death in 1764. At that time the painting was kept in a room on the ground floor of the Hôtel d'Evreux (today's Elysée Palace) along with other works brought in from various residences.[1] Bailey speculates that the picture may have been in the *chambre du roi* at Bellevue, a residence Pompadour sold to the Crown in 1757.

Notwithstanding the eroticism of its subject, Boucher delivered here an almost austere composition with little in the way of narrative elements. Devoting his full attention to the description of a beautiful female body, he used props only to enhance it. The clouds and fabrics on which Venus rests are like the linings of a jewel box, intended to highlight the luminescence of her flesh.

It is tempting to interpret the painting in light of Pompadour's own trajectory at court. If the painting was indeed commissioned in 1751 (a preparatory drawing for Venus in the Hamburg Kunsthalle bears that date), it follows

by only a few months the end of her carnal relationship with Louis XV, a fact that did not diminish her prominence and role as an art patron. Its subject—Cupid being disarmed—may indeed be an elegant illustration of her own situation. The fine striped fabric that covers Venus was sometimes associated with the image of the vestal, as noted by Colin Jones.[2] Four years before her death, for instance, Pompadour was painted as a vestal, wearing a striped veil of the same fabric.[3] Oblivious to the vestal's traditional virginity, she preferred seeing herself as a symbol of fidelity and discretion, qualities to which she credited her success with the king.

JPM

Notes

1. I am grateful to Colin Bailey, from whose entry in the above-mentioned catalogue I borrow most of the information here, for having corrected in it an error of mine published in the catalogue *Three Masters of the French Rococo*, in which I stated that the painting had been on view in the Hôtel d'Evreux.

2. Colin Jones, *Madame de Pompadour: Images of a Mistress* (London: National Gallery of Art, 2002), 75.

3. For example, in a version after François-Hubert Drouais in the David M. Stewart Museum, Montreal; see *Madame de Pompadour et la floraison des arts* (Montreal: Musée David M. Stewart, 1988), 108, no. 287.

139

Jean-Honoré Fragonard (French, 1732–1806)

WINTER, c. 1752–55

Oil on canvas

31 x 64 in. (78.7 x 162.5 cm)

Los Angeles County Museum of Art, Gift of Hearst Magazines (inv. no. 47.29.9)

Page 83

Provenance: Duc and duchesse de Galliera, Paris (by 1852); Ferrari de la Renotière, Paris; sold, June 7, 1922, no. 8; Wildenstein, 1922–26; William Randolph Hearst; Marion Davies; acquired by the Los Angeles County Museum with funds provided by Hearst Magazines, Inc., 1947.

Exhibitions: *French Taste in the Eighteenth Century*, Detroit Institute of Arts, 1956, no. 20; *Fragonard*, National Museum of Western Art, Tokyo, and Municipal Museum, Tokyo, 1980, no. 10; *Fragonard*, Galeries Nationales du Grand Palais, Paris, and Metropolitan Museum of Art, New York, 1988, no. 7; *Consuming Passion: Fragonard's Pictures of Love*, J. Paul Getty Museum, Los Angeles, 2008.

Bibliography: Jean-Pierre Cuzin, *Jean-Honoré Fragonard: Life and Work: Complete Catalogue of the Oil Paintings* (New York: Abrams, 1988), 30, 269, no. 53; Pierre Rosenberg, *Tout l'oeuvre peint de Fragonard* (Paris: Flammarion, 1989), 72–73, no. 18; Georges Wildenstein, "Quatre Fragonard inédits," *Gazette des Beaux Arts*, May 1935, 271–74, fig. 1; Georges Wildenstein, *The Paintings of Fragonard* (London: Phaidon, 1960), no. 56, fig. 40.

It has been established (*Fragonard* [1988]) that this painting, part of a set of four representing the seasons, did not belong to the original decoration of the Hôtel Matignon, where the three others still adorn the *grand salon*. The paintings were instead part of a decorative scheme put in place in 1852 by the duc de Galliera, the *hôtel*'s owner at the time. Pierre Rosenberg (*Fragonard* [1989], 50) suggested that the four paintings had been bought by Galliera but that only three fit the decorative scheme and that the fourth one, *Winter*, the least cheerful allegory, was then sold by an heir in 1922. Another reason for not retaining *Winter* was perhaps because it did not quite fit with the other seasons, all represented by young adults accompanied by children. Here Fragonard used a young girl as the protagonist. The use of children as allegorical figures had been abundantly explored by both François Boucher, Fragonard's teacher, and Carle van Loo, notably in his Allegories of the Arts (Palace of the Legion of Honor, San Francisco), painted in 1752–53 for Bellevue. That date has also traditionally been attached to the Los Angeles painting because of its obvious ties with Boucher, in whose studio Fragonard was working that year. Although Fragonard copied Boucher, his early paintings already display some of his own characteristics: even in the generic evocation of *Winter*, the composition, depiction of nature, and energetic brushstrokes are closer to Fragonard's mature work than to Boucher's style.

JPM

140

Joshua Reynolds (English, 1723–1792)

PORTRAIT OF A WOMAN, POSSIBLY ELIZABETH WARREN, 1758–59

Oil on canvas

93¾ x 58¼ in. (238.1 x 147.8 cm)

Signed and dated on the top of the pedestal: *Reynolds pin/1759*

Kimbell Art Museum, Fort Worth, Texas (inv. no. ACF 1961.02)

Page 112

Provenance: Probably Thomas James Bulkeley (later Warren-Bulkeley), seventh Viscount Bulkeley of Cashel, and Lord Bulkeley, Baron of Beaumaris, Baron Hill, Beaumaris, Anglesey, Wales; by descent to his nephew, Richard Williams-Bulkeley, tenth Baronet, Baron Hill, Beaumaris, Anglesey, Wales; by descent to his son, Richard Lewis Mostyn Williams-Bulkeley, eleventh Baronet, Baron Hill, Beaumaris, Anglesey, Wales; by descent to his son, Richard Henry Williams-Bulkeley, twelfth Baronet, Baron Hill, Beaumaris, Anglesey, Wales, and London; his sale, Christie's, London, April 28, 1922, lot 43; sold to Duveen Brothers, London and New York; sold to William Randolph Hearst, New York; his sale, Parke-Bernet, New York, January 5–7, 1939, lot 26; Newhouse Galleries, New York; acquired by the Kimbell Art Foundation, Fort Worth, 1961.

Bibliography: Algernon Graves and W. V. Cronin, *A History of the Works of Sir Joshua Reynolds* (London: H. Graves & Co., 1899–1901), vol. 3, no. W44; *Kimbell Art Museum: Catalogue of the Collection* (Fort Worth: Kimbell Art Foundation, 1972), 124–25; David Mannings, *Sir Joshua Reynolds: A Complete Catalogue of His Paintings*, 2 vols. (New Haven and London: Yale University Press for the Paul Mellon Centre for Studies in British Art, 2000), no. 1835.

Reynolds's ledger records a Miss Warren, who sat for the artist at least seven times (and possibly as many as eleven) in 1758 and five times in 1759, with final payment in 1760. Algernon Graves identified the subject of this portrait as a sister of Sir George Warren, KB, of Poynton, Cheshire, either Harriet or Elizabeth, a connection further secured by its presence in the Williams-Buckley family, along with a now-untraced portrait of George Warren's second wife, Jane. As Elizabeth Edwards has noted, the painting probably depicts Elizabeth Warren (and was possibly commissioned to celebrate her marriage) because Harriet Warren died by 1754, before the date recorded on the portrait.[1]

Painted several years after Reynolds's second trip to Italy, this work is one of the artist's earliest classicizing full-length female portraits of the 1750s and 1760s. The garments are an adaptation of current fashion intended to lend classical gravitas and elegance to the image.

JLS

Notes
1. Elizabeth Edwards, personal communication to the author, August 2007.

141

Sir Joshua Reynolds (English, 1723–1792)
PORTRAIT OF MRS. BALDWIN, 1782

Oil on canvas
54 x 43½ in. (137 x 110.5 cm)
Lent anonymously
Page 113

Provenance: The artist's posthumous sale, Greenwood's, April 14, 1796; sold to Carl F. von Breda; Mr. N. Pearce; his sale, Christie's, London, March 26, 1860; William Frederick, ninth Earl Waldegrave, until July 30, 1883, sold to Wertheimer; his sale, Christie's, London, March 9, 1892; sold to J. Wigzell; sold to Robert Hall McCormick, Chicago; his sale, New York, April 15, 1920; sold to William Randolph Hearst; his sale, New York, January 5–7, 1939; sold anonymously, New York, November 15, 1945; sold, Parke-Bernet, New York, October 14, 1948; by descent to present owners.

Bibliography: *Important British Pictures*, sale cat., Sotheby's, London, July 1, 2004, lot 8, 22–27; David Mannings, *Sir Joshua Reynolds: A Complete Catalogue of His Paintings* (London: Yale University Press, 2000), no. 101; Mannings, in *Sir Joshua Reynolds's "Portrait of Mrs Baldwin,"* sale cat., Christie's, London, November 26, 2003; "Market Preview," *Apollo* 157 (June 2004): 56.

Three versions of this composition exist, according to David Mannings (2000): one, formerly in the Lansdowne collection, was sold at Sotheby's (London) in 2004 and is now at Compton Verney. The second is the present painting, described by Mannings as an autograph version of the Lansdowne picture. A third was catalogued by Mannings as a copy. The Lansdowne version was engraved by

S. W. Reynolds, and as recorded by references in Hearst Corporation papers, it was known to Hearst.

The British sitter, Jane Maltass, was born in Smyrna in 1763; she married George Baldwin of Alexandria. She was a famous beauty who attracted the attention of Emperor Joseph I, the prince of Wales, and Reynolds himself, to judge from the fact that the two prime versions of the portrait remained in the artist's studio until his death. The sitters' book kept by Reynolds records at least eight meetings.

The sumptuous costume and embroidered shawl are combined with other references to the Near East (the cross-legged pose and sofa) in a luscious prelude to the orientalism of the next century.

MLL

142

Arthur William Devis (British, 1762–1822)
THE HON. WILLIAM MONSON AND HIS WIFE, ANNE DEBONNAIRE, WITH A SERVANT, c. 1786

Oil on canvas
40½ x 51½ in. (101.6 x 129.5 cm)
Los Angeles County Museum of Art, Gift of Hearst Magazines (inv. no. 47.29.16)
Page 81

Provenance: H. S. Keene, C.I.E. [?], England; C. J. Blampied, England; Christie's, London, December 10, 1910, lot 81; F. Sabin; Christie's, London, March 19, 1920, lot 148 (bought in); Stapleton collection(?), London; Christie's, London, March 26, 1926, lot 55 (as "a British governor with Calcutta in the distance"); Vicars Brothers, London; Leggatt Brothers, London, 1927; Ernest Permain, London, 1928; William Randolph Hearst, 1928; Marion Davies, Los Angeles; acquired by the Los Angeles County Museum with funds provided by Hearst Magazines, Inc., 1947.

Exhibitions: *English Conversation Pieces of the Eighteenth Century*, Detroit Institute of Arts, 1948, no. 19.

Bibliography: Mildred Archer, *India and British Portraiture, 1770–1825* (London: Sotheby Parke Bernet, 1979), 246, fig. 168; Beth Fowkes Tobin, "The English Garden Conversation Piece in India," in *The Global Eighteenth Century*, ed. Felicity A. Nussbaum (Baltimore: Johns Hopkins University Press, 2003), 178–79, fig. 11.6; Tobin, *Colonizing Nature: The Tropics in British Art and Letters, 1760–1820* (Philadelphia: University of Pennsylvania Press, 2005), 109–10, fig. 12.

There has been considerable confusion regarding both the authorship and the subjects of this picture, one of the finest examples of an English conversation piece set in British India. While the early twentieth-century literature correctly ascribes the painting to Arthur William Devis, the son and pupil of the noted portraitist Arthur Devis (1711–1787), it was later attributed to Tilly Kettle, the first professional artist to visit India, who remained there from 1769 to 1776. The correct identification of the sitters makes this attribution unsustainable.

Wearing the uniform of the Fifty-second Regiment of the king's army is the Honorable William Monson. Next to him, seated, is his wife, Anne Debonnaire, whom he had married on January 10, 1786. The painting was probably commissioned as a commemoration of their union. A servant in Indian costume is at their side, and in the background a building with columns and the shores of the Ganges Delta can be seen.

The confusion of William Monson with a Colonel George Monson, who died (as did his wife, also named Anne) in 1776 in Calcutta, excluded the possibility of Devis as the author of the painting, as Devis did not arrive in India until 1784. By then, less than a decade after Kettle's pioneering work on the subcontinent, India was host to a small but active group of British painters—including Thomas Hickey (1741-1824), Johann Zoffany (1733-1810), and William Hodges (1744-1797)—who all vied for a growing clientele. Official portraits were in demand, as were more informal ones and genre paintings. In 1795 Devis returned to England, where he continued painting for the next twenty-seven years.

JPM

143

Sir Thomas Lawrence (English, 1769-1830)
PORTRAIT OF ARTHUR ATHERLEY AS AN ETONIAN, c. 1791

Oil on canvas
49½ x 39½ in. (125.8 x 100.3 cm)
Los Angeles County Museum of Art, Gift of Hearst
Magazines (inv. no. 47.29.5)
Page 76

Provenance: The sitter; by descent to the Hon. Mrs. William McGowan and Mrs. Arthur Smith-Bingham (both *nées* Atherley); Pawsey and Payne; Duveen; William Randolph Hearst, 1928; Marion Davies; acquired by the Los Angeles County Museum with funds provided by Hearst Magazines, Inc., 1947.

Exhibitions: Royal Academy, London, 1792, no. 209 (as *Portrait of an Etonian*); *Sir Thomas Lawrence, Regency Painter*, Worcester Art Museum, Worcester, Massachusetts, 1960, no. 4; *Romantic Art in Britain*, Detroit Institute of Arts and Philadelphia Museum of Art, 1968, no. 104; *Great British Paintings from American Collections: Holbein to Hockney*, Yale Center for British Art, New Haven, and Huntington Library, Art Collections, and Botanical Gardens, San Marino, California, 2001-2, no. 38.

Bibliography: Marion Davies, *The Times We Had: Life with William Randolph Hearst* (Indianapolis: Bobbs-Merrill, 1975), 119-21; Kenneth Garlick, ed., *Sir Thomas Lawrence: A Complete Catalogue of the Oil Paintings* (Oxford: Phaidon, 1989), 114, no. 50; D. E. Williams, *The Life and Correspondence of Sir Thomas Lawrence* (London: H. Colburn and R. Bentley, 1831), vol. I, 128.

Exhibited in 1792 at the Royal Academy as a "portrait of an Etonian," the painting is known to be a portrait of Arthur Atherley (1772-1844). After Eton, Atherley became a banker and from 1806 until 1833 was an intermittent member of

Parliament for Southampton. It is likely that the portrait was executed on the occasion of the sitter's completion of his studies at the college. Such "leaving portraits" were traditional and usually remained at the college, but others, such as this one, may have been retained by the sitter. Lawrence may have painted the portrait in his studio from a sketch of the sitter's head (private collection, United Kingdom). A panoramic view of Eton College can be seen in the background. Young Atherley's uniform is not the school's regular uniform but instead that of captain of the Ad Montem club, an institution with roots to medieval times that survived until 1874. One of the club's traditions was to take part in a procession to Salt Hill during which boys in fancy costume, the salt bearers, participated in the maintenance of their "captain" at university by levying contributions from passersby.

Like all the great amateurs of his generation, Hearst collected British painting of the eighteenth and early nineteenth centuries. His appetite—and Marion Davies's—for such works was fed by Duveen, the most prominent purveyor of English school paintings to the American market. To Hearst and Davies, Duveen sold more than twenty paintings, including works by Sir Joshua Reynolds (*Mrs. Sheridan as Saint Cecilia*, Los Angeles County Museum of Art), John Hoppner, William Hogarth, and George Romney. JPM

Acts of the Tapestry Symposium, November 1976. San Francisco: Fine Arts Museums of San Francisco, 1979.

Adelson, Candace. *European Tapestry in the Minneapolis Institute of Arts.* Minneapolis: Minneapolis Institute of Arts, 1994.

Adelson, Candace, and Sheila Ffolliott. *Images of a Queen's Power: The Artemisia Tapestries.* Exhibition catalogue. Minneapolis: Minneapolis Institute of Arts, 1993.

Aidala, Thomas R. *Hearst Castle, San Simeon.* New York: Hudson Hills Press, 1981.

Alpern, Andrew. *Luxury Apartment Houses of Manhattan.* New York: Dover, 1992.

"The Art of the Past." *Burlington Magazine* 107 (June 1965): 337-38.

The Arts of France: From François Ier to Napoléon Ier. Exhibition catalogue. Directed by Guy Wildenstein; text by Joseph Baillio. New York: Wildenstein, 2005.

Barghini, Sandra. "Spanish Collections at Hearst Castle." Lecture delivered at Los Angeles County Museum of Art, 1994.

Beard, Charles R. "Armours from St. Donat's Castle, Part I." *Connoisseur,* January 1939, 3-9.

———. "Helmets at St. Donat's Castle." *Connoisseur,* March 1939, 129-35, 177.

———. "Horse-Armour at St. Donat's Castle." *Connoisseur,* February 1940, 62-68.

———. "Silver from St. Donat's Castle." *Connoisseur,* December 1938, 288-95.

Beazley, J. D. "Citharoedus." *Journal of Hellenic Studies* 42, no. 1 (1922): 70-98.

Behrman, Samuel N. *Duveen.* Boston: Little, Brown, 1972.

Bell, Evelyn. "Attic Black-Figured Vases at the Hearst Monument, San Simeon." PhD diss., University of California, Berkeley, 1977.

Bennett, Anna. *Five Centuries of Tapestry from the Fine Arts Museums of San Francisco.* San Francisco: Fine Arts Museums of San Francisco/Chronicle Books, 1992.

Bimbenet-Privat, Michèle. "L'orfèvrerie de François Ier." *Bulletin de la Société de l'histoire de l'art français,* 1995, 41-67.

———, ed. *L'orfèvrerie parisienne de la Renaissance.* Exhibition catalogue. Paris: Centre culturel du Panthéon, 1995.

Blades, John M., and John Loring. *Tiffany at the World's Columbian Exposition.* Exhibition catalogue. Palm Beach, Fla.: Henry Morrison Flagler Museum, 2006.

Blomberg, Nancy. *Navajo Textiles: The William Randolph Hearst Collection.* Tucson: University of Arizona Press, 1988.

Blunk, Robert. "Remarks on Wyntoon." Lecture delivered at Library Associates Annual Banquet, California Polytechnic State University, San Luis Obispo, January 11, 1991.

Bothmer, Dietrich von. "Bronze Hydriai." *Metropolitan Museum of Art Bulletin,* n.s., 13 (February 1955): 193-200.

———. "Greek Vases from the Hearst Collection." *Metropolitan Museum of Art Bulletin,* n.s., 15 (March 1957): 165-80.

———. *Wealth of the Ancient World.* Exhibition catalogue. Fort Worth: Kimbell Art Museum, 1983.

Bott, Katharina. "Un illustre viaggiatore e collezionista a Roma: Franz Erwein von Schönborn." In *Bertel Thorvaldsen, 1770-1844: Scultore danese a Roma,* edited by Elena di Majo, Bjarne Jørnaes, and Stefano Susinno, 97-103. Exhibition catalogue, Galleria Nazionale d'Arte Moderna. Rome: De Luca, 1989.

Bourne, Jonathan, and Vanessa Brett. *Lighting in the Domestic Interior.* London: Sotheby's, 1991.

Boutelle, Sara H. *Julia Morgan, Architect.* New York: Abbeville, 1995.

Bremer-David, Charissa. "French & Company and American Collections of Tapestries, 1907-1959." *Studies in the Decorative Arts* 11 (Fall-Winter 2003-4): 38-68.

Brimo, René. *L'évolution du goût aux États-Unis.* Paris: James Fortune, 1938.

Cahn, Walter. "Romanesque Sculpture in American Collections, XIV: The South." *Gesta* 14, no. 2 (1975): 75-77.

Carter, Randolph, and Robert Reed Cole. *Joseph Urban: Architecture, Theater, Opera, Film.* New York: Abbeville Press, 1992.

Caruso, Carlo, and Katherine Hahn. "The Third Version of Canova's 'Venus.'" *Burlington Magazine* 135 (December 1993): 828.

Chafee, Richard. "Mrs. O. H. P. Belmont Residence." In *Long Island Country Houses and Their Architects, 1860-1940,* edited by Robert E. Mackay, Anthony K. Baker, and Carol A. Traynor, 231-32. New York: Society for the Preservation of Long Island Antiquities in association with W. W. Norton, 1997.

Coffman, Taylor. *Hearst as Collector: The First Fifty Years, 1873-1923.* Summerland, Calif.: Coastal Heritage Press, 2003.

Darr, Alan Phipps, and Tracey Albainy. *Woven Splendor: Five Centuries of European Tapestry in the Detroit Institute of Arts.* Detroit: Detroit Institute of Arts, 1996.

Davies, Marion. *The Times We Had: Life with William Randolph Hearst.* New York and Indianapolis: Bobbs-Merrill, 1975.

Davis, Frank. "Masterpieces of Furniture from St. Donat's Castle." *Connoisseur,* December 1938, 296-302.

Davis, John D. *English Silver at Williamsburg.* Williamsburg, Va.: Colonial Williamsburg Foundation, 1976.

"Distinctive Phases of the Chimney-Piece." *International Studio* 94 (October 1929): 51-55.

Dufty, A. R., and A. N. Kennard. "Arms and Armour from the Hearst Collection Acquired for the Tower of London Armouries." *Connoisseur,* April 1953, 23-27, 30.

Dunlop, Beth. "Interview: Timothy F. Rub on the Work of Joseph Urban." *Journal of Decorative and Propaganda Arts* 8 (Spring 1988): 104-19.

"Early Flemish Tapestries in the Collection of William Randolph Hearst...Based on an Analysis by Dr. Phyllis Ackerman." *Connoisseur,* June 1940, 187-94, 210.

Edwards, Anne. "Marion Davies' Ocean House." *Architectural Digest,* April 1994, 170-75, 277.

Egyptian, Greek, and Roman Antiquities,... Italian and French Furniture and Decorations. Sale catalogue. Sotheby Parke Bernet, New York, December 13-14, 1949.

Emery, Edwin. "William Randolph Hearst: A Tentative Appraisal." *Journalism Quarterly* 28 (Fall 1951): 429-40.

"English Panelled Rooms in America." *International Studio* 93 (June 1929): 46-51.

Forsyth, William H. "A Spanish Mediaeval Relief of the Miracle of the Palm Tree." *Metropolitan Museum of Art Bulletin* 34 (August 1939): 197-200.

Frankfurter, Alfred M. "Grandeur and Double Exit: Hearst and Barnes." *Art News* 50 (October 1951): 13.

Fredericksen, Burton. *Handbook of the Paintings in the Hearst San Simeon State Historical Monument.* N.p.: Delphinian Publications in cooperation with the California Department of Parks and Recreation, 1977.

Gallagher, Brian. "William Randolph Hearst and the Detroit Institute of Arts." *Bulletin of the Detroit Institute of Arts* 78, nos. 1-2 (2004): 53-65.

Galvin, Carol, and Phillip Lindley. "Pietro Torrigiano's Portrait Bust of King Henry VII." *Burlington Magazine* 130 (December 1988): 892-902.

Gothic and Renaissance Art in Nuremberg, 1300-1550. Exhibition catalogue. Munich: Prestel; New York: Metropolitan Museum of Art, 1986.

Grancsay, Stephen. "Armor with Etching Attributed to Daniel Hopfer." *Metropolitan Museum of Art Bulletin* 34 (August 1939): 189-92.

Gray, Christopher. "Hearst's Opulent Quintuplex." *New York Times*, May 1, 1994.

Guiles, Fred. *Marion Davies*. New York: McGraw-Hill, 1972.

Hackenbroch, Yvonne. *Bronzes, Other Metalwork, and Sculpture in the Irwin Untermyer Collection.* New York: Metropolitan Museum of Art, 1962.

———. *English and Other Silver in the Irwin Untermyer Collection.* London: Thames & Hudson, 1969.

Hall, Alan. *St Donat's Castle: A Guide and Brief History.* N.p.: Atlantic College, 2002.

Harris, John. "How Citizen Kane Bought Up Britain." *Country Life*, June 14, 2007, 118-21.

Hartmann, Jörgen B. "Canova e Thorvaldsen." *Colloqui del Sodalizio* 2 (1951-52/1953-54 [published 1956]): 71-89.

Hawes, Elizabeth. *New York, New York: How the Apartment House Transformed the Life of the City (1869-1930).* New York: Knopf, 1993.

Hayward, Jane. "Stained-Glass Windows from the Carmelite Church at Boppard-am-Rhein." *Metropolitan Museum of Art Journal* 2 (1969): 75-114.

Hayward, J. F. *Virtuoso Goldsmiths, 1540-1620.* New York: Rizzoli International; London: Sotheby Parke Bernet, 1976.

Head, Alice. *It Could Never Have Happened.* London: William Heinemann, 1939.

"Hearst." *Fortune*, October 1935, 42-55, 121-24, 152-58.

"Hearst." *Time*, May 1, 1933, 19-22.

"Hearst at Home." *Fortune*, May 1, 1931, 56-68, 130.

"Hearst Journalism." *Life*, August 27, 1951, 22-31.

Hearst, William Randolph. *Selections from the Writings and Speeches of William Randolph Hearst.* Edited by E. F. Tompkins. San Francisco: San Francisco Examiner, 1948.

Hearst, William Randolph, Jr., with Jack Casserly. *The Hearsts: Father and Son.* Niwot, Colo.: Roberts Rinehart, 1991.

Hellman, Geoffrey. "Monastery for Sale." *New Yorker*, February 1, 1941, 29-35.

Henderson, Rose. "Murals of Fairy Tales." *International Studio* 82 (October 1925): 61-66.

Hoentschel, Nicole. *Georges Hoentschel*. Saint-Rémy-en-l'Eau: Éditions Monelle Hayot, 1999.

Husband, Timothy. "Valencian Lusterware of the Fifteenth Century: Notes and Documents." *Metropolitan Museum of Art Bulletin*, n.s., 29 (Summer 1970): 11-19.

Jenkins, Ian. "Adam Buck and the Vogue for Greek Vases." *Burlington Magazine* 130 (June 1988): 448-57.

Jones, E. Alfred. "Some Early English Silver Drinking Vessels in the Collection of William Randolph Hearst." *Connoisseur*, December 1929, 345-54.

———. "Some Old English Silver in the Collection of Mr. William Randolph Hearst." *Connoisseur*, April 1930, 207-13.

———. "Some Old Foreign Silver in the Collection of Mr. William Randolph Hearst." *Connoisseur*, October 1930, 220-25.

Jones, Howard C. "W. R. Hearst and St. Donat's." In *The Story of St. Donat's Castle and Atlantic College*, edited by Roy Denning, 69-83. Cambridge, U.K.: D. Brown & Sons, 1983.

Kastner, Victoria. *Hearst Castle: The Biography of a Country House.* New York: Harry N. Abrams, 2000.

Künstlerleben in Rom: Bertel Thorvaldsen (1770-1844), der dänische Bildhauer und seine deutschen Freunde. Exhibition catalogue. Nuremberg: Verlag des Germanisches Nationalmuseum, 1992.

LaRocca, Donald J. "Carl Otto Kretzschmar von Kienbusch and the Collecting of Arms and Armor in America." *Philadelphia Museum of Art Bulletin* 81 (Winter 1985): 4-24.

Levkoff, Mary. "L'art cérémonial de l'Ordre du Saint-Esprit sous Henri III." *Bulletin de la Société de l'histoire de l'art français*, 1989, 7-23.

———. "A Brief History of the Museum and the Formation of Its Collection of European Art" [unsigned essay]. In *Los Angeles County Museum of Art: European Art*, by J.-Patrice Marandel, Claudia Einecke, et al. Paris: Fondation BNP Paribas/RMN; Los Angeles: Los Angeles County Museum of Art, 2006.

———. "Hearst and the Antique." *Apollo* 161 (forthcoming).

———. "The Little-Known American Provenance of Some Well-Known European Sculptures." In *La sculpture en occident: Études offertes a Jean-René Gaborit*, edited by G. Bresc-Bautier, 294-305. Dijon: Éditions Faton, 2007.

———. "William Randolph Hearst's Gifts of European Sculptures to the Los Angeles County Museum of Art." *Sculpture Journal* 4 (2000): 160-71.

Loe, Nancy. *Hearst Castle: An Interpretive History of W. R. Hearst's San Simeon Estate.* Santa Barbara, Calif.: Companion Press, 1994.

———. *William Randolph Hearst: An Illustrated Biography*, 2nd ed. Bishop, Calif.: Companion Press, 2005.

Loring, John. *Magnificent Tiffany Silver.* New York: Harry N. Abrams, 2001.

Mann, James G. "The Scott Collection of Arms and Armour." *Burlington Magazine* 78 (January 1941): 22-23.

"A Marble Mystery." *Connoisseur*, March 1939, 165.

McMurry, Enfys. *Hearst's Other Castle.* Bridgend, Wales: Seren, 1999.

Meyer, Daniel. "A Chimneypiece from Saintonge." *Metropolitan Museum of Art Journal* 25 (1990): 27–32.

Middeldorf, Ulrich. *Sculptures from the Samuel H. Kress Collection.* New York: Phaidon, 1976.

Murray, Ken. *The Golden Days of San Simeon.* Garden City, N.Y.: Doubleday, 1971.

Nasaw, David. *The Chief: The Life of William Randolph Hearst.* New York: Houghton Mifflin, 2000.

Natoli, Marina, ed. *Luciano Bonaparte: Le sue collezioni d'arte.* Rome: Istituto Poligrafico e Zecca dello Stato, 1995.

Nikliss, Alexandra M. "Phoebe Apperson Hearst's 'Gospel of Wealth,' 1883–1901." *Pacific Historical Review* 71 (November 2002): 575–605.

Nouvel, Odile, and Véronique de Bruignac. "Papiers peints panoramiques." *L'estampille/ L'objet d'art,* no. 239 (September 1990): 46–55.

"Oceanhouse." *Architectural Digest* 12, no. 2 (1949): unpaged.

Oliver, Andrew, Jr. "Two Hoards of Roman Republican Silver." *Metropolitan Museum of Art Bulletin,* n.s., 23 (January 1965): 177–85.

Oman, Charles. Review of *English and Other Silver in the Irwin Untermyer Collection,* by Yvonne Hackenbroch. *Burlington Magazine* 106 (July 1964): 348.

Packard, Pamela M., and Paul A. Clement. *The Los Angeles County Museum of Art.* Corpus Vasorum Antiquorum, USA fasc. 18. Berkeley: University of California Press, 1977.

Parker, James. "Designed in the Most Elegant Manner…: The Chimneypiece from Chesterfield House." *Metropolitan Museum of Art Bulletin,* n.s., 21 (February 1963): 202–13.

Parmenter, Ross. *The Lienzo of Tulancingo, Oaxaca: An Introductory Study of a Ninth Painted Sheet from the Coixtlahuaca Valley.* Philadelphia: American Philosophical Society, 1993.

Patterson, Augusta Owen. "A Gothic Castle on Sands Point." *Country Life,* May 1932, 24–31.

Pavlik, Robert. "Something a Little Different." *California History* 71 (March 1, 1992): 467–72.

Peterson, Richard H. "The Spirit of Giving: The Educational Philosophy of Western Mining Leaders, 1870–1900." *Pacific Historical Review* 53 (August 1984): 309–36.

Pittman, Jennifer. "The Silver Legacy of William Randolph Hearst." *Silver Society of Canada* 4 (Fall 2001): 6–12.

Raggio, Olga. "The Lehman Collection of Italian Maiolica." *Metropolitan Museum of Art Bulletin,* n.s., 14 (April 1956): 187–89.

Randall, Richard, Jr. "Lusterware of Spain." *Metropolitan Museum of Art Bulletin,* n.s., 15 (June 1957): 213–21.

"Rare Furniture from the W. R. Hearst Collections." *Connoisseur,* May 1939, 288–89.

Raubitschek, Isabelle. *The Hearst Hillsborough Vases.* Exhibition catalogue, Stanford University Art Museum. Mainz: Philipp von Zabern, [1969].

Robinson, Judith. *The Hearsts: An American Dynasty.* San Francisco: Telegraph Hill Press, 1991.

Ruiz, María José Martínez. "Luces y sombras del coleccionismo: El conde de la Almenas." *Goya,* nos. 307–8 (July–October 2005): 281–94.

Schrader, J. L. "George Gray Barnard: The Cloisters and the Abbaye." Special issue, *Metropolitan Museum of Art Bulletin,* n.s., 37 (Summer 1979).

Schroder, Timothy. *The Gilbert Collection of Gold and Silver.* Los Angeles: Los Angeles County Museum of Art, 1988.

Seely, Jana. "Found but Not Lost." *Silver Magazine* 30 (May–June 2001): 20–25.

Seligman, Germain. *Merchants of Art, 1880–1960: Eighty Years of Professional Collecting.* New York: Appleton-Century-Crofts, 1961.

Smith, Matthew Wilson. "Joseph Urban and the Birth of American Film Design." In *Architect of Dreams: The Theatrical Vision of Joseph Urban,* by Arnold Aronson, 48–55. Exhibition catalogue. New York: Miriam and Ira D. Wallach Art Gallery, Columbia University, 2000.

Sterne, Margaret. *The Passionate Eye: The Life of William R. Valentiner.* Detroit: Wayne State University Press, 1980.

Swanberg, W. A. *Citizen Hearst: A Biography of William Randolph Hearst.* New York: Scribner's, 1961.

Toesca, Ilaria. "Un coffret parisien du XVIe siècle." *Gazette des Beaux-Arts* 66 (November 1965): 309–12.

Tomkins, Calvin. *Merchants and Masterpieces: The Story of the Metropolitan Museum of Art.* New York: E. P. Dutton, 1970.

Urrea, Jesus. "A New Date for the Choir Screen from Valladolid." *Metropolitan Museum of Art Journal* 13 (1978): 143–47.

"Valencian Lusterware of the Fifteenth Century." *Metropolitan Museum of Art Bulletin,* n.s., 29 (Summer 1970): 20–32.

Vicinelli, Susan. "An American History of the Marble Relief Sculptures from Sicily." *Bulletin of the Detroit Institute of Arts* 73, nos. 1–2 (1990): 55–59.

Vincent, Clare. "Precious Objects in Iron." *Metropolitan Museum of Art Bulletin,* n.s., 22 (April 1964): 272–86.

Watts, W. W. "The Hearst Collection of Silver." *Burlington Magazine* 73 (December 1938): xv–xvii.

Whittle, Elisabeth. "The Tudor Gardens of St. Donat's Castle, Glamorgan, South Wales." *Garden History* 28 (Summer 1999): 109–26.

Wildenstein, Daniel, and Yves Stavridès. *Marchands d'art.* Paris: Plon, 1999.

The William Randolph Hearst Collection: Photographs and Acquisition Records. New York: Clearwater Publishing, [1987?].

Woodbridge, Sally. *Bernard Maybeck: Visionary Architect.* New York: Abbeville, 1992.

———. "Wyntoon." *Architectural Digest,* January 1988, 99–103, 156.

Woosnam-Savage, Robert C. "The 'Avant' Armour and R. L. Scott." In *The Seventh Park Lane Arms Fair.* [London]: D. A. Oliver, [1990].

Research undertaken for this catalogue led to the identification of a multitude of works of art that had previously belonged to Hearst, which can now be found in various public and private collections. Limitations of space made it impossible to document all of them in this volume and even to list them individually below. To give the reader a sense of the breadth of the dispersal of Hearst's collections and to demonstrate that the quality of the art that he acquired was worthy of numerous museums, however, a summary list of locations where Hearst objects have been identified is provided here. Some museums will be recognized as lenders to this exhibition; most of them house many more Hearst objects beyond those mentioned in this book. This list is not comprehensive, as it reflects only the current state of research.

Particularly interesting works of art in these varied locations include the name vase of the Hearst Painter (Zurich); a Hellenistic bronze bed (Walters Art Museum, Baltimore); the largest (28⅜ in. [72 cm]) fifteenth-century monstrance in a German museum (Bonn); a cloister from Ávila now in Mexico City; the late seventeenth-century Ta'amra Maryam illuminated manuscript that belonged to Emperor Zyasu I of Ethiopia, which is perhaps today in Norway; and numerous objects better known as part of the Untermyer Collection in the Metropolitan Museum of Art.

EUROPE

AUSTRIA
Vienna: Sammlung für Plastik und Kunstgewerbe

BELGIUM
Brussels: Musées Royaux d'Art et d'Histoire

DENMARK
Copenhagen: Thorvaldsens Museum

FRANCE
Aurillac: Musée de Cire historial Haute Auvergne
Écouen: Musée national de la Renaissance
Paris: Musée du Louvre

GERMANY
Augsburg: Maximiliansmuseum
Bonn: Rheinisches Landesmuseum
Nuremberg: Germanisches Nationalmuseum

GREAT BRITAIN
Boston (Lincolnshire): Council Chamber, Municipal Buildings
Glasgow:
 Burrell Museum
 Kelvingrove Museum
Leeds: Royal Armouries
London:
 Gilbert Collection, Somerset House
 Victoria and Albert Museum

NETHERLANDS
Amsterdam: Rijksmuseum

NORWAY
Possibly Oslo, private collection

SWITZERLAND
Basel: Antikenmuseum und Sammlung Ludwig
Zurich: Archäologische Sammlung der Universität Zürich

NORTH AMERICA

UNITED STATES OF AMERICA
Various private collections

California
Berkeley: Berkeley Art Museum
Glendale: Forest Lawn Cemetery
Los Angeles:
 J. Paul Getty Museum
 Los Angeles County Museum of Art
 Natural History Museum of Los Angeles County
San Francisco:
 De Young Museum
 Legion of Honor Museum
San Marino: Huntington Library and Art Collections
Santa Barbara: University of California
Vina: New Clairvaux Abbey

Connecticut
New Haven: Yale University Art Gallery

Florida
North Miami Beach: Monastery of Sacramenia
Tampa: Tampa Museum of Art

Hawaii
Honolulu: Shangri-La Museum (Doris Duke Foundation for Islamic Art)

Illinois
Chicago:
 Art Institute of Chicago
 Smart Museum of Art

Kentucky
Louisville: Speed Art Museum

Maryland
Baltimore:
 Peabody Conservatory of Music
 Walters Art Museum

Massachusetts
Boston:
 Boston University
 Museum of Fine Arts
Cambridge: Fogg Art Museum, Harvard University
Northampton: Smith College Museum of Art
Williamstown: Sterling and Francine Clark Art Institute
Worcester: Worcester Museum of Art

Michigan
Dearborn: Henry Ford Museum
Detroit: Detroit Institute of Arts

Minnesota
Minneapolis: Minneapolis Institute of Arts

Missouri
Kansas City: Nelson-Atkins Museum
Saint Louis: Saint Louis Art Museum

New Jersey
Princeton: Art Museum, Princeton University

New York
Brooklyn: Brooklyn Museum
Corning: Corning Museum of Glass
New York City: Metropolitan Museum of Art

North Carolina
Raleigh: North Carolina Museum of Art

Ohio
Cincinnati: Cincinnati Art Museum
Cleveland: Cleveland Museum of Art
Toledo: Toledo Museum of Art

Pennsylvania
Philadelphia: Philadelphia Museum of Art
Pittsburgh: Carnegie Museum of Art

Rhode Island
Providence: Rhode Island School of Design

South Carolina
Greenville: Museum and Gallery at Bob Jones University

Texas
Dallas: Dallas Museum of Art
Fort Worth: Kimbell Art Museum
San Antonio: San Antonio Museum of Art

Virginia
Richmond: Virginia Museum of Art
Williamsburg: Colonial Williamsburg (Dewitt Wallace Decorative Arts Museum)

Washington, D.C.
National Gallery of Art

Wisconsin
Milwaukee: Milwaukee Art Museum

PUERTO RICO
Ponce: Museo de Arte de Ponce

BAHAMAS
Paradise Island: Cloister overlooking Nassau Harbor

MEXICO
Mexico City:
 Franz Mayer Museum
 Instituto Cultural Helénico

CANADA
Private collection

OTHER LOCATIONS

BRAZIL
São Paolo: art market, 1998

ISRAEL
Jerusalem: Israel Museum

NEW ZEALAND
Christchurch: University of Canterbury

ILLUSTRATION CREDITS

Most photographs are reproduced courtesy of the lenders of the material depicted. For certain artwork and documentary photographs, we have been unable to trace copyright holders. The publishers would appreciate notification of additional credits for acknowledgment in future editions.

All photographs of artworks in the collection of the Los Angeles County Museum of Art (LACMA) are credited as © 2008 Museum Associates/LACMA.

Front cover, p. 52: Reproduced from the Collections of the Library of Congress (LC-USZ62-111341). Photo by Underwood & Underwood; pp. 2–3, 47, 48, 76, 81, 83, 85, 86, 87, 111, 117, 119, 123, 133, 134, 137, 138–39, 140, 142, 143, 178, 180, 181, 182 (right), 188, 189, 193, 196, 197, 202, 203, 204, 205, 206, 207, 210, 211, 212 (bottom), 214, 216, 218, 219, 221, 222, 223, 226, 235, 241: Photo © 2008 Museum Associates/LACMA; p. 7: Photograph courtesy the J. Paul Getty Museum, Villa Collection, Malibu, California; p. 9: Photograph by Victoria Garagliano/© Hearst Castle®/CA State Parks (890-051); p. 12: Photo © Erich Lessing/Art Resource, NY; p. 13: Image © 2008 Board of Trustees, National Gallery of Art, Washington, D.C., photo by Philip A. Charles; p. 14: Courtesy the Malcolm Wiener Collection; pp. 15, 98, 126: Photograph by The J. Paul Getty Museum, Los Angeles; p. 17: Photo courtesy Fortune magazine/Time Inc.; p. 18: Photo courtesy Culver Pictures (PEO073 CP003 005); p. 19: Photo by Grey Villet/Time Life Pictures/Getty Images; p. 20: Image © Board of Trustees, National Gallery of Art, Washington, D.C.; p. 21: Image courtesy of the Board of Trustees, National Gallery of Art, Washington, D.C., photo by Lyle Peterzell; p. 22: © The Gilbert Collection; p. 23: Photograph courtesy of author (56.234.1); pp. 24 (left), 51: Photograph © The Metropolitan Museum of Art; p. 24 (right): Courtesy of The Bancroft Library, University of California, Berkeley (POR 1). Photograph by Edouart & Cobb; pp. 25 (top), 159,

163 (right): © 1994 The Detroit Institute of Arts; pp. 25 (bottom), 168: Photograph © 1984 The Metropolitan Museum of Art; p. 26: Photograph by Victoria Garagliano/© Hearst Castle®/CA State Parks (495-40); pp. 27, 28 (right), 32, 60, 61, 65, 66–67, 69, 71 (right), 127, 141, 153 (top), 155, 185, 186, 228, 229, 230, 231: Photograph by Victoria Garagliano/© Hearst Castle®/CA State Parks; p. 28 (left): Courtesy of The Bancroft Library, University of California, Berkeley (5). Photograph by Sarony, New York; p. 29: Reproduced from the Collections of the Library of Congress (LC-USZ62-56690). Photo by Frances Benjamin Johnston; p. 30: Photograph courtesy Victoria Garagliano/Hearst Castle®/CA State Parks (405H); p. 33: Photo courtesy Museo Franz Mayer; p. 35: Photo by Brooklyn Museum, Brooklyn, New York; p. 36: Photo Antiquest Inc. J. P. Tombro, New Jersey; p. 37: Photo by Minneapolis Institute of Arts; p. 38: Photo by Rijksmuseum, Amsterdam; p. 39: Collection of The New York Historical Society (80652d); p. 43: Reproduced from the Collections of the Library of Congress (LC-USZ62-44219). Photo by Underwood & Underwood; pp. 44, back endsheets: Photograph © 1992 The Metropolitan Museum of Art; p. 45: Collection of The New York Historical Society (80498d); pp. 49, 166, 198, 199, 200, 201, 212 (top), 217: Photograph © 2008 The Metropolitan Museum of Art; p. 50: Photo courtesy Museo de Arte de Ponce, Puerto Rico; pp. 53, 170, front endsheets: Photo by Fine Arts Museums of San Francisco; p. 55: Photograph by Victoria Garagliano/© Hearst Castle®/CA State Parks (615-055); p. 56: Photograph by Victoria Garagliano/© Hearst Castle®/CA State Parks (529-9-1571); pp. 58, 59, 147, 148, 149, 150, 151, 152, 153 (bottom), 156, 157, 213, 227: Photo courtesy Museum Associates/LACMA; p. 62: Photograph by Victoria Garagliano/© Hearst Castle®/CA State Parks (DFN5132); p. 70: Photograph by Victoria Garagliano/© Hearst Castle®/CA State Parks (465-057); p. 71 (left): Photograph © 2005 The Metropolitan

Museum of Art; p. 75: Courtesy Everett Collection; p. 77: Courtesy of the Academy of Motion Picture Arts and Sciences. Photo by Clarence Sinclair Bull (B2950); p. 80: Courtesy of the Academy of Motion Picture Arts and Sciences. Photo by Clarence Sinclair Bull (B4286); p. 82: Courtesy of the Academy of Motion Picture Arts and Sciences. Photo by Clarence Sinclair Bull (B4280); p. 84: Courtesy of the Academy of Motion Picture Arts and Sciences. Photo by Clarence Sinclair Bull (B4285); p. 89: Photo © Country Life, courtesy Country Life Picture Library (12151); p. 90: Photo © Country Life, courtesy Country Life Picture Library (L6616); p. 92: Photo © Country Life, courtesy Country Life Picture Library (15094); p. 93: © North Carolina Museum of Art (52.9.8); p. 95: Photo © The Makins Collection/The Bridgeman Art Library (MAK87467); p. 96: Photo © Country Life, courtesy Country Life Picture Library (526034); p. 97: Photo courtesy The Bridgeman Art Library (YBA136234); p. 101: Photo © Thorvaldsens Museum; p. 102: Photo © Culture and Sport Glasgow (Museums) (E.1939.65.e); pp. 103, 146, 158, 160, 161, 165, 167: Photo © The Royal Armouries, Leeds; p. 105: Reproduced from the Collections of the Library of Congress (LC-USZ62-34493). Photo by Irving Underhill; p. 106: Photograph owned by the B. Davis Schwartz Memorial Library, Long Island University, C. W. Post Campus (hearst_110_lot823_art1); p. 108: Photograph owned by the B. Davis Schwartz Memorial Library, Long Island University, C. W. Post Campus [hearst_110_lot702_art6-11-15(1)]; p. 109: Photo © Danny Bright; p. 110: Photograph owned by the B. Davis Schwartz Memorial Library, Long Island University, C. W. Post Campus [hearst_110_lot226_art1(1)]; p. 112: Kimbell Art Museum, Fort Worth, Texas/Art Resource, NY; p. 113: Photo courtesy Christie's, London; pp. 115, 116: Photograph © and courtesy of Richard Barnes; p. 121: Tim Street-Porter/Architectural Digest/© Condé Nast Publications; p. 124:

Photo courtesy Pace Wildenstein Gallery, New York; p. 128: Photo © The Colonial Williamsburg Foundation (1938-42); p. 129: Photo courtesy Fine Arts Museums of San Francisco; p. 131: Photo © The Cleveland Museum of Art; p. 136: Photo © Natural History Museum of Los Angeles County; pp. 145, 164: Photograph © 1990 The Metropolitan Museum of Art; p. 163 (left): © 1995 The Detroit Institute of Arts; pp. 169, 179, 183: Photograph © 2008 Museum of Fine Arts, Boston; p. 173: Photo courtesy The Speed Art Museum, Louisville, Kentucky; pp. 177, 184: Photo © Toledo Museum of Art; pp. 182 (left), 238: Photo © The Walters Art Museum, Baltimore; p. 209: Photo by Sotheby's Picture Library (CM7400 Koeppe); p. 232: Photograph © 2003 The Metropolitan Museum of Art; p. 233: Photo courtesy of the Huntington Library, Art Collections, and Botanical Gardens, San Marino, California; p. 237: Photograph © 1998 The Metropolitan Museum of Art; p. 244: Photo courtesy Lynda and Stewart Resnick; Back cover: Photograph by Victoria Garagliano/© Hearst Castle®/CA State Parks (DFN5237)